SIENA, FLORENCE AND PADUA:
ART, SOCIETY AND RELIGION 1280–1400

SIENA, FLORENCE AND PADUA:
ART, SOCIETY AND RELIGION 1280–1400

Volume II: Case Studies

Edited by Diana Norman

Yale University Press, New Haven & London
in association with The Open University

Library of Congress Cataloging-in-Publication Data

Siena, Florence, and Padua: art, society, and religion 1280–1400/
edited by Diana Norman.
p. cm.
Includes bibliographical references and index.
Contents: v. 1. Interpretative essays -- v. 2. Case studies.
ISBN 0-300-06124-2 (v. 1: hb) -- ISBN 0-300-06125-0 (v. 1: pb)
-- ISBN 0-300-06126-9 (v. 2: hb) -- ISBN 0-300-06127-7 (v. 2: pb).
1. Art, Italian. 2. Art, Gothic -- Italy. 3. Art, Early Renaissance -- Italy. 4. Art and society -- Italy.
5. Art patronage -- Italy. 6. Art and religion -- Italy. I. Norman, Diana, 1948-
N6913.S53 1995
701'.03'094509023--dc20 94-25653
 CIP

Edited, designed and typeset by The Open University

A354vol2i1.1

Printed in Singapore by C.S. Graphics PTE Ltd
1.1

Contents

List of plates

Preface

This book is the second of two volumes on the relationships between art, religion and society in Siena, Florence and Padua from 1280 to 1400. It is published by Yale University Press in association with the Open University. The essays in both volumes were written with the needs of Open University undergraduate students primarily in mind. However, the authors hope that they will also be of value to other readers with an interest in this subject.

The illustrations within each volume are accompanied by captions which supply essential information concerning the identity of the artists (where known); the dates at which the works of art are thought to have been executed; the medium and scale of the works; and both their present and (where known) original locations. The measurements of many sculptures and frescoes have proved impossible to obtain. In these cases the authors have endeavoured to indicate the broad scale of the works concerned within the text of the essays.

The authors wish to acknowledge the essential contribution made to the production of both volumes by a number of other members of Open University staff: Roberta Wood (course administrator), Julie Bennett, Abigail Croydon, Jonathan Hunt and Nancy Marten (editors), Tony Coulson (librarian), Sarah Hofton and Richard Hoyle (designers), John Taylor (graphic artist) and Sophie White (course team secretary).

The authors also wish to thank Professor Martin Kemp for his careful and constructive comments on the first drafts of all the essays within these two volumes. Additionally they wish to thank Louise Bourdua, Paul Davies, Christa Gardner von Teuffel, Dillian Gordon, Laura Jacobus, Andrew Martindale and Gervase Rosser for critical comments on the first drafts of particular essays. Each of the authors has benefited from the criticisms and observations made by these readers. Any inaccuracies or questionable judgements that remain are the responsibility of the authors alone.

The authors of the essays in the two volumes are:

Diana Norman (Lecturer in Art History, The Open University)

Tim Benton (Professor in Art History, The Open University)

Colin Cunningham (Staff Tutor in Art History, The Open University)

Charles Harrison (Staff Tutor and Professor in the History and Theory of Art, The Open University)

Catherine King (Senior Lecturer in Art History, The Open University).

Case studies in context

In the last years of his life the celebrated nineteenth-century historian Jacob Burckhardt wrote three long essays on the art of the Italian Renaissance. He had originally planned to write a full volume to accompany his pioneering history, *The Civilisation of the Renaissance in Italy*. The three essays emerged from the material he had been collecting for this second volume. The essays – on collecting, portraiture and altarpieces – were published together in 1898, the year after their author's death.[1] The approach embodied in them was typical of Burckhardt. The major innovation in his earlier work – subsequently acknowledged as one of the great historical works of the nineteenth century – had been the thematic rather than chronological organization of the material. As an English editor of his work has observed:

> instead of narrating a sequence of events, he gradually built up a composite picture of the most significant aspects of Italian Renaissance life (political institutions, attitudes towards the individual, the revival of classical antiquity, the rediscovery of external nature, attitudes to religion, etc.).[2]

The uncompleted account of Renaissance painting was similarly conceived not as a chronology beginning with the thirteenth-century painter Cimabue and ending with the sixteenth-century painter Veronese, but as a 'composite picture', built around such topics as 'external conditions', 'techniques and media', 'types of composition', 'methods of animation and dramatization' and 'painting according to tasks' (*Aufgaben*). The last of these topics was to have been subdivided under such categories as 'pictures for confraternities', 'pictures for hospitals', 'secular history paintings' and 'altarpieces'. In 1988 the essay on altarpieces was published in an English translation for the first time, under the title *The Altarpiece in Renaissance Italy*. The publication of this translation was no more than a belated recognition of the enormous influence already exerted by Burckhardt's essays and their methodology. Art historians concerned with the ways in which the social and intellectual environments of artists in the Italian Renaissance affected their work are deeply indebted to Burckhardt's approach. Such indebtedness is particularly apparent in recent studies of the Italian Renaissance altarpiece,[3] but it is also evident in other aspects of recent and contemporary scholarship on Italian Renaissance art.

Much of the appeal of Burckhardt's work lay in the fact that he did not study Italian Renaissance art simply from the perspective of the work of a particular artist or school, or a particular historical phase or style. Instead he approached the art of the period as a history of *Aufgaben*. The term eludes precise translation into English, but it appears from Burckhardt's own explanations that he saw it as signifying the kinds of artistic challenge – or task – posed by particular types of commission. Both commission and 'task' were defined by the work's secular or religious function. For example, painters awarded commissions for altarpieces in the fourteenth century faced challenges that could not be resolved simply by recourse to personal aesthetic preference or technical skill. Artists had to work within well-established traditions of altarpiece painting, in which particular liturgical and devotional requirements had to be met. Similarly, they had to be aware of the religious significance of the subject-matter and bear in mind the representational repertoire of holy figures, concepts or narratives conventionally associated with that subject. And in addition to these factors, they had to accommodate the preferences, wishes and intentions of the commissioning patron. This, then, was the artist's original *Aufgabe* or task.

In Burckhardt's view, the art historian was also faced with a task – namely to reconstruct from the works of art themselves and other kinds of historical evidence what these original challenges had been and how artists had responded to them. It is precisely the close interdependence of artistic form, content and function implied by the concept of *Aufgaben* that has persuaded a number of art historians of the continuing validity of Burckhardt's model for present-day art-historical research.[4]

In his work on Italian Renaissance culture, Burckhardt ranged over the entire Italian peninsula, referring to individual cities only as elements within a broader pan-Italian perspective. In this volume and its companion the focus is narrowed to the art of three particular cities: though this, however, is no more than an extension and adaptation of the underlying principle of Burckhardt's work. Indeed, Martin Wackernagel, one of his successors, chose the art of one of the cities studied in the present volume – Florence – for study in an influential work published in 1938. As the title of the work indicates, Wackernagel was indebted to Burckhardt's interest in the 'tasks' and 'problems' that particular projects or commissions presented for the artist, and he duly acknowledged his debt both to *The Civilisation of the Renaissance* and to Burckhardt's later essay on Renaissance collectors.[5]

The narrowing of focus implied by Burckhardt's essays on altarpieces and portraits and Wackernagel's study of the art of fifteenth-century Florence carries a number of distinct advantages for the student of Italian Renaissance art. Given that one of the major objectives of art history is the close visual study of objects – whether executed in paint, wood, stone or metal – such an approach allows a greater concentration and focus upon a defined and select number of works of art. Furthermore, as a glance at the contents page of either Burckhardt's essay on the Renaissance altarpiece or Wackernagel's study of fifteenth-century Florentine art clearly reveals, their approaches encompass an extraordinary range of objects and encourage great versatility in the study of Italian Renaissance art. Burckhardt's essay on altarpieces ranges over such diverse topics as sculpted altarpieces, polyptychs, donor portraits within altarpieces, narrative

altarpieces, scenes from the life of the Virgin and scenes from the lives of the saints. Wackernagel's much longer work considers Florence's cathedral and baptistery, the city's town hall, sculpture for church and domestic buildings, wall paintings, panel paintings, banners and vestments.

Today we would probably be inclined to characterize this as a case-study approach. With its inherent versatility, such an approach offers considerable potential. It facilitates the study of a single work of art from a variety of distinct perspectives – aesthetic, technical, religious, social or political, for example. It demands due attention to the wider contexts of the commissioning, production and reception of works of art, and it obliges recognition of the multiple meanings and significances which may be attributed to a particular painting, sculpture or building. In this volume, the case-study approach is deployed on two levels simultaneously. First, the essays focus upon the art of three specific cities, Siena, Florence and Padua; secondly, the case-study method is carried a stage further by examining particular works of art within each city.

The first essay accordingly takes as its starting point the urban development of the three cities. The comparison which results enables the reader to assess the impact of the early economic and political histories of the three cities upon their subsequent growth and development, taking into account the role of foundation myths in shaping each city's sense of urban identity. It also allows the reader to consider, in turn, such salient factors as the cities' strikingly different geographical locations and the effects of both local materials and building traditions upon their respective urban topographies. The study of particular categories of civic building is similarly instructive. The second essay in this volume considers the town halls of each of the three cities – a topic which acts as an architectural analogue to Burckhardt's studies of altarpieces and portraits. As a class of buildings designed with a number of varied but specific functions in mind – residential, judicial, governmental and commercial – town halls had certain features in common. In spite of such 'family' likenesses, however, they also exhibited great variety in terms of design and architectural repertoire – in itself often a reflection of specifically local conditions. Thus, the Palazzo Pubblico in Siena, the Palazzo Vecchio in Florence and the Palazzo della Ragione in Padua – and the urban spaces in which they are situated – are shown to belong to a more general development of major secular, civic building projects. Yet each of these impressive buildings also presents a highly individual example of a town hall designed with local architectural forms and functions firmly in mind.

A second major type of fourteenth-century building – the *duomo* or cathedral – provides the subject for the sixth essay, which compares the design and structure of the cathedrals of Siena and Florence. A key aim of this essay is the reconstruction of the kinds of *Aufgaben* faced by the designers and builders of these complex projects. Using the available evidence, the essay speculates on how the designers, builders and sculptors resolved a variety of seemingly intractable difficulties in the construction and embellishment of these buildings.

The third essay focuses upon the *Maestà* – the early fourteenth-century monumental altarpiece by the Sienese painter Duccio – and shows how Burckhardt's concept of *Aufgaben* can assist in the study and investigation of a single, complex painting. This composite work, which once comprised over 50 paintings unified within a single architectonic frame, survives today as a number of separate panel paintings. The task facing the modern art historian, therefore, is one of detailed reconstruction, utilizing a wide variety of techniques and types of evidence. The dismembered remains of the altarpiece have been subjected to detailed technical investigation in order to reconstruct its original appearance and design. Similarly, art historians have painstakingly reconstructed the probable order and organization of the narrative sequence of the numerous paintings incorporated into this one altarpiece. Detailed attention has also been given to the location of the altarpiece above the high altar of Siena Cathedral and its consequent function as a monumental civic and religious icon. Such acts of historical reconstruction are also dependent upon the ability to situate the *Maestà* within a 'family' of other comparable works of art – including both altarpieces and extended narrative cycles of religious imagery.

The altarpiece as a specialized type of painting provides the subject of the ninth essay, which re-examines Burckhardt's original perception that the altarpiece is a highly versatile form, capable of serving a variety of liturgical, devotional and patronal requirements. The essay discusses the production of specifically Marian altarpieces by fourteenth-century Sienese, Florentine and Paduan painters. It argues that during the first half of the fourteenth century, Sienese painters produced a number of highly influential designs and formats specifically conceived for key ecclesiastical sites in Siena and other neighbouring cities. Such was the success and prestige of these early fourteenth-century altarpieces that Sienese artists later in the century tended to adopt a deliberately similar range of conventions in subsequent altarpiece commissions. Acknowledging the predominance of Sienese precedents, the essay explores the extent to which altarpiece painters – including those in Siena – were also influenced by or indebted to Florentine and Paduan traditions of altarpiece painting.

The study of fourteenth-century sculpture is similarly susceptible to analysis in terms of genre – for example, the tomb, reliquary or equestrian monument.[6] As with the discussion of the altarpiece, one of the major virtues of this approach is that it allows consideration of the designated functions of such sculpted monuments and the role of commissioners and patrons in determining their final form. In order to examine examples of the kind of artistic challenge faced by sculptors, the fifth essay studies a particular representational type – 'the body'. Surveying a range of fourteenth-century sculptures – notably tomb monuments, reliquaries and sculptures of Christ and the Virgin Mary – the essay reviews concepts and attitudes concerning 'the body' and its representation within fourteenth-century Italian culture.

The fourth essay in this volume provides another example of the advantages of focusing upon a single work of art in its historical context, in this case an entire fresco cycle covering the wall of a substantial privately owned chapel. Any survey of the period would give ample consideration to Giotto's mural scheme for the Arena Chapel, which is generally

considered a landmark in the western tradition of painting; the fourth essay asks how far Giotto himself was personally responsible for the overall conception and design of the painted scheme. In order to assess the nature of his contribution, the essay considers the technical and organizational demands involved in the execution of an extended cycle of fresco paintings; the potential offered by the building itself; and the role of the patron, the Paduan merchant Enrico Scrovegni, in the conception of the subject-matter and the choice of religious imagery.

The case study of the paintings in the Sala dei Nove in the Palazzo Pubblico, Siena, presented in the seventh essay, provides a second example of the analysis and interpretation of an entire fresco scheme. Like the study of the Arena Chapel paintings, it too examines the complex interplay of influences between the painter, Ambrogio Lorenzetti, and the commissioners of the scheme, namely Siena's principal governing body. In this instance, however, the imagery is designed to express and exemplify the civic identity, values and ideology of a fourteenth-century Commune. By contrast with the Arena Chapel cycle, the subject-matter is thus primarily and predominantly – though not exclusively – secular in nature and significance.

The fresco cycle in the Sala dei Nove was by no means unique in its attempt to portray a complex body of ideas in visual terms. Other fourteenth-century artistic monuments similarly attempted to depict equally elaborate intellectual concepts. The tenth essay examines two such works of art, both located in Florence. The essay compares and contrasts the sculpted reliefs on the Campanile of Florence Duomo with the mural painting of *The Triumph of Saint Thomas Aquinas* in the chapter-house of the Dominican priory of Santa Maria Novella, and explores the distinctive way in which each work of art expressed contemporary perceptions of knowledge, its organization and dissemination.

Patronage, an important factor in the study of fourteenth-century art – and hence addressed implicitly in most of the essays in this volume – is the explicit subject of the eighth case study. The essay examines specifically familial patronage of art from the perspective of two fourteenth-century funerary chapels – the Baroncelli Chapel in Santa Croce, Florence and the Chapel of Bonifacio Lupi in Sant'Antonio, Padua. Funerary chapels, founded by one or several individuals acting on behalf of their family, constitute one of the most decisive and fruitful expressions of this kind of patronage. These particular chapels – both located within major Franciscan churches – raise a number of pertinent issues, including the precise circumstances of the commissions and the role of the patron or patrons; the extent to which the Franciscan context impinged upon the private and familial functions of the artistic schemes; and the possibility that the Paduan commission allowed for a more overt display of the patrons' personal aspirations and familial status than was possible in a Florentine context.

Patronage is also central to the final essay in the volume. Most of the works of art discussed in the various essays were commissioned by men – that is, by patrons who enjoyed a variety of political, economic and cultural privileges within the predominantly patriarchal society of fourteenth-century Siena, Florence and Padua. The final essay focuses upon women as patrons in the fourteenth century. In so doing it considers three broad groups of women – those of royal or noble rank, abbesses and their communities of nuns, and widows – whose social positions allowed them to commission art for both public and more private venues. It thus challenges conventional assumptions about the production and reception of fourteenth-century art and suggests a number of new avenues of intellectual inquiry within this particular field.

The essays in this volume are, therefore, indebted to the case-study approach pioneered by Burckhardt and seek to explore the continuing potential of this method of study. They share also with Burckhardt the underlying belief that fourteenth-century Italian art should be studied not narrowly as a self-sufficient tradition of artistic styles, techniques and interpretative skills, but broadly, bearing in mind the ways in which artistic concerns were affected by wider social, political, intellectual and cultural contexts. How, then, do the essays in this volume differ from Burckhardt's own use of the case-study approach? Burckhardt's work was completed nearly a century ago, and his interpretations are inevitably constrained by a variety of assumptions typical of his generation. He remained an adherent of that Vasarian teleology of the history of artistic development[7] which read Italian Renaissance art in terms of a steady progression – beginning with Giotto to be sure, but culminating in the achievements of the sixteenth century. For Burckhardt, the fourteenth century may have included moments of advance and progress in artistic achievement, but in the end it remained no more than a prelude to the 'Golden Age' of the early sixteenth century and, above all, the art of Raphael.[8] Similarly, despite his attention to questions of context, his analysis of the art of the Italian Renaissance remained essentially 'formalist': questions of style and aesthetic evaluation retained a marked priority. Even in his essay on the altarpiece, passage after passage recommended the reader to give careful and leisurely scrutiny to particular pictorial details.[9] The various works of art were still examined rather as if they were paintings or sculptures in a gallery, not as functioning artefacts possessed of particular religious and cultural roles and meanings as well as aesthetic qualities and artistic merits.

The case studies presented here are no doubt also marked by the preoccupations and predilections of their authors and their own late twentieth-century context. They nevertheless seek to emulate Burckhardt's example not least by challenging his own limited perspective on fourteenth-century art. Thus, if the essays in this volume are distinguished by any common convictions, these would include a determination to locate the works of art studied firmly within their fourteenth-century contexts, attending to their religious, civic, political or familial significances, allowing that their origins lay in particular desires and aims on the part of patrons and that their artistic merits were as much a matter of the successful fulfilment of such aims as of the achievement of aesthetic or stylistic 'quality'. Similarly, the present essays seek to read and interpret the artistic legacy of fourteenth-century Siena, Florence and Padua not as the prelude to a greater era in Italian art, but rather as an impressive testimony to a civic, religious, intellectual and artistic culture well worthy of study and appreciation in its own, unqualified right.

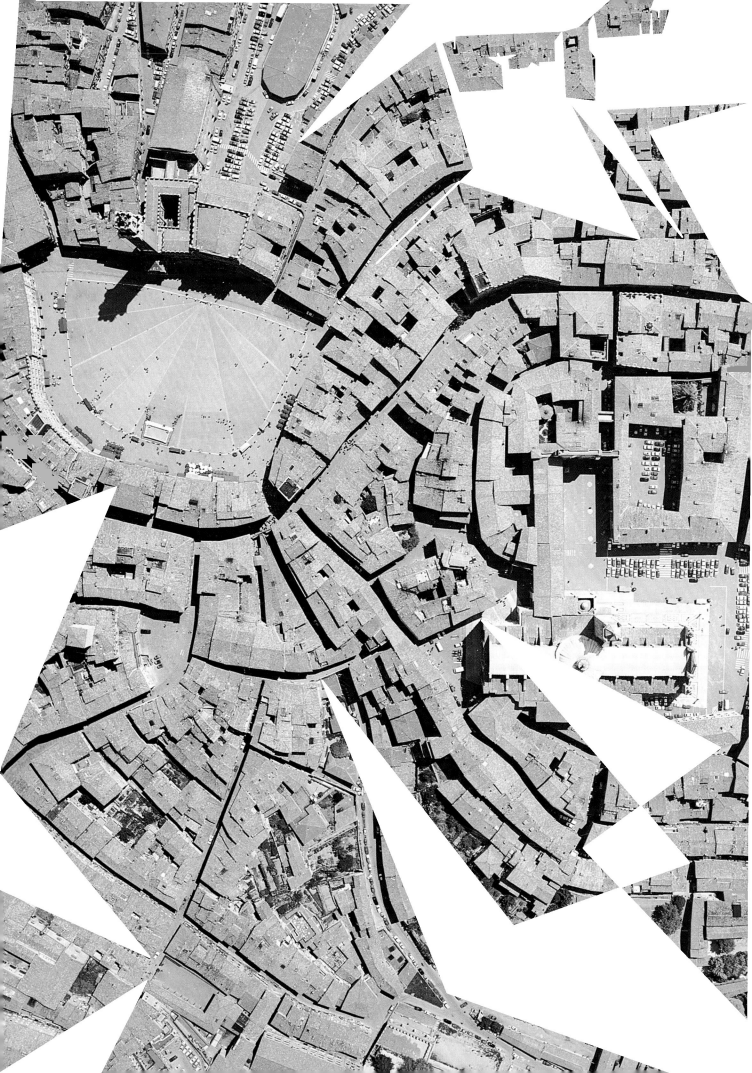

The three cities compared: urbanism

Every city has a character of its own, but it is an open question what significance to draw from this unique individuality.

> Individual institutions have always tried to express the ideals that quickened them. Monumental buildings propagandise for forms of government. They also propagandise for forms of coexistence and for the comprehension of the world and the ultramondane by means of everything that is called art. … The architectural form of churches, city palaces or town halls, cloth merchants' halls and guildhalls, even the fountain in the market place and its sculpture, bears witness to the meaning of those ideologies. Castle, city walls and their gates, interpret and justify existing orders – or even orders which are sought after. They define ideal notions in an imperishable language and in this way give them a higher reality.[1]

The three cities selected for study appear at first glance particularly distinctive, one from another. Siena's hilltop location, its winding streets and blood red brick walls (Plate 1) make a striking contrast with the river valley location of Florence, its more geometrically ordered streets and buff and grey stone walls (Plate 2). Padua, again, makes a notably different impression, with its network of canals, rendered walls and porticoed streets (Plate 3). These differences can partly be accounted for by the facts of topography, the availability of local building materials, the influence of nearby centres (for example, that of Pisa and Lucca on Florence and Siena and of Venice and Verona on Padua) and the different fates of the cities as they survived the Ostrogothic, Lombard and Hun incursions of the so-called Dark Ages. However, beyond these material factors, it is possible to talk about a distinct urban culture in each city, the tangible expression of a fiercely partisan identity, finding shape not only in buildings and decorative sculpture, but in new piazzas, streets and public amenities.

At the same time, it can be said that these cities shared important elements of their political, economic and social histories. Each city was founded in Roman times or before, sacked repeatedly afterwards, developed under the control of local bishops or counts, occasionally drawn into Ghibelline, pro-imperial alliances, furthering the ambitions of Holy Roman Emperors in their struggles with the papacy, and emerged during the twelfth and thirteenth centuries as an independent Commune, usually committed to the Guelph, pro-papal cause, with its own statutes, seals and coinage. The transition to fully independent Commune was not a smooth one. During the twelfth and thirteenth centuries, individual magnate families had acquired great local power and many areas of the cities were virtually closed enclaves, 'no-go' areas to those from other districts. The communal administrators

won control over these families and the troublesome districts only slowly and with great difficulty. In each case, the cities fell under the dominion of *signori*, for longer or shorter periods. In each case, their populations grew dramatically during the second half of the thirteenth century, probably levelled off before the epidemics of the Black Death, which began in 1348, and then lost between half and two-thirds of their numbers. In each case, a great new cathedral, a town hall and public squares were founded or enlarged in the late thirteenth or early fourteenth centuries. Each city shows a similar pattern of large mendicant churches built outside the walls in the thirteenth century (Plates 6, 14 and 26), to be enclosed within great new walls in the fourteenth century. In each case, the bristling towers of the aristocratic families were cut down by civic decree during the thirteenth century. In the end, the three cities were more like each other than like any other city north of the Alps. They traded with each other, shared news, exchanged exiles, officials and intellectuals, and fought with and against each other.

We might summarize by observing that each city underwent similar pressures and urban processes but with different fortunes and to a slightly different timescale. A common theme is the sense in which each city's urban development was determined in part by its past history, real and mythological, and in part by explicit policy decisions taken by its governing classes.

MYTH, TRADITION AND POLITICAL ASPIRATIONS

Essential for a sense of identity, for all the north Italian city states, was a foundation myth capable of comparison with that of Rome, and an evolving modern mythology of heroic struggles against tyrants and hostile neighbours. Siena, Florence and Padua had both, and the different forms that these took reveal important differences in their real and imagined histories.

Of the three cities, Siena had least claim to significant status in antiquity. The Florentine chronicler Giovanni Villani[2] has the city founded by the aged and infirm camp followers of the Senoni Gauls, left behind during the Gauls' descent on Rome. A more flattering myth identifies the founders as Seno and Aschio, sons of one of the mythical founders of Rome, Remus. Siena's adoption as a civic emblem of the she-wolf suckling twins, borrowed from Rome, refers to this story.

The thirteenth-century *Chronica de Origine Civitatis* attributed the foundation of Florence under Julius Caesar to the 'flower of Roman manhood'.[3] The city did, indeed, have an important history in Roman times, reaching a size of some 37 hectares and a population of more than 10,000. Both this

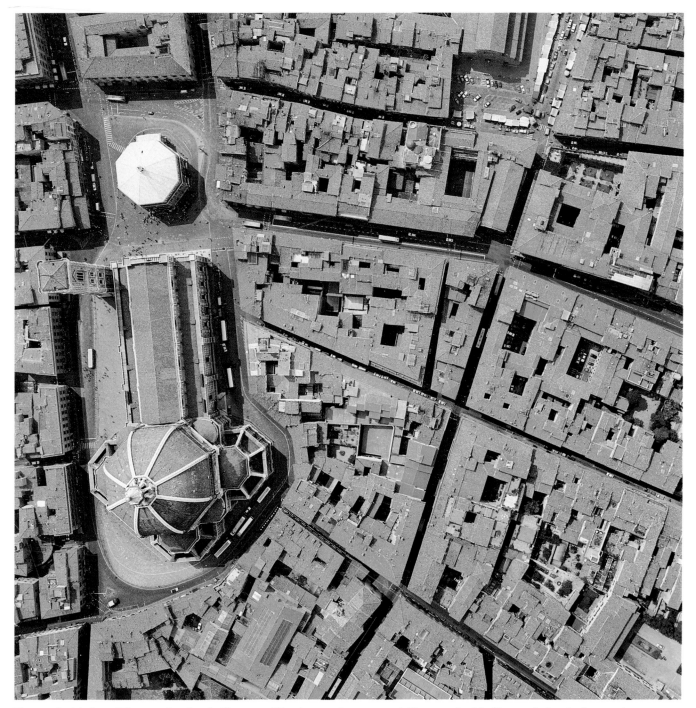

Plate 2 Aerial view of Florence, showing the Duomo and Baptistery and new streets laid out north of the Duomo during the fourteenth century. Photo: Index/Compagnia Generale Ripresearee.

modest anonymous chronicle and the more ambitious fourteenth-century history by Giovanni Villani and his son Matteo sought to link the Roman foundation to a Christian restoration after the ravages of the barbarians in the fifth century.[4] To fourteenth-century Florentines, proof of continuity between the Roman foundation and the Christian present was the supposed first cathedral, the baptistery (Plate 2), dedicated to John the Baptist, where every male Florentine was baptized. This building was thought by Villani and others to have been built in Roman times as a temple to the god Mars and to have withstood the siege of Florence by Totila the Hun (c.550).

The ancient Roman writers Livy and Virgil both repeat the myth of the foundation of Padua by Antenor, a refugee from Troy. It is true that Roman Patavium (Padua) was an imposing city with as many as 50,000 inhabitants and a large, colonized hinterland, perhaps the second city of the Empire.[5] The memory of this glorious past played an important role in fourteenth-century history and urban planning. The desire, by architects and intellectuals of the Commune, to find some means of expressing the dignity and antique renown of Patavium in the resurgent Padua can be identified in the episode of the so-called Tomb of Antenor. In 1274, during the rebuilding of the Ponte di San Lorenzo and the excavation of

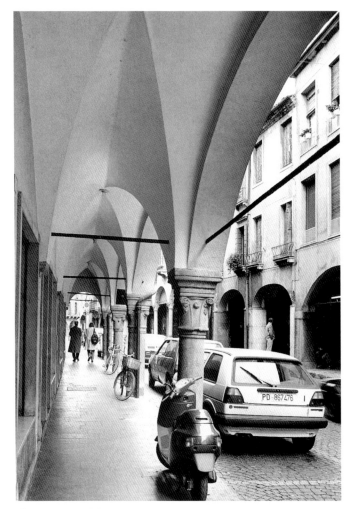

Plate 3 View of the Via Vescovado, Padua, showing medieval 'porticoes'. Photo: Tim Benton.

the old Roman bridge, a leaden casket containing a wooden coffin with the skeleton of a soldier was unearthed along with two vases of Roman coins. The judge Lovato dei Lovati decided that the skeleton was that of none other than Antenor, the mythical founder of Padua. In 1283–85 the engineer Leonardo Bocaleca was asked to build a protective canopy over the casket and it survives to this day. This is a potent image of the interrelationship between genuine scholarship, the process of rediscovering the Roman history and archaeology of the city, and a mythical past.

The idealistic yearning to rebuild the peace and authority of Roman antiquity was one of the factors that fuelled Ghibelline politics, whose proponents looked to the Holy Roman Emperors (usually Germans) to restore the Empire. However, increasingly during the thirteenth and fourteenth centuries, the realism of commercial and banking interests in all three cities dictated the adoption of Guelph policies. In practice, on a day-to-day basis, Guelph–Ghibelline conflicts invariably turned on jealousies and long-nurtured feuds between neighbouring towns or families. Nowhere was this conflict of aspirations more curiously the case than in Siena. During the thirteenth century Siena espoused the Ghibelline cause by contrast with Guelph Florence. In the famous victory of Montaperti in 1260, the Sienese beat a superior Florentine army, with imperial assistance. For a brief period Siena

dominated Tuscany and precipitated a mass exile of Guelph families from Florence. Throughout the fourteenth century, however, the practical politics of Siena was Guelph, although the imperial cause retained the charismatic appeal of independence from Florence. For Florence Dante advocated a hopelessly idealistic Ghibelline policy and described his native city as: 'Florence, most beautiful and renowned daughter of Rome'.[6] Of Padua, too, the chronicler Rolandino could write in 1262: 'Cannot … Padua now be called a second Rome?'[7] – in spite of the fact that he was celebrating the Guelph-assisted liberation of the Commune from the tyranny of Ezzelino III da Romano (1237–56), whose claim to the *signoria* (lordship) was in the name of the Holy Roman Empire. The appeal of the ideal of order and stability associated with the Roman Republic and Empire was, therefore, capable of uniting Guelph and Ghibelline sympathizers.

The remains of a landed feudal aristocracy, whose castles and lands often extended beyond the territorial limits of individual city states, still existed in the fourteenth century. These noble families all claimed their titles from eighth-century Carolingian or subsequent emperors. Strictly controlled within the cities by the emergent Communes, they were still able to play an important role in political life, as Podestà (the chief law officer and head of the local judiciary), ambassadors and generals, and by assimilation into the Popolo (the non-patrician or merchant class) through marriage and membership of guilds or the judiciary. Thus, in the fourteenth century, the exercise of military, political and economic power was not understood as a purely pragmatic matter. Men looked to antiquity, to the Carolingian epics, to the history of the Lombard kings and to the lives of the saints for instruction and example. Their cities reflected these aspirations as much as the purely material ones of independence, political aggrandizement and economic success.

GROWTH OF THE CITIES

Siena

Siena may well have been Etruscan in origin, and as late as the first century A.D. Pliny the Elder refers to it as an Etruscan colony. However, the city was made a Roman colony, probably under the Emperor Augustus (27B.C. – A.D.14), and given authority over a large territory in the midst of a group of older and established Etruscan cities. Virtually nothing survived of the Roman city, as built form, but the tradition persisted of referring to the fortified town on one of its hills as the *castrum*. This, together with the buildings occupying the adjoining hill, formed the basis of the fortified secular and religious stronghold of the city. What raised Siena from a minor Roman outpost to one of the most important city states in Italy, however, was the Via Francigena, the road from the north via Lucca to Rome.[8] The road came to prominence during the turbulent years of the Lombard and Frankish kingdoms. The Roman Via Aurelia, following the Mediterranean coast, proved impossible to defend against pirates and fell into disrepair, and the Via Cassia, passing through Bolsena, Arezzo and Florence to join the coast road

Plate 4 Hospital of Santa Maria della Scala, Siena, from the steps of the Duomo. Photo: Tim Benton.

north of Lucca, also declined. The Lombard and Frankish rule, from the Duchy (later County and Marquisate) of Lucca, had a policy of founding powerful bishoprics and abbeys in Tuscany, and these provided a defensive screen around the Via Francigena, which gradually became the main link between Rome and the north. Siena was given a bishopric, and the bishops of Siena increased their authority until they were awarded temporal power by Emperor Henry III (mid eleventh century), to the detriment of the counts.

The accounts of travellers such as Sigeric, Archbishop of Canterbury (travelling between 990 and 994), and Nikulas of Munkathvera, Abbot of Iceland (c.1154), show that Siena was an important stopping-off point on the journey south. The hospital of Santa Maria della Scala serves as a kind of paradigm of Siena's topographical potential and limitations (Plate 4). Its foundation was supposedly the pious act of a certain Sorore, whose mother had a miraculous vision in 832, just before giving birth. In a dream, she saw her future son climbing a ladder to heaven and this, according to one theory, explains the word *scala* (ladder) in the hospital's dedication. At any rate, the hospital must have been founded at least a century before the first documented record (1090). Originating as one of over a dozen hospices for pilgrims in Siena, it grew rapidly from the donations of pilgrims falling sick or dying on the pilgrimage route.[9] The Sienese government intervened increasingly in its affairs, contributing to the growth of its very large holdings of land. This served to provide a discreet cover for Sienese territorial expansion, and, most important, allowed the hospital to become a major supplier of wheat and, through the provision of well-sited mills, flour for the city in times of famine. By 1300, when Pope Boniface VIII declared the first Jubilee Year, rewarding pilgrims to Rome with generous indulgences, Siena derived much of its business from the Via Francigena as a major pilgrimage route. Its urban form reflected this influence, strung out along the ridge of the hill on either side of the Via Francigena, with a deviation towards the hill on which the Roman and Byzantine *castrum* had been built and where the hospital of Santa Maria della Scala was founded. The division of the city into thirds (*terzi*) for the purposes of administration reflects this topography.

The Via Francigena (as the Via Montanini and the Banchi di Sopra) extends from the Porta Camollia, in the north, to the

Croce del Travaglio, where the Via di Città splits off from it to run south-west to the old *castrum* and cathedral. The Via Francigena then extends south-east (as the Banchi di Sotto) to the Terzo di San Martino, where successive rings of walls each had a gate described as the Porta Romana or Porta Nuova (Plate 6). Along the main roads, the noble families had their towers and *castellari* (fortified houses), often dominating the roads and terrorizing passers-by. For example, papal arbitration had to be resorted to in order to settle a dispute between two families whose houses faced onto the Piazza del Postierla (Plate 5). One family accused another, the Forteguerri, who owned a tower on the corner of the piazza with a bridge connecting it across a road to another property, of making the road impassable for their family members. The need to arbitrate in these disputes was not only a political but an economic priority, since free circulation was vital for trade. The city frequently invested in the construction of new streets parallel to the main arteries in response to the petitions of citizens demanding an alternative route to avoid factious neighbours. For example, in the Constitution of 1309–10, a problem with the stretch of the Via Francigena running along the ridge of the hill to the north of the city is addressed:

> Aware that the Terzo di Camollia, being not very wide, from the church of San Donato onwards, is poorly provided with roads, since there is only the *strada* and one *Via*, and since the

Plate 5 Piazza del Postierla and Casa-torre dei Forteguerri, Siena. There used to be a bridge from the Forteguerri tower across the Via di Città, on the right. The remains of the arches can be seen some 15 metres above ground level. Photo: Tim Benton.

Old city, enclosed during eleventh century

Extension to enclose Via Francigena, early twelfth century

Extension to enclose newly populated areas, end of twelfth and beginning of thirteenth centuries

Extensions to include San Domenico and Fonte Branda on west side and new suburbs at south-east, mid thirteenth century

Extension to include buildings owned by Carmelite, Augustinian and Franciscan Orders, begun 1326

Via Francigena

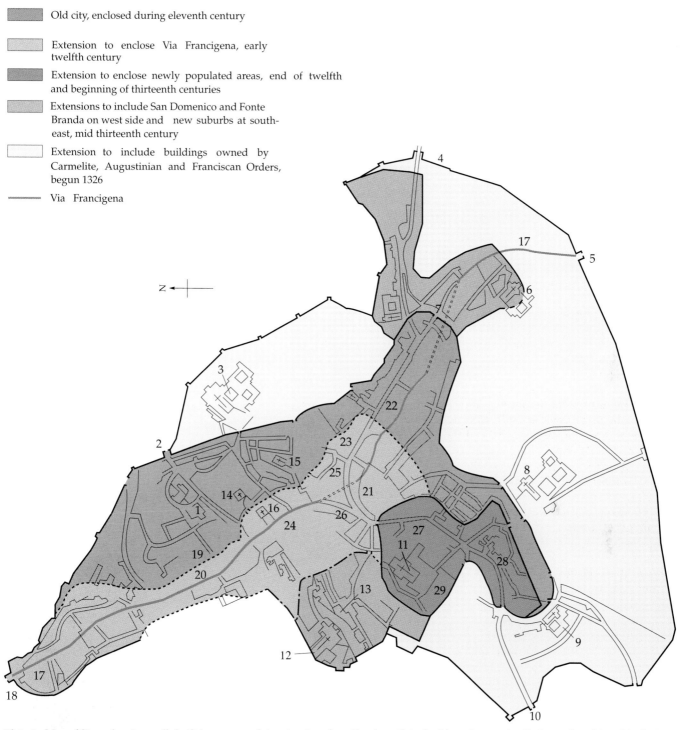

Plate 6 Map of Siena showing walls built to accommodate extensions from the eleventh to the fifteenth centuries. Redrawn from Pietro Nardi, 'I borghi di San Donato e di San Pietro a Ovile', *Bollettino senese di storia patria*, 3rd series, 25–7, 1966–68, opposite page 16.

Key:

1 Fonte Nuova d'Ovile	11 Duomo	21 Campo
2 Porta d'Ovile	12 San Domenico (Dominican)	22 Via del Porrione
3 San Francesco (Franciscan)	13 Fonte Branda	23 Via Sallustio Bandini
4 Porta Pispini	14 San Donato	24 Banchi di Sopra
5 Porta Romana	15 San Pietro d'Ovile	25 Banchi di Sotto
6 Santa Maria dei Servi (Servite)	16 San Cristoforo	26 Croce del Travaglio
7 Porta di San Maurizio	17 Via Francigena	27 Via di Città
8 Sant'Agostino (Augustinian)	18 Porta Camollia	28 *Castrum*
9 San Niccolò del Carmine (Carmelite)	19 Via della Stufasecca	29 Hospital of Santa Maria della Scala
10 Porta San Marco	20 Via Montanini	

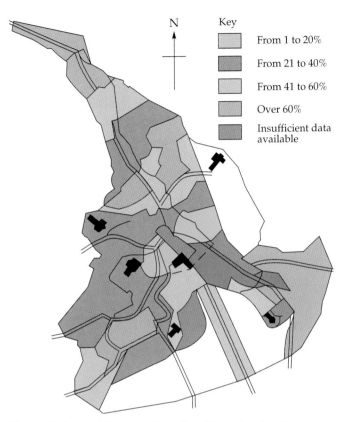

Plate 7 Estimate of the economic profile of Siena, showing the distribution of properties valued at less than 100 lire in 1318–20. From Duccio Balestracci and Gabriella Piccinni, *Siena nel Trecento. Assietto urbani e strutture edilizie*, 1977 Edizione CLUSF, Florence.

immigrants may have moved onto plots of cultivated land leased out by the monasteries on the periphery of the city, only to be incorporated into the city later.[11] This seems to have been the case on the eastern slopes of the city, near the Abbey of San Donato, which were leased out for agricultural purposes in the twelfth century and gradually urbanized. The area was then given a parish church, San Pietro d'Ovile, and acquired further significance with the construction of the Franciscan friary of San Francesco (1247–55). The process of assimilation into the city proceeded during the thirteenth century with the recognition of two military societies, San Pietro ad Ovile di Sopra and di Sotto, which became associated with two *contradas* (neighbourhood districts arising out of military associations) and a *lira* (an area used for assessment for tax purposes). With the expensive construction of the Fonte Nuova d'Ovile (Plate 8) and the Porta d'Ovile, and the paved street (Via dei Rossi) that linked the latter to the Via Francigena, this quarter became one of the most densely populated and vibrant areas in the city, if also the poorest (Plate 9).

To become a citizen, a man had to own a house worth at least 100 lire, and thus required some capital (often provided in the form of a dowry). The rules were often modified (for example, by offering a period of exemption from taxes) to encourage immigration of skilled workers. Most Sienese citizens did not lose contact with the countryside, however,

strada is usually blocked up with foreigners and inn-keepers and also because the citizens of other Terzi, when they have cause to pass through Camollia, cannot or will not pass before the houses of some great men, another road in this district would be most useful and necessary.[10]

The Via della Stufasecca was laid out precisely to provide this secondary circulation route. This was of particular benefit to the poorer people, whose houses tended to occupy the low-lying districts in the valleys formed by the main ridge, or to be situated far out to the north and south of the city (Plate 7).

The population grew dramatically during the twelfth and thirteenth centuries, with *borghi* or suburbs extending beyond the gates of the city along the access roads. The pressure to extend the city walls to enlarge the area contained within them was thus in the first instance demographic. It was important to incorporate the suburbs within the city walls, not only for defensive reasons but also for financial ones. There was an area around the city, known as the Masse, in which the inhabitants had some of the privileges and burdens of citizenship, but full citizenship only obtained within the city walls. It was usual to build the gates for a new ring of walls first and then link the gates with a ditch, thus delimiting the new area to be incorporated into the city, which would be inscribed within the *Tavola delle possessioni*, the official register of citizens' properties.

Much of the population increase occurred through immigration from the country. In fact, some of the

Plate 8 Fonte Nuova d'Ovile, Siena. Photo: Tim Benton.

Plate 9 Costa di Mezzo, Piano d'Ovile, Siena. Photo: Tim Benton.

As the city grew, it became increasingly important to provide a space where large crowds could meet in controlled conditions. The area of the Campo (literally, field) had been the site of the upper, or grain, market, separated from the lower livestock market by a retaining wall. A custom-house here was enlarged into the imposing Palazzo Pubblico, begun between 1293 and 1305 and completed *c.*1326 (Chapter 2, Plates 41 and 43). The Torre del Mangia, the highest tower of the city, was built between 1325 and 1344.[14] The Palazzo Pubblico housed the Podestà and the Council, which consisted of nine elected councillors, with a chapel and meeting rooms. Before its construction, the Council of Nine had met either in one of the churches, usually San Cristoforo (Plate 6), or one of the magnate's houses. The Campo was paved in brick in 1333–34 and provided with a public fountain in 1334–46, which was supplied with water from the River Staggia by an enormously expensive and complex system of underground aqueducts. As important as their functional utility was the prestige and dignity of these new works. A law of 1297 stipulated that any new buildings facing the Campo were to have biforate or triforate windows 'with columns' (like those of the Palazzo Pubblico).

A building that fits precisely between the stone-built fortified houses of the magnate families and the more 'civilized' palaces approved by the Council of the Nine is the Palazzo Tolomei (Plate 10). The Tolomei family were among the oldest noble families of Siena (referred to as the *casate*), alongside the Salimbeni and the Piccolomini. Their feudal properties extended widely over Tuscany. They were also among the wealthiest merchants and bankers, comparable with the Buonsignori, and their business interests led them to lean towards Guelph alliances. Although all the aristocratic families fought together in the great victory of Montaperti over the Guelph Florentines, several of the more extreme Ghibelline families carried out a vendetta against the Guelph alliances, so that for most of the 1260s the Tolomei were in exile. When the Guelph alliances, under Florentine leadership, won the upper hand after the battle of Colle Val d'Elsa in 1269, the Tolomei were eventually allowed back into Siena, where they played an increasingly important role in Sienese politics. Following an edict of 1277 excluding aristocrats (Guelph and Ghibelline) from power, the Tolomei simply reformed their family business into a collective company.

The Tolomei family had owned a group of properties around the church of San Cristoforo from at least the beginning of the thirteenth century.[15] A first palace was built on this site at the turn of the twelfth century by Tolomeo and Jacopo di Rinaldo Tolomei.[16] This palace was ransacked during the anti-Guelph riots of 1267, not without the support and encouragement of the Tolomei's arch enemy and neighbour Provenzano Salvani, and when the family was exiled the palace was demolished. Amazingly, the demolition was paid for by the state and the cost duly recorded. The workmen entrusted with the job saved some of the window columns from the old building. Between 1270 and 1272 a new palace was built (reputedly with stone salvaged from the Salvani houses which, in turn, had been demolished). It is possible that part of the ground floor of the old palace was retained.

retaining possession of lands and agricultural connections wherever possible and frequently settling in parts of the city where natives of the same area resided. The main economic turnover of fourteenth-century towns was in the trading of foodstuffs and industrial raw materials. All capital investment, in banking, usury or industry, was based ultimately on these staples.

Most people lived in single- or two-storeyed houses, packed very tightly together, although there were still some who took shelter in caves dug into the soft sandstone hillsides. There must have been a large number of wooden and daub and wattle houses, judging by the severity of the many fires that are documented. For example, a fire in 1297 caused the destruction of 300 houses in the Ovile district. Another in 1413 was caused by a *linaiolo* (wool worker), working all night by candlelight: the fire raged for eight days and must have been fuelled by many wooden houses.[12] A tacit admission that many cheaper houses were built of mud emerges from the Constitution of 1262, in which it is stipulated: 'If in the city or suburbs houses are built of mud walls with arches, let the front walls and piers be walled and consist of brick, so that these houses should add beauty to the city.'[13]

Plate 10 Palazzo Tolomei,
1270–72, Banchi di Sopra, Siena.
Photo: Tim Benton.

The new palace combined the stone construction and high ground-floor loggia (which could be isolated from the living quarters in times of trouble) of the old aristocratic houses, with a formal symmetry and delicacy of detail quite new in Sienese domestic architecture. During the disturbances of 1321, when the Salimbeni family attacked the Tolomei, they were able to take refuge in this palace and withstand an armed assault. A recent restoration has revealed the very high vaults of the loggia (over 10 metres high) supported by a double line of brick piers. This space was used mainly as a meeting place for all the members of the Tolomei clan and as their place of business. It was common for members of a family and associates to join together in a grouping, known as a *consorteria*. The *consorteria* offered the defence of a tower or strong palace and the economic strength of shared assets. According to a document of 1254 in the Tolomei archive (and therefore referring to the old palace), the apartments above were shared out by different family groups, changing round every ten years. Traces of a bridge to the neighbouring house along the street, coupled with documentary evidence of the presence of many other Tolomei properties in the area, indicate that members of the *consorteria* could move from one apartment to another at first- and second-floor level. However, despite the provision of this defensive architectural organization, the Tolomei palace, with its elegant Gothic biforate windows, breathes the spirit of civic good order and civilized behaviour, which matched the aspirations of the Council of the Nine.

Plate 11 View of San Domenico, Siena (begun *c.*1225), from the roof of the Duomo. Note the thirteenth-century walls, on the left. The large porticoed building on the right is a *tiratoio* textile factory. Photo: Tim Benton.

During the thirteenth century two further factors helped to change the scale and character of urban development in Siena: the arrival of the mendicant orders, who built their priories and friaries outside the walls, and the development of the industrial areas around the fountains, such as the Fonte Branda and the Fonte Nuova d'Ovile (Plate 6). The Dominican church, San Domenico (begun around 1225 on land given by the powerful magnate family, the Malavolti), and the Fonte Branda (probably begun in its present form in 1193 and vaulted in 1246) with its associated textile industry to the west were incorporated within the walls in the thirteenth century (Plate 11). However, the Augustinian church, Sant'Agostino, to the south and the Franciscan church, San Francesco, to the east remained outside the walls. The circle of walls begun in 1326 was intended to incorporate these establishments, the new suburbs that had sprung up along the roads to the south-east and south-west and a large swathe of countryside in between. With over 165 hectares, 6.6 kilometres in perimeter, to be incorporated, progress on extending the walls was slow, some parts being completed only in the fifteenth century. Work began with a weekly government subvention of 2000 lire, which was an enormous burden on the taxes.[17]

Today much of the land enclosed within this ring of walls consists of vineyards or olive groves, suggesting that the catastrophic fall in population after the Black Death, and the economic decline that had already begun before it, restricted urban development. However, this may be in part deceptive. For example, the Council invested in new streets and a parish church, San Luca (built in 1339 but in ruins by 1402), in a new district to the south of the Campo, in the area to be enclosed by these walls.[18] This new district, known as the Borgo di Santa Maria, was begun in the 1320s, with a considerable investment by the state. It acquired a sizeable population but probably never progressed beyond the stage of cheap housing, because by 1400 it had fallen into disrepair as the population moved into more convenient and better-built properties left vacant after the Black Death (Plate 12). By 1393 special laws were being passed to exempt immigrants from all taxes apart from the *gabelle* (import duties) and the salt levy for ten years, as a stimulus to repopulate the city, which was also affected by armed mercenaries and bandits plaguing the countryside.

Padua

The growth of the city of Padua was conditioned by the changing state of the Paleovenetian river courses. Roman Padua grew up on the banks of the Meduacus (now the Brenta). This substantial river divided to the north-west of Padua, rejoining to form a double meander in which the city

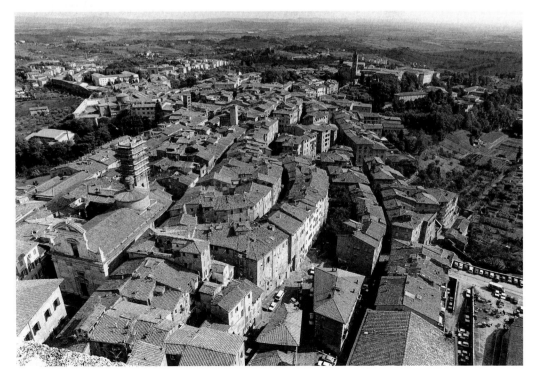

Plate 12 View from the Torre del Mangia, Siena, towards the south. In the background is Santa Maria dei Servi and on the right the area of the Borgo di Santa Maria. Photo: Tim Benton.

was founded, before dividing again into a major course running east into the Venetian lagoon, and a minor channel that flowed south-east to join the River Adige just before its mouth in the Adriatic south of Chioggia (Plate 13). The Meduacus made Padua a central entrepôt and military base in the Roman operations in the north-east of Italy. The city continued to play a very important role under Byzantine rule, when it became the western outpost of the Byzantine Empire in Italy. In 589 a disastrous flood in the plain of the Meduacus led the river to form a completely new channel to the north of Padua. The old river bed south of Padua dried up but was eventually occupied by the much smaller River Edrone, later known as the Bachiglione, which flowed from the west through Vicenza. Padua immediately lost its strategic importance and was subjected to a succession of sacks over the next 300 years. As late as the early eleventh century, 85 fields, totalling 33 hectares, were in cultivation in the central area of the city, showing that repopulation had hardly begun.[19] By the end of the century, however, the beginning of the Commune had begun to assert itself, seizing effective power from a bishopric enfeebled by schismatic tensions within the Church and at the centre of the bloody struggle between Emperor Frederick I Barbarossa and Pope Alexander III (1154–83).

The city that struggled to reassert itself over the next

centuries had certain fixed points, but no trace of the Roman street pattern (Plate 14). The cathedral, located within the centre of the city, and the monastery of Santa Giustina, to the south, were both rebuilt during the twelfth century. Roman bridges, such as the Ponte dei Tadi (restored in 1026), the Ponte Molino (restored in the mid twelfth century), the Ponte di San Lorenzo (restored in 1053) and the Ponte Altina (restored c.1058), had been some 40 metres wide, with two or three arches, reflecting the importance of the Meduacus. When these bridges were restored, they were mostly of a single arch, spanning a much narrower river bed.

Outside the city, a system of canals was built in the twelfth and thirteenth centuries. This provided access to the south via the Bassanello (1189–1201) and the Bovolenta, which ran into the Venetian lagoon. In 1209 an important canal, the Piovego, was opened up along the line of the old Meduacus river bed, linking the city to the Brenta at Stra and providing a trade route to the Venetian lagoon. To the south-west of the city the Bachiglione suffered not only from a limited flow of water but also from the controlling position on it, upstream, of Vicenza. Between 1311 and 1314 a strategic canal, known as the Brentelle, was cut at enormous expense to link the Bachiglione to the Brenta at Limena 'because the Vicentines were taking away the water of the Bachiglione which came to Padua and diverted it in their direction'.[20]

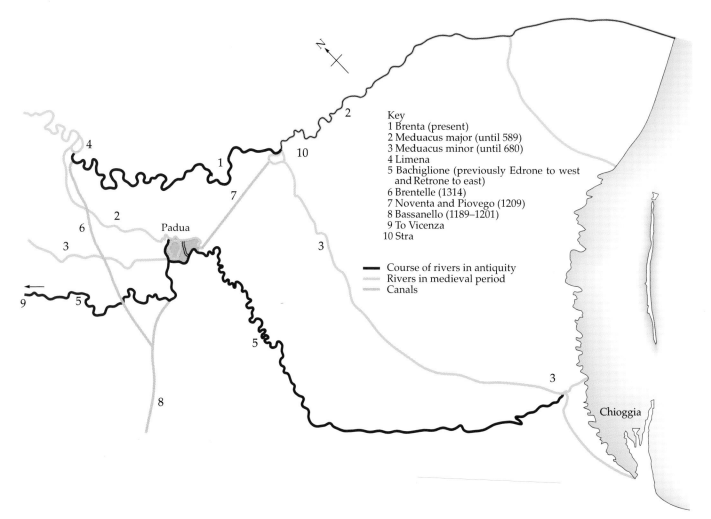

Key
1 Brenta (present)
2 Meduacus major (until 589)
3 Meduacus minor (until 680)
4 Limena
5 Bachiglione (previously Edrone to west and Retrone to east)
6 Brentelle (1314)
7 Noventa and Piovego (1209)
8 Bassanello (1189–1201)
9 To Vicenza
10 Stra

━━━ Course of rivers in antiquity
Rivers in medieval period
Canals

Plate 13 Plan of water courses in the Veneto.

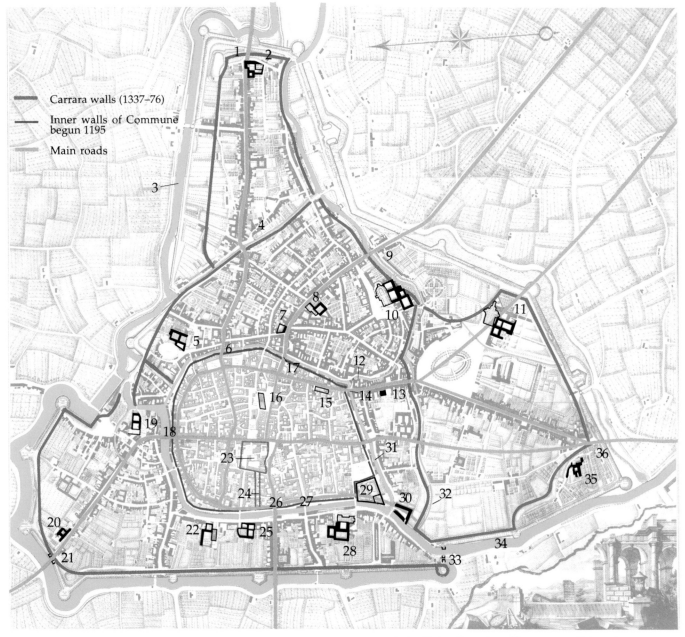

Plate 14 Map of Padua, based on Giovanni Valle, *Map of Padua, 1779–1781*, Museo Civico, Padua. Reproduced by courtesy of Musei Civici Padova, Gabinetto Fotografico.

Key:

1 Porta d'Ognissanti
2 Church of Ognissanti (Benedictine)
3 Noventa Canal*
4 Canal of Santa Sofia
5 Eremitani (church and priory of the Augustinian Hermits)
6 Porta Altina
7 Palazzo Zabarella
8 Church of Saint Augustine (Franciscan)

9 Porta di Ponte Corvo
10 Santo (basilica of Saint Anthony, Franciscan)
11 Santa Giustina (Benedictine)
12 Canal of Santa Chiara
13 Palazzo Capodilista
14 Ponte delle Torricelli
15 Il Cristo dei Servi (Servite)
16 Palazzo della Ragione
17 Ponte di San Lorenzo
18 Porta di Ponte Molino

19 Santa Maria del Carmine (Carmelite monastery)
20 Convent of the Scalzi [destroyed]
21 Porta di Codalunga [destroyed]
22 San Benedetto Vecchio (Benedictine)
23 Reggia [destroyed]
24 Traghetto [destroyed]
25 San Benedetto Novello (Benedictine)
26 Ponte dei Tadi
27 Ponte di San Giovanni delle Navi

28 San Agostino (Dominican) [destroyed]
29 Torlonga (Ezzelino's Castle)
30 Carrara citadel
31 Naviglio Canal
32 Acquette Canal
33 Porta dei Saraceni
34 Bachiglione River
35 Church of the Transfiguration and friary (Capuchin)
36 Porta di Santa Croce

*The fourteenth-century bed of this canal followed a different course.

The roads indicated were founded in Roman times.

Within the city, the waters of the Bachiglione were divided at Ezzelino's Castle (the Torlonga, first documented in 1062, later rebuilt by Ezzelino III da Romano). One branch ran clockwise round the city centre to the north, where it joined the Noventa Canal, which itself joined the Piovego Canal running north-east to Stra. The other branch ran anti-clockwise round the city, in a canal known as the Naviglio, to join up with the Bachiglione, continuing along the southern side of the city and then south-east to the Venetian lagoon. Numerous other canals, some of them private developments by the monastic establishments that occupied the suburbs of the city, supplied water for drinking, power and transportation. At the Ponte Molino, on the northern axis of the old city, the river bed was taken up by over 40 mills (Plate 24). Other concentrations of mills were found near the Ponte delle Torricelli (built in 1217), where the Canal of Santa Chiara bifurcated off the Naviglio. The mills provided an obstruction to navigation, so their siting was carefully controlled to allow navigable routes through the city.

The main port and market in Roman times had been on both banks of the Meduacus, between the bridges now known as the Ponte Altina and the Ponte di San Lorenzo. In medieval Padua this area was still important as a trading centre, although all the goods had to be transported through the narrow streets or ferried round the Naviglio after transhipment in one of the two river ports. One of these, located by the Ponte di San Giovanni delle Navi, carried the traffic from the Bachiglione (from Vicenza) (Plate 15) and the Bassanello (from Battaglia, Carrara, Monselice and Montagnana). The other, located in the eastern part of the city on the Piovego Canal, served the Venetian trade. A building that at one time housed the customs officials is located by the Ponte di San Giovanni delle Navi (Plate 16). The retail markets for cloth, fruit and grain were made independent of the bishop's jurisdiction in 1191, and it was in the area of the markets that the Palazzo della Ragione, the town hall, was begun in 1218, with other government buildings directly associated with it (Plate 17 and Chapter 2, Plates 59 and 60).[21] Until then, the meetings of the Council had taken place in the church of San Martino, close by, and possibly in an earlier,

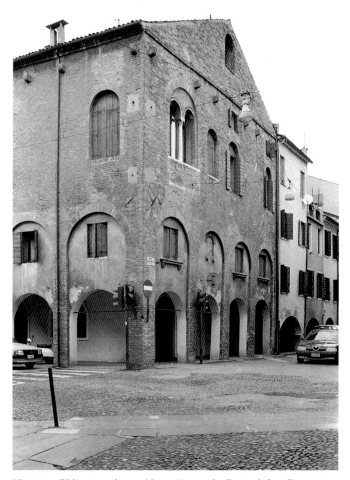

Plate 16 Old custom-house (*dogana*), near the Ponte di San Giovanni delle Navi, on the River Bachiglione, Padua, fourteenth century. Photo: Tim Benton.

more modest town hall. Within a few metres of the Palazzo della Ragione was concentrated much of the retail trade in Padua. Near to the Piazza dei Frutti and the Piazza dell'Erbe (housing the fruit and vegetable markets respectively), on the Naviglio Canal stood the Piazza de'Noli (with the hay market), where there were a number of inns where horses could be changed, the Piazza delle Legne (with the wood market) and, across the canal, the fish market (*pescheria*). A wool exchange (*garzeria*) was added as part of the Carrara policy of encouraging the wool trade (Plate 18). Francesco il Vecchio da Carrara (1350–88) also constructed a meat market in the vicinity. It was here that the *studium*, or university, founded by a splinter group of academics from Bologna in 1222, grew up; it was popularly known as '*Il bo*' (the ox) from the site of its original meeting place.

As in Siena and Florence, the development of the Commune progressed through the gradual humiliation of the great landed families. In Padua the magnate families, such as the Camposampiero, da Carrara and da Romano, built their fortified houses overlooking the key routes into the city, often outside the walls. For example, Ezzelino III da Romano bought or rebuilt a tower just outside the Porta di Ponte Molino, on the north–south axis of the city, and the Carrara family possessed a tower and houses on the Via San Francesco, just outside the Porta di San Lorenzo (Plate 19).

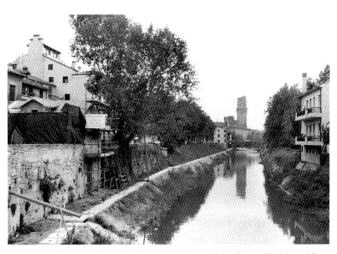

Plate 15 View southwards along the River Bachiglione, Padua, with the Ponte di Sant'Agostino and the remains of Ezzelino's Castle in the background. Photo: Tim Benton.

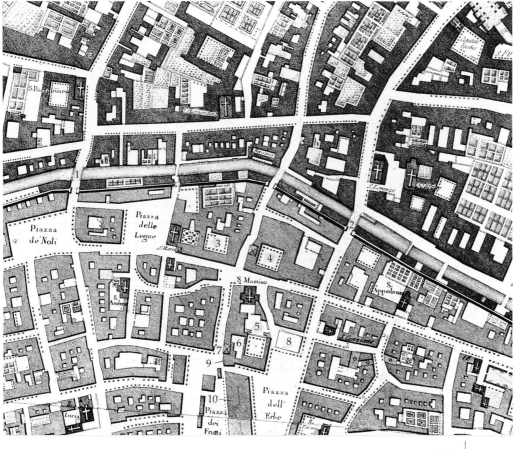

Plate 17 Map of the area around the Palazzo della Ragione, Padua, from Giovanni Valle, *Map of Padua, 1779–1781*, Museo Civico Padua. Reproduced by courtesy of Musei Civici Padova, Gabinetto Fotografico.

Key:
1 Ponte and Porta Altina
2 Ponte and Porta di San Lorenzo
3 *La garzeria* (wool exchange)
4 *'Il bo'* (university)
5 Palazzo del Podestà
6 Palazzo degli Anziani
7 Torre del Municipio or 'white' tower
8 Fondaco delle Biade (grain market)
9 Palazzo del Consiglio
10 Palazzo della Ragione

One of the houses and the tower were sold to the Zabarella family around 1280.[22] Although the house has been heavily restored over successive centuries, and the tower cut down, its strategic siting can be appreciated, on the street leading from the city centre to the Ponte Corvo and the main road south-east to Piove di Sacco and Chioggia. Another thirteenth-century fortified house belonging to one of the feudal families was that of the Capodilista, on the road leading south from the Ponte delle Torricelli towards the Borgo di Santa Croce (Plate 20). The siting of these houses, which included large establishments of stables and out-houses, outside the then city walls indicates something of the rural roots of these great families, many of them enfeoffed with castles and lands by the church or by successive emperors and thus at first independent of the city. Some families, recognized by the Holy Roman Emperors as long ago as the ninth century, went on to become *signori* of cities like Verona (the della Scala family) or Ferrara (the d'Este). Padua held out under communal government longer than any of the north-eastern cities apart from Bologna, until it too came under the control, first, of Ezzelino III da Romano and then, more precariously, of the Carrara family (1318–1405).

The site of the Palazzo della Ragione (Plate 21) was expropriated from the old magnate Manfredi family, just as the tower that defended the adjoining Palazzo del Consiglio was purchased from the aristocratic Camposampiero family. To the east of the Palazzo della Ragione and joined to it by a bridge was the Palazzo del Podestà, with metal-working

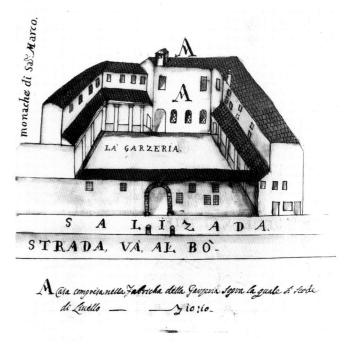

Plate 18 L. Mazzi, *La garzeria*, c.1735, Archivio di Stato, Padua, b.320, c.40v.

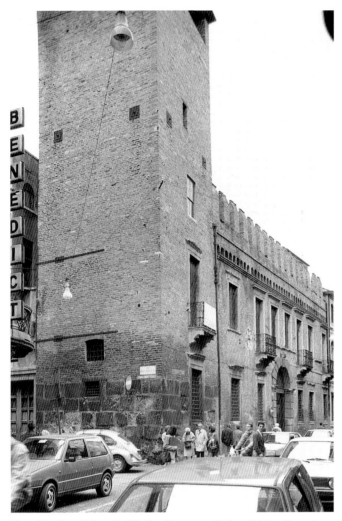

Plate 19 Casa Zabarella, Via San Francesco, Padua, thirteenth-century tower and house (much restored). Photo: Tim Benton.

Plate 20 Palazzo Capodilista, Via Umberto I, Padua, thirteenth-century house (restored). Photo: Tim Benton.

shops under its *portici* (the Paduan term for the arcades that line many of the city's streets).[23] Underneath the bridge was the Arco della Corda, so called because this was where criminals were given the lash (*corda*). North of the Palazzo del Podestà, facing the Via del Sale, were the Palazzo degli Anziani and the Palazzo del Consiglio (including under its 'porticoes' the shop for the state salt monopoly and a shop for Veronese cloths), and facing these across the street was a house and tower of the Carrara family, dating back to the thirteenth century and mentioned in a will of 1289. It seems likely that there were a number of other important houses and even streets in the area, which might help to explain the strange orientation and plan form of the Palazzo della Ragione.[24] That these were cleared away to make place for the Piazza dei Frutti and the Piazza dell'Erbe is a typical example of the demonstration of communal authority at the expense of aristocratic interests.

The large size of the Palazzo della Ragione was necessary to house meetings of the Consiglio Maggior (Great Council), with its 400 members, and a number of legal committees, but the building also housed numerous other functions, including a prison. In the Commune (after Ezzelino III da Romano's expulsion), the size of the Consiglio Maggior grew to 600, with a Podestà advised by a group of Elders (*Anziani*) elected

in part by the guilds and in part by the *communancia del popolo* (decision of the people). From the chronicler Giovanni da Nono's very detailed description,[25] it is possible to reconstruct the layout of the markets in the Piazza dei Frutti and the Piazza dell'Erbe (Chapter 2, Plate 60). In 1301 a covered grain market, the Fondaco delle Biade, was built in the vicinity of the Palazzo della Ragione, to the design of the great engineer–architect Fra Giovanni degli Eremitani (Plate 22). Fra Giovanni also added the two-storeyed galleries to the exterior of the Palazzo della Ragione (1306) and built a new wooden roof, based on raised walls that curve in towards the top to reduce the span of the wooden vault. The awe produced by this great wooden roof was echoed by the chronicler Ongarello, who wrote:

> After 1306 there came a great engineer from the order of the Hermits, or rather St Augustine, who was called Fra Zuanne [Giovanni] and had searched all over the world and said that he had found in a part of India the most solemn covering to a palace that he had ever seen and that he had brought with him the design. And the Paduans, seeing this design and being at that time very powerful, asked him if he knew how to carry it out, but he, before answering wanted to examine the foundations of the walls and finally answered that he would carry it out in the same form.[26]

Plate 21 Palazzo della Ragione, Padua. Photo: Massime Deganello. Reproduced by courtesy of Musei Civici Padova, Gabinetto Fotografico.

Fra Giovanni was given, as reward for roofing the Palazzo della Ragione, the timbers and nails from the old roof, and he used these to build the fabulous timber roof of the Eremitani in 1306. His name, along with that of Leonardo Bocaleca, has also been associated with the Palazzo degli Anziani and the Palazzo del Consiglio, which is linked to the Palazzo della Ragione on the Via del Sale. The Palazzo del Consiglio bears an inscription about the Podestà Fantone de'Rossi fiorentino and the date 1285 (the fact that the Podestà was a Florentine providing evidence of links between Padua and Tuscany); another inscription names the architect as Leonardo Bocaleca.[27] What these buildings have in common is the use of bold stone arches (Chapter 2, Plate 59) facing a newly enlarged open space, and it has been argued that there was a clear idea here of constructing ordered urban spaces evocative of a Roman forum.[28] Similarly, the facing in stone of the Eremitani church (Plate 23) shows bold stone arches, albeit much taller. In all these interventions, we can see a commitment to a thoroughly urban architecture, with little obsessive attention to individual buildings, but with openings of a regular scale linking into the common pattern of 'porticoes'.[29] Although it is virtually impossible to date with precision any of these street 'porticoes', since they were constantly added to and altered over the centuries, it is clear that their almost universal use in Padua stimulated architects like Leonardo Bocaleca and Fra Giovanni to adopt the design. On a map of 1779–81 by Giovanni Valle, the 'porticoes' are scrupulously marked and can be shown to run from end to end of the city (Plate 14).

The growth of the city devolved around the bridges across the river and canal system, leading to extensive *borghi*: to the north (along the road to Vicenza, with its pilgrimage hostels and hospitals, and the convent of the Scalzi or barefoot friars),

to the south (with the Borgo di Santa Croce, with its inns and Capuchin friary) and to the east (with the church of Ognissanti, which was in existence at least as early as 1117, and the large suburb of Rudena, which grew up along the road to the Ponte Corvo). In 1202 for administrative purposes the city was divided into four *quartieri*: (Duomo (to the west), Altinate (east), Pontemolino (north) and Torricelli (south), based on the old city within the old walls, with extensions into the *borghi*. Each quarter was further subdivided into *centenari* for secular purposes (military recruitment and taxation), but an important organizational factor in Padua was the 16 *capellae* (parishes), which also performed a political function and whose boundaries were agreed in 1178.

Plate 22 Fra Giovanni degli Eremitani, Fondaco delle Biade (grain market, now demolished), 1301, in the vicinity of the Piazza dell'Erbe and the Palazzo della Ragione, Padua. Reproduced by courtesy of Musei Civici Padova, Gabinetto Fotografico.

Plate 23 Attributed to Fra Giovanni degli Eremitani, stone lower façade, church of the Eremitani, Padua, *c*.1310. Photo: Tim Benton.

The first ring of walls (1195–1220) followed the line of the Bachiglione and the Naviglio, linking up the bridges. When Giovanni da Nono wrote his description of the city, around 1318, he began with these walls and 19 gates, starting with the Porta di Ponte Molino.[30] Each gate was associated, in his description, with the suburb and territory to which it led. As late as 1623, when Vincenzo Dotto drew a reconstruction of mid fourteenth-century Padua, the gates and bridges forming the inner ring of the fortifications were highlighted (Plate 24). It was common in medieval iconography to represent the city as a compact unit surrounded by its gates and walls, a symbol not only of protection but the very definition of citizenship. For Giovanni da Nono, the walls were a symbol of the city's defiance of tyrants, although Ezzelino III da Romano enormously strengthened the walls, rebuilding the Torlonga into a veritable fortress at the southern tip of the old city. Similarly, when the Carrara came to power, they embarked on an enormous campaign of fortifications, not all of which were intended to keep external enemies out. Ubertino da Carrara (1338–45), for example, created a fortified centre, the Reggia, in the heart of the city (shown by Dotto as a single building, the Palazzo di Corte) and linked it to the old walls and the castle by means of the Traghetto, a walkway carried on high arches. The Carrara also set about incorporating within a great new ring of walls the *borghi* and monastic establishments outside the old walls.

By 1318 many more people lived outside the inner ring of walls than inside. The suburb of Rudena had been given an enormous boost by the construction of the church of Sant'Antonio (popularly known as the Santo), which was built to house the relics of the Franciscan friar Saint Anthony, who died near Padua in 1231 and was canonized the following year. The construction of the church was largely paid for by the Commune, and the importance of the cult of Saint Anthony was symbolized by the combination of the religious festival honouring his death, on 20 June, with that of the liberation of the city from Ezzelino III da Romano and the feast days for the early Christian martyrs Saint Giustina and Saint Prosdocimo.

Marsiglio da Carrara (d.1338) began the stretch of walls from the north-west corner (the Porta di Codalunga) (Plate 14) running southwards and incorporating the religious establishments that had sprung up on the western bank of the Bachiglione, including the White Benedictine monastery of San Benedetto and the Dominican friary of Sant'Agostino (begun 1226). These walls were built quickly and with poor materials, often following a line of earthworks and moats, which had been thrown up at various times for defence against the Veronese. In 1372 Francesco il Vecchio da Carrara extended the walls south to include the Borgo di Santa Croce, then along the southern side of the city to the Porta d'Ognissanti in the east, and then west to the Portello (the port on the Piovego Canal), making the whole population of the city take part (according to the chronicler Galeazzo Gatari[31]). Francesco il Vecchio also rebuilt Ezzelino's Castle and added a citadel to the south of the Naviglio.

The period of Carrara rule was dogged by war against the della Scala (Scaligeri) family, rulers of Verona, and the struggle to maintain independence from Venice. Unable fully to confront either the Scaligeri or the Venetians, Carrara policy relied on secret alliances, intrigue and deception, as when Marsiglio da Carrara invited Cangrande della Scala to accept the *signoria* of Padua in 1328, while secretly forming alliances against him with the Florentines and Venetians. Giacomo da Carrara had been inscribed in the Venetian aristocracy, having married the daughter of Doge Pietro Gradenigo. During the second half of the fourteenth century, especially under Francesco il Vecchio, the policy of intrigue worked well, with Paduan ascendance over Feltre, Treviso and Belluno, but the political stakes were being raised with the rise to power of the Visconti family of Milan. Francesco il Vecchio finished his life as a prisoner of the Visconti and died in prison in Monza. (Twenty years later Siena, too, came briefly under the influence of the Milanese, when the city called in Gian Galeazzo Visconti as *signore* in 1399.) Concerns for the instability on her western border finally led Venice to turn against her former ally and form an alliance with the Visconti. In 1405 Padua was taken and submitted to Venetian suzerainty and Francesco il Novello da Carrara and his sons were subsequently executed by strangulation.

Under the Carrara, the university in Padua flourished and a brilliant culture shone in the court. Only fragments of this culture survive, such as the Lupi Chapel in the Santo, the Oratory of San Giorgio and some tombs, all of which will be considered later in this volume. A frustration in studying the architecture of the period is that the Venetians studiously removed every trace of Carrara patronage, from the Reggia to the tombs of Francesco il Vecchio and Fina Buzzacarina, his

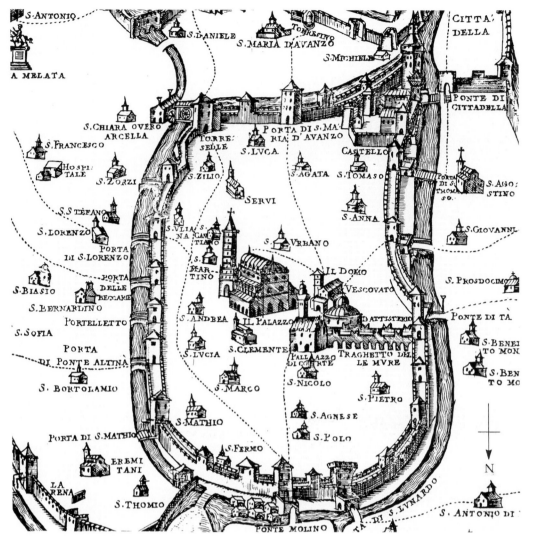

wife, in the baptistery. Only a section of one of the buildings in the Reggia survives, with some of its frescoes.[32]

Florence

Of the three cities, it was in Florence that the physical form of the Roman city played the most important role in the development of the medieval city. In any plan of the city, a central grid of streets can be clearly seen to stand out from the rest. This is, roughly, the layout of the Roman city in Julius Caesar's day, when the city had been raised to a *municipium* (Plate 25). The layout consists of a tight grid of streets around the forum, flanked by a more open spacing of *insulae* (blocks) to the east, where the original military *castrum* had expanded. The Cassia Antica had bypassed the city to the north, but connections to it were provided from the western, northern and eastern gates. A new Via Cassia, linking directly to Pisa, ran along the south bank of the River Arno, while the main road to Volterra and Siena ran south-west. In later imperial times a further extension to the east included a suburb along the road to Arezzo, an amphitheatre and theatre and some baths to the south, near the river. The Roman bridge across the Arno was slightly to the east of the Ponte Vecchio.

During a period of invasions, the population of the city dwindled to a few thousand, and a fortified enclosure was created in the heart of the Roman city, using the remains of the Roman buildings as strongholds. By the end of the ninth century the city had been provided with regularized walls. The palace of the bishop, and of the Lombard counts and the imperial margrave, lay outside these walls to the north, and it was here that a group of religious buildings was founded, including the baptistery and the cathedral of Santa Reparata. To the east, the Badia (a Benedictine monastery), founded in 978 by Countess Willa, had a large tract of territory outside the walls. By the time that Florence began to intervene actively on the Italian political scene, supporting Pope Gregory VII and Countess Matilda against Emperor Henry IV in the mid eleventh century, the population of the city was already rising rapidly (probably numbering about 20,000).[33] Churches sprang up, or were rebuilt, outside the Carolingian walls: Santa Maria Novella to the west (begun *c.*1094), San Lorenzo to the north (rebuilt in 1060), San Remigio (eleventh century, rebuilt *c.*1350) and San Pier Maggiore (1067 with its hospital) in the eastern suburbs, Santi Apostoli to the south (*c.*1075) and Santa Felicita (1056) south of the river near the early Christian cemetery. The old forum was still used as a market (the *mercato vecchio*), while a new market was provided slightly to the south.

The Commune was not given formal imperial recognition until 1183, but by this time effective government was carried

Plate 25 Plan of Florence
*c.*50B.C., superimposed on a
plan of the modern city.
Reproduced from Gian Liugi
Maffei, *La casa fiorentina nella
storia della città*, 1982 Marsilio
Editore, Venice, figure 5.

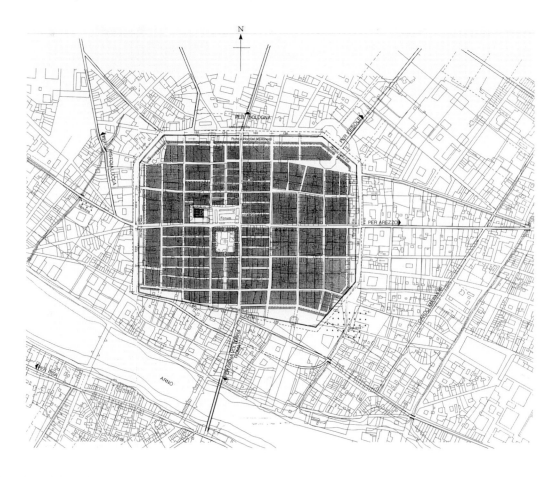

out by councils dominated by the aristocratic families and the clergy. The process leading towards the seizure of power by the Popolo had already begun. The growing wealth of the merchant and banking classes, based on the manufacturing and service industries that served most of Tuscany, led to the formation of powerful guilds, the *arti*, and, in the end, to the humbling of the troublesome aristocratic families, whose internecine fighting constantly threatened to draw Florence into external wars. When the new walls of 1173–74 were built, enclosing the outlying churches and suburbs which by now had swelled the population to around 30,000, the city expanded to around 80 hectares (Plate 26).

In 1178 a disastrous fire and flood destroyed the old Roman bridge, and it was decided to build a new one slightly to the west and reorganize the main north–south axis of the city. New bridges were added in 1218–20 (Ponte alla Carrara), 1237 (Ponte Rubaconte or Ponte alla Grazie) and 1252 (Ponte della Trinita). All these bridges were carried away in the flood of 1333, except the Ponte alla Grazie, and were rebuilt.

The division of the city into quarters was changed to division into sixths (*sestieri*), each one including part of the old town and expanding outwards into the *borghi*. This was necessary because there was already a stratification in which the wealthier families clustered round the centre of the city and the main access routes, while the new artisan classes mushroomed in the suburbs, many of them on plots leased out by the monasteries. The Benedictine monks of the Badia, for example, began to lay out streets and sell or lease plots in the suburb to the east. In the centre, the aristocratic families began to build towers for self-defence (Plate 27). By 1200 there may have been as many as 200 towers in Florence, some of

them clustered in family groups (such as the Amidei towers lining the Via di Por San Maria which led to the Ponte Vecchio over the river or the Uberti family houses on the site of the present Palazzo Vecchio). In other cases, a group of families shared a tower in a *consorteria*. The beginning of the end for the magnate families came with the assertion of power by the Popolo in 1250. The populace was organized into 20 military companies, with their *gonfaloni* or leaders, and the Podestà was empowered to make use of these forces to keep the peace. All the towers were trimmed to a maximum height of 50 braccia (29 metres). In 1252 Florence began minting the gold florins that became the major currency of Europe.

The alliance of the wealthy merchants with the Guelph magnates in the 1250s led to the expulsion of many Ghibelline families, with the demolition or confiscation of their properties. When, after the battle of Montaperti, the victorious Ghibelline family exiles returned to Florence to exact their revenge, they demolished a large number of Guelph houses, a fact meticulously recorded in a document.[34] Completely demolished were 103 palaces, 580 houses and 85 towers, as well as numerous shops, mills and wool factories. Ironically, the destruction of Ghibelline and then Guelph palaces and towers allowed the urban planners of the fourteenth century space, within the tight urban texture of the inner city, to create the public buildings (for example, the Palazzo dei Priori with its piazza) and open spaces that distinguished the period of the Commune.

During the 1280s the wealthy merchants, organized in their *arti*, imposed order once again on the aristocratic families and the artisan classes. All the occupations were reorganized into

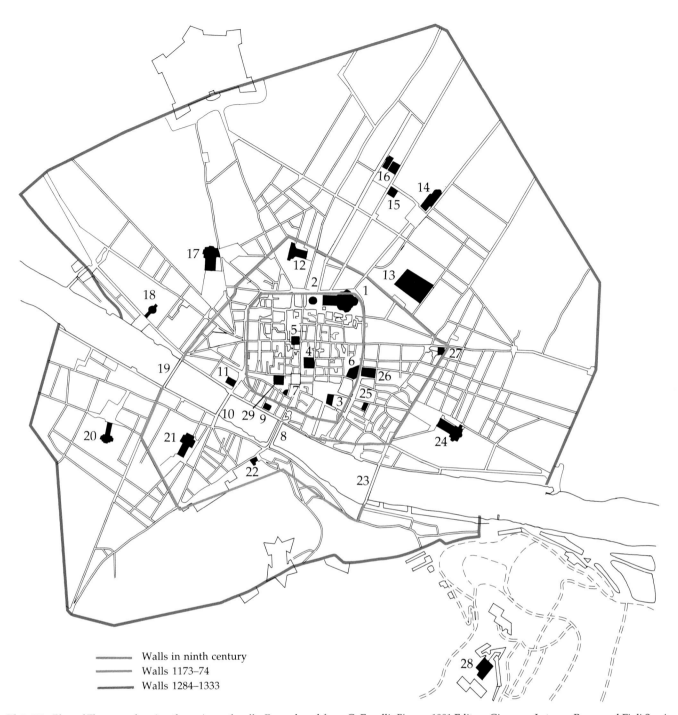

Plate 26 Plan of Florence, showing three rings of walls. Reproduced from G. Fanelli, *Firenze*, 1981 Editore Giuseppe Laterza, Rome and Figli S.p.A.

Key:

1 Duomo
2 Baptistery
3 Palazzo dei Priori (Vecchio)
4 Orsanmichele
5 Site of Roman forum and old market
6 Badia (Benedictine)
7 Palazzo della Parte Guelfa
8 Ponte Vecchio
9 Santi Apostoli
10 Ponte della Trinita

11 Santa Trinita (Vallambrosan)
12 San Lorenzo
13 Hospital of Santa Maria Nuova
14 Santissima Annunziata (Servite)
15 Hospital of San Matteo
16 San Marco
17 Santa Maria Novella (Dominican)
18 Church of Ognissanti (Humiliati)
19 Ponte alla Carrara
20 Santa Maria del Carmine (Carmelite)

21 Santo Spirito (Augustinian)
22 Santa Felicita
23 Ponte Rubaconte
24 Santa Croce (Franciscan)
25 San Remigio
26 Bargello (Palazzo del Podestà)
27 San Pier Maggiore (Benedictine)
28 San Miniato (Benedictine)
29 Palazzo Davizzi (Davanzati)

Plate 27 Torre della Castagna, near the Badia, Florence. The Commune held some of its council meetings here before the construction of the Palazzo dei Priori. Photo: Tim Benton.

west the Dominicans took over and rebuilt Santa Maria Novella (1221, rebuilt from 1278), to the east the Franciscans founded Santa Croce (1226–28, rebuilt from 1295), to the north the Servites founded Santissima Annunziata (1250) and to the south of the river the Augustinian Hermits founded Santo Spirito (rebuilt 1269) and the Carmelites founded Santa Maria del Carmine (1268). The state was involved in the construction of these establishments, being very sensitive to their enormous hold on the imaginations of the huge, new urban populations in the suburbs.

The Commune also intervened on a substantial scale in the laying out of new streets and squares. The pattern of streets around the new cathedral, begun in 1296 to a design by Arnolfo di Cambio but subsequently extended to its present layout in 1357, embodies the use of a virtually standardized elevation (Plates 2 and 30). Each building was allocated one or more large, arched openings, which could be used for shops or store rooms and which helped to give a commercial return on investment. Similar arched properties arose along other new or widened streets, such as the Via dei Calzaiuoli. What is striking in these innovations is the sense of urban scale, the imposed order of building façades seen as part of a street rather than the reality of tortuous patterns of ownership in the properties behind. Another aspect of street life, which has

arti maggiori and *arti minori* (major and minor guilds), of which only the first had access to real power. The Arte della Lana (guild of woollen cloth manufacturers) was one of the most powerful. Like most of the guilds, it had its headquarters (Plate 28) in the centre of the commercial city, near the grain market. This covered market, known as Orsanmichele, changed its character during the fourteenth century. It began as a purely secular building, with well-built rooms on three floors: for buying and selling grain (ground floor), for the officials of the grain market and for storage (top two floors) (Plate 29). Aristocrats were allowed to take part in government only if they joined one of the *arti* and their rights of free association in *consorterie* were severely limited. All this was regularized in 1293 in the Ordinances of Justice, severely limiting the power of the old families (including those that had been active as bankers and merchants). The administration of the city was again changed, reverting to a system of quarters.

The population explosion led to a new building boom between 1280 and 1300 and a further enormous expansion of the walls (1284–1333). As in Siena and Padua, this last circuit extended far beyond the urbanized city, partly to include the great new establishments of the mendicant orders. To the

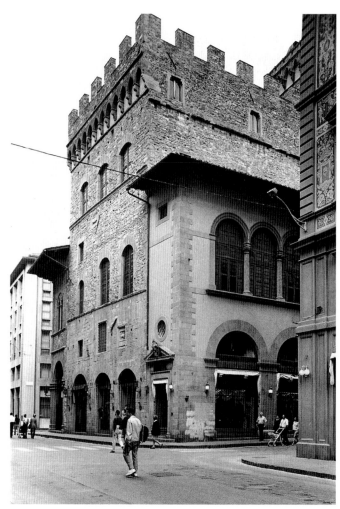

Plate 28 Building housing the headquarters of the Arte della Lana, Florence. Photo: Tim Benton.

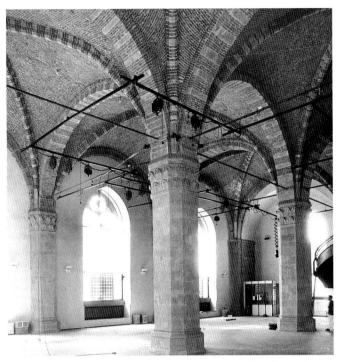

Plate 29 Orsanmichele (old grain market), Florence, first floor. Photo: Tim Benton.

virtually disappeared today, was the presence of the loggias that the wealthier families built onto their palaces. Some of these were large, stone arcades, left open to the street. Others were wooden lean-to additions. Their function was to allow members of the family or *consorteria* to meet and do business. The Loggia dei Lanzi, part of the Palazzo Vecchio, was a larger municipal version of the seigneurial loggia.

CONCLUSION

Walking around the three cities today, it is all too easy to attribute their charm and harmonious integration, sense of scale and proportion to some 'natural', organic process of growth. In fact, we find their histories full of conflict, changes of direction and confusion, but we also find a level of state intervention that would hardly be tolerated today. At every stage we find documentary evidence of painstaking, rational decision-making. The decisions taken were in part reactive, in response to the local and national crises that succeeded each other through the period. However, they generally shared a commitment to a sense of history and continuity, a firm dedication to the value of beauty and decorum for the ennoblement of the cities, and an expression of common identity.

Plate 30 View from the Duomo of standardized street layout, including the original building of the Opera del Duomo, Florence on the left. Photo: Tim Benton.

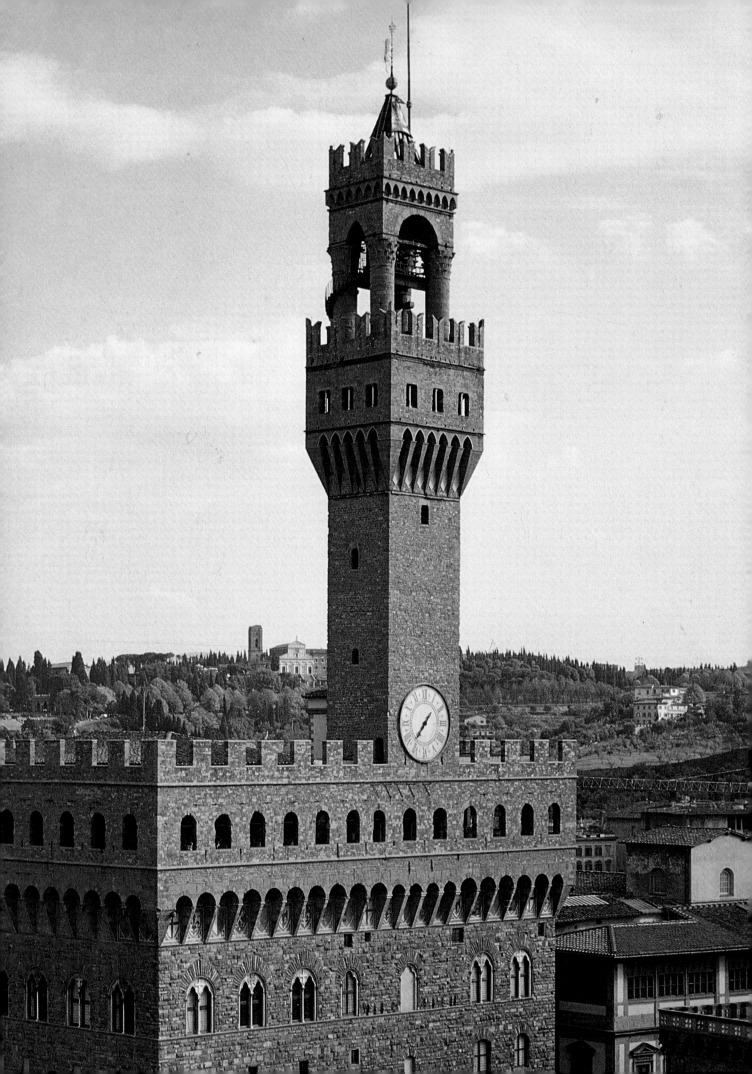

For the honour and beauty of the city: the design of town halls

In the flourishing economy of the late thirteenth century and of the fourteenth century, civic palaces of one sort or another were built and decorated in towns and cities all over Italy. Boldly conceived and often dramatically sited, they have usually shaped, and still dominate, the civic centres of their towns. Yet this burst of secular creativity was as varied as it was vigorous. No two cities were organized in precisely the same way. Some, like Padua, came under monarchical rule. Most, like Siena and Florence, had some form of democratic government. Some were fully independent states, while others, mainly the smaller towns, were subject satellites, usually controlled by a governor. There were, however, two constant factors. All the towns and cities had some sort of council, usually serving for a limited period, and all had a separate judicial arm, headed by a Podestà, an outsider (and therefore thought to be unbiased) on a short-term contract. This essay will examine the principal civic buildings of the three cities of Siena, Florence and Padua. First, however, it is important to establish the background of civic building elsewhere in Italy, and to consider the range of structures and their various forms that might have provided precedents for the three cities.

THE FUNCTION OF TOWN HALLS AND RELATED BUILDINGS

The English term 'town hall' covers a range of different buildings and has no exact equivalent in Italian. However, the image of the town hall is of a building of some splendour, designed for the honour and glory of its city; and the same aspirations are apparent in the civic buildings of fourteenth-century Italy. A conscious attempt to build in a way that would enhance an urban lifestyle has been central to life in the Italian peninsula for centuries, and the experience may well go back to Roman times. Even tiny communities such as Monteriggioni saw themselves as towns and surrounded themselves with walls, while minute cities such as Buonconvento acquired the trappings of civic life.[1] A part of this civic consciousness arose from the real need to organize and control the daily life of concentrations of population. This required meetings, to make regulations and officers, to see they were obeyed. In the politically unstable times of the late Middle Ages, there was also a need for defence, and for citizen militias or mercenary forces. Finally, there was a need to raise money to finance these activities.

The need for structures to house the resulting bureaucracies is clear enough; and they were usually designed with close attention to their appearance, and with lavish decoration. As key buildings of their cities they were also carefully sited, either in existing squares or as the centrepieces of new open areas. The ensemble of civic building(s) and piazza would form the secular focus of each town, and was often distinct from the religious centre. However, for these buildings to express civic pride, their forms needed to be recognizable. Thus, an architectural and decorative language that expressed civic pride was developed by the builders of the thirteenth and fourteenth centuries, a language that remained dominant throughout the Renaissance and beyond.

The number of civic buildings varied considerably. Most towns would have two, a Palazzo Comunale and a Palazzo del Podestà. It is not uncommon, however, to find three or even more civic buildings, depending on the form of local government. Four basic functions can be identified – control of trade, local democracy, judicial control and public ceremonial – and these were variously expressed in a range of buildings. Different combinations of functions, and different forms of government, resulted in slightly different structures. Almost all civic buildings were given the title *palazzo*, but the specific function of each was reflected in its layout and title. Some gave pride of place to the local parliament function and have the title Palazzo della Ragione. Others refer to the groups of notables – priors, consuls, etc. – who formed the government and who usually lived in the *palazzo*. Thus, we find the Palazzo dei Priori of Volterra (Plate 32) or the Palazzo dei Consoli at Gubbio (Plate 33). Some buildings were called simply Palazzo Comunale (Plate 34), and usually contained a council chamber and offices; but did not necessarily afford accommodation for the councillors. The ubiquitous Palazzi dei Podestà take their title from the Podestà, who lived in the *palazzo* with his retinue and held his courts there. Where there was a single elected leader, often with the title Capitano del Popolo (Captain of the People), a separate *palazzo* would be provided for him, as at Orvieto (Plate 35). Sometimes sets of buildings would be sited together, often as a combined piece of urban design, as with the Palazzo del Capitano and the Palazzo del Popolo at Todi (Plate 36). Sometimes, as we shall see in Siena, a whole range of functions was housed in a structure which then took a more neutral title, such as Palazzo Pubblico.

While all these buildings expressed civic pride, their individual forms also reflected their separate functions. Thus, at Piacenza (Plate 34) and Cremona the Palazzo Comunale has a lower floor open to the public, reflecting the importance of trade. (At Padua the open ground floor of the Palazzo della Ragione still contains market stalls today.) The upper floors, however, were reserved for the councillors and their officials, and were substantially grander. In general, the provision for local democracy offered a better opportunity for civic display than the mere market function, and the Palazzo Comunale at Piacenza is notable for richly decorated windows and handsome crenellations.

Plate 31 (Facing page) Detail of Palazzo Vecchio, Florence (Plate 49). Photo: Scala.

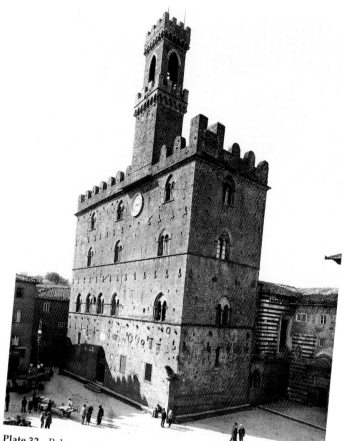

Plate 32 Palazzo dei Priori, Volterra, 1208–57. Photo: Alinari.

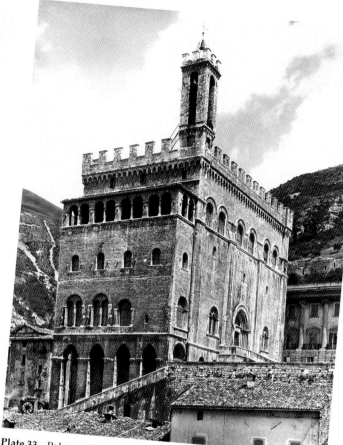

Plate 33 Palazzo dei Consoli, Gubbio, begun 1322, possibly by Angelo da Orvieto. Photo: Alinari-Anderson.

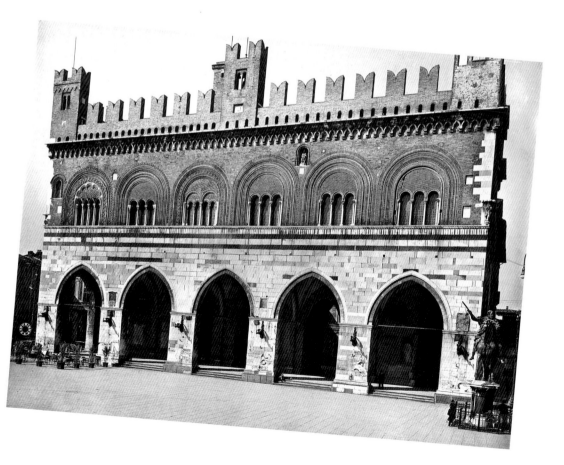

Plate 34 Main façade, begun 1280, Palazzo Comunale, Piacenza. Photo: Alinari-Anderson.

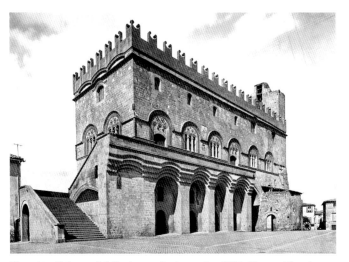

Plate 35 Palazzo del Capitano, Orvieto, after 1250. Photo: Alinari-Anderson.

In the uncertain political climate of the times, military control of one's territory was often of primary importance; and many towns were governed by a Capitano del Popolo who might also act as Capitano della Guerra (Captain of War). This role seems to have led to a stress on defensibility, and buildings were designed, such as the Palazzo del Capitano at Orvieto (Plate 35), in which the principal floor

was separated from the surrounding square by a great stairway, akin to the external stairs, designed to make access difficult, in some medieval castles.

Since public ceremonial was also very much a part of life in medieval Italy, it was common for these stairways in civic palaces to be designed with some splendour; and they, as well as platforms outside the *palazzo*, became important elements in the public life of the town government (Plates 35 and 36). At Todi, for instance (Plate 36), two buildings were related to one grand stairway, creating a unified piece of urban design at the end of the town's main square. Occasionally the ceremonial dimension might lead to the provision of a further structure, such as an open loggia fronting the piazza, as in the Loggia dei Lanzi in Florence (Plate 52).

Internal control was an important element, with most towns employing a nobleman from another city as Podestà, who was housed in a fortress-like *palazzo* (Plate 50). Some designs, as at Todi, were developed from the magnatial tower dwellings that were common in the thirteenth century. In many towns the *palazzi* designed for the small groups of priors or consuls emphasized their temporal power by repeating forms that had been developed for the seigneurial castles of the countryside. Arguably this was consciously done as a part of the expression of the new power that was being won by the towns and cities at the expense of the feudal barons.

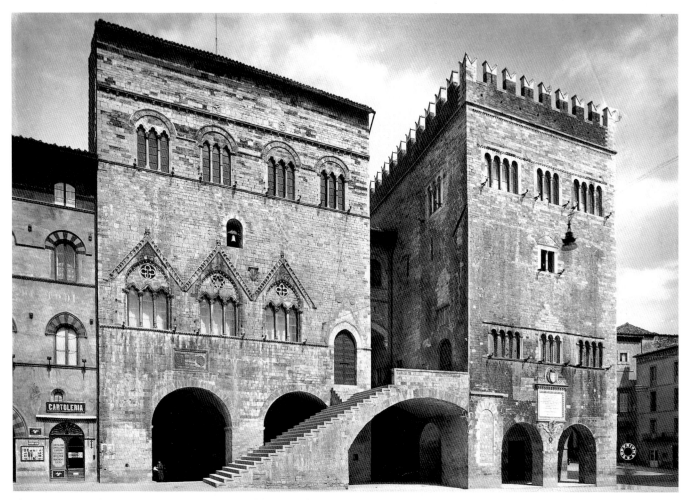

Plate 36 Palazzo del Capitano, *c.*1290, and Palazzo del Popolo, begun 1213, upper storey 1228–33, completed 1267, Todi. Photo: Alinari-Anderson.

URBANISM AND THE EXPRESSION OF CIVIC PRIDE

Largely because of the desire, or actual need, to express the individual identity of each town, these palaces of power were built and decorated richly. Most were large in relation to the surrounding buildings, and many incorporated major schemes of paintings. In short, the public buildings of the late Middle Ages were a rich field for patronage in architecture, painting and, to a lesser extent, sculpture. The Sala del Consiglio at Volterra (Plate 37) gives a good impression of the richness of the principal chamber of a communal palace.[2]

Each community fiercely asserted its independence, even though many smaller towns accepted the suzerainty of larger cities and accepted their overlord's nomination of Podestà and other officials such as the governor. One result of this was a degree of competition as town after town sought to outdo its neighbours in the splendour or size of its Palazzo Pubblico. An extraordinary amount of money and effort was dedicated

to these structures. For instance, the relatively small town of Gubbio built a massive stone castle for its consuls (Plate 33), which closes one side of the main square. Yet that is not all. The square is flanked at the other side by a Palazzo Pretorio, and the square itself, the focus of civic life in the town, is partly built up on huge arches to make a level platform on the hillside. Civic buildings were clearly designed to dominate. At San Gimignano a law was passed that no tower should be built higher than that of the Palazzo Comunale. It was always important to express the wealth and *civiltà*[3] of the town; yet not all public *palazzi* were designed on fortress lines. The closed approach was, for instance, a good deal less common in the north than in Tuscany.

The construction of a prominent civic building could also be a part of a conscious policy of urban aggrandizement. During the first half of the fourteenth century Florentine territorial ambitions were secured by the founding of a number of new towns, and the enlargement of many older ones, in the Florentine *contado* (territory).[4] Their plans

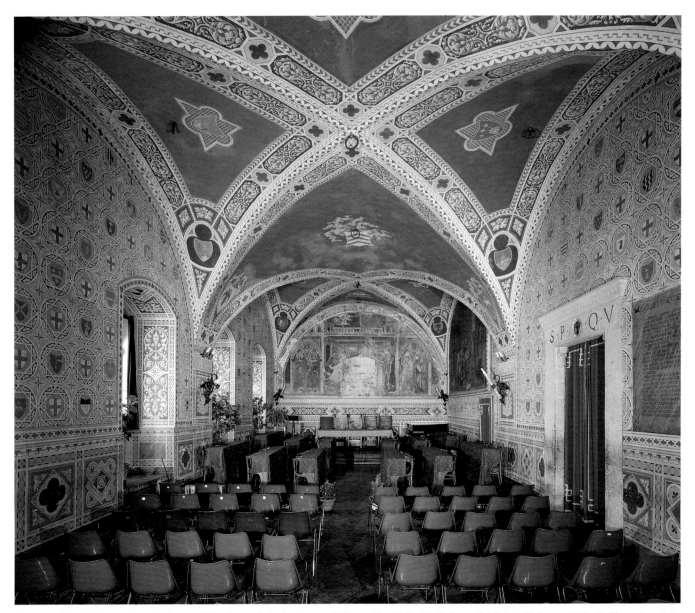

Plate 37 Sala del Consiglio with fresco of *The Annunciation* by Jacopo di Cione (doc.1362–98), Palazzo dei Priori, Volterra, 1208–57. Photo: Lensini.

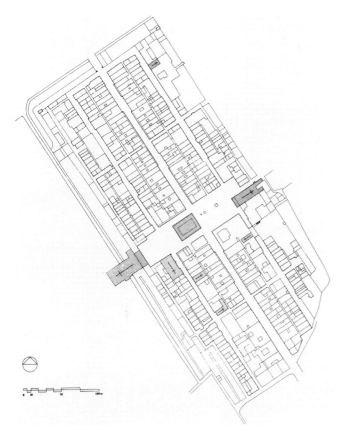

Plate 38 Town plan showing central square with Palazzo Pretorio (begun 1299), San Giovanni Val d'Arno. Reproduced from David Friedman, *Florentine New Towns: Urban Design of the Late Middle Ages*, 1988 MIT Press, Cambridge, Mass. by permission of the publishers.

generally incorporated a major central square with a public *palazzo* (Plate 38). In some cases, such as Scarperia, where strategic requirements were paramount, the governor's palace was made particularly dominant. In these towns the architects provided their *palazzi* with towers based closely on the prototype established in the Bargello at Florence. The direct quotation gave the buildings a particular meaning as

surrogates of the building in their overlord's city.

The principal elements of a civic *palazzo*, then, seem to have been an open site, a tower, an external stairway, an open loggia, and, generally, bulk in relation to the surrounding structures. This recipe can be seen complete, even in the little Palazzetto dei Capitani of 1373 in the tiny hamlet of Palazzuolo sul Senio (Plate 39). But there the building, understandably, derives its character from a vernacular charm, which hardly measures up to the grand structures of the larger cities.

It was only in the larger cities that there was the fullest scope for artistic achievement. Thus, the Palazzo dei Priori in Perugia (Plate 40) is probably a more fruitful prototype for any of the three *palazzi* we shall be studying. At first sight it seems something of a large mass, although it is undeniably palatial. However, only the first ten bays of its length and the first three of its width belong to the original design of 1293–97.[5] This was a building which, like its much smaller counterpart in Città di Castello, originally disdained the towers that were common in later Florentine communal *palazzi*. Instead the Perugians erected an elegant three-storey block, whose walls are broken by two rows of large, regular windows, those of the upper storey being particularly rich. The strong lines of these openings give a harmonious unity that is merely emphasized by the crowning line of corbelled merlons. Compared with some of the earlier communal *palazzi*, such as that at Prato, or the older Palazzo del Podestà at San Gimignano, or the Palazzo dei Priori at Volterra, the Palazzo dei Priori in Perugia is remarkably assured and elegant. The steps spreading out into the piazza lead directly towards Nicola Pisano's splendid Fontana Maggiore (completed in 1278) and to the cathedral. Thus, this *palazzo* makes a carefully considered and important contribution to the urbanism of this major city.

We shall now consider how the Palazzo Pubblico in Siena, the Palazzo Vecchio in Florence, and the extensions of the Palazzo della Ragione in Padua were all in different ways designed to fulfil similar functions as centrepieces of their respective cities.

Plate 39 Palazzetto dei Capitani, Palazzuolo sul Senio, 1373. Photo: Index/Firenze.

Plate 40 Giacomo di Servadio and Giovanello di Benvenuto, Palazzo dei Priori, Perugia, 1293–97 and later. Photo: Alinari.

THE PALAZZO PUBBLICO IN SIENA

On 4 July 1297 the General Council of the Bell, the ruling council of Siena, ordered that the Nine Governors and Defenders of the People and City should appoint 'twelve good and legal and wise men, and men [who are] merchants, namely four per *terzo*,[6] who must deliberate and provide in what way and how the said palace, or work of the palace, is to be commenced, and from what direction, for the utility and honour of the Sienese *Comune*'.[7] At the same meeting, and again in October, the Council announced a payment of up to 2000 Sienese denari every six months until the *palazzo* should be 'gloriously completed'.[8] Unfortunately the documentation is insufficiently complete to provide an accurate figure for the total cost. In any case, construction went on until 1310, with major later additions lasting until 1344; and the interior decoration, which was begun at least as early as 1312, was added to and altered right through the fourteenth century and beyond. However, the end result was a Palazzo Pubblico which, for its grandeur, its contribution to urban form and the richness and range of its surviving fresco decoration, has few equals.

The Palazzo Pubblico made Siena's Campo the second urban focus after the cathedral, and its square the dominant public space of the city (Plate 41). It also established the standard for *palazzo* architecture in Siena. It is unique in the way that it combines most of the civic functions in a single building; yet it can be taken as a paradigm for civic patronage of architecture, painting and sculpture. Curiously for so fine a building, the original designer is unknown, although we do know the names of some of those who worked on the building later. Also, although there is no precise precedent for a building of this form, the Palazzo Pubblico is firmly rooted in tradition. For a start, the site of the building was predetermined. A Council Chamber and the Dogana[9] already stood at the lower end of the Campo.[10] By 1284 the Podestà had been assigned a house to the east of the Dogana for his home; and in about 1285 the Commune leased a house on the other side for the Council of the Nine. The first resolution to build was taken in 1287;[11] and, although construction was put off for a decade, the final building was erected on the same site and with the same arrangement of functions. Indeed some of the initial work was simply a remodelling of existing structures. It is particularly interesting that so conservatively

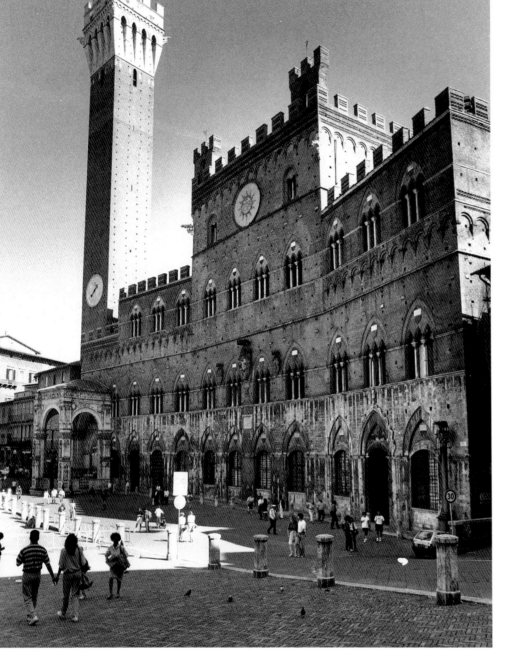

Plate 41 Façade to the Campo, Palazzo Pubblico, Siena, 1298–1310. Photo: Tim Benton.

rooted a project should have resulted in a building of such commanding individuality.

The stages of construction can be identified as follows. Work began in 1297, and by 1298 the central *torrione*, which contained the Sala del Consiglio (Plate 42) and offices of the state, was built as far as the first storey. The eastern (left-hand) wing, destined for the Podestà, was under construction by the early 1300s; meanwhile the central *torrione* was completed to its battlements. By 1310 the western wing, designed to house the Nine; was completed, and they were in residence. Then in 1330 a new prison was added at the rear and the massive tower was begun in 1325 (Plate 43). This reached the height of the battlements by 1338, and was finished in 1344. In 1342 the prison was topped by a massive new Sala del Gran Consiglio. The following year a new

fountain basin was constructed in the Campo; and the scheme was completed with the paving of the Campo in 1333–34. Almost immediately there was an addition in the form of the Cappella di Piazza, begun in 1352 and completed, in its first form, around 1376. The most significant later change was the addition, in the sixteenth century, of a further storey to the wings, effectively destroying the original relationship between wings and centre.

The whole structure was built on a steeply sloping site between the Campo and the Piazza del Mercato. There is a fall of some nine metres from the front to the back of the building; so the façade and all the principal rooms are raised on a massive substructure. This was built with solid brick vaults running across the contours of the slope for stability. The fact that they have withstood nearly seven centuries of wear

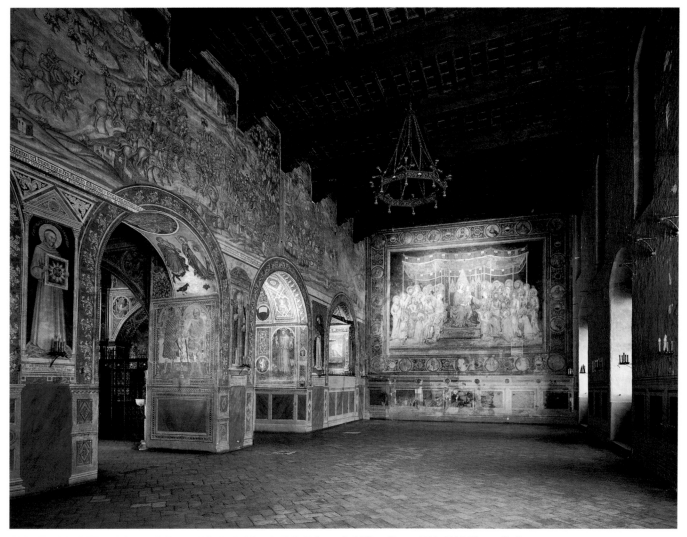

Plate 42 Sala del Consiglio, with Simone Martini's *Maestà*, 1315, Palazzo Pubblico, Siena, 1298–1310. Photo: Scala.

(including minor earthquakes) is a considerable tribute to the craft of the brickmakers and the builders.[12] But these vaults were never so much waste space. Instead they were used as stores for the salt that was an important commodity in the Sienese economy. Thus, the very foundations of the Palazzo had a direct and functional link with the life of the Commune.

The central *torrione* and the wing of the Nine housed the civic legislature and treasury, functions that in Florence were to occupy the whole of the Palazzo Vecchio. The wing of the Nine combined living quarters (since the Nine had to live in the Palazzo for the whole of their two-month term of office) with the necessary public spaces. It was almost totally reconstructed in the sixteenth century. However, a sixteenth-century plan, made before the rebuilding, allows us to recover the original arrangements (Plate 44), although it is evident that some of the functions of rooms had changed, and significant internal alterations had been made already.

Entrance was through a vaulted hall to a *cortile* (courtyard),[13] with a stairway rising round two sides. It was presumably here that the Nine, as they were sworn to do, made themselves available to all and sundry, once a week in a public place, for petitions. A stairway led to the principal floor where a door, now blocked,[14] led into the Sala dei Nove

where the Nine, together with the Podestà, the executors of the *gabelle* and official visitors, would have met. Bowsky[15] calculates that the gatherings would hardly have numbered as many as 40 people, which, in a room roughly 24 by 42 feet (8 by 14 metres), suggests that they allowed themselves a good deal of space. It was accordingly decorated by Ambrogio Lorenzetti with frescoes depicting an allegory of *Good Government* on two walls, contrasted with an allegory of *Bad Government* on the remaining long wall (Chapter 7, Plates 182–184). The decoration of this important chamber is an integral part of the town hall scheme as a whole. It is, however, described in more detail in Chapter 7. It is significant that the original entrance was at the junction between the images of good and bad government, in the corner of the room, so that those entering would naturally turn to see the fruits of good government.[16]

There was a further grand chamber on this floor, the use of which is unclear. It was probably dedicated to the more formal communal life of the Nine, but it was lit by three of the elegant *trifore* (three-light) windows of the façade, and by further, matching windows on to the *cortile* (cf. Plate 46) ,[17] so it would have been both light and spacious. It apparently opened to a stairway leading to the apartments of the Nine on the upper floors of this wing.

A private stairway led from the apartments of the Nine to the spacious roof-top loggia (Plate 45). This striking feature faced the rear of the building, and was thus a less public statement of civic pride. Such loggias were in fact common domestic elements, and in this case the loggia was necessary for the recreation of the Nine. It was unusually large, as befitted the status of the building, and afforded wide views to the south over the city and its *contado*, for which, after all, the Nine were responsible.

The central *torrione* had no doorway to the Campo, which would have helped to make the treasury more secure. (It is worth remembering that the building was indeed attacked, and successfully defended, during the riots of 1318.) Access was from the *cortile* of the Nine into a massive vaulted hall with side offices, which housed the treasury (the Biccherna) and the offices of the four *Provveditori* (overseers) of the finances. These rooms were all decorated with frescoes, some by Lippo Vanni, dating from the later fourteenth century; but most have now been covered by later works or repainted.

The principal room of this section was the Sala del Consiglio (Plate 42) on the first floor. Designed for the large ruling council, it originally opened through arcades to fill two-thirds of the first floor.[18] It is not quite clear how access was arranged. An image of the fifteenth century (Chapter 7, Plate 180) suggests that members may have reached it by steps from the piazza leading to a staircase in the eastern end of the wing and so in through the room later called the Balía (Plate 44).[19] It is possible that the formal entry was into what became the principal chapel (decorated in 1414). If so, the doorway would have fallen naturally behind the present altar. There may also have been access direct from the Sala dei Nove.[20] At one stage there was also a small door in the wall beneath Simone Martini's great *Maestà*.

Although important original frescoes survive in the Sala del Consiglio, it must have proved inadequate from an early stage. Southard and Bowsky have pointed out[21] that the room will hold about 300 people, which was the number of the full council, but that there might also be in attendance a further 150 members of the *radota* (additional members co-opted to councils), the Podestà and his judges, the *maggior sindaco* (chief official), the signory and the consuls of the wool guild. In all, the gathering may have numbered something approaching 500. Accordingly a new Sala del Gran Consiglio was added to the rear in 1342.[22] It is difficult to explain the

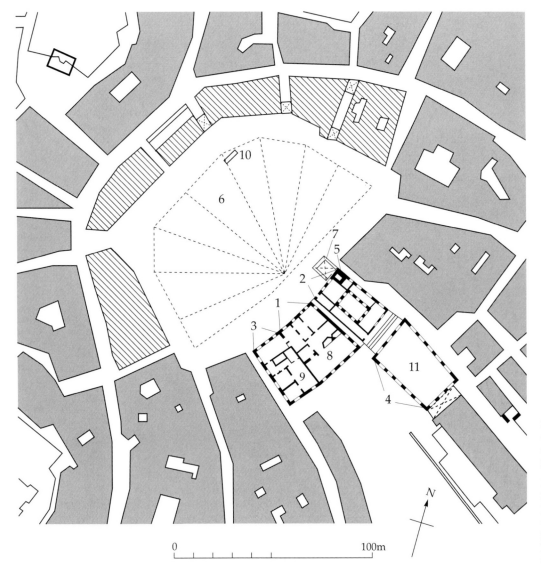

0 100m

N

Plate 43 Plan of the first floor of the Palazzo Pubblico, and outline plan of the Campo, Siena.

Key: 1 *Torrione*; 2 Wing of the Podestà; 3 Wing of the Nine; 4 Prison; 5 Torre del Mangia; 6 Campo; 7 Cappella di Piazza; 8 Sala del Consiglio; 9 Sala dei Nove; 10 Fonte Gaia; 11 Sala del Gran Consiglio.

Plate 44 Sixteenth-century plan of the first floor of the Palazzo Pubblico, Siena (top), with the ground floor of the wing of the Nine (bottom). (The plan carries dimensions in Sienese braccia and the rooms are named: some of the titles had changed since the thirteenth century.) Biblioteca Apostolica Vaticana, Fondo Chigi.

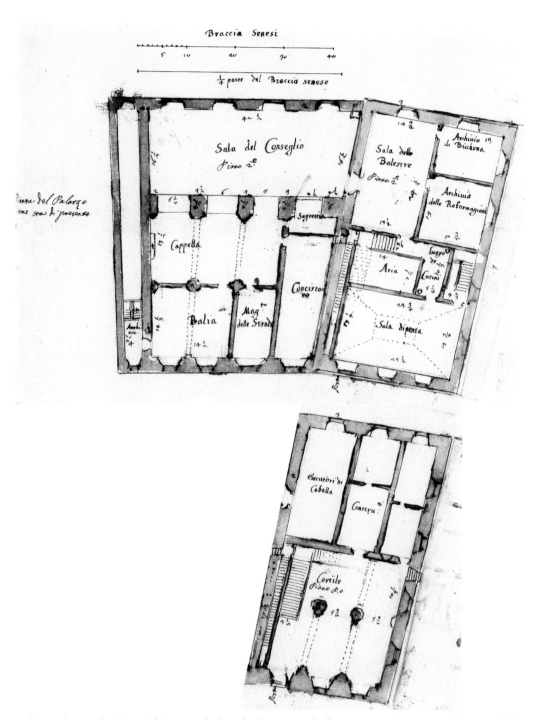

failure to provide adequate space for such a gathering within the Palazzo, since there was no sudden growth of democracy during the period of its construction or immediately after. It seems more likely that some rearward extension was intended from the start, and that the dimensions of the *torrione* were determined by the existing buildings on the site.

The eastern wing was devoted to the Podestà, a nobleman from another city appointed for a six-month period as chief of the Sienese judiciary. He had to live in the Palazzo, and his staff of judges, notaries and armed retainers would be quartered there as well (Plate 46). His bodyguard numbered from 40 to 60 men, with knights and squires in addition, and we know that by 1326 he was paid 6000 livres for his six-month term, three times the sum set aside for building the Palazzo, so he evidently merited a grand headquarters. The

whole of the ground floor was given over to a *cortile*, measuring roughly 20 by 30 metres, ideal for assembling the Podestà's guard. He himself and his household lived on the upper floors.[23]

There is a curious space between the *torrione* and the wing of the Podestà, which is interesting and symbolically important (Plates 43 and 44). In effect the two sections of the Palazzo are structurally separate, just as they are functionally distinct. An alleyway expresses this separation, although it does not show on the exterior, where it simply occupies one undifferentiated bay of the façade. However, it had another important function, in that it linked the lower Piazza del Mercato with the Campo, and probably maintained a right of way that was older than the Palazzo. Thus, a link with the practices and traditions of the city was built into its Palazzo Pubblico.

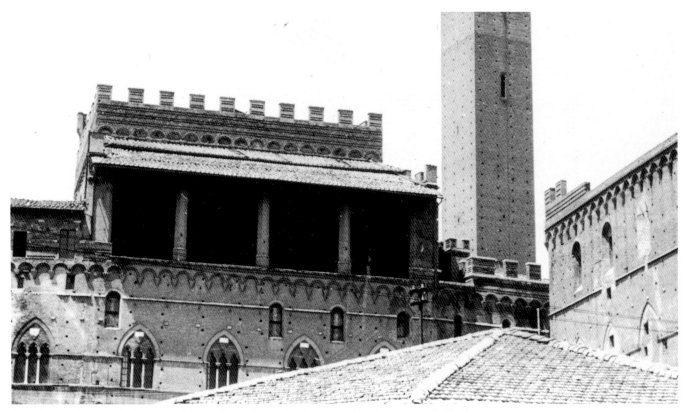

Plate 45 Roof-top loggia, Palazzo Pubblico, Siena, 1298–1310. Photo: Archivio Fotografia Editalia, Rome.

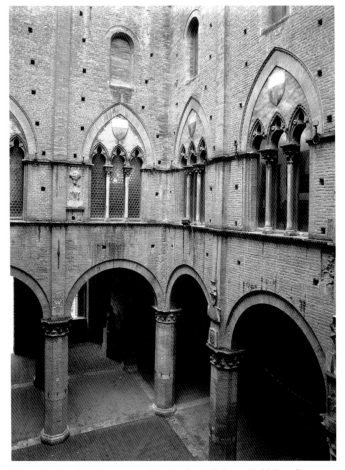

Plate 46 *Cortile* of the wing of the Podestà, Palazzo Pubblico, Siena, 1298–1310. Photo: Tim Benton.

Connected with the wing of the Podestà was a rear wing, containing the prison. The siting of a prison within the headquarters of the chief officer of the judiciary is entirely logical. In the new gaol there were three sections, one for those convicted of major crimes, one for those convicted of lesser crimes and one for debtors and women. The cells were in vaulted brick spaces, rather like the substructure of the Palazzo itself, but this time forming the substructure of the new Sala del Gran Consiglio. The new prison may have been seen as a real civic improvement, in that Bowsky records that as many as 60 prisoners had died in two years because of the terrible conditions in the private gaols of Siena. It was certainly a public statement of the extent to which all citizens were under the law, and must obey it if good government was to be maintained. Little remains of the prison or the new Sala. The whole wing was of considerable bulk, however, amply matching the scale of the main Palazzo (Plate 47). The Sala was reached from the wing of the Podestà by a wide bridge, beneath which there was presumably access to the Piazza del Mercato.

The final architectural feature of the Palazzo was an imposing tower called the Torre del Mangia[24] (Plate 41). A bell, an essential adjunct to a town hall, was used for summoning the Council, for sounding curfew at dawn and dusk, and for announcing the time. To set it high in a tower was to let it be heard and seen far and wide, and so to allow a public expression of civic pride. Rising 87 metres (102 metres to the tip of the ironwork) this tower is among the tallest of the period. We may assume that a part of the drive for height was a consciousness that Florence had just built a 94 metre tower on the Palazzo Vecchio; but the great height also allowed this tower to compete with the campanile of the

Plate 47 Rear façade with extension, 1330, containing the prison and the Sala del Gran Consiglio, Palazzo Pubblico, Siena, 1298–1310. Photo: Archivio Fotografia Editalia, Rome.

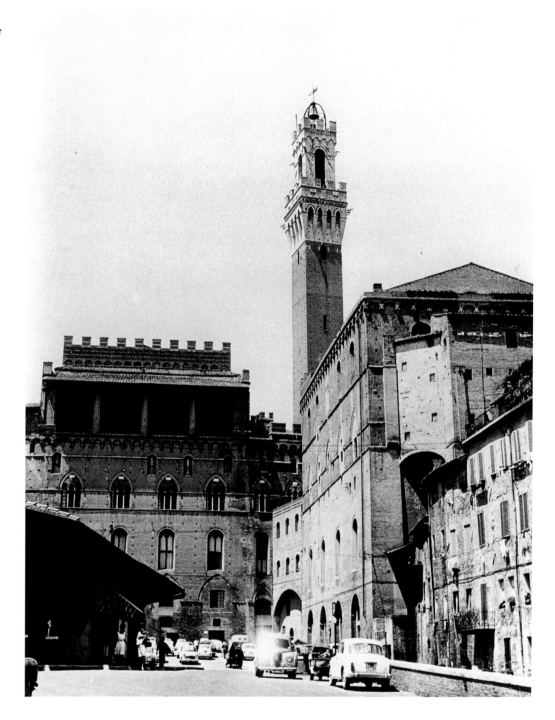

cathedral on its higher site on the top of the hill. Surviving records of its construction indicate a deep interest in the project. At the foundation-laying ceremony in 1325, for instance, Ugo de'Fabbri, the works foreman, 'put into the foundation of the said tower some pieces of money … and set in each corner a stone with bits of writing in Hebrew, Greek and Latin letters, to make it safe against injury from thunder, lightening and tempest'.[25] The tower itself is a massive but plain structure of brick that bursts into flower with a flourish of stone battlements at the top. It appears that construction was originally in the hands of two Perugian master builders.[26] However, it is clear that close attention was paid to the upper stages, where there is evidence, in a row of unused corbels at the top of the brickwork, for a possible change of design. The

final version of the upper stages is credited to 'maestro Lippo',[27] who is most likely to be the painter Lippo Memmi, brother-in-law of Simone Martini. The top, with its boldly corbelled lower stage, marks a significant development of what by 1330 was an established type (cf. Plate 32).

The completion of the whole scheme was the formal laying out of the Campo in front of the Palazzo Pubblico as the civic centrepiece of Siena.[28] The first concern, in 1343, was the provision of a proper fountain basin. Fresh water had recently been brought into the Campo as part of a major urbanistic effort to supply the whole city; and a fountain basin was erected to receive it, designed by the sculptors Agostino di Giovanni, who had worked on the Palazzo Pubblico in 1331, and Lando di Pietro.[29]

The rest of the regular space had to be made suitably presentable. The problem, however, was that the space already existed, and could not be specially shaped to fit the Palazzo. When the Campo was paved in 1333–34, the bricks were laid in nine segments in a nice recognition of the 'Nine Governors and Defenders of the People and City'.[30] And there are some subtle spatial relationships, which may well have been planned,[31] and which suggest that considerable thought was given to designing a *palazzo* that would relate to its space. The overall width of the building roughly equals the radius of the irregular semicircle of the brick paving. The 102 metre extreme height of the tower is only a very little greater than the depth of the Campo. Thus, the viewer, at the moment of entering the Campo, sees a 1:1 relationship of height to distance from each of the three entrances opposite the Palazzo.[32] Also, the width of the central *torrione* at 23 metres approximates quite closely to the outer width of the nine sections.[33] The relationships are not exact; but that may be because the irregular space was already there. In any case, the ground slopes, so that precise equalities would not be so easy to appreciate. There is, however, no documentary proof that these relationships were sought; but we shall see that there is a likelihood of a similar approach to planning in the case of the Palazzo Vecchio in Florence.

Siena's Palazzo Pubblico is the centrepiece of an outstanding achievement in urban design. Its style has a number of points of interest. In the first place, the material – brick – is typical of Siena, although a number of the magnatial *palazzi* were of stone, and stone was the common material for communal palaces elsewhere. Then the Palazzo adopts the fortress image with crenellations, but, where a working fortress would have real machicolations,[34] this civic fortress has only heavy corbels resembling machicolations. So there is a concentration on image, within the shapes of the language of feudal power. The ground floor, however, speaks another architectural language. Although the Palazzo had only three doors facing the Campo, the stone walling was cut to form a blind arcade across the entire façade. This is almost a denial of the solidity of the wall, and more in keeping with the open arcades of the earlier civic buildings of the north (Plate 34). The two languages, of seigneurial fortification and of commercial enterprise, are both essential in this building, and are the keys to meaning in its appearance.

A fine appearance was something that this *palazzo* also helped to establish in Siena. The design of the windows of the upper floors was used to set a standard for the rest of the city. It appears to have been a deliberate policy from the start, for as early as 1297 it was ordered that 'if any house or building should ever be built around the Campo, each and every window of such house and building, which should look out upon the Campo, must be made with columns and without any balconies'.[35] The precise pattern of the *trifore* windows themselves soon became widespread in Siena. A unique early drawing for the street façade of the Palazzo Sansedoni,[36] which was being rebuilt to the designs of Agostino di Giovanni in 1340, shows rows of windows precisely like those of the Palazzo Pubblico. In addition, the new constitution of 1309–10 decreed that all new houses were to be 'adorned with arches and to have their columns and front façade walled with brick so that those houses lend beauty to the city'.[37]

Thus, this one civic building was used to establish a standard for visual *civiltà* in its city.

There remains the question of the painted and sculptural decorations of the Palazzo, which, here as elsewhere, were an integral part of the venture. The principal fresco schemes that survive are those in the Sala del Consiglio and in the Sala dei Nove.[38] Here it is only important to note that the Sala del Consiglio was decorated with a *Maestà* by Simone Martini (Plate 42) on one wall, and representations of castles and towns captured by the Sienese on the others. These military scenes seem to have been considered almost as official records of the achievements of the Commune; and were, accordingly, important elements in the iconography of a successful civic building. The *Maestà* relates very specifically to the function of the Sala, with the injunction 'Judge wisely, you who rule the earth' written on the scroll held by the infant Christ.[39] It repeats the theme of the city's dedication to the Virgin and of her continuing care for her city, and is a reminder that religious and secular art were by no means separate categories in the fourteenth century. Although there is much controversy as to the precise symbolic programme of the allegory of *Good Government* in the Sala dei Nove, it is clear that the viewers could have made out many details reminiscent of their own experience of life.

The whole scheme of the Palazzo Pubblico and its painted decoration is a major achievement for a city of only 50,000 people. Its continuation from 1297 to the 1340s is also a tribute to the commitment of the Commune to expressing its identity and pride in its success. Even more impressive is the decision to complete the task by paving the piazza in the year after the Black Death, which may have carried off as much as half the population of the city. Although the resulting instability was to lead to the end of the rule of the Nine in 1355, there seems to be no indication that their aspirations for the beautification of their city were dimmed by the plague.

In 1352 the Nine commissioned the Cappella di Piazza (Plate 48) to stand at the foot of the Torre del Mangia in fulfilment of a vow made at the time of the Black Death. It was completed around 1376, but now appears an intrusive feature, because its appearance was drastically altered in the 1460s, its height being increased by half so that it obstructs the regular rhythm of the windows. The chapel's original roof was a simple pitched affair that would have risen very little, if at all, above the stone ground floor, and would, in any case, only have abutted on the blind window of the tower.[40] What makes the chapel particularly important, however, is its sculptural programme. The piers are richly moulded, with niches with projecting hoods, the work of Giovanni di Cecco in the 1370s. Their capitals are a riot of carved foliage and figures, the equal of anything at the new cathedral.[41] White remarks that the design is richer even than Orcagna's tabernacle in Orsanmichele.[42] The niches were eventually filled with images of the twelve apostles by other Sienese sculptors, of which only five copies now remain. More interesting are the panels of the low wall enclosing the chapel. The two at the front date from 1470, but the side panels were reused from the old baptismal font of the cathedral, and so would have been easily recognized by the Sienese citizenry. This was an unusual means of creating an artwork; but it had the virtue of linking the chapel even more firmly to the past of

Plate 48 Giovanni di Agostino and Giovanni di Cecco, Cappella di Piazza, 1325–76 (upper parts 1461–68), Palazzo Pubblico, Siena. Photo: Tim Benton.

the city, in much the same way that the chapel itself celebrated the city's survival from a specific, if terrible, happening in the city's history.

The close involvement of the Cappella di Piazza with the city's history and life is an essential element of its success as an artistic conception. Significantly the Campo was then, as it still is, the centre of ceremonial life in Siena. The celebrated Palio, the horse race around the Campo, was only one of a number of festivities that were held there; and it is a clear acknowledgement of the building's meaning in Siena that the jockeys of the Palio still attend Mass in the Cappella di Piazza before the race. Presumably they have done so since the fourteenth century.

THE PALAZZO VECCHIO IN FLORENCE AND RELATED BUILDINGS

The palpable bulk of the Palazzo Vecchio in Florence, surrounded as it is by open space, marks it out immediately as a structure of importance (Plate 49). Its height is considerably greater then that of the church of Orsanmichele, a spacious piazza opens on two sides (Plate 52), and the building has an immense tower, rising almost 100 metres. Yet it is difficult to study, because of its later history. It was hugely extended and internally reconstructed from the mid fifteenth century on, to accommodate the Medici rulers of Florence. Both the design of the palace and the layout of the

piazza evolved slowly over a number of years. So a degree of historical detection has to underly our study. Also, the Palazzo Vecchio is only one of two major public buildings in Florence. Unlike Siena, the Podestà was housed in a separate and older *palazzo*, and we need to consider both buildings to understand the nature of civic architecture in fourteenth-century Florence.

The Palazzo Vecchio[43] was planned in 1285, just three years after the Priorate was established in Florence.[44] It was the end of a period of civil disturbance. The lengthy strife between Guelphs and Ghibellines had reached some form of peace with the Guelph Party firmly established in Florence. The merchant class was emerging victorious; and peaceful trade and economic expansion were the basis of Florentine success in the first half of the fourteenth century. As Becker has pointed out, 'the need for public order and concern for the good of the commonwealth rather than for private interests ... lay at the heart of the *trecento* classical revival'.[45]

One can very roughly divide fourteenth-century Florentine society into four classes: the magnates (feudal barons), the *popolo grasso* (merchant princes), the *popolo minuto* (smaller traders), and the disenfranchised craftsmen and share-cropping peasants, who were bound as serfs until 1289. The divisions among the upper ranks were judicial rather than socio-economic, but relate importantly to the organization of the Florentine state and to its buildings. The magnates, ostensibly those possessed of knighthood, had military power but were not officially eligible for the Priorate, although they held between one-quarter and one-third of the major fiscal posts. There were some 150 magnatial families in Florence, who were supposed to swear allegiance to the state and put up a bond of 2000 livres for good behaviour.[46] The *popolo grasso* were members of the *arti maggiori*,[47] and it was from their number that the six priors were selected to serve for their two-month period. It is clear that by 1295 magnates were able to enrol in the major guilds simply to have the right to serve as priors. There were 25 *arti minori* and some of these had a minor share in power;[48] but the populace at large had none, although they could usually be relied on to follow a charismatic leader and to fight in the streets at his behest.

Law enforcement over this unstable mixture was in the hands of the Podestà, who was housed in the Bargello (Plate 50). Originally built as the dwelling of the Capitano del Popolo,[49] this became the home of the Podestà after the battle of Montaperti (1260), when Florence reverted to less democratic government. In form it is similar to the Palazzo dei Priori in Volterra (Plate 32), which had recently come under Florentine control. One important difference is the placing of the tower at the corner. This was because the base of the tower was an older structure incorporated into the new building. Just as towers were built as fortress homes, so this building was designed for defence, although on a grander scale; and the projecting balconies, with which it was originally equipped, would have been just as useful for defence against a mob in the streets as for air and relaxation in times of peace. The castellar form was established in Florence as the principal seat of government by about 1260, whereas the priors had at first to meet in the Torre del Castagno, an older tower like the one incorporated into the Bargello.

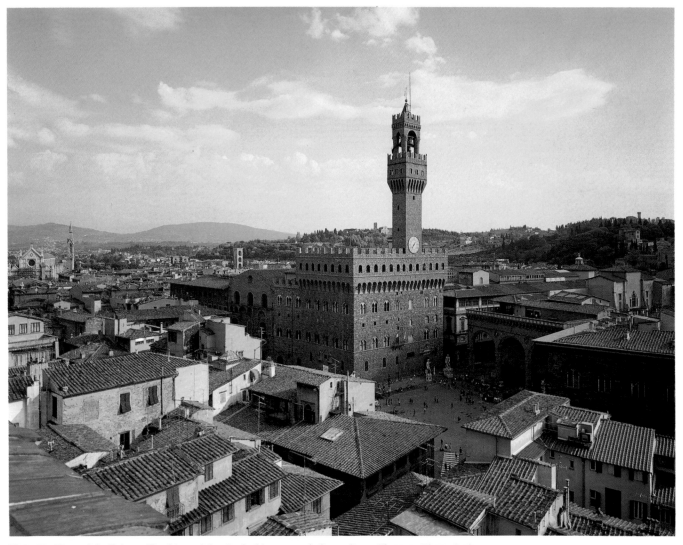

Plate 49 View of the Palazzo Vecchio and the city looking towards Santa Croce, Florence. Photo: Scala.

From 1260 to 1285 the Bargello was considerably extended, with slightly lower buildings surrounding a spacious and elegant *cortile* (Plate 51).[50] This has a fine arcade on three sides of the ground floor, and, on the southern side, an upper arcade as well. Despite the elegance of the *cortile*, the Bargello was essentially a defensible headquarters, and needed to be. In 1295–96 it was extensively damaged in riots, and the subsequent refortification included a new door to the south to allow for armed sorties from both sides of the building. In 1334, under the Duke of Athens,[51] new windows in the courtyard added to the palatial character. The building was sacked in 1343 when the Duke was overthrown. Thereafter, the wooden roof of the hall was replaced with a stone vault, and a grand window was formed in its south wall by Benci di Cione, later to work on the Loggia dei Lanzi.[52] The new window and vault add considerably to the grandeur of the hall, giving this fortress a distinctly palatial character. The vault might be compared favourably to the timber ceiling of the Sala del Consiglio at Siena.[53] In spite of all the stages of building, and all the structural compromises, there was sufficient continuity for the building to appear as a dignified and unified structure, worthy of a great city.

Against this background of continuing unrest and a defensible palace for the Podestà, the fortress-like appearance of the Palazzo Vecchio is entirely natural. Although the building was conceived in 1285, construction did not begin until 1299. The priors were in occupation by 1302; and the building was complete by 1318, although there were alterations and extensions in 1343 and 1371.[54] There is no documentary proof, but it is usually accepted that the design was in the hands of Arnolfo di Cambio, who was also *capomaestro* of the works at the cathedral.

It was a relatively short construction period, and it is often assumed that the design was conceived as one, and possibly even derived from the magnatial castle of the Conti Guidi at Poppi, in the upper Arno valley.[55] Trachtenberg, in two important articles,[56] has argued that this is far from the case, and that the design of the Palazzo Vecchio must be seen as developing organically, even with radical changes. At first sight this view is difficult to comprehend, because the simplicity of the form, and the way the building addresses its piazza, seem so natural and effective (Plate 52). Also, the form of the Florentine Palazzo Vecchio has itself helped to establish the image of what a town hall should be, so that it is difficult

Plate 50 Bargello, Florence, begun *c.*1255. Photo: Alinari.

to think away the effect of the final design. But the piazza itself was not there in 1299 (or very little of it was) and even in 1318 it was less than half the size it eventually reached in 1356. So it is worth examining the original site and the building designed for that site, before considering how the relation of the whole building to its piazza was worked out (Plate 53).

It is clear that the General Council, which took the decision to build, was not unanimous.[57] There was no immediately suitable site in the city centre, or any obvious alternative on the edges of the built-up area. The General Council met in the Palazzo Vescovile (Bishop's Palace), and then in the parish church of San Pier Scheraggio (Plate 53); the priors met in the Torre del Castagno. Only the Podestà had his Consiglio (Council) in a proper *palazzo*. The site eventually chosen was close to the Palazzo del Podestà, and north of the church of San Pier Scheraggio. There lay a small piazza that had been created by the demolition of the houses of the rebellious Uberti family.[58] The new palazzo was constructed along the south side of this piazza, and extended back to the Via della Ninna.[59] In plan it was very similar to the Bargello; and, like the Bargello, it included an old tower, which had belonged to the Foraboschi family, irregularly placed on the western side.

A major advance on the design of the Bargello was the provision of large windows with clearly marked voussoirs set in the rusticated masonry, whose pattern was continued for the full height of the building (Plate 54). These windows, and the slightly pointed arch of their voussoirs, came to be a hallmark of building in the city in the fourteenth century.

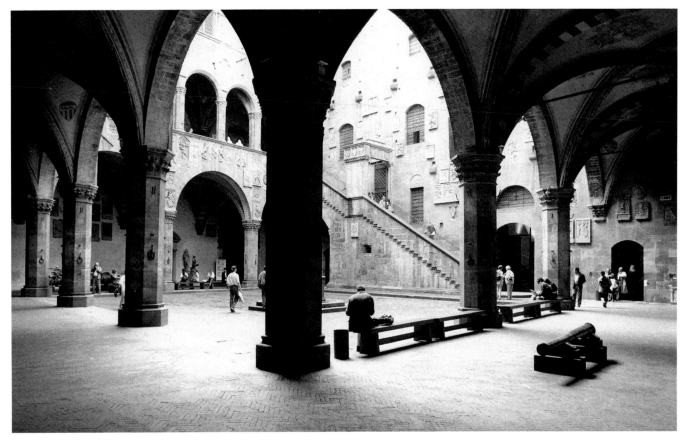

Plate 51 *Cortile*, 1280–85, stairway, 1345–67, Bargello, Florence. Photo: Tim Benton.

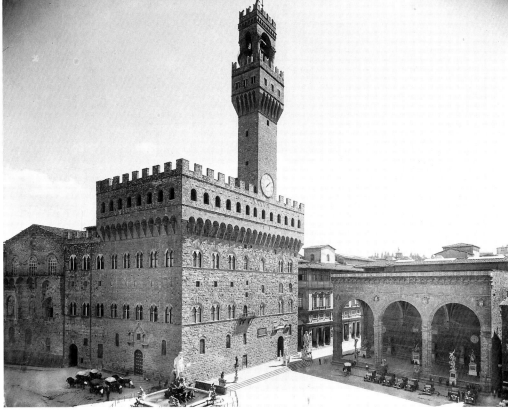

Plate 52 Arnolfo di Cambio, Palazzo Vecchio, Florence, 1299–1314, extended 1343; Benci di Cione and Simone Talenti, Loggia dei Lanzi, Florence, 1376. Photo: Alinari.

There was a further sophistication in the regular spacing of the windows on the north façade. Trachtenberg argues convincingly that this façade was topped only by simple crenellations, thus giving the building an appearance similar to the Palazzo del Popolo at Todi (Plate 36) or the Palazzo Comunale at San Gimignano. The Palazzo Vecchio would thus be firmly within the tradition of communal building. Indeed that tradition was continued in Florentine territory when the Palazzo Pretorio at Prato was enlarged in 1333.

Such a simple castellated façade would have been perfectly effective as an element of the small Piazza degli Uberti. However, the building had a side façade, incorporating the Torre dei Foraboschi, along the continuation of the Via delle Farine, where the fenestration was very far from regular. The less than satisfactory nature of this façade would have become evident when a second piazza was opened up to the west between 1299 and 1306. This was probably envisaged from the start, and the Palazzo was designed with a doorway into each piazza. Partly to counteract the weakness of the second façade, the tower was redesigned and enlarged, and the orientation of the Palazzo effectively turned through 90 degrees. At the same time, to give the building greater bulk and to accord with the great height of the new tower, the crenellations were redesigned as the unusual double height *ballatoio* (gallery), which is so much a part of the character of this building.

The final design gave the piazza a façade that hangs together as a composition and disguises the irregularity of the early part of the structure. The tower rises directly opposite the Vaccherecchia, the street leading into the western side of the new piazza; and the left side of the tower falls almost in the centre of the façade. This was vital in that the piazza was

extended to its present width in the years after 1319, making this area larger, and more important, than the Piazza degli Uberti, fronting the original main façade of the Palazzo Vecchio. The piazza was closed by a massive wall. This structure, known as the Tetto dei Pisani from the Pisan prisoners of war employed to build it, was a substantial structure, concealing the houses and the church of Santa Cecilia, which had been demolished in whole or in part to form the square, and established the important western boundary of the piazza opposite the Palazzo Vecchio.

The tower is an extraordinarily daring piece of construction, and we may assume there were strong reasons for wanting it so tall. In the first place it is just higher than the Torre del Mangia at Siena (discounting the ironwork on top of the Siena tower). Then, the bitter rioting in Florence of 1301–4 would have been a reason for visual aggrandizement of the symbol of communal authority. The siege of Florence by Henry VII, Holy Roman Emperor, may have helped the determination to build a tower that stands out as a landmark for the *contado* as well as for the city. When completed in 1318 it housed the bell (ordered in 1306) to summon the Consiglio. Plate 55 shows just how daring a structure the tower is, with the whole of the forward wall resting on the corbelled-out *ballatoio*. In fact it could only be maintained by completely filling in the old Torre dei Foraboschi, which explains the blind windows of the façade.[60]

Trachtenberg points to a further reason for so daring a tower in the final dimensions of the Piazza della Signoria, and suggests that the organic incrementation of the design may have been part of a larger plan for the whole area. His thesis rests on the observation of medieval buildings rather than on documentary evidence. However, the relationships he cites

Plate 53 Plan of the ground floor of the Palazzo Vecchio, Florence, and surrounding area, showing original streets and buildings cleared for the Palazzo and its piazza.

Key: 1 Sala d'Arme; 2 *Cortile*; 3 Torre dei Foraboschi; 4 *Ringhiera*.

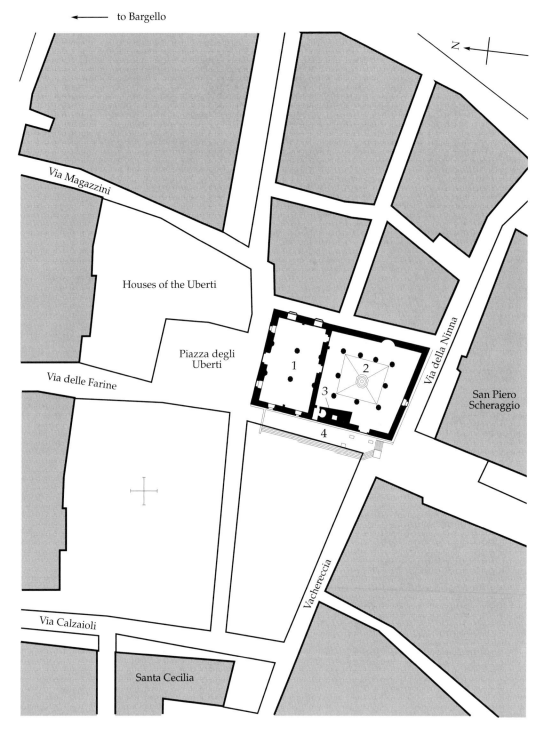

argue a sophistication of design that makes the theory worth considering in detail. The Piazza della Signoria was enlarged in 1343–56 to its present size, so as to make what had previously been two separate spaces into one. If one accepts that medieval architects were not always concerned with precise measurements, but rather with what appeared visually satisfying, and with simple mathematical relationships, then it is possible to see the Piazza della Signoria and the Palazzo Vecchio as a complex interaction of spaces and solids that deliberately relate to one another. This relationship is based on the common medieval habit of designing a pair of squares in which the diagonal of the smaller square equals the side of the larger. The diagonal of the Palazzo is 51 metres, and the old Piazza degli Uberti was almost 52 metres square. That produces a diagonal of about 75 metres, which approximates to the sides of the larger section of the Piazza della Signoria. Finally, the diagonal from the base of the tower to the Via Calzaioli, the principal entrance to the square, at roughly 95 metres, equals the height of the tower. This gives a 1:1 relationship at a 45 degree angle, which is particularly satisfying. It is also significant that the striking cap of the tower is just nicely visible over the Palazzo (also at a distance of almost 94 metres) from the end of the Via dei Maggazini.

Plate 54 Façade to the Via del Ninna under restoration in 1929 with traditional scaffolding, Palazzo Vecchio, Florence. Reproduced from Giulio Lensi-Orlandi, *Il Palazzo Vecchio di Firenze*, 1977 Editore Aldo Martello by permission of the publishers.

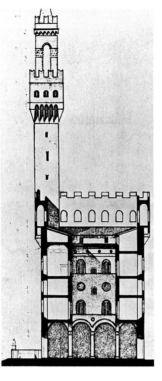

Plate 55 Section through the *cortile*, Palazzo Vecchio, Florence, after a drawing by Rohault de Fleury, 1874. Reproduced from Georges Rohault de Fleury, *La Toscane au Moyen Age: architecture civile et militaire 1868–9*, tome 2–3, Palazzo de Podesta à Florence. Photo: Bibliotheque Nationale, Paris.

The relationship of Palazzo to Piazza is crucial for our understanding of this building. As Becker has pointed out, 'pageant, ceremony and tournament were the hallmarks of Florentine society till the 1340s'.[61] All the major guilds had their own courts, rituals, festivals, hospitals, altars, churches, retainers and prisons. It was only logical that the Commune should be seen as a leader in ceremony, as in architecture. Indeed one reason given for demolishing so many houses, and even two churches, to make the square was to accommodate the citizen militia, which was increased to 4000 after the Ordinances of Justice in 1293. The decisions of the priors recognized that the Piazza della Signoria 'ought to be neater and more level [than other squares in the city] for the honour of the Commune and the appearance of the Palazzo'.[62] Accordingly the Piazza, like the Campo at Siena, was carefully paved with herring-bone brickwork, the warm pink of which would probably have complemented the ochre colour of the stone rather better than the present grey paving (Plates 49 and 56).[63] More important still was the erection in 1323 of a *ringhiera*, or raised platform, linking the two doors of the Palazzo Vecchio. It was decorated with a large gilded lion, a *marzocco*, the badge of Florence; and was central to the ceremonial life of the square. Nothing remains of the *ringhiera* today, but we can get some idea from representations in

paintings and relief. Plate 56 shows the Piazza, with its original pink brick surface, as the scene of the execution of Savonarola. The high platform for the scaffold extends directly from the *ringhiera*, and appears to be some one and a half metres high. Other representations suggest that the *ringhiera* was a substantial platform, with rings, such as are common on Italian *palazzi*, for tethering horses, and that it was fitted with stone benches at the back for the priors.

The *ringhiera* and the Piazza della Signoria were all-important in creating a suitable theatre for civic ceremonial. It was in the Piazza, for instance, that the banners of the civic militia were presented. More importantly, it was in the Piazza that the priors took their oath of office. But, although the *ringhiera* would be adequate for ceremonies held in fine weather, in winter or in the rain it was hardly consistent with the dignity of the leadership of a major city. Accordingly in 1356 a decision was taken to build a loggia of some sort for the use of the priors.[64] It was designed by Benci di Cione, who had worked on the Bargello, and Simone Talenti. As befits a building for ceremonial, it is consciously elegant, with finely carved capitals (now sadly worn), delicate sculptural accents representing the virtues[65] and a decorative balustrade. Yet it should not be seen as distinct from the Palazzo Vecchio. Significantly the distance between it and the Palazzo is almost precisely the same as the width of its arches. Its height corresponds almost exactly to the string course of the second-floor windows of the Palazzo. Thus, it appears well integrated into the south-east corner of the square (Plate 52).

Although not begun until 1376 and only completed in 1382, this loggia has to be seen as a final element in an organic design for a complete civic symbol. It followed immediately on the east wall extension of the Palazzo of 1371, which apparently set out to consolidate various city offices within the Palazzo.[66] There was a long period of development with many pauses caused by war, riot, floods or lack of finance;

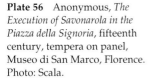

Plate 56 Anonymous, *The Execution of Savonarola in the Piazza della Signoria*, fifteenth century, tempera on panel, Museo di San Marco, Florence. Photo: Scala.

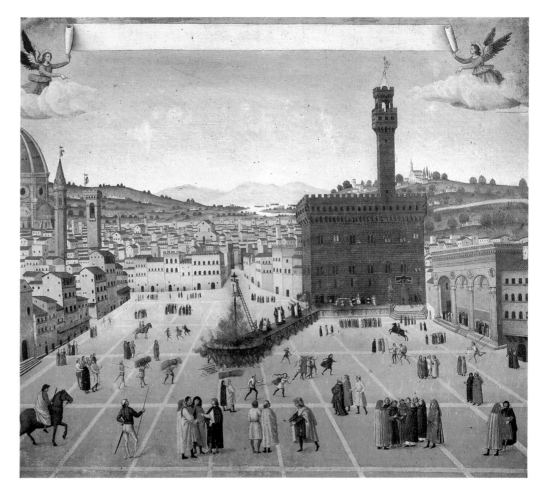

but it is still possible to trace a continuity in the commitment. The first plans were formed in 1285. Construction began in 1299. The design was modified in 1306–7. The Piazza was enlarged in the 1320s while the interior was being decorated. The *ringhiera* was constructed in 1323. Then in 1342–43 the Duke of Athens turned it into a private fortress,[67] but continued the enlargement of the Piazza. Four gilded lions for the four *quartieri* (quarters) of the city were added in 1348. In 1351 the doorway was decorated. Five years later the Loggia dei Lanzi was planned; and, finally, in 1386, the whole Piazza was repaved, presumably with a consistent pattern.

This then was the setting for the government of the priors; and it was in the Palazzo Vecchio that they lived. The Camera dell'Arme survives as the only room in anything like its original condition; and even this is missing its gallery and all the fresco decorations that were ordered in 1318 at a price of 200 gold florins. Above the Camera dell'Arme was a Sala del Consiglio,[68] with another great hall above that. However, the total loss of the fresco decoration makes it difficult to assess what sorts of art work the Commune of Florence was commissioning, although we can assume it was of the highest quality;[69] and it would seem that Florence, like Siena, was following a practice of decorating the Palazzo Vecchio with images of political and military events and personages who were important in the city's history.[70]

The southern half of the Palazzo afforded lodgings and offices for the priors. Here there was a sophisticated adjustment of the colonnade to give an apparently regular arcade in the irregular space of the *cortile* that resulted from the site bounded by existing streets (Plate 53). Since the great hall in the northern half was tall, there was room for an ample mezzanine, three floors above the ground level *cortile*, and additional attics under the roof. To judge by fragments of a decorated staircase found on the mezzanine floor (Plate 57), the priors' apartments were of some grandeur, but they were completely restored by Michelozzo for the Medici in the mid fifteenth century. Restoration in 1972–73 revealed the structure of the *cortile* walls, with traces of the original openings, from which it was possible to reconstruct its fourteenth-century appearance (Plate 58). The projecting wooden balconies would have been very much in the tradition of feudal castles such as that at Poppi. The Palazzo Vecchio as a whole takes on the traditional appearance of a fortress; and the capture of the Bargello in 1295 is a reminder that this was necessary. Here the fortifications are built to work, and the machicolations in the *ballatoio* are real.[71]

Over the first half of the fourteenth century, the period of building of the Palazzo Vecchio, Florence was undergoing something of an economic and artistic boom. By about 1350 the city was undoubtedly, as Boccaccio describes it, 'a noble city, which for its great beauty excels all others in Italy'.[72] At that stage the cathedral and its campanile were unfinished, only the baptistery, a building of an earlier century, was complete. The cathedral was the prime architectural project of the second half of the fourteenth century and rapidly became the symbol of the state; but for the whole of the first half of

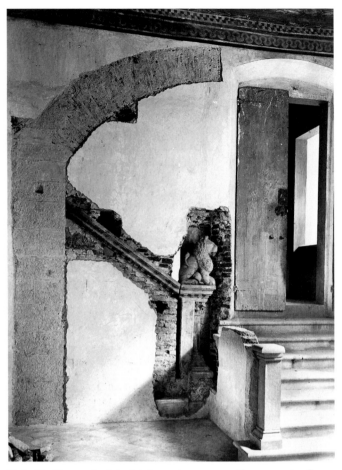

Plate 57 Traces of original stairway in a room on the mezzanine floor, Palazzo Vecchio, Florence. Fototeca dei Musei Comunale di Firenze.

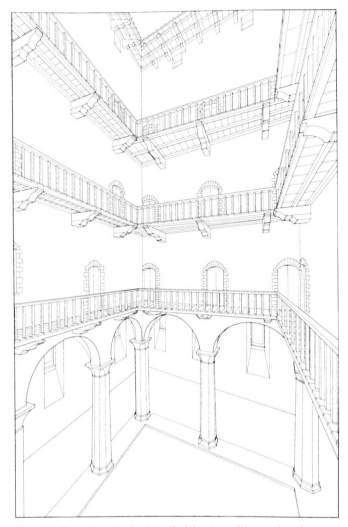

Plate 58 Reconstruction by Atwell of the view of the south and east sides of the *cortile*, Palazzo Vecchio, Florence, as it may have appeared *c.*1314. Reproduced from *Art Bulletin*, December 1989, figure 20 by permission of Adrienne Attwell and Professor Marvin Trachtenberg.

the century it was the Palazzo Vecchio, along with the baptistery, that stood out as the visible symbol of the city. The building seems to symbolize the power of the communal government, rather than its glory; but effectively this *palazzo* captured the essence of Florentine pride at the start of our period, where the cathedral, still without its dome, has to be seen as a summing up.

THE PALAZZO DELLA RAGIONE IN PADUA AND RELATED BUILDINGS

Padua's Palazzo della Ragione (Plate 59) strikes one immediately as a building of a different sort. It is a much earlier building than its equivalents in Florence and Siena, although it was altered in the early fourteenth century (Plates 61 and 62), and one might assume that under the monarchical rule of the Carrara family there was less opportunity for display of conscious civic pride. Yet the building remained very much in use throughout the period of Carrara rule; and its domination of the city centre, together with its rich decoration, would have been a part of the consciousness of the Paduan citizenry.

Two elements of this civic consciousness are important. First, the very early date of the building (1218–19) shows Padua's comparative wealth in the early thirteenth century. Padua's Palazzo della Ragione predates that of Milan by a

decade; Como (1215) and Bergamo (1199) are almost the only other north Italian towns with significant civic buildings that are any earlier. Second, and equally important, when, a century after it was built, the Paduans reconstructed their Palazzo della Ragione, they retained the whole earlier structure, a crucial admission of the importance of tradition in such a building.

The plan of the Palazzo is an irregular parallelogram, about 82 by 28 metres, probably built to follow the line of an ancient watercourse along the south side of the Piazza della Frutta. It functioned as a communal meeting place and covered market; and its siting is important. It stands between two market squares called, from the produce sold in them, the Piazza della Frutta and the Piazza dell'Erbe. This reflects the fact that Padua was essentially a market town dealing mainly in local produce, and her economy was an agricultural one.[73] The small traders regularly congregated round, and in, the Palazzo della Ragione. Giovanni da Nono[74] gives a detailed description of the stalls and workshops; and it is possible from this to reconstruct the spaces allotted to the various traders and suppliers (Plate 60). Thus, the Palazzo della Ragione stands at the very core of commercial activity of the

city. Paired stairways from either side led up to a central hall over 40 metres in length, the roof of which was supported by a row of central pillars.[75] Here justice was dispensed, and at its centre stood the Stone of Vituperation, on which bankrupts were publicly seated. At either end of the hall was a series of separate chambers, including a chapel and a prison. Thus, the upper floor of this building accommodated all the same public functions as the Palazzo Vecchio in Florence.

This *palazzo*, then, functioned in a different way from its equivalents in Florence and Siena. It is more essentially a building of community than of control; and it was accordingly designed as a more open structure. We have already seen, however, that judicial and administrative control over an area, as well as commercial activity, are essential parts of the character of township; and it is important to recognize that this building was only the grandest of a larger group of administrative and legal structures.[76] The period from 1254 to 1320 was one of economic growth for Padua, and also one of steadily increasing democratization. Anti-magnatial laws were passed in 1266, 1270 and 1277–78; and in 1277 the membership of the Consiglio Maggiore was fixed at 1000. Padua was sending her own Podestà to 27 named communities in a *contado* measuring something like 1000 square miles. Judicial control of all this was in the hands of a Podestà in Padua, who in turn was advised by a Council of the *Anziani*, responsible for putting the wishes of the people to him. In addition the guilds

(mainly small traders)[77] were co-operating with monthly meetings under their *gastaldioni* (stewards) 'for the honour and utility and peaceful state of the city of Padua and its district and the *comunanza* and all the guilds of the Paduan people'.[78] All this was reflected in the public buildings.

We learn from Giovanni da Nono that the Palazzo della Ragione housed on its first floor, in addition to the chapel of San Martino, the formal seat of the Podestà, the tribunals of his four judges and fourteen benches for ordinary judges, as well as the various judicial secretariats and desks of the notaries. Thus, the exhibition of the bankrupts has a more understandable context. There was also a prison, the 'Basta', attached at the eastern end and a debtors' prison to the west. The Palazzo del Podestà was built to the east of the Palazzo della Ragione in 1281, and the Palazzo degli Anziani further east in 1285. These two buildings were separated by the ancient Torre del Municipio, which was incorporated in the whole group of municipal buildings. Both these *palazzi* had open loggias beneath,[79] built of fine stone work, that of the Podestà being noticeably more richly carved.[80]

The beginning of the fourteenth century, then, saw a flourishing and well-organized Commune well supplied with civic buildings. It is against that background that the enlargement of the Palazzo della Ragione must be judged. In the first decade of the century the southern market square was enlarged, a new corn market built, and the northern square was unified. As part of this scheme of civic improvement, the

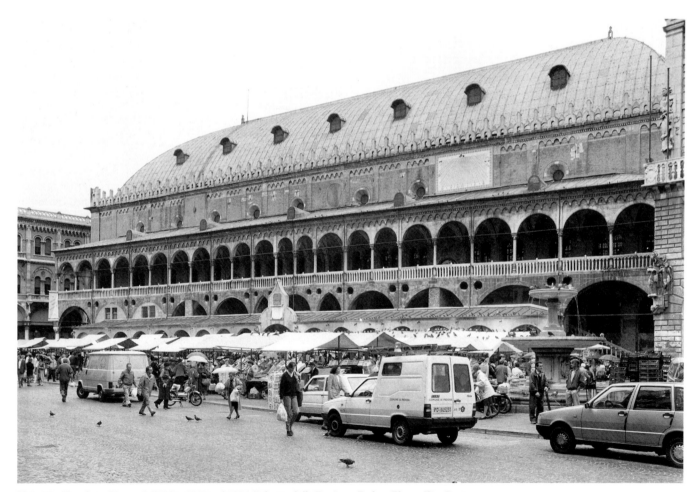

Plate 59 Façade to Piazza dell'Erbe, 1219 and 1306, Palazzo della Ragione, Padua. Photo: Tim Benton.

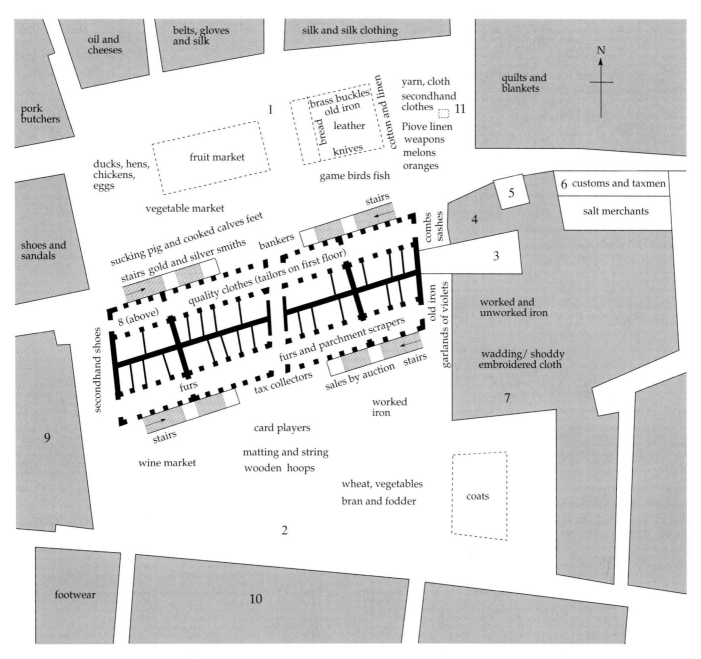

oil and
cheeses

belts, gloves
and silk

silk and silk clothing

N

quilts and
blankets

pork
butchers

brass buckles
old iron

1

bread

leather

cotton and linen

yarn, cloth
secondhand
clothes 11

Piove linen
weapons
melons
oranges

knives

ducks, hens,
chickens,
eggs

fruit market

game birds fish

6 customs and taxmen

5

salt merchants

vegetable market

stairs

4

combs
sashes

shoes and
sandals

sucking pig and cooked calves feet

stairs gold and silver smiths

bankers

3

quality clothes (tailors on first floor)

8 (above)

old iron
garlands of violets

worked and
unworked iron

furs and parchment scrapers

wadding/ shoddy
embroidered cloth

secondhand shoes

furs

tax collectors

sales by auction stairs

7

9

stairs

card players

worked
iron

wine market

matting and string
wooden hoops

wheat, vegetables
bran and fodder

coats

2

footwear

10

Plate 60 Plan of the ground floor of the Palazzo della Ragione and market-places with traders' stalls, Padua, after Verdi, 'Il mercato padovano'.

Key: 1 Piazza della Frutta; 2 Piazza dell'Erbe; 3 'Basta' Prison; 4 Palazzo del Consiglio; 5 Torre del Municipio; 6 Palazzo degli Anziani; 7 Palazzo del Podestà; 8 Carcere Vecchio (old prison); 9 Carcere Nuovo (new prison/debtors' prison); 10 Ospizio di San Urbano (Hospice of Saint Urbanus); 11 original site of Berlina dei Falsari (Stone of the Bankrupts).

Palazzo della Ragione was transformed (Plates 61 and 62). First, in 1306 the interior was stripped of all the divisions, the outer walls were increased in height from 16 to 24 metres, and the whole was covered with an immense whaleback roof, rising a further 12 metres (Plate 62a). It is this that gives the building its characteristic shape; and it evidently changed the character of the Palazzo, for the upper floor now became a single, vast, uninterrupted space (Plate 63). The daring roof spanned almost 27 metres.[81] However, this transformation cannot be seen as representing a change in the management of Padua. Rather it is akin to the provision of the Sala del Gran Consiglio at Siena; and the new Sala would have accommodated the Consiglio Maggiore of 1000 in style. The

Sala also remained the seat of judgement; and the Stone of Vituperation was retained for the bankrupts. Prisoners were now housed in a separate building to the west, which could be reached by a bridge, leaving the whole *palazzo* as an expression of civic pride.

Nor was the raising of the roof all that was done. In 1318 double-height loggias were added to the north and south, enclosing the old external stairways and virtually doubling the depth of the building (Plate 62b). Nonetheless this was still the old building, and tradition was evidently important as well. The arcade of the loggia was constrained by the rhythm of the old building, which had a slightly enlarged central bay (Plates 59 and 61). One generous round arch supports an

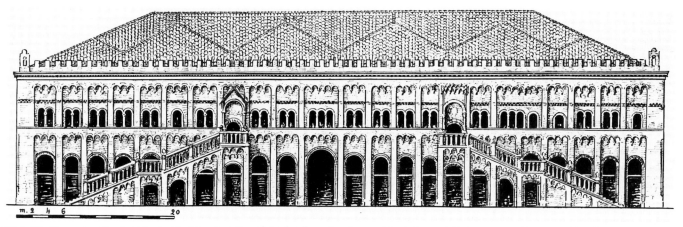

Plate 61 Reconstruction by Moschetti of the elevation of the façade to the piazza of the Palazzo della Ragione, Padua, as in 1219. Reproduced from A. Moschetti, 'Principale palacium communis Padue', *Bollettino del Museo Civico di Padova*, 26, 1933 by courtesy of Biblioteca Civica Padova.

upper loggia built with arches of exactly half the span, a harmonious relationship similar to that in the *cortile* of the Bargello in Florence, but all the more telling here because the arcades are of great length and external. This simple rhythm is interrupted at the centre, where, because of an irregularity in the old building, two narrow pointed arches have to be squeezed in instead of the more generous round arches. The awkwardness is almost concealed by the elegance of the basic rhythm. These new wide loggias were built on arches keyed into the old structure, with the result that the ground-floor arches had to rise higher than the narrower arcade of the old building. The result is that the floor of the upper loggias is almost a metre above the doorways of the Salone.[82] The *ad hoc* solution of additional steps from the tops of the old stairs suggests that the view from the piazzas was the important factor. Any awkwardness in use was a small price to pay for

the elegance of the design. The building was completely transformed, given vastly greater dominance by its increased bulk, while the substitution of open loggias for the solid wall of the old hall added its sense of openness.

The new Salone was, of course, decorated, and frescoes survive on the walls. There are considerable difficulties in assessing these works, however, because of extensive restoration.[83] None the less, enough remains for us to see that the Salone once contained an important cycle of secular paintings.[84] The upper part of the walls was divided into three zones, which were filled with 333 separate images that constituted a complicated astrological scheme.[85] There is less doubt about the paintings of the lower walls of the Salone, which reveal the same mix of religious and secular imagery that was evident in the frescoes of the Palazzo Pubblico in Siena. It appears that this second programme was painted

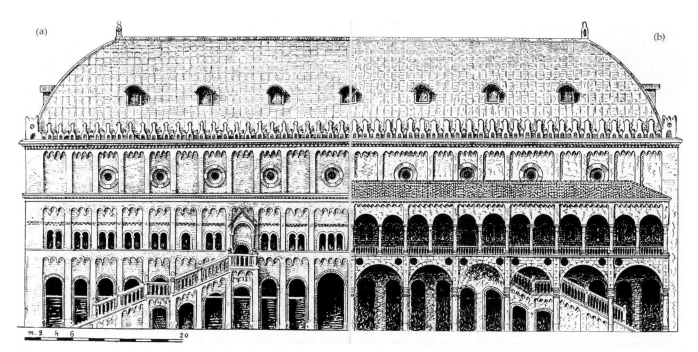

Plate 62 Reconstruction by Moschetti of the elevations of the Palazzo della Ragione, Padua: (a) façade to piazza as in 1306, (b) façade to piazza as in 1318. Reproduced from A. Moschetti, 'Principale palacium communis Padue', *Bollettino del Museo Civico di Padova*, 27–8, 1934–39 by courtesy of Biblioteca Civica Padova.

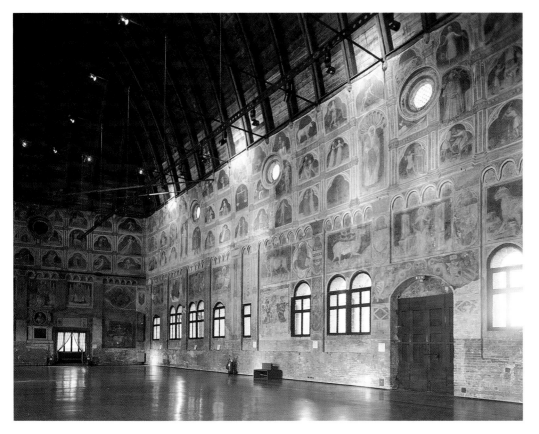

Plate 63 General view, Sala del Consiglio, Palazzo della Ragione, Padua. Photo: Alessandro Romanin.

under the period of Carrara rule, probably between 1370 and 1380, which suggests that the Palazzo della Ragione retained at least some of its importance as a functional and symbolic centre of civic display even under the Carrara.

The decoration of the Palazzo della Ragione places it firmly in the same tradition as its counterparts in Florence and Siena. Its size and grandeur indicate that the Paduan Commune set the same value as Siena and Florence on the expression of identity. It is a building that, in its retention of the old fabric, embodies a strong sense of tradition, and even under Carrara rule it continued to be a *locus* for significant artistic commissions. What makes it different is the general architectural language of openness in its loggias, which contrasts with the fortress-like character of the Florentine and Sienese buildings.

CONCLUSION: TOWN HALLS AS AN EXPRESSION OF SECULARISM IN TRECENTO ART

The three great *palazzi* of the three cities all demonstrate the commitment of their Communes to an expression of identity and civic pride in public architecture. Both in size and richness they dominate the lesser *palazzi* of their respective cities. It is possible that an element of competition between the cities was a factor in their development. This could explain some of the correspondences between the Palazzo Vecchio in Florence and the Palazzo Pubblico in Siena. It is also surely significant that the transformation of the Romanesque Palazzo della Ragione in Padua was later repeated at nearby Vicenza.[86] Certainly, few cities of the Italian peninsula in the fourteenth century could boast civic palaces to equal the three we have been studying; and this is

some reflection of the artistic dominance of the cities.

There is a marked contrast between the Palazzo Vecchio in Florence and the Palazzo della Ragione in Padua, in that the latter is an essentially open building, while the former appears closed and fortress-like. The Palazzo Pubblico at Siena has the fortress form too, but also some of the appearance of the open type, although functionally it is much closer to the Palazzo Vecchio. Thus, the three buildings display the same civic pride in different ways, but adopt forms that express both their differing functions and the varied character of their cities.

All three buildings are a testament to the importance and scope of civic patronage in the fourteenth century. All three are substantial buildings and, together with their related buildings, they show the remarkable range of the late Gothic style. All three had important schemes of painted decoration, and also significant sculptural elements, particularly at Siena. They represent the high peaks of secular patronage in their cities; yet, as we have seen, they are not entirely divorced from the religious sphere. In Florence the Arte della Lana, the leading guild that supplied many of the priors, was also responsible for the building of the cathedral. In the civic palaces of both Siena and Padua, frescoes survive of specifically religious subjects, which are none the less linked to the civic function. Finally, architects, painters and sculptors in all three cities worked on both the civic *palazzi* and the principal religious sites. Thus, these monuments, although bold expressions of secular civic power, are inextricably linked with the whole range of the life and artistic activity of their cities. They have all been much altered, and many parts of their decorative schemes are lost; none the less their quality needs to be judged alongside the other major schemes which form the subjects of further essays in this volume.

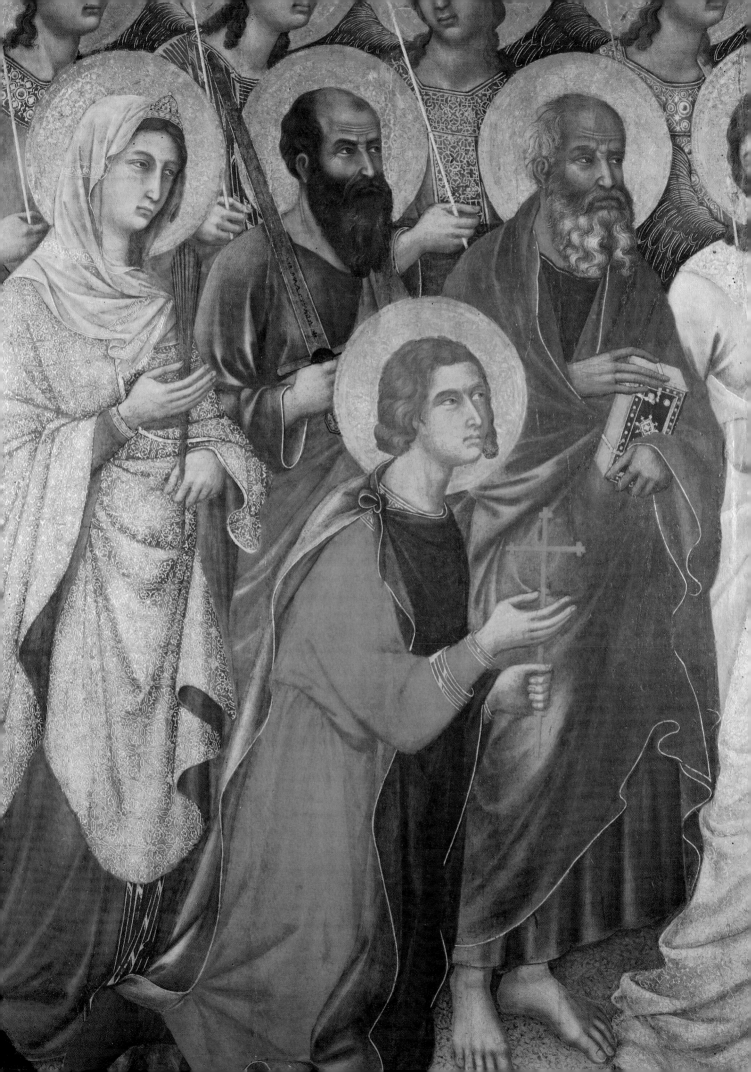

'A noble panel': Duccio's Maestà

On 9 June 1311 Duccio's *Maestà* (Plates 65 and 66) was carried in triumph from the painter's workshop to its place over the high altar of Siena Duomo. The lively description of the event given by an anonymous mid fourteenth-century Sienese chronicler conveys something of the intensely celebratory nature of this occasion and the enthusiastic reception that Duccio's painting received:

> On the day on which it was carried to the Duomo, the shops were locked up and the Bishop ordered a great and devout company of priests and brothers with a solemn procession, accompanied, by the Signori of the Nine and all the officials of the Commune, and all the populace ... and they accompanied it right to the Duomo making procession round the Campo, as was the custom, sounding all the bells in glory, out of devotion for such a noble panel as was this.[1]

Some 250 years later, Giorgio Vasari, writing in the second edition of his famous *Lives of the Artists*, remarked of Duccio:

> ... in the Duomo he executed a panel which was put on the high altar and afterwards removed ... It was painted on both the back and the front, as the high altar stood out by itself, and on the back Duccio had executed with great care all the principal histories of the New Testament in very fine small figures. I have endeavoured to discover where this panel is located at the present time, but although I have taken much care, I have not succeeded in finding it.[2]

By 1568 Duccio's monumental altarpiece had, indeed, been removed from its prestigious location and relegated to a position near the crossing of the cathedral. In its place had been set up, in 1506, a fifteenth-century bronze tabernacle – an expression of the increasing use of altar decoration with an overtly eucharistic function. Sadly, however, this was by no means the end of the process of destroying the physical, iconographic and aesthetic integrity of the *Maestà*. In 1771 the painting was stripped of its framing and pinnacle panels, the main panel was cut into seven vertical strips and the front separated from the back face by the panel being sawn apart. At this point the slip of a saw severely damaged the face of the Virgin. Meanwhile, the predella was cut into individual scenes and the pinnacle panels were drastically cut down. Thereafter, the surviving fragments of the altarpiece led a peripatetic existence and although most of them, including the two main panels, are now displayed in the Museo dell'Opera del Duomo in Siena, several of the subsidiary panels remain dispersed in art collections throughout the world.[3] Despite the near-catastrophic history of the painting, the surviving parts of the *Maestà* have, fortunately, been the

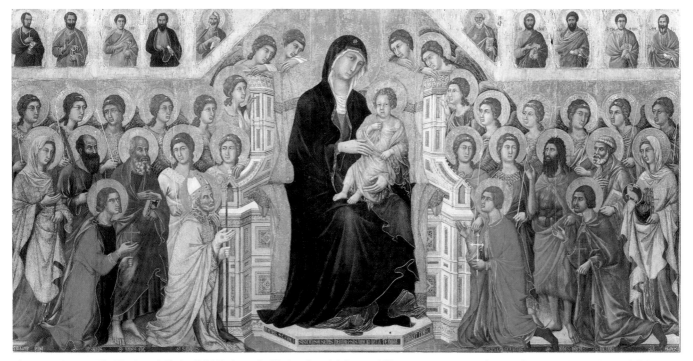

Plate 65 Duccio, *The Virgin and Christ Child Enthroned with Angels and Saints*, c.1308–11, tempera on poplar panel, 211 x 425 cm, Museo dell'Opera del Duomo, Siena, formerly on the front face of the *Maestà*, high altarpiece of the Duomo, Siena. Photo: Lensini.

Plate 64 (Facing page) Duccio, *Saints*, detail of *The Virgin and Christ Child Enthroned with Angels and Saints* (Plate 65). Photo: Lensini.

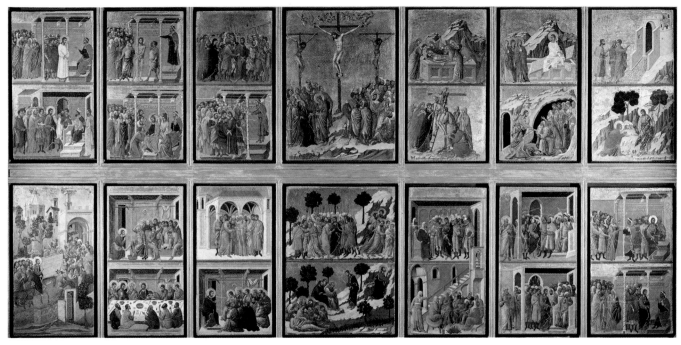

Plate 66 Duccio and assistants, *Scenes from the Passion of Christ*, *c*.1308–11, 217 x 425 cm, Museo dell'Opera del Duomo, Siena, formerly on the back face of the *Maestà*, high altarpiece of the Duomo, Siena. Photo: Lensini.

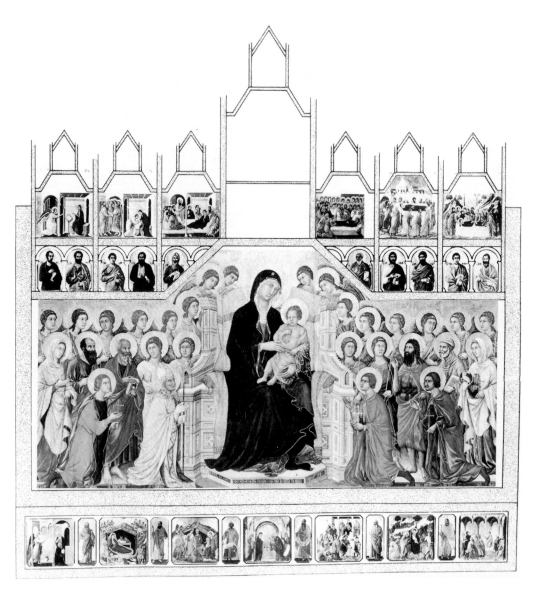

Plate 67 Reconstruction after White of the front face of the *Maestà*. Reproduced from John White, *Duccio: Tuscan Art and the Medieval Workshop*, 1979 by permission of Professor John White and Thames & Hudson, London.

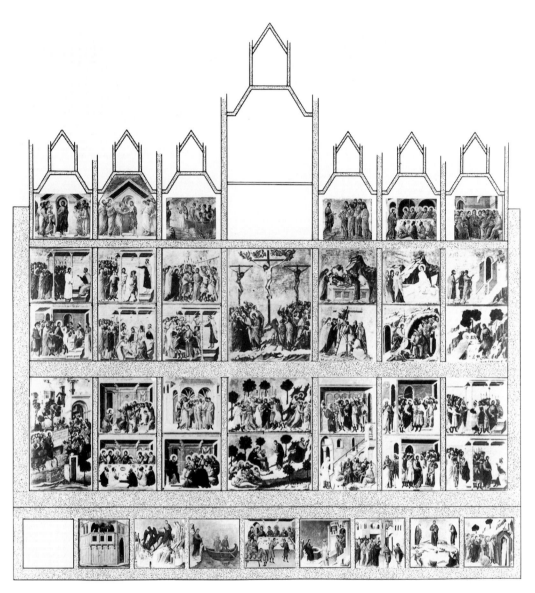

Plate 68 Reconstruction after White of the back face of the *Maestà*. Reproduced from John White, *Duccio: Tuscan Art and the Medieval Workshop*, 1979 by permission of Professor John White and Thames & Hudson, London.

object of skilful conservation by modern restorers, whose investigations have revealed much about the techniques of fourteenth-century panel painting and workshop practice. Duccio scholars have also subjected the *Maestà* to intense archaeological and historical study and have offered a number of plausible hypotheses as to the original physical structure of this remarkable double-sided altarpiece and the extent and significance of its highly versatile iconographic programme (Plates 67 and 68; the subject-matter of the *Maestà* is outlined in the Appendix at the end of this essay).

Of the several reconstructions of the *Maestà* attempted by modern scholars, the one that is most attentive to both surviving physical and historical evidence is that of John White.[4] On the basis of White's reconstruction, it appears that the work was a vast, double-sided altarpiece some 468 by 499 centimetres in its overall dimensions. The front face of this huge edifice once displayed an imposing image of *The Virgin and Christ Child Enthroned with Angels and Saints*, with a sequence of three-quarter length images of the apostles above (Plate 65). On the upper part of the altarpiece was a series of pinnacle panels – rendered the more distinctive by their truncated gable shape – which represented narrative events

associated with the death of the Virgin. This sequence of pinnacle panels began with the narrative scene of *The Annunciation of the Death of the Virgin* (Plate 73) and ended with *The Entombment of the Virgin* (Plate 67). Between these two scenes was located a series of further pinnacle panels, four of which survive and one of which is now probably lost. This missing pinnacle panel was probably a centrally placed painting of the Virgin Mary crowned as queen of heaven.

The entire structure of the altarpiece was supported by a predella – a box-like structure – which had both its front and back surfaces painted with further sequences of narrative scenes. The front face depicted scenes from the Infancy of Christ, beginning with *The Annunciation* (Plate 74) and ending with *The Disputation in the Temple,* these scenes being separated by paintings of prophets (Plate 67). The back face of the predella once depicted scenes from the Ministry of Christ, of which the opening scene is now lost. The closing scene in this series was probably *The Raising of Lazarus* (Plate 68).

On the back face of the altarpiece itself were 26 scenes from the Passion of Christ, starting at the bottom left-hand corner with *The Entry into Jerusalem* (Plate 69) and ending at the top right-hand corner with *The Apparition on the Road to Emmaus*

Plate 69 Duccio and assistants,
The Entry into Jerusalem, 101 x 56
cm, detail of *Scenes from the Passion
of Christ* (Plate 66). Photo: Lensini.

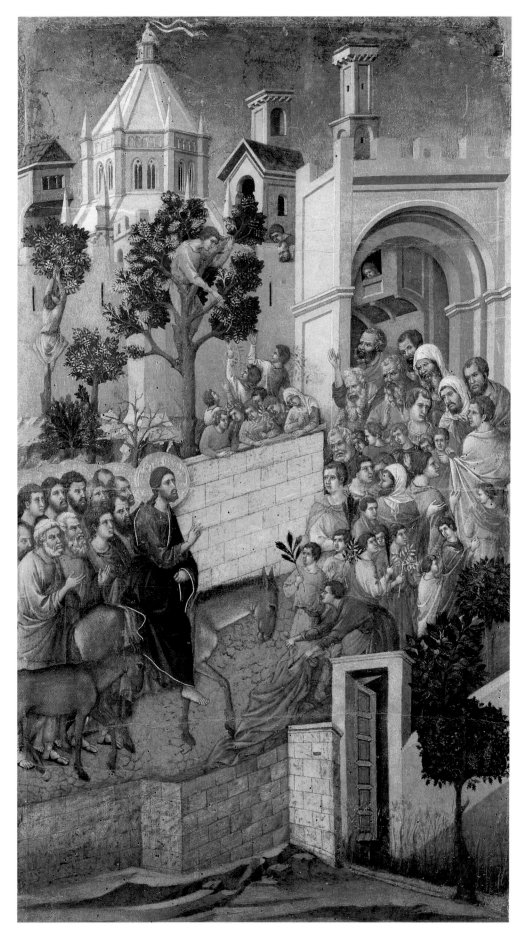

(Plate 66). This Christological cycle continued in a series of pinnacle panels that showed scenes depicting events following Christ's Resurrection. These began with *The Apparition Behind Closed Doors* and ended with *The Pentecost* (Plate 68). The central scene, now missing, may once have depicted *The Ascension* with an image of *Christ in Majesty* above it.[5]

The composite physical structure of the altarpiece and its wide variety of religious subject-matter amply support the assertion by White that the *Maestà* represents 'the richest and most complex altarpiece to have been created in Italy'.[6] It is the aim of this essay to examine and test this claim. In so doing, the essay will focus upon a number of salient features of the *Maestà* and its production. It will discuss the way in which the *Maestà* exemplifies a high degree of technical, narrative and representational skill on the part of its painters. Particular emphasis will be placed upon the organizational skill required of Duccio and members of his workshop in painting an altarpiece of this size and complexity. The essay will also consider the significance of the original position of the *Maestà* over the high altar – a location at the very heart of the cathedral in liturgical terms. In so doing, it will focus upon the various ways in which the painting's complex iconographic programme was highly appropriate to the altarpiece's original function as a monumental, civic icon.

THE COMMISSION

Two documentary records provide tantalizingly brief evidence of the circumstances surrounding this prestigious civic commission and the complex and long drawn-out process of its execution. The earlier of the two documents, dated 9 October 1308, records that the Sienese painter Duccio di Buoninsegna had accepted from Jacopo de Mariscotti, clerk of works (*operarius*) of the Opera del Duomo, 'the task of painting a certain panel to be placed on the high altar of the church of S. Maria of Siena'. Furthermore, Duccio promised Jacopo that he would work continuously on the panel and not accept other work until he had completed it. Jacopo, in return, promised to pay Duccio sixteen soldi for every day that the painter worked on the panel. For any day or part of a day that the painter did not work, an appropriate deduction would be made. In addition, he was to be paid a basic monthly salary of ten lire. Jacopo also promised to supply Duccio with 'all those things which shall be needed for the working of the said panel'. The document ends by naming a sum of money as a penalty clause should either of the contracting parties default on their agreed commitments. The document also records that, in order to make the agreement more solemnly binding, Duccio 'swore voluntarily on the Holy Gospels of God, physically touching the book, that he would observe and implement everything in good faith and without fraud'.[7]

A second document, copied in the nineteenth century but thought to date from 1308–9, records a further agreement concerning the amount that Duccio should be paid for the production of the back face of the altarpiece. The document indicates that the painting was to consist of 34 histories and 'little angels above'. It further states that Duccio should be paid as if for 38 histories, at a rate of two and a half florins per history. Once again, Duccio was to be paid specifically for the task of painting – 'the craft of the brush' – and an unnamed clerk of works would provide the necessary materials. Duccio was to receive an immediate payment of 50 florins, with the remainder of the payment being paid on a pro rata basis, history by history.[8]

These two documents supply useful insights into both the well-established, legally binding procedures for the commissioning and production of fourteenth-century art and the unusual nature and burden of this particular project. Commissions for fourteenth-century works of art of the scale and degree of public prestige of the *Maestà* characteristically involved at least three sets of interested parties: the painter acting on behalf of his workshop; the commissioners; and other persons acting in a legal capacity on behalf of either the painter or the commissioners. We learn from the first document that the Opera del Duomo had delegated to one of its members the responsibility for dealing directly with Duccio and overseeing the painter's payment. We also learn that Duccio accepted a legally binding, contractual obligation on behalf of himself and his heirs. From the second document we learn that two other individuals (one of them probably acting specifically on Duccio's behalf and the other on behalf of the Opera) were employed to assess payment for the back of the double-sided altarpiece – a common procedure in fourteenth- and fifteenth-century Italy for establishing fair payment for work done.

Since the first of the documents is securely dated October 1308 and the altarpiece was installed in June 1311, the project clearly extended over a long period. Moreover, although Duccio scholars had generally thought that the document of October 1308 represented the initial contract, it has been pointed out that it makes no reference to the form and subject of the altarpiece, as was usual for a contract. It may, in fact, represent only an interim agreement referring back to an earlier and now lost contract. It is possible, therefore, that the work on the *Maestà* began even earlier than 1308. Indeed, the 1308 document may be an endeavour by the Opera to secure from Duccio a further guarantee of his whole-hearted and exclusive commitment to the project.[9]

The two documents give an indication of two different styles of payment offered to fourteenth-century artists. The pro rata basis for payment, cited in the second document as Duccio's mode of payment for the histories on the back of the altarpiece, was more usual. Clearly, the back of the *Maestà*, with its multiple scenes, lent itself to such an arrangement (Plates 66 and 68). The front of the *Maestà*, by contrast, with its large, unified figural composition of the Virgin and saints, could not easily be divided into pieces of distinct work (Plates 65 and 67). It was probably for this reason that the earlier document referred to a more complex procedure for paying Duccio. The painter was to receive a fixed monthly salary, but as a further incentive he was also to receive extra payments for work done on a day-by-day basis. In general, pro rata payment was preferred, since it was much easier for the patrons and commissioners to control than the system of supervision whereby the clerk of works had to keep a record of precisely how many days or parts of a day a painter worked on a commission.[10]

The second document also offers valuable evidence concerning what the back of the altarpiece once comprised. What survives of this part of the altarpiece today, discounting the predella scenes, is 26 scenes on the main part of the panel (Plate 66) and six pinnacle panels (Plate 68). Since the agreement refers to 34 histories, it would, therefore, seem at first sight that White's inclusion of two lost narrative scenes as the centrepiece of the pinnacle panels is correct (Plates 67 and 68).[11] However, when compared with other contemporary, multi-tiered altarpieces, White's proposed centrepiece for the *Maestà* is unusually tall (Chapter 9, Plates 240 and 242). It is arguably more likely, therefore, that only one narrative scene was placed at the centre of the pinnacle panels. The calculation of 34 'histories' may have been made on the basis that certain of the scenes, such as *The Crucifixion* and *The Entry into Jerusalem*, were of a larger format.[12] The agreement also makes reference to 'little angels above', implying that above the pinnacle panels appeared a sequence of angel panels. Four of these six panels depicting angels have been located. Since the document also states that Duccio was to be paid as for 38 paintings in total, payment for these single-figure panels, one of which may well have been a central image of *Christ in Majesty*, must have been calculated as equivalent to four narrative paintings.[13]

It is notable that neither of the documents refers to the predella of the altarpiece. It appears, therefore, that this particular feature was considered a discreet and separate part of the altarpiece design. Circumstantial confirmation of this occurs in an entry in a cathedral inventory of 1423 in which two hangings are listed, one to cover the altar and the other to cover the predella.[14] Although there is earlier evidence of predellas being commissioned as parts of altarpieces, at this date they still remained relatively rare.[15] It is quite likely, therefore, that in 1308–9 the final form and subject-matter of the predella for the *Maestà* was still to be decided upon. If this was the case, we have a further indication that this ambitious project gradually evolved over a period of time.

The two documents also provide information on the cost of materials (in the case of the *Maestà*, a large quantity of well-seasoned poplar wood, gesso (gypsum), gold leaf and pigments) and the cost of the labour (which could encompass many diverse and highly skilled tasks). When working on the earlier *Rucellai Madonna*, Duccio was paid for both painting materials and labour, whereas for the *Maestà* Duccio was apparently paid only for his labour. This does not necessarily mean, however, that Duccio worked alone on the *Maestà*. The sheer ambition of the project and the collaborative nature of fourteenth-century artistic practice make this highly unlikely. The stipulation in both documents regarding Duccio's participation occurs specifically in relation to the conditions necessary for Duccio *himself* to receive payment. The implications of this are two-fold. First, the financial recompense of the master painter who, as head of a major project, was undoubtedly involved in organizing and directing other painters, was a key concern of the Opera del Duomo. Secondly, Duccio's individual expertise as an established master painter, tried and tested on other civic projects both within Siena and in other city Communes such as Florence and Perugia, was highly valued and stood as guaranty for the overall quality of the work.

THE CONSTRUCTION

The surviving 1285 contract for the *Rucellai Madonna* indicates that Duccio received a ready-made panel on which to paint. On the testimony of this contract and of later fourteenth-century contracts for altarpieces, it is generally assumed that the complex structure of the *Maestà* must have been designed and built before the painting began. White, a staunch proponent of this view, observes that 'not one brush stroke can have been painted until the entire structure, with its attendant processes of carpentry and clamping, nailing, and gluing, and gessoing, had been completed'.[16] This view for the most part corresponds well with what is known about the preparatory stages of fourteenth-century panel painting in general and what has been discovered in respect of the *Maestà*. It is clear that, unlike a modern painting, which is placed in its frame only after its completion, the complex framing of the *Maestà* was attached to the panels *before* the paintings were executed. On one of the back predella panels, which still retains most of its original inner frame, it is possible to observe how the mouldings of the frame were nailed and glued to the surface of the panel (Plate 70). In addition, due to the loss of the gilding on both the frame and the panel, it is possible on the painting itself to see how a layer of linen canvas was glued to the entire surface of both panel and frame, layers of gesso then being applied to this canvas ground.[17]

Although the close integration of frame and panel on the *Maestà* demonstrates that the greater part of the altarpiece was assembled as a single structure prior to painting, recent research undertaken by the National Gallery, London has challenged the view that the *entire* work was assembled prior to painting. On the basis of a detailed examination of what survives of the slightly later high altarpiece by Ugolino di Nerio for Santa Croce, Florence, it has been suggested that the *Maestà* may have been carried to the cathedral in separate parts – the main panel, the pinnacle panels and the predella – and then assembled.[18]

The question of what provided the necessary stability for the massive structure of the altarpiece has likewise been the subject of debate among art historians. The box-like structure of the predella, projecting substantially in front and to the sides of the main panel, undoubtedly provided one stabilizing factor. White, on the basis of his detailed examination of the *Maestà* and other early fourteenth-century Tuscan altarpieces, proposes that the *Maestà* once possessed a 'wrap around frame', which terminated at approximately two-thirds of the height of the pinnacle panels.[19] White's suggestion is supported by surviving pieces of work, such as a polyptych painted by Duccio's workshop (Plate 71) and a number of polyptychs produced by close contemporaries of the painter. It has been observed, however, that these examples represent relatively simple structures, comprising no more than one thickness of panel, two or three tiers of paintings, and no predella. It has therefore been suggested that the *Maestà* was further supported and given added stability by two lateral buttresses, which would have run down and been secured to the floor of the cathedral.[20] Since such buttresses are a standard feature of later fourteenth-century altarpieces with predellas, it is possible that the *Maestà* included these

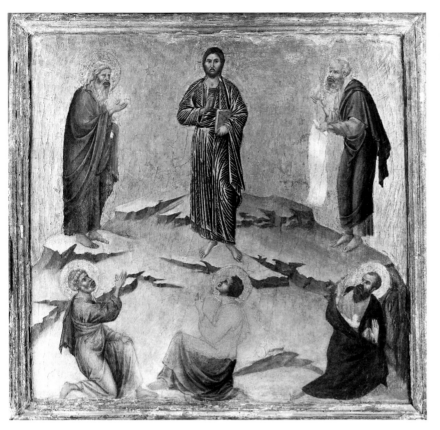

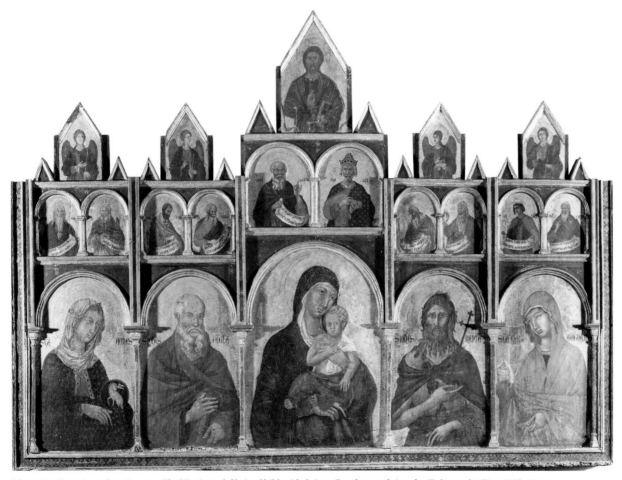

Plate 71 Duccio and assistants, *The Virgin and Christ Child with Saints, Prophets and Angels*, 'Polyptych 47', *c.*1305–10, tempera on panel, 184 x 257 cm, Pinacoteca, Siena, possibly formerly the high altarpiece of Santissima Annunziata, church of the hospital of Santa Maria della Scala, Siena. Photo: Lensini.

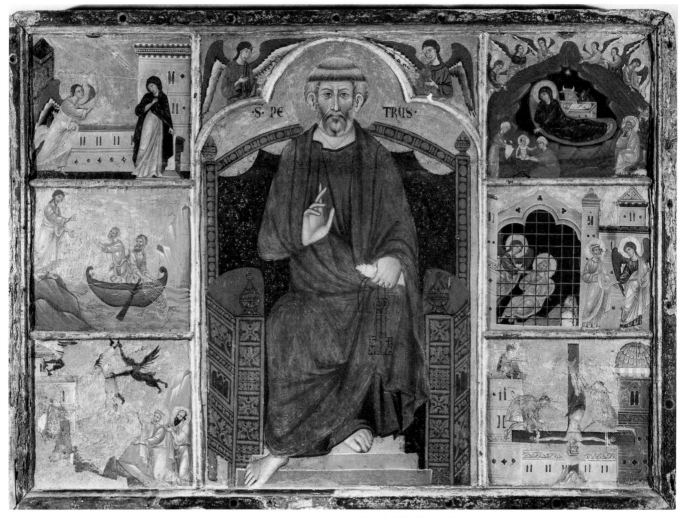

Plate 72 Anonymous, *Saint Peter and the Annunciation, the Nativity and Scenes from the Life of Saint Peter,* late thirteenth century, tempera on panel, 100.5 x 141 cm, Pinacoteca, Siena, possibly formerly in San Pietro in Banchi. Photo: Lensini.

architectonic features and may, indeed, itself have been markedly influential in the adoption of this aspect of fourteenth-century altarpiece design (Chapter 9, Plate 256).

Whatever the precise details of its construction, what is definitely beyond dispute is that the *Maestà* represented an architectonic enterprise that, in terms of its scale and the variety of its component parts, was remarkably ambitious. A sense of the audacity of the *Maestà* may be gained by comparing it with earlier altarpieces. The *Rucellai Madonna* and the *Ognissanti Madonna* represent examples of comparable height, yet their gable format is much more simple than the multiple tiers, varied framing and Gothic pinnacles of the *Maestà*. Later polyptychs offer examples of a multiplicity of subsidiary panels and pinnacles and yet lack the impressive overall scale of the *Maestà* (Chapter 9, Plates 240 and 242); above all, they are not double-sided. In fact, the double-sided format of the *Maestà* was not without precedent. The dating of the early fourteenth-century double-sided high altarpiece for Saint Peter's, Rome is controversial but it was probably executed later than the *Maestà*.[21] It has convincingly been argued that there was a late thirteenth-century double-sided high altarpiece in San Francesco, Perugia.[22] However, the Perugian altarpiece was relatively

modest in scale, comprising only a series of small-scale, full-length painted figures on one side and narrative scenes alternating with standing figures on the other – the latter possibly the inspiration for the front face of the predella of the *Maestà*. A partial precedent for the back of the *Maestà* exists in altarpieces that characteristically portrayed an enthroned holy figure with narrative scenes arranged on either side (Plate 72). What was so extraordinary about the *Maestà* was that it represented a highly sophisticated amalgam of *all* these different altarpiece formats.

As the painter in charge of this imposing enterprise, would Duccio have been directly concerned with the details of the physical structure of the *Maestà* and its complex carpentry? White argues that such is the ambition of the *Maestà* that its very manufacture required the mind of an artist such as Duccio to organize it into a cohesive and aesthetic whole (Plates 67 and 68). White therefore proposes that the entire design of the altarpiece was based upon a system of proportions whereby the measurements of the side and the diagonal of a square were used to generate a succession of larger or smaller squares. This relatively simple system had been devised by medieval masons and was commonly used in Europe throughout the fourteenth century.[23]

Duccio may well have exercised a role in designing the physical structure of the altarpiece. It is also possible, however, that the necessary mathematical expertise was supplied not by Duccio but by Sienese woodworkers experienced in the construction of three-dimensional objects, monumental in scale and well-proportioned in their constituent parts. Even if this was the case, the commission for the *Maestà* specifically required the portrayal of an extraordinary number of figures and narrative scenes. In order to respond to such a demanding brief, Duccio undoubtedly had to think extremely carefully about the component parts of the altarpiece and how these were organized in relationship to one another. Close consultation with those directly responsible for the initial construction of the altarpiece would therefore have been essential. Such collaborative involvement in the realization of the precise specification of the *Maestà's* design would have been entirely plausible within the close-knit community of artistic practitioners within early fourteenth-century Siena.

WORKSHOP COLLABORATION

It is generally agreed that the scale and ambition of the *Maestà* were such as to require the involvement of a number of different painters working upon it. Indeed, examination of different parts of the *Maestà* reveals markedly different approaches, both to the representation of the figures themselves and to the spatial considerations in the locations in which they are portrayed. Such divergences of approach are strikingly apparent in two narrative scenes from the front face of the *Maestà*, which share a broadly similar subject (Plates 73 and 74). In *The Annunciation of the Death of the Virgin*, Mary is represented sitting upon a tip-tilted seat. In addition, the seat is somewhat uneasily located in relation to the right-hand wall of the room in which it is situated (Plate 73). Furthermore, the figure of the Archangel Gabriel overlaps the painted architecture, thereby rendering insecure his position within the building. In *The Annunciation*, by contrast, Gabriel is convincingly represented emerging through an open archway and both he and Mary appear as if situated within a single coherent space, defined by the painted architecture (Plate 74). The figural types are also markedly different in the two paintings. In *The Annunciation*, Mary and the Archangel are represented as tall, slender figures. In *The Annunciation of the Death of the Virgin*, they seem much bulkier in form and, in particular, the modelling of the volumes of the heads is noticeably more heavy handed (Plate 73). Similar discrepancies occur in the treatment of the architectural interiors and figural groupings in such scenes as *The Apparition of Christ at Supper* and *The Feast at Cana* (cf. Plates 75 and 82). Likewise, the various cityscapes portrayed show marked differences in the sophistication of their handling (cf. Plates 69 and 76).

When the *Maestà* is examined from this perspective, a common pattern begins to emerge. The painting of *The Virgin and Christ Child Enthroned* is not only of uniformly high quality but also significantly innovative in its treatment of the *Maestà* theme, as befitted the principal image on the front face of the altarpiece (Plate 65). By contrast, the pinnacle paintings on both the front and back of the altarpiece are markedly more conservative in their approach. At first sight, no striking variation is readily apparent when the pinnacle paintings are compared with the series of narrative scenes of the Passion on the back face of the altarpiece. However, a higher degree of inventiveness occurs within the lower half of the main panel than within the upper half. For example, the cityscape in *The Entry into Jerusalem* and the two-storied edifice with its exterior staircase and enclosed courtyard in *Christ before Annas and the First Denial of Peter* are both notable for their ambitious approach to spatial representation (Plates 69 and 77). Such sophistication of pictorial means is also apparent within the scenes on both the front and back faces of the predella.

A number of proposals have been made to account for such discrepancies in style. James Stubblebine, for example, has divided the *Maestà* into discreet areas and assigned each of these to specific fourteenth-century painters, some of whom are documented as independent masters who worked on later commissions within the first half of the century. Stubblebine suggests that Duccio was only responsible for the main painting on the front face of the altarpiece (excluding the series of apostles above) and the paintings on the front face of the predella. On the basis of perceived similarities with securely documented paintings by three other well-known Sienese painters – Simone Martini and Ambrogio and Pietro Lorenzetti – Stubblebine assigns responsibility for painting the back of the predella, the back pinnacle panels and a proportion of the narrative scenes on the back face of the altarpiece to these three painters. The pinnacle scenes on the front of the altarpiece he assigns to Segna di Bonaventura, a painter whose documented activity suggests that he was slightly younger than Duccio. The sequence of apostles on the front of the altarpiece he assigns to Ugolino di Nerio, a painter who subsequently executed the high altarpiece for Santa Croce, Florence. Finally, Stubblebine assigns the angel panels and the remainder of the narrative scenes on the back of the altarpiece to three other painters, none of whom can be identified by name and whose other works remain solely within the realm of scholarly attribution.[24]

White, by contrast, argues strongly that no such parcelling out of work into discreet, separate entities occurred. He rightly emphasizes that fourteenth-century painting practice was based upon closely collaborative patterns of work. In his view, several individuals might have worked on a single narrative scene, each deploying his particular skills. He therefore attributes control of the entire project to Duccio, with the unnamed collaborators contributing only according to the master painter's direction. White proposes a fairly rapid sequence of work from top to bottom, beginning with the back pinnacle scenes and then, in sequence, the front pinnacle scenes, the upper part of the back of the altarpiece, the lower part of the back of the altarpiece, the front main panel of the altarpiece, the front predella scenes and finally the back predella scenes. By proposing such a sequence of work, White largely accounts for the perceptible changes of style from one part of the *Maestà* to another in terms of a kind of stylistic 'progress' from top to bottom, with Duccio and his assistants learning as they went and becoming progressively more confident as they worked down the surface of this monumental painting.[25]

Plate 73 Duccio and assistants, *The Annunciation of the Death of the Virgin,* 41 x 54 cm, Museo dell'Opera del Duomo, Siena, formerly on a pinnacle panel on the front face of the *Maestà.* Photo: Lensini.

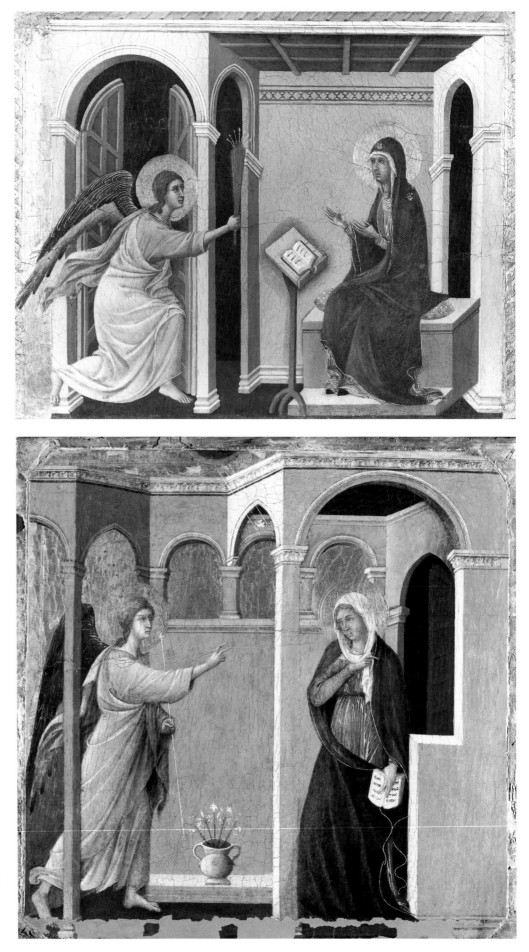

Plate 74 Duccio, *The Annunciation,* 43 x 44 cm, formerly on the front predella panel of the *Maestà.* Reproduced by courtesy of the Trustees, The National Gallery, London.

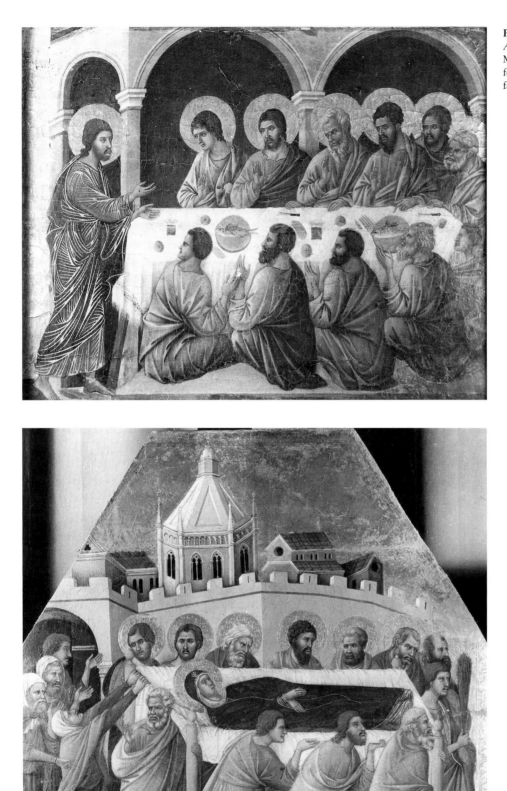

Plate 75 Duccio and assistants, *The Apparition of Christ at Supper*, 39.5 x 52 cm, Museo dell'Opera del Duomo, Siena, formerly on a pinnacle panel on the back face of the *Maestà*. Photo: Lensini.

Plate 76 Duccio and assistants, *The Funeral Procession of the Virgin*, 58 x 52 cm, Museo dell'Opera del Duomo, Siena, formerly on a pinnacle panel on the front face of the *Maestà*. Photo: Lensini.

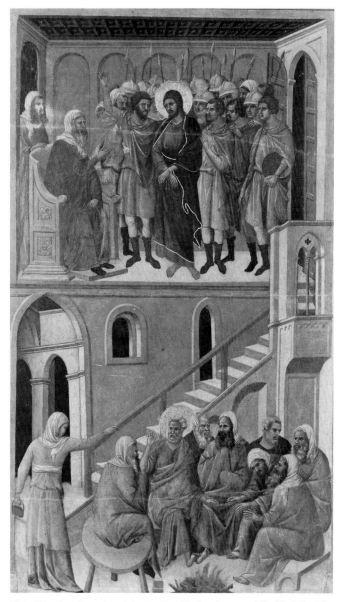

Plate 77 Duccio and assistants, *Christ before Annas and the First Denial of Peter*, 99 x 54 cm, detail of *Scenes from the Passion of Christ* (Plate 66). Photo: Lensini.

The views of both scholars are predicated on the *Maestà* being executed in a time span of some two years and seven months. Given that the *Maestà* represents an enormously ambitious scheme of paintings, this would have necessitated fairly rapid execution, particularly if the workshop was also working concurrently on other commissions. Stubblebine accounts for such speed of execution by assigning the work to Duccio and eight other painters. White accounts for it in terms of an enormously energetic campaign of work analogous to a fresco scheme. As already noted, the campaign on the *Maestà* may well have occurred over a longer time period, allowing for the complex collaborative patterns of work suggested by White to occur in a more measured way.

White's model of closely collaborative work becomes even more persuasive when the results of modern technical investigations of the *Maestà* are taken into account. The evidence of one such technical investigation, undertaken by

the National Gallery, London and focused on *The Healing of the Blind Man*, offers valuable insight into how patterns of collaboration once worked and how, in any given painting, adjustments and changes in direction might occur (Plate 78).[26] An array of modern scientific techniques (X-radiography, infra-red reflectography, the use of raking light) was used to reveal the procedures employed. Once the panel had been gessoed, the circumference of Christ's halo was incised with a metal stylus upon the surface of the gesso ground precisely at the centre of the panel. Next, the figures of the greatest religious importance and narrative significance (Christ, Peter and Paul in the group on the left and the two figures of the blind man on the right) were drawn in. In order to indicate where the base of the architecture should be, a thick, dark stroke of paint or ink was confidently added to the left of the blind man at the fountain, which can be seen at the far right of the finished painting. Then, the general area of the figure group on the left was roughly indicated but not given any detail.

After these initial states of design had been completed by a first painter – in all probability Duccio himself – the design and planning of the painting was apparently taken over by a second painter, who drew in the architectural background of the city of Bethsaida (Mark 8:22). Straight lines were accordingly incised on to the surface of the gessoed panel and frequently extended further than was required for the final, painted architectural forms. Thus, the mouldings that form the arcade of the upper floor were established by three continuous ruled lines, which extend across the open arches in the centre of the building on the left.[27] At this stage Duccio probably intervened again, adding extra decorative details such as the lunette of the door above Christ's head and the capitals of the door between the two versions of the blind man. These additional details were, in fact, later ignored by the painter of the architecture. They have become visible due to the increased transparency of the paint over the years. The group of apostles was then drawn in, apparently by a less competent painter than Duccio. Thereafter, the architecture was painted, very meticulously, with the edges of blocks of colour precisely abutting one another. The main architectural lines were then incised in order to reinforce the emphatic, linear quality of the painted buildings. The figures were then painted and the foreground filled in with a distinctive cross-hatched stroke, which may, again, have been Duccio's own.

Meanwhile, the pose of the blind man apparently underwent several transitions. Initially, the figure was drawn as if bending over the fountain in order to reinforce the narrative point that the miracle was concluded by his action of washing his eyes (John 9:7). However, even before the head was drawn, this pose was abandoned and replaced by a representation of the blind man standing and gazing upwards. It has plausibly been suggested that this decision was taken because it provided a narrative link between this scene and *The Transfiguration*, the next scene on the back face of the predella (Plates 68 and 70).[28] The blind man was, as a result of this alteration, represented looking up at a Christ appearing in his divine glory at the moment of transfiguration. Conceivably, when Duccio came to execute the design for *The Transfiguration*, he saw the potential of this iconographic link and adjusted the pose of the blind man

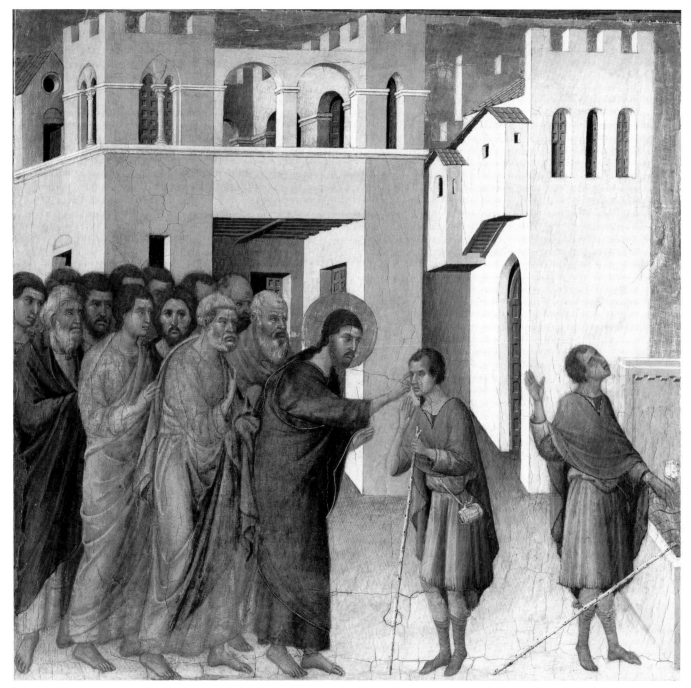

Plate 78 Duccio and assistants, *The Healing of the Blind Man*, 43.5 x 45 cm, formerly on the back predella panel of the *Maestà*. Reproduced by courtesy of the Trustees, The National Gallery, London.

accordingly. Furthermore, the blind man's right arm was never drawn in at all but merely executed in paint over the already painted building behind the figure. Such an alteration represents additional evidence of Duccio's essentially pragmatic and resourceful approach to the painting. It appears that the painter changed the pose in order to disguise a fault on the surface of the panel just visible below the elbow of the figure. The result conveys very well the sense of the blind man rejoicing in the restoration of his sight and gesturing before the visionary scene in the adjacent painting (Plates 68 and 78). In addition, the blind man was originally drawn with bare feet, with his stockings added only at the painting stage.

This reconstruction of the order of work on a single panel reveals very clearly the collaborative nature of the enterprise. It also suggests that the process of painting the *Maestà* proceeded in an empirical way and was constantly subject to changes of mind and adjustments. These were often made (as in the case of the blind man) in order to enrich the iconographic and devotional content of the painted scheme.[29] If Duccio's hand can be detected in the drawing and painting of both the most important figures and particular enlivening details on this single predella panel, it would appear that he did, indeed, control the project and, as the work progressed, was constantly intervening and refining upon his collaborators' contributions.

LOCATION AND ICONOGRAPHY

Although documentary and material factors offer plausible evidence of Duccio's close, personal supervision of the construction and painting of the *Maestà*, the question of responsibility for the choice of subject-matter and its treatment remains more conjectural. The documents for the commissioning of the *Maestà* make only very generalized reference to its highly complex subject-matter and offer no indication at all of who was responsible for its choice. Given the prestigious nature of the *Maestà*, it is legitimate to see this aspect of the altarpiece's design as firmly within the remit of

the Commune and the Bishop of Siena. Nevertheless, it was also undoubtedly the case that the communal and ecclesiastical authorities valued Duccio's personal skill in representing the kinds of religious image and narrative required for this ambitiously conceived altarpiece. Once again, it appears that the *Maestà* represents the outcome of collaboration – on this occasion between the communal and ecclesiastical authorities and the painter. In order to appreciate fully the force of such a conjectured collaboration, it is necessary to consider in more detail the painting's designated location over the high altar of Siena Duomo and the significance of this location.

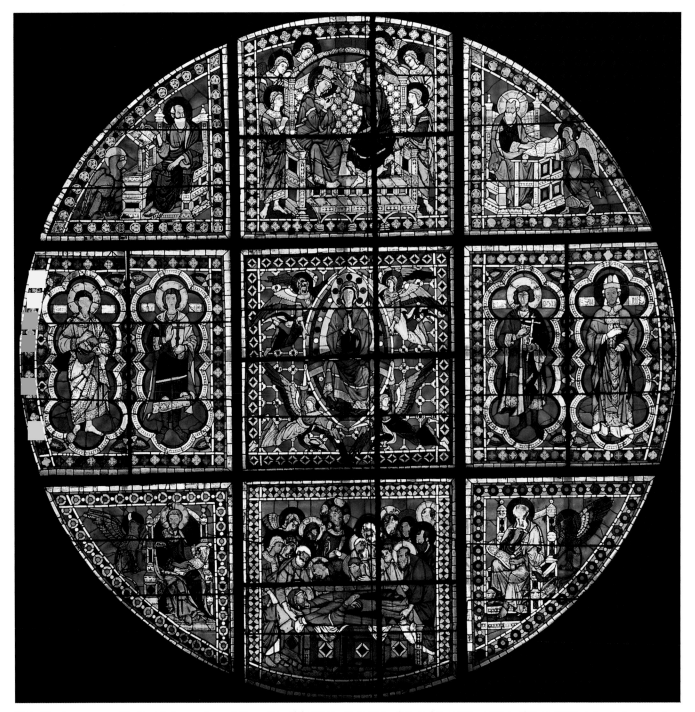

Plate 79 Anonymous, *The Burial, Assumption and Coronation of the Virgin, Four Evangelists and Four Patron Saints of Siena*, 1287, stained-glass window, choir of the Duomo, Siena. Photo: Tim Benton.

Plate 80 Anonymous, *Offering the Keys of the City to the Virgin*, 1482, tempera on panel, 59.1 x 40 cm, Archivio di Stato, Siena, formerly the cover of a volume of records for the Office of the Gabella. Photo: Lensini.

At the time of the painting of the *Maestà*, the cathedral was a more modest edifice than it subsequently became in the second half of the fourteenth century. The crossing existed in its present hexagonal form but the transepts and the chancel were on a much reduced scale. The chancel was rectangular in shape, only three bays wide and two bays deep. It had on its end wall an oculus, which contained a fine late thirteenth-century stained-glass window, sometimes attributed to Duccio (Plate 79), and, probably, three lancet windows below.

The dark green and white marble facing of the walls of the cathedral effectively prohibited fresco paintings or mosaics.[30] The complex narrative cycles of the *Maestà* can, at one level, be accounted for by this lack of other pictorial decoration. However, the façade of the cathedral was already richly embellished with Giovanni Pisano's sculpted figural programme. Moreover, in close vicinity to the high altar (as may be seen on a fifteenth-century painted book cover, Plate 80) stood Nicola Pisano's mid thirteenth-century carved

pulpit. The pulpit itself bore a sequence of six narrative reliefs, which depicted scenes from the Infancy and the Passion of Christ as well as the Last Judgement.[31]

On the basis of a documentary reference, made in 1259, to the canons' choir being placed 'beneath the dome' of the cathedral, it has generally been assumed that the high altar and the *Maestà* were set up on the east side of the crossing, with the choir stalls arranged somewhat haphazardly around them.[32] However, it has recently been pointed out that this particular reference to the placement of the choir represents the expression of only one point of view in a debate conducted by the Consiglio della Campana in 1259. A document of 1368, which deals with the construction of new choir stalls, suggests that the thirteenth-century choir had been built in straight lines. It seems much more likely, therefore, that the high altar was located in the first bay of the chancel, with the choir stalls built behind it as two rows facing each other in a uniform rectangular shape (Plate 81).[33] What is critical about such an arrangement is that the *Maestà* must once have stood between the part of the cathedral accessible to the laity and that part accessible only to the clergy. Moreover, its front face – with its celebration of Mary as mother of Christ and queen of heaven, the events of the Incarnation and the last days of the Virgin – would have been directed towards the lay audience. Meanwhile, the Christological scenes of the Ministry, Passion and post-Resurrection appearances of Christ on the back face of the altarpiece would have been the exclusive preserve of the

cathedral canons performing their daily offices within the choir.

The *Maestà* was not the first altarpiece to grace the high altar of Siena Duomo. Well before the festive installation of Duccio's painting, the high altarpiece had become the focal point of civic and popular devotion. The dedication of Siena to the Virgin in 1260 took place in front of the early thirteenth-century painted relief depicting the Virgin and Child enthroned, known popularly as the *Madonna degli occhi grossi* (Our Lady of the big eyes), which then stood on the high altar of the cathedral.[34] This carved altarpiece was in the form of a rectangular panel with the central relief of Mary and her Son framed by a series of narrative reliefs on either side. It appears that, shortly after 1260, it was replaced by a more contemporary painted panel of the Virgin and Christ Child framed by saints, which probably took the form of a rectangular gabled panel.[35] This later thirteenth-century altarpiece was, in turn, cut down and became a popular votive object, preserved in its own chapel and still today brought out every year to be placed upon the high altar as part of the celebrations for the Feast of the Assumption (15 August) and the Palio. In place of these horizontal panels, which were undoubtedly modest in scale, format and construction, Duccio gave his civic patrons a much more architectonic structure, equipped with such novel features as a predella base and, possibly, sturdy buttresses.

The traditional association of the high altarpiece with Siena's civic fortunes was preserved by Duccio on the *Maestà*. On the base of the Virgin's throne is a painted text, which reads in translation: 'Holy mother of God be thou the cause of peace for Siena, and, because he painted thee thus, of life for Duccio' (Plate 65).[36] The votive nature of this painted inscription is further emphasized by the four saints kneeling in the foreground, whose posture and hand gestures underline their significance as intermediaries between the painting's audience and the Virgin. They are, moreover, identified by both figural type and inscription as the four patron saints of Siena: Ansanus, Sabinus, Crescentius and Victor.

Further elaborating upon his earlier treatment of the subject of the Virgin enthroned in majesty in the *Rucellai Madonna*, Duccio portrayed the Virgin in the *Maestà* as tenderly maternal and yet also immensely regal. She is seated upon a monumental marble throne which, in terms of its material splendour, must once have reflected the interior embellishment of the cathedral. In addition, the Virgin appears not merely with attendant angels but with a whole company of saints, whose graceful poses and richly coloured and exquisitely decorated garments (Plate 64) contribute to a powerful evocation of a ceremonial and courtly setting. The impression given is that the Virgin is queen not only of heaven but also of Siena.

The whole-hearted celebration of the Virgin, which lay at the very centre of fourteenth-century Sienese civic religion, undoubtedly also dictated the choice of subject-matter for the front surface of the predella and the front pinnacle panels. The six predella scenes from the Infancy of Christ, as recounted in the gospels according to Matthew and Luke, naturally provided a vehicle for the Virgin's role in the Incarnation and the birth of Christ (Plate 67). Similarly, the

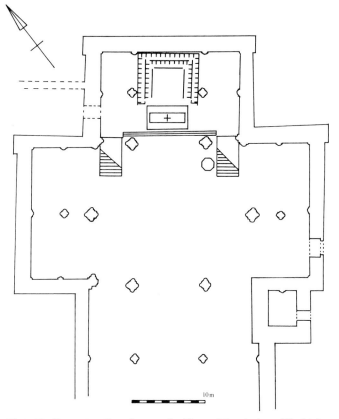

Plate 81 Reconstruction after van der Ploeg of the placing of the high altar and choir stalls in the Duomo, Siena, in the early fourteenth century. From Kees van der Ploeg, *Art, Architecture and Liturgy: Siena Cathedral in the Middle Ages*, 1993 Egbert Forsten, Groningen.

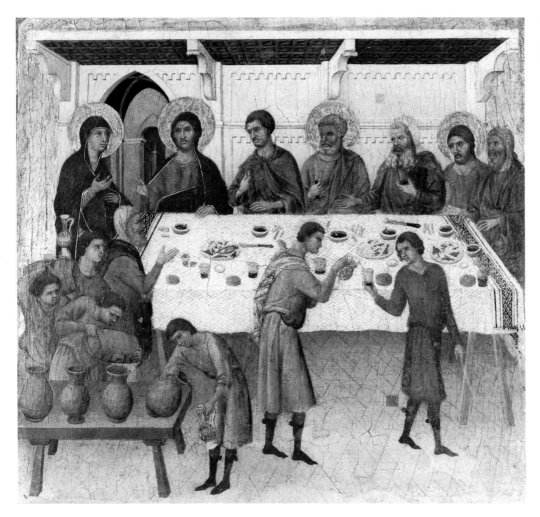

Plate 82 Duccio and assistants, *The Feast at Cana*, 47 x 50 cm, Museo dell'Opera del Duomo, Siena, formerly on the back predella panel of the *Maestà*. Photo: Lensini.

pinnacle scenes of the last days of the Virgin further glorified her unique religious significance. This sequence of events, as recounted in such late medieval texts as the thirteenth-century *Golden Legend* by Jacobus de Voragine, was believed to have presented a close analogy to the events of Christ's Resurrection and Ascension into heaven. Moreover, it should be recalled that Siena Duomo was itself dedicated to the Virgin of the Assumption. Furthermore, directly above the *Maestà* when viewed from the body of the cathedral would have appeared the stained-glass oculus, with its sequence of images directly reiterating the cathedral's Marian dedication (Plate 79).

By contrast, the extensive narrative series on the back of the *Maestà* is not principally directed towards such Mariological concerns. At one level, it describes in great detail Christ's Ministry and Passion as recounted in all four gospels (Plates 66 and 68). The epic story of Christ's sacrifice on the Cross and his Resurrection – the climax of the Christian drama of redemption – is therefore central to the painted series. Within this narrative cycle, moreover, a number of scenes may well have been chosen for their particular relevance to the celebration of Mass, itself understood to be a symbolic re-enactment of both the Last Supper and the Crucifixion. The largest scene of all on the back of the altarpiece is *The Crucifixion* (Plate 66). Directly below it, at the centre of the back of the predella, appears *The Feast at Cana*, at

which Christ was believed to have miraculously turned water into wine. This miracle story was often interpreted as a prefiguration of the Mass (Plates 68 and 82). If the canons' choir behind the high altar included a subsidiary altar for the communal celebration of Mass by the canons, then such specifically eucharistic symbolism was particularly apposite. Quite apart from potentially eucharistic imagery, however, the many scenes of the Ministry, Passion and Resurrection of Christ would in any case have provided a sequence of images upon which the canons could meditate during the performance of their offices.

Eucharistic imagery was not, however, exclusively confined to the back face of the altarpiece. The front face of the *Maestà* was designed to be viewed in the context of the high altar at which, on feast days, high Mass would be celebrated. The portrayal in *The Presentation in the Temple* at the very centre of the predella of the Christ Child – shown as he is in the arms of the High Priest – would also have had strong eucharistic associations, since it was believed that at every celebration of Mass the wafer in the hands of the officiating priest miraculously became the body of Christ (Plates 67 and 83). The depiction of the altar, with its intricate textile hanging and ciborium (broadly similar in style to high altar ciboria in contemporary Italian churches), acted as a further allusion to the liturgy of the Mass, which took place upon the altar directly below the painting.

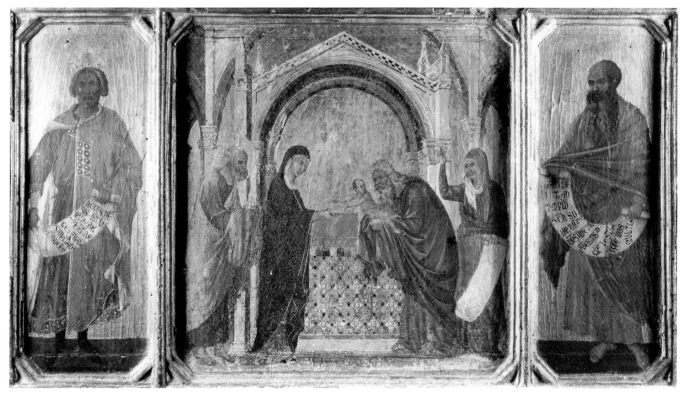

Plate 83 Duccio, *The Presentation in the Temple (with Prophets)*, 48 x 86.5 cm, Museo dell'Opera del Duomo, Siena, formerly on the front predella panel of the *Maestà*. Photo: Lensini.

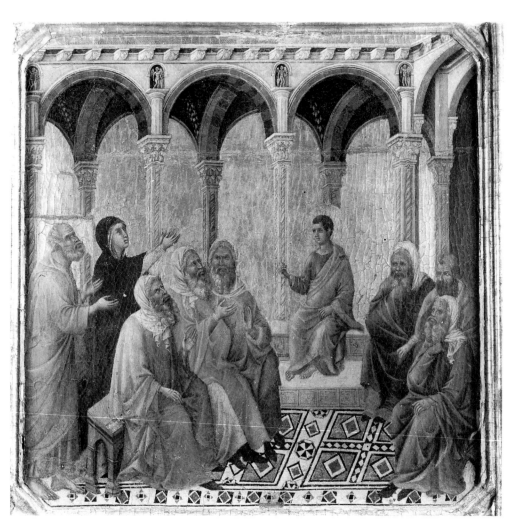

Plate 84 Duccio, *The Disputation in the Temple*, 48 x 48 cm, Museo dell'Opera del Duomo, Siena, formerly on the front predella panel of the *Maestà*. Photo: Lensini.

NARRATIVE: ORGANIZATION AND CONTINUITY

As master-in-charge of a very ambitious series of paintings, which were required to fulfil a number of specific liturgical and devotional functions, Duccio was presented with a daunting task in terms of thematic and formal organization. In this respect, the front face of the altarpiece must have provided a somewhat easier prospect, since the principal part of the painted surface was taken up by the great iconic image of *The Virgin and Christ Child Enthroned* (Plate 65). Duccio placed the narrative scenes of the Infancy of Christ and the last days of the Virgin in two series at the bottom and the top of the altarpiece. They followed, for the most part, a sequential order that corresponded broadly to the time-honoured convention in western art of 'reading' the narrative 'over time' from left to right. The exceptions are the now lost paintings of *The Coronation of the Virgin* and *The Virgin of the Assumption*, which were placed centrally because of their greater religious significance. Whereas in a mural cycle (such as the one in the Arena Chapel) the line of the narrative follows a downward movement from the top to the bottom of the wall, on both faces of the *Maestà* the narrative has been arranged to be read from the bottom of the altarpiece to the top (Plates 67 and 68). Duccio was thus able to place the scenes of Mary's death and assumption and Christ's post-Resurrection appearances and Ascension symbolically closer to heaven.[37] The temporal dimension implied by such organization was further underlined by the introduction on the front face of the predella of a sequence of Old Testament prophets, each of whom holds a painted text that relates to the scene from Christ's Infancy immediately to the prophet's right (Plates 67 and 83). The intention behind this arrangement was that the scenes of the Incarnation of Christ were seen as fulfilling the promise of the Old Testament.[38]

One of the ways in which Duccio skilfully provided a sense of continuity within this complex and potentially disparate pictorial narrative was by scrupulous observance of unity of place. Thus, the first four scenes of the last days of the Virgin all take place in the same wooden-beamed house (Plates 67 and 73). In this pinnacle series, the individual apostles appear in robes and mantles of the same colours as those in which they are shown in the Passion series on the back of the altarpiece. A rather telling example of Duccio seeking to indicate the passage of time between events that took place during the life of Christ and the Virgin's subsequent death is supplied by the detail of a youthful, clean-shaven John in *The Healing of the Blind Man* having acquired a light beard when portrayed at the head of the Virgin's bier in *The Funeral Procession of the Virgin* (Plates 76 and 78).[39]

The highly skilful organization of the narratives on the front and back faces of the predella is also particularly striking. In *The Annunciation* on the front face of the predella, the portrayal of the Archangel Gabriel actively entering through an archway offers a strong sense of the *beginning* of a narrative (Plates 67 and 74). In *The Presentation in the Temple*, the ciborium and the placing of the figures on either side of it provide a stable, centralized composition for the mid point of the predella (Plates 67 and 83). Just to the left and right of the ciborium one catches a glimpse of a vaulted bay, an architectural feature that is taken up in the last scene on the

front face of the predella, where the young Jesus is shown discoursing with the elders in the Temple (Plates 83 and 84) – a painted detail that offers a further sense of continuity to the narrative as a whole.

It has generally been assumed that, due to its significance as a prefiguration of the Christian rite of baptism, *The Baptism of Christ* would have been the now lost initial scene on the back face of the predella. However, since the Baptism often occurred in cycles of imagery designed to celebrate the cult of Saint John the Baptist, there remains the strong possibility that this first scene instead depicted the Temptation of Christ in the desert by the devil (Matthew 4:1–4).[40] An accurate reflection of the now lost scene of the *Maestà* may be provided by *The Temptation in the Desert* on a mid fourteenth-century Sienese painted triptych (a work that mirrors in detail many of the narrative scenes of the *Maestà*, Plate 85). If so, then the narrative on the back face of the predella would have begun with a painting of two figures facing one another, which would have formed a figural composition broadly similar to *The Raising of Lazarus* at the other end of the back of the predella (Plate 86). As regards overall organization, the narrative scenes on the back face of the predella (Plate 68) would probably once have comprised three sets of three. Each set would have had as its centrepiece a painting with a central focus to it (Plates 70, 82 and 93). The figural composition of *The Raising of Lazarus* would then have provided a visually satisfying closure to the sequence as a whole (Plates 68 and 86). In purely iconographic terms, this painting of the miraculous prefiguration of Christ's Resurrection would also have provided a highly appropriate introduction to the Passion series situated above.

The Passion series, like that of the back of the predella below it, represents a recension of all four gospel accounts. It is a much more ambitious sequence than those of the predella and pinnacle panels and various proposals have been put forward as to its intended order, the most plausible of these being those of White and Florens Deuchler.[41] Both scholars suggest that the sequence should be read from the lower left-hand corner beginning with *The Entry into Jerusalem*. The narrative proceeds thereafter in a left to right direction, first across the lower half of the painting and then left to right again across the upper half of the painting. It does not, however, follow a simple, linear sequence within each of the two halves, but rather, a boustrophedonic pattern, that is to say, a pattern of disposition combining both vertical and horizontal sequences within it (Plate 87).[42] Such patterns were common in the narrative sequences of stained-glass windows in northern Europe (Plate 88). The attractiveness of such a sequential order is that it is repetitive and orderly but also highly flexible, allowing for more than one kind of directional reading. Indeed, it appears that Duccio deliberately sought to exploit the multi-directional possibilities of such an arrangement.

Whereas White proposes a continuous boustrophedonic pattern throughout the two halves of the painting, Deuchler suggests that several such patterns were devised around a central vertical axis, which incorporated three key scenes of both narrative and symbolic importance – *The Agony in the Garden of Gethsemane*, *The Betrayal of Judas* and *The Crucifixion*. Although White's proposal allows for a fairly scrupulous

adherence to the order of the gospel accounts, it means that the narrative in the lower half of the painting ends on a downward alignment, which does not match the upward alignment at the end of the narrative in the upper half of the painting. It also appears to run counter to the figural and spatial compositions of both the scene of *The Entry into Jerusalem* and the combined scenes of *Christ before Annas and the First Denial of Peter* (Plates 69 and 77). On the whole, therefore, Deuchler's proposed sequence of narrative appears to be more plausible (Plate 87). Although it involves certain liberties with the biblical text, such as the introduction of the cockerel in the scene of Peter's second denial, it more readily complements the main compositional flow of the lower half

of the painting. Moreover, as Deuchler points out, by adopting such an arrangement it is possible to perceive a logical progression of steps for the design of the whole of the back of the *Maestà*, beginning with the largest and most important scene of *The Crucifixion* in the upper half of the panel and then ordering the other scenes accordingly around this key central painting.[43]

As on the front of the *Maestà*, continuity of costume and place is scrupulously observed (Plate 67). Other formal considerations provide further insights into the degree of care taken over the effect of the painting as a whole. Every narrative scene is shown as if lit from a source on the left. This constant fall of light from left to right further assists in the

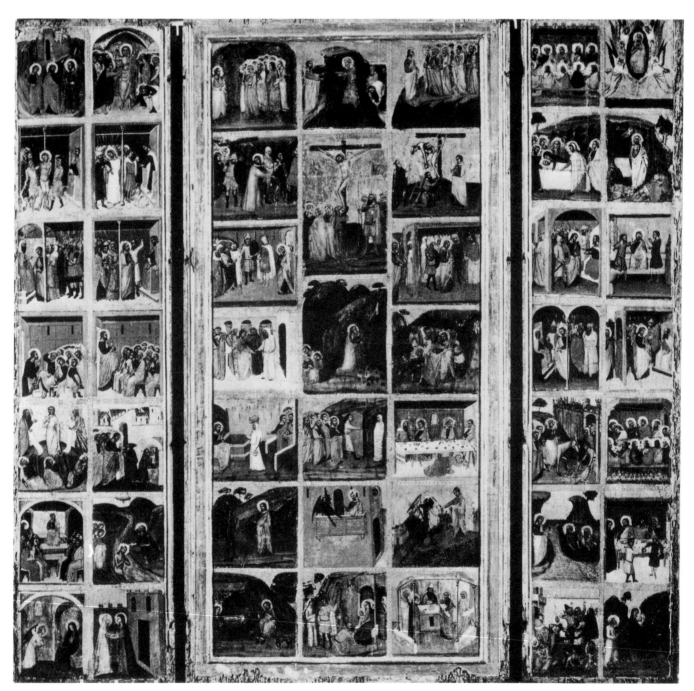

Plate 85 Anonymous, triptych with *Scenes from the Life of Christ*, mid fourteenth century, tempera on panel, Museo della cattedrale, Pienza. Reproduced by courtesy of Editore Editalia, Rome from Enzo Carli, *Pienza, la città di Pio II*, 1993 and Conservatorio "S. Carlo Borromeo", Pienza.

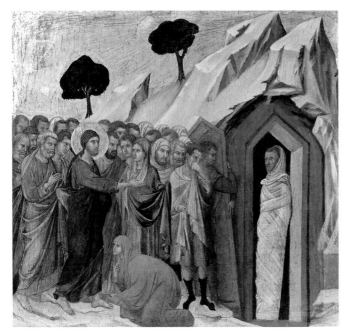

Plate 86 Duccio and assistants, *The Raising of Lazarus*, 43.5 x 46 cm, formerly on the back predella panel of the *Maestà*. Kimbell Art Museum, Fort Worth, Texas.

Plate 88 Anonymous, showing (from right bottom in an anti-clockwise direction) *The Death, the Funeral, the Raising of Lazarus*, early thirteenth century, stained glass, lower section of the Mary Magdalen window, Chartres Cathedral. Photo: Giraudon.

broad movement of the narrative from left to right across the panel. Within the consistent portrayal of light, there are, however, subtle variations appropriate to different times of the day. Thus, in the evening scene of *The Entombment of the Virgin*, the main face of the tomb is a deep, warm pink and the contrast between the lit and shadowed surfaces of the medium-grey rocks is not greatly differentiated. In *The Maries*

at the Tomb, the cooler light of dawn is suggested by the light pink of the tomb and a stronger contrast between the surfaces of the rocks that are lit and those that are in shadow.[44] Finally, despite the restricted palette characteristic of fourteenth-century panel painting, the organization of colour is strikingly well balanced throughout. For example, Duccio's and his assistants' use of the limited colour range available to them included a skilful exploitation of blues and reds. In *The Virgin Enthroned and Christ Child*, the rich, resonant blue of Mary's mantle strikingly draws attention to her status as principal cult figure. Similarly, the vivid reds deployed on the costumes of the standing and kneeling saints emphasize their prominence within the hierarchic scheme of the painting (Plate 65). This use of vibrant colour also sets the tone for the front and back faces of the predella and becomes, if anything, more striking within the Passion series, where various shades of red predominate, both in the costume of the figures and in the architecture (Plate 66).[45]

As suggested above, it is highly likely that the civic and ecclesiastical authorities of Siena specifically expected Duccio to represent hallowed religious images and narrative scenes in a manner that was conventional and yet innovative in form. It becomes apparent just how imaginatively Duccio responded to such expectations if the *Maestà* is compared with two examples of late thirteenth-century Sienese painting (Plates 72 and 89),[46] which themselves combine both representation of a holy figure and scenes replete with narrative incident. On the one hand, he continued to adhere to essentially Byzantine pictorial conventions whilst, on the other, he extended the expressive range and possibilities of such conventions. For example, he continued to adopt the pictorial convention of representing a landscape setting in the form of a number of schematically rendered rocks. Yet if the thirteenth-century

Plate 87 Narrative sequence of the Passion series on the *Maestà* after White (top) and Deuchler (bottom). Reproduced with permission of Electa Editrice, Milan from Florens Deuchler, *Duccio*, 1984.

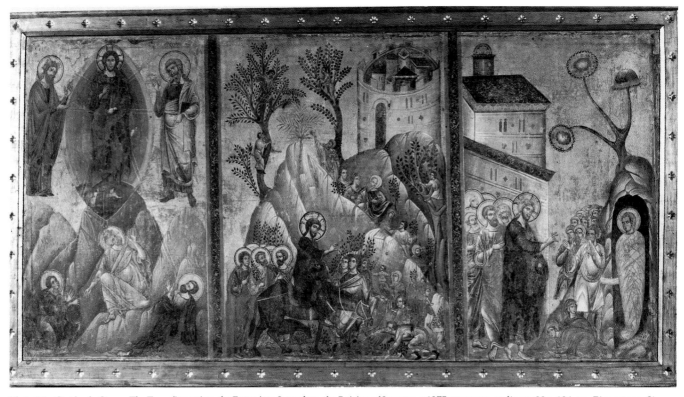

Plate 89 Guido da Siena, *The Transfiguration, the Entry into Jerusalem, the Raising of Lazarus*, c.1275, tempera on linen, 90 x 186 cm, Pinacoteca, Siena, possibly formerly a Lenten hanging for the Duomo, Siena. Photo: Lensini.

version of *The Calling of Peter and Andrew* is compared with that of the *Maestà*, it is at once apparent how in the latter the rocky background has been used much more effectively to accommodate and complement the key actor in this narrative drama (cf. Plates 90 and 91). Similarly, whilst in his *Entry into Jerusalem*, the thirteenth-century painter Guido da Siena was able to convey a sense of a landscape setting and an implied progression from foreground to background, in his portrayal of the scene, Duccio supplied a much more convincing illusion of a hilltop town. This is set back at a distance from the immediate foreground and approached by a steeply inclined and paved road, and is a town, moreover, that offers a convincing sense of accommodating both people and buildings (cf. Plates 69 and 89). Likewise, the representation of the interiors and exteriors of individual buildings in the *Maestà* tends to be far less schematic than in earlier Sienese paintings (for example, Plates 72 and 74).

Considering the treatment of the human form, it again appears that Duccio and his assistants both learned from and improved upon their predecessors. If the two versions of *The Calling of Peter and Andrew* are once more compared, it is possible to see how the earlier version provided a model for the concise portrayal of a dramatic encounter between figures, with details of the background exploited to make such an encounter the more telling (cf. Plates 90 and 91). In Duccio's version, the three figures are rendered in such a way as to give a much stronger sense of the volume of the bodies, and the emotion that each figure is experiencing is more subtly portrayed than the rather overwrought mood conveyed in the earlier painter's representation.

As the previous paragraphs demonstrate, Duccio was clearly aware of the work of his thirteenth-century predecessors and their debt to Byzantine art. He was also indebted to precedents derived from northern Gothic art, especially that of France. Indeed, within the *Maestà* it has proved possible to discern the creative interplay between these two influences upon Duccio's art. It appears from infrared photography and X-radiography of *The Raising of Lazarus* (Plate 86) that the figure of Lazarus was first represented arising diagonally from a low, horizontally placed sarcophagus. This pictorial iconography was common in northern Gothic art (Plate 88), although it was also occasionally present in thirteenth-century Italian art.[47] The decision was subsequently taken to portray the sarcophagus in a traditional Byzantine format, as a vertical, rock-cut tomb with Lazarus in his white burial bands framed within it. This revision prompted the introduction of a gabled tomb lid with two grave attendants to support it.[48] It has rightly been noted both that the vertical tomb format probably derived from Byzantine manuscript illuminations and was characteristically featured in thirteenth-century Sienese paintings of this subject (Plate 89), and that the earlier version was in many ways more inventive. There was, however, a strictly compositional motivation for the decision to opt for the older, less innovative depiction. In terms of the overall composition of the back face of the predella, the vertically placed rock tomb, which frames the upright figure of Lazarus, provides an emphatic closure to the last scene on the back of the predella (Plate 68). Even in this one feature of a single panel, therefore, we see the subtle interplay between meticulous attention to detail and concern for overall conception that was characteristic of Duccio's orchestration of the *Maestà* as a whole.

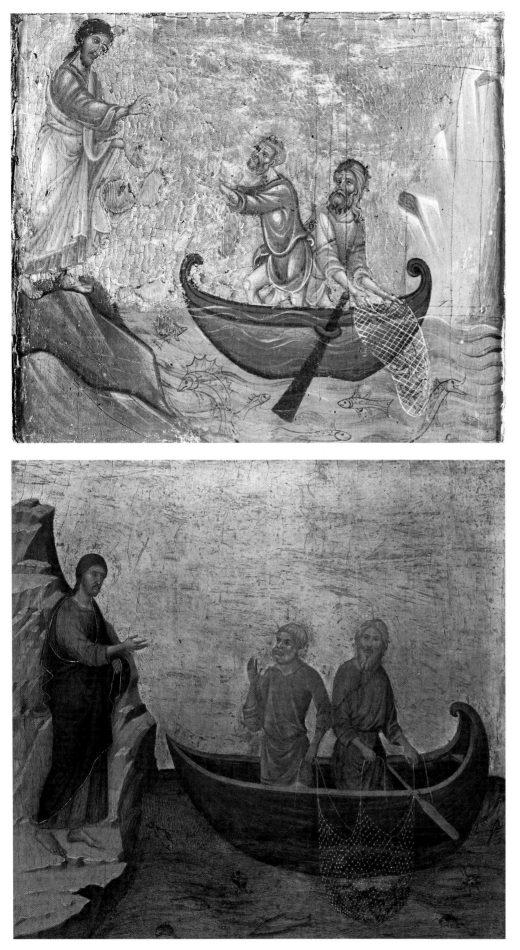

Plate 90 Anonymous, *The Calling of Peter and Andrew*, detail of *Saint Peter and Scenes from the Annunciation and the Life of Saint Peter* (Plate 72). Photo: Lensini.

Plate 91 Duccio and assistants, *The Calling of Peter and Andrew*, 43 x 46 cm, formerly on the back predella panel of the *Maestà*. Samuel H. Kress Collection copyright 1993 National Gallery of Art, Washington, D.C.

CONCLUSION

How, then, can the achievement of the *Maestà* best be summarized? Not surprisingly, locally at least, the *Maestà* inspired copies and imitations. We know of at least two versions, reduced in scale and less technically assured, but unambiguously inspired by and indebted to the *Maestà*. The first – generally attributed to a close associate of Duccio – was executed for the cathedral of Massa Marittima some ten years after the completion of the *Maestà* (Plate 92). The second – generally attributed to a Sienese painter working in the mid fourteenth century – takes the form of a large triptych (Plate 85).[49] Such copies notwithstanding, it is clear that this extraordinary double-sided altarpiece could not easily be emulated. The triptych replicated only imagery from the front face of the predella and the back face of the altarpiece of the *Maestà*. The Massa Marittima altarpiece, although double-

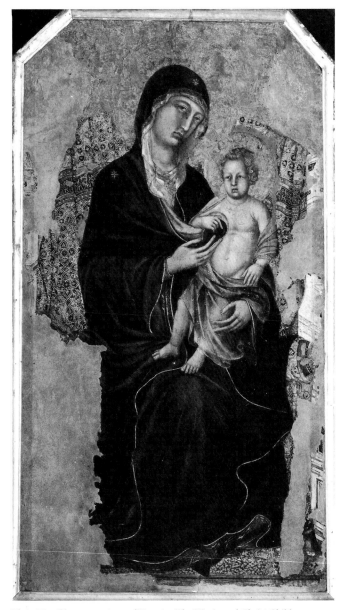

Plate 92 Close associate of Duccio, *The Virgin and Christ Child Enthroned*, c.1315, tempera on panel, 179 x 99 cm (considerably cut down from original size), Duomo, Massa Marittima, formerly the double-sided high altarpiece. Photo: Scala.

sided, constituted a much simplified version of both the front and back faces of the *Maestà*.

Local imitations aside, what of the more diffused influence of the *Maestà*? A double-sided altarpiece was painted by close associates of Giotto for the high altar of Saint Peter's in Rome, probably in the second or third decade of the fourteenth century, at the behest of Cardinal Stefaneschi.[50] Like the *Maestà*, its format and iconography appear to have been dictated by its original ecclesiastical location over a high altar, behind which was a canons' choir and below which, it was believed, lay the tomb of Saint Peter. Yet, despite its highly prestigious location, this double-sided altarpiece was much more modest than the *Maestà* in terms of scale and iconography.

Indeed, in sheer scale and iconographic complexity the *Maestà* was to remain unique. A comparably ambitious narrative scheme was never again attempted within the field of Italian panel painting. It is only in the realm of fourteenth-century mural painting that a similar degree of sophistication can be found.[51] By contrast, in at least two other respects the *Maestà* proved profoundly influential. The broad, expansive figural composition of *The Virgin and Christ Child Enthroned* became a marked feature of the subsequent handling of the *Maestà* theme by Sienese artists. Similarly, the multi-tiered design of the front face of the *Maestà* was widely used by other Sienese painters commissioned to produce altarpieces for prestigious Tuscan and Umbrian churches. Particularly influential examples of such diffusion include the high altarpieces executed by Ugolino di Nerio for Santa Croce, Florence and by Simone Martini for Santa Caterina, Pisa (Chapter 9, Plate 242).

It is appropriate to end by focusing once more upon the *Maestà* itself and, in particular, upon one recurring detail of its painted narrative. In this one detail many of the concerns and achievements encompassed within this extraordinary altarpiece are cumulatively expressed. The ambitious narrative cycle within the *Maestà* required the repeated representation of the Temple in Jerusalem. Such was Duccio's grasp of his overall narrative plan that, at different points, he was able to provide both a series of recognizable representations of the Temple and also a number of varied aspects of its architectural style and decor. In *The Temptation on the Temple*, the building is daringly represented as a white octagonal structure, one side of which is shown as parallel to the front surface of the painting (Plate 93). The close viewpoint thus afforded facilitates appreciation of the way in which the painter has portrayed a building constructed of rich and splendidly crafted materials – porphyry and serpentine panels on the balcony, elaborate brackets, Gothic tracery in the windows, double columns. The painting even allows a glimpse of an interior with an inlaid pavement and complex vaulting supported on slender columns. From this one close-up view it is possible to identify the same octagonal building within the cityscapes of Jerusalem in *The Entry into Jerusalem* and *The Funeral Procession of the Virgin* (Plates 69 and 76). Taking a cue from the interior view in *The Temptation on the Temple*, it is possible to see how the Temple's well-appointed architectural features also recur in the paintings of *The Presentation in the Temple* and *The Disputation in the Temple* on the front face of the predella (Plates 83 and 84).

Plate 93 Duccio and assistants, *The Temptation on the Temple*, 43 × 46 cm, Museo dell'Opera del Duomo, Siena, formerly on the back predella panel of the *Maestà*. Photo: Lensini.

It has been suggested that the distinctive features of Duccio's cityscape in *The Entry into Jerusalem* constitute an attempt on the painter's part to represent, albeit in contemporary form, the principal buildings of Jerusalem as described in *The Jewish War* by the first-century Jewish author Flavius Josephus (Plate 69).[52] This may or may not have been the case, although it must be said that there is no other evidence that Duccio had such a text in mind. In respect of the detailed representation of the Temple, however, there was already a well-established iconographic tradition that the Temple was octagonal in shape. For this reason, Italian medieval baptisteries frequently adopted just such an

architectural form. Likewise, Duccio's depiction of Jerusalem is generically similar to the appearance of the hill town of fourteenth-century Siena. It was a well-developed feature of Sienese civic ideology that Siena was the second Jerusalem, a belief further nurtured by the city's placing of itself under the divine protection of the Virgin.

It was a common aspect of medieval piety that people should envisage events described in the Bible and other religious texts as taking place within their own environments.[53] The portrayal of Jerusalem in such a way as to suggest the appearance of Siena would have facilitated this devotional practice. The fact that the Temple on the *Maestà*

was reminiscent of the architecture of Siena Duomo further tied the imagery of the altarpiece to the official liturgical and civic rituals that took place at the cathedral's high altar. Moreover, because the exterior view of the Temple took the familiar outline of a typical Tuscan baptistery, the altarpiece also expressed a personal and essentially private dimension by reminding worshippers of their own baptisms and the promise of personal salvation embodied within them. It is surely this impressive combination of coherent organization and inventive versatility, which extended throughout every aspect of the altarpiece's structural and pictorial design, that makes the *Maestà* deserving indeed of the accolade 'the richest and most complex altarpiece to have been created in Italy'.[54]

Appendix

KEY TO THE SUBJECT-MATTER OF THE *MAESTÀ* (PLATES 67 AND 68)

Titles in square brackets indicate the probable subjects of panels that are now lost

FRONT FACE

Main panel

Virgin Mary Enthroned with the Christ Child, Angels, Saints and Apostles

Front predella

Annunciation: Isaiah
Nativity and Annunciation to the Shepherds: Ezekiel
Adoration of the Magi: David
Presentation in the Temple: Malacai
Massacre of the Innocents: Jeremiah
Flight into Egypt/Return from Egypt: Hosea
Disputation in the Temple

Front pinnacle panels

Annunciation of the Death of the Virgin
Arrival of Saint John the Evangelist
Gathering of the Apostles
[Coronation of the Virgin]
Death of the Virgin
Funeral Procession of the Virgin
Entombment of the Virgin

Gable panels above pinnacle panels

[Virgin of the Assumption as centrepiece] with three angels on either side

BACK FACE

Main panel

For narrative sequence, see also Plate 87

Entry into Jerusalem
Washing of the Feet
Last Supper
Christ's taking Leave of the Apostles
Judas taking the Bribe
Agony in the Garden of Gethsemane
Betrayal of Judas
First Denial of Peter and Christ before Annas
Christ before Caiaphas and Second Denial of Peter
Christ before Caiaphas and Third Denial of Peter
Christ before Pilate
Christ Accused by the Pharisees
Christ before Herod
Christ in the Robe before Pilate
Flagellation before Pilate
Crowning with Thorns
Pilate Washing his Hands
Carrying of the Cross
Crucifixion
Deposition
Entombment
Maries at the Tomb
Harrowing of Hell
Apparition of Christ to Magdalen
Apparition on the Road to Emmaus

Back predella

[Baptism of Christ/Temptation in the Desert]
Temptation on the Temple
Temptation on the Mountain
Calling of Peter and Andrew
Feast at Cana
Christ and the Woman of Samaria
Healing of the Blind Man
Transfiguration
Raising of Lazarus

Back pinnacle panels

Apparition behind Closed Doors
Incredulity of Saint Thomas
Apparition on the Sea of Tiberius
[Ascension of Christ]
Apparition in Galilee
Apparition at Supper
Pentecost

Gable panels above pinnacle panels

[Christ in Majesty as centrepiece] with three angels on either side.

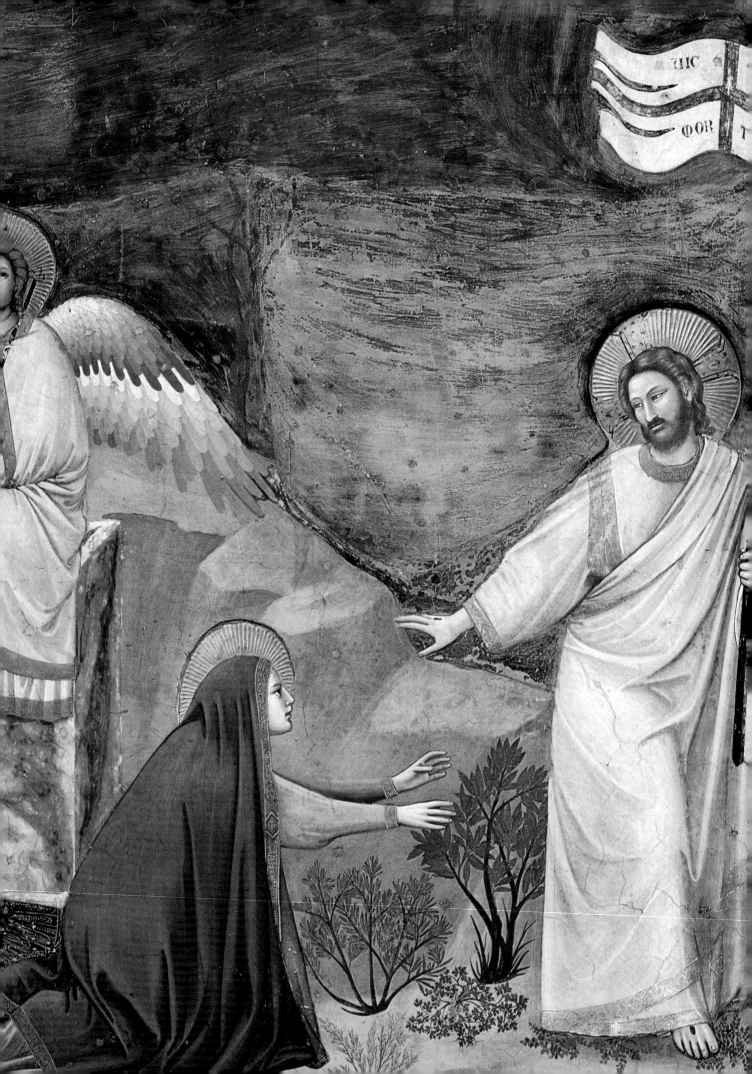

The Arena Chapel: patronage and authorship

GIOTTO'S MOMENT

Writing at the outset of the twentieth century, the critic Roger Fry described Giotto as 'the most prodigious phenomenon in the known history of art'.[1] Fry continued:

> To have created an art capable of expressing the whole range of human emotions; to have found, almost without a guide, how to treat the raw material of life itself in a style so direct, so pliant to the idea, and yet so essentially grandiose and heroic; to have guessed intuitively almost all the principles of representation which it required nearly two centuries of enthusiastic research to establish scientifically – to have accomplished all this is surely a more astounding performance than any other one artist has ever achieved.[2]

This is the Giotto who is celebrated in the standard modern histories of art, the artist who occupies a primary position in what Fry called 'the development of modern culture' (by which he meant modern western culture). The nature of this development was conceived by Fry in terms of a kind of dialectic. On the one hand, Giotto shared with Dante 'the privilege of seeing life as a single, self-consistent, and systematic whole'; on the other, he also shared with the poet a 'new self-consciousness' in which the very transitoriness of that vision was implied: for how could 'the unity of a cosmic theory based on theology' be confidently maintained once their own critical and analytical powers were brought fully to bear?[3] In later times, the possibility that 'life could be viewed as a whole' became in Fry's view increasingly hard to sustain. Not even so considerable an artist as Leonardo da Vinci was able to keep the 'genial but shrewd sympathy for common humanity which makes Giotto's work so eternally refreshing'.[4] Giotto's art is thus seen as ushering in a vivid form of what is experienced as the modern condition. In the later twentieth century, this condition has typically been conceived in terms of an unremitting existential tension: on the one hand, a 'conservative' enjoyment of communality and wholeness; on the other, a 'progressive' recognition of difference and division.

The Giotto who emerges from this account has indeed been a substantial and influential figure within the history of art. It is questionable, however, how realistically that figure can be identified with the historical individual who worked for a time in the Arena Chapel at Padua. Knowingly or not, Fry's assessment repeats the idealizations of earlier writers, many of them Florentines with a particular cause to advance. In turn, Fry adapts these idealizations in the interests of a modern cause: the definition of the typical artist as someone whose insights are authentic because they are free from the constraints of dogma. Underlying Fry's account was his own agnostic tendency to distinguish religious and theological belief from knowledge based on scientific and empirical inquiry, and to identify the latter with cultural progress and development. However attractive Fry's image of Giotto may be to a modern regard – as it was designed to be – it relies on notions of individuality and originality that do not necessarily correspond to the values of Giotto's own times, and it involves a severe underestimation of the achievement and sophistication of late medieval culture in general.

The principal purpose of starting with the quotation from Fry is to identify a range of idealizations associated with Giotto's work, and to furnish a point of departure from which to proceed in pursuit of a more adequate account. However, by citing Fry's estimation of Giotto's supremacy, I mean also to draw attention to the persistence with which the painter's work has been celebrated over the course of seven centuries. That is to say, I mean to allow for the possibility that, whilst Fry's picture of Giotto is highly misleading, he may nevertheless have been justified in describing the painter's achievement as 'astounding'.

It should be said that the Giotto Fry had in mind was someone whose *oeuvre* was more substantial than modern scholarship would accept. In particular, he followed tradition in ascribing to Giotto the primary responsibility for the cycle of the Life of Saint Francis in the Upper Church of San Francesco at Assisi. However, in the qualitative assessment of Giotto's status, pride of place has generally been given – as it is by Fry – to the decorations of the Arena Chapel at Padua, and notably to the sequence of 36 consecutive narrative scenes that occupies the side walls and the chancel arch (Plates 95–99). This commences with the story of Joachim and Anne, the parents of the Virgin Mary, and ends with Christ's Resurrection and the inspiration of the apostles at the Feast of Pentecost. As Fry's account suggests, remote though Giotto's achievement may be in time, this painted scheme has been taken throughout the modern period as a powerful and exemplary vehicle of expression, which is capable of uniting different observers by eliciting a sense of a shared humanity.

The opening quotation from Fry thus serves to set a context of inquiry for this essay as a whole. Should we resist the notion of Giotto's 'astounding achievement' on the grounds that the power of such valuations renders us unsympathetic to different values, different histories, different forms of art? Is it simply a form of Modernist idealism to suppose that Giotto's work is capable of uniting its observers in a common response? Should we regard this supposition as the form in which the propaganda of Florentine writers has unwittingly been transmitted to the present, perpetuating an image of the artist as a being able to transcend social and historical conditions?

Plate 94 (Facing page) Giotto, *Noli me tangere*, detail of *The Resurrection* (Plate 118). Photo: Scala.

Plate 95 South wall (left), Arena Chapel, Padua. Narrative illustration panels each approximately 200 x 185 cm. Photo: Barbara Piovan.

Plate 96 North wall (left), Arena Chapel, Padua. Photo: Barbara Piovan.

Plate 97 South wall (continuation), Arena Chapel, Padua. Photo: Barbara Piovan.

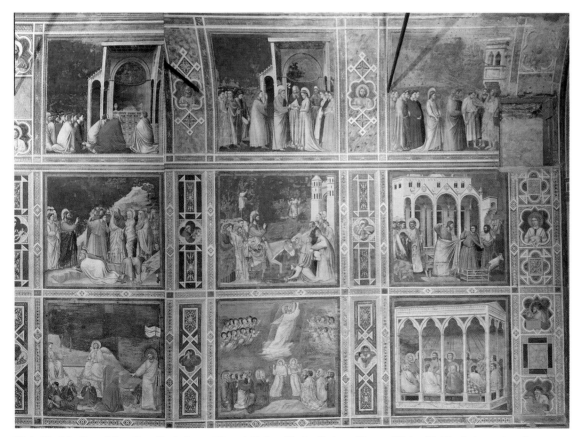

Plate 98 North wall (continuation), Arena Chapel, Padua. Photo: Barbara Piovan. (Plates 95–98, photomontage.)

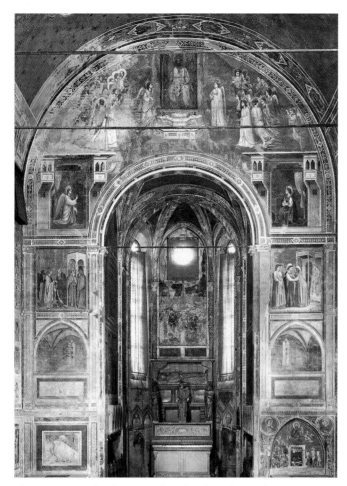

Plate 99 Chancel arch, Arena Chapel, Padua. Photo: Alinari.

Alternatively, could we say that the abiding attraction of the frescoes in the Arena Chapel is, indeed, evidence of some continuity in human experience and human values? Is the apparent constancy and consistency of this attraction a reliable pointer to the *limitation* of any art history that is predicated on the relativity of all values and the inevitability of difference?

I take these to be open questions. It seems more important that the merits of each position should be considered than that either should be exclusively adopted. In the spirit of that assertion, I shall aim in this essay to balance two sets of considerations. I shall try to keep in mind that Giotto's work in the Arena Chapel was done under practical and intellectual conditions different from our own. But I shall also try to direct attention to such features of that work as may help to explain its continuing interest, relevance and appeal. Each of these considerations is meant to serve as a check on the other. I take it that no account of Giotto's decorations in Padua will be adequate if it fails to contribute to an explanation of the relative aesthetic power that Fry and many other writers have acknowledged (for instance, if it would serve equally well to explain a more pedestrian rendering of the same themes). But I also assume that no assessment of the work's aesthetic properties (that is, of its supposed 'quality') will be justifiable if it requires that false ideas are entertained about the circumstances of its production (for example, if it requires us to accept that Giotto's work was without significant

precedent, that he was solely responsible for the choice of subject-matter, or that no hand but his was at work in the chapel).

AUTHORSHIP AND AUTHENTIFICATION

The Arena Chapel is the measure against which any other candidates for inclusion in Giotto's *oeuvre* must be tested. It is the most extensive of the surviving works for which he can reliably be taken as author, and it has survived, moreover, in a far better condition than any other comparable work associated with his name. It must therefore form the basis for any identification of Giotto's style and achievement. This generalization holds good not only for the frescoes in Assisi but also, for reasons given by John White,[5] for those surviving panel paintings that are inscribed with Giotto's name. This is not to say, however, either that no other artist could have worked in the Arena Chapel, or even that Giotto's own involvement is a matter established beyond all possibility of question. Even as regards the Arena Chapel, the case for his authorship depends not on the sure evidence of a surviving contract or comparable document, but on the secondary testimony of literary sources.

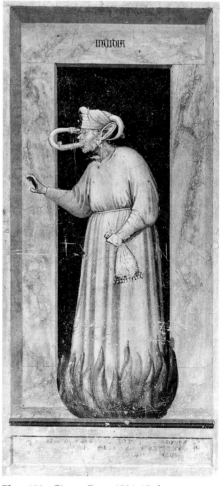

Plate 100 Giotto, *Envy*, 1304–13, fresco, 120 x 55 cm, Arena Chapel, Padua. Reproduced by courtesy of Musei Civici Padova, Gabinetto Fotografico.

These sources are early enough, however, both to have been unaffected by the development of a mythology around the name of Giotto, and to serve as indicators of the probable date of his work on the chapel. The first occurs in an allegorical poem called *Documenti d'amore* written by Francesco da Barberino. In a footnote to his text, Barberino refers to the figure of 'Invidia' (Envy) which 'Giotto painted excellently in the Arena at Padua' (Plate 100). Envy forms one of a series of allegorical representations of the vices and virtues, which are located at the lowest register of the Arena Chapel (Plate 101). Given that it was the normal practice of painters to work from the top of the wall downward, it would follow that the decorations of the chapel were finished or in their final stages by the time the footnote was written. Barberino's text was probably completed in 1312 or 1313, but he had left Italy for Provence in 1308, and may well have written his poem during his absence. The evidence of the poem thus suggests that the decorations of the Arena Chapel were very probably finished by 1313, and may well have been completed before 1308.

The second early reference to Giotto's work in Padua occurs in a contemporary chronicle, the *Compilatio cronologica*, written by Riccobaldo Ferrarese some time between 1312 and 1318. Each of its different manuscript and printed versions includes the following passage: 'Giotto is acknowledged as an excellent Florentine painter. What kind of art he made is testified to by works done by him in the churches of the Minorites [that is, the Franciscans] in Assisi, Rimini and Padua, and in the church of the Arena in Padua.'[6] This provides further confirmation of Giotto's authorship and gives 1318 as the very latest date by which the Paduan frescoes could have been completed. As a record of notable events in the early years of the fourteenth century, the *Compilatio cronologica* also serves to establish that by the second decade of that century Giotto was already being accorded a form of recognition that was exceptional for a mere painter.

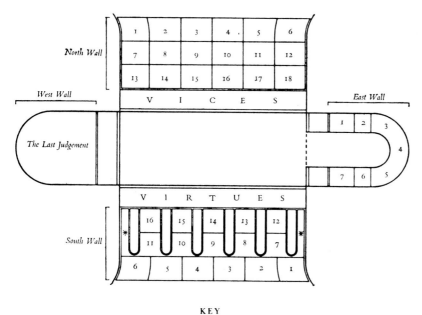

KEY

South Wall

1. Expulsion of Joachim
2. Joachim's Return to the Sheepfold
3. Annunciation to Anna
4. Sacrifice of Joachim
5. Vision of Joachim
6. Meeting at the Golden Gate

7. Birth of Christ
8. Adoration of the Magi
9. Presentation of Christ
10. Flight into Egypt
11. Massacre of the Innocents

12. Last Supper
13. Washing of the Feet
14. Judas' Betrayal
15. Christ before Caiaphas
16. Mocking of Christ

East Wall

1. Perspective of chapel
2. Judas receiving the Bribe
3. The Angel of the Annunciation

4. God the Father sending the Angel Gabriel

5. The Virgin of the Annunciation
6. The Visitation
7. Perspective of chapel

North Wall

1. Birth of the Virgin
2. Presentation of the Virgin
3. Wooers bringing the Rods
4. Wooers praying
5. Marriage of the Virgin
6. The Bridal Procession

7. Teaching in the Temple
8. Baptism of Christ
9. Feast of Cana
10. Raising of Lazarus
11. Entry into Jerusalem
12. Cleansing of the Temple

13. Carrying of the Cross
14. Crucifixion
15. Lamentation
16. Resurrection and Noli me tangere
17. Ascension
18. Pentecost

Plate 101 Plan of frescoes in the Arena Chapel, Padua. Based on John White, *Art and Architecture in Italy 1250–1400,* 1993 Yale University Press.

*The decorative dividing panels between the separate story panels are not included, and account for the blank spaces marked * on the extreme left and right of the south wall.

As might be expected, both Lorenzo Ghiberti[7] and Giorgio Vasari[8] mention the Arena Chapel in their accounts of Giotto, written in the mid fifteenth and mid sixteenth centuries respectively. Although neither describes the work in any detail, both refer to it as 'una gloria mondana' – a glory of the world. The repeated phrase has the quality of a conventional superlative.

CIRCUMSTANCES OF THE COMMISSION

For the date of commencement of Giotto's work in the Arena Chapel we are dependent on evidence concerning the institution of the building itself. The nature of this evidence is such as initially to direct attention away from the painter and towards the patron responsible for his employment. The question of responsibility will engage us at various points throughout this essay. At the macroscopic level, we shall need to consider questions concerning the philosophical and theological commitments guiding the whole ensemble, whilst, at the microscopic level, we might have to consider the distribution of responsibility for different parts of the painted surface. This section will be concerned to establish those factors for which Giotto was *not* responsible, the better to establish the conditions under which his contributions may be assessed.

The relevant documents are translated and published by James Stubblebine.[9] The first is a parchment dated 6 February 1300, which records the purchase by 'Lord Enrico Scrovegni' of the walled area of the former Roman Arena, and of the various buildings contained within it. Scrovegni was a wealthy merchant (the title was not a sign of actual nobility, but rather a function of the honorific style of the document). His intention seems to have been to use the site for a private palace. It is not clear whether he partially adapted the existing residence of the vendors, the Dalesmanini family, or whether he built from scratch (a palace remodelled in the Venetian style in the fifteenth century was finally demolished in the early nineteenth century), but it is clear that the construction of an adjoining chapel was an important priority of the project as a whole. Consent for this chapel must have been granted by the Bishop of Padua before his death in March 1302, and it appears from an inscription transcribed in the sixteenth century but now lost that the foundations were laid in March 1303.

Three further documents serve to confirm that the building of the chapel proceeded speedily. On 1 March 1304 a papal bull was issued, which granted indulgences to all those who visited 'the church of the Blessed Virgin Mary of Charity [Santa Maria della Carità] in the Paduan Arena' on the Feasts of the Nativity, the Annunciation, the Purification and the Assumption of the Virgin. Besides confirming that the building of the chapel must have been completed by the date of its issue, the bull testifies to the dedication of the chapel to Saint Mary of Charity and to its early association with the mythology of the Virgin's life, in which the major feast days cited were seen as notable events.

Records of the deliberations of the High Council of Venice for 16 March 1305 suggest that the chapel was consecrated in that year. Scrovegni had asked that wall hangings or tapestries from San Marco be loaned for the occasion, and the

council acceded to his request. Circumstantial evidence from documents in the archives of the Chapter of the Duomo at Padua suggests that the actual date of consecration was 25 March, the Feast of the Annunciation.[10] One further surviving document serves to confirm the date of construction of the chapel. It also testifies to some conflict between the normal decorum associated with private chapels and the considerable ambition that Scrovegni displayed in the design and furnishing of his own. The Paduan Arena adjoins the Augustinian church of the Eremitani, which was at the time part of a large religious site. On 9 January 1305 the friars of the Eremitani complained to the Episcopal Court that 'the noble and powerful soldier, Lord Enrico Scrovegni the Magnificent' had exceeded the terms of the late bishop's original concession. Specifically, they complained that the chapel ought not to have a bell-tower and bells, that it ought not to have more than one altar, and that it ought not to be open to the public but should be restricted to the use of Scrovegni and his immediate family (a crucial consideration, no doubt, where what was at stake was the offerings of a limited congregation). The friars make no mention of painted decorations, but refer in general terms to 'the many other things which have been made there more for pomp, vainglory and wealth than for praise, glory and honor of God'.[11]

In considering the circumstances of the commission, there are two further factors that need to be taken into account. The first is that Enrico Scrovegni's late father Reginaldo (or Rinaldo) was notorious for usury (money-lending at interest).[12] In the eyes of the church this practice was a mortal sin, which attracted the penalty of damnation. In Canto XVII of Dante's *Inferno*,[13] the poet goes to look at the usurers seated on the burning sand in the seventh circle of hell. There, among a number of notable Florentines, the Paduan Reginaldo Scrovegni is identified by the family badge of a pregnant sow, which is stamped on his purse. The *Inferno* was probably first circulated in finished form around 1314, and may thus have been in the process of composition while Giotto was working in the Arena Chapel. As the inheritor of Reginaldo's wealth, Enrico Scrovegni would have needed both to distance himself publicly from the means of its acquisition, for example through some conspicuous form of atonement, and to make clear, by keeping any surplus wealth as it were out in the open, that he was not himself engaged in similar practices. It is at least possible that the construction and endowment of the Arena Chapel was intended by Enrico Scrovegni as a means of fulfilling these two requirements at once, and thus of saving both his soul and his reputation.[14] The west wall of the chapel is painted with a large picture of *The Last Judgement* (Plate 102), in which the delights of salvation are contrasted with the torments of the damned. The composition follows precedents established in earlier Byzantine and southern Italian versions of the theme, which were given vivid form in mosaic in the Duomo of Torcello and, more recently, in the Baptistery in Florence (Plate 103). In a scene of dedication included at the bottom of the tableau, Enrico Scrovegni is shown offering the Arena Chapel in miniature form to a figure probably intended to represent Saint Mary of Charity. The implication of her answering gesture is that he will, indeed, be received into heaven (Plate 104).

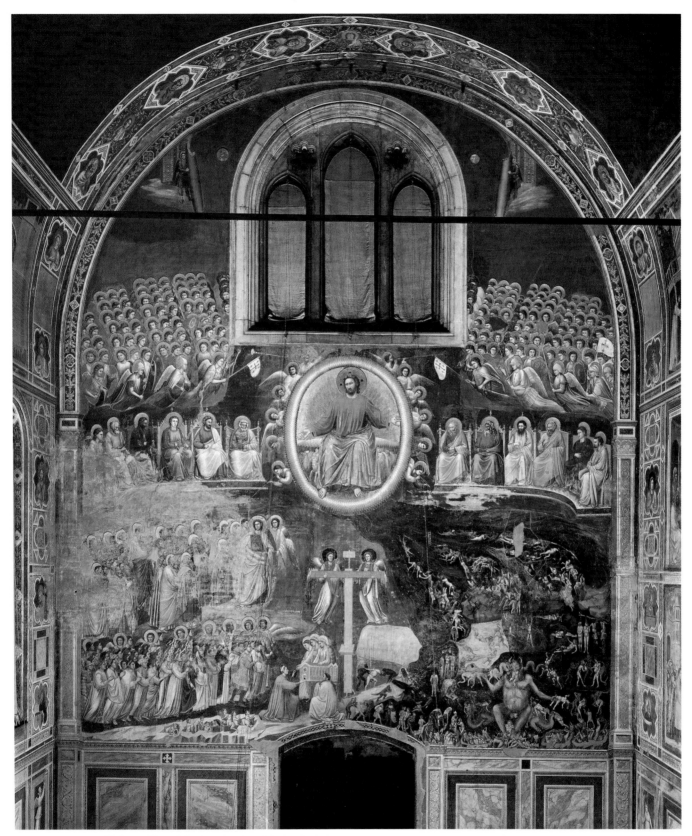

Plate 102 West wall, Arena Chapel, Padua, showing Giotto, *The Last Judgement*, 1304–13, fresco. Photo: Scala.

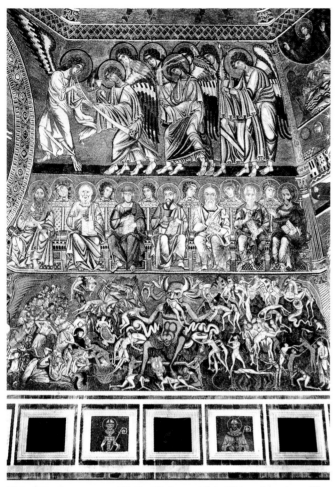

Plate 103 Anonymous, *The Last Judgement*, late thirteenth century (?), mosaic, Baptistery, Florence. Photo: Scala

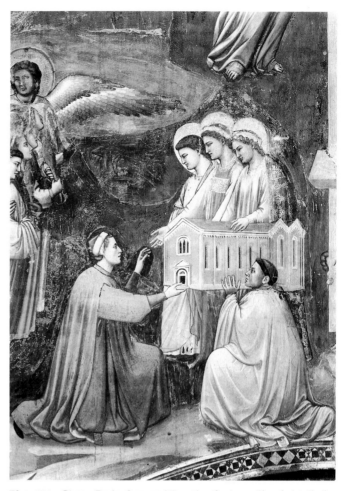

Plate 104 Giotto, *Enrico Scrovegni Donating the Arena Chapel*, detail of *The Last Judgement* (Plate 102). Reproduced by courtesy of Musei Civici Padova, Gabinetto Fotografico.

The minuscule chapel in the painting is shown as supported by a figure in clerical dress. The second consideration bearing on the commission concerns the possible identity of this figure. In his will, written in 1336 in the year of his death, Scrovegni specified that he was to be interred in a sepulchre in the Arena Chapel. He also stated: 'I built that church and that monument at my own expense and by the grace of God.' There is some reason to believe that this statement was untrue, and that the figure in clerical garb serves to represent the interests of the chapel's co-donors, a military–religious order known as the Cavalieri di Santa Maria or the Cavalieri Gaudenti. According to the Paduan chronicler Giovanni da Nono, writing before 1337,[15] Scrovegni was a member of the order at the time of the dedication of the chapel. A fifteenth-century version of the chronicle in question states that the Cavalieri Gaudenti was granted ownership of the chapel by Pope Benedict XI in virtue of a contribution of money. It is not entirely clear that this contribution was made to finance the building of the chapel, but an eighteenth-century historian of the Cavalieri cites early legal documents to establish the order's ownership.[16] The only form of membership for which Scrovegni would have qualified was that of the *coniugati*, or married laymen, on whom the order enjoined a vow of conjugal chastity – celibacy within marriage. It is argued by Robert Rough[17] that

if Scrovegni were concerned to identify himself with the *coniugati*, this would serve to explain the emphasis accorded in the Arena Chapel to narrative episodes involving Joachim, father of the Virgin (Plate 105), Joseph, her husband (Plate 106) and John the Evangelist (seen, for example, in the figure with arms outstretched in Plate 107), each of these three men being associated with asceticism and chastity in a range of apocryphal writings.

The involvement of the Cavalieri would certainly help to explain two other aspects of the chapel's iconographical programme, as Rough argues. In the constitution of the order, its members were directed to two specific goals: a chivalrous devotion to the Virgin Mary and freedom from the practice of usury. There can be no mistaking the emphases placed in the Arena Chapel frescoes both on the role of the Virgin and on the theme of usury and its punishment.[18] As we have seen, it is not absolutely necessary to presume the involvement of the Cavalieri in order to account for these emphases, but it can certainly be said that involvement of the order would have rendered these themes all the more apposite.

There is a last point to be made about the Cavalieri Gaudenti, and this may help finally to connect the circumstances of the Arena Chapel commission with the artist to whom that commission was awarded. The aims of the Cavalieri reflect a widespread tendency among the laity of the

Plate 105 Giotto, *The Expulsion of Joachim from the Temple*, 1304–13, fresco, Arena Chapel, Padua. Reproduced by courtesy of Musei Civici Padova, Gabinetto Fotografico.

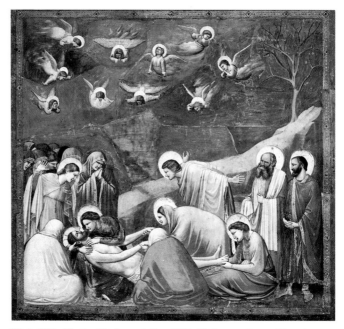

Plate 107 Giotto, *The Lamentation*, 1304–13, fresco, Arena Chapel, Padua. Reproduced by courtesy of Musei Civici Padova, Gabinetto Fotografico.

later thirteenth century to combine humanist piety with reforming zeal. In its conservative form this tendency appeared as a militant engagement in the suppression of heresy, and it may well be that by the beginning of the fourteenth century the Cavalieri had become conservative in this respect. However, the tendency in question also took part of its direction from the teachings of Saint Francis, and the Cavalieri was formed in 1261 when the influence of those teachings was strong. Even if we do not allow that Giotto was practically engaged in the painting of the prestigious cycle of the Life of Saint Francis in Assisi – and the case for his participation at least in a subsidiary capacity must be

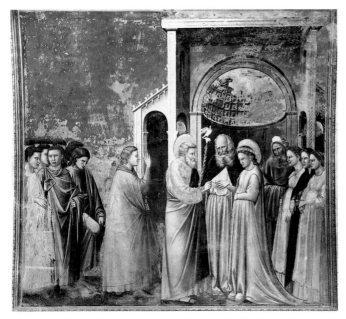

Plate 106 Giotto, *The Marriage of the Virgin*, 1304–13, fresco, Arena Chapel, Padua. Photo: Alinari.

considered a strong one[19] – his career still clearly reflects both a pattern of Franciscan commissions and a pattern of opportunities involving the public demonstration of lay piety. If the Cavalieri Gaudenti was implicated in the establishment of the Arena Chapel, Giotto would have appeared all the more suitable as a candidate to interpret those particular themes to which its painted decorations were to be publicly directed.

In fact, Scrovegni's identification of himself with a programme of piety and asceticism may well have been little more than the public form behind which a considerable opportunism was concealed. If Giovanni da Nono is further to be believed, the merchant renounced his membership of the Cavalieri within a few months of the consecration of the chapel.[20] The implication is that Scrovegni enlisted the co-operation of the order in the establishment and building of the chapel, and then, once it had been completed, dissolved his ties and claimed it as his own.

This implication may well be the invention of interests hostile to Scrovegni's memory, but even if it is justified it does not follow that the taint of opportunism must necessarily cling to the decorations he commissioned. The argument of this section can be summarized as follows. The Arena Chapel was built and decorated in the context of a complex set of conditions and interests. Among the more general factors it may be appropriate to consider are, on the one hand, the intellectual and ethical impetus of a broad reforming movement, as that impetus was expressed (and perhaps diverted) through the aspirations of the Cavalieri Gaudenti, and, on the other, the climate of civic and economic opportunity that prevailed in Padua under the Commune. (These factors were not necessarily in conflict. The 'new men' of the Commune were on common ground with the 'new men' of the religious orders, in combining opposition with opportunism in their relations with traditional forms of

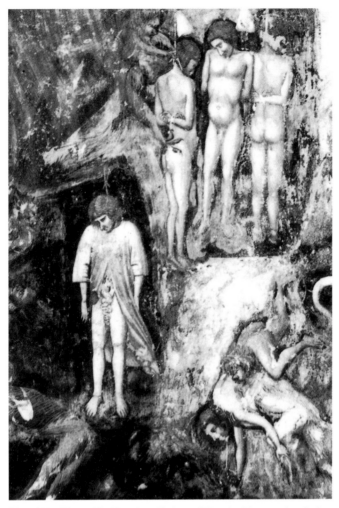

Plate 108 Giotto, *The Hanging of Judas and Hanging Usurers*, detail of *The Last Judgement* (Plate 102). Reproduced by courtesy of Musei Civici Padova, Gabinetto Fotografico.

function would also make it appropriate that motifs associated with themes of damnation and salvation should be stressed throughout the remaining decorations.

The second condition is the identification of usury as a mortal sin requiring explicit condemnation. The association of money with mortal sin is clearly reflected in *The Last Judgement*, where prominence is given to the hanging figure of Judas (Plate 108), who betrayed Christ for the love of money,[21] and where various of the damned are seen hanging by their purse strings (Plate 108). As Schlegel observed, the association of cupidity with mortal sin may also explain the prominence accorded to Judas' taking of the bribe, which is pictured beneath the angel of the annunciation on the chancel arch (Plates 99 and 109). At the lowest level of all, where Giotto painted allegorical figures of the virtues and vices, Charity tramples on a pile of money bags (Plate 110) while, facing her, Envy clutches a purse, although consumed by fire (Plate 100).

A third condition that bears on the chapel's iconography is the idea, prevalent both in the ideology of the Servite Order and in the Franciscan movement and its wake, that the Virgin should be accorded a prominent role in devotion as the guarantor of Christ's humanity. This idea can be seen as expressed not only in the dedication of the chapel and in the prominence given to the theme of annunciation, but also in the devotion of a significant proportion of the narrative sequences on the side walls to the Virgin's lineage and early life. Her role in the process of salvation is further emphasized by her substantial presence within *The Last Judgement*, framed in a mandorla below and to the left of the central figure of Christ the Redeemer (Plate 111).

autocracy.) Among the factors that relate specifically to Enrico Scrovegni are a possible desire to expiate his father's usury and at the same time to make his own expenditure conspicuous; an ambition for status combined with a fear of damnation; a desire, on the one hand, to be regarded as an ascetic devoted to the cult of the Virgin, and, on the other, to secure for himself a fitting property to serve as his personal monument.

These various considerations help, with varying degrees of certainty or conjecture, to define a form of opportunity that Giotto was to exploit. Some or all of these factors may have played a part in shaping a programme for the frescoes he was to paint. In fact, we can now isolate those conditions that are most likely to have had a specific determining effect on the chapel's iconography.

First, the decoration of the chapel would need to be appropriate to the services to be celebrated there and relevant to the readings specified in those services. Thus, many of the narrative scenes painted on the central and lower registers of the Arena Chapel side walls illustrate episodes from the New Testament that feature prominently in the liturgical calendar, from Advent to Pentecost. In addition, the scene of *The Last Judgement* would be of particular relevance to a building in which prayers were to be said for the souls of the dead. This

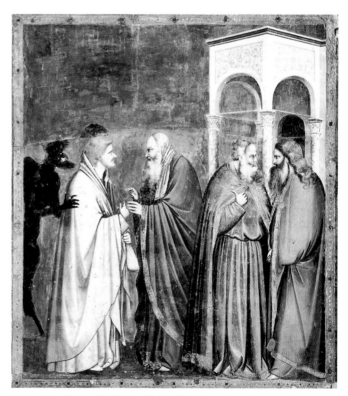

Plate 109 Giotto, *The Bribe of Judas (Judas Receiving Money for his Betrayal)*, 1304–13, fresco, Arena Chapel, Padua. Reproduced by courtesy of Musei Civici Padova, Gabinetto Fotografico.

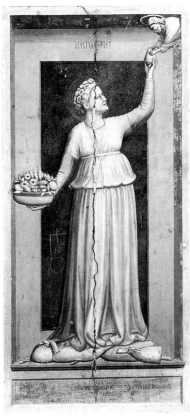

Plate 110 Giotto, *Charity*, 1304–13, fresco, Arena Chapel, Padua. Reproduced by courtesy of Musei Civici Padova, Gabinetto Fotografico.

Lastly, and perhaps most speculatively, we may attribute to the influence of the Cavalieri Gaudenti an investment of particular status in those male figures from the Christian legend who could plausibly be celebrated for their chastity. Thus, in the narratives concerned with the lineage of the Virgin, prominence is given to her father Joachim, whose wife Saint Anne became miraculously pregnant after a long and childless marriage, while the Virgin's own husband Joseph also features prominently as an elderly and formerly childless figure. It may also be that the prominence accorded to Saint John the Evangelist is due to the apocryphal emphasis given to his chastity and celibacy. (Rough follows Schlegel in identifying Saint John Evangelist with the lightly bearded figure standing at the far side of Saint Mary of Charity in the scene of donation (Plate 104).)

These are, as it were, among the materials of which the Arena Chapel frescoes are made – and by materials I mean to refer not only to the iconographic themes themselves, but also to the specific social, religious and psychological interests and imperatives that gave these themes pertinence at this time and place for the individuals concerned. No account of the Arena Chapel will be secure if it does not allow these interests and imperatives some place in its scheme of explanation.

It does not follow, however, that the meaning or value of the decoration can be reduced to a register of interests and motives on the part of Enrico Scrovegni or anyone else. To talk of the *work* of art is precisely to talk of the power of aesthetic considerations and procedures to transform the meaning and value of a given range of materials – whether these materials are of a practical nature, like plaster and pigment, wood and stone, or whether they are the stuff of religious or philosophical commitments or pretensions.

Now that the actual and hypothetical conditions of Giotto's commission have been sketched out, we can shift our attention from the probable requirements and concerns of the patron or patrons to the practical skills of the artist, which is to say that we can begin to consider the manner in which the work of decorating the Arena Chapel was carried out.

CONCEPTION AND DESIGN

It is natural to view the organization of the frescoed decorations in the Arena Chapel as the solution to a set of compositional problems defined by the architectural framework (Plates 101 and 112). It is just conceivable, however, that Giotto was the architect of the Arena Chapel as well as its decorator. If that were the case we could safely assume that an already envisaged organization of the decorations was enabled by the architectural proportions and divisions of walls and windows. There are two principal reasons for considering that Giotto might have been involved as an architect. The first is his appointment in 1334 as *capomaestro* of the Duomo in Florence, together with his traditional if questionable standing as designer of its Campanile. If we take the appointment to have been more than honorary, we are likely to assume that some prior architectural experience must have lain behind it.[22] The second reason is the powerful impression given by the Arena Chapel that painted decoration and architectural structure

Plate 111 Giotto, *The Virgin Mary*, detail of *The Last Judgement* (Plate 102). Reproduced by courtesy of Musei Civici Padova, Gabinetto Fotografico.

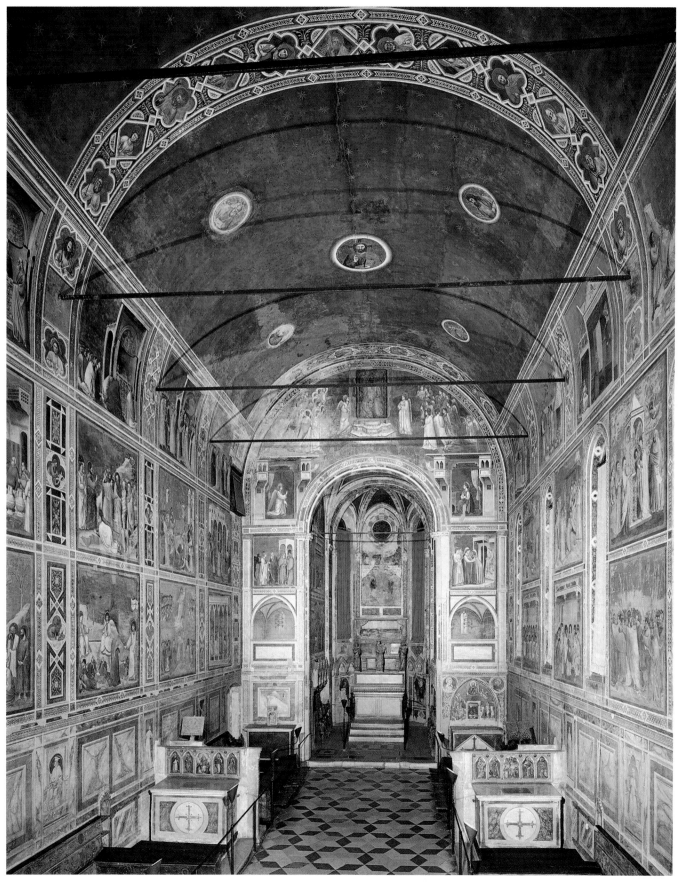

Plate 112 View of the nave, Arena Chapel (overall dimensions in metres: height 12.80, length 20.82, width 8.42), Padua. Photo: Scala.

and volume do, indeed, complement one another with remarkable success.

These two points are vulnerable to countering arguments, however. First, as Andrew Martindale has suggested, Giotto's appointment as architect is more likely to have been a means of rewarding his status and retaining him in Florence than a form of recognition of any prior architectural skills or achievements.[23] Secondly, it could be said that the integration of decoration with architecture is better explained through recognition of Giotto's proven skills as a painter than by inventing an unproven competence as an architect. Lastly, and most persuasively, there is evidence that changes were made to the recently completed building before work on the paintings began. These include the filling-in of a door in the south wall and of a window in the north. As Paul Hills observes, following the researches of Irene Hueck:[24]

> Giotto opened the triumphal arch to add the choir and polygonal apse [perhaps it was this addition that provoked the friars of the Eremitani to worry about the proliferation of altars]. He filled the window above the arch with a panel depicting God the Father [see Plate 99]. Most likely it was the proximity of the Scrovegni palace that precluded provision of windows in the north wall of the chapel to match the row in the south. Giotto compensated for this asymmetry by ingenious planning.[25]

From this evidence it seems clear, first, that Giotto was not consulted until after the building was finished, and, second, that once he had been consulted, sufficient priority was given

to his proposals for certain elements of the building to be altered so that these proposals could be accommodated.

It seems reasonable to assume, then, that Giotto's initial brief was defined, on the one hand, by a series of more or less explicit suggestions and instructions concerning the themes that his pictures were to illustrate and, on the other, by the overall structure of the chapel and the basic dimensions of its walls. What he in turn must have brought to the task was a considerable range of skills in visualization and design, underwritten by basic competences in mathematics and geometry, together with a practised repertoire of figurative types – ways of representing buildings and landscapes, manners of modelling and draping figures, poses, gestures, facial expressions – both derived from the examples of others and developed within his own practice. All of these were in essence the same kinds of practical and conceptual skills that his contemporary Duccio must have brought to the painting of the *Maestà* for the high altar of Siena Duomo. In Giotto's case, it could only have strengthened his qualification for the task of decorating the Arena Chapel if he was in a position to derive some of the relevant figurative types, or indeed whole configurations, from the prestigious frescoes in the Upper Church of San Francesco at Assisi, whether the derivation in question was based on mere familiarity or on practical involvement (cf. Plates 107 and 113). It is also likely that Giotto would have been able to count on the command of an organized workshop, and on the ability to employ assistants who were practised in a range of subordinate tasks, from the mixing of plaster and colours to the laying-in of grounds and

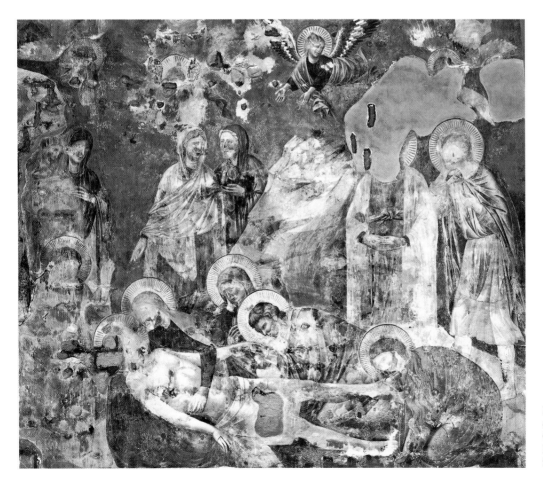

Plate 113 *The Lamentation, c.1290–1300?*, fresco, Upper Church, San Francesco, Assisi. Photo: Archivio Fotografico Sacro Convento, Assisi.

draperies, the repetition of decorative motifs such as those by which the narrative panels of the Arena Chapel were to be divided (Plate 117) and even the execution of whole figures in a style consistent with his own and probably on the basis of his outlines. Certainly, we would have to assume the steady employment of a well-organized team if we were to accept that the whole scheme was completed by the date of consecration in March 1305, given both that the initial building work on the chapel cannot have been finished until some considerable time after March 1303, and that it was not practical to continue fresco work during the winter.

In the absence of a contract, we can conjecture an initial stage involving Giotto at which some agreement must have been established between what the patron (or patrons) wanted and what the artist was able to offer. There is no reason to believe that relations between artists and patrons have changed so much that we cannot realistically imagine the respective tendencies of the two parties: the artist would be inclined to talk up what might and could be done, in order to stimulate the imagination of the patron and to enlarge the contract; the patron would be inclined to talk down the price, or at least to ensure the conditions of its containment, while attempting to secure the best exposition of the artist's skills. At some point, both artist and patron would need to establish agreement such that the patron could expect his or her wishes to be fulfilled, while the artist could feel confident both of what was explicitly required of him and of the extent to which he was free to exercise initiative or to delegate.

This agreement might have been concluded in terms of the texts to be illustrated, or on the basis of drawings, or both. It is certainly inconceivable that Giotto could have planned and executed his decorations without making some form of scale-drawing, whether or not the patron required it. This would need to have shown the proposed geometrical organization of each of the walls and the selection and placing of the various narrative scenes.

Whether or not directed by the patron or by a theological adviser in the patron's circle, Giotto would also have needed an authoritative textual source for those scenes. The Bible was the obvious common recourse. In the case of scenes concerned with the life of Christ, the New Testament gospels would have furnished appropriate material. The artist may have selected from among the gospels on the basis of specific instructions or requirements (for example, to match a set programme of liturgical readings) or to some extent on his own initiative, in order to give prominence to the most picturesque subjects.

In the case of the scenes concerned with the Virgin's lineage and early life, Giotto's pictures correspond closely to the apocryphal Gospel of Saint James the Less and to *The Golden Legend* of Jacobus de Voragine, first circulated in the 1260s and thereafter widely used as a source of religious narratives. The sequence of events in Giotto's painted narratives do not exactly match those in *The Golden Legend*, however. If we number the first six scenes of the painted narratives in order (Plates 95, 97 and 101), the corresponding passages from *The Golden Legend* would run 1, 2, 5, 3, 6, Giotto's fourth scene, *The Sacrifice of Joachim*, not being mentioned, although it *is* mentioned in the Gospel of Saint James the Less. What Giotto has done is to move the scene of *The Annunciation to Saint Anne* (Plate 114) towards the centre of the wall and away from the position it would otherwise occupy after the angel's appearance to Joachim and near the end of the sequence. This decision had various consequences:

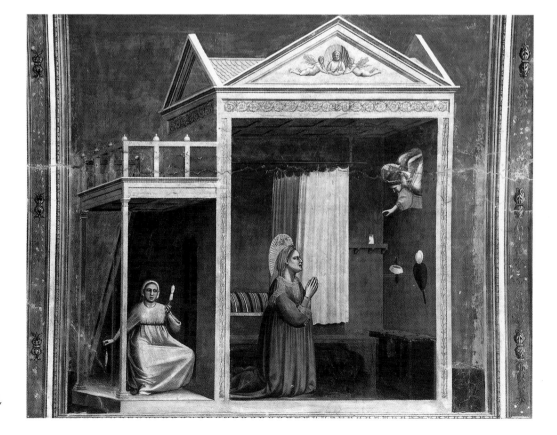

Plate 114 Giotto, *The Annunciation to Saint Anne*, 1304–13, fresco, Arena Chapel, Padua. Photo: Alinari.

it served the aesthetic ends of composition by locating a strong architectural feature between two landscape scenes in the upper register, where otherwise it would have been placed next to the scene of reunion at the Golden Gate; it had an effect on the significance of the narrative by changing its precedence, so that whereas in *The Golden Legend* it is Joachim who is given priority, in the painted version the angel's message is primarily for Saint Anne; and it had a hermeneutic implication in that it served to draw the scene of annunciation to Saint Anne closer to the annunciation to the Virgin on the chancel arch, and thus to emphasize the prefiguring of the one event in the other.

Were all these consequences thought out and intended? If not, why was the order changed? If so, whose was the intention? How might we decide? These are open questions. What matters is that none of the effects in question should have to be ignored in order to simplify an explanation of the others.

However these questions are answered, we can be sure that the artist would have needed at an early stage to establish some workable relationship between geometrical organization and intellectual content. This would have required careful measurement of the available wall surfaces and the development of a complex plan for disposing the various components of the scheme. In Giotto's design a crucial function is fulfilled by the wide bands of decoration that mark the divisions between the different components, bisecting the vault and separating the lateral walls from the chancel arch at one end and the west wall with *The Last Judgement* at the other (Plates 95–98, 102, 112). These bands serve two important functions: they soak up the remainders of the wall surfaces once these have been divided into the appropriate number of regular units, and they serve to mediate visually between the various represented scenes, both dividing them one from another and assisting their integration into a total decorative ensemble. As if to emphasize the integration of geometrical with intellectual organization, small-scale prefigurations of the main events of the narratives are incorporated into the bands on the north wall. Thus, for instance, a picture of the infant Christ's circumcision precedes the larger scene of his Baptism, and the ascension of Elijah in a chariot of fire recalls an Old Testament precedent for the ensuing Ascension of Christ (see Plates 96 and 98).

The decorative style of the bands reproduces a form of coloured stonework developed in Rome in the thirteenth and fourteenth centuries and known as Cosmati work after the family of craftsmen largely responsible (Plate 117). In fact, the walls of the Arena Chapel are plastered flat from floor to vault and from end to end. In reproduction it is not clear that the architectural mouldings and decorative inlays dividing the scenes of the Arena Chapel are all forms of painted illusion. Even in the presence of the frescoes themselves, sections of the painted framework appear initially as forms of actual relief. It is clear that Giotto must have been thoroughly confident of his workshop's possession of the appropriate skills, for a great deal was allowed to depend on the success of this illusion. It is through the figurative divisions of its painted surface that the intellectual and decorative organization of the chapel is both articulated and integrated.

Here, then, we have the first unquestionable measure of

Giotto's responsibility. However detailed the specification of subject-matter may have been on the part of the patron(s) and any advisers, its organization in graphic terms required the practical and imaginative skills of the artist.

EXECUTION

Following its conception, the next conjectured stage in the decoration of the chapel would have involved the practical preliminaries necessary to put the design into effect with the greatest economy. The two principal processes involved would have been scaffolding and plastering. Then as now lack of forethought at the planning stage would be costly in time and resources. It would be sensible to proceed one wall at a time, working from top to bottom, plastering and painting. Given the amount of mess inevitably involved in plastering, it would be crucially important to keep the different processes and stages separate and to avoid spoiling finished work. The technical examination first published by Tintori and Meiss[26] confirms that the first of the narrative scenes to be painted were those in the upper registers: the story of Joachim on the south wall (Plates 95, 97 and 101) and the early life of the Virgin on the north (Plates 96, 98 and 101).

Fresco painting requires a number of different stages. A rough plaster is first laid over the bare brick. This is then covered with a second, finer coat known as the *arricciato*. At this stage, the divisions of the wall are established using plumb lines and compasses, and by snapping strings drawn tight between one measured point and another so that straight lines are impressed in the still-damp surface. The composition is then drawn out in charcoal, and perhaps sketched in with an earth-coloured wash or *sinopia*, the degree of detail established at this stage depending both on individual practice and on the importance and difficulty of the subjects in question. The master then estimates how much of any given scene can be painted in a day's work, and this area or patch is covered with an extremely fine layer of new plaster, the *intonaco*. The profile of each patch is made to coincide as far as possible with divisions of the composition, so that the join between one day's work and the next (or *giornata*) can be covered by outlines or changes of colour.[27] It is, however, still possible to distinguish the individual work patches in the Arena Chapel (Plates 115 and 116). Examination of these confirms, as one would expect, that large areas of *intonaco* were laid on where skies and landscape backgrounds were to be painted, and far smaller patches for individual figures and even single heads.

The concealed portions of the drawing are normally redrawn over the *intonaco*, and the painting is then done into the wet plaster, using colours mixed with water. In order to ensure consistency of coloration on a large scheme of decoration, ample quantities of paint would be kept ready mixed in large dishes. At the end of the day's work, any unpainted areas of *intonaco* would be cut away.[28]

Substantial revisions would require that a section of the *intonaco* be chopped out and replastered. Small corrections could be made on the dried-out surface – *a secco*. The *a secco* technique would also be used for the deeper colours and denser pigments that were not suited to the fresco technique nor easily used for gradual shading and modelling effects.

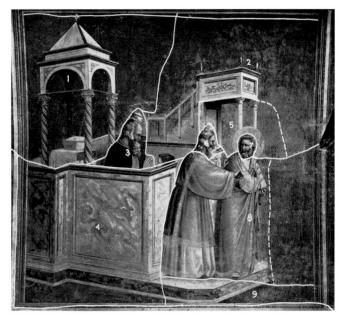

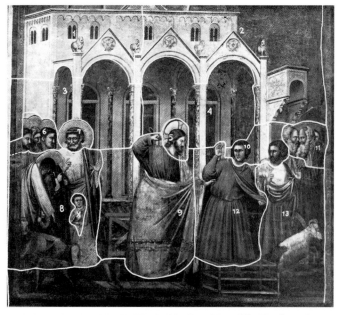

Plate 115 Work patches in Giotto, *The Expulsion of Joachim from the Temple*, 1304–13, Arena Chapel, Padua. Reproduced from Leonetto Tintori and Millard Meiss, *The Painting of the 'Life of St Francis' in Assisi with Notes on the Arena Chapel*, 1962 New York University Press.

Plate 116 Work patches in Giotto, *The Expulsion of the Merchants from the Temple*, 1304–13, Arena Chapel, Padua. Reproduced from Leonetto Tintori and Millard Meiss, *The Painting of the 'Life of St Francis' in Assisi with Notes on the Arena Chapel*, 1962 New York University Press.

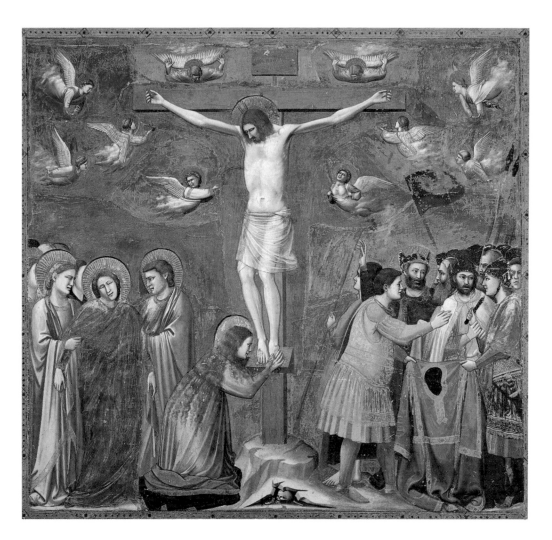

Plate 117 Giotto, *The Crucifixion*, 1304–13, fresco, Arena Chapel, Padua. Photo: Scala.

Thus, the deep azurite blue used throughout the Arena Chapel narratives for the robe of the Virgin was always applied over fresco underpainting in which the underlying form had first been established (Plate 117). The *a secco* technique was also used for certain white highlights and for fine decorative additions, such as the detailing of the sleeping soldiers' armour in *The Resurrection* (Plate 118). Whereas the colours applied in true fresco technique would bind with the plaster to form a hard and waterproof surface, painting done *a secco* was more liable to flaking off and abrasion. Thus, it is in the areas originally painted *a secco* – and particularly in those portions once painted dark blue – that the decorations of the chapel have suffered greatest loss of colour and detail. Similarly vulnerable were those areas of gilding that would also be applied over the dried-out surface, on haloes, on the borders of garments, or where heavenly radiance was to be suggested.

As in the case of Duccio's work on the *Maestà*, there is clear evidence that Giotto made substantial adjustments to individual narrative scenes in order to improve compositions and to enhance details. In *The Expulsion of Joachim from the Temple*, for example, he lowered the wall of the sanctuary, with the result that more was seen of the head of the seated young man within (Plates 105 and 115). In *The Expulsion of the Traders from the Temple*, he added the figure of a boy holding a dove, partly on a patch of new plaster and partly *a secco* over the existing fresco (Plates 116 and 119).[29]

The vault is likely to have been painted first, although in how many stages would presumably depend on the depth of the scaffolding out from each wall. It is easy to underestimate its effect on the narrative scenes beneath. In fact, the intense blue serves to establish a powerful condition of naturalism for the chapel as a whole. The impression of space and depth carries down through the illusionistic architectural framing of the upper register to breathe life through each of the lower scenes in turn, so that the various episodes appear as components of a single and integrated imaginary world.

The sense of overall spatial integration is furthered by the even tenor of colouring maintained throughout the individual scenes, and by the consistent scale adopted for the foreground figures. Giotto also established a consistent pattern of illumination, modelling the figures within each narrative scene as if light fell on them from a single source and direction. The light by which the fresco painter worked was the light in which his finished work would be seen. As if to make the best of this limitation, Giotto organized the light within his narratives so that its fictional point of origin coincides with the actual Gothic window above the figure of Christ the Redeemer on the west wall (Plate 102). Thus, even when located in interiors, figures on the south wall are consistently lit from the right, figures on the north wall from the left (Plates 95–98).

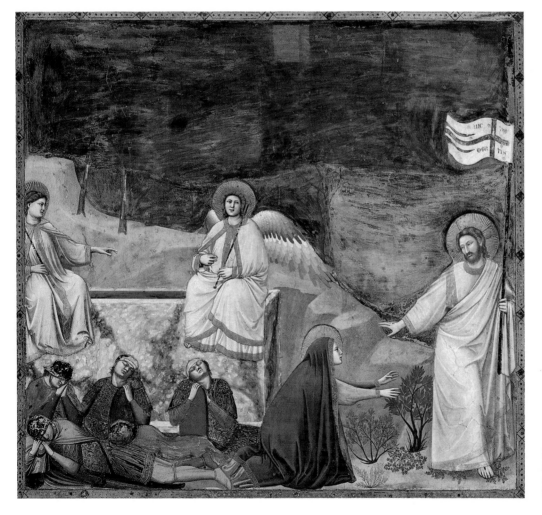

Plate 118 Giotto, *The Resurrection*, 1304–13, fresco, Arena Chapel, Padua. Photo: Scala.

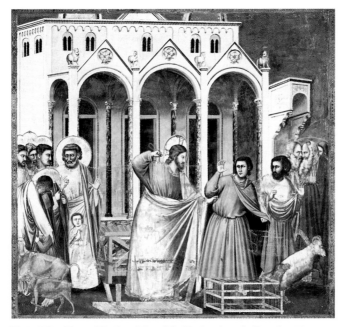

Plate 119 Giotto, *The Expulsion of the Traders from the Temple*, 1304–13, fresco, Arena Chapel, Padua. Reproduced by courtesy of Musei Civici Padova, Gabinetto Fotografico.

Hills notes that in painting before this date a highlight on an object had normally been represented as if the light were one of that object's properties – the roundness of a sphere, for instance, would be conveyed in part by its possession of a point of light:

> Giotto's attention to the direction of light undermined this useful convention. In the traditional system the position of the highlight refers to the shape of the object: in Giotto's frescoes the position of the highlight refers to the direction of light. A fundamental change in conceptual habits has taken place.[30]

This change has important consequences for the way in which meaning and emotional expression are conveyed and understood. Hills suggests: 'Whereas earlier traditions of modelling tended to conflate cause and effect, source and object illuminated, it was dawning on Giotto that their separation, allowing for that invisible traversing of a gap, was a key to the illusion of space.'[31]

We might add that, under the conditions of painting at the time, the development of the illusion of space was in turn a key to the development of complex meaning and expression. The tendency of the traditional method was to distinguish

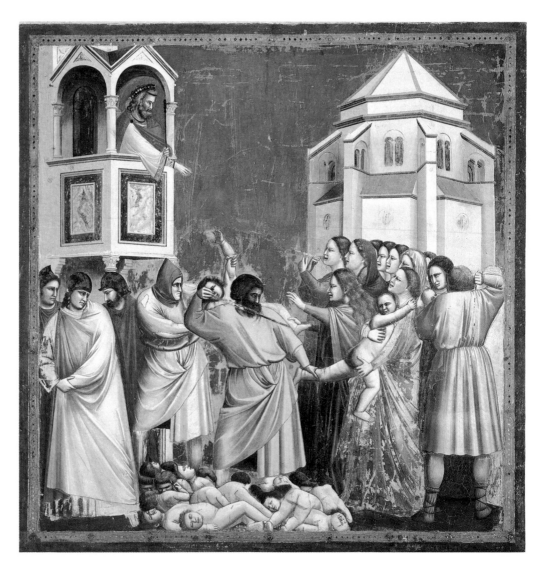

Plate 120 Giotto, *The Massacre of the Innocents*, 1304–13, fresco, Arena Chapel, Padua. Photo: Scala.

individual figures one from another, and to make each the isolated bearer of a specific expressive condition. The tendency of Giotto's method, on the other hand, is to encourage the reading of figures as related within a single imaginable context, so that the emotion of one figure is more readily experienced as a response to the actions of another. As can be seen, for instance in *The Massacre of the Innocents* (Plate 120), the result is a considerable increase in dramatic power, that is to say, in the power of the picture to resonate within the imagination of the spectator.

This gives us our second measure of Giotto's responsibility for the work in the Arena Chapel: the distinctive, and for his time apparently unmatched, ability to achieve meaning and expression for the picture as a whole through the organization of plastic figures in coherent and luminous illusionistic spaces.

GIOTTO'S 'REALISM'

To recall the quotation from Fry with which I opened this essay: to 'treat the raw material of life' in a 'direct ... grandiose and heroic' style is to achieve what might be considered a form of artistic realism. Realism is, of course, a modern concept and, therefore, not one that could have been determining on Giotto's work in the Arena Chapel. We do not know the precise terms in which that work might have been conceived by members of the literate and scholarly circles of contemporary Paduan society, let alone by a skilled artisan such as Giotto himself. However, we can observe how rapidly admiration for the verisimilitude of Giotto's figures became a standard form of praise. This is Filippo Villani, writing in his *De Origine Civitatis Florentiae et Eiusdem Famosis Civibus* in 1381–82:

> After John [that is, Cimabue], the road to new things now lying open, Giotto – who is not only by virtue of his great fame to be compared with the ancient painters, but is even to be preferred to them for skill and talent – restored painting to its former worth and great reputation. For images formed by his brush agree so well with the lineaments of nature as to seem to the beholder to live and breathe; and his pictures appear to perform actions and movements so exactly as to seem from a little way off actually speaking, weeping, rejoicing, and doing other things, not without pleasure for him who beholds and praises the talent and skill of the artist. Many people judge – and not foolishly indeed – that painters are of a talent no lower than those whom the liberal arts have rendered *magistri,* since these latter may learn by means of study and instruction written rules of their arts while the painters derive such rules as they find in their art only from a profound natural talent and a tenacious memory. Yet Giotto was a man of great understanding even apart from the art of painting, and one who had experience in many things. Besides having a full knowledge of history, he showed himself so far a rival of poetry that keen judges consider he painted what most poets represent in words.

This passage is quoted and translated in Michael Baxandall's elegant study *Giotto and the Orators*,[32] which traces the development of a form of art-critical vocabulary in the works of a generation of humanist observers writing in the later fourteenth and early fifteenth centuries. As Baxandall

observes, there are two reasons why we should treat this and similar testimonies with caution. The first is that the terms of praise, although they may seem particularly apt to Giotto's work, are standard forms of rhetorical device, which tend to repeat the phrases in which semi-mythical classical artists were celebrated by classical authors. In other words, the supposed development of art serves primarily as the pretext for a classicizing development in literary style. The second point is that Villani was a contributor to that specifically Florentine view of achievement and historical progress by which the history of art has been marked ever since. As Baxandall puts it:

> Villani's semi-humanist account of early fourteenth-century painting is compelling enough for the history of art not yet to have outgrown it. The pattern in our handbooks is still substantially his adaptation of Pliny's account of Apollodorus, Zeuxis, and his followers to the Trecento situation: Cimabue, Giotto, and Giottesqui [*sic*]. It is an attractive pattern; it articulates very boldly an awkward chapter in the history of painting [by which Baxandall presumably means to refer to the moment of transition from 'medieval' to 'Renaissance' modes of representation] and it is inherently satisfying because it embodies so compactly such varied differentiations – priority, quality, stature, kind.[33]

With these cautions in mind, however, we may still note the connection made in Villani's text between Giotto's achievement of compelling forms of mimesis on the one hand, and his understanding and knowledge on the other. We should not assume that the use of standard classical formulae necessarily devalues the writer's response. Villani's substantial point is a perceptive one. He questions the assumption that, in Giotto's case, the skills of painting are essentially practical and empirical skills, learned through 'doing', and, by implication, forgotten once the 'doing' is over except by those with 'a tenacious memory'. Although he is not able explicitly to express the thought, it is clear that the quality of Giotto's art encourages him to think of painting as a possible form of knowledge; that is to say, as a form of practice which might appropriately develop a body of theory, which might involve the learning and the transmission of rules and standards, which might thus be able to advance in significant ways and which might attract serious criticism and interpretation of the sort devoted to poetry.

The crucial advance in question is one that involves the connection between observation, picture and concept. The ability successfully to illustrate given religious texts was a *sine qua non* of even the thirteenth-century painter's trade. But it was Giotto's notable achievement in practice to equate interpretative illustration with the imaginative observation and visualization of individuals. That visualization was then given effect in pictorial compositions that were experienced as vehicles for religious emotions and concepts. It is likely that this achievement was of considerable topical value in the light of the early fourteenth-century tendency to lay piety. This tendency was supported by the Franciscan *Meditations on the Life of Christ* (attributed to Giovanni de Caulibus) and by teachings from other religious orders, which encouraged the imaginative transcendence of barriers between religious experience and everyday experience. I also suggest that it was this achievement more than any other that accounted for the

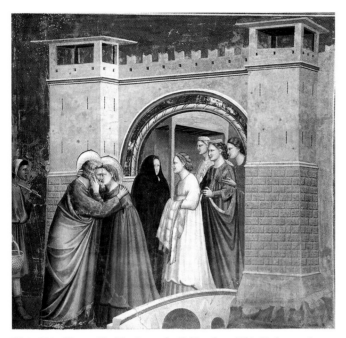

Plate 121 Giotto, *The Meeting at the Golden Gate*, 1304–13, fresco, Arena Chapel, Padua. Photo: Alinari.

interest taken in Giotto's work by subsequent artists, for whom the possibility of advancement came increasingly to depend on the possibility of defending the practice of art, not simply as a skilled trade but as a *cognitive* practice.

Since it is a part of the prejudice of our culture that the scientific and the rational are of a different order from the intuitive and the sensuous, it may be necessary to explain more clearly just what it is that is being claimed here for Giotto. It has been the contention of this essay that the distinctive quality of his work is largely a consequence of his having grasped what painting uniquely could achieve. This potential was associated with the development of appropriate forms of spatial and plastic illusion – that is to say, with the development of naturalistic pictorial spaces that could plausibly be occupied by groups of animated figures. This development was not simply a matter of refining the craft skills of the painter: it required certain forms of knowledge and understanding, and it enabled their further development. In particular, it required knowledge and understanding of patterns of human experience and expression and of the specifically pictorial – as opposed to literary – ways in which these might be represented.

It is the further contention of this essay that Giotto made a distinct advance in painting's ability to show how things look: or rather, not so much to show how *things* look, as to show how *people* look. The advance in question concerns the ability to show how people look *under certain dispositions*. Giotto does not need to *tell* us which is the villain, for instance by using a label or conventional sign. He *shows* the physiognomy of villainy. In the process he stimulates our intuitive sense of the relations between motives and appearances. The study of facial expressions has often been pursued as if it could be conventionalized. (The expression of emotion in the academic art of the eighteenth century was conventionalized in this sense.) Physiognomy was in fact among the medieval sciences

known in Padua. Giotto's tendency is not to systematize character, however. On the contrary, his strategy is rather to trust to the spectator's empirical experience. By inviting us to make significant distinctions between similar forms – between a kiss expressive of affection (in *The Meeting at the Golden Gate*, Plate 121) and a kiss as a form of betrayal (in *The Taking of Christ*, Plate 122) – Giotto enables us to practise skills that remain crucial to the conduct of ethical life: skills of discrimination between forms of falsehood and forms of sincerity, between forms of just action and forms of unjust action, between forms of avarice and forms of charity. Because the means to the discovery of these distinctions are the viewer's sensuous and intuitive responses to what is pictured, it does not follow that we should abandon the idea that what is involved is an advance in knowledge. On the contrary, advances in the power to differentiate are the necessary conditions of significant advances in knowledge.

I do not mean to suggest that we should conceive of Giotto as a kind of scientist. I believe that it is precisely because his skills were *artistic* skills that so much could be achieved by them at the time. However, when we come to consider the complex of conditions that led to the painting of this remarkable decorative scheme in Padua at this particular moment, it would be perverse *not* to bear in mind that Padua under the Commune was associated with other forms of development in learning. There is one further work associated with Giotto's name that may serve to draw together three distinct and relevant strands: the artistic skills associated with that name; the civic and economic character of Padua in the early fourteenth century; and the status of Padua as an ancient university town associated with the development of various branches of learning.

There is a tradition that the upper hall of the Palazzo della Ragione was decorated by Giotto and his school in the early fourteenth century, under the guidance of Pietro d'Abano.

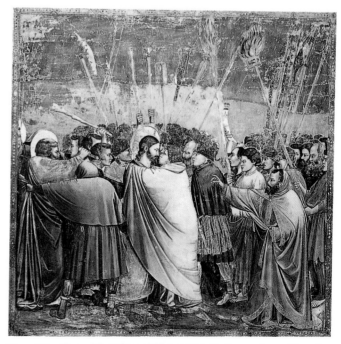

Plate 122 Giotto, *The Taking of Christ*, 1304–13, fresco, Arena Chapel, Padua. Photo: Alinari.

D'Abano was one of the foremost scholars and scientists of the period. He had settled in Padua in about 1306 and was lecturing in Padua on philosophy and medicine at around the time when Giotto was working in the Arena Chapel.[34] As Hills notes: 'Pietro's commentaries, though not strikingly original, contain discussion of colour, light and the geometry of vision.'[35] The great 'ship's keel' roof of the Palazzo della Ragione was destroyed by fire in 1420 and the original decorations were for the most part lost; certainly the walls were largely repainted under an entirely new roof. If parts of the surviving decorations seem still to echo the style of Giotto, any form of attribution to him must be tentative in the extreme. However, it does seem possible that Giotto was employed to supervise the original decorations. These were organized on the theme of the planets and their influences. Although nowadays we would tend to associate such themes with the interests of astrology, and thus of *non*-science, in the medieval sciences astrology and astronomy were not conceptually distinguishable, nor was the study of astrology entirely distinct from the study of medicine, for which Padua was an important centre. I do not mean to conscript Giotto to the medieval sciences, nor indeed to suggest that the cosmology explored on the ceiling of the Palazzo della Ragione was a real alternative to Christian theology for Giotto or for any other artist of his time. The advances in knowledge of the world and of the human that were made in the early fourteenth century were for the most part made within a conceptual framework regulated by religious beliefs. It is notable in this respect that the painted cosmology of the Palazzo della Ragione is organized in its surviving form around figures of saints, while the position of Venus is filled by a Virgin and Child. It is nevertheless a supportable conjecture that the development of a form of 'civic

humanism'[36] in Padua and the circulation of new theories of optics and of the heavens were among the conditions that enabled the religious beliefs in question to be given new forms of expression on the walls of the Arena Chapel.

In conclusion, then, it may be said that the painting of the Arena Chapel was enabled by a specific complex of conditions, for many of which Giotto was certainly not himself responsible. In this sense, the character of the painting in question is informative about the context of its production, and needs to be interpreted with that context very much in mind. On the other hand, it seems also to have been an important condition of the commission that Giotto was given his head as he might not have been had he been working for a different patron or in a different type of location. This condition itself seems to have been enabling of a certain independence from the normal levels of meaning and expression. To return to a question raised at the outset of this essay, it does seem that we may view the decoration of the chapel, in its qualitative aspect at least, as touching upon forms of human experience and as testifying to kinds of human capacity that have remained constant, at least over the limited period that separates us from its execution.

We do not need to trade in universals to allow these frescoes a continuing aesthetic power. We need simply to acknowledge our own tendency – desire even – to respond to high levels of specialist human skills when these are exercised at high levels of intensity. Whatever the moral content of his pictures may be supposed to be, the quality of Giotto's painting serves to remind us – and we need reminding – just how good being human can be made to be. This, perhaps, can be said to be the final factor serving to identify the distinctive character of Giotto's contribution to the decoration of the Arena Chapel.

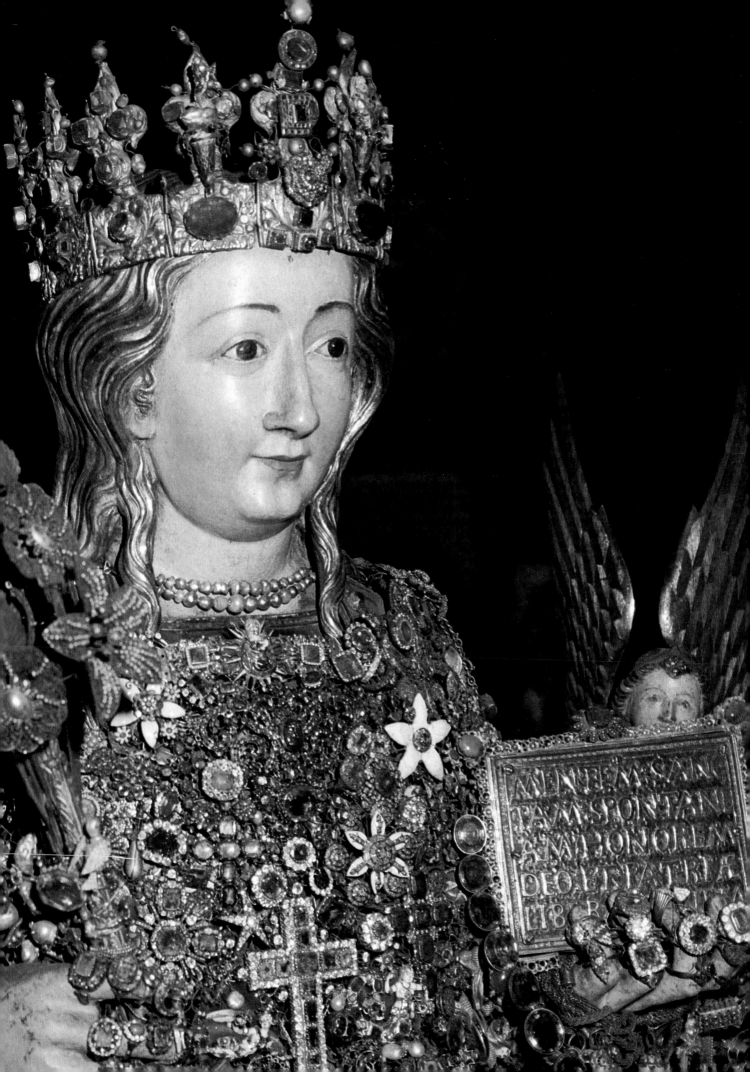

Effigies: human and divine

During the fourteenth century sculptors developed a wider and wider repertoire of realistic techniques to suggest persons and personalities convincingly and to tell stories vividly. There were many determinants of the degree of realistic conventions allowed or encouraged in a sculptural commission, not least the ambitions of and skill acquired by specific masters and their assistants, as well as the wealth of patrons and their taste. However, the way the same artists treated different subjects, often within the same monument, suggests that contemporaries were very sensitive to stylistic decorum. For instance, on the tomb of Cardinal de Bray, Arnolfo di Cambio provided an effigy of the dead man which brings to mind both the solemnity and the pity of the actual cadaver, but when he came to the image of the seated Virgin Mary above, he seems to have turned to the stately abstractions of the ancient Roman pantheon for suitable exemplars (Plate 124). The wealth of patrons was presumably an important element in attracting skilled artists, as we see the Angevin sovereigns of Naples bringing Tino di Camaino from Siena to southern Italy, and the commissioning powers of Roman patrons to bring Arnolfo di Cambio from Florence. Arguably, the taste of different commissioners would have been significant, and can be discussed where one can compare items with the same function ordered from one workshop by different commissioners. Such a comparison is possible, for example, between the tombs of Cardinal Petroni and Gastone della Torre (Archbishop of Milan and Patriarch of Aquileia) by Tino di Camaino (Plates 125, 126). In this case we might assume that Gastone's heirs were less keen on subtly realistic representations than were Petroni's, since the latter effigy is less convincingly carved in terms of the suggestion of real cloth and flesh.

In this essay I shall argue that the stylistic decorum associated with different functions had an important part to play in deciding the degree of realism of a sculpture. For example, the commissioners of the reliquary bust of Saint Zenobius for Florence Duomo in the 1330s had sufficient funds to buy the skills of any artist (the bust is made of silver, gold, enamel and jewels). They could have called on the talents of the sculptors working at the same time on the realistically styled reliefs for the baptistery doors (commissioned by the Arte di Calimala) or for the campanile (commissioned by the Opera del Duomo on behalf of the Arte della Lana). The bust is not documented, though it is inscribed with the artist's name – Andrea Arditi of Florence – and has the arms of the diocese at the base (Plate 127). The taste of the patron(s) probably played a part in determining the sculptural result, but it is likely that the function of the piece was significant too. The bust has a rigidity of expression

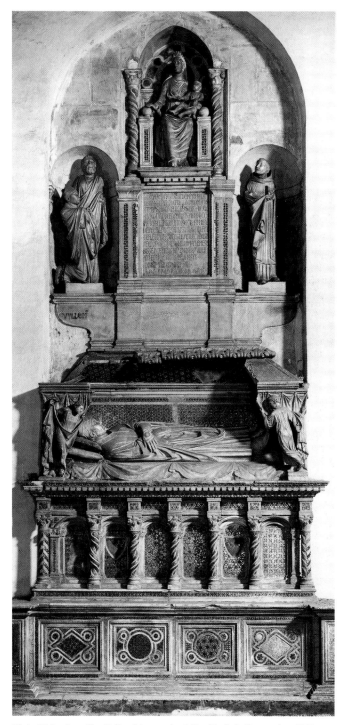

Plate 124 Arnolfo di Cambio, tomb of Cardinal de Bray, after 1282, marble, San Domenico, Orvieto. Photo: Alinari.

Plate 123 (Facing page) Giovanni Bartolo da Siena and his father, detail of bust of Saint Agatha (Plate 149). Photo: Archivio del Capitolo Cattedrale, Catania.

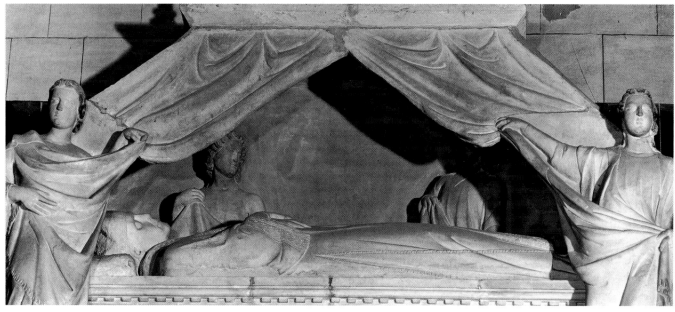

Plate 125 Tino di Camaino, detail of tomb of Cardinal Petroni, *c.*1318, marble, Duomo, Siena. Photo: Tim Benton.

and a harshness of modelling which rebuff viewers expecting verisimilitude or the sense of a sympathetic spiritual presence. The abstract treatment could have functioned to stress the qualities which had lifted the first Bishop of Florence above the ordinary, commonplace people he had converted to Christianity. Or since the silver shell enclosed the head of Zenobius and so much trust was placed in the healing powers of the dead bodies of saints, Andrea Arditi could have set out deliberately to avoid suggesting the illusion of a real person. The danger that the viewer could move from honouring the saint signified in the bust to honouring the bust itself might have counselled caution in employing very realistic techniques. In trying to decide how function could relate to

such stylistic choices, we need to have an idea of what kinds of styles were thought suitable for, say, reliquary busts. Then we could gauge whether the bust of Saint Zenobius is unusual (in which case we could suggest that the *taste* of the patrons was the key determinant), or whether abstraction of some sort was common for the housing of the relics of saints' bodies: in which case we could suggest that Andrea Arditi was asked to obey the conventions of the genre.

In practice, for every commission it seems plausible to suppose that factors like the wealth, power, taste and knowledge of patrons would interweave with the skill, knowledge and ambition of artists, the function of the sculpture being made, and the social and spiritual status of

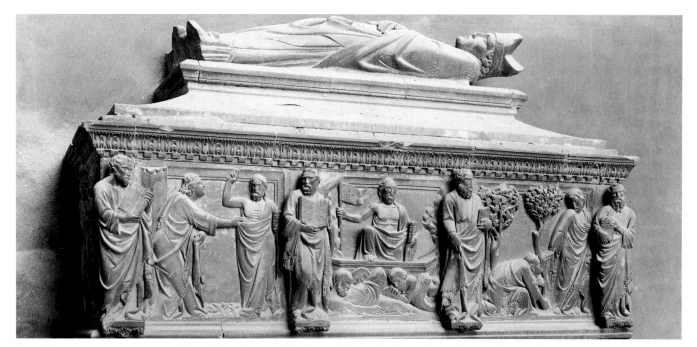

Plate 126 Tino di Camaino, tomb of Archbishop Gastone della Torre, 1321, marble, Santa Croce, Florence. Photo: Alinari.

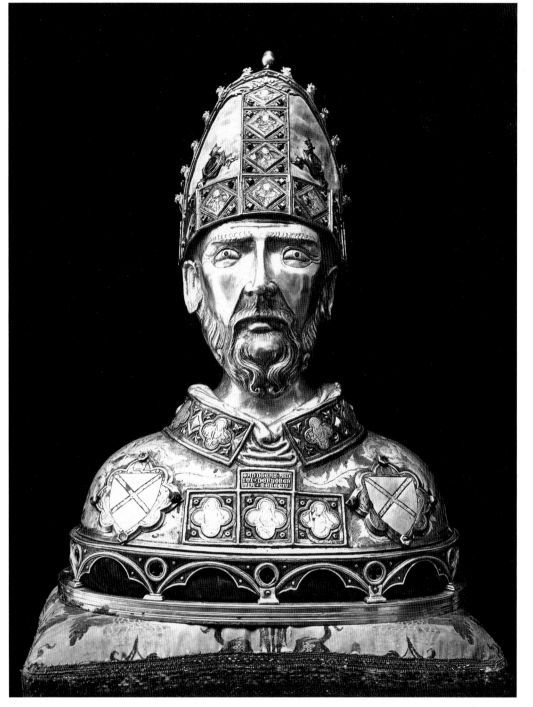

the persons and things being represented. This essay consciously sets out to stress the latter factors by selecting groups of sculptures which represented different sorts of persons: the monuments and tombs of clerics and lay people of various social grades, the casings for the bodies of saints in their *arcae* and reliquaries, and the cult figures of Christ and Mary and other saints which were made to remind worshippers of what they should adore.

Historians considering the development of interest in creating the illusion of reality have tended to make comparisons without much regard for the differing functions of the various images they use for evidence and the status of

the people represented. I hope, here, to draw attention to the relative appropriateness of realistic techniques and their varied meanings. Where we might think of the creation of convincing portraiture as quite commonplace, it seems from the study of portraiture on tombs that only an élite were capable of commanding the privilege of this mode. Within this élite there were differences depending on gender, on class and on whether the subject of the sculpture was clerical or lay. What little we know of the portraiture of women on tombs suggests that warts-and-all realism was less likely to be regarded as suitable for their commemoration. With the statuary of Christ and Mary, it seems that only with the figure

of the tormented Christ were extremely life-like conventions employed to suggest the depths of agony. Representations of the Virgin show her as relatively serene. Even with the housings of relics, images tended to be gendered; the brutal shapes of the human head were considered suitable for the relic of the skull of Saint Zenobius, while sweeter idealizations were created for the cranium of Saint Agatha (cf. Plates 127 and 149).

According to one's place in both the ecclesiastical and the lay hierarchy, one might be accorded a more realistic portrayal or, indeed, be given a tomb or monument with more than one portrait effigy, as well as variable quantities of figurative reliefs narrating the events in one's life or referring to religious beliefs. Realistic motifs to commemorate the dead and represent the tenets of their faith appear in the Italian peninsula first in the commissions to entomb clerics (from the second half of the thirteenth century), not lay persons. This may be something of a surprise given our notions of the modesty and humility of the religious life in contrast to the pomp and vanity of secular life. However, monastic leaders remained self-abnegating by eschewing tombs rich with effigies and reliefs.

Another important distinction to draw is that the convincing representation of a contemporary – even though it might use similar stylistic ploys to realistic effigies of saints and the divine – would be read as having different significance. The effigy of a merchant simply stood for the merchant. With the effigies of divine bodies, contemporaries had to insist that they *only* reminded the viewer of what they should worship; they were never to be worshipped as idols in themselves. Realism in divine images was desirable to incite devotion, but theologians and artists were aware of the danger of idolatry. When artists were asked to make casings for the relics of saints' bodies in the form of effigies of the part of the body they contained, it seems that they and their patrons were probably sensitive about the consequences of making the reliquary look too much like the actual hand or head, say, of the saint. This caution may explain why reliquaries tend to idealize or indicate the body quite abstractly. Since relics were usually considered to have healing powers, the combination of the powerful remains and a very convincingly realistic casing could have created too much temptation for the devout to idolize the image.

In considering these functional differences I have selected for study only sculptures made for commissioners who were from Paduan, Sienese and Florentine territory, or made by artists from the three cities. This necessarily excludes a range of items – in particular, effigies of women. Only two tombs representing women could be considered, one of which is so worn that it hardly counts as evidence.

THE REPRESENTATION OF ORDINARY HUMANS

From the second half of the thirteenth century onwards, first clerical and then lay monuments explored a variety of highly realistic motifs to commemorate the dead and represent the tenets of their faith. The dead lie in effigy upon their bier, or occasionally seated over their tomb.[1] On tombs, angels and deacons were shown drawing the curtains of the tomb chamber,[2] and attention was lavished on suggesting the cloth draping the bier.[3] The clergy and mourners may appear performing the service for the dead,[4] and the dead may kneel to the Virgin, presented for her mercy by their patron saints.[5] Narratives of their lives, or more often of the life of Christ, may decorate the chest.

All but the last two traits are exhibited in the tomb by Arnolfo di Cambio for Cardinal de Bray made soon after 1282 when the cardinal died (Plate 124).[6] The idea of providing an effigy of the corpse was already traditional north of the Alps, and could be regarded as a gothicizing element in this tomb. The motifs of showing the dead man kneeling, to be introduced to the Virgin by his patron saint, were well established in the Italian peninsula but had previously been rendered pictorially, not sculpturally. What seems to have been an Italian invention entirely of this period, however, is the representation of angels or deacons holding the curtains of the tomb chamber. The cardinal is shown in life-like terms, both in his supine body and in his kneeling portrayal above, as are the patron saints of his titular church in Rome, Saint Mark, and of the church in which the tomb was placed, Saint Dominic. Separated from both the cardinal and the saints is the mother of Christ, assumed to be the prime intercessor on the Last Day, and shown here in a classicizing grandeur which seems to abstract formally in order to show her spiritual distinction.[7]

Clerical tombs

During the late thirteenth and the early fourteenth centuries, these formulae (being a mixture of gothicizing style, the traditional indigenous style and sheer local invention) were developed to provide a convention for the clerical tomb which could be elaborated to express the status of the most powerful ecclesiastics, or simplified to denote more modest dignity. The most prestigious variant of this form of wall tomb is to be found in the monument of Guido Tarlati, Lord-Bishop of Arezzo, sculpted by two Sienese artists, Agostino di Giovanni and Agnolo di Ventura, and dated 1330 (Plate 128). Guido Tarlati was accorded all the elements Arnolfo had given to Cardinal de Bray, and on top of these he also had reliefs showing the masses at his funeral and sixteen reliefs narrating his life-story. (It is surmized that among the statues originally on a shelf over the tomb chest were figures of the kneeling bishop and his patron saints.) The tomb seems to have been so lavish with its realistic story-telling in token of the fact that Tarlati was *both* lay and ecclesiastical ruler of Arezzo. Where a cleric was only a church leader – like Archbishop Tabiati of Messina, whose tomb was made soon after 1333 by the Sienese sculptor Goro di Gregorio (Plate 129) – the prestige of realism was not extended so far. Here the effigy of the corpse was placed over not reliefs of the man's biography, but scenes from the life of Christ to express his faith. Examining the tomb of Bishop Tommaso d'Andrea at Casole d'Elsa by Gano da Siena, which was made sometime after 1303 when the bishop died, it seems that clerics who were of more modest status could be given solely a mortuary portrait (Plate 132).

The Tarlati monument was commissioned by Pier Saccone to honour his brother Guido Tarlati, who had been Bishop of Arezzo. The monument was originally in the Cappella del Sacramento of the cathedral, but was damaged in 1341 in

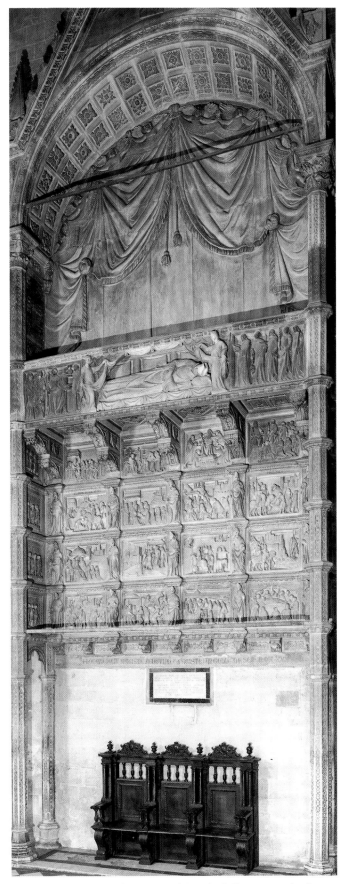

Plate 128 Agostino di Giovanni and Agnolo di Ventura, tomb of Guido Tarlati, Lord-Bishop of Arezzo, 1330, marble, Duomo, Arezzo. Photo: Conway Library, Courtauld Institute of Art.

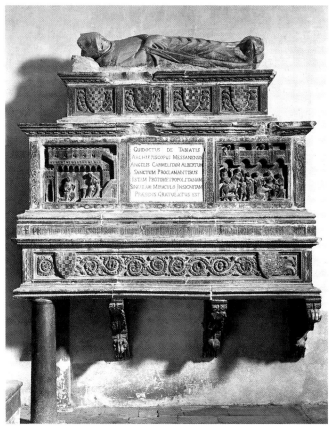

Plate 129 Goro di Gregorio, tomb of Archbishop Guidotto Tabiati, after 1333, marble, Duomo, Messina. (The relief of the Nativity was replaced in the seventeenth century by an inscription.) Photo: Alinari-Brogi.

faction fighting. Bishop Guido had been appointed as Lord of Arezzo in 1312, and it was by virtue of his governmental status conjoined with his episcopal status that events in his life could be considered worthy of memorial (Plates 130, 131). With unremitting emphasis, the statues of fifteen bishops were carved to divide the scenes. Two reliefs employ allegory with images of the Commune as a bearded person enthroned. First we see it assaulted by seven people. But then in the next frame a cleric has joined the Commune on the platform. The bearded person now metes out justice to people who are shown quietly standing by his dais, executing his order (the soldier), kneeling humbly or, indeed, bound for summary execution (Chapter 7, Plates 198, 199). But the other fourteen reliefs employ realistic scenes as if to present the facts of good clerical government to the citizens of Arezzo. We see the bishop consecrated and appointed at Avignon. We see that he has the prestigious role of crowning Ludwig Holy Roman Emperor and his consort Beatrice of Bavaria in the Ambrosiana at Milan. And in between we are shown victory after victory of the battling bishop, as he brings all the cities around Arezzo into dependency. His excommunication in 1325 is ignored, while his corresponding favour with the emperor is stressed through the coronation scene. Working with shallow relief, the sculptors pluck small realistic details to verify their tale: a cluster of wooden siege-towers for the taking of Chiusi, a boat for the capture of Rondine, the ornate dome of the basilica Ambrosiana in Milan to indicate the coronation, the builders bowing to the ground before the

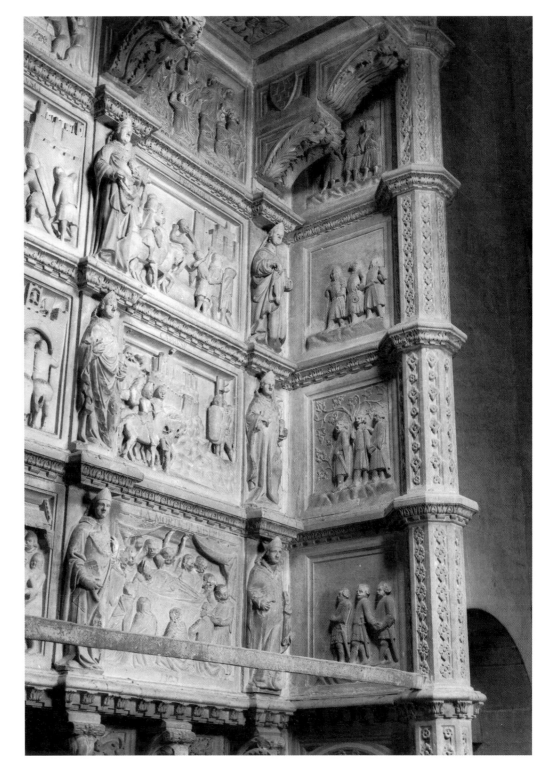

bishop while they are making the walls of Arezzo itself, different walling systems to distinguish each of the conquered cities – all well known to spectators. Although not complete and somewhat repaired (the present heads are stucco repairs), the effect is imposing and comparable only with the tombs of the rulers of Milan, Naples and Verona. At about four metres wide, the tomb probably emulated the vast imperial tomb of Emperor Henry VII at Pisa.[8]

Where an ecclesiastic was commemorated 'merely' as leader of a key diocese, the prestige of realism was not

extended so far. In the funerary monument of Archbishop Guidotto Tabiati in Messina Duomo, we are given a full-length portrait of the dead man lying on his bier in a realistic style (Plate 129). But on the tomb chest we see convincing representations of events from the life of Christ: the Adoration, Annunciation, Flagellation and Crucifixion. This tomb is inscribed by the Sienese sculptor Goro di Gregorio, but the identity of the commissioner is not known. Where the tomb of Tarlati seems to have avoided the personal and partisan signs of family heraldry to emphasize communal

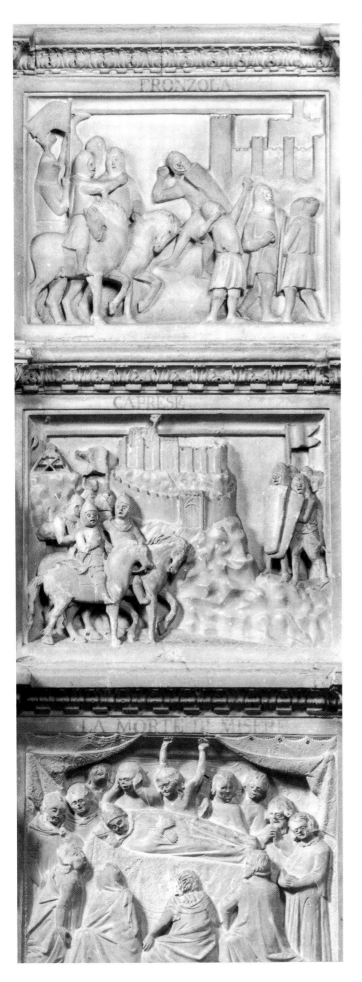

Plate 131 Agostino di Giovanni and Agnolo di Ventura, detail of reliefs showing, from top to bottom, the siege of Fronzola, the siege of Caprese, and the death of Guido, tomb of Guido Tarlati (Plate 128). Photo: Conway Library, Courtauld Institute of Art.

interests, the Tabiati tomb uses the man's shield liberally as an ornamental motif. It seems likely that some sort of canopy was placed over the tomb. However, fire and earthquake have damaged the monument considerably. The sculptor employs great narrative economy carving his figures as if on a shallow stage with little articulation of the back plane. In the Adoration there is room only for three kings (and one horse), three shepherds (and just one sheep dog) and the Virgin. A king swoops down to kneel in a pose which conveys awe. At present, therefore, the praise of the person is balanced by the prominent reliefs showing the articles of the archbishop's faith in convincing terms.[9]

In comparison, a bishop (one rung lower in status than Guidotto Tabiati) merited only a fine and elaborate effigy. The tomb of Bishop Tommaso d'Andrea at Casole d'Elsa, which was inscribed by Gano da Siena, celebrated a bishop in this way (Plate 132). The sepulchre is located in its original position in the cathedral, and shows Tommaso lying on his bier with angels at head and feet. Other angels gather the shroud with which to enfold his body. Between the brackets sustaining the bier, his heraldry has been placed. The inscription recording Gano's work is splendid: 'Gano da Siena carved this excellent work: his hand is worthy of immense praises.'[10] On a scroll held by the bishop, spectators are exhorted to consider their own mortality (Plate 133). A further inscription was placed beneath the bier. This explained that Tommaso had been Bishop of Pistoia and had died in 1303. His two blood brothers (that is, born of the same mother) and presumably his heirs, Domini Jacomo and Andrea, commissioned the monument.

> Here lies a priest of Pistoia, who was a solace of the clerical people, the glory of his forbears, worthy of his family and homeland, and stood on a peak of honesty. Tommaso was a beautiful hero of piety, and a spring flowering with ripe vines of doctrine. He was the blossom of the clergy and the jewel of behaviour. Here he lies, may you wish, Bountiful Father, that he may join you in the heavens. He died when thirteen hundred and three years had passed since the birth of Christ. May he find rest at the blissful end, Venerable Father. Dominus Tommaso, once Bishop of Pistoia, lies here, in whose memory the Lord Jacomo and his co-Lord Andrea, the other sons of his mother, had this monument made. He died July 30 in the said year.[11]

Considering these clerical examples it seems that the more eminent the rank, the greater the physical space they were allowed (in terms of the extent to which the tomb juts from the wall and occupies its surface) and the greater the quantity of both portraiture and convincing narration they achieved. The lord-bishop had the most space and realism in terms of subject-matter, and the archbishop and the cardinal had a little less at their command. The claims made for the bishop were still more modest. This is, surely, partly a question of the more wealthy being able to pay for masters with a great repertoire of realistic skills, but it is also probably a question of social decorum, announcing the dignity of the person entombed.

Plate 132 Gano da Siena, tomb of Bishop Tommaso d'Andrea, after 1303, marble, Duomo, Casole d'Elsa. Photo: Alinari-Brogi.

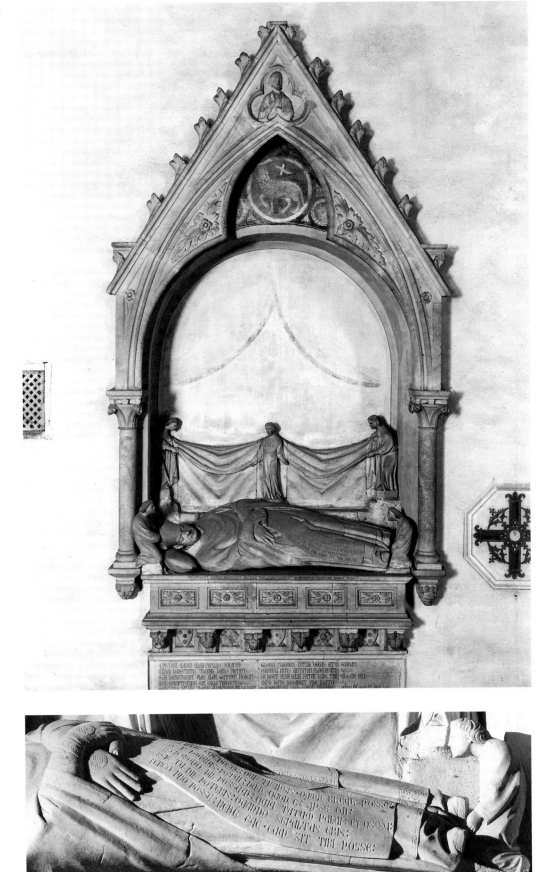

Plate 133 Gano da Siena, detail of effigy, tomb of Bishop Tommaso d'Andrea (Plate 132). Photo: Lensini.

Tombs of secular leaders

The presentation of sculpted effigies of the dead in Italy after antiquity did not reappear until the mid thirteenth century, and was at first confined to the commemoration of clerics. However, patrons of the tombs of secular leaders like Henry VII at Pisa and the rulers of Naples began to emulate these precedents in the fourteenth century. They took over other formulae, too, such as the representation of the suppliant dead person begging the mercy of the Virgin or God the Father, the clergy singing the Mass for the dead over the corpse, and the imagery of fictive drapery in the curtaining of the tomb chamber, the cloths covering the bier, or the enshrouding of the body. Among these lay persons' tombs with effigies of the dead appear a small number of portrayals of individual women. The monument of Mary of Valois, commissioned by her father-in-law King Robert of Naples, idealizes the dead woman, however, and this approach, in strong contrast to the realistic conventions developed for male effigial sculptures, requires some explanation (Plates 134, 135). The abstract, beautifying approach could be argued to denote the woman's noble status as mother of the heir to the throne. However, lay men of the same or higher status – like Henry VII (the Holy Roman Emperor), her husband Charles of Calabria (d.1328) and her father-in-law Robert I (d.1343) – were provided with realistic portrayals of their bodies on the bier. Following the theories of John Berger, arguably what is represented is a gender difference concerning the way – within the codes of realistic representation – women are shown as having a beautiful appearance desirable to the masculine gaze, while men are shown as active possessors of that masculine gaze, whose status has everything to do with not looking attractive.[12] While it seems likely that such conventions of representation would have been mediated by considerations of class, evidence is not available for discussing this question. The only other funerary portrayal of a woman made in Siena, Florence or Padua, or by an artist from the three cities, is that of Bettina, teacher of canon law at Padua, which, as a floor slab, is in such a poor state of preservation that the degree of realism employed for her effigy is indecipherable (Plate 139).

The commissions of tombs for lay persons of lower rank than sovereigns could order funerary effigies represented as supine in a tomb chest, as for example the Paduan merchant banker Enrico Scrovegni (Plate 137) and the Paduan soldier Manno Donati (Plate 138). However, these lower ranks apparently did not aspire to possess figurative carvings of other sorts to adorn their monuments. Lay persons of even more modest rank were commemorated by their executors or heirs with portrayals in shallow reliefs on a floor slab, as in the case of Bettina di Giovanni d'Andrea (mentioned above) and Domenico Torreglia, doctor of law (Plate 140), both of Padua. Both religious and lay persons were commemorated with portrayals on a tomb chest, in a wall monument or on a floor slab (the latter seems to have been favoured on the rather rare occasions when members of religious communities were provided with effigies). However, only commemorations of lay men appear to have developed the representation of the standing effigy sheltered by a niche. For example, we find this form of monument, somewhat

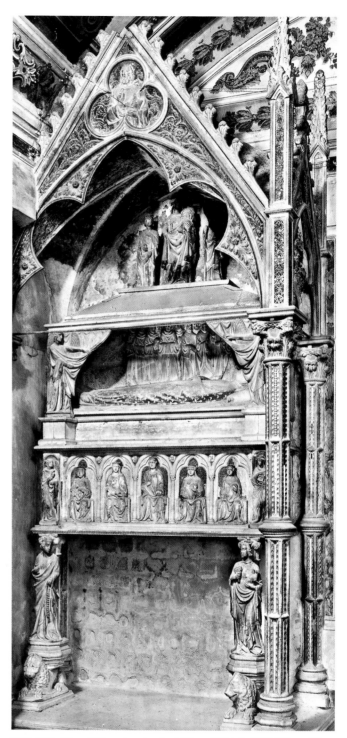

Plate 134 Tino di Camaino, tomb of Mary of Valois, 1331–37, marble, Santa Chiara, Naples. Photo: Alinari.

detached from the site of burial, in the effigy of Enrico Scrovegni at the Arena Chapel (Plate 142), and that of a member of the Porrina family, who was either Lord of Casole d'Elsa or a doctor of law (Plate 141). In the case of the tomb of the Pistoian jurist Cino, however, the standing effigy is placed *on* the funerary chest of the dead man, as if declaiming, and is surrounded by listeners. On the chest below is a relief representing the further teachings of Cino da Pistoia (Plate 143).

Plate 135 Tino di Camaino, detail of effigy, tomb of Mary of Valois (Plate 134). Photo: Bildarchiv Foto Marburg.

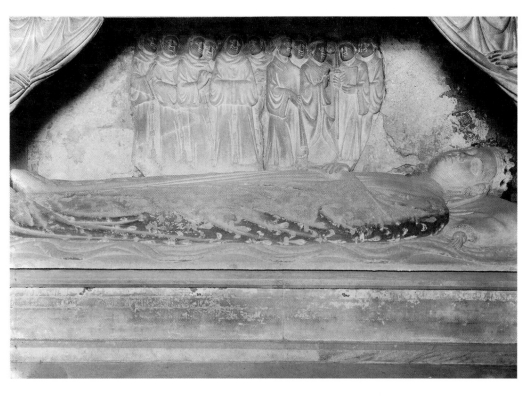

Plate 136 Tino di Camaino, detail of effigy, tomb of Charles of Calabria, 1332–33, marble, Santa Chiara, Naples. Photo: Bildarchiv Foto Marburg.

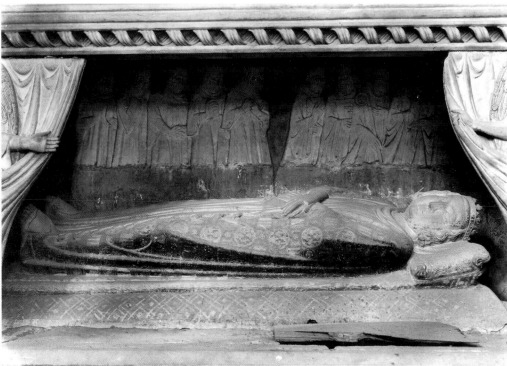

The tomb of Mary of Valois in Naples is an interesting example of the adaptation of this relatively new cluster of conventions for wall tombs to suit a secular ruler and a woman (Plates 134, 135). Commissioned after her death in 1331 and completed in 1337, it was ordered by her father-in-law King Robert of Naples, and situated in the church of Santa Chiara in Naples. Mary was a widow of three years – her husband Charles, Duke of Calabria, having been the sole heir to the kingdom. The tomb was conceived as a wall monument with a gothicizing canopy. The effigy is disclosed by angels backed with a relief of mourning figures of the friars of Santa Chiara, who were paid to sing her funerary masses, and a bishop with his staff who blesses her. On the roof of the mortuary chamber is a group of the Virgin and Child standing. The dead woman is shown kneeling here above her effigy, signifying her hope that on the Last Day, when she would receive her body back, she might seek the mercy of God through the intercession of her patron saints. She is crowned and wears a blue mantle decorated with golden lilies. At the apex of the canopy is a relief of God the

Father blessing. On the front face of the tomb chest are seated figures which appear to represent her live and dead children, and herself in the centre with the globe and sceptre in her hand. On either side are two figures. Each is swathed in a mantle scattered with the heraldic lily. Her son Carlo Martello (who had lived only a week) is probably shown at the extreme left playing with a dog. Beside him is a young woman also with a dog, who has been identified as one of Mary's dead daughters, either Maria or Ludovica. On the right are two more seated young women, but this time with crowns and holding orb and sceptre like their mother. These are probably Joanna (her eldest surviving daughter) and Maria (her other living daughter). On either end are figures of the Virgin and Gabriel to create an annunciation. The chest is supported by two caryatid figures of Charity (with a burning candle) and Faith (with a Lamb of God and a posy of flowers) standing on the backs of lions. Such caryatids seem to be a hallmark of the tomb designs of Tino di Camaino, and were elaborate symbols of the importance of the dead woman. The tomb is in relatively good condition with traces of original pigment. It is conceivable that a third virtue once supported the chest – possibly Hope.[13]

Idealizing features are provided for Mary and her two daughters, and the ages of the dead children at death are ignored to create a symmetrical row of potential monarchs. Mary of Valois died at the age of 22 having sustained five pregnancies since her marriage at 15. Where the Lord-Bishop of Arezzo had had his *curriculum vitae* carved beneath his body, Mary has the equivalent in terms of contemporary expectations of the dynastic job of a married woman – to create heirs for her husband. The presence of the virtues supporting her could have alluded, in addition, to the religious principles which it was expected mothers would teach their children. The sufferings of her brief life – the five births in five years, three baby deaths, the death of a husband and finally her own death in a foreign court, having failed to provide a male heir to the throne – are veiled and masked by her serene features. Mary's tomb underlines the view that in

some respects the status conferred by class intersected with that of gender. Arguably a woman would be commemorated in ways which presented her as desirable to the masculine gaze – through codes of idealization – whereas a man could be shown as individual arbiter and owner of the gaze – through conventions of 'warts and all' realistic portraiture.

We can compare this tomb with that of Mary's husband Charles of Calabria in the same church (Plate 136). This was executed by Tino di Camaino between 1332 and 1333. The components are similar in terms of the beliefs expressed in the importance of intercession before the judgement of God. However, there are differences. Unlike the idealized image of his wife, the young heir-apparent is shown with an effigy displaying a double chin and pendulous cheeks. The tomb chest is also supported by the virtues, but for the tomb of a potential head of state and leader in war, the more active Christian virtues of Temperance, Fortitude, Justice and Prudence are the preferred ones – not the contemplative ones chosen for his wife. On the tomb chest are reliefs, but they do not show Charles's children and his consort. Rather, they show him enthroned as the King of Naples he would have been, ranged about with his counsellors doing him homage. While later the Queen of Naples, their daughter Joanna I, did commission a tomb for King Robert which showed him with his family (Chapter 11, Plate 303), the issue here is how husband and wife were shown in a pair of tombs in the same church.

Tombs of merchants, soldiers and lawyers

On a social level below that of the leading nobility, a merchant banker or a successful soldier could be considered worthy of a wall tomb with a realistic effigy. Enrico Scrovegni in the Arena Chapel was provided with a tomb which shows his corpse on the bier with the conventional motif of angels drawing the curtains round his deathbed, and his heraldry and a shield with a cross perhaps denoting his allegiance to the Commune of Padua (Plate 137). Although Enrico died in

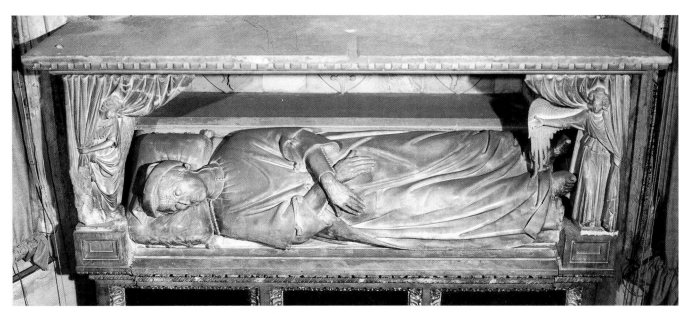

Plate 137 Detail of effigy, tomb of Enrico Scrovegni, after 1336, marble, Arena Chapel, Padua. Reproduced by courtesy of Musei Civici Padova, Gabinetto Fotografico.

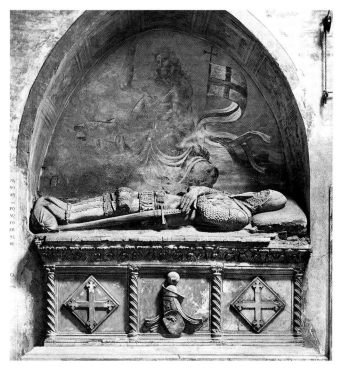

Plate 138 Anonymous, tomb of Manno Donati, *c.*1370, marble, cloister, Sant'Antonio, Padua. Photo: Alinari.

1336, the tomb was quite probably conceived when the chapel was built and painted (1304–13), since it is placed on the wall behind the altar. In this position he could harness the imagery of the charitable Madonna now placed on the altar below. On either side of the tomb the presbytery decoration was turned into a large funerary ensemble: the annunciation promising the possibility of salvation through Christ's birth, while the Madonna's intercession was hoped for by the dead banker. Enrico, therefore, could afford in terms of both finance and what was felt socially appropriate to have himself portrayed as if in a mortuary chamber of the sort we have seen normally claimed by prominent rulers and clerics. Perhaps it is relevant to note that in 1301 the republic of Venice had ennobled him.

It could also be considered decorous to memorialize a soldier with a realistic effigy. Tombs of this type do not survive in Siena or Florence, as if to stress their more communal traditions. In Padua, however, there are some extant, including the tomb of Manno Donati in Sant'Antonio representing the soldier on his tomb in full armour (Plate 138).[14] The tomb was inserted in the wall of the access corridor between the cloister of the noviates and the cloister of the chapter-house, sheltered with an arched canopy. Manno was a Florentine fighting in the service of Florence and the Carrara family who ruled Padua, where he died in 1370; like Enrico Scrovegni, his executors stressed his allegiance to Padua with the communal shield placed on his tomb bracketing his own heraldry. This soldier obtained the kind of space and the degree of realism we have seen permitted otherwise to the Bishop of Pistoia, Tommaso d'Andrea. Other Paduan soldiers like Raimondino Lupi and Lavellongo had lavish sepulchres at Sant'Antonio with multiple effigies (the Oratory of San Giorgio for the Lupi family and in the case of Lavellongo a tomb chest adorned with figures of mourners).

This military presence in monuments relates to the seigneurial structure of society in Padua, as opposed to Florence and Siena. To get monuments like this there needed to have been an aristocracy whose male members were eligible for knighting, or a *condottiere* (leader of mercenaries) like Sir John Hawkwood, whom the Florentines considered commemorating in the 1390s.

Floor tombs were considered suitable for persons of lesser social status who none the less were thought worthy of commemorating with a full-size effigy. The floor slab covered the inhumed corpse, but possessed less prestige than the sarcophagus with its protective canopy. People could walk round it looking down to read the inscription traced on the edge, and they could walk over it too. Such damage has rendered it impossible to judge the degree of realism provided by the carvers for the effigies of Bettina di Giovanni d'Andrea and the lawyer Torreglia, who were both given floor slab tombs in the mid fourteenth century at Sant'Antonio in Padua (Plates 139, 140). The effigies are probably shown in the dress denoting their status as jurists: Bettina was a teacher in the University of Padua assisting her husband Giovanni di Sangiorgio, who was a doctor of canon law from 1347, and Domenico Torreglia was also apparently a doctor of law. Domenico died in 1350 and Bettina in 1370.[15] Both tombs were placed on the paving of the cloister of the chapter-house. Bettina was well known as a learned woman who had been taught canon law along with her sister Novella by their father, who was a professor of jurisprudence at Bologna. The history of the University of Padua relates that she often changed places with her husband (who held the official teaching post) to lecture in Latin on the law. Her family arms and those of her husband are placed on either side of her. The shield on the right is inscribed HUNC GENITA: 'here as she was born', while that on the left is inscribed HIC NUPTA: 'here as she was married'. Rather than being veiled as a matron, she seems to wear a variant on the lawyer's head gear. The inscription relates the status of her father and husband and gives the day of her death: Monday, 5 October 1370. The epitaph of Domenico is equally succinct, except that it only relates the status of his father; his relationship to his spouse was not regarded as relevant. In order to maintain a relatively steady surface to walk on, the effigies were flattened.

For men only, there developed a potentially very animated and dramatic form of commemoration showing the man standing in the shelter of a niche. Some of these monuments seem to be cenotaphs. For instance, the monument of a member of the del Porrina family at Casole d'Elsa took this form (Plate 141). Apparently alive and well, the man stands under a tall, narrow canopy, on a podium as if to make a speech, with his heraldry over his head. The niche for the monument resembles the biforate windows on the *piano nobile* (residential first floor) of the civic palace, at which we could imagine him standing to harangue the citizens. While there is a prophet and probably an apostle at his feet, the imagery seems secular in comparison with many tombs. Indeed the man has a book in his right hand, and his sword is strapped to his left side. This monument was taken in 1939 from the chapel of the Porrina family adjacent to the cathedral – where

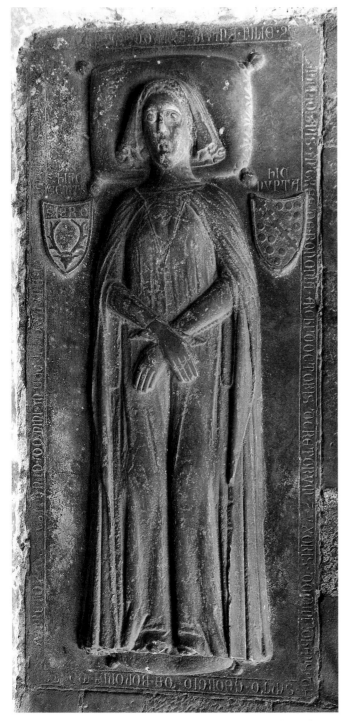

Plate 139 Anonymous, tomb of Bettina di Giovanni d'Andrea, after 1370, marble, cloister, Sant'Antonio, Padua. Reproduced by courtesy of Musei Civici Padova, Gabinetto Fotografico.

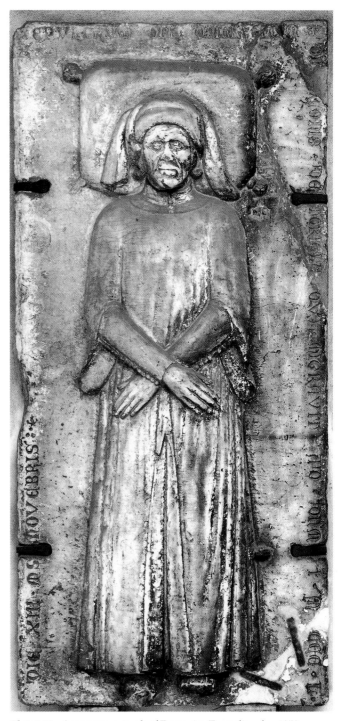

Plate 140 Anonymous, tomb of Domenico Torreglia, after 1350, marble, cloister, Sant'Antonio, Padua. Photo: Barbara Piovan.

it now is – and presumably the body of the dead man was interred beneath the pavement of this chapel. A votive fresco of the Virgin Mary in majesty survives from this chapel with kneeling portraits of two members of the Porrina family, who were prominent Sienese nobles. This was painted during the first two decades of the fourteenth century. On the right a kneeling bishop, protected by the patron of the town, Saint Donatus, is inscribed DOMINUS RAINERIUS EPISCOPUS. On the left is a layman protected by Saint Michael and

inscribed DOMINUS PORRINA. It is not clear whether the statue commemorated this del Porrina, who was the bishop's brother and a doctor of law and Papal Advocate, or the jurist's son – who was Lord of Casole d'Elsa but exiled to Pisa in 1317, and subsequently Podestà of Fabriano (1323) and Todi (1325). It seems likely that the statue represents the Papal Advocate (who died in 1313) and that the funerary chapel was conceived by the two brothers (his brother the bishop died in 1317). The sword would signify his secular status while the

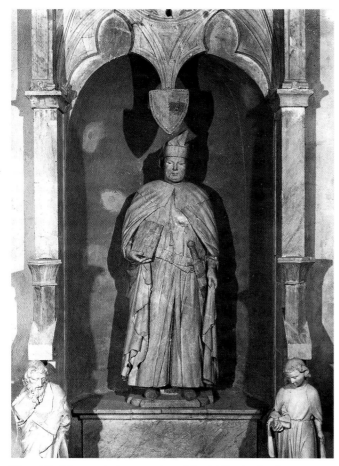

Plate 141 Monument for a member of the del Porrina family, *c.*1300–20, marble, Duomo, Casole d'Elsa. Photo: Lensini.

book would prove his learning. The lack of spiritual affirmation on the monument itself could be explained if it had been created to accompany the votive fresco. Unlike the tombs with a supine effigy (with their thirteenth-century clerical precedents), the genealogy of the monument with a standing image of the dead, in the manner of a saint or prophet standing in a niche, is uncertain.[16]

Related to this new mode of commemoration is a life-size standing effigy of a member of the Scrovegni family – probably the chapel's founder, the banker Enrico Scrovegni – at present placed in the sacristy of the Arena Chapel in Padua (Plate 142). Since this is undocumented, we can only surmise that it could have been located here or on the façade of the chapel to record Enrico's patronage of the building which he had had frescoed about 1305 with murals attributed to Giotto. It is likely that the carving was made when the main building and painting took place, and when Enrico probably commissioned a group of statuary for the altar possibly from the Pisan sculptor Giovanni Pisano. The effigy gives the impression of showing the devout man truthfully, dressed in a tight-sleeved gown with an ermine-tailed cape. The merchant is represented as having a sharp profile and hands rigidly pressed together in a vertical of prayer. His shield is above his head, and the whole is framed by a niche consisting of two spiral fluted semi-columns supporting a gothic trilobate arch and gabled frontispiece. (The effigy could be compared with the portrait of Scrovegni on the chapel's fresco

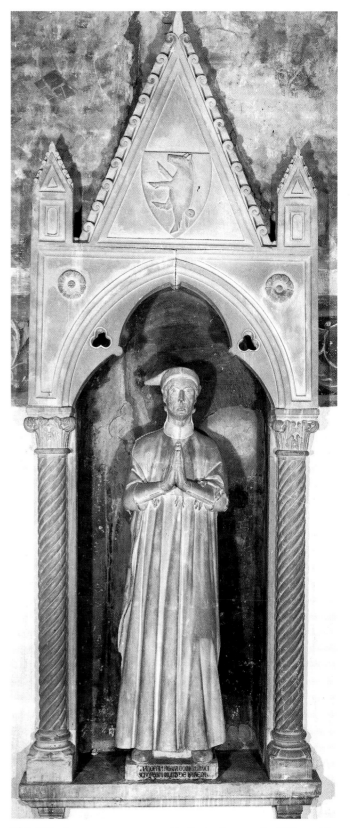

Plate 142 Anonymous, monument to Enrico Scrovegni, *c.*1305, marble, sacristy, Arena Chapel, Padua. Reproduced by courtesy of Musei Civici Padova, Gabinetto Fotografico.

of the Last Judgement – Chapter 4, Plate 104.)

Around 1337 the sepulchre of the doctor of law Cino da Pistoia was made by a local artist, Cellino di Nese, and an

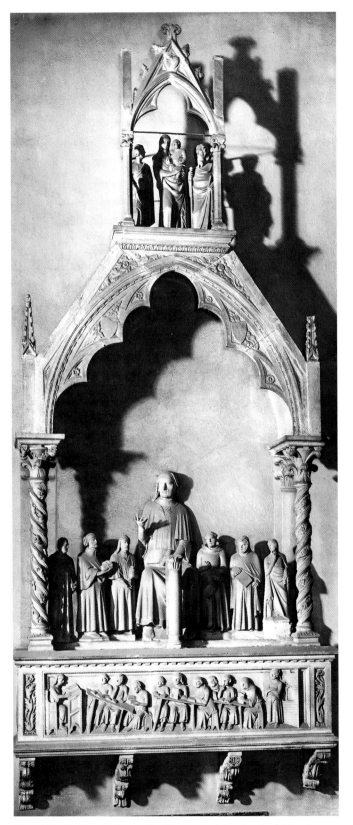

Plate 143 Cellino di Nese and a Sienese sculptor, tomb of Cino da Pistoia, *c*.1337, marble, Duomo, Pistoia. Photo: Alinari.

tomb chest is at the base, adorned with a relief demonstrating his prowess as a teacher, and the fame of this son of Pistoia is praised with a tableau surrounding the lawyer listening to his words. The deceased is shown in the act of speaking seated before a short column, perhaps suggesting his lectern. To represent his pre-eminence he is seen as more than twice their size. One figure of a woman with a book to the far right is smaller than the others. It seems likely that she is a Virgin Mary from an original annunciation group placed perhaps on the tops of the pilasters of the frame on either side of the arched canopy. At the apex of the canopy is the deceased kneeling with two patron saints beside the standing Virgin and Child. Here *he* is seen as of much smaller stature than his holy sponsors. On the plinth is a relief showing the master as if teaching pupils, who are seated at three sloping desks with their books. Where the teacher has a seat with arms and a back and an ornamented separate desk, the pupils only have stools and plain tables.

Cino was born in Pistoia in 1270 and died there in 1336. He was called Guittone, and then Guittoncino, of the Sinibuldi family, which was later shortened to Cino as his fame and citation increased. Trained at the University of Bologna, he was appointed as a judge by his home city in 1307. Exiled, he travelled in France and Lombardy, and composed his 'Commentary on the Codex' by 1316. This rapidly became the authoritative treatise on the civil law. Perhaps the tableau over his tomb chest portrays petitioners – some carrying little packages of codices or single scrolls – asking his opinion on legal matters. He then had a prestigious career teaching law at Treviso, Siena, Perugia and Florence between 1318 and 1332, returning to be buried in the cathedral of his home town. Although he was a renowned poet, it was his teaching which was celebrated on his sarcophagus. A 'memorial' survives by Charlini and Schiatta dated 1337 to the effect that they had agreed that 'Master Cellino who is working at San Giovanni Rotondo will complete a tomb of Sienese marble for the beautiful and magnificent tomb of Cino, according to a drawing that the same has given us which was made by Master [X] of Siena'.[17] Although the name of the Sienese master is illegible, we know that the monument was produced by co-operation between Sienese and local expertise. Charlini and Schiatta were relations of Cino mentioned in his will, perhaps acting for the widow Margareta. On the cusped gothic arch forming the canopy of this tomb chest were placed the arms of Cino.[18]

This is the first instance we have considered where the career of a dead layman is celebrated. But while the tomb of the Lord of Arezzo, Bishop Tarlati, had specified a long sequence of events, the three surviving scenes on the Cino tomb are abbreviated, indicating his pious hopes of heaven, his authority on matters of law and his career as a teacher. Care is taken to differentiate the personalities of the pupils one from another and the listeners or petitioners. An arresting declamatory gesture is provided by the sculptors for the craggy-faced lawyer. While idealization is employed for the Annunciate Virgin and the Virgin and Child, realistic conventions are brought into play to identify his protecting patron saints, the earnest but easily distracted learners in the classroom, and men bringing various thorny points of law to the master. We should note that the 'pupils' in the classroom

unnamed Sienese sculptor, and placed in the Duomo at Pistoia. Like the monuments to Enrico Scrovegni and the man of the del Porrina family, it shows this famous jurist alive and animated in a niche (Plate 143). However, in this case the

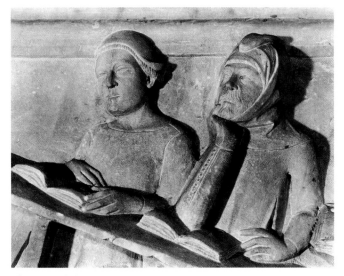

Plate 144 Cellino di Nese and a Sienese sculptor, detail of tomb chest relief, tomb of Cino da Pistoia (Plate 143). Photo: Laboratorio Fotografico, Universita degli Studi di Pisa, Dipartimento di Storia delle Arti.

include young and old (there is a bearded man seated next to a youth – Plate 144), as if to tell us that the brilliant Cino forced experienced jurists back into the classroom. Reliefs showing the teacher in the classroom appeared on the tombs of lawyers in Siena and especially Bologna, but without the wide age range and with supine effigies of the dead lying on the tomb chest.

THE TOMBS AND RELICS OF SAINTS

For the entombment of the body of a saint a large amount of physical space was considered proper, and figurative skills would be appropriate to recount his or her life. The tomb would be the focus of local or general pilgrimage, and the relics of this saint were normally expected to possess the power to enable healing through the saint's intercession before God. Reliquaries sheltering parts of the bodies of saints fulfilled functions quite similar to that of *arcae*. However, they were portable so that they could be displayed on set occasions – at an altar or from a pulpit – and carried in procession. Most used precious metals and gems to show the value of the relic, though some did employ cheap materials like wood or leather. In some cases, the shape of the reliquary stated in a summary way the nature of the relic within: moulding a hand or a head to signify the body enclosed. In other cases, the reliquary took over architectural motifs, displaying the fragments of the body in miniature tabernacles sealed with glass. Like ordinary tombs and *arcae*, reliquaries had lids or doors in them for reaching the substances enclosed. Sometimes, as with *arcae* or the tombs of the greatest rulers, reliefs represented the legend of the saint. Reliquaries tended to refer to the human form in idealizing or abstract terms, possibly to guard against the viewer honouring the image enclosing the relic rather than the fragments of the specially distinguished person within.

In 1324 Goro di Gregorio created the tomb of Saint Cerbonius, patron saint of the Duomo of Massa Marittima (then a Pisan dependency), presumably commissioned by the cathedral chapter itself (Plate 145). On the cornice of this tomb is a dedicatory inscription: 'In 1324, in the seventh interdict, Master Peruzzi clerk of works of the church had the work done by Master Goro di Gregorio of Siena.'[19] It is now situated behind the high altar. Possibly a stone canopy was placed over the casket. It is important to note that the body of Saint Cerbonius was given the special distinction of being placed in a free-standing full-size sarcophagus, whereas all the other monuments we have considered so far were

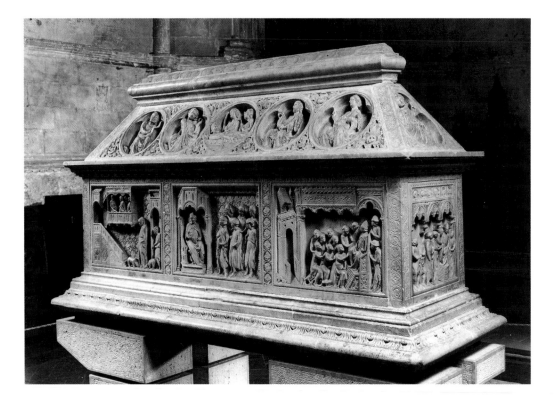

Plate 145 Goro di Gregorio, *arca* of Saint Cerbonius, 1324, marble and polychromy, Duomo, Massa Marittima. Photo: Lensini.

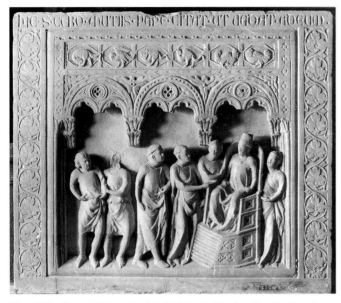

Plate 146 Goro di Gregorio, detail of short side showing the Pope's ambassadors requesting the saint to go to Rome, *arca* of Saint Cerbonius (Plate 145). Photo: Lensini.

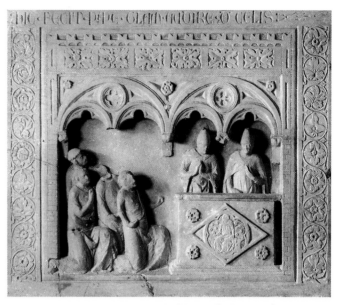

Plate 148 Goro di Gregorio, detail of short side showing the Pope's joint Mass with Cerbonius, *arca* of Saint Cerbonius (Plate 145). Photo: Lensini.

attached to the wall or sunk into the floor. This was customary to enable people to progress round the tomb to venerate the relic of the body within. Considering the angling of the reliefs in the trilobate fields on the gabled lid (which show the Madonna and Child, several saints and prophets, a bishop, and the death of Saint Cerbonius mourned by angels), it is likely that the chest was placed quite low down. Because the bodies of saints were usually credited with healing powers, pilgrims wished to get relatively close to the revered corpse. The *arca* of Saint Cerbonius told his life-story in reliefs placed on the sides of the casket (Plates 145–148).[20] He had come from Africa to bring Christianity to the diocese of Populonia, whose cathedral in the sixth century had been on the coast at Piombino. After the destruction of this city, the bishopric had been moved to Massa Marittima.

To read the saint's story, the viewer begins facing one of the long sides scanning left to right. The first scene shows him thrown to the bears by the barbarian leader Totila, because he had sheltered Christian soldiers fighting the invader of Italy (Plate 145). The story was told by Pope Gregory the Great in his dialogues:

Out of its den was the beast let loose, and in a great fury and haste set upon the Bishop: but suddenly, forgetting all cruelty, with bowed neck and humbled head, it began to lick his feet: to give them all to understand that men carried towards the man of God the hearts of beasts, and the beasts, as it were, the heart of man.[21]

Goro di Gregorio had to convey this dramatic scene with the minimum of actors and scenery. Totila looks down from a balcony, and the watching crowd is signified by two spectators. The next scene shows Saint Cerbonius confronting a recalcitrant congregation in the diocese of Populonia where he had been appointed bishop. He is seated *in cathedra* insisting on saying Mass before dawn, despite the pleas by the group of men for postponement. In the next episode the congregation, furious at his refusal, set off to report him to the Pope in Rome. The story continued on the following short side, representing the ambassadors from the Pope reaching Populonia and requesting the saint to go to Rome (Plate 146). Latin captions along the cornice explain the import of each scene. Bass relief was selected so that virtually free-standing figures mime the events on shallow stages.

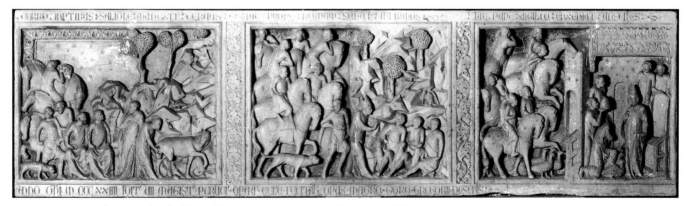

Plate 147 Goro di Gregorio, detail of long side showing the journey to Rome, *arca* of Saint Cerbonius (Plate 145). Photo: Lensini.

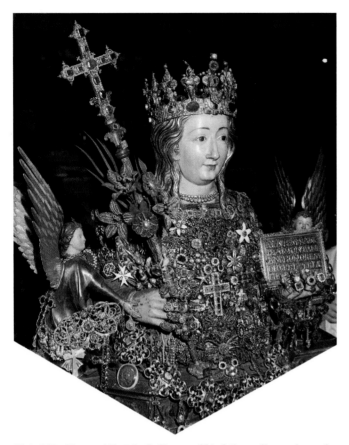

Plate 149 Giovanni Bartolo da Siena and his father, reliquary bust of Saint Agatha, 1376, silver gilt, paint, enamel and jewels, Duomo, Catania. Photo: Archivio del Capitolo Cattedrale, Catania.

The story of the journey to Rome is told along the second long side (Plate 147). In the first relief we find two moments of time suggested, whereas in the previous frames single events were conveyed. According to the legend, the ambassadors had refused to celebrate Mass, and consequently became violently thirsty as they trudged through a waterless terrain. On the right we find the saint milking some does, and the figure beside him is the bishop again, only this time turning to give the bowl of milk to his guards. The central relief displays the bishop healing three travellers, with his horse standing patiently behind him. Beneath this scene Goro di Gregorio placed his own name. Finally the saint is shown at the walls of Rome, where he finds some geese which he decides to present as a gift to the Pope. To the right the travellers are ushered into the presence of the Pope. Pope Vigilius was, according to the legend, so astounded at the saintly innocence of Cerbonius that he rose from his seat in greeting, and the sculptor was asked to show this mark of favour traditionally given to succeeding Bishops of Populonia. The final relief is on the following short side of the *arca* (Plate 148). It shows the Pope's approval of the bishop and consequent decision to say Mass jointly with him. According to the legend, Saint Cerbonius suddenly trod hard on the Pope's right foot during this Mass and, looking up, the Pope was able to share his vision of heaven.

The sculptor was being asked to create images without a dense tradition to work within, and being given quite small fields in which to narrate them. As with the reliefs on the

Tarlati tomb, only a handful of figures, props and bits of scenery are allowed. Our understanding of the story must be cued by the most thoughtful selection of a few convincing – and here often amusing – details. So, in the relief showing the ambassadors summoning Cerbonius, the great chair becomes a potent symbol of the bishop's status (Plate 146). In the healing scene, a rider leans forward on his horse's neck as if in tiredness (Plate 147). In the scene of the joint Mass, we really can imagine that the bishop has just trodden hard on the Pope's toe (Plate 148). On our left Vigilius is staring down at his hurt foot, while on our right Cerbonius is gazing at the vision, suggested for the viewer by the shallow relief on the altar frontal of the Redeemer seated on the tomb showing the stigmata and surrounded by flowers. The story really ends on the roof of the *arca* in the relief showing the entombment of the saint, bringing us back to the fact that his body has been re-interred in this chest. This is a magnificent piece telling a story which stresses the proper control of Pope and diocese over congregation and emphasizing papal approval of Cerbonius. While the Pope remained away from Rome, it perhaps recalled better days when the power of Pope Vigilius had been firmly situated at Rome.

Because of the spiritual significance of sculpting the containers of saints' relics, artists and their commissioners seem to have preferred an abstract or idealized approach, as shown in two reliquary busts by Sienese craftsmen and in a reliquary from the sacristy of the Duomo in Padua. The reliquary of Saint Agatha for the Duomo of Catania was made by Giovanni Bartolo da Siena and his father, and is a full-size bust of silver gilt with enamelled plaques (Plates 123, 149). The bust was made in 1376. The skin has been treated so that it is pigmented in flesh colour. The angels on either side present her to the viewer; one holds a plaque inscribed with a statement carved on her tomb to do with the legend of her powers to save the city of Catania from fire. Around the original base, on which are placed enamelled coats of arms, is the inscription stating the date and Giovanni's authorship.[22] These enamels represent the lives of Saints Agatha, Catherine and Lucy, and also the patrons who were Bishops of Catania. Giovanni worked at Avignon for Urban V and Gregory XI, and it seems that he was commissioned to make the bust while he was at Avignon. Bishops Marziale and Elia of Catania were both Frenchmen from Limoges; Marziale was bishop from 1357 to his death at Avignon in 1376, where he had been sent by the King of Sicily, Frederick III, to Gregory XI to announce Frederick's succession to the throne. The new bishop, Elia, travelled back from France to his diocese with the reliquary bust in 1377 – hence the appearance of enamels on the base portraying both commissioners kneeling. The bust represents Agatha as serenely confident and lovely. Rather than indicating the saint's torment, the representation realizes her beatification.

In comparison, the reliquary bust of Saint Fina of San Gimignano is modestly made of painted and gilded wood (Plate 150). Yet it also employs an idealizing style of representing the young saint, who had spent most of her life on her sick bed. The life-size reliquary bust offers us instead a plump, smiling young woman with flushed cheeks, brown eyes and curling golden hair. As so often with representations of female saints and the Virgin Mary, the artists provide fair

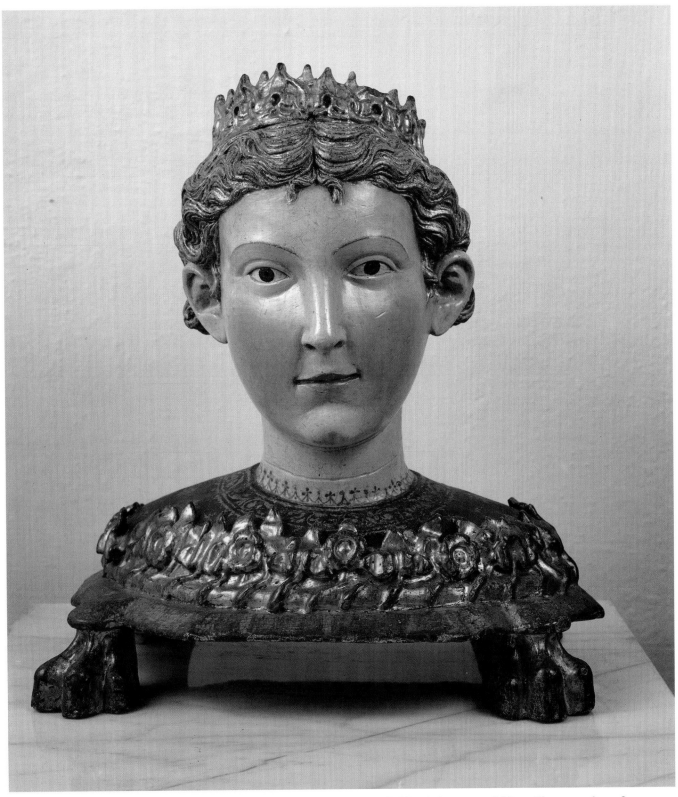

Plate 150 Attributed to Mariano d'Agnolo Romanelli, reliquary of Saint Fina, *c.*1380–90, polychrome wood, Museo Diocesano e Sacro, San Gimignano. Photo: Lensini.

hair. Only the dimpled chin, prominent ears and the way the gaze is angled downwards hint at a specific personality. The saint has a blue dress with golden stars on it, and the bust is supported by lions' paws. These carry a wreath of flowers, possibly referring to the legend of the golden flowers appearing miraculously on Fina's bed. The bust is not inscribed, and there is no information about its provenance or patronage. Bagnoli argues on convincing stylistic grounds that it may be the work of the Sienese wood-carver Mariano d'Agnolo Romanelli and probably dates from the late fourteenth century. The crown provides a convenient lid, closing the cavity in the head for a relic of the saint. On the

of Saint Andrew already recorded in the 1405 inventory and commissioned by Nicolò da Vigonza, canon of the cathedral, along with his brother Jacopo and, probably, his brother Corrado (Plate 151). It is of silver gilt, enamel, glass and coral and in a perfect state of preservation.[24] The reliquary creates a small airy building raised on a tall support to show off the fragments of the apostle. The heavy base is adorned with rosettes on five of its six lobes and has the arms of the donors on the other. Two large bosses punctuate the stem – presumably to give purchase for lifting this top-heavy object. The lower boss is faceted with six lozenges and adorned with stars and the letters 'A' and 'V'. The upper boss is a hexagonal tabernacle with elaborate pointed arches, pinnacles and its own tiny cupola. Its sides are decorated with the initials of the patrons – 'N', 'C' and 'I' (that is, 'Iacopo') – alternating with their arms in enamel. Resting on its roof, the goldsmiths have imagined a foliate support to carry the large hexagonal shrine holding the bones. The dome of this shrine is closed with a further hexagonal 'lantern', and the whole is topped with a piece of coral. In crystal, enamel, gold, silver and coral, the reliquary provides imaginative architecture to signify the power of the bones of the apostle for the believer.

STATUES OF CHRIST AND HIS MOTHER: THE REPRESENTATION OF THE DIVINE

Sometimes life-size images of Christ, his mother and the saints were made to remind spectators of the holy figures they should venerate. Rather than enclosing the actual body to be adored (like the *arca* or reliquary) or signifying an ordinary human body (the statesman or bishop), these sculptures are material 'similitudes' – to use the word of the Sienese sculptor Lando di Pietro – of holy persons one should adore. It was believed that Christ had left no corporeal remains at his ascension to heaven. Further, some held that the Virgin Mary at her assumption had also been raised up to heaven entirely. The devout could only revere supposed fragments of the cross, the shroud or the nails, painted images of Christ and his mother reputedly made by Saint Luke the Evangelist, or things supposed to belong to the Virgin Mary like her house, bed or girdle.

In splitting open the life-size painted crucifix made by Lando di Pietro, the bombing in 1944 of the Osservanza, Siena provided important evidence as to the attitude of a carver when giving shape to the body of the Saviour (Plate 152). The provenance of the statue was a confraternity in whose church – San Domenico a Camporegio – the sculptor was buried in 1340. Perhaps this confraternity (which was dedicated to Saint Dominic) commissioned the figure from their fellow artist or perhaps, even, he donated it. Only the head, one knee and the left arm survive. The fragments of the statue display profound realism in modelling a face as if drawn down with pain, the eyes closed. The hair is carved and painted in a way suggesting dirt and sweat, and the large size of the nose implies the pathos of a specific person rendered helpless by suffering. Complete statues of this sort survive which indicate the tug at the viewer's heartstrings that Lando was making (Plates 153, 154).[25] To achieve the subtlety of facial expression and the complexity of figural pose, Lando used joints, parchment and glue to assemble partially carved out

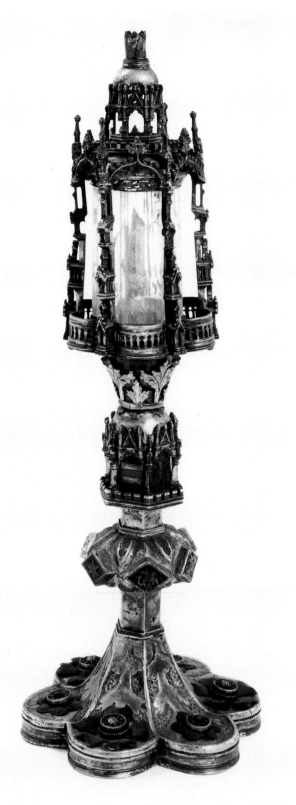

Plate 151 Anonymous, reliquary of Saint Andrew, before 1405, silver gilt, enamel, crystal and coral, Sagrestia dei Canonici, Duomo, Padua. Photo: Barbara Piovan.

inner side of this lid is the head of a seraphim with a golden aureole and a red face.[23]

Most small relics were housed not in cases imitating the shape of the saint's body, but in elaborate abstract vessels. For instance, in the sacristy of the Duomo in Padua is a reliquary

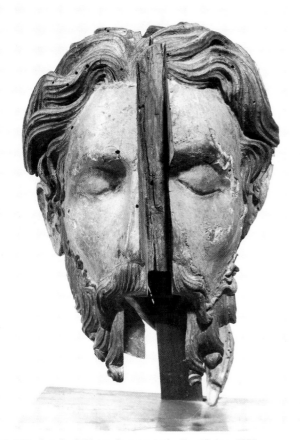

Plate 152 Lando di Pietro, fragment of a Crucifixion, 1338, polychrome wood, Osservanza, Siena. Photo: Lensini.

elements, and he gessoed and painted the completed effigy. Inside the head the sculptor placed two inscriptions written on parchment and dated January 1337 (modern date 1338).[26] His intentions in creating this arresting image are stated in the inscription:

> The Lord God made it possible for Lando di Pietro of Siena to carve this crucifix in this wood in the similitude of the real Jesus to remind people of the passion of Jesus Christ Son of God, and of the Virgin Mary, therefore you true and holy cross of Jesus Christ Son of God, render the said Lando to God.
>
> O blessed Virgin Mary, mother of Jesus Christ Son of God, pray the holy cross of your son that it may render the said Lando to God.
>
> O John the Evangelist, beloved disciple of Jesus Christ Son of God, pray the holy cross of Jesus Christ Son of God that it may render the said Lando to God.
>
> O John the Baptist that bore witness to Jesus Christ Son of God, pray the holy cross of Jesus Christ Son of God that it may render the said Lando to God.
>
> O Mary Magdalen, the woman that loves Jesus Christ Son of God, pray the holy cross that it will render the said Lando to God.
>
> All the saints, men and women, pray Jesus Christ Son of God that he may have mercy on the said Lando and on all his family, that he may save them, and guard them from the hands of the enemy of God. Jesus – Jesus – Christ Son of the living God, have mercy on all of human generation. Amen.[27]

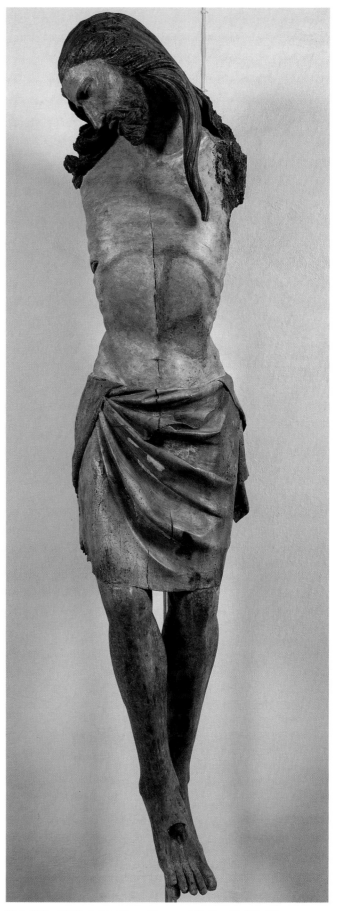

Plate 153 Attributed to Marco Romano, *The Crucified Christ*, polychrome wood, *c.*1310, Pinacoteca Nazionale, Siena. Photo: Lensini.

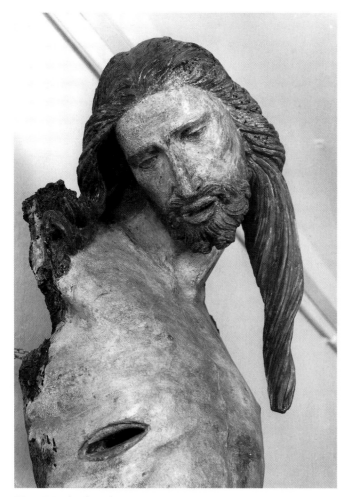

Plate 154 Attributed to Marco Romano, detail of *The Crucified Christ* (Plate 153). Photo: Lensini.

The prayer has been linked to the *Meditations on the Life of Christ* written in the late thirteenth century by the Franciscan of San Gimignano, Giovanni de'Cambi, also known as Giovanni de Caulibus. The notion that the statue would remind the spectators of the Passion recalls the letter of Pope Gregory the Great (590–604) to the abbot and historian Secundinus (d.612).

> Your request [for images] pleases us greatly … being so accustomed to the daily corporeal sight, when you see an image of him you are inflamed in your soul for love of him whose picture you wish to see … by taking us back to the memory of the Son of God, the image, like the scriptures, delights our mind with the resurrection, or caresses it with the Passion.[28]

Lando might also have been thinking of statements like that of the Dominican theologian Aquinas:

> The images of Christ and the saints are made in the church for three reasons: first, for the instruction of the unlettered, who are taught by these images as if they were books; secondly, so that the mystery of the incarnation and the example of the saints may remain the better in our memory, when they are presented daily to our eyes; and thirdly, so that a feeling of devotion may be excited, which can be aroused more successfully by things seen than heard.[29]

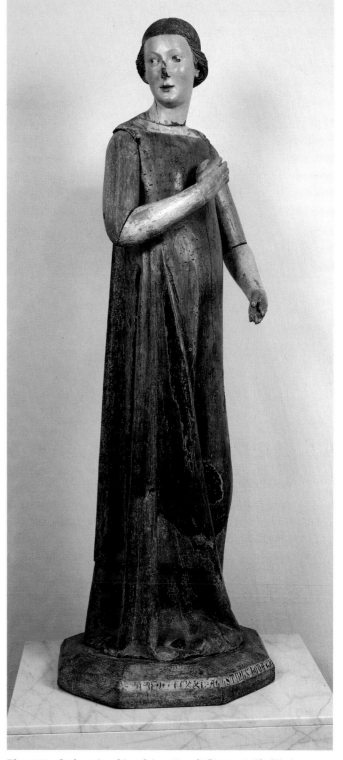

Plate 155 Stefano Accolti and Agostino di Giovanni, *The Virgin Annunciate*, 1321, polychrome wood, 172 cm high, Museo Nazionale, Pisa. Photo: Lensini.

Lando completed his prayer with a statement registering his awareness of the possible dangers of such extreme life-likeness. 'The year of our Lord January 1337 was completed this figure in the similitude of Jesus Christ crucified Son of God living and true. And it is he that one must adore and not

this wood.'[30] Here Lando exemplifies the correct attitude to the status of the image, perhaps most continually available to sculptors in the accounts of the martyrdom of the patron saints of the stone-cutters' guild, the Four Crowned Martyrs, whose feast they celebrated annually. On being asked to make a pagan idol of a god by the Roman Emperor, the Christian sculptors named Claudius, Nicostratus, Castorius and Simphorianus had refused: 'We have never adored the work of our hands, but we do adore the Lord of heaven and earth who is Emperor perpetual and God eternal.'[31] In a slip of parchment rolled up in the cavity of Christ's nostril, Lando added the date again and, 'Jesus Christ through your mercy let the soul of Lando di Pietro, who made this crucifix, be recommended.'[32] Lando's prayers emphasize the privileges of the artist in being able to earn some hope of heaven through the good work of making images to lead people's minds to God. And since it seems likely that the presence of these inscriptions was known only to Lando, his statements presumably expressed a devout sentiment. It seems probable that other artists felt similarly and that the representation of the divine body was regarded as a very different business to that of making an image of the ordinary human body.

Painted wooden life-size images were able to produce the most convincing representations of divine creatures. Examples survive (like the crucifix in San Francesco, Siena) which have even been given a leather skin, and there were also wooden statues which had movable joints like huge dolls. For example, in 1321 two Sienese sculptors completed a large painted wooden figure of the Virgin Annunciate. The head was carved separately and is fixed to the body by means of a dowel below the nape of the neck (Plate 155). The arms are jointed at wrists, elbows and shoulders.[33] (The shoulders have been restored.) It is not known for which church this sculpture was made, but the base is inscribed with the names of Stefano Accolti and Agostino di Giovanni. The sculptors evoke a personality of intense innocence, serenity and youth, securely rounded in her flesh yet slender and, by implication, pliant. Going by other examples, the figure would have been paired with an angel, and the owners would have been able to dress, garland, bejewel and light their large dolls in a great variety of poses to dramatize the annunciation. The Virgin here is a wooden actor, and the sculptor and painter have ingeniously chosen an expression, in the skewed glance of the eyes, which will show the angel surprising her convincingly – whether the head is placed to face forward or twisted round more tensely. This statue stresses the range of emotions which the painted wooden 'similitude' of a divine figure might be required to evoke. The artists' task was different to that of the sculptor designing for a fixed location in an immovable medium like stone. They had to design well for flexible use. And by having such a flexible sculpture at their disposal, the patrons' power over its appearance thus extended beyond the commissioning phase to encompass the entire life of the work.

In comparing the realistic conventions used on the tomb of Archbishop Tabiati by Goro di Gregorio with those of the *arca* of Saint Cerbonius made earlier by the same sculptor (perhaps to follow his stylistic development or debate the date of the tomb), it is important to keep in mind the differing spiritual grading of archbishop and saint, or of scenes from the life of Christ and scenes from the life of Cerbonius. Equally, when we look at the earlier Virgin Annunciate by Agostino di Giovanni and his later Tarlati tomb, we need to be aware of their different spiritual status too. Praising the Lord-Bishop of Arezzo with convincing scenes and a portrait effigy entailed social prestige and risk. But as the prayer of Lando di Pietro proposes, creating a credible image of the divine meant a different type of investment: reward or risk in eternity.

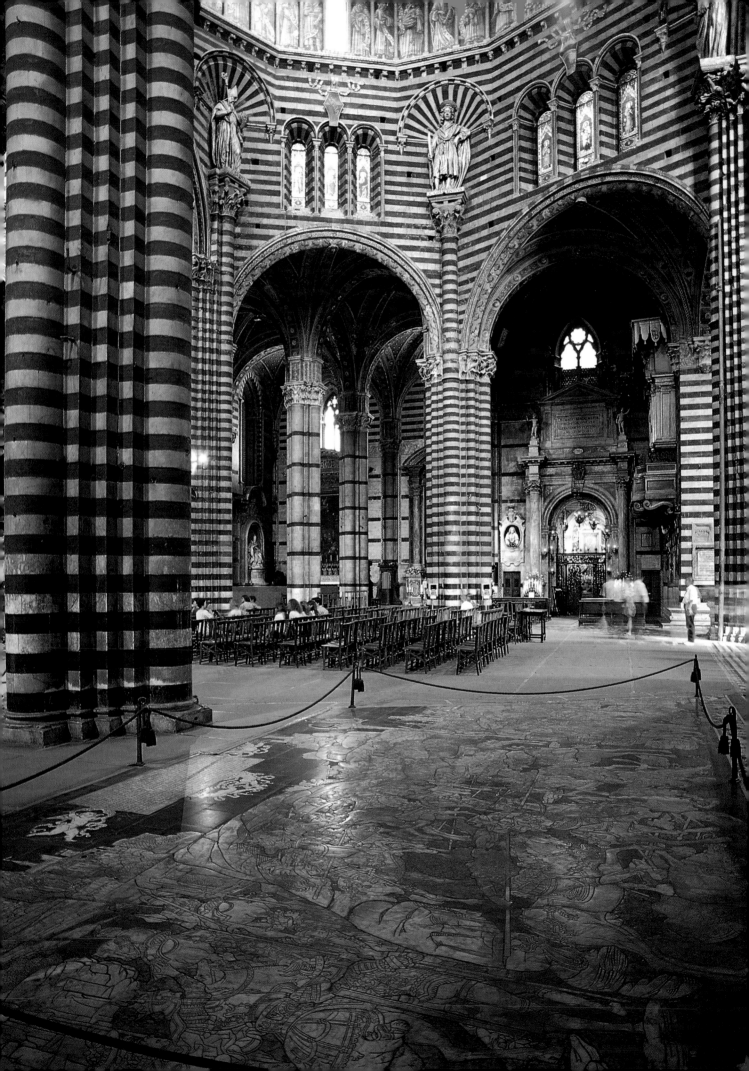

The design of Siena and Florence Duomos

We are accustomed to think of buildings being designed by 'architects', who control every detail of structure and decoration from the drawing board. However, large, complex projects such as the new Duomos in Siena and Florence, which took several generations to build, were never designed in one act of volition. Successive builders and sculptors added their own creative impulses, as the taste of their contemporaries changed. It would, though, be a mistake to imagine architectural design in the fourteenth century as an 'organic' process of continual adaptations, with no attempt at overall design. The first and most important point to make about the two cathedrals which are the focus of this essay is that they embody unprecedented inventions in a number of significant respects. No large cupola based on a hexagonal crossing existed before that of Siena Duomo, nor was there any post-antique precedent in western Europe for the scale of the cupola of the Duomo in Florence. Secondly, there is no case for imagining the architectural design as exclusively a series of *ad hoc* decisions taken on site. We know that architects were capable of making measured drawings, in plan and elevation, as well as detailed models in wood or brick, and there is documentary evidence (tantalizingly fragmentary as it is) of detailed discussion of design alternatives. There were major changes of intention in both projects, causing surprising inconsistencies in the finished buildings, but these seem to have come about for unavoidable reasons, rather than indecision or incompetence.

The building history of both cathedrals has left scholars with fertile ground for controversy and speculation. In between points of absolute certainty, where a very clear idea of events can be obtained, lie large *lacunae* where agreement on the most basic facts may never be reached. Most of the debates, which require documentary, archaeological and stylistic analysis, are beyond the scope of this essay. However, it is possible to use a comparison of the two projects to demonstrate, not only how different solutions were found to comparable problems, but also how the gaps in certain kinds of evidence can be filled in speculatively by referring to the sequence of events in the other case. We will also find some points of direct contact – rivalry as well as emulation – between the two stories.

The process of building the existing Duomo of Santa Maria dell'Assunta in Siena began (*c*.1226) over half a century before the building of the present Duomo of Santa Maria del Fiore in Florence (1293–96). Curiously, however, the façade of Santa Maria dell'Assunta was being built (*c*.1284–1310) at just the time when the façade of Santa Maria del Fiore was being designed (1294–96) and the man in charge of the latter, Arnolfo di Cambio, had himself earlier worked on the Duomo in Siena as a sculptor. Similarly, soon after the Florentine

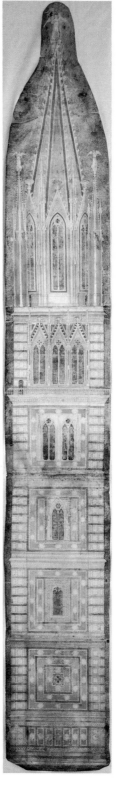

Plate 157 Drawing of the Campanile for the Duomo in Siena, based in part on Giotto's Campanile for the Duomo in Florence, *c*.1334, pen and coloured wash on parchment, 222 x 32 cm, Museo dell'Opera del Duomo, Siena. Photo: Lensini.

Plate 156 (Facing page) Interior of the Duomo, Siena from the south aisle, looking towards the dome. Photo: Tim Benton.

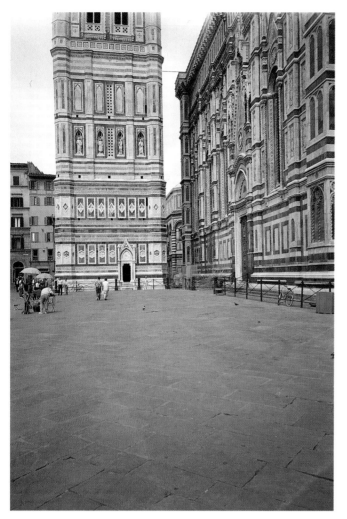

Plate 158 Campanile and south flank, Duomo, Florence. Photo: Tim Benton.

architect Francesco di Simone Talenti advised the Sienese authorities to give up their half-executed project for a great enlargement of their cathedral (1355), the Florentines decided on a significant enlargement of their cathedral (1367).

A particularly intriguing example of the relationship between the two projects, and a cautionary tale about the certainties and doubts of academic analysis, is provided by a beautiful and very large elevation drawing of a campanile conserved in the Opera del Duomo of Siena (Plate 157). The lowest storey of this design corresponds fairly closely with that of the Florentine Campanile (Plate 158), but the rest departs radically from what was built in Florence. For some scholars, this fact proves that the drawing is a copy, or even the original, of the design by Giotto for the Florentine Campanile, begun under his direction in 1334.[1] The fact that Lando di Pietro, who was called from Naples to take charge of the Sienese Duomo works in December 1339, visited Florence in 1337 is identified as a means by which the drawing might have come to Siena. However, another argument proposes that Lando di Pietro, or another Sienese draughtsman, took the base of the Florentine Campanile as a starting-point to design a completely different campanile for Siena. Proponents of this train of thought claim that the sculptural details are typically fanciful and Sienese. As we

shall see, the dramatic proposal to double the size of the Duomo in Siena, conceived between 1321 and 1339, would have entailed the destruction of the old campanile and the need to build a new one.[2] For some, the drawing is a pure reflection of Giotto's aesthetic and the firmest evidence of his architectural design methods. For others, the drawing is quintessentially Sienese. Some date it to 1334–36, others to the 1380s. This anecdote draws attention to the fact that, although it is usually argued that Florentine architecture was very different from Sienese architecture and that there were fundamental stylistic changes during the century, these discriminations are clearly not simple. The interest of controversies like this lies less in deciding between the options and more in realizing how little we really know about many of the key assumptions made in the literature. Suitably chastened, we should now briefly survey the building histories of the two cathedrals, paying particular attention to similarities and differences in form and process. I will then draw out some more specific points of comparison to discuss.

FIRST COMPARISONS

The Duomo in Siena had been consecrated to the Virgin of the Assumption from at least 913. Florence Duomo was originally consecrated to Santa Reparata, but Villani tells us that the dedication on laying the foundation stone of the new cathedral in 1296 was to Santa Maria del Fiore, although the nomenclature of the cathedral remained ambiguous until a formal decision on the subject was taken in 1412.[3] With this proviso, both buildings reflect a devotion to the Virgin Mary.

How do the present buildings compare? From the exterior, both buildings share certain features: a cupola on a drum over the crossing, a campanile and a highly decorated façade. The façade of Florence Duomo, however, was given its present form only in 1875–87 by the architect Emilio de Fabris. On closer inspection, the buildings could hardly be more different (Plates 156 and 159). Whilst Siena Duomo exudes mystery and exoticism, with its striped piers, ambiguous space and rich sculptural details, Florence Duomo seems austere and monastic by comparison. This effect can in part be explained by the much earlier date (c.1250–60) of parts of Siena Duomo (shown in Plate 156) and the influence on its construction of the Romanesque Pisa Duomo. The nave of Florence Duomo, by comparison, was not given its present form until c.1357–75, by which time the Gothic style was well established (see, for example, the contemporary Loggia dei Lanzi shown in Chapter 2, Plate 52). Although the design of the eastern part of Florence Duomo was fixed in 1367, the drum was not completed until 1421 and the cupola not until 1436. The marble incrustation of the exterior continued into the fifteenth century.

THE BUILDING OF THE NEW CATHEDRALS

The origins of the present Duomo in Siena are obscure.[4] We know that between 1226, when the series of accounts begins, and 1258 substantial building work was under way, paid for largely by the city government and administered by the Opera del Duomo, which had been established in the twelfth

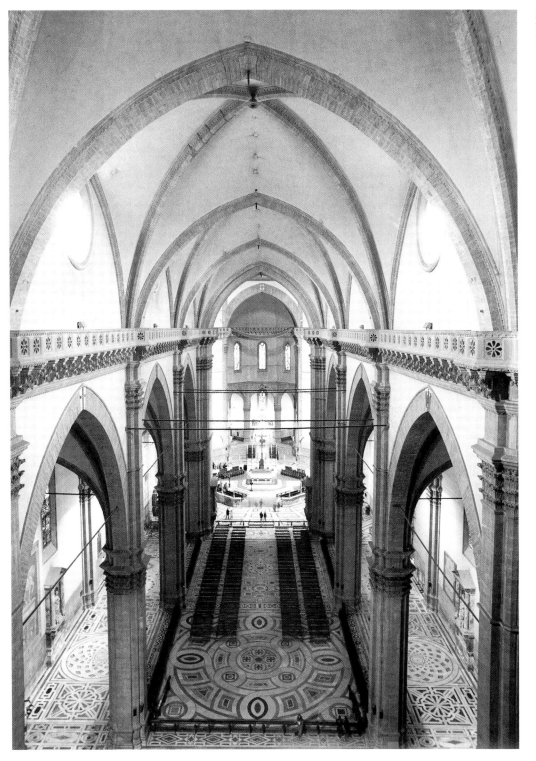

Plate 159 Interior of the Duomo, Florence. Photo: Tim Benton.

century. By 1258 work on the choir, transepts and crossing had reached the point at which urgent discussions were taking place about making the new space usable. Choir stalls, a high altar and a pulpit (by Nicola Pisano, contracted in 1265) were all commissioned at great expense over the next seven years. In 1264 the wooden outer covering of the dome was leaded and completed.[5] Although the hexagonal arrangement of the piers supporting the dome survives unchanged today, the chancel and transepts we see today are quite different from what had been built by this time

(Plate 160). The evidence for the building as it was then comes from a recent architectural survey, which located the base of the choir, the north transept and one pier, and found indications that the original bay width was narrower than that seen today. In addition, it located the external wall of the north-east corner of the cathedral, which descended some 10 metres below floor level before reaching ground level because the ground sloped away sharply in this area.

It is difficult to imagine the choir and crossing as it was in 1260. Looking down into the crossing (Plate 161), the transept

Plate 160 Plan of Siena Duomo, showing the thirteenth-century building (blue) compared with the present building (brown). (The cardinal points used are the liturgical ones.) In practice, the nave was not constructed according to the original narrow plan indicated. Redrawn by the OUPC from plans in Carla Pietramellara, *Il duomo di Siena*, 1980, reproduced by permission of Casa Editrice Edam, Florence.

Key:

1 Nave; 2 West façade; 3 Campanile; 4 Cappella del Voto; 5 South transept; 6 New choir over Baptistery; 7 Old choir; 8 North transept; 9 Cappella di San Giovanni; 10 Outline of the cathedral as completed (*c*.1356–70); 11 Hypothetical plan of the church as proposed before 1260.

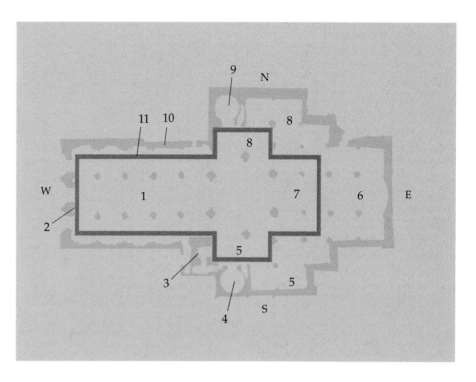

would have been only as deep as one bay of the present arrangement and the choir would have ended at a point where now there are three steps (on the right in Plate 161). Illumination for the crossing came from four triforate windows, which would have been exposed to the exterior. Now, due to the raising of the roof all the way round the building, these windows are enclosed under the transept roofs. Plate 162 shows, on the right, the south-most point of the hexagonal crossing in the roof space, and the unfaced masonry next to the niche indicates where the shallow, pitched roof of the much lower transept would have come. In the interior of the cathedral a difference in the banding of piers that were added in the 1360s to support the enlargement of the building, compared with the crossing piers of *c*.1240–58, can be seen. The piers in the transepts directly adjacent to the crossing piers were replaced in the 1360s by

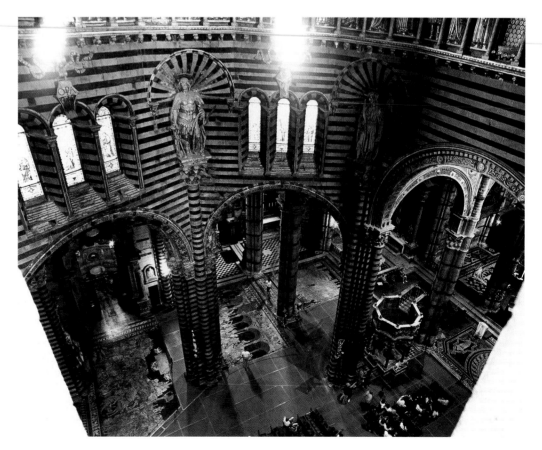

Plate 161 Duomo, Siena, view down into the north-east corner of the hexagonal crossing from the drum. Photo: Tim Benton.

Plate 162 Duomo, Siena, view of triforate windows in the roof space over the south transept. Photo: Tim Benton.

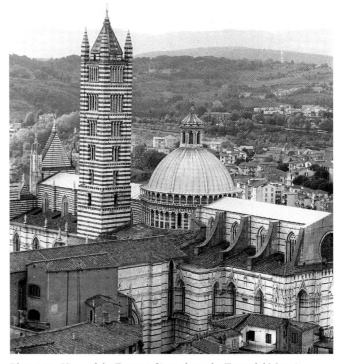

Plate 164 View of the Duomo, Siena, from the Torre del Mangia, showing the relation between the clerestory of the choir and nave and the drum arcade above the junction between the planned extension to the cathedral (on the left) and the south transept. Photo: Tim Benton.

piers with the wider banding stripes, similar to those in the enlarged choir. The original choir was not only less deep, it was also considerably less high, as can be seen from a section through the building (Plate 163). The roof of the original choir would have been lower than the arcade of the drum. In the present arrangement, the raised clerestory of choir and nave completely swallows up the drum arcade externally (Plate 164). Internally, the effect is to expose the drum, with its arcade, inside the nave roof (Plate 165). It takes an effort of imagination to visualize the dome and drum dominating a choir only two bays deep, and a nave roof only as high as the present aisle roofs.

Over the next 20 years, work proceeded on the nave, working westwards. The Bishop's Palace (to the south) and the Canonica or canonry (to the north) were begun after 1277,

Extension completed *c*.1355–86

Baptistery added *c*.1316–25

Cathedral *c*.1225–70

Raised level of thirteenth-century church, made of spoils of earlier church

Sandstone rock

Western bay *c*.1284

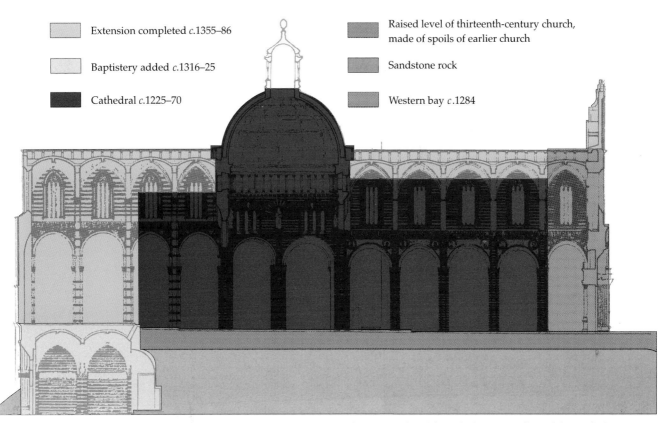

Plate 163 Longitudinal section of the Duomo, Siena, showing the stages of building. Reproduced from Carla Pietramellara, *Il duomo di Siena*, 1980 by permission of Casa Editrice Edam, Florence.

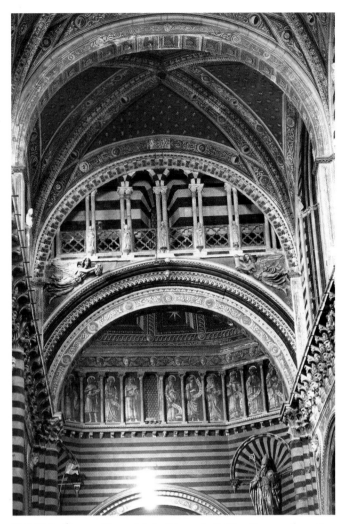

Plate 165 Duomo, Siena, detail of the arch dividing the nave from the crossing, showing the external face of the drum exposed to the interior. Photo: Tim Benton.

It is a matter of bitter controversy how much work was done on the façade between 1300 and 1316 following Giovanni Pisano's overall scheme (if, indeed, there was one), and how far it had progressed before work was halted to move onto the next stage of the construction. We will return to this below.

Meanwhile, in Florence around 1293–96, at the time that Giovanni Pisano was working on the façade of Siena Duomo, discussion about repairing the venerable cathedral of Santa Reparata turned to talk of building anew.[6] The main decision taken was to demolish the western end of the old cathedral and set the façade of a new cathedral further away from the baptistery of San Giovanni Battista, in order to create a more dignified space between the two buildings (Plate 174). The sculptor Arnolfo di Cambio, who had been one of Nicola Pisano's assistants working on the pulpit of Siena Duomo, was named in 1300 as *capomaestro*. He may have been in charge since 1293 or 1296, but he died quite soon afterwards (either in 1300 or 1310 according to different interpretations of the documents). It is certain that some sculptures that have been attributed to Arnolfo di Cambio and his school were made,[7] and it is also recorded that work began at the east end of the cathedral, probably on foundations. For half a century, however, the area now covered by the east end of the cathedral still had several properties on it, as well as the remains of a church and a public road where the crossing now is. There is no consensus about what Arnolfo di Cambio's plan for the cathedral looked like, or even whether such a plan existed in more than outline. Nor is there agreement on his design for the west façade, despite a good sixteenth-century drawing recording its appearance before its demolition in 1587.[8]

In Siena in 1296 Giovanni Pisano had been asked to build a new baptistery to replace the old one, which is presumed to have been a free-standing building somewhere near the west façade of the cathedral. However, by 1316–17, and possibly before, a bold new plan had been decided upon: to extend the whole cathedral to the east over a steeply falling site, by constructing a new baptistery in a space carved out of the rock and building over it to extend the choir. The work was to be completed by an impressive east façade to the new baptistery and choir above. Astonishingly, there is a copy of a parchment elevation drawing which, it has now been generally agreed, represents the design for the new baptistery façade (Plate 167). The lower half of the present façade follows this drawing fairly closely. The baptistery was vaulted in 1325 and the lower half of the façade was decorated with marble incrustation and sculptures. The façade was not completed until the choir was extended over the baptistery, after a sufficiently long interval for the decorative system to be disrupted.

In 1321–22 a group of experts was called in to make an assessment of the structural condition of the new work. Their technical report, signed by the Sienese architect Lorenzo Maitani among others, raised the question of whether to start a completely new project, a 'Duomo Nuovo'.[9] I will come back to this report and speculate about its significance below. The proposal was to make the existing nave and choir the transepts of a new nave at right angles to the old one (Plates 164 and 168), some 140 metres long and 33.5 metres

and the piazza between the cathedral and the hospital of Santa Maria della Scala to the west of it was cleared. The nave was laid out to a larger scale than the original choir and transepts (Plates 160 and 161). The piers of the original chancel and transepts were spaced around 5 metres apart, whilst the intercolumniation of the nave measured *c*.7.5 metres. The nave and aisles now measure *c*.24.3 metres across, wall to wall, whereas the original choir was 19 metres across. The campanile projects into the south aisle quite noticeably. Whether this increase in scale was part of an enlargement of the whole project, or simply a desire to make the nave wider and higher, the effect was to make the arch from the nave into the crossing higher than the corresponding arch into the choir (Plate 165). Even without the high clerestory added to the nave, probably in the 1360s, the roof would have cut into the gallery running round the drum at its apex.

In 1284 work began on the façade (Plate 166), probably under the direction of Giovanni Pisano, although he was not named as *capomaestro* until 1295. He was strongly criticized in 1297 for the disorder reigning on site, with sculpted pieces lying about with no known destination, and around 1300 he left Siena (he returned later and probably died there by 1319).

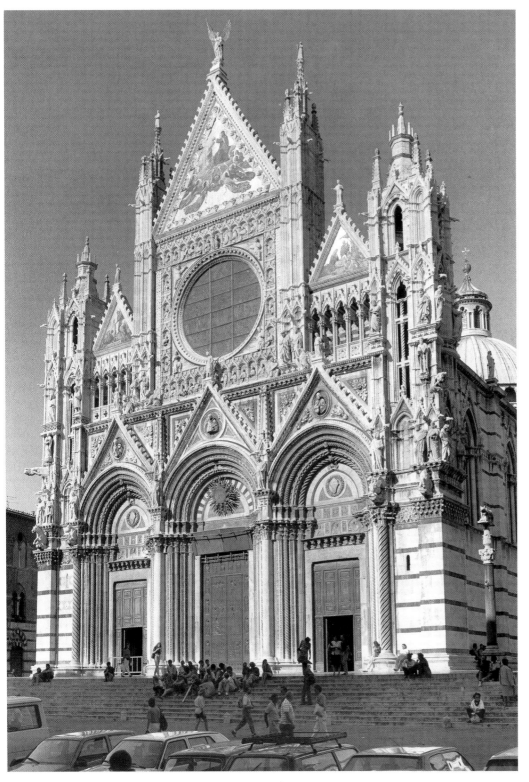

Plate 166 West façade, Duomo, Siena. Photo: Tim Benton.

wide, with a monumental new south-facing façade, the *facciatone*. By comparison, the old cathedral measured 71 metres from the west façade to the old choir, 86 metres including the new choir to be built over the baptistery. If we compare the view towards the old cathedral (Plate 169) with the view towards the *facciatone* (Plate 170), as seen now, and mentally construct the clerestory that would have risen above the nave arcade up to the height of the new façade, it is clear that the old dome and nave would have been dwarfed.

Whether the intention was to destroy all the old work is still unclear. What is certain is that work soon began on clearing the ground of houses to the south of the crossing and in 1339 the foundation stone was laid for the Duomo Nuovo, work on which proceeded at breakneck speed until the first dreadful visitation of the Black Death in 1348. In that short period of time the new façade had been completed (bare on the exterior but with all its marble facing and decorative detail inside) and the nave and aisles had been raised and in part vaulted.

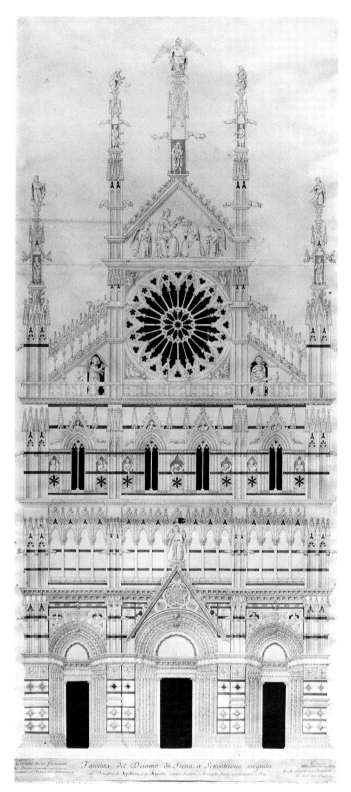

Plate 167 Minucci, copy of a parchment elevation drawing (original *c.*1317) for the façade of the Baptistery and choir, Duomo, Siena, 1820, watercolour, Archivio dell'Opera della Metropolitana, Siena. Photo: Tim Benton.

As in Siena, controversy surrounds the work on the Duomo in Florence: how much was achieved before 1334, when Giotto was enticed back to the city from Naples to take on the prestigious role of city architect and *capomaestro* of the cathedral? In 1331 the Arte della Lana was made responsible

for fund-raising and administering the building works. Villani recorded the laying of the foundation stone of the campanile on 18 July 1334 and cited Giotto as the designer, but when Giotto died in 1337 only the lowest storey of the campanile had been completed. The pace of work then picked up, possibly in emulation of the rapid pace of expansion of the Duomo in Siena. The campanile rose quickly, under the successive leadership of Andrea Pisano (1337–*c.*1343) and Francesco Talenti (*c.*1348–55), at which point, it seems, attention turned from the nearly complete campanile to the body of the cathedral. In 1357 work began on the great piers and pilasters of the nave and aisles to the design of Francesco Talenti. This required the demolition of almost all the remains of Santa Reparata, which had been in use until then (Plate 175).

Only at this point, with the abundance of documentation and the clear evidence of the building itself, is some certainty available. Francesco Talenti's plan seems to have been similar to the finished scheme, except that the nave would have been of three bays instead of four. His large, vaulted bays in the nave (at nearly 20 metres square, each one was larger than the dome in Siena) clashed with the existing articulation of the side walls, which had been built and partly decorated at some point in the preceding half century. Two of the new bays were the equivalent of five and a half bays as articulated on the side walls. The windows detailed on the exterior did not match the centre of these internal bays and were left blind, the effects of which are visible on the exterior.[10] A clear join between the narrow bays and the first of those articulated on the exterior to match the internal arrangement can be seen to the east of the Porta del Campanile (Plate 171). A view of the interior, showing the bays on the north side of the nave, betrays none of this excitement (Plate 172). In 1367 the decision was taken by a committee of seven architects and painters to extend the nave by adding one more bay to the east and to increase the diameter of the cupola from 62 braccia (36.18 metres) to 72 braccia (42 metres), more than double that of Siena. A large model was made, which all workmen on the site were sworn to follow in detail, and this project was scrupulously carried out until 1421 and the completion of the octagonal drum, when the problem of how to vault the cupola halted work.

A lack of documentation before the 1350s means that we will probably never know for certain when the decisions were taken leading to the pre-1355 articulation of the side walls. One factor remains constant. At each stage, the whole project became taller as well as larger. The large units of the internal arrangement disguise the great height of the central nave and aisles. The height of the nave of the church of Santa Maria Novella would fit under the aisle vaults of the cathedral in their finished form. It is almost certain that, if Arnolfo di Cambio designed a system of articulation for the side walls, he would have made them much lower than the present arrangement. Indeed, the decorative system we see now seems to have been designed to give the impression of elongating the window frames upwards (Plate 171). Furthermore, the aisle roofs conceal large, arched buttresses supporting the clerestory walls. It is certain that at one point it was intended to expose these to view, since the clerestory wall below the present aisle roof line is decorated with blind

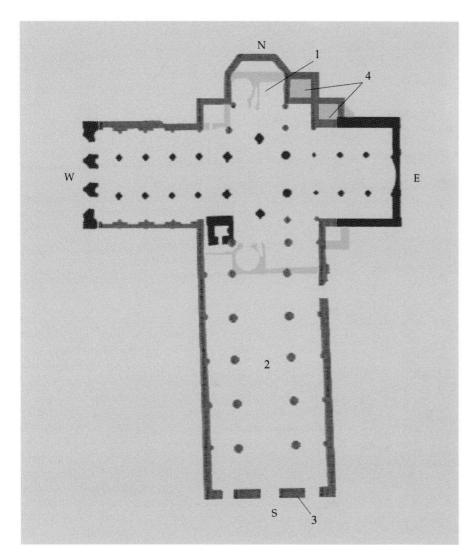

Plate 168 Diagrammatic plan of the Duomo Nuovo, Siena superimposed on the old cathedral. Redrawn by the OUPC from plans in Carla Pietramellara, *Il duomo di Siena*, 1980, reproduced by permission of Casa Editrice Edam, Florence.

Key:
1 Apse [not built]; 2 New nave [partially demolished]; 3 *Facciatone*; 4 Ancillary spaces.

arches, which would only have been visible if the attic running along the top of the side walls had been omitted.

The Black Death created only a temporary interruption on site in Florence, and was followed by a further expansion of the project. By contrast, in Siena the Black Death led, at least indirectly, to the abandonment of the project of the Duomo Nuovo. Although work seems to have been taken up again between 1348 and 1355, severe structural difficulties led to an invitation to a new group of experts, including the Florentines Francesco Talenti and Benci di Cione, to give an opinion.[11] Their report was even more damning than that of Maitani and his colleagues, and the times were not right for headstrong optimism. The government of the Nine had come to a violent end in March 1355 and been replaced by the rule of the Twelve. The decision was taken in June 1357 to abandon the Duomo Nuovo project, tear down the vaults, and proceed to complete the still-unfinished carcass of the 'old' cathedral. Between 1358 and the 1380s the new choir over the baptistery was completed and vaulted, and a new, higher clerestory and vaults were added to the whole length of the cathedral. The façade was also completed, perhaps to a new design or perhaps in faithful emulation of that of Giovanni Pisano. The *facciatone*, the right aisle and the outside wall of the left aisle are all that remain of the Duomo Nuovo today.

BUILDING OVER THE PAST

The first topic that I would like to develop further is the relationship between these two cathedrals and the buildings that they replaced. We know that a substantial cathedral dedicated to the Virgin and roughly on the site of the present Duomo in Siena was under construction during the twelfth century, perhaps begun in the eleventh century and dedicated in 1178 or 1179 (based on different readings of a document of 1186). Indeed, a document dated to 1215 provides us with a tantalizingly precise description of the cathedral's interior. This document, the *Ordo Officiorum Ecclesiae Senensis*, attributed to Odericus, one of the cathedral canons, gives a detailed description of liturgical practices all year round, and enables us to guess at the location of the various altars, the pulpit and the choir stalls.[12] From this we learn that the chancel was raised above a large crypt containing three altars and the relics of a number of saints, including the city's four patron saints: Crescentius, Ansanus, Sabinus and Bartholomew (the latter replaced at the end of the thirteenth century by Saint Victor, whose head had been kept on the altar of Saint Sabinus). We also learn that there was an enclosure for the choir stalls in the chancel, partly separated from the congregation in the nave by the high altar. There

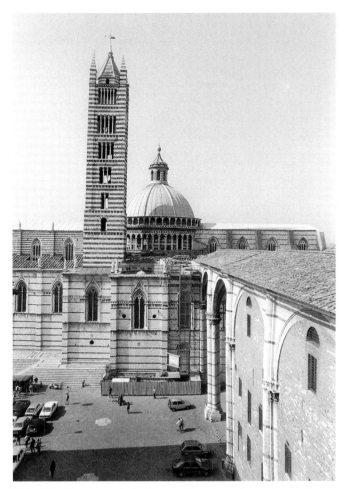

Plate 169 View towards the Duomo, Siena from the south, showing the right nave arcade and aisle of the Duomo Nuovo. The line of piers for the left of the nave is indicated by white stone marks on the pavement. Photo: Tim Benton.

were two pulpits: a 'major' one, presumably of stone, on the left (or 'gospel') side facing the high altar from the nave, and a wooden one, which was probably little more than a lectern next to the high altar in the raised choir.

Although the *Ordo Officiorum* gives us an intimate feel for the daily duties of the bishop, deacon and canons, it must be accepted that there is no firm evidence of the precise location, size or shape of the Romanesque cathedral as it was before rebuilding began after 1215. Many scholars have assumed that the chancel of the old cathedral lay roughly where the present chancel is, and have tried to identify the crypt of Odericus's day with some curious remains in a crypt under the present choir (known as the Crypt of the Statues because it was taken over to store some of the sculptures originally decorating the cathedral fabric) (Plate 173). For a number of reasons, this cannot be so,[13] but scholars have been distracted by a sixteenth-century description of the cathedral, which suggested that the present cathedral originally had a crypt similar to the previous one.

In the case of Florence, we know exactly where the old cathedral lay, due to an extensive archaeological survey (1965–74)[14] (Plate 174). The effect of the siting of the old cathedral on the building history of the new cathedral was very important. The first action taken towards the new building was to demolish the hospital of San Giovanni, as well as the porch and western bays of Santa Reparata. Documents record that work proceeded on the west façade and at the east end, entailing a partial demolition of the church of San Michele Visdomini, which had stood beside a minor gate in the Carolingian walls of the city, long since demolished. A reconstruction of the state of the project before 1353, based on archaeological evidence and the view of Florence in the Madonna della Misericordia fresco in the Bigallo, shows the façade half built and side walls built for some seven bays along the north and south sides (Plate 175).

Plate 170 View towards the *facciatone* from the nave of the Duomo Nuovo, Siena. Photo: Tim Benton.

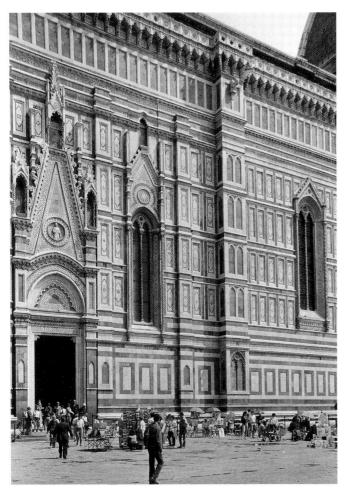

Plate 171 Duomo, Florence, view of the third and fourth bays of the nave from the exterior, south side, with the Porta del Campanile. The bay on the right is to the large scale of Talenti's design. Photo: Tim Benton.

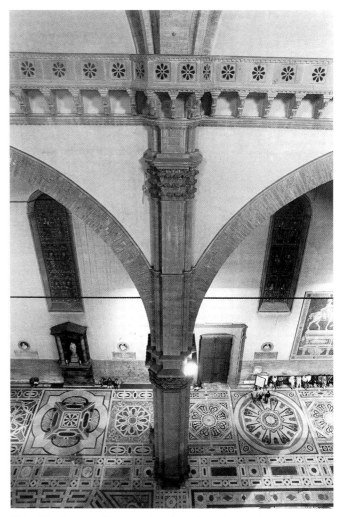

Plate 172 Duomo, Florence, view down from the cornice passage towards the pier dividing the first and second bays, north side. Photo: Tim Benton.

It will be seen that the south portal in the new façade gave onto an open space between the old and the new cathedrals, which was used as a temporary burial ground. The first portal in the south flank (now referred to as the Porta del Campanile, Plate 175) leads directly from the cloister of the canonry into the south chapel of Santa Reparata, and the alignment with this wall led to a skewing of the whole cathedral off axis from the baptistery. At the east end of the old cathedral were two campaniles, of which one was built after 1300. The ground level of the new cathedral was raised some 2.3 metres above that of the old cathedral, which accounts for the good preservation of the old building under the floor of the new one.

The form of Santa Reparata, with its raised choir and a *confessio* or crypt running the full width and depth of the chancel, may give us an idea of the structure of the old Duomo in Siena. It would not be unreasonable to imagine that, in Siena as in Florence, there was an intention to move the west façade of the new building away from an important existing building, in Siena the hospital of Santa Maria della Scala.[15] Assuming that the old cathedral was smaller than the new one (the most pressing reason for building a new cathedral was to increase the size and capacity), and hypothesizing a shift of the new building towards the east, we

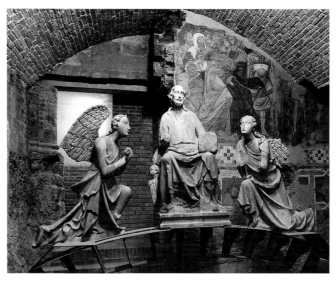

Plate 173 Duomo, Siena, view of the Crypt of the Statues underneath the chancel constructed between 1215 and 1258. The three statues, by Giovanni di Agostino (*c*.1345–48), were removed from the east portal of the Duomo Nuovo. Photo: Tim Benton.

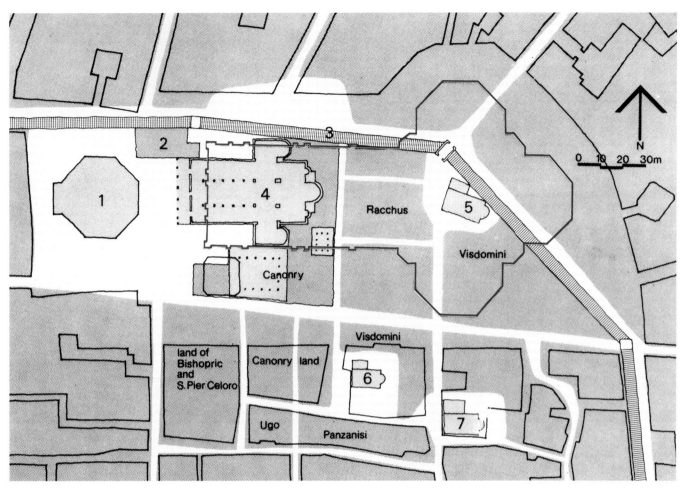

Plate 174 Plan of the site of Santa Reparata, the Baptistery and Santa Maria del Fiore in the twelfth century.

Key:
1 San Giovanni Battista [standing]; 2 Hospital of San Giovanni Evangelista [destroyed 1296: reconstruction]; 3 Carolingian city wall [superseded 1172, later destroyed: reconstruction]; 4 Santa Reparata [destroyed 1293–*c*.1375: excavated]; 5 San Michele Visdomini [destroyed 1300 and 1368: reconstruction]; 6 San Pier Celoro [standing]; 7 San Benedetto [standing]. Reproduced from Franklin Toker, 'Florence cathedral: the design stage', *Art Bulletin*, 60, June 1978, p.220 by permission of Professor Toker.

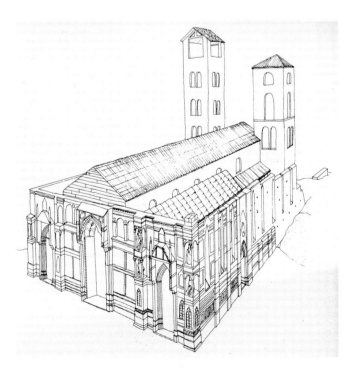

would expect the east end of the old cathedral to lie half-way down the new building. The seventeenth-century commentator Benvoglienti recorded that the entrance to the old crypt in Siena Duomo was to be found 'under the wheel' in the pavement.[16] A 'wheel of fortune', possibly dating originally from 1373, although remade in 1864–65 and possibly remade several times in between,[17] can be found in the first bay to the west of the crossing. In 1779 Giovanni Borghese made an exploration under this part of the pavement, which was at that time notably higher than the rest, to search for remains of the crypt, but was apparently unsuccessful. In Florence, although most of the old cathedral had been demolished by 1357, the confessio, with its precious relic of the head of Saint Zenobius (Chapter 5, Plate 127), was preserved and accessible in the floor of the new cathedral until 1439. It is conceivable that a similar arrangement pertained in Siena.

Plate 175 Reconstruction drawing showing the new walls of Santa Maria del Fiore framing the remains of Santa Reparata in the mid fourteenth century. Reproduced from G. Rocchi *et al.*, *Santa Maria del Fiore*, 1988 by permission of Editore Ulrico Hoepli, Milan.

THE FAÇADE OF THE DUOMO IN SIENA

The history of the west façade of Siena Duomo has many controversial elements. Documents do not help much, except to make it clear that much work remained to be done in the 1360s.[18] This proves nothing, since if there is a constant in Italian architecture, it is that façades are rarely finished, once the weather has been kept out and a start made on some spectacular sculpture close to the ground. This was certainly the case for all the façades in this history: the Siena Baptistery façade and the *facciatone*, as well as the façade of the Duomo in Florence. The question that has absorbed generations of scholars is: did Giovanni Pisano work out the general lines of the west façade between 1284 and 1300, perhaps in an elevation drawing similar to the one for the baptistery façade? This question can be broken down into subsidiary questions. First, if the west façade was 'designed' all together, why do the verticals of the upper storey not coincide with those below, as those of the baptistery façade do (Plates 166 and 167)? Second, how could an architect have designed a rose window as large and as high as this, when the apex of the thirteenth-century nave vault would have reached no higher than half way up the window? Third, how can the stylistic range of decorative motifs be explained?

All these questions have answers, but whether they are

Plate 177 Duomo, Siena, view of the clerestory wall in the present aisle roof space. Note the changed treatment in the bay on the left, the last before the west façade. Photo: Tim Benton.

convincing is undecided. If there is a discrepancy in the articulation of the verticals, the mistake lies in the lower storey. Inspection of the plan shows that Giovanni Pisano, in his keenness to have three great portals of roughly the same size, makes the side portals wider than the aisles, and the central portal narrower than the distance between the nave piers. The framing piers of the upper storey return to the axis of the nave arcade, as they would have to if the central section was to line up with the nave clerestory (Plate 176). Observing the façade from the back shows this relationship, as well as the great thickness of the façade.

The question of whether a rose window whose position made it too high for the existing nave could have been designed raises a number of points for consideration. There is evidence that the last bay of the nave before the façade is not homogeneous with the others. It is neither the same depth or height, nor in line with the others. More critically, an inspection of the nave wall in the present roof space over the aisles shows that the wall was faced with white and green marble blocks along its length, above a moulding where the old aisle roof came. In place of the present tall clerestory windows would probably have been shorter windows, flanked by blind arches, which can still be seen abutting the buttresses. In the last bay before the façade, however, this arrangement has been shelved and we find marble facing extending much lower (Plate 177). An interpretation of this evidence would be that the west façade was built, free standing, one bay away from a temporary wall closing off the rest of the nave. Whenever the last bay was completed, clumsily joining the two structures, it would have adjusted for the different height levels, with the intention that the rest of the nave would then be heightened accordingly.

We are left with two grand hypotheses. First, that Giovanni Pisano (or another architect before 1315) decided to raise the façade above the level of the existing nave, knowing that this would mean raising the height of the nave, possibly with the intention of adding a monumental baptistery façade at the

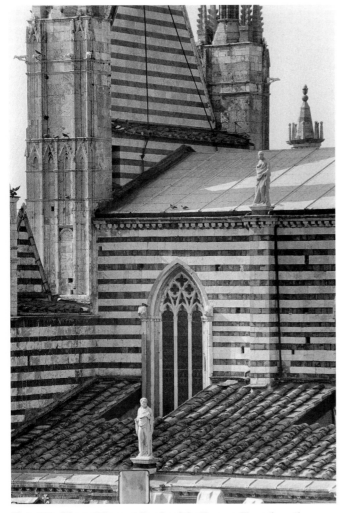

Plate 176 View of the west façade of the Duomo, Siena, from the south-east. Photo: Tim Benton.

other end of the building. It is worth noting that the rose window in the baptistery façade drawing is roughly the same size and height as the one in the west façade (Plates 166 and 167). An alternative hypothesis is that the top half of the west façade was designed in the 1360s, after the events surrounding the new baptistery and the Duomo Nuovo had been experienced. The question then is: how could Giovanni di Cecco, a rather unadventurous builder working as *capomaestro* of the cathedral at this time, have reverted to the classicizing style of 1300 after the Gothic ecstasy of the intervening designs?

At the time of writing, these architectural arguments are being sidelined by issues of sculptural attribution. Antje Middeldorf-Kosegarten has carried out a detailed analysis of the sculptural work in the cathedral and believes that most of the high-quality sculpture on the west façade, from the forefathers of Christ in their tabernacles framing the rose window to the angels on the topmost pediments, must be by Sienese followers of Giovanni Pisano in the circle of Camaino di Crescenzio, and be datable to no later than 1310.[19] It is then perfectly possible to assert that parts of the façade may have been left unfinished (which is supported by distinct signs of weathering on parts of the inner façade as well as by documentary evidence of much work still proceeding in the 1370s) and that some of the statues may not have been fixed in place until later.[20]

THE DUOMO NUOVO

It is generally agreed that a prime motivation for the extension of the cathedral to the east, and the creation of a great façade on the east side, was the new focus given to the city centre by the organization of the Campo and the construction of the Palazzo Pubblico.[21] When Maitani and his colleagues made their criticism of the structure of the baptistery in 1321–22, they went on to suggest starting a new building. Was this idea already in the air? If we think of the baptistery façade as a response to a west façade already designed to be as tall as its present form, the question of symmetry asserts itself. It is precisely in terms of symmetry that Maitani criticizes the extension of the choir: 'Item: it seemed to us that this work should not be proceeded with further, since the dome of the said church, once the work was complete, would not remain in the middle of the cross, as it reasonably should do.'[22] He then went on, at the end of this report and in another one on the same day, to propose a new building. The passage cited has not been properly understood. It is true that the passage makes no sense if it is taken to refer to the unequal length of the choir to the east of the crossing and the nave to the west, since this is the norm. But neither is it necessary to postulate the plan of the Duomo Nuovo, which would transform the choir into an east transept and the nave into a west transept, in which case the asymmetry would be highly unusual. Instead, we only have to consider the plan in hand, which was to extend the choir over the baptistery. We have already seen that the old choir was narrower than the nave. The baptistery was built to the same width as the nave, but it was not lined up properly on the old choir. To mask this difference, the architects must have intended to make the transepts deeper and wider by adding extra bays to the east of the dome crossing, which were in fact constructed (Plate 160). Now we do have an asymmetry because the axes of the transepts lie to the east of the crossing. Only the distracting presence of the Baroque Cappella del Voto (1659–62) and the corresponding fifteenth-century Cappella di San Giovanni, which help to disguise the asymmetry, prevent the viewer instantly realizing this fact (Plate 178). That Maitani was addressing the plan to extend the choir and not only the building of the baptistery is clear from other observations:

> Item: it seemed to us that this work should not be proceeded with, since it would be necessary to demolish the building, from the middle of the upper dome, on the side towards the work already begun.

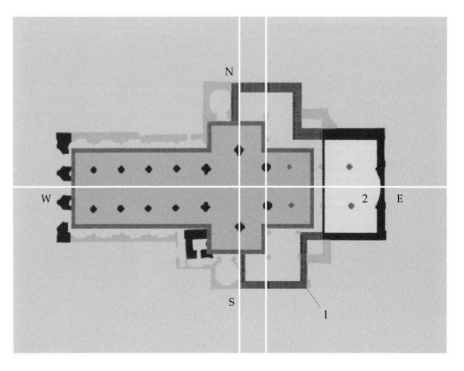

Plate 178 Plan of Siena Duomo, showing the implications of extending the choir over the Baptistery. The axes of the old church and the hypothetical extension are highlighted. Redrawn by the OUPC from plans in Carla Pietramellara, *Il duomo di Siena*, 1980, reproduced by permission of Casa Editrice Edam, Florence.

Key:
1 Hypothetical planned extension to link the new choir; 2 Extension to accommodate the Baptistery at the lower level and the choir above.

Item: it seemed to us and was apparent that it should not be proceeded with on the stated work, because in wanting to dismantle the old work, in order to join it to the new work, it would not be possible without great danger to the dome and old vaults.[23]

To understand what Maitani is talking about here, we have to think back to the placing of the walls of the old choir (Plates 160 and 178) and the role played by these in buttressing the piers of the hexagon. To remove these walls and all the piers of the old choir, and replace them with new piers, was indeed a perilous task, although one that was subsequently carried out. If we now look at a plan showing the relationship of the proposed Duomo Nuovo to the existing fabric, we can see that the Duomo Nuovo resolves a number of problems (Plate 168). First, it returns the dome to the crossing point between the central axes of nave and transepts. Secondly, it uses as many of the existing foundations as possible, although the plan would have meant demolishing the campanile. We know this because one of the piers of the Duomo Nuovo is embedded in the side of the campanile. Thirdly, it proposes the practical arrangement of two rectangular spaces at the north-east corner of choir and transept, which could be used as a sacristy at the level of the cathedral and for a crypt or confraternity chapel below. Indeed, work on these spaces was carried out next to the baptistery. Finally, the polygonal apse would have projected the minimum distance beyond the north transept. This would have had the advantage of being manageably located inside the line of the Via dei Fusari, which borders the site along the north side.

The Duomo Nuovo proposal would also throw light on the commissioning of four altarpieces to the protector saints,

discussed in Chapter 9. There would be space, flanking the high altar, to place two altarpieces on each side, in the arrangement which, after 1357, was carried out in the revised transept. However, if the Duomo Nuovo plan can be defended in some respects, it reveals a casual recklessness that is almost unthinkable today. For example, the levels at which the bases of the piers of the Duomo Nuovo were set varied by nearly a metre along the length of the nave. The floor of the nave would have required steps every bay, or a steep slope, to accommodate the difference in height. A further problem would have been that the north and south piers of the hexagon would have blocked the view to the high altar, which could only have been overcome by their removal, necessitating reconstruction of the cupola.

The restless searching for ever bigger scale, which unites the stories of the Sienese and Florentine Duomos, had finally driven the architects beyond their powers. By 1355 the thin piers of the Duomo Nuovo in Siena had begun to buckle outwards, lacking sufficient buttressing from the side. Following the very negative report of Francesco Talenti, Benci di Cione and others (1356), the *capomaestro* Domenico di Agostino, brother of Giovanni di Agostino, the previous *capomaestro* in charge of the Duomo Nuovo, gave a report in which he claimed that to make all the changes advocated, including rebuilding the campanile and dome, raising the vaults of the cathedral and dismantling the pulpit and Cardinal Petroni's tomb, would cost 150,000 gold florins and would take a century to complete. Instead, the existing cathedral could be enlarged (by completing the new choir over the baptistery), decorated and opened for use in five years.[24] In this he was optimistic, but the job was done in around 20 years.

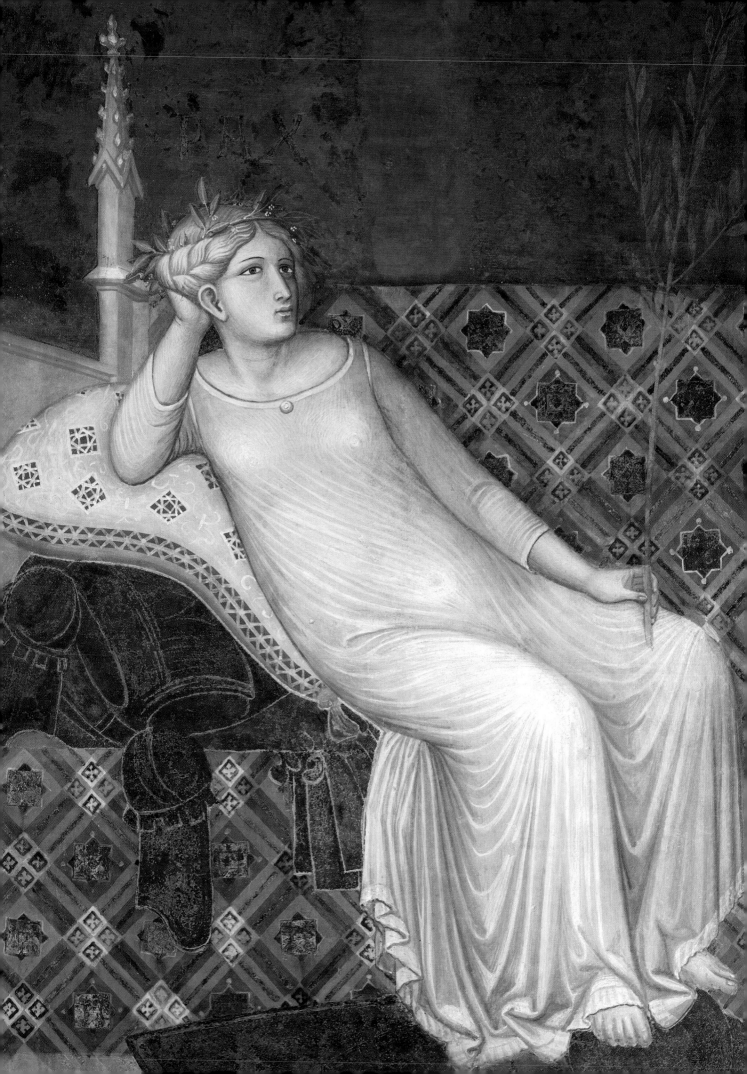

'Love justice, you who judge the earth': the paintings of the Sala dei Nove in the Palazzo Pubblico, Siena

In 1427 while preaching in Siena's Campo, Saint Bernardino (Plate 180) declared to his audience: 'you have it painted above in your palace, where to see Peace painted is a joy. And conversely it is a sadness to see War painted on the other side.'[1] Saint Bernardino's statement constitutes one of the earliest mentions of the cycle of frescoes executed by Ambrogio Lorenzetti within the Palazzo Pubblico. It also makes a number of succinct and revealing points about the function and content of these paintings. First, it suggests that the saint's audience – drawn from all classes and both sexes of the Sienese community – perceived the Palazzo Pubblico as its own and was familiar with the building's interior embellishment. Secondly, it refers to the subjects of the paintings in terms of contrasting opposites. Thirdly, by defining the appropriate human emotions to be experienced when viewing the two painted subjects, it implies that the paintings had a moral, didactic purpose.

The painted scheme to which Saint Bernardino was referring is situated in the Sala dei Nove, a large, rectangular room lying on the second floor of the south side of the west wing of the Palazzo Pubblico (Plate 181). The scheme is thus directly adjacent to the Sala del Consiglio, the earlier fourteenth-century painted decoration of which appears to have influenced certain iconographic details of the paintings in the Sala dei Nove.[2] Three walls of the Sala dei Nove are covered by frescoes executed in the fourteenth century, each wall containing a single painting enclosed by a wide, painted border punctuated by a series of painted medallions (Plates 181–183). Both the paintings and this painted framework, which was clearly conceived as integral to the painted scheme, incorporate a number of detailed inscriptions, those in the painting being in Latin and the vernacular and those in the framework in the vernacular. The fourth, southern wall of the room contains a deep window embrasure opening out onto a panoramic view of Siena and the surrounding countryside.[3]

One of the inscriptions, located in the lower border of the painting on the north wall, records in Latin, in large Roman letters, the name of the artist responsible for the execution of this painted scheme – Ambrogio Lorenzetti of Siena.[4] A brief and tantalizing indication of the circumstances of the commission for the paintings is given by documents that record seven payments, totalling the substantial sum of 171 gold florins, made to the painter between 29 April 1337 and 20 June 1340. Since the records describe the room for which the painter was paid to execute 'figures' as 'the room of the Lords Nine',[5] scholars have quite reasonably assumed that the patrons for the commission were the Nine, the magistracy of nine officials who, at this period, constituted the principal executive committee of Siena's communal government. In addition, it is notable that the commission involved the painting of a room that functioned as the principal meeting room of the Nine, a factor that undoubtedly determined the subject-matter chosen for the painted scheme.

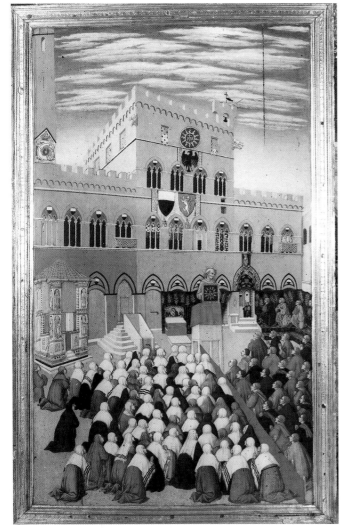

Plate 180 Sano di Pietro, *Saint Bernardino Preaching in the Campo*, fifteenth century, panel, Museo dell'Opera del Duomo, Siena. Photo: Lensini.

Plate 179 (Facing page) Ambrogio Lorenzetti, *Peace*, detail of *The Good Government* (Plate 184). Photo: Lensini.

Plate 181 General view, Sala dei Nove, Palazzo Pubblico, Siena, showing north and east walls (overall dimensions of the room in metres 14.04 x 7.70). Photo: Lensini.

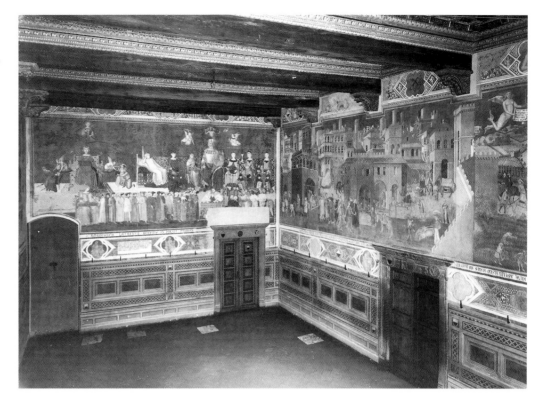

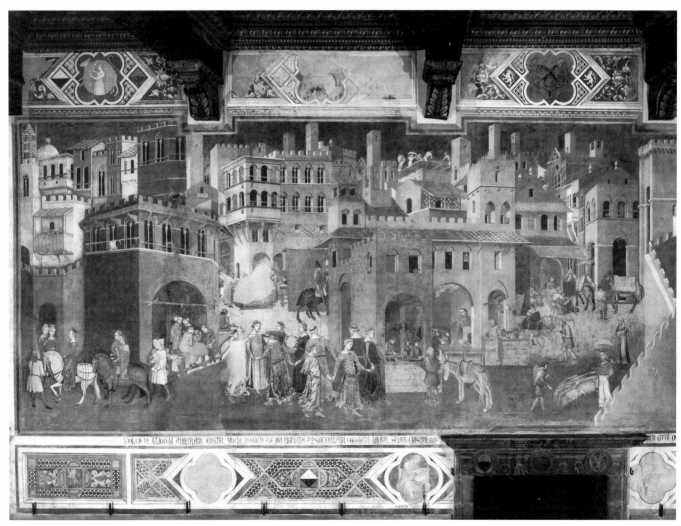

Plate 182 Ambrogio Lorenzetti, *The Good City*, 1337–40, fresco, east wall, Sala dei Nove, Palazzo Pubblico, Siena. Photo: Lensini.

Ambrogio Lorenzetti's mural scheme thus furnishes an exemplar of public, civic patronage of fourteenth-century art. Yet, in common with many fourteenth-century commissions, no documentary evidence survives to indicate either why such an act of public patronage occurred or the processes by which it was achieved. No contract has been found to inform us of the expectations that the Nine had of this commission. No record survives of how the painter reacted to his brief. Likewise, contemporary documents remain silent as to how the paintings were received and interpreted by their designated audience, and it is only in the fifteenth century that brief references to the painted scheme begin to occur. What do survive (albeit with some changes to their original state[6]) are the paintings themselves. Indeed, such is their presence and pictorial inventiveness that they have attracted much historical and art-historical comment and, due to their key political location, they have been the subject of a number of complex and highly ingenious interpretative studies.

This essay has three principal aims. First, it will analyse the different types of imagery deployed by Ambrogio Lorenzetti in this monumental pictorial scheme, taking into account the inscriptions within the paintings and their borders. Secondly, it will offer a critical analysis of a number of competing modern interpretations as to the meaning of the scheme. Finally, the essay will consider the extent to which such interpretive studies enhance our understanding of the ways in which the scheme as a whole was tailored to the requirements of its site and its original audience.

THE THREE PAINTINGS

The images and their Latin inscriptions

A good point at which to start a consideration of the Sala dei Nove's pictorial scheme is in *The Good Government*[7] on the short north wall, where the painter's name features conspicuously in the lower border (Plate 184). A first, fleeting impression of the painting is one of a series of imposing seated figures. Closer scrutiny allows the spectator to identify these figures individually by their Latin titles and to follow a sequential ordering from left to right of the figural scheme.

On the left appears an enthroned female figure (Plate 185), identified by the inscription around her head as a personification of justice.[8] Hovering above Justice is another female figure, identified as Wisdom (SAPIENTIA). This painted figure is portrayed holding in her right hand a balance, the scales of which are kept in equilibrium by Justice. On each of the scales appears an angel. The left-hand angel (labelled DISTRIBUTIVA – distributive justice) is shown in the act of beheading a kneeling figure and holding a crown over the head of another figure who holds a palm in his right hand. The right-hand angel (labelled COMUTATIVA – commutative justice), appears to allocate one cylindrical and two shaft-shaped objects to two kneeling men.

Two cords (one grey, one red) drop from scales to be joined and twined together by another seated female figure, who holds in her lap a carpenter's plane labelled concord (CONCORDIA), and thus represents a personification of that

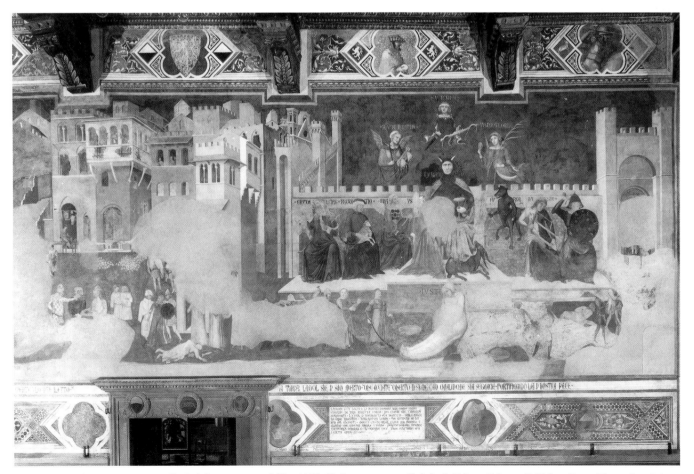

Plate 183 Ambrogio Lorenzetti, *The Bad Government and City*, 1337–40, fresco, west wall, Sala dei Nove, Palazzo Pubblico, Siena. Photo: Lensini.

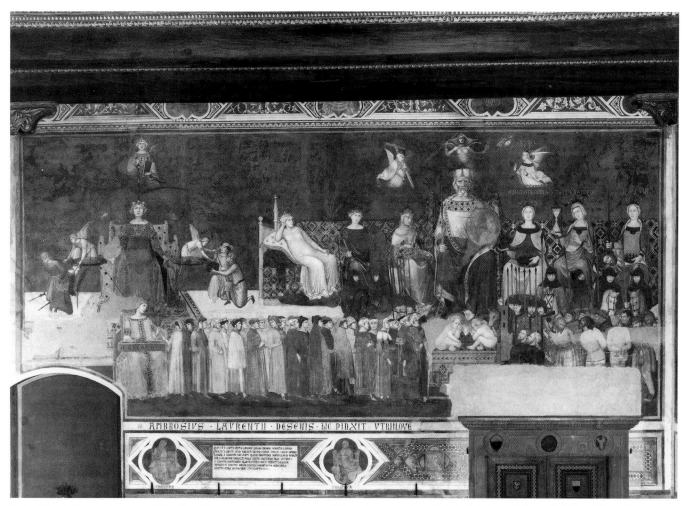

Plate 184 Ambrogio Lorenzetti, *The Good Government*, 1337–40, fresco, 774 cm long, north wall, Sala dei Nove, Palazzo Pubblico, Siena. Photo: Lensini.

virtue. She is shown in the act of handing the twined cord to a group of 24 men, who conduct it in dignified procession to a large-scale, seated male figure to whose right wrist the cord is knotted (Plate 184).[9] This figure, who with his sceptre appears in the guise of a ruler or presiding judge, wears a robe of black and white – the colours of the Sienese coat of arms shown on the *balzana*. In his left hand he is holding a shield, the gold surface of which had painted upon it an image of an enthroned Virgin and Child framed by two angels, each holding a candle. Around the rim of the shield is a very faint and fragmentary inscription.[10] At the feet of the ruler figure appears the Sienese device of the she-wolf suckling Romulus and Remus, a reference to the city's mythical foundation. On either side of the figure, as if seated on a bench, are six female figures who can be identified by the inscriptions above their heads as personifications of the four cardinal virtues and two other virtues (peace and magnanimity). Reading from left to right, the figures are, first, Peace (PAX), who is distinguished by her elegant, half-reclining pose and a white, close-folded, semi-transparent robe of classical derivation (Plate 179). This figure is further identified by other attributes intended to allude to the state of peace: a wreath of olive leaves on her head, an olive branch in her left hand, a discarded suit of armour beneath her cushion and a shield and helmet below her feet. Next to Peace appears Fortitude (FORTITUDO)

holding a sceptre and shield, and below her, as if to further emphasize the human quality that she represents, are two mounted knights (Plate 184). Next is Prudence (PRUDENTIA), who is depicted nursing a small black lamp with three flames and pointing to an abbreviated inscription which refers to the past, the present and the future (PRAETERITIM PRAESENS FUTURUM). To the right of the ruler figure appears Magnanimity (MAGNANIMITAS), whose quality of generosity is signified by her attributes of a crown and, on her lap, a dish filled with coins. Next is Temperance (TEMPERANTIA), who is depicted pointing towards an hour-glass. Finally, Justice (IUSTITIA) is portrayed for a second time, here shown grasping with her left hand a crown and with her right a sword, underneath the pommel of which lies a decapitated head.

The group of enthroned virtues is supplemented by a further three virtues who appear as hovering, disembodied figures situated above the ruler figure. They represent the three theological virtues: Charity (CARITAS), who, like Peace, is represented in antique garb and carries as her attributes a javelin and burning heart; Faith (FIDES), who is shown in profile, supporting a large cross; and Hope (SPES), who is shown staring intently upwards at a heavenly apparition of Christ. In the lower right-hand foreground, as counterparts to the procession of 24 male citizens, appears a group of

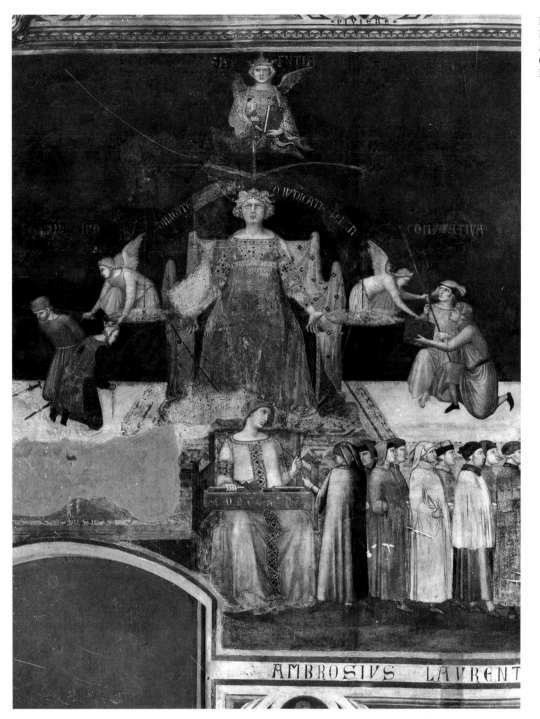

Plate 185 Ambrogio Lorenzetti, *Justice and Other Personifications*, detail of *The Good Government* (Plate 184). Photo: Lensini.

prisoners and their armed guards. Represented at the front of this grouping are two kneeling knights, who are shown in the act of presenting a miniature fortress to the enthroned ruler figure. Behind this pair appears a tightly packed group of soldiers, and behind the prisoners are further representatives of military might in the form of four mounted knights.

In direct contrast to the tightly knit figural scheme of the north wall, the mural on the long east wall – *The Good City* – presents an expansive, panoramic vista of a medieval city and its surrounding countryside (Plates 182 and 189). The two environments are separated from one another by a crenellated city wall and gateway which, with their

strongly delineated outlines, divide the painted composition almost into two. The depiction of the city (particularly in terms of its red brick buildings, impressive ecclesiastical dome and black and white campanile, and the statue of a she-wolf over the heavily fortified city gateway) bears a generic resemblance to the urban topography of Siena (Plate 186). The cityscape is further animated by numerous details of people engaged in activities closely associated with city life. Most striking in this respect is the group of nine figures in the centre foreground, who are shown arrayed in colourful and ornate garments and in the act of performing a dance to the accompaniment of a tambourine player (Plate 187).

Elsewhere are a procession on horseback (which, given the prominence of the young and finely attired woman on horseback, probably represents a wedding procession), a tavern full of customers, a shoemaker's shop, a teacher with an attentive audience, men and women carrying foodstuff or driving livestock and, high against the skyline, builders working upon a raft of scaffolding (Plate 188).

To the right of the city appears a panoramic view of countryside which, like its urban counterpart, is full of closely observed detail of patterns of cultivation, rural dwellings and rural activity (Plate 189). For example, there is a caravan of mules crossing a bridge and, beyond the mules, a peasant ploughing, a sower and two huntsmen with their hunting dogs. In the middle distance, meanwhile, harvesting is taking place (Plate 190). A variety of rural dwellings is portrayed, ranging from, on the left, a castellated building with a vine-covered pergola to a more humble group of farm dwellings in the middle of the scene. In contrast with the relatively cultivated countryside to the left and centre of this landscape, the countryside on the right is shown as sparser in terms of vegetation and human occupation. The panoramic vista includes an expanse of water with a town on its shoreline. This has been identified by an inscription as Talamone – the

much-coveted port on the Tuscan coastline that was acquired by Siena in 1303. Presiding over the countryside, and yet by virtue of her position also closely associated with the city, appears a female figure who is identified by an inscription as Security (SECURITAS). Strongly resembling a classical winged victory,[11] this figure is shown holding in one hand a small gallows with a hanged man and in the other a scroll inscribed with a number of verses (Plate 189).

Finally, on the west wall is a painting – *The Bad Government and City* – whose subject acts as a negative counterpart to the paintings on the north and east walls. It thus combines two kinds of pictorial scheme – one embodying abstract principles and the other portraying concrete scenes of urban and rural life (Plate 183). The task of deciphering the painting on the west wall is rendered extremely difficult by its very poor condition, in particular by the considerable loss of its paint surface.[12] On the right, portrayed against a backdrop of a crenellated wall are seven personifications of vicious and negative aspects of human behaviour, who thus form a direct contrast to the virtues portrayed on the north wall (Plate 191, cf. Plate 184). The central figure, labelled TYRAMNIDE (which is presumably an allusion to tyranny[13]), is, like the ruler figure in *The Good Government*, much larger than his

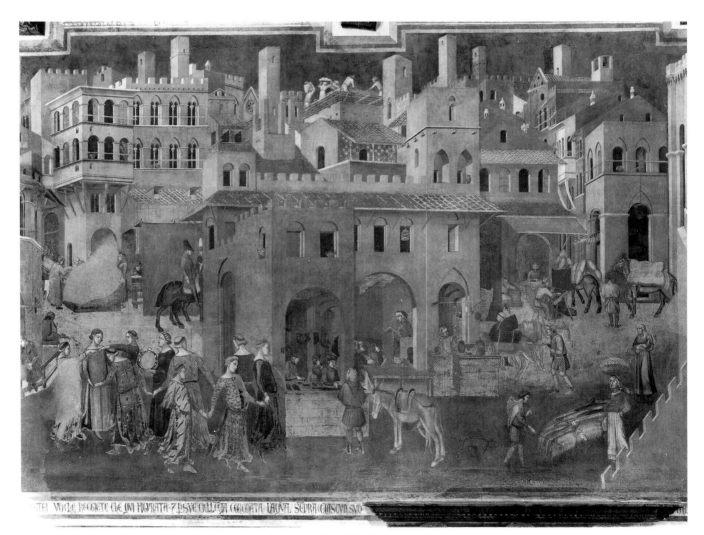

Plate 186 Ambrogio Lorenzetti, *The City*, detail of *The Good City* (Plate 182). Photo: Lensini.

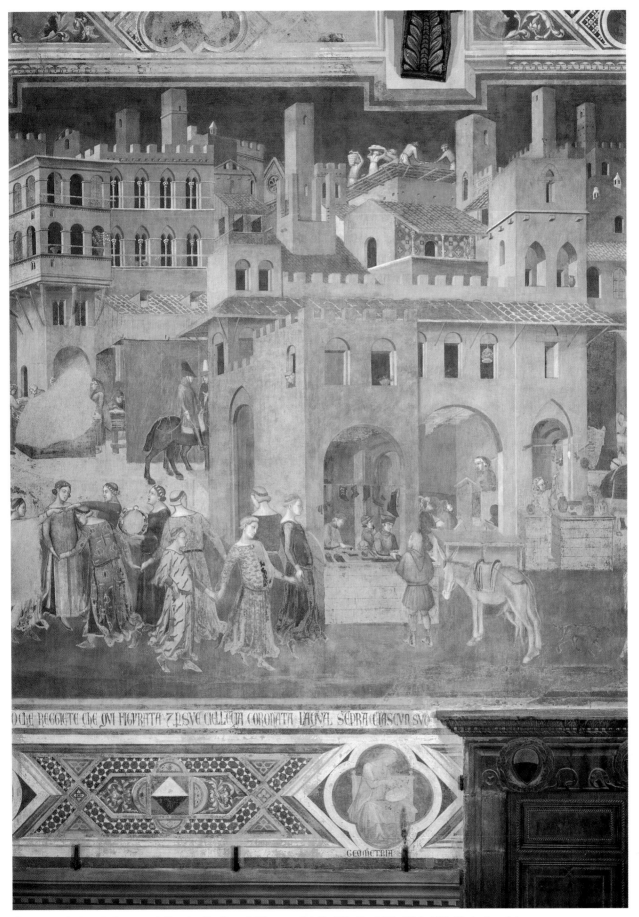

Plate 187 Ambrogio Lorenzetti, *Dancing Youths and Cityscape*, detail of *The Good City* (Plate 182). Photo: Lensini.

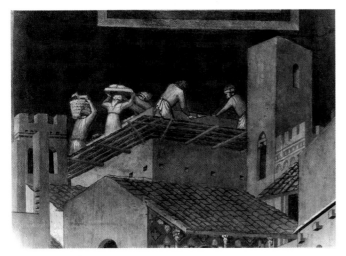

Plate 188 Ambrogio Lorenzetti, *Builders*, detail of *The Good City* (Plate 182). Photo: Lensini.

companions. This figure has been portrayed with a decidedly demonic appearance, having horns and sharp pointed teeth, and is shown wearing armour and a red cloak. In one hand he holds a gold object – possibly a poison chalice – and in the other a knife. Beneath his feet lies a goat. Among his companions, reading from left to right, are

Cruelty (CRUDELITAS), who is portrayed as a woman grasping a snake and tormenting a child; Treason (PRODITIO), portrayed as a man nursing in his lap a hybrid animal – a sheep with a scorpion's tail; Fraud (FRAUS), portrayed as a bearded figure with bat's wings and a claw foot; Fury (FUROR), portrayed as a black, hybrid beast, armed with a stone; Division (DIVISIO), portrayed as a woman with loose, dishevelled golden hair, arrayed in a parti-coloured white and black gown with the Italian words SI and NON (yes and no) emblazoned across the bodice, and in the act of wielding a huge, jagged saw; and War (with the Italian for war – GUERRA – inscribed on his shield), shown helmeted and with sword in hand. Above the central figure, in an analogous position to the three theological virtues in the painting on the north wall, are three further personifications of vice: in the centre, Pride (SUPERBIA), red horned and carrying a yoke and a sword; Avarice (AVARITIA), an old woman with two purses and a flail; and Vainglory (VANAGLORIA), carrying a reed, wearing a surcoat edged with gems and scrutinizing herself in a hand-held mirror. At the feet of the central ruler figure appears Justice, now no longer enthroned and active, but bound and with her scales broken on the ground beside her. Other violent acts perpetrated against both men and women are shown in the foreground, but due to damage are barely decipherable.

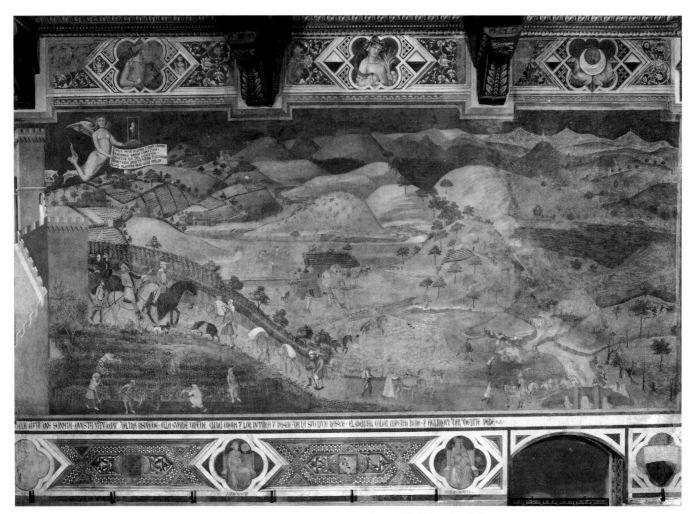

Plate 189 Ambrogio Lorenzetti, *The Good Countryside*, detail of *The Good City* (Plate 182). Photo: Lensini.

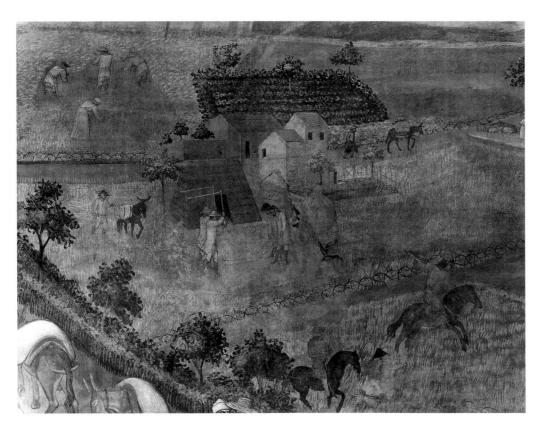

Plate 190 Ambrogio Lorenzetti, *The Reaping and Threshing of Corn*, detail of *The Good City* (Plate 182). Photo: Lensini.

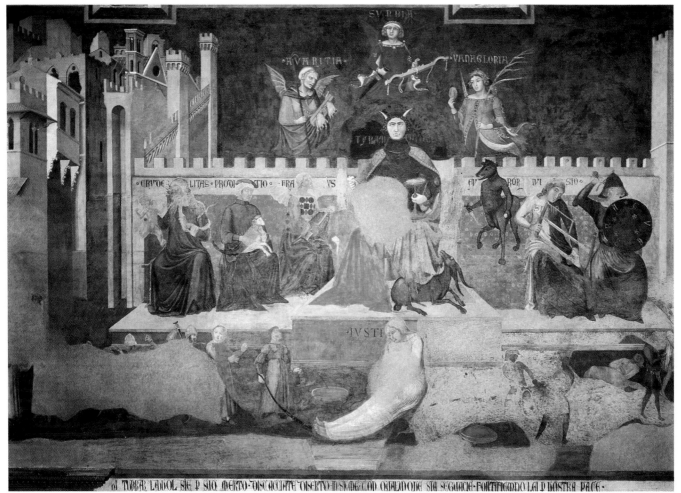

Plate 191 Ambrogio Lorenzetti, *Tyranny and Vices*, detail of *The Bad Government and City* (Plate 183). Photo: Lensini.

Plate 192 Ambrogio Lorenzetti, *The Bad City*, detail of *The Bad Government and City* (Plate 183). Photo: Lensini.

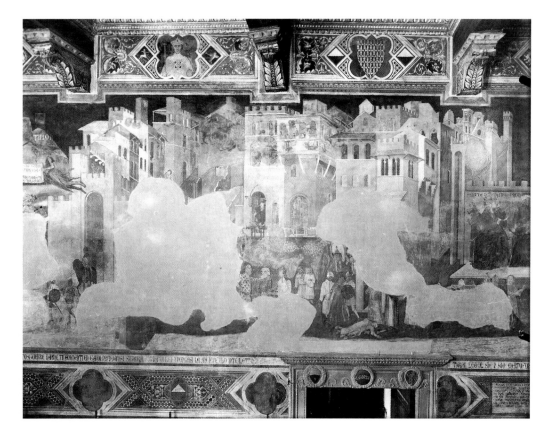

To the left another city and countryside are portrayed, but the human activities depicted within them are of looting, fighting and men assaulting women (Plates 183 and 192). Two soldiers abduct a struggling woman (Plate 193), others demolish a house with pick-axes. The only person shown at work is a blacksmith making weapons – instruments of war. The countryside is shown as uncultivated and desolate with, in one instance, a burning village and, in another, ruins on a hill. In a position equivalent to that of Security on the east wall, Fear (TIMOR) is represented as an old, gaunt woman, bearing a scroll with a lengthy inscription and threatening the devastated countryside with her sword (Plate 194).

Incorporated within the wide, painted borders of these three epic murals is a scheme of painted quatrefoil medallions, whose subjects have a bearing both upon the individual paintings that they frame and upon the painted decoration of the room as whole. On the upper borders of the three murals the medallions contain a series of personifications of the seven planets (with their associated zodiacal signs), the four seasons and heraldic devices of Siena and her political associates. Of the three medallions in the upper border of the north wall, only the medallion depicting the sun can still be readily identified. On the upper border of the east wall (Plate 182), reading from left to right, the

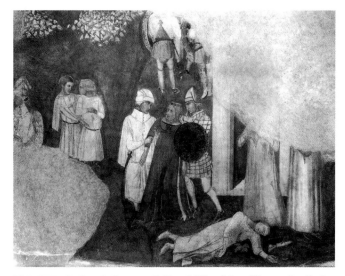

Plate 193 Ambrogio Lorenzetti, *Two Soldiers Seize a Woman*, detail of *The Bad Government and City* (Plate 183). Photo: Lensini.

Plate 194 Ambrogio Lorenzetti, *Fear*, detail of *The Bad Government and City* (Plate 183). Photo: Lensini.

Plate 195 Ambrogio Lorenzetti, *Venus*, detail of upper border of *The Good City* (Plate 182). Photo: Lensini.

medallions depict Venus (Plate 195); a badly abraded and therefore illegible figure (but in all likelihood once a personification of spring); the crossed keys of the papacy; Mercury; summer, as a woman with a garland, holding a scythe and a stock of wheat; and the moon, as a gold face over a silver crescent. On the upper border of the west wall (Plate 183), again reading from left to right, are Saturn; autumn, as an old man, holding black and white grapes and a branch; Jupiter; a badly abraded Angevin coat of arms; winter, as a bearded man, in profile, holding a snowball; and Mars, as a knight on horseback.

The medallions of the lower borders of the murals, meanwhile, portray in monochrome against a red background personifications of the liberal arts, philosophy and tyrants from antiquity. Thus, on the lower north border appear Grammar, teaching a child from a book, and Dialectic. A third medallion, depicting Rhetoric, was destroyed by the insertion at a later date of a doorway. On the lower east border (Plate 182) appear: Arithmetic (no longer visible); Geometry, holding a compass; Music (barely visible); Astrology, holding a sphere; Philosophy, holding a sceptre and three books; and the *balzana*. On the lower west border (Plate 183) only the medallion labelled NERO is still legible, but early sources identify three other of the medallions as once containing depictions of Antiochus, Geta and Caracalla.[14]

The texts in the vernacular

Clearly, in order to gain any reliable sense of the intended meanings of these paintings and their subjects, it is also essential to take into account the content of both the inscriptions that feature prominently within the painted borders of all three paintings and the inscriptions in the paintings themselves. In the paintings, texts in the vernacular are held by the personifications of security and fear (see the Appendix at the end of this essay). The content of the texts is, moreover, a particularly crucial consideration in the present context – that of an essay concerned with questions of patronage – since texts within paintings were

characteristically the preserve of those responsible for issuing the commissions, that is, the patrons.

Together with the visual evidence of the paintings, the formidable array of text provides a number of clues as to both the precise significance of the personifications portrayed within *The Good Government* and *The Bad Government* and the relevance of these personifications in relation to the urban and rural scenes depicted in *The Good City* and *The Bad City*. In particular, the evidence provided by the texts reiterates the characterization of the various personifications that is provided visually by the paintings, by highlighting two radically contrasting kinds of rule or government. The positive ideal evoked is that of a 'holy Virtue' (Appendix, A), which on the evidence of the texts as a whole can be identified with the virtue of justice, thus accounting for the imposing representation of justice in the left-hand portion of *The Good Government* (Plate 185). The negative alternative proposed by the texts is that of tyranny (Appendix, C1–3), which is clearly to be associated with the huge, satanic figure represented in *The Bad Government* (Plate 191). The vernacular texts belonging to all three paintings also offer strong corroborative evidence that the various kinds of human activity depicted should be seen as the consequences of the rule either of justice or, conversely, of tyranny.

In the case of *The Good Government*, such consequences are stated explicitly in the text in the lower border (Appendix, A1) and then rendered pictorially within the figural composition (Plate 184). For example, the attribute of justice, that it 'induces to unity the many souls', is rendered by the representation of concord and the closely related group of citizens. Similarly, the textual references to the 'Common Good' as a 'Lord', its characterization as a governor and its close relationship to the virtues are all tellingly conveyed in pictorial terms by the representation of the enthroned ruler figure, his female companions and the depiction of military tribute before him.

In the case of *The Good City*, the long text that runs the entire length of the lower border of the painting, together with the text held by Security, offer a broad description of the rule of justice and its beneficial consequences for the Commune. Thus, in a city where justice is preserved and honoured, all will be fed and defended (Appendix, B1). Similarly, if justice is sovereign, then all can travel and work the land without fear (Appendix, B2). Such sentiments, in turn, can be related to the network of associations surrounding the personification of security and to the tranquil scenes of commercial and agricultural activity portrayed within the painting (Plate 182).

Similarly, the vernacular texts belonging to *The Bad Government and City* all offer graphic descriptions of the dire consequences of allowing tyranny to prevail over justice (Appendix, C1–3). The gloomy statements are amply reiterated in visual form by the activities graphically portrayed within both the badly governed city (Plate 183) and the devastated and war-torn countryside.

Finally, it should be noted that, in the case of the texts along the lower borders of both *The Good City* and *The Bad Government and City*, there is a strong sense that a specific audience is being addressed and given practical advice. The text along the lower border of *The Good City* refers to 'you

who are governing' and urges this audience to 'behold' the various benefits for the city if justice is preserved (Appendix, B1). The damaged text along the lower border of *The Bad Government and City*, meanwhile, similarly suggests that, in order to secure peace for themselves and their city, those charged with government should endeavour to keep each citizen subject to justice and ensure that 'whoever wishes to disturb her' should be 'banished and shunned together with all his followers' (Appendix, C2).

Analysis of the paintings in the Sala dei Nove and their accompanying texts thus reveals a number of essential features of their construction. First, they are immensely rich in pictorial detail. Secondly, they intricately combine text and pictorial imagery. Thirdly, the balance between text and image shifts between each of the three murals. Whilst *The Good Government* and *The Bad Government* are replete with inscriptions that identify and expound the significance of the allegorical figures portrayed there, *The Good City* and *The Bad City* rely much less on texts and make their impact principally by highly descriptive pictorial imagery.[15] Finally, it is abundantly clear from the interaction of text and image that the paintings were intended to perform a role at once both didactic and exemplary. It is to this latter consideration that the essay now turns.

THE MEANINGS OF THE PAINTINGS

The Good Government

Whilst the texts, if open to varying interpretation, are relatively straightforward in their message, Ambrogio Lorenzetti's paintings are much more expansive in their descriptive detail and thus more susceptible to a greater variety of meanings being attributed to them. Much attention has been focused upon *The Good Government* on the north wall and the politico-philosophical programme that it is thought to encapsulate (Plate 184). The most influential thesis is that of Nicolai Rubinstein, who proposes that the meaning of the pictorial scheme turns on Aristotelian theories of justice as interpreted and adapted by medieval scholars and jurists. More recently, Quentin Skinner has proposed instead that the scheme's inspiration came from a more specific and local body of political literature, which began to flourish in Italian city republics in the early years of the thirteenth century. The authors of these rhetorical treatises had little direct acquaintance with the moral and political works of Aristotle, but relied primarily on the Roman authors Cicero, Seneca and Sallust.[16]

Such critical debate has facilitated a fuller perception of the range of possibilities as to the political significance of the allegorical figures portrayed in Ambrogio Lorenzetti's murals and their relationship with one another. It also acquaints the student of these murals with a rich body of texts on the political theory of the day, texts that might, indeed, have been utilized by the painter and those who advised him. Such texts include both major works of medieval scholasticism, such as the treatises of Saint Thomas Aquinas (particularly the *Summa Theologiae*), and also minor but more local political treatises, such as the encyclopaedic *Li livres dou tresor* written in the

early 1260s by the Florentine writer Brunetto Latini. In addition, from within Siena itself, the *Breves officialium communis senensis* of 1250, together with the civic constitution of 1262 originally written in Latin and its extended vernacular version of 1309–10,[17] all of which were compiled by Siena's governors, provide an invaluable indication of both the political ideology informing the city's government and the specific duties expected of its officials.

As noted above, the inscription below *The Good Government* guides the viewer to attribute the greatest significance to the personification of justice. Within the pictorial scheme Justice is shown twice, her presence made far more emphatic on the left-hand side of the composition by her portrayal as a dignified, enthroned figure and by the biblical text that forms a halo around her head – a text that occurs frequently in the political treatises of the Italian Communes (Plate 185). She is portrayed, moreover, as the person who maintains the balance of the scales of justice and who is the source from which the rope of concord ultimately derives. Above her and on the same level as the theological virtues hovers Wisdom. The presence of this personification and her significance in relation to the other figures is a matter of speculation. For Rubinstein she acts as a pictorial exemplification of the belief, commonly held among medieval civil lawyers, that wisdom should be the guiding principle of government. In Rubinstein's view, she also alludes to the proposed relationship, as set out in Aquinas's *Summa Theologiae*, between, on the one hand, divine and natural law and, on the other, human law. Skinner, by contrast, maintains that Aquinas did not conceive of *legal* justice as a direct product of wisdom and proposes that, in representing Wisdom hovering above Justice, the painter, constrained by pictorial requirements, could only treat his literary sources with a degree of licence.[18] What is apparent from the painting, however, is that the figure of Wisdom, by virtue of being *above* that of Justice and therefore closely associated with the three theological virtues, has been conceived as a heavenly apparition. In addition, a text from the Book of Wisdom occurs within her close vicinity. Evidently, the inclusion of the figure of Wisdom was intended, at the very least, to indicate that Justice should be seen as receiving both guidance and inspiration from a specifically heavenly source.[19]

The actions and identities of the two angels on the scales of Justice have likewise been the object of debate. Whilst the precise nature of their activities is open to interpretation, it is clear that the angel on the left (labelled distributive justice) is portrayed in the act of beheading a man. As Rubinstein himself admits, neither Aristotle nor Aquinas included punitive justice under their discussions of distributive justice.[20] Indeed, in his commentary on Aristotle's *Nicomachean Ethics*, Aquinas identifies distributive justice as an allocation of a common stock of things to be divided among those who share a bond of citizenship. This definition of distributive justice would seem a more appropriate description of the activities of the angel on the right (albeit labelled commutative justice), who appears to be allocating to one figure an object which could represent a cylindrical container for money and to the other figure two staffs that signify high office. Aquinas defined commutative justice in terms of recompense, and is thus broadly in correspondence

with our modern-day usage of the word. The idea of recompense or reward arguably finds a closer pictorial counterpart in the activities of the angel on the left (albeit labelled distributive justice), who is shown awarding a crown to one person, who also holds a victor's palm, and punishing another by cutting off his head.[21] Since the activities of these two groups do not appear to correspond very well to Aristotelian and Thomist interpretations of distributive and commutative justice, Skinner has quite reasonably proposed that an explanation for the activities can be found more readily in Latini's *Li livres dou tresor*. In this treatise, the author, relying on idiosyncratic paraphrase of the *Nicomachean Ethics* by the twelfth-century Muslim scholar Averroes, interprets justice essentially in terms of rectifying inequalities, citing such examples as fair exchange between tradesmen, reward of money and honours, and rectification by execution. In Skinner's view, the two angels are both represented as engaged in this more generalized form of justice.[22] By all accounts, what is apparent is that if the titles are original they furnish an example of the painter either misunderstanding or ignoring the cluster of Aristotelian and Thomist concepts surrounding the two forms of justice and choosing instead to portray a broader, and at a purely local level perhaps more familiar, picture of the kinds of activity that the administration of justice was believed to encapsulate.[23]

By being vertically aligned to the figures of Justice and Wisdom, the seated figure of Concord, with her striking attribute of a carpenter's plane, is closely associated with these figures. She is also related to Justice by virtue of her bringing together of the two hitherto separate cords of Justice's scales. Furthermore, by being represented as handing the now-twined cord to the first of the procession of 24 citizens, she initiates the integration of the entire figural group of Justice and her counterparts with that of the ruler figure and his virtuous companions (Plates 184 and 185). As Skinner has remarked, the carpenter's plane symbolizes the fact that in order to achieve concord differences must be smoothed out, a message reiterated in the political treatises of the Italian Communes, where the only way to achieve peace was by ensuring that no-one pursued his or her own ambitions at the direct expense of others.[24] Arguably, it is possibly for this reason that the eye-catching figure of Peace appears as the virtue furthest to the left of the ruler figure and therefore the one closest to Justice and Concord (Plate 184). The striking device of the twin bonds of concord also features in contemporary political treatises, and, indeed, in Latini's poem *Il tesoretto* the author presents a strikingly analogous poetic metaphor, stating: 'All in common should pull together on a rope of Peace and good deeds.'[25]

As their costumes indicate, the 24 figures in procession are clearly intended to represent male members of the Sienese community and, more precisely, those citizens who were deemed fit to govern. It is of interest that 24 figures are represented rather than nine, the number of the magistracy that awarded the commission to the painter. The 24 figures could conceivably represent the Nine's predecessors, a magistracy of 24 citizens (1236–70), who were pledged to control the political influence of Siena's noble families. Their depicted presence would thus situate the Nine within a

continuous tradition of popular government.[26] In all events, the ordering of the figural scheme makes it clear that Justice should be perceived as directing the imposing ruler figure through the mediation of the citizen body.

The precise identity and significance of the ruler figure is arguably more complex than at first appears. The figure is portrayed in a robe of black and white, the heraldic colours of the Sienese *balzana*. At his feet appears another of Siena's emblems – the wolf. Around his head were originally the letters C.S.C.V., which form the initials of the Latin words *Commune Senarum Civitas Virginis* (the Commune of Siena, city of the Virgin), a designation that also featured on Sienese coins from 1279 onwards.[27] The figure can, therefore, plausibly be identified as a personification of the Commune of Siena. However, Rubinstein has argued that the figure is not only a personification of the Commune of Siena but also of the 'Common Good' (*ben comune*) referred to in the text in the border (Appendix, A1). Rubenstein argues that the concept of the common good as a basis and criterion of good government achieved unprecedented importance within the Italian city republics after the translation in 1260 of Aristotle's *Politics* into Latin. In his commentary on the *Politics*, Aquinas utilizes an Aristotelian adage, which he renders as: 'The good of the community … is better and more holy than the good of the individual.'[28] For the Italian city republics the Aristotelian concept of the common good represented a means of securing civic peace and unity without recourse to despotism. It also constituted a politically articulate alternative to the claim that only an autocratic ruler could bring salvation to cities torn by faction and social struggle. By the early fourteenth century, therefore, it was a commonplace in the political thought of the Communes that only by placing common welfare above private interest could internal peace and economic prosperity be secured. Neglect of the common good, conversely, could only lead to civic strife and the decline of economic prosperity. In Rubinstein's view, the term *ben comune* in the text in the border of the painting of *The Good Government* has clear overtones of 'the good of the Commune', a terminological ambivalence which suggests that Ambrogio Lorenzetti may have intended to conflate the idea of the Sienese city state and the concept of the common good within this one personification.[29]

The plausibility of such an identification of the ruler figure with both *ben comune* and Siena receives further endorsement from two painted wooden book covers designed to enclose the city's accounts. On one, attributed to Ambrogio Lorenzetti, the figure of the ruler is again portrayed dressed in the colours of Siena with the she-wolf at his feet and a shield carrying the initials of the Latin title of the Commune of Siena held in his left hand (Plate 196). On the other, later cover the same figure is shown in the company of male representatives of Siena's community, who, like those in the group in Ambrogio Lorenzetti's mural painting, are linked to the ruler figure by their mutual action of carrying a cord (Plate 197).[30]

Skinner also locates the significance of this magisterial figure in its close association with the procession of Sienese citizens. In his view the ruler figure is represented in such a way as to suggest that he must wield his sceptre according to the dictates of justice and the will of the citizen body as a whole (Plate 184). To support his interpretation, Skinner cites

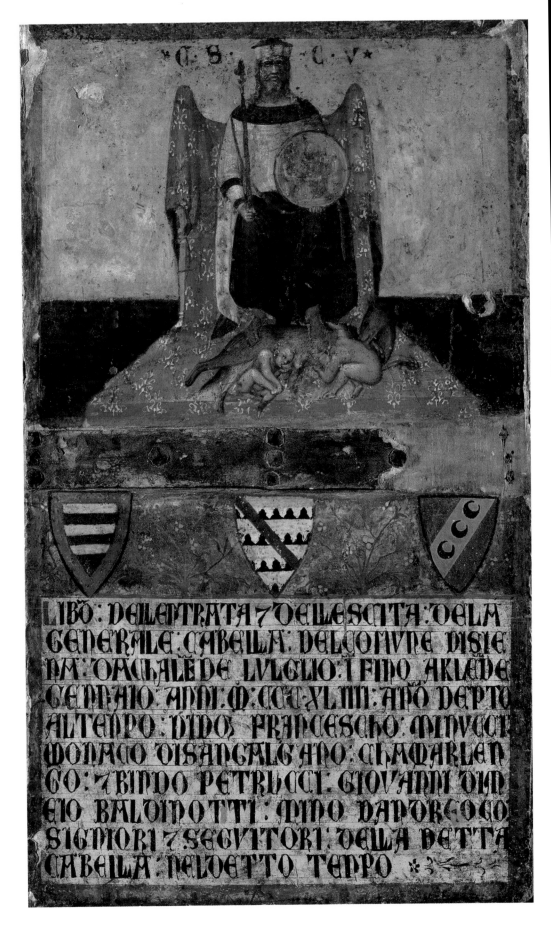

Plate 196 Attributed to Ambrogio Lorenzetti, *The Commune*, 1344, tempera on panel, 41.8 x 24.7 cm, cover of an account book for the magistracy of the Gabella, Archivio di Stato, Siena. Photo: Lensini.

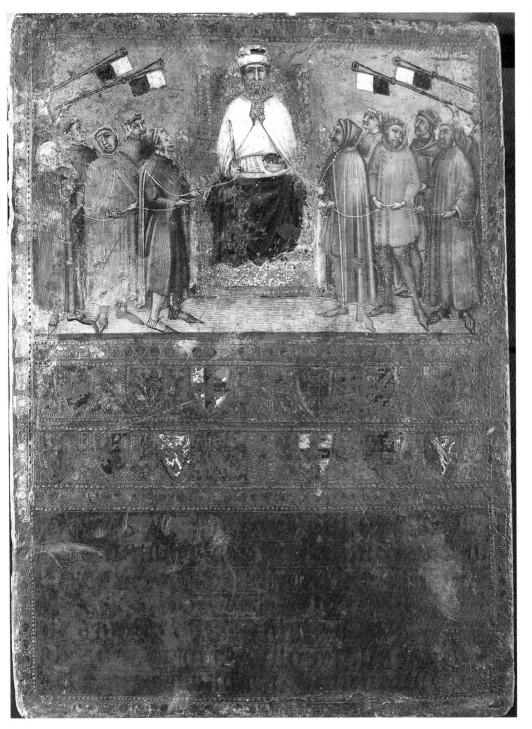

Plate 197 Anonymous, *The Commune and the Citizens of Siena with the Rope of Concord*, 1385, tempera on panel, 43.8 x 31.5 cm, cover of an account book for the magistracy of the Biccherna, Archivio di Stato, Siena. Photo: Lensini.

Cicero's *On Duty*, a text in which the magistrates bear in their own persons the *persona* of the city. Thus, for Skinner, the ruler figure constitutes a personification not only of both the common good and the Commune of Siena, but also of the type of magistracy that Siena needed to elect if the dictates of justice were to be followed and the common good secured.[31]

These interpretations of this figure also place Ambrogio Lorenzetti's painting firmly within a specific iconographic tradition. There are two examples in particular which, since each of them once formed part of a civic monument with comparable political functions to the Sala dei Nove, are especially worthy of consideration. Giorgio Vasari describes a

lost painting by Giotto in Florence's Palazzo del Podestà (the present-day Bargello):

> in the great hall of the Podestà of Florence, he [Giotto] painted the commune … in the form of a judge with a sceptre in hand; and also represented him seated, and above his head he placed level scales for the just decisions delivered by him, when aided by the four Virtues, which are Fortitude with the soul, Prudence with the laws, Justice with arms, and Temperance with words.[32]

The second example is to be found among the sculpted reliefs that celebrate the political achievements of Bishop Tarlati, the

despotic ruler of Arezzo. In this case, a significantly different set of political ideals from those that Ambrogio Lorenzetti and his patrons were endeavouring to celebrate is at stake. Although it celebrates the personal autocratic rule of Tarlati, one of the reliefs represents *The Commune Ruling* (*Il Comune in signoria*), showing a figure who, in terms of his age and his sceptre and orb, is very similar to Ambrogio Lorenzetti's ruler figure (cf. Plates 184 and 198). As in the Sienese painting, the consequences of effective rule by the Commune are conveyed by the figures of a kneeling petitioner and two men being executed. As appropriate to the seigneurial government of the bishop, Tarlati is portrayed beside the ruler figure with three of his counsellors. In order to further emphasize the dependency of the Aretine Commune upon the personal power of the bishop, another relief set to the immediate left of this one shows *The Commune Stripped* (*Il Comune pelato*), where the figure of the ruler is represented in isolation and set about by people who rip at his hair, beard and clothing (Plate 199).[33]

The depiction of the virtues in *The Good Government*, although of interest in various ways, is less problematic in terms of their intended meaning. The association of rulers with the practice of human virtues, and thereby with the Christian allegorical tradition of the three theological and four cardinal virtues, was a commonplace within both contemporary political literature and contemporary art.[34] It is of interest that Charity is shown with a javelin and burning heart, attributes that fourteenth-century artists had bestowed on this figure in order to signify this virtue's love of God (Plate 184).[35] Indeed, throughout this painting allusions are made to specifically religious concepts, clear evidence of the constant blurring of the sacred and the secular within fourteenth-century society. The nine virtues with whom the ruler figure is so closely associated may well have been chosen as an allusion to the Nine themselves, as well as a visual reminder of the civic values that they had sworn to uphold.[36] It is notable, however, that the four cardinal virtues here carry strikingly different attributes from other

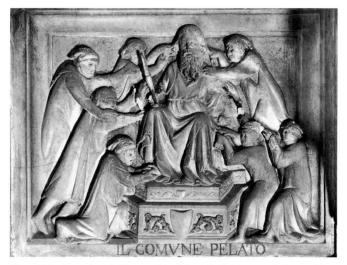

Plate 199 Agostino di Giovanni and Agnolo di Ventura da Siena, *The Commune Stripped*, 1330, relief on the tomb monument of Bishop Guido Tarlati, Duomo, Arezzo. Photo: Alinari.

contemporary representations of them, such as those in Giotto's mural scheme within the Arena Chapel, Padua and those on the reliefs of the Florence Campanile. However, as Skinner notes, Latini's *Li livres dou tresor* provides a source for at least three of these virtues' unusual attributes: Prudence is described with a lamp to show the other virtues the way, Temperance as enjoying the quality of measuring time and Fortitude as serving 'as a shield and defence of man'. Furthermore, Latini associates all four cardinal virtues with the precious gemstones that feature on the costumes of Ambrogio Lorenzetti's four virtues.[37]

The assembly of Christian virtues in the Sala dei Nove has been increased by the inclusion of the personifications of two further virtues, namely magnanimity and peace. In the case of the former, it is appropriate, given the virtue that is personified, that the figure is placed in close proximity to the ruler figure and to the two supplicant knights (Plate 184). In terms of her pivotal position within the figural composition and her striking costume and reclining pose, Peace was clearly intended to be a figure of some significance for the meaning of the painting as a whole. In addition, she has below her feet emblems of warfare (Plate 179). Ambrogio Lorenzetti here deploys a pictorial device that was well established in Christian art as a means of signifying triumph over a negative quality. The figure, therefore, represents peace secured by military victory – a reading that receives ample confirmation from the presence of both armed and captive men within the painting. For Rubinstein, the full significance of this figure is best gauged by reference again to the political philosophy of Aquinas and his successors, in which justice and common good are closely connected with concord and peace. For Skinner, however, once again statements within thirteenth- and fourteenth-century civic treatises to the effect that the goal of good government is the preservation of peace provide a source closer to both the painter and his patrons.[38]

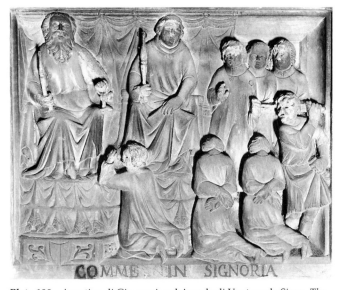

Plate 198 Agostino di Giovanni and Agnolo di Ventura da Siena, *The Commune Ruling*, 1330, relief on the tomb monument of Bishop Guido Tarlati, Duomo, Arezzo. Photo: Alinari.

The Good City

The mural on the east wall of the Sala dei Nove (Plate 181) has

probably attracted as much scholarly attention as its counterpart on the north wall. Opinion has been divided as to whether its greatest significance lies, on the one hand, in its descriptive and narrative powers or, on the other, in its alleged allegorical content. In support of the latter view, Uta Feldges-Henning has observed that certain of the activities shown in the countryside are those associated by contemporaries with the labours of the months, and more especially with those practised during the spring and summer – the two annual seasons that are represented in the upper border of the painting (Plate 182). She thus identifies viniculture (March), sowing (April), riding (May), ploughing and stock-raising (June), grain harvesting and fishing (July), threshing (August), and hunting (September) (Plate 189).

These, however, account for only some of the human activities depicted within the painting, and Feldges-Henning therefore proposes that another category of human activity, the mechanical arts, defined in medieval scholasticism as useful and necessary to human life, is also depicted within the painting. Thus, the tailor at his bench, the dyers and the wool-sorter under the arch, and the shoemakers in their shop represent *Lanificium* (specifically the manufacture of woollen cloth but also of other kinds of goods); the goldsmith's workshop and the five workers building a house represent *Armatura* (metal-work and the building trade); the many examples of buying and selling and transport of goods represent *Navigatio* (travel and commerce by land and water); the ploughing, sowing, harvesting and vine-growing, the peasants with their livestock, and the country gardens and city plant pots represent *Agricultura* (agriculture); the hunt, bird-catching, fishermen and the cooking implied by the tavern represent *Venatio* (hunting and fishing); the spice-seller and teacher with adult pupils represent *Medicina* (the practice of medicine and learning); and the group of dancing and music-making figures represents *Theatrica* (theatre and recreation) (Plates 182 and 186).[39]

Jack Greenstein, meanwhile, whilst accepting Feldges-Henning's arguments that the painting represents the labours of the spring and summer seasons, expands upon a point made by an earlier cultural historian, Fritz Saxl, that the painting also includes representatives of the Children of the Planets. Greenstein points out that nearly all the occupations associated with the moon are represented by the spinning, teaching, reading, goldsmithing, begging and general mercantile activities portrayed within the town and also by the liberal arts represented in the lower border of the painting. The Children of Venus also feature in the form of weavers, sewers, and falconers and in the bridal procession and dancers. Since in the upper border Venus is paired with the sign of Taurus (Plate 195), an association that, according to medieval astrological lore, signified spiritual as opposed to carnal love, the bridal group and dancers may have been included in order to personify the chaste, legitimate love of marriage, friendship and sociability.[40] By contrast, the harsh seasons of autumn and winter and the fiercer pagan deities of Mars, Saturn and Jupiter are portrayed in the upper border of *The Bad Government and City*.

The suggestions that the labours of the months, the mechanical arts and the Children of the Planets have deliberately been included are attractive for two reasons. First,

this would furnish an explanation for the inclusion of the representations of the planets, seasons and liberal arts within the borders of the painted scheme. Secondly, it firmly places Ambrogio Lorenzetti's painting within a tradition of civic artistic enterprise which specifically sought to encompass representations of all branches of human activity and knowledge (Plate 200).[41]

The group of dancers and the tambourine player have, due to their prominence and colourful costume, attracted particular attention from scholars (Plate 187). Although they have traditionally been assumed to be dancing maidens, it is more likely in view of their physiques, short skirts and hairstyles that they are, in fact, young men. Given their activity and their festive garb, they probably represent *guillari*[42] – itinerant professional entertainers, who were a familiar feature in fourteenth-century Siena. Indeed, certain rubrics in the constitution of 1309–10 attempt to control and restrict their activities. Why these itinerant entertainers, who were thus the object of government restrictions, have been included in the painting is another matter. It has been suggested that they may be intended to allude to the value of mutual camaraderie, an interpretation that, if correct, would correspond very well to the message of concord and unity spelt out so clearly in *The Good Government*.[43] In all events, given the overall tone of the painting, this group was clearly intended to convey a positive message – analogous to that of the trio of dancing figures beneath Giotto's *Justice* in the Arena Chapel (Plate 201) – which possibly alluded to contemporary medical theory that good health was connected with music, dance and marriage.[44]

Ambrogio Lorenzetti's depiction of the city and its surrounding countryside has also been the object of much scholarly speculation. Is it, for instance, intended to represent Siena or not? Certainly, its hilltop situation and the style of its architecture would suggest that this is the case, yet the topographical accuracy of certain details is open to question.[45] It is significant, however, that within *one* painting Ambrogio Lorenzetti represented both a city and its countryside and also portrayed a series of mutually reciprocal activities going on between them. He thus put into pictorial form the strongly held belief of Italian Communes that the *contado* was an extension of the city and should be of benefit to its citizens. It is striking, therefore, that the countryside is conceived in terms of cultivated and fruitful fields, abundant water and a paved road to the city crossing a well-maintained bridge. Such details were all highly relevant to Siena's government officials, who were pledged by the city's constitution to supply food and water to the city, maintain roads and bridges for purposes of commerce and facilitate the continued political domination of the *contado*.[46]

As if to reinforce this city-based set of priorities, the painter has privileged the city in a number of different ways. Not only is it the centre of the most intense human activity, but, as John White observes, it also acts as the centre of the pictorial light and the beginning of the pictorial recession. Thus, it is from the centre of the city (where the youths are shown dancing) that the painted light is depicted as shining out to left and to right onto the city's buildings, consequently (unlike the other paintings on the north and west walls) contradicting the natural flow of light from the window on the south wall.[47]

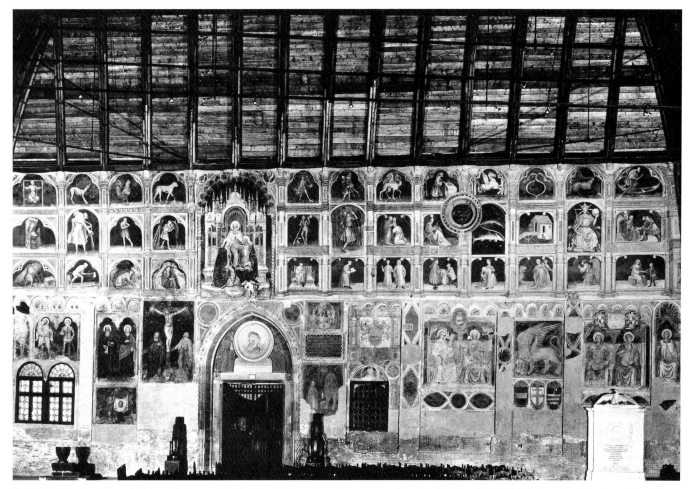

Plate 200 East wall mural, Salone, Palazzo della Ragione, Padua, showing, among other details (from left to right), *Aquarius*, *The Coronation of the Virgin*, *The Labour of the Month for February*, *Pisces* and *Jupiter*, fifteenth-century repainting of early fourteenth-century mural attributed to Giotto. Reproduced by courtesy of Musei Civici Padova, Gabinetto Fotografico.

The group of youths and the space that it occupies also features as the centre of the painting's perspective. The horizontals of the buildings established by the roof lines (seen from a realistically low viewpoint) and the cornices all slope down left or right in gentle recession from this centre point. Similarly, all the architectural features depicted in the countryside diminish in proportion to their relation to the city.[48]

As asserted by the initials around the head of the ruler figure on the north wall, Siena was considered within Sienese civic ideology to be the city of the Virgin Mary. The association of the city with the spiritual was a powerful one, which received further impetus from the widely held notion of Siena as a copy of the heavenly Jerusalem.[49] Indeed, according to early accounts, when Ambrogio Lorenzetti was commissioned to paint a now-lost monumental map (belonging to the *mappae mundi* iconographic type) for the walls of the Sala del Consiglio, next door to the Sala dei Nove, he apparently placed Siena and its *contado* and not, as was customary, Jerusalem at its centre.[50] It seems, therefore, that Hans Belting may well be correct that in the Sala dei Nove Ambrogio Lorenzetti intended first to describe an ideal city and then to ensure that this ideal city was understood to be Siena.[51]

The Bad Government and City

Due to its fragmentary condition, *The Bad Government and City* has received less critical attention than the allegorical paintings on the north and east walls of the Sala dei Nove (Plate 183). Scholars have rightly interpreted it in terms of the antithesis that it presents to the figural composition and scenes of human activity on the north and east walls. It thus follows the iconographic tradition firmly established by such pictorial schemes as the Tarlati tomb monument in Arezzo and the programme of virtues and vices in the Arena Chapel, Padua (Plates 198, 199, 201 and 202). The principal figures are the gigantic and demonic figure of Tyranny and the despondent figure of Justice who, unlike her triumphant counterpart in *The Good Government*, is no longer capable of constructive action (Plate 191). The nine other vices portrayed around the figure of Tyranny, which personify aspects of tyrannous government, do not conform to the traditional seven deadly sins, but seem rather to have been chosen with a very specific political application in mind. Aristotelian political theory, adapted to contemporary conditions within Italian city states, perceived tyranny as political oppression either by an individual or by the city's own nobles and magnates.[52] Thus, Division is dressed in black and white, the

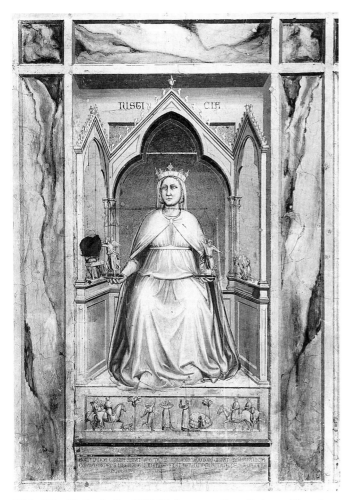

Plate 201 Giotto, *Justice*, 1304–13, fresco, south wall, Arena Chapel, Padua. Reproduced by courtesy of Musei Civici Padova, Gabinetto Fotografico.

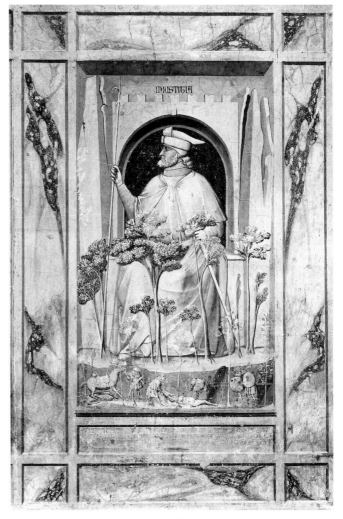

Plate 202 Giotto, *Injustice*, 1304–13, fresco, north wall, Arena Chapel, Padua. Reproduced by courtesy of Musei Civici Padova, Gabinetto Fotografico.

heraldic colours of Siena, but unlike their application on the robes of the ruler figure on the north wall, the colours are here conceived as divisive, since the Italian words SI and NON appear upon Division's parti-coloured robe. She saws at her flesh with a toothed saw – an apt pictorial metaphor for Sallust's description of civic discord tearing at the body politic, a phrase much loved by the authors of civic treatises.[53] Division's hair – loose and dishevelled – presents a striking contrast to the braided hair of Concord and of Peace (cf. Plates 179, 185 and 191). She thus embodies the dangers that Siena's governing regime associated with faction and sedition. The close companions of Division – Fury and War – similarly embody vices associated with civic faction and sedition. The former is portrayed in bestial form, with stone in hand, and is thus closely associated with the lawless, brutish mob armed with stones which is roundly excoriated in many civic treatises. Division's other close companion is identified as GUERRA – War. The use of the vernacular for this title in contrast with the Latin used for the titles of the other allegorical figures, together with the Italian words SI and NON on Division's robe, may indicate that these two personifications, along with Fury, represented concrete perils and threats of direct concern to the painting's first audience –

the magistracy of the Nine and their close political political associates and allies.[54]

The consequences of tyranny are further spelt out by the now-fragmented action below these enthroned vices – a direct contrast to the orderly and unified procession of the citizens in *The Good Government* – and in the scenes of the devastated city and countryside that occupy the remainder of the west wall. As White points out, in order to convey both the effects of the rule of tyranny and the intensely negative feeling that such a concept would arouse in the minds of contemporaries, the painter has deliberately subverted the harmonious design established upon the opposite wall (cf. Plates 182 and 192).[55] The pictorial space is depicted as cramped and confined and the changes of colour are incessant and abrupt. Indeed, it has been proposed that what is intended here is nothing less than a representation of the infernal city of Babylon (Revelations 17:13–18).[56] It may well also be the case that the antithetical urban typologies of the two cities had some political significance. It has been argued that *The Good City* represents an older, politically independent, Tuscan, Guelph hill town, as evidenced by the she-wolf on the barbican gate and the papal insignia in the border above; *The Bad City*, by contrast, represents an imperially founded Ghibelline valley town with

an undistinguished church and main gate devoid of civic emblems, a message further amplified by the portraits of tyrannical emperors in the border below.[57]

THE PAINTINGS' ORIGINAL FUNCTION AND AUDIENCE

In the absence of any surviving documentary evidence either of instructions to the painter on what he should paint or of contemporary reactions to the completed paintings, the modern viewer has, of necessity, to attempt to reconstruct the intentions of both the commissioners of the paintings and the painter himself. As a commission for a town hall which survives in reasonably good condition – compared with such schemes as the now almost totally destroyed embellishment of the Palazzo dei Priori, Florence and the repainted scheme in the Salone of the Palazzo della Ragione, Padua – the painted scheme of the Sala dei Nove remains a key example of a commission awarded to a fourteenth-century painter by a public, corporate body. It is clear from the documented payments to the painter that the paintings were intended for the meeting room of the Nine, the supreme magistracy of Siena's republican government. Indeed, the inscription on the lower border of *The Good Government* begins: 'Turn your eyes to behold her, *you who are governing*' (Appendix, B1, emphasis added), which suggests strongly that the exemplary messages established by both the texts and the images on the walls of the Sala dei Nove were intended for the members of Siena's supreme magistracy who once sat and deliberated in this room. The paintings' primary audience would, therefore, have been members and close political associates of that magistracy and, given the political structure of Siena at that date, the paintings would have needed to express a corporate ideology conducive to the political aspirations of that body.

Just how specific were these pictorial messages to the Nine and their interests? As Rubinstein and Skinner have demonstrated, in the political treatises of the Italian Communes the particular virtues represented on the north wall of the Sala dei Nove, and conversely the particular vices represented on the west wall, were generally associated with the practice of good as opposed to bad government. Beyond this general political message, however, which arguably would have found acceptance in any scheme of pictorial decoration for an Italian Commune's town hall, is there anything of more specific import to Siena or to the Nine themselves? In other words, to what extent is it a legitimate assumption that the patrons played a role in the paintings' organization and content?

As noted above, it is significant that the traditional number of the virtues who surround the ruler figure has been increased by two to nine, and therefore corresponds to the number of the members of the magistracy for whose use the Sala dei Nove was designed (Plate 184). Visitors to the Sala dei Nove – be they members of official delegations, petitioners or honoured guests – would probably have seen the Nine seated on a platform against the north wall, with painted personifications of *ben comune* and the virtues above them.[58] In general political terms, this magistracy was given the highest legal authority: the power of judicial execution

and the responsibility for the maintenance of armed support within the city and *contado*. In the 1309–10 Sienese constitution, the opening rubric on the duties of the Nine declares that the goal of good government must be that 'this city and all its people, its *contado* and all its jurisdictions are conserved in perpetual peace and pure justice … the city should be governed by men who are lovers of peace and justice'. The Nine were further empowered by this constitution 'to reduce the city, Commune and people to a state of true and rightful and trustworthy peace and unity, both individually and as a community'.[59]

These contemporary legal injunctions thus provide a number of striking correspondences to the painted scheme itself: first, in identifying justice and peace as two special qualities to which the Nine should aspire; and secondly, in requiring the magistracy to maintain the unity of the Sienese community. The treatment of the personifications of justice and peace in *The Good Government* ensures, moreover, that they are especially eye-catching figures: Justice by virtue of her size and dominance within the left-hand figural composition, and also by her second appearance as a personal attribute of the ruler figure, and Peace by virtue of her distinctive pose and costume (Plates 179 and 184). The political aim of uniting the citizens is aptly summarized in pictorial terms by the depiction of the personification of concord and by this figure's inter-relationship with the procession of 24 citizens. Furthermore, the various pictorial details that associate Peace with military power, be they discarded armour, armed cavalry and infantry or acts of submission, offer further correspondences between the pictorial scheme and the duties of the Nine. Turning to *The Good City*, the inclusion of the personification of security – made all the more striking by the classical form in which the figure is portrayed and the very vivid and specific detail of the gallows – offers a concrete pictorial allusion to the Nine's power of judicial execution (Plate 182). More generally, the carefully observed detail of the city's building fabric and the paved road and well-maintained bridge within the countryside would similarly act as further reminders to the fourteenth-century spectator that the Nine were pledged by the constitution to maintain these public amenities.

In their depiction of the conditions prevailing in the well-governed city, the paintings in the Sala dei Nove are, of course, highly idealized and bear little relation to the conditions prevailing in Siena at the time when they were executed. Several years before the commencement of the project in the Sala dei Nove there had been a number of uprisings against the regime of the Nine. Indeed, in 1337, at a time when the project was probably just beginning, the Nine, endangered by conspiracies among certain noble families and their adherents, had responded to this threat to their political dominance by issuing lists of nobles excluded from government office and by promising to open such office to new candidates drawn from a wider representation of Siena's male population.[60] In 1339, when the scheme in the Sala dei Nove was probably nearing completion, the political stability of the Nine was further complicated by food shortages and outbreaks of disease within both Siena and its *contado*.[61] Thus, the conditions portrayed on the west wall, of a city and its *contado* in a state of lawlessness and decay (Plate 183), a

Plate 203 Andrea Pisano, *Weaving*, c.1334–43, marble relief, 83 × 69 cm, first zone, south face, Campanile, Florence (original sculpture now removed to the Museo dell'Opera del Duomo, Florence). Photo: Alinari.

Plate 204 Anonymous, *The Labour of the Month for July (Threshing)*, detail of south wall mural, Salone, Palazzo della Ragione, Padua. Reproduced by courtesy of Musei Civici Padova, Gabinetto Fotografico.

situation brought on by faction and discord among the citizens (as vividly embodied by the right-hand group of three vices, Plate 191), were a real possibility – at least within the minds of the Nine and the mercantile oligarchy that supported them and provided candidates for their rotating membership.

In short, it appears plausible to argue that in commissioning the paintings for the Sala dei Nove the Nine intended to secure a pictorial manifesto for their political regime, thereby providing both reassurance of its beneficial effects and a warning to those who considered attempting to replace it. The paintings thus represent a powerful panegyric on the relative political stability and prosperity that the magistracy of the Nine had succeeded in preserving for over five decades. It also acted as a warning to the politically powerful families and factions within Siena that only through unity could they hope to preserve a republican regime and thereby maintain their own political ascendancy.

One further word on the paintings in the Sala dei Nove is appropriate. Although these paintings and their accompanying inscriptions present a compelling instance of an artistic monument in respect of which the patrons and their close associates almost undoubtedly exercised a major role in defining what subjects should feature and how they should be represented, the role of Ambrogio Lorenzetti should not be underestimated. It is likely that some learned notary or chancellor with legal training and philosophical

interests in contemporary political thought devised the subjects of the paintings and their accompanying texts, but the painter had a specific reputation (at least in the fifteenth century) for being learned. He is recorded in a document of 2 November 1347 as a member of an advisory council called by the Nine and as speaking with 'words of wisdom' in favour of proposals for strengthening the office of the Capitano del Popolo and regulating conflicts of interest amongst officials.[62] He was, therefore, probably not unaware of the political concepts and issues that modern scholars associate with his paintings.[63] In addition, he must have studied comparable artistic programmes, such as Nicola and Giovanni Pisano's pulpit in Siena Duomo – an artistic scheme that, quite apart from its religious narratives, also includes representations of the virtues and the liberal arts. Moreover, if one considers *The Good Government* in its entirety – including the borders – and compares it with other civic images (such as the sculpted reliefs on the Fontana Maggiore in Perugia and the paintings in the Palazzo della Ragione in Padua), a measure of Ambrogio Lorenzetti's personal achievement can be gauged. Gone are the separate and discreet depictions of the labours of the months and the mechanical arts. Instead, these have been skilfully integrated within a unified and expansive spatial setting (cf. Plates 182, 203, 204 and 205). Moreover, the setting is very specifically that of a city and its *contado* – an ideal city first and foremost, but an ideal city that closely resembles Siena. The programmatic world-view of the

Plate 205 Nicola Pisano and assistants, *The Labour of the Month for June (Harvesting) under the Sign of Cancer*, relief on the lower basin of the Fontana Maggiore, Perugia. Photo: Alinari.

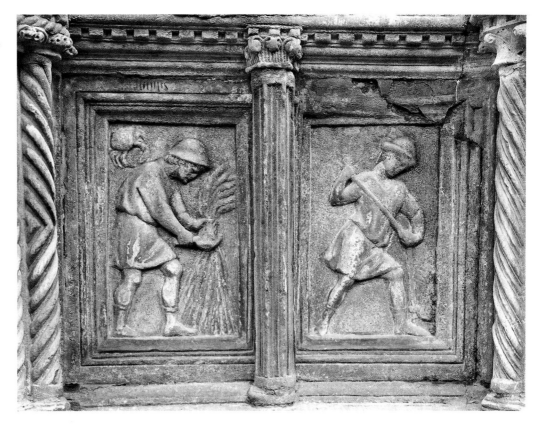

Plate 206 Biadaiolo Master, *The Good Harvest*, c.1335–40, Biadaiolo Codex, Biblioteca Laurenziana, Florence. Photo: Alberto Scardigli.

medieval scholastics has been given an immediacy and veracity that would have been all the more compelling for the paintings' original audience. Similarly, the specific reported detail of everyday urban and rural activity, which had hitherto been confined to the illuminated pages of didactic works designed to record and celebrate civic life, such as Domenico Lenzi's record of Florentine grain prices and political events, has been dignified and given monumental form (cf. Plates 182 and 206).[64] By imaginatively combining these two kinds of artistic genre into one epic image, Ambrogio Lorenzetti provided his patrons with a highly idealized but compelling pictorial statement that the collective concerns and interests of the Sienese community were best protected by the wise and judicious rule of its elected governors.

Appendix

A. GOOD GOVERNMENT
NORTH WALL

The text within the lower border
A1

This holy Virtue [Justice], where she rules, induces to unity the many souls [of citizens], and they, gathered together for such a purpose, make the Common Good [*ben comune*] their Lord; and he, in order to govern his state, chooses never to turn his eyes from the resplendent faces of the Virtues who sit around him. Therefore to him in triumph are offered taxes, tributes and lordship of towns; therefore, without war, every civic result duly follows – useful, necessary, and pleasurable.

B. THE GOOD CITY
EAST WALL

The text along the lower edge of the painting
B1

Turn your eyes to behold her, you who are governing, who is portrayed here [Justice], crowned on account of her excellence, who always renders to everyone his due. Look how many goods derive from her and how sweet and peaceful is that life of the city where is preserved this virtue who outshines any other. She guards and defends those who honor her, and nourishes and feeds them. From her light is born [both] requiting those who do good and giving due punishment to the wicked.

The text held by Security
B2

Without fear every man may travel freely and each may till and sow, so long as this commune shall maintain this lady [Justice] sovereign, for she has stripped the wicked of all power.

C. BAD GOVERNMENT
WEST WALL

The text within the lower border
C1

There, where Justice is bound, no one is ever in accord for the Common Good [*ben comun*], nor pulls the cord straight; therefore, it is fitting that Tyranny prevails. She,[65] in order to carry out her iniquity, neither wills nor acts in disaccord with the filthy nature of the Vices, who are shown here conjoined with her. She banishes those who are ready to do good and calls around herself every evil schemer. She always protects the assailant, the robber, and those who hate peace, so that her every land lies waste.

The text (partly obliterated) along the lower edge of the painting
C2

… and for the reason that, where there is Tyranny, there are great fear, wars, robberies, treacheries and frauds, she must be brought down. And let the mind and understanding be intent on keeping each [citizen] always subject to Justice, in order to escape such dark injuries, by overthrowing all tyrants. And whoever wishes to disturb her [Justice], let him be for his unworthiness banished and shunned together with all his followers, whoever they may be: thus Justice will be fortified to the advantage of your peace.

The text held by Fear
C3

Because each seeks only his own good, in this city Justice is subjected to Tyranny; wherefore, along this road nobody passes without fearing for his life, since there are robberies outside and inside the city gates.[66]

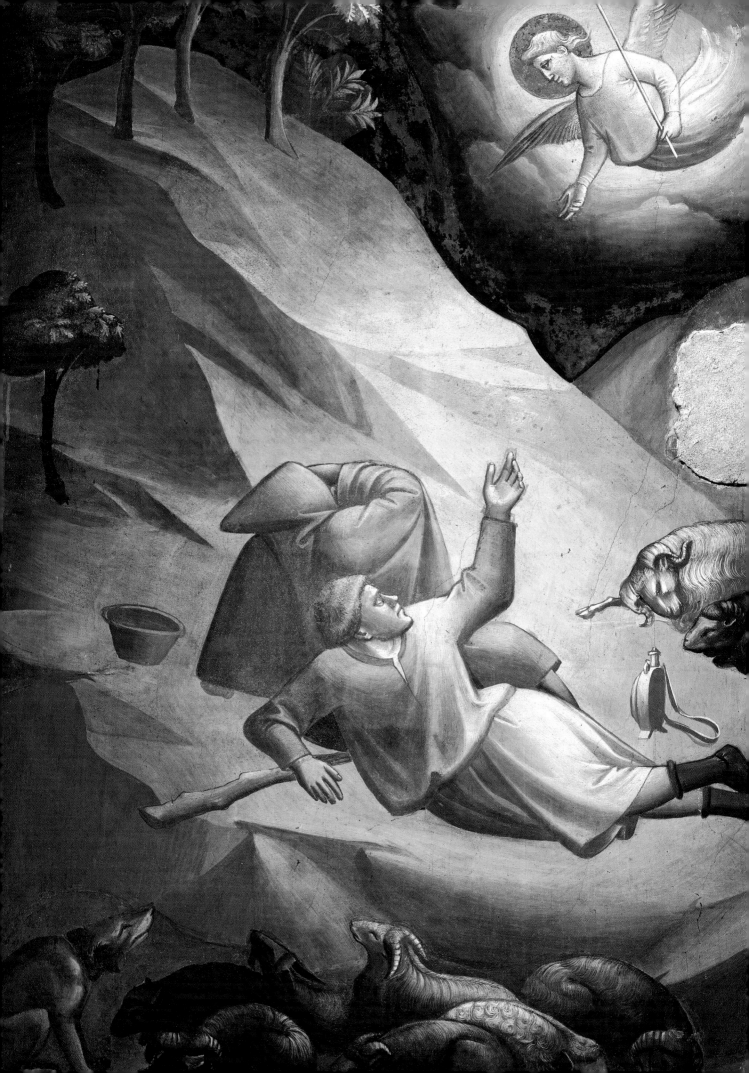

Those who pay, those who pray and those who paint: two funerary chapels

On 1 June 1340 Vannes di Tofi of the noble Sienese family of the Salimbeni made his will. He instructed that he was to be buried in the 'church of the Friars Minor' in Siena – that is, in the city church of San Francesco. He wished to be buried in a Franciscan habit and placed in the family tomb where his son Nerio already lay. Vannes further directed that the abbot and monks of the great rural abbey of San Galgano were to receive four measures of grain annually from a farm owned by him in the close vicinity of the abbey. In exchange for this gift of grain, the monks were required to build near their church 'a most beautiful chapel of well cut stone' which was to be 'vaulted and skilfully painted'. The abbot and monks were also to delegate to one of their number the task of celebrating in perpetuity masses on certain days, commending the soul of the testator and that of his son to 'the omnipotent God, the blessed Virgin Mary, the blessed Galgano and the entire celestial court'. Having dealt with this chapel and the practical arrangements for its endowment, Vannes's will then turned to consideration of his family and their inheritance. Financial provisions were made for his daughter Francesca and he named his grandson (son of his deceased son Nerio) his universal heir. Should Giovanni die without issue, Vannes's patrimony was to pass to the hospital of Santa Maria della Scala in Siena, whose officials were to build a chapel in either the Duomo of Siena or the hospital itself. Once again a chaplain was to be appointed in order to celebrate requiem masses for the souls of both Vannes and Nerio.[1]

The provisions of this will vividly express many of the characteristic preoccupations concerning death and inheritance commonly held by wealthy citizens of fourteenth-century Italian city states. They also show how such preoccupations might be translated into various acts of specific patronage. Typically a portion of an individual's wealth might be bequeathed to a religious community – be it the Cistercians of San Galgano or the hospital authorities of Santa Maria della Scala in Siena. Frequently bequests of this kind took the form of concrete acts of art patronage, such as the construction and embellishment of a chapel where the donor and members of his or her family[2] would be buried and where, crucially, a priest would celebrate requiem masses for the deceased. Indeed the funerary chapel, founded by either one or several individuals acting on behalf of their family, arguably constitutes the most decisive and – in purely artistic terms – the most fruitful expression of fourteenth-century private patronage of art. In order to explore the validity and further ramifications of this statement, this essay will examine two such fourteenth-century chapels which

survive today in relatively good condition. Both are situated within major Franciscan churches, one in Santa Croce, Florence and the other in the Santo, Padua. In particular, the essay will analyse the two chapels and their sculpted and painted embellishment in terms of three distinct questions. First, what were the precise circumstances of the commission for each chapel, and what evidence does each commission provide concerning the patron's role in determining the artistic form that the chapel took? Second, to what extent is it legitimate to judge the chapels and their paintings and sculptures as an expression of the aspirations and preoccupations of their patrons? Third, is there a discernible difference between the aims of the creators – both artists and patrons – of the Florentine and Paduan chapels? In particular, is it legitimate to argue that the political and cultural ambience of seigneurial Padua allowed within the context of a funerary chapel for a more overt display of the patrons' tastes than was possible in similar contexts within republican Florence?

THE BARONCELLI CHAPEL

There is, unfortunately, no known contemporary documentation for the Baroncelli Chapel in Santa Croce, Florence (Plate 208). As is so often the case for fourteenth-century works of art, the historical circumstances of its commissioning, including the patrons' motives and aspirations, must be reconstructed from the physical appearance of the monument itself. The principal evidence for the chapel being a commission from the wealthy and politically influential Baroncelli family is the presence of their coat of arms in four areas: at the apices of the entrance arch and the tall lancet window behind the altar (Plates 208, 218), on the ends of the predella of the chapel's fourteenth-century painted altarpiece (Plate 209) and in the gable of the tomb monument located to the immediate right of the chapel's entrance (Plate 211). Furthermore, an inscription on a panel immediately below the finely wrought metalwork screen of the tomb names five male members of the Baroncelli family – Bivigliano, Bartolo, Salvestro, Vanni and Pietro – as the founders of this chapel. The inscription also offers a date of February 1327 (1328 in the modern style of dating).[3] The inscription states that the chapel is dedicated to God and to the Annunciate Virgin and that it had been founded for the health of the souls of these five men and for all the deceased members of their family.[4] Responsibility for the initiation of this chapel and its painted and sculpted decoration can

Plate 207 (Facing page) Taddeo Gaddi, *The Annunciation to the Shepherds, c.*1328–34, fresco, south wall, Baroncelli Chapel, Santa Croce, Florence. Photo: Scala.

Plate 208 Baroncelli Chapel, general view from south transept, Santa Croce, Florence. Reproduced by permission of the Conway Library, Courtauld Institute of Art, University of London.

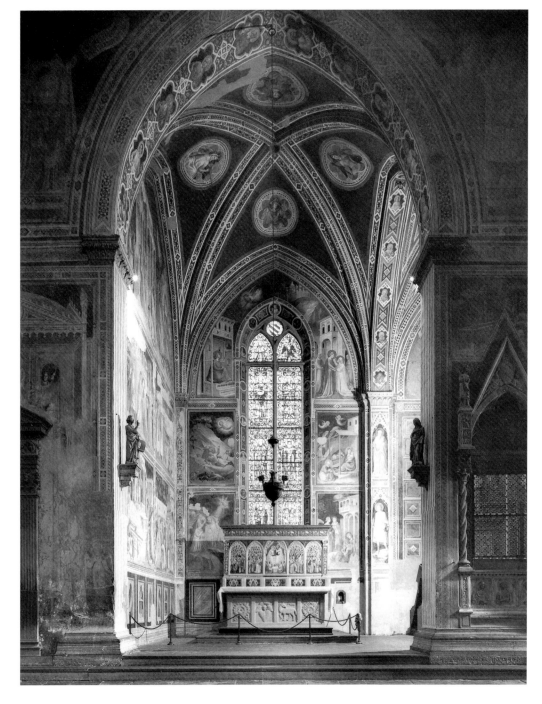

therefore be attributed uncontroversially to the Baroncelli, a family whose members founded at least one and possibly two other chapels within Santa Croce during the fourteenth century.[5] The family also had close business connections with another of the most important Florentine mercantile families, the Peruzzi, who were in turn responsible for commissioning a frescoed chapel by Giotto in the south transept of Santa Croce. It also seems from the tomb inscription that the project was a collective enterprise on the part of representatives of two distinct branches of the Baroncelli family, thus emphasizing the extent to which even 'private' familial patronage was frequently a co-operative endeavour involving more than merely 'individual' ambitions and resources.

The chapel, situated at the head of the south transept, comprises two vaulted bays and is flanked on the left (when facing the entrance) by the corridor leading to the church's sacristy and on the right by another chapel founded by the Castellani family (Plate 210). The style of the architecture suggests that its construction took place shortly after that of the transept chapels, themselves dated c.1295–1310.[6] It was, therefore, probably already built when, in 1328, the five members of the Baroncelli family made it the object of their patronage. The distinctive contribution of the Baroncelli patrons to the chapel probably lay in the commissioning of an ambitious and impressively unified scheme of stained glass, sculpture, fresco and panel painting.

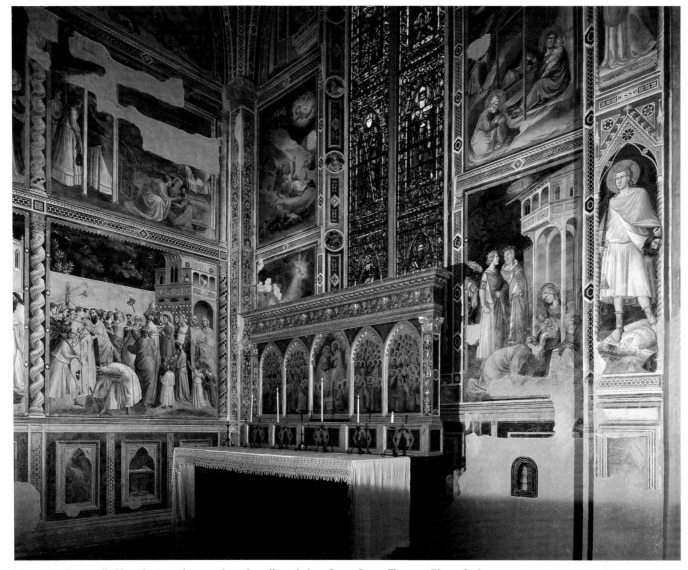

Plate 209 Baroncelli Chapel, view of east and south walls and altar, Santa Croce, Florence. Photo: Scala.

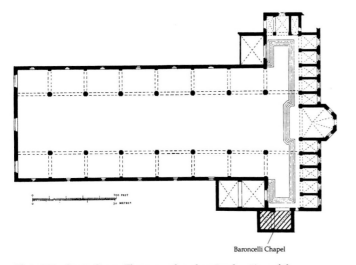

Baroncelli Chapel

Plate 210 Santa Croce, Florence, plan showing location of the Baroncelli Chapel. Redrawn by Donald Bell-Scott from Walter and Elizabeth Paatz, *Die Kirchen von Florenz*, 1952–55, V. Klostermann, Frankfurt-am-Main, for John White, *Art and Architecture in Italy 1250–1400*, 1993, Yale University Press, New Haven and London.

Today all that remains of the chapel's original fenestration is a lancet window piercing the south wall of the first bay and still containing its original fourteenth-century glass (Plates 208, 218). On it is represented a series of six saints – Peter, John the Baptist, John the Evangelist, Bartholomew, Sylvester and the Franciscan saint, Louis of Toulouse. At the apex of the window appears a representation of Saint Francis receiving the stigmata from Christ crucified upon the Cross. Before the building of the fifteenth-century chapter-house – the Pazzi Chapel – to the immediate south of the chapel, another window pierced the chapel's south wall.[7] The decoration of the entrance arch is enlivened by two fourteenth-century statues set on plinths. As appropriate to the chapel's dedication to the Annunciate Virgin, the sculpted figures represent, on the left, the Archangel Gabriel and, on the right, the Annunciate Virgin (Plate 208). The chapel's sculpted programme also includes a tomb monument inserted into the north wall which, quite apart from its architectural and sculpted decoration, incorporates a mural painting of *The Virgin and Child* (Plate 211). The alignment of this painted figural group and indeed the Christ Child's gesture of

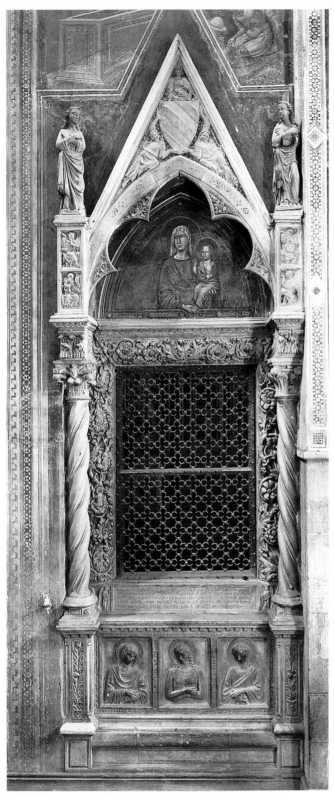

Plate 211 Anonymous, tomb of the Baroncelli family, *c*.1328–34, marble (incorporating a mural of *The Virgin and Child* by Taddeo Gaddi), north wall, Baroncelli Chapel, Santa Croce, Florence. Photo: Alinari.

blessing act as a positive encouragement to the spectator to focus upon the chapel's altar, altarpiece and murals.

The chapel's painted programme comprises a series of frescoed narrative scenes situated on the two walls of the eastern bay, which are directly in view from the south transept (Plate 208). These painted narratives show eleven scenes from the life of Mary.[8] On the east wall, to the left as one enters the chapel, are five scenes from her early life. The narrative reads from left to right and from top to bottom. In the upper lunette within a single picture field two events are depicted: Joachim's expulsion from the Temple and the annunciation to Joachim in the wilderness (Plate 212). Below this composite scene are two scenes separated from one another by a painted twisted column showing, respectively, Joachim's meeting with Anne at the Golden Gate and the birth of the Virgin Mary (Plate 209). Below these appear two more scenes: the presentation of the Virgin in the Temple and her marriage to Joseph (Plate 219). On the altar wall are six murals with scenes from the biblical narrative of the birth of Christ. Reading from left to right and from top to bottom, the scenes represent the annunciation, the visitation (Plate 218), the annunciation to the shepherds (Plate 207), the Nativity, the annunciation of the three Magi and the adoration of the Magi.

In the eight compartments of the two vaults of the chapel are representations of the three theological virtues and the four cardinal virtues – Faith being represented twice (Plate 217). This painted assembly of virtues is further supplemented by representations of various other personifications of human virtue which appear within the framework of the window and on the intrados of the chapel's arches. On the broad pilaster that separates the two bays of the chapel appear representations of other holy figures, including David firmly grasping Goliath's head in his hand. Below the frescoes on the east wall are two fictive niches within which appear a number of liturgical objects (Plate 213) – mementoes of the requiem masses that would have taken place within this family chapel – and the finely crafted artefacts with which the Baroncelli would have undoubtedly equipped their funerary chapel.

The celebration of Mary in the frescoed narratives on the walls of the chapel finds its culmination in the painted altarpiece which stands on the original fourteenth-century altar (Plate 214).[9] Now housed in a unifying fifteenth-century frame, it once comprised a pentaptych – a five-part polyptych – with the coronation of the Virgin appearing on its centre panel and rank upon rank of saints and angels on the four side panels. On the predella are a series of five medallions depicting Christ displaying his wounds in the centre, with Saint Francis, also displaying the wounds of his stigmata, to the right and Saint John the Baptist, patron saint of Florence, to the left. When the altarpiece was incorporated into its new frame, a sequence of pinnacle panels were removed and thought to be all lost. However, the central pinnacle panel has been rediscovered and shows God the Father surrounded by angels, three of whom are shielding their eyes from God's brilliance and two of whom are holding up mirrors as if to reflect his radiance (Plate 215).[10]

In the absence of any known contemporary documentation for the chapel, the identities of the artists whom the Baroncelli employed have had to be deduced from other kinds of historical evidence. The altarpiece is signed by Giotto, but scholarly opinion is divided as to whether the master actively participated in the painting's execution or whether he left it to his workshop.[11] Given the sophistication of its design,

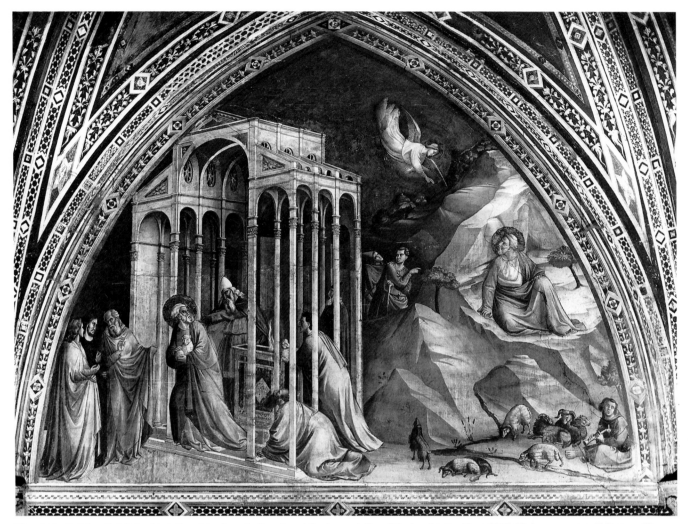

Plate 212 Taddeo Gaddi, *Joachim's Expulsion from the Temple and the Annunciation of the Angel to Joachim*, *c*.1328–34, fresco, east wall, Baroncelli Chapel, Santa Croce, Florence. Photo: Alinari.

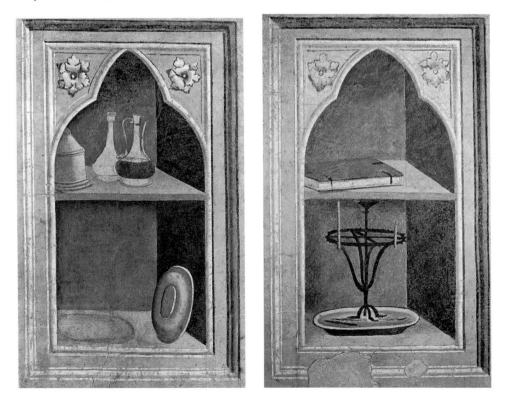

Plate 213 Taddeo Gaddi, two painted fictive niches, *c*.1328–34, base of the east wall, Baroncelli Chapel, Santa Croce, Florence. Photo: Scala.

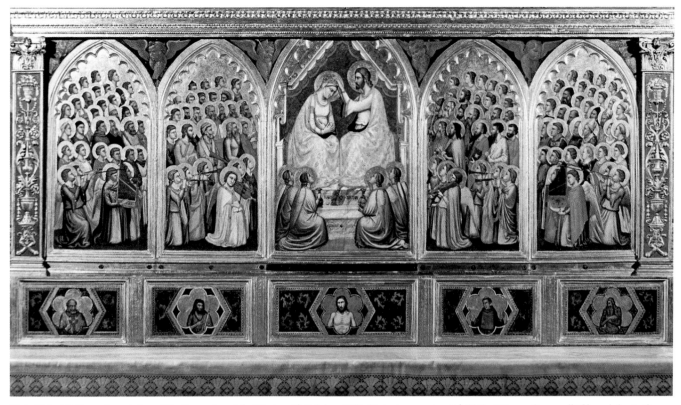

Plate 214 Giotto and workshop, *The Coronation of the Virgin with Saints*, *c*.1328–34, tempera on panel, 31.5 x 321 cm, Baroncelli Chapel, Santa Croce, Florence. Photo: Scala.

particularly the complex organization of its figural composition and its inventive iconography (Plates 214, 215), it seems highly likely that Giotto had a significant role in the

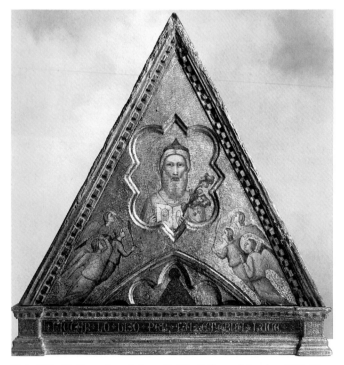

Plate 215 Giotto and workshop, *God the Father and Angels*, *c*.1328–34, tempera on panel, 30 x 28 cm, pinnacle panel of *The Coronation of the Virgin* altarpiece, formerly Baroncelli Chapel, Santa Croce, Florence. San Diego Museum of Art. Gift of Anne R. and Amy Putnam 1945:026.

initial conception and overall design of the altarpiece, even if he subsequently delegated its execution to competent and gifted members of his workshop. From as early as the fifteenth century, the frescoes have been attributed to Taddeo Gaddi, a painter who, although he worked as an independent master in his own right, is generally acknowledged to be a close and highly gifted associate of Giotto.[12] The names of the artists responsible for the sculpture and stained glass are not known, although in the case of the former (Plate 211) there was clearly a degree of collaboration between the sculptor and the painter, and in the case of the latter (Plate 218) it is likely that Taddeo himself supplied the figural design for the window.[13] The dating for the execution of the chapel's scheme is also a matter of scholarly conjecture, but the general consensus is that it fell between 1328 – the date on the Baroncelli tomb – and 1334, the year in which Giotto is known to have returned to Florence from a period of employment at the Angevin court in Naples.[14]

In the absence of a contract or other specific instruction from the patrons on what they wanted painted, any discussion of how the Baroncelli might have intervened in the conception and design of their chapel's decoration must remain speculative. Nevertheless, in terms of their subject-matter and distinctive iconography, the paintings are suggestive of certain preoccupations on the part of the patrons who initiated and financed the scheme. Indeed it is possible to discern at least two kinds of intention for the chapel's painted programme, one serving the needs of the Baroncelli, and the other serving the needs of the community of Franciscan friars who celebrated holy offices within the chapel on behalf of the Baroncelli family.

In terms of the devotional needs of the Baroncelli, the chapel's decoration includes discreet but highly personalized acknowledgement of the patrons' identities and a more general expression of the Christian hope of redemption. Thus, apart from the various coats of arms that appear within and without the chapel, there is very little overt reference to the Baroncelli themselves, either in the form of specific portraits of members of the family or in the form of representation of more generalized donor figures. Nevertheless, it has been noted that the stained glass in the chapel window arguably commemorates the name saints of the five members of the Baroncelli clan recorded on the tomb monument.[15] In more general terms, however, the chapel's paintings celebrate the titular saint to whom the Baroncelli dedicated their chapel – the Annunciate Virgin – and the patrons' collective hope that by the practice of the Christian virtues, they might themselves gain life-everlasting.

The Virgin, in her specific guise as the Annunciate Virgin, appears twice within the chapel, first in sculpted form at the entrance (Plate 208) and second in the painting on the upper wall to the left of the altar (Plate 218). Indeed, it is a remarkable feature of the chapel's painted narrative scheme that it contains not only the scene of Gabriel's revelation to Mary of God's plan for human salvation, but also three other comparable scenes of divine revelation. In more general terms, the paintings give witness to more straightforward Marian devotion, detailing as they do, first, the extraordinary circumstances of Mary's birth and early life and, second, the events initiating the Incarnation of God as man. This was a miracle in which Mary played a crucial role and for which she was subsequently rewarded by being received into heaven by her Son and crowned queen of heaven. Since she was also believed to be the principal mediator between God and humankind, her prominent representation throughout the painted and sculpted chapel scheme must have been highly conducive to the pious aspirations of the Baroncelli. Indeed the juxtaposition at the top of the Baroncelli tomb of the paintings of Mary as the mother of Christ and of Christ's empty tomb (Plates 211, 216) encapsulates rather neatly the patrons' hopes that Mary would intercede to secure their own resurrection from the dead on the day of judgement. They would then join the company of saints in heaven as portrayed so spectacularly upon the chapel's altarpiece (Plate 214). The presence of an astounding number of representations of the

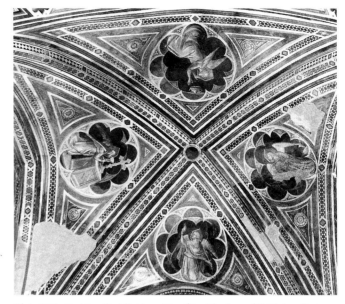

Plate 217 Taddeo Gaddi, *Hope, Humility, Charity and Faith* (reading clockwise from the top), *c.*1328–34, fresco, vault in the second western bay, Baroncelli Chapel, Santa Croce, Florence. Photo: Index/Tosi.

Christian virtues (Plate 217) – 23 in all – acts as further evidence that the patrons' hopes for salvation were predicated upon the practice of such Christian precepts.

It is likely, however, that the Franciscans of Santa Croce also played a part in determining which sacred narratives and holy figures were represented within this privately owned chapel. Their founder, Saint Francis, and another of their most revered saints, Louis of Toulouse, feature on the chapel window and Saint Francis appears on the predella of the altarpiece. Another remarkable aspect of the chapel's iconographic scheme is the portrayal within the stained glass window of another angelic visitation – that of the seraph to Saint Francis on the occasion of the saint receiving the stigmata (Plate 218). According to an official Franciscan hagiographic text, the seraph's visit to Francis on Mount Verna took place on the eve of the Feast of the Holy Cross (a feast which had a special significance for the Franciscans of Santa Croce). Francis's response, as described in the text, echoes that of the Annunciate Virgin to Gabriel, and thus might well account for the close juxtaposition of the two scenes within the chapel scheme. Furthermore, the assent that both the Annunciate Virgin and Saint Francis made at these two events had significant spiritual consequences. In the case of the former, the miraculous process of the Incarnation of God as man was initiated; in the case of the latter, Christ's wounds were imprinted upon Francis's body.[16]

What particular artistic skills did the Baroncelli demand for the execution of their funerary chapel? Once again, in the absence of any known historical documentation, one can only offer informed speculation based on visual observation of the chapel itself. It is noteworthy, however, that the Baroncelli obtained their art from well-established artists. They secured an altarpiece from the workshop of Giotto, who at that time had reached the apogee of his profession and reputation, as indicated by his nomination in 1334 as master of works for the Florentine Opera del Duomo. In the case of the mural paintings for the chapel, they obtained the services of Taddeo

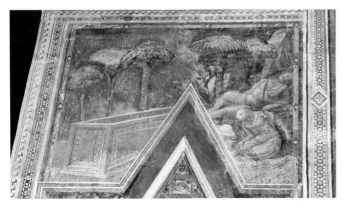

Plate 216 Taddeo Gaddi, *Christ's Empty Tomb*, *c.*1328–34, mural located above the Baroncelli tomb, Santa Croce, Florence. Photo: Index/Tosi.

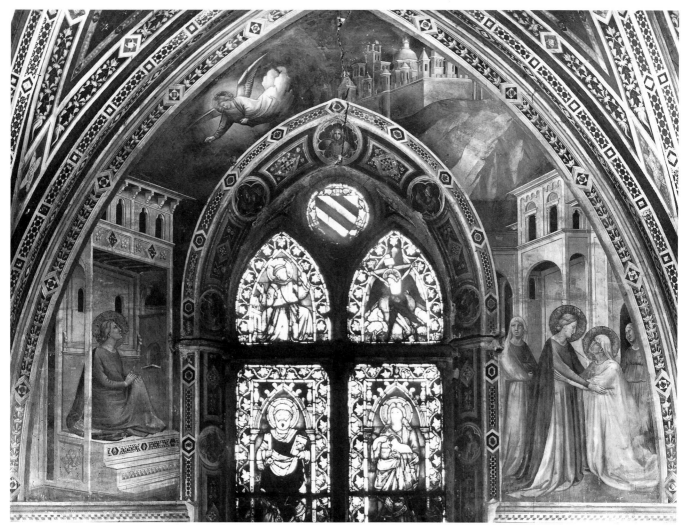

Plate 218 Taddeo Gaddi, *The Annunciation and the Visitation*, *c.*1328–34, fresco on upper part of south wall, also showing *Saint Francis Receiving the Stigmata* in the original stained glass window, Baroncelli Chapel, Santa Croce, Florence. Photo: Alinari.

Gaddi, who not only was one of Giotto's most gifted associates but also had evolved an artistic repertoire which was both highly innovative and distinctive from that of Giotto. Finally, while the chapel's sculpture has received less critical attention, it too is suggestive of the work of a competent mid fourteenth-century sculptor (Plates 208, 211).

The mural paintings, however, are the most striking and visually memorable feature of the Baroncelli Chapel. They are remarkable for the evidence they provide of Taddeo Gaddi's powers of pictorial narration, figural organization, empirical observation, sophisticated deployment of perspective devices and, above all, exploitation of light and colour. *The Marriage of the Virgin*, for example, furnishes evidence of the skilful manner in which Taddeo was able to depict a narrative event. He focuses visual attention upon the Virgin by means of an architectural backdrop and a brightly coloured hanging, yet also includes a large number of subsidiary figures whose vivacious characterization adds variety, emotion and humour to this scene (Plate 219).[17] The painter's powers of naturalistic observation are graphically portrayed in the paintings of the cruets of wine and water, the pyx and jug, the book and candleholder in the two niches on the dado below the *Presentation* and *Marriage of the Virgin* – painted objects which

appear as almost tangible in their illusionism (Plate 213). Meanwhile, Taddeo's twofold representation of the Temple of Jerusalem – the first in splendid isolation in *Joachim's Expulsion from the Temple* (Plate 212) and the second in the context of other buildings in *The Presentation of the Virgin in the Temple* (Plate 209) – provides an example of the painter's skilful deployment of perspective. Using the diagonal placement of the building, Taddeo offers an illusion of an eye-catching spatial structure which complements the dramatic events taking place within it.

However, the murals on the altar wall arguably show Taddeo's powers of pictorial organization and illusionism to their best advantage. Thus, the disposition of the painted architecture with the building's strongly stated diagonals, together with the precise positioning of the figure, create the powerful illusion of an enclosed space – a space, moreover, which was designed to house the altarpiece and its triumphant, celebratory Marian imagery (Plate 208). The treatment of pictorial light is also at its most striking upon the altar wall. As for all the paintings in the chapel, the pictorial light has been organized as if to mirror the actual light from the window on the altar wall. Taddeo was also determined, however, to portray 'supernatural' light emanating from a

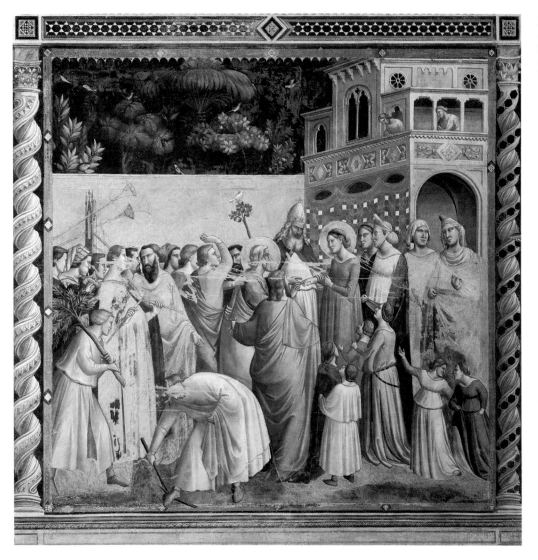

number of angelic messengers. Indeed, such was his apparent preoccupation with this particular aspect of the painting's iconography that he included within the altar wall's painted scheme the unusual device of portraying the Christ Child in place of the conventional star which appeared to the three Magi and led them to Bethlehem. The painter's interest in light and his ability to convey it appear to have been based on close observation of the actual qualities of light, its behaviour and its impact upon human sight. For example, in *The Annunciation to the Shepherds*, Taddeo has managed to convey in extremely graphic terms the sense of the shepherds being dazed by the brilliance of the light of the angels (Plate 207). It has been observed that he achieved this effect not only by the poses in which he placed the shepherds, which are highly suggestive of startled amazement, but also by his use of monochrome colour and indistinct outlines of objects which mirror closely the visual experience of perceiving a sudden flash of light illuminating the night sky.[18]

What explanation may be offered for Taddeo's particular concern with light and its effects? It has to be acknowledged that the depiction of light is essential for any kind of naturalistic representation – an imaginative and technical capability in which both Taddeo Gaddi and Giotto excelled.

Taddeo was doubtless simply anxious to acquit himself well in a chapel scheme which was prestigious in terms of both its well-placed patrons and its public location within one of the city's grandest churches. In this ambition, moreover, he was by no means unsuccessful. It is significant to note that the mural paintings subsequently influenced later chapel schemes – most notably in the Rinuccini Chapel situated in the nearby sacristy where the paintings, executed some 40 years later, emulate certain aspects of the iconography and representational conventions of the Baroncelli Chapel murals (Plate 220). There remains, however, the possibility that Taddeo's intense concern with the portrayal of light was also the result of the particular demands of the commission and its combination of the specific interests of the Baroncelli family and the Franciscans of Santa Croce. In a letter written between 1338 and 1348, signed 'Taddeo of Florence' and addressed to a celebrated Augustinian preacher, Fra Simone Fidati da Cascia, the writer complains that he has suffered eye damage from looking at an eclipse of the sun. The preaching of Fra Simone, which included particularly graphic imagery relating to the Virgin and the Christ Child, was both popular and well attended at the time of the painting of the Baroncelli Chapel. It has been suggested that 'Taddeo of Florence' who wrote the

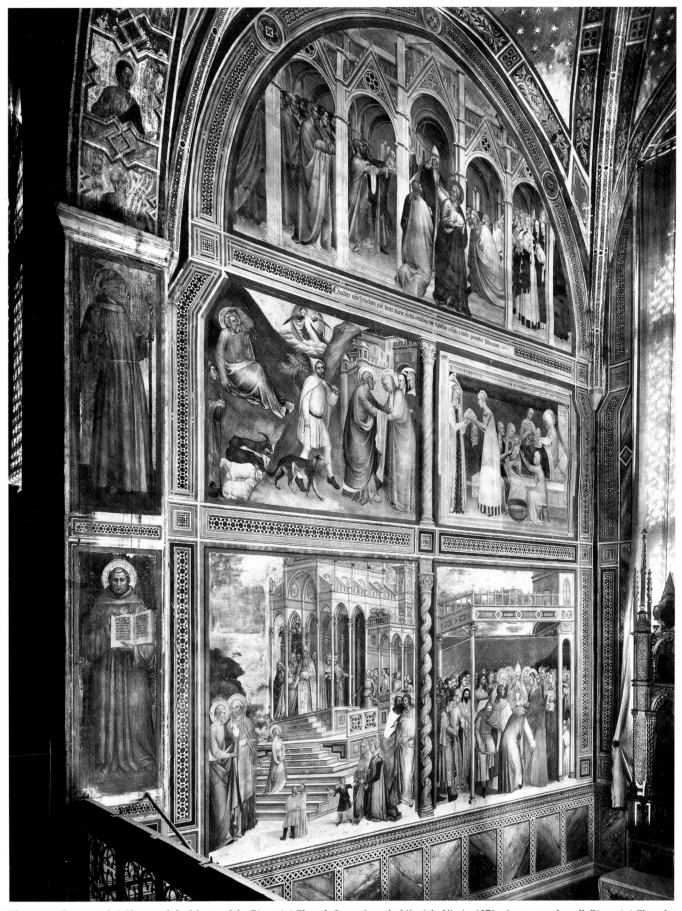

Plate 220 Giovanni da Milano and the Master of the Rinuccini Chapel, *Scenes from the Life of the Virgin*, 1370s, fresco, north wall, Rinuccini Chapel, Santa Croce, Florence. Photo: Alinari.

letter to Fra Simone was in fact Taddeo Gaddi, and that the letter both confirms the painter's personal interest in the phenomenon of light and points to a specific source for his treatment of the life of the Virgin in the chapel murals.[19]

This proposal is far from conclusive. The name Taddeo was a common one, and in the letter the writer makes no direct reference to painting as such.[20] Nevertheless, the proposed link between astronomical observation and theological discussion is not without interest. It is quite possible that Taddeo Gaddi had witnessed the total eclipse of 13 May 1332, and subsequently utilized his observations of this unusual event in his pictorial treatment of light in the Baroncelli Chapel. From the theological perspective, meanwhile, it is quite possible that Taddeo Gaddi was aware of contemporary Franciscan discussion of the significance of light both as verification of the presence of God and as a metaphor for spiritual enlightenment. To take but one example, Saint Bonaventura, the great thirteenth-century Master General of the Franciscan Order and author of the canonical biography of Saint Francis, opened his first sermon on the annunciation with the biblical text: 'I am … the bright morning star' (Revelations 22:16).[21]

It is possible, therefore, to hypothesize that this particular and distinctive feature of the Baroncelli Chapel's scheme – evident in both the mural paintings and the altarpiece – was the result of a fruitful juxtaposition of the interests of the patrons, their Franciscan advisers and the painters involved in the project. A legitimate reconstruction of events might be that, first, the Baroncelli chose the Annunciate Virgin as their spiritual advocate and stipulated that the altarpiece and murals for their chapel should commemorate scenes from her life. Second, the Franciscans of Santa Croce urged the inclusion of numerous details which celebrated their order and founder and which, crucially, drew specific parallels between Francis and the Annunciate Virgin in respect of their common experience of receiving a heavenly visitation. Finally, Taddeo Gaddi (and perhaps also Giotto in the altarpiece) responded to this combination of requirements by furnishing a set of images which, by their graphic portrayal of divine light, powerfully evoked precisely the transforming visionary experiences that were so central not only to the lives of Saint Francis and the Virgin, but also to the broader narrative of the nativity of Christ.

THE CHAPEL OF BONIFACIO LUPI

The subject of the second of these two case studies of privately owned funerary chapels is located within the shallow south transept of the vast Franciscan church of Sant'Antonio – the Santo – in Padua (Plate 221). The Chapel of Bonifacio Lupi[22] thus occupies a highly prestigious site, lying directly opposite the north transept chapel which contains the relics of Saint Anthony himself. Unlike the Baroncelli Chapel, the documentary records for both the various stages of the chapel's execution and the practical arrangements for its endowment survive in unusual completeness. They begin with the contract for the architectural and sculptural work on the chapel, drawn up on 12 February 1372 by the prominent Paduan lawyer and scholar Lombardo della Seta, on behalf of its patron Bonifacio Lupi and the Venetian sculptor Andriolo

de'Santi.[23] This contract itemizes very precisely the building materials to be used, and cites the chapter-house of the Santo as one model for certain of its architectural features and a house owned by Lombardo della Seta and his brother as another. It also insists that Andriolo should not subcontract out the carving of the twelve columns of Veronese marble and their capitals. The patron undertakes to pay for the scaffolding (an expensive item in any artistic enterprise, involving as it did buying large quantities of wood) and also the bricks, chalk and iron required for the chapel's construction. Quite apart from the actual construction, Andriolo is also commissioned to execute an altar and five statues for the façade of the chapel. These statues were to be executed in the same materials as the *ancona* (altarpiece) on the high altar, an instruction which offers evidence of the existence of a sculpted altarpiece on the high altar of the Santo.

The remaining accounts for the chapel list payments to the sculptor and also to his son Giovanni, and date the completion of the chapel's tomb monuments to 20 March 1376, the dismantling of part of the scaffolding to July 1376, and the lowering of the scaffolding to March 1377.[24] Apart from Lombardo della Seta and his brother Domenico acting as Bonifacio Lupi's agents in these practical matters, Coradino Lovo also acts in this capacity on behalf of Bonifacio's wife Caterina dei Francesi, thus giving a revealing insight into how wealthy, well-placed women might participate in the commissioning of art at this time. These accounts imply that the construction and sculpted embellishment of the chapel, its façade and two tomb monuments within it took place between 1372 and 1377. The accounts then name the Veronese painter Altichiero as a contributor to the chapel's subsequent decoration. An entry dated 1379 records that Altichiero had received the substantial sum of 792 ducats 'for all that he had to do with Bonifacio in the painting of the chapel of Saint James and the sacristy' (the chapel was dedicated to Saint James the Great). It seems unlikely, however, that Altichiero would have received such a huge lump sum, and it is more likely that this was a record of the total payments the painter had received during the course of his work on the chapel.[25] In the same year a sculptor – identified by modern scholars as the Gascon Rainaldino di Pietro da Francia – was paid for completing the altar begun by 'another sculptor' and for the statues to go on this altar.[26]

Altichiero is the only painter referred to in these accounts. Nevertheless, a number of early writers attribute all or part of the execution of the paintings in the Lupi Chapel to the Bolognese painter Jacopo Avanzo – an attribution perpetuated by some modern scholars.[27] Other scholars, however, have argued persuasively for Altichiero's sole contribution to the chapel's painted scheme.[28] In particular, it has been suggested that it is possible to reconstruct a 'chain of relationships' which led to the award of the commission for the painting of Bonifacio's chapel to Altichiero. Thus, it is quite plausible that Altichiero, having worked for Francesco il Vecchio in the Sala Virorum Illustrium of the Reggia under the close direction of Lombardo della Seta, would have been recommended by Lombardo della Seta to Bonifacio Lupi and on the strength of this recommendation have received the commission for the chapel.[29]

Plate 221 Andriolo de'Santi
and assistants, façade of the
Chapel of Bonifacio Lupi,
c.1372–77, southern transept of
the Santo, Padua. Photo:
Alinari.

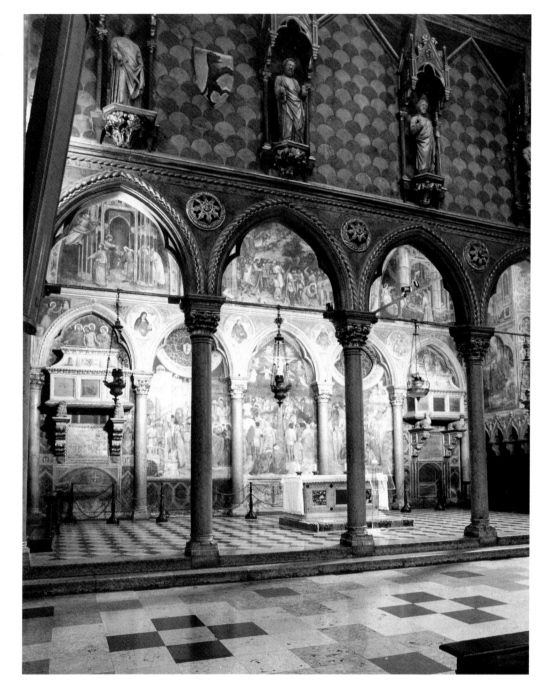

Examination of the chapel both confirms and amplifies the brief indications given in the accounts of Bonifacio Lupi's wishes for his chapel. The whole of the extremely shallow southern transept of the Santo was transformed into a remarkably coherent scheme of architecture, sculpture, woodwork and fresco painting, thus suggesting close collaboration between all parties concerned with this artistic venture – patrons, agents, architects, sculptors and painters (Plate 221). The chapel's interior space was carved out of the transept by the introduction of three groin vaults whose profiles were masked by a tall screen placed over the north arcade.[30] This screen was embellished by a highly decorative fish-scale pattern of white and peach-coloured Veronese marble and sculpture incorporating statues of five saints and the Lupi family emblem of the wolf – a pun on the Latin for wolf, *lupis* (Plate 222).[31] The chapel was further distinguished

from the rest of the church by the level of its pavement, lying two steps above that of the south aisle of the Santo. The irregular ground plan of the chapel, with its east wall longer than its west wall by some 150 centimetres, was skilfully overcome by the realignment of the north arcade to match that of the south wall (Plate 223). This irregularity was further masked by the placing of wooden choir stalls with interlocking stone canopies along the east and west walls (Plate 224). The original fenestration of the transept was altered, resulting in two blind almond-shaped apertures being placed on the south wall and a single lancet window on the west wall, the latter supplying the only source of light for the chapel. The architectural components itemized in the 1372 contract were magnificently realized in terms of the marble columns, the finely carved detail of the gilded capitals and the highly ornate entrance façade (Plates 221, 225).

Plate 222 Anonymous, nineteenth-century drawing of the façade of the Chapel of Bonifacio Lupi showing the sixteenth-century remodelling of the altar to accommodate the remains of Saint Felix, the Santo, Padua. Reproduced by courtesy of Musei Civici Padova, Gabinetto Fotografico.

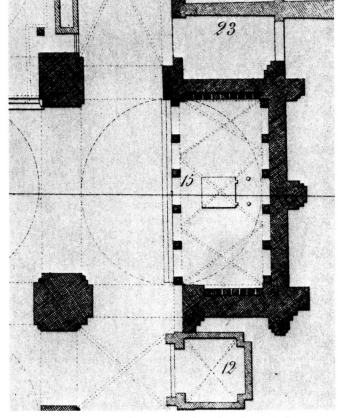

Plate 223 Ground plan of the Chapel of Bonifacio Lupi, the Santo, Padua. Reproduced from B. Gonzati, *La basilica di Sant'Antonio di Padova*, 1852–53. Biblioteca Civica Padova.

Two tomb monuments, conforming to the well-established Paduan tradition of tomb chests set high on the wall, occur within the first and fifth bays of the south wall (Plates 225, 233). Their relatively simple design incorporates heraldic emblems and inscriptions identifying them as tombs of, on the left, four members of the Rossi family, close relatives of the chapel's founder,[32] and, on the right, Bonifacio Lupi himself. As well as their sculpted embellishment, the tombs characteristically include frescoed decoration. Thus, above each tomb chest is a lunette enclosing a mural painting (Plates 226, 233) and below it a *trompe-l'oeil* evocation of a burial chamber. What is now missing from the chapel is the handsome tomb slab of Bonificio's wife Caterina dei Francesi, which shows her carved in effigy upon its front face. Once located within the pavement of the chapel, it was removed in 1773 and can now be seen in the passage between the church and the principal cloister of the Santo.[33]

The chapel's original altar and its sculptures are no longer *in situ*. The present altar, installed in 1962, comprises a simple altar chest placed on a single step, and in all probability mirrors the dimensions of the original fourteenth-century altar.[34] Four original sculpted figures for the altar, depicting the Virgin and Child and Saints Peter, Paul and James, are presently displayed within the museum of the Santo (Plate 227). A fifth is likely to have been the statue of Saint Anthony of Padua recovered from the façade of the church and now also displayed in the museum.[35] It is remarkable that the chapel scheme originally incorporated a sculpted rather than a painted altarpiece – an unusual decision

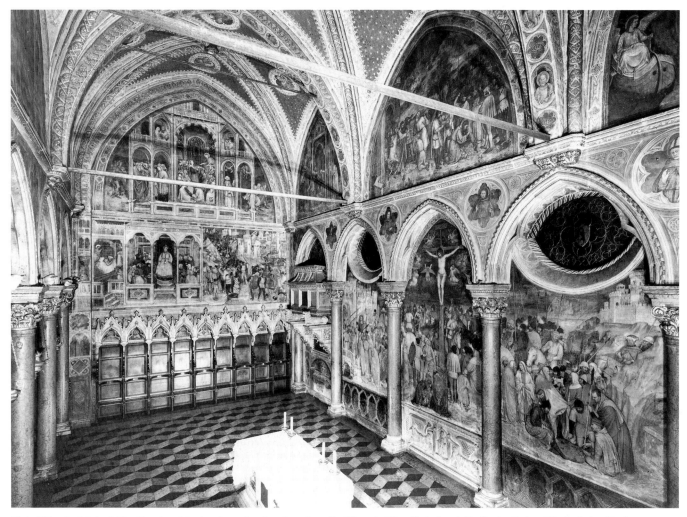

Plate 224 Andriolo de'Santi and assistants, view of east and south walls, Chapel of Bonifacio Lupi, the Santo, Padua. Photo: Index/Lufin.

determined in part by the existence of a sculpted altarpiece over the high altar of the Santo. It is likely, therefore, that the present location of the altar at the centre of the chapel mirrors the original arrangement – and that it and its sculpted figures would have been seen in conjunction with *The Crucifixion* behind it, thereby bestowing upon this painting a prominence and status customarily reserved for the painted altarpiece of a chapel (Plates 221, 236).

The paintings in the chapel are situated principally on the south and east walls and in the nine lunettes which mark the transition between the groin vaults and the rest of the chapel's architecture. The presence of the window on the west wall restricts the surface available for painting, but it too displays painted imagery. The south wall is taken up with narrative scenes from the New Testament and more specifically from Christ's Passion. A panoramic depiction of *The Crucifixion* occupies the three central bays (Plate 236), whilst the lunettes over the two tombs show, on the left, *The Entombment of Christ* (Plate 226) and, on the right, *The Resurrection* (Plate 233). The Christological theme of the south wall is further extended by the depiction of Gabriel and the Annunciate Virgin on the outer extremities of the first and fifth bays.

Meanwhile, the upper lunettes and the east wall display a series of narrative murals celebrating the ministry,

martyrdom and posthumous miracles of Saint James the Great. The principal literary source for the scenes shown in the lunettes is the great medieval hagiographical compendium, *The Golden Legend*, a text whose content the painter follows with a remarkable degree of fidelity.[36] The narrative sequence begins in the lunette of the east wall with a composite scene showing James disputing with Philetus, who had been sent by the magus, Hermogenes, in order to discredit the apostle. A subsidiary scene on the right of this painting shows Hermogenes, foiled in this first attempt, dispatching demons to torment James. The sequence continues in the south wall lunettes with three scenes. These depict, respectively, Hermogenes' eventual conversion and baptism; Saint James's martyrdom (a painting which shows, on the left, the saint's cure of a paralytic on the way to his execution thus causing a scribe, Josias, to become a Christian, and, on the right, the beheading of James and his fellow martyr Josias – Plate 228); and finally, the saint's body, having been miraculously carried over the sea to Spain in a boat guided by an angel, being deposited by his disciples on a rock within the vicinity of the palace of the ruler of that land, Queen Lupa. The paintings of the lunettes on the west wall show Queen Lupa ordering the imprisonment of the saint's disciples and the imprisonment itself.

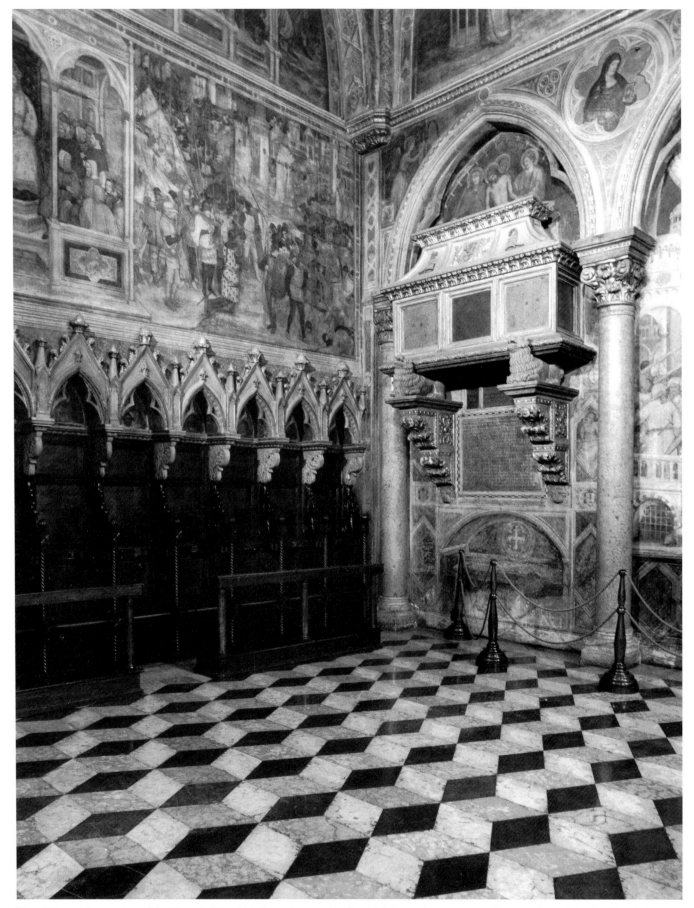

Plate 225 South-east view of the Chapel of Bonifacio Lupi showing (on the right) the tomb monument of four members of the Rossi family by Andriolo de'Santi and assistants, the Santo, Padua. Photo: Tim Benton.

Plate 226 Altichiero and assistants, *The Entombment of Christ*, *c.*1377–79, frescoed lunette of the Rossi tomb, Chapel of Bonifacio Lupi, the Santo, Padua. Photo: Barbara Piovan.

The three lunettes on the inner side of the north arcade depict three complex scenes. The first illustrates the release of the disciples by an angel, and how attempts to recapture them were foiled by the collapse of a bridge which plunged their pursuers into a river (Plate 229). The second shows Queen Lupa's attempt to destroy the bodies of both the saint and his disciples by dispatching a cart harnessed with wild bulls to carry the saint's body up into the mountains. At the sign of the cross, however, the bulls became as quiet as lambs, and were, furthermore, unable to move either the saint's body or its bier. The third lunette painting shows the triumphant finale of this episode when Queen Lupa is baptized a Christian (Plate 230). The three paintings on the east wall illustrate another of the posthumous miracles attributed to the saint, a subject derived not from *The Golden Legend* but from medieval chivalric literature celebrating the saint's intervention on behalf of Christian knights against the infidel. Reading from left to right, these scenes represent the appearance of Saint James to the ninth-century King Ramiro of Oviedo in a dream in which the saint urged the king to take arms against the enemies of Christ, the announcement by King Ramiro to his courtiers at a council meeting of his dream and his intention to follow James's instructions (Plate 234), and the battle at which the saint miraculously caused the ramparts of the besieged city of Clavigo to fall (Plate 231).[37]

The lower surfaces of the west wall are occupied by a votive image showing the patron Bonifacio Lupi and his wife Caterina dei Francesi. Bonifacio is shown being presented to the Virgin by the titular saint of the chapel, Saint James, whilst Caterina is presented by her name saint, Catherine of Alexandria (Plate 232). Elsewhere the chapel is also embellished by an impressive number of other holy figures. In the vaults appear a sequence of twelve medallions depicting four Old Testament prophets, the symbols of the four evangelists, and the four Latin church fathers. Busts of saints also figure in the spandrels of the arches, the canopies

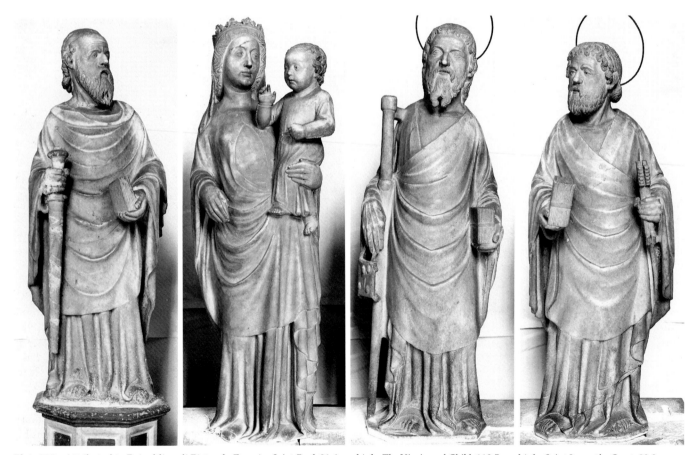

Plate 227 Attributed to Rainaldino di Pietro da Francia, *Saint Paul*, 91.4 cm high, *The Virgin and Child*, 110.5 cm high, *Saint James the Great*, 93.2 cm high, *Saint Peter*, 90.8 cm high, *c.*1378–79, marble, Museo Antoniano, the Santo, Padua, formerly altar of the Chapel of Bonifacio Lupi. Photo: Index/Lufin.

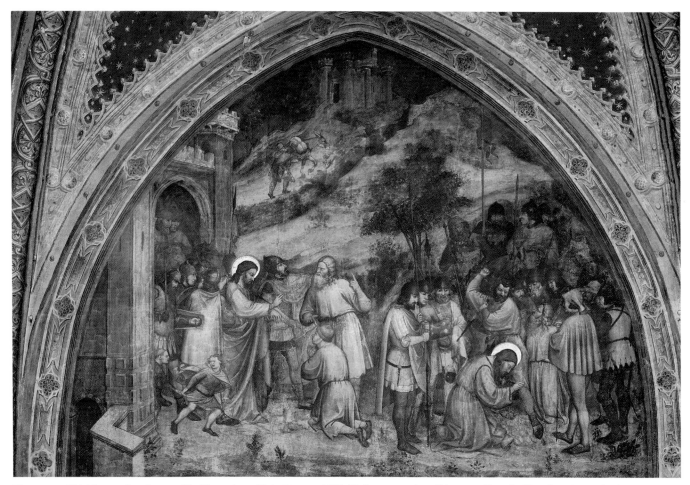

Plate 228 Altichiero and assistants, *The Martyrdom of Saint James, c.*1373–79, fresco, south wall lunette, Chapel of Bonifacio Lupi, the Santo, Padua. Photo: Index/Lufin.

of the stalls (Plate 224) and on the transverse ribs of the chapel vaults. The embrasure of the window also contains an image of the Trinity surrounded by a company of angels.

BONAFACIO LUPI

In the absence of the contract between Bonifacio Lupi and Altichiero for the painting of the chapel, the patron's intentions for the painted imagery must be reconstructed from other documentary sources and other kinds of historical information. Fortunately a quantity of such information survives, and thus allows the modern scholar an insight into both the mortuary function of the chapel and the significance for the patron of the paintings' iconography. Contemporary chronicles and subsequent historical research reveal that Bonifacio Lupi was from a Parmesan family which for generations had held the title of Marquis of Soragna (a small town near Parma). In the first decade of the fourteenth century the Lupi were driven out of Soragna and Bonifacio became a soldier of fortune. He entered into the service of the Carrara family and served the rulers of Padua as a military leader, counsellor and diplomat. In the latter capacity he served on numerous embassies, visiting Tuscany, Bologna and Venice. He also travelled further afield on behalf of the Carrara, visiting the court of the Angevin ruler of Hungary,

Louis the Great, at Buda in May 1372.[38] As we shall see, this diplomatic expedition was to feature in the painted iconography of Bonifacio's chapel. As a soldier and diplomat, Bonifacio served Francesco il Vecchio but then transferred his allegiance to the Visconti after their conquest of Padua in 1388. The Gatari in their chronicle report that on the 20 June 1390 Bonifacio refused Francesco il Novello entry to Padua and bragged of his new loyalty to Gian Galeazzo Visconti.[39] It is not known whether Bonifacio was subsequently executed by Francesco il Novello when the latter again secured control over Padua in 1390, or whether he was banished and ended his days in exile.[40]

It is also notable that in addition to commissioning his chapel in the Santo, Bonifacio oversaw the completion of a further funerary chapel built to commemorate the Lupi family. The Oratory of San Giorgio – a free-standing oratory built in the precincts of the Santo and dedicated to Saint George – was begun *c.*1377 by a close kinsman of Bonifacio, Raimondino Lupi. Raimondino died on 30 November 1379 before completion of the oratory, and Bonifacio, as Raimondino's heir and executor, ensured that this additional prestigious family project was brought to fruition. Ostensibly built as a funerary monument to Raimondino, its sculpted and painted imagery in practice constituted a celebration and commemoration of the entire Lupi family, including Bonifacio

Plate 229 Altichiero and assistants, *The Escape of the Disciples of Saint James*, *c.*1373–79, fresco, lunette on north arcade, Chapel of Bonifacio Lupi, the Santo, Padua. Photo: Alinari.

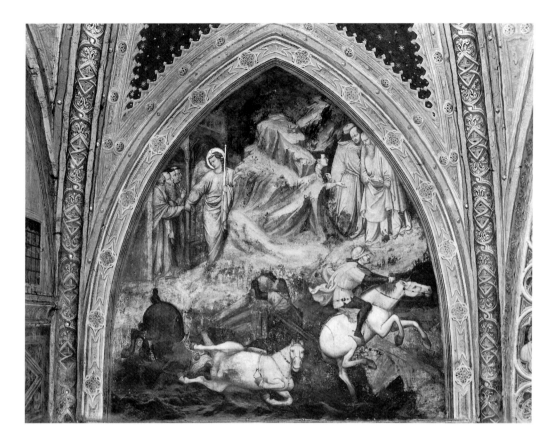

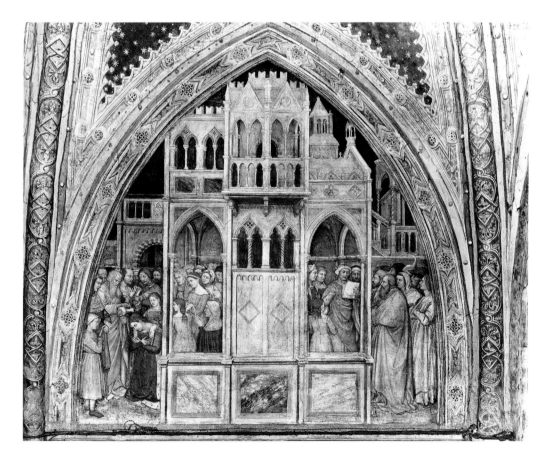

Plate 230 Altichiero, *The Baptism of Queen Lupa*, *c.*1373–79, fresco, lunette on north arcade, Chapel of Bonifacio Lupi, the Santo, Padua. Photo: Alinari.

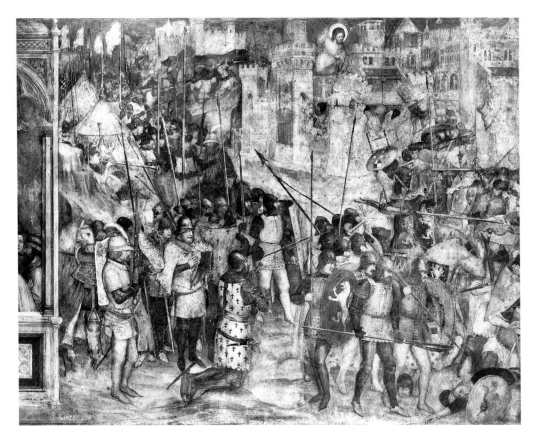

Plate 231 Altichiero, *The Battle of Clavigo*, c.1373–79, fresco, east wall, Chapel of Bonifacio Lupi, the Santo, Padua. Photo: Alinari-Anderson.

himself. Significantly the principal painter involved in the project was again Altichiero.[41]

Bonifacio's career, both politically and as a patron of art, was not confined to Padua; he also had close political and cultural contacts with Florence. In 1362 he served a term as Capitano del Popolo of Florence and expressed a wish to be buried within Florence's Duomo – a wish that was apparently denied him.[42] In 1376 he founded a hospital and oratory dedicated to Saint John the Baptist, which still stands at the intersection between the Via San Gallo and Via Bonifacio Lupi in Florence. A number of documents attest to the careful provision made by Bonifacio to ensure that the oratory served the religious needs of both pilgrims and the poor.[43] In addition, in her will of 12 May 1385 Caterina dei Francesi bequeathed to her husband's Florentine hospital property that she owned in her ancestral home of Staggia, just north of Siena.[44]

Apart from such historical evidence for the patron and his social and cultural contacts, other documents survive which list in detail purchases for the chapel of liturgical equipment – *paramenta* – made by Bonifacio in 1374 and by Caterina dei Francesi in 1395 and 1396. These included not only vestments, cloths and candle holders for the altar, but also the liturgical utensils necessary for the celebration of Mass such as chalices, patens and thuribles.[45] The attention to detail on the part of Bonifacio and his wife in respect of their family monument is also indicated by the description in a fifteenth-century inventory of a missal for the chapel, covered in red leather and silverwork and bearing the Lupi coat of arms on both its cover and final page.[46]

It is also significant that, like Vannes Salimbeni some 30 years earlier, Bonifacio made careful provision for regular

celebration of masses commemorating himself and his family within the chapel. On 19 October 1376 he obtained an undertaking from the friars of the Santo (subsequently ratified by a number of later agreements) that after his death they would celebrate three daily masses within the chapel. In return for this service he guaranteed a regular annual payment.[47] The details of the source of this income occur in a later document, dated 29 September 1384, where Bonifacio states that he had given land to a community of nuns belonging to the convent of Santa Clara at Arcella Nuova – a Franciscan convent with close contacts with the friary of the Santo. In return, during Bonifacio's lifetime the nuns were to pay the friars 24 ducats to celebrate the stipulated number of masses within Bonifacio's chapel. Meanwhile, Bonifacio undertook to underwrite other expenses within the chapel, principally the purchase of large quantities of wax for the candles required for the regular masses celebrated within it. After Bonifacio's death, the nuns were to pay 104 ducats annually to the friars. This sum was to pay for the celebration of the three daily masses, candles and repair of the chapel, with precise stipulations concerning the repair of the glass and the maintenance of the roof.[48] In particular, the feast days of Saint James and All Souls – the latter when the souls of the dead were commemorated – were to be marked by greater liturgical ritual. A stone tablet set into the west wall of the chapel repeats in abbreviated form the information included in the endowment documents, but stipulates that now the endowment should be 140 ducats. While carrying the date of 1376, the inscription was probably only installed in the chapel after 1384, once the final details of the financial arrangements had been worked out to the satisfaction of all parties concerned.[49] A year later Bonifacio Lupi made his will.[50]

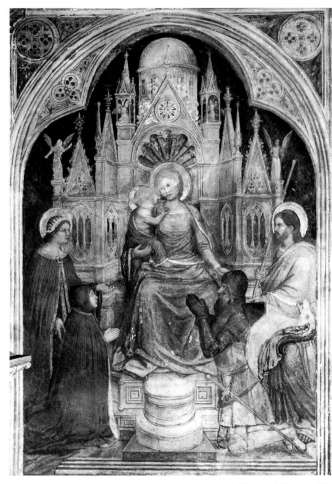

Plate 232 Altichiero, *Bonifacio Lupi and Caterina dei Francesi Presented to the Virgin and Child by Saints James the Great and Catherine of Alexandria,* c.1373–79, fresco, west wall, Chapel of Bonifacio Lupi, the Santo, Padua. Photo: Osvaldo Böhm.

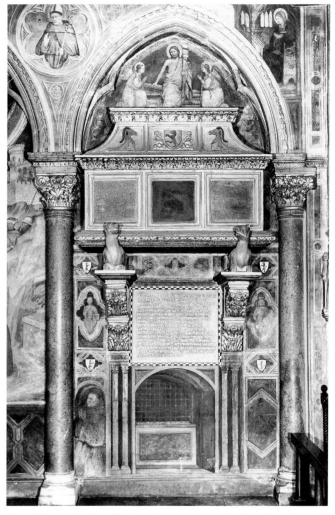

Plate 233 Andriolo de'Santi and assistants, tomb of Bonifacio Lupi, c.1372–77, south wall, Chapel of Bonifacio Lupi, the Santo, Padua. Reproduced by courtesy of Musei Civici Padova, Gabinetto Fotografico.

Although this document makes no specific reference to the tomb monument already present in the chapel, it does state that Bonifacio wished to be buried in the chapel which he had constructed.

The actual circumstances of Bonifacio's death are not known, but it is clear from the documents relating to the chapel and its endowment that Bonifacio initiated the chapel within the Santo in order that it should perform a mortuary function for himself, his wife and his Rossi relatives. While the chapel was ostensibly founded for the *private* needs of the Lupi family, it also appears that at least once a year – on the feast day of Saint James the Great – it performed a more public role. Thus, on 12 February 1386 Pope Urban VI granted an indulgence of one year and 40 days to those visiting the chapel on the Feast of Saint James.[51] The chapel must, therefore, have constituted one of the major focal points of pilgrim devotion within the Santo and, indeed, have further contributed to the already flourishing cult of Saint James, not only within Padua itself but throughout the whole of Europe.

We know, then, that Bonifacio Lupi's chapel in the Santo was specifically designed as a funerary chapel for himself, his wife and close male relatives. We know also that it was

generously endowed for the celebration of requiem masses and that in due course it became the local focus of the cult of Saint James. What light does such knowledge shed upon the painted and sculpted embellishment of the chapel? In particular, how did it express the intentions of Bonifacio Lupi for his chapel?

As we have seen, the chapel lacks a painted altarpiece. In place of such conventional embellishment of the altar, however, there once stood both statuary (representing the Virgin Mary and her Son in the company of saints, a standard subject for altar decoration – Plate 227) and, behind the altar, the impressive, monumental *Crucifixion,* a painting whose subject graphically portrays the very sacrifice celebrated within the liturgy of the Mass (Plate 236). Moreover, it is significant that, whereas narrative paintings of the Crucifixion normally included representations not only of Christ but also of the good and bad thieves crucified with him, Altichiero chose to portray only Christ. Thus, within the upper part of the painting – that is, the area framed by the arches of the blind arcade of the south wall – *all* attention is focused upon the single, central figure of the crucified Christ surrounded by a circle of mourning angels. Within the busy and highly

anecdotal treatment of the Crucifixion as a narrative event, therefore, there is also an assertion of the deeply symbolic and iconic nature of this religious subject. Such an assertion was highly appropriate for the liturgical function envisaged by the patron for his chapel. The lunette scenes above the tombs, meanwhile, not only narrate events subsequent to Christ's death on the Cross, but also underline the mortuary function of the tombs themselves. On the left appears the body of the dead Christ lowered into the Rossi tomb (Plate 226) whilst, on the right, the body of Christ rises triumphantly out of Bonifacio's tomb (Plate 233). By juxtaposing these two subjects and the tombs, Altichiero neatly encapsulated in pictorial form the hopes of Bonifacio Lupi and his Rossi relatives that they, like Christ, would overcome death and attain everlasting life. And it is Bonifacio's tomb, we may note, that is surmounted by the triumphant imagery of the Resurrection itself, the founder of the chapel thus being most closely associated with the figure of the risen Christ.[52]

In the tablet recording the chapel's endowment, the Virgin Mary is named first as the saint in whose honour the chapel is dedicated, and she duly appears in the painting of *The Crucifixion* (Plate 236), as the central subject of the votive image on the west wall (Plate 232) and as the Annunciate Virgin. Despite these appearances, however, she takes a relatively minor role within the imagery of the chapel. Nevertheless, as in the Baroncelli Chapel, such a dedication to the Virgin carried with it the pious hope that she would act as principal intercessor on behalf of the founder and his relatives. This wish finds its pictorial expression in the votive image of Bonifacio and Caterina dei Francesi kneeling before the enthroned Virgin and Child. Significantly, the convention of showing the male donor on the left of the painting – and therefore on the right and more honorific side of the holy figures – has here been reversed so that Bonifacio may be portrayed facing his tomb, from which, by the good offices of the Virgin, he hoped on the day of judgement to rise again and to gain everlasting life.

By contrast, a much greater proportion of the chapel's painted imagery commemorates and celebrates the second titular saint of the chapel – Saint James the Great. Both the choice of narrative scenes from the saint's hagiography and indeed their sequential ordering may plausibly be explained in terms of the patron's aspirations for the glorification of himself and his family. The organization of the narrative scenes enables certain pictorial parallels to be drawn, the most significant being that between the martyrdom of Saint James and the Crucifixion of Christ – thus encapsulating in concise pictorial terms the Church's belief that the special sanctity of the saints lay in their emulation of Christ himself. The legend of Saint James and his relics and his miraculous interventions in battles against the Moors in Spain was also highly appropriate to the knightly, chivalric culture of late medieval Europe – a culture undoubtedly cultivated by the Carrara, whose political viability depended largely upon their military proficiency and skill. Moreover, whilst *The Golden Legend* describes the role of Queen Lupa in the preservation and sanctification of Saint James's relics, it was rarely depicted within art.[53] Clearly, the most likely explanation for the inclusion of these incidents in this particular context is that the Lupi family wished to associate themselves with this

legendary queen who shared their family name. By so doing, moreover, they also associated their familial history with Saint James, who was himself the focus of a major international religious cult.

It is, however, in the three scenes on the lower east wall that the personal impact of Bonifacio Lupi is arguably most evident. The scenes, illustrating Saint James's intervention on behalf of King Ramiro, are essentially military and chivalric in tone. Given Bonifacio's own career as a knight, this choice of subject-matter and its pictorial treatment are entirely apt. In addition to such general appropriateness, the three scenes also apparently include a striking number of contemporary portraits. It has justly been observed that the central scene of *The Council of King Ramiro* amounts to 'an allegory of contemporary politics, reflecting issues of crucial importance in the history of Padua in the 1370's'. This interpretation is supported by the convincing identification of the features, regal costume and insignia of King Ramiro with those of King Louis the Great of Hungary, a ruler whom Bonifacio visited as a diplomat in 1372 (Plate 234).[54] The identification of Louis with Ramiro is in turn amply supported both by the detail of the Angevin fleur-de-lis which ornaments the canopy over the king's throne and by comparisons with other contemporary representations of King Louis.[55] Bonifacio himself is probably identifiable as the male figure on the extreme right with *AMOR* written on his helmet (Plate 235). Bonifacio's patrons, Francesco il Vecchio and his son Francesco il Novello, may similarly be represented by the two male figures standing to the left of Ramiro and looking intently towards the king. Two other illustrious members of the Carrara court – Petrarch and Lombardo della Seta – are also probably portrayed within the painting, seated just to the left of King Ramiro.[56] If all these proposed portraits are correctly identified, the scene indeed represents an impressive allegorical treatment of key elements in the life of the patron of the chapel: no fewer than five of Bonifacio's most illustrious associates and Bonifacio himself are inserted into a portrayal of an idealized Christian ruler responding to a divinely inspired message from Saint James that he should lead an expedition against the infidel.

Nor, arguably, is *The Council of Ramiro* the only scene in which portraiture occurs. It has been suggested that *The Battle of Clavigo* may include further elements of portraiture (Plate 231). The kneeling figure of King Ramiro is shown wearing a surcoat over his armour ornamented with the Angevin fleur-de-lis, and Bonifacio's features have been discerned on the face of the isolated soldier left of centre of the figural composition.[57] It has further been proposed that the soldier in the right-hand foreground shown as if looking in the direction of the Rossi tomb on the adjacent wall may be a member of the Rossi family, whose distinctive family device of a lion rampant upon a red field appears on his shield.[58] Finally, it has been suggested that Caterina dei Francesi may be the figure seated to the left of Bonifacio in *The Council of Ramiro* (Plate 234).[59] On balance, however, it is unlikely that she would be portrayed within the context of a political council – such events being overwhelmingly male gatherings in the fourteenth century. A middle-aged veiled woman is, however, shown kneeling in prayer to the right of the baptised queen in *The Baptism of Queen Lupa* (Plate 230). The distinctive profile of this woman is similar to that of Caterina

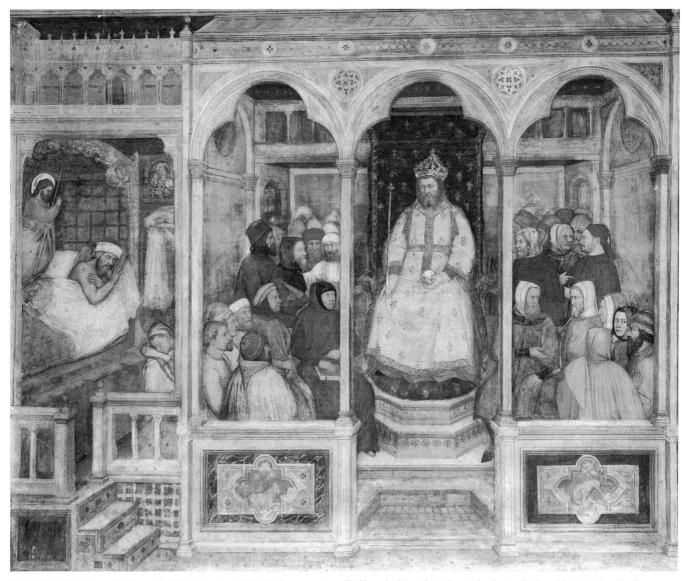

Plate 234 Altichiero, *The Council of King Ramiro*, *c*.1373–79, fresco, east wall, Chapel of Bonifacio Lupi, the Santo, Padua. Photo: Index/Lufin.

dei Francesi in the votive image of the west wall (Plate 232). Moreover, whereas her proposed appearance within the overtly male context of a council is relatively implausible, her appearance within a mural devoted to the baptism of Queen Lupa, accompanied by numerous other women, is entirely appropriate within the prevailing norms of social decorum concerning the distinctive roles assigned to men and women.

It seems, therefore, that Bonifacio – and perhaps Caterina as well – may well have supplied Altichiero with both the overall subject-matter and a number of personal details for inclusion within the murals of the chapel. But what particular artistic skills were sought from the painter and sculptors employed in this project? The documentary sources offer little evidence on this question. The contract between Bonifacio and Andriolo de'Santi clearly indicates that Bonifacio wished to secure the personal handiwork and skill of the Venetian sculptor. In the case of Altichiero, however, all we learn from the documents is that Bonifacio was satisfied with the Veronese painter's work – no specific contract apparently having survived. We should recall, however, that Bonifacio

probably secured Altichiero's services shortly after the painter had completed a prestigious commission for the Carrara in the Reggia and that Bonifacio himself subsequently entrusted Altichiero with the paintings of the Oratory of San Giorgio. The paintings themselves, however, offer rather more evidence of the particular skills Bonifacio sought from Altichiero. Two aspects of the painter's work within this chapel are particularly striking in this respect: his exploitation of the architectural setting of his work and his perceptive use of portraiture.

The overall aspect of the south wall provides good evidence of the painter working imaginatively within the architectural and sculptural framework of the chapel. The blind arcade and the tomb monuments furnish an imposing framework for the panoramic painting of *The Crucifixion* which unfolds across the three central bays of the wall (Plates 221, 236). The generous expanse of wall devoted to this scene allowed Altichiero to portray an extraordinarily large number of people witnessing this event, and indeed to depict a rich variety of physiognomies, ages, races, costumes and

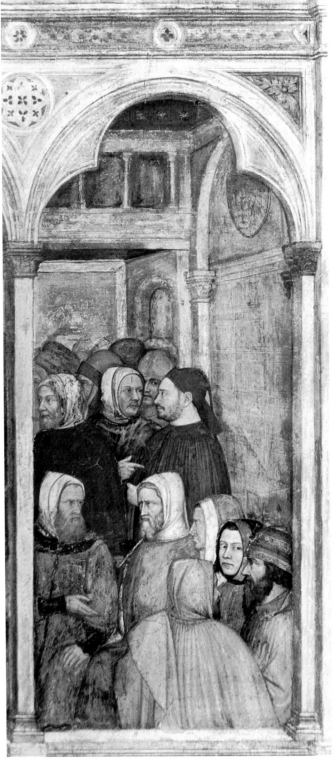

Plate 235 Altichiero, *Bonifacio Lupi*, detail of *The Council of King Ramiro* (Plate 234). Photo: Scala.

anecdotal details. Furthermore, the low viewpoint adopted for the figural composition and the gentle curve of the head height of the figures gathered at the foot of the Cross create the illusion that the viewer is a participant in the event. Such illusionism was particularly appropriate in view of the public function that this chapel once performed on the Feast of Saint James.

No less impressive – though less immediately obvious – is the apparently cumulative use of portraiture to enhance the commemoration and glorification of Bonifacio, his wife and family and their associates. Thus, quite apart from the conventional donor portraits of Bonifacio and Caterina in the votive mural on the west wall (Plate 232), Bonifacio himself, as we have seen, may well appear at least twice more within paintings celebrating Saint James and his cult (Plates 231, 234, 235). Moreover, even if there remains some doubt as to the multiple representations of Bonifacio, it is clear that several other leading contemporary figures of the Carrara court in Padua and one of the most important of the Carrara allies are represented within the murals in question. And, as we have noted, it is also possible that Caterina's portrait is included within *The Baptism of Queen Lupa* (Plate 230).

The artistic skills of Altichiero were thus ably deployed in the service of this patron's religious and familial requirements. His abilities in pictorial illusionism enabled him to involve the viewer in the depiction of a key moment within the Christian drama of redemption, apparently drawing the worshipper into the circle of observers of the Crucifixion. His skill in portraiture, meanwhile, ensured the presence and prominence of the Lupi family and their associates with the sacred narratives of this painted chapel.

SEIGNEURIAL PADUA VERSUS REPUBLICAN FLORENCE

Both the Baroncelli Chapel in Santa Croce, Florence and the Chapel of Bonifacio Lupi in the Santo, Padua provide striking evidence of their patrons using their chapel foundations to commemorate and celebrate their own identities and reputations and those of their families. Nevertheless, there remain important differences between the expression of such familial ambitions in the examples examined here. Clearly, in the case of the Paduan chapel such intentions are far more transparent and easier to reconstruct. Thus, quite apart from the two tomb monuments within the chapel, it includes within its painted imagery a striking number of portraits of the founder, his wife and close associates. The choice of Saint James as titular saint allowed for the expression of chivalric themes and the depiction of contemporary costume and social mores appropriate to the patron and his immediate social circle. By contrast, the Baroncelli Chapel is much more discreet in its celebration of the identities of the patrons and their personal concerns and aspirations. In fact, apart from the tomb epitaph, their personal identities can only be deduced from the representation of their name saints depicted within the stained glass. Otherwise, the overwhelming impression given by the chapel's painted imagery is that of a paean of praise directed towards the Virgin Mary.

Is it feasible to argue, therefore, that a particular cultural ambience of seigneurial Padua allowed for a more pronounced expression of private interests within the context of the painted and sculpted imagery of the funerary chapel than was possible in republican Florence? We have, of course, a far greater amount of documentation for the Chapel of Bonifacio Lupi than for the Baroncelli Chapel. Thus, it is possible that in the Baroncelli Chapel there are more allusions

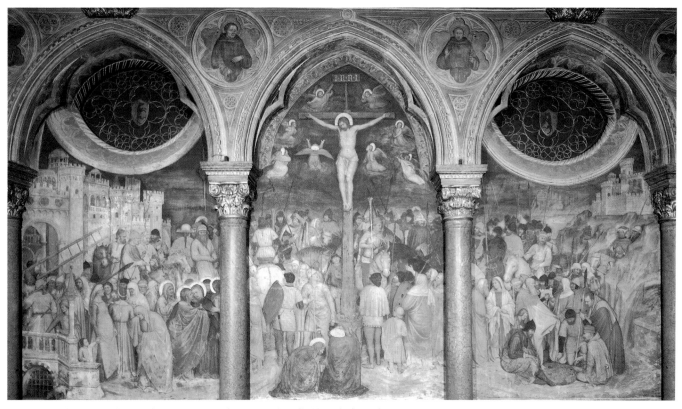

Plate 236 Altichiero, *The Crucifixion*, c.1373–79, fresco, south wall, Chapel of Bonifacio Lupi, the Santo, Padua. Photo: Index/Lufin.

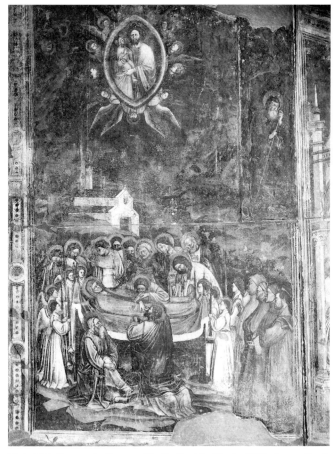

Plate 237 Jacopo da Verona, *The Death of the Virgin*, 1390s, fresco, Bovi Chapel, Oratory of San Michele, Padua. Photo: Alinari.

to the patrons and their particular concerns than are now apparent.

In Padua the practice of including contemporary portraiture within the context of a privately founded funerary chapel apparently established itself early in the fourteenth century, as witnessed by the striking painted and sculpted portraits of Enrico Scrovegni within the Arena Chapel (Chapter 4, Plate 104, Chapter 5, Plate 137). Such portraiture appears to have enjoyed continued popularity throughout the century as evidenced by a sequence of highly personalized tomb monuments – and to have reached its culmination in a number of private chapels founded within the last three decades. The group of portraits of Pietro de Bovi and his associates, commissioned in the last decade of the century and executed on the walls of the Bovi family chapel in San Michele Arcangelo, provides compelling evidence of the persistence of this tradition (Plate 237).[60] Although the Scrovegni portraits suggest that this tradition of personal commemoration preceded the period of Carrara political and cultural dominance in Padua, the frequent appearance of the Carrara themselves within various private chapels of the later fourteenth century – and indeed their own contributions to this particular artistic genre – suggest that the seigneurial and chivalric ethos of their regime was apt to foster the overt and explicit expression of personal and familial commemoration.

A similar survey of contemporary portraiture and allusion within the pictorial decoration of Florence's private chapels reveals a situation which is much less obvious. For example, the Strozzi Chapel, situated at the end of the west transept of the Dominican church of Santa Maria Novella, is embellished with a mid fourteenth-century altarpiece of *Christ in Glory*

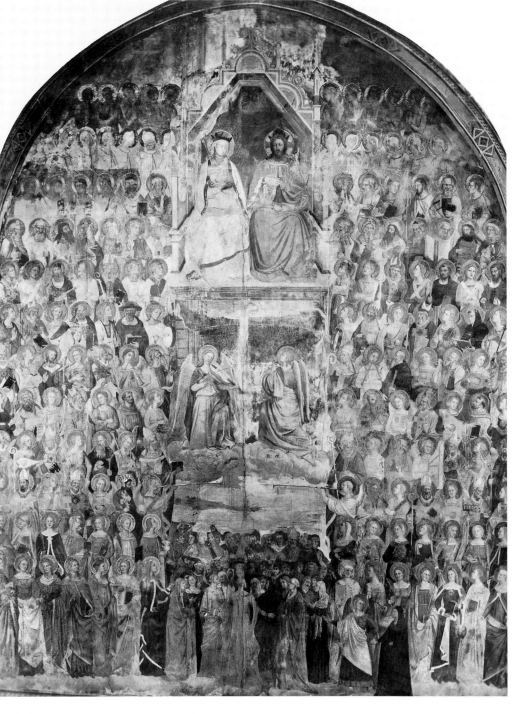

with Saints by Orcagna and mural paintings of *The Last Judgement, Paradise* and *Hell* by Nardo di Cione. As in the Baroncelli Chapel, the Strozzi apparently did not instruct their painters to include prominent and explicit portraits of members of the Strozzi family or to celebrate their worldly reputations and preoccupations. The most that can be claimed for these paintings in this respect is that among the many painted figures of these three murals, a man and a woman may represent Jacopo di Strozza Strozzi (d.1351) and his wife Diana Giambullaris Strozzi, and that this couple may also be identified as the diminutive figures being led by the Archangel Michael towards the heavenly company portrayed in the painting of *Paradise* (Plate 238).[61]

As with so much of fourteenth-century art-historical debate, conclusions in this matter can only be based upon a judicious balancing of less than complete evidence. It does appear, however, that the seigneurial ambience of Padua did allow – and even encourage – much more overt displays of private, familial glorification within the context of funerary chapels than appears to have been the custom within republican Florence. In Florence it was not until the mid fifteenth century – most notably in the procession of contemporary portraits represented in the Sassetti family chapel in Santa Trinita and the Tornaquinci family chapel within Santa Maria Novella – that the Paduan commitment to the commemoration and celebration of individuals, their families and friends reached a comparable degree of expression within the private funerary chapel.

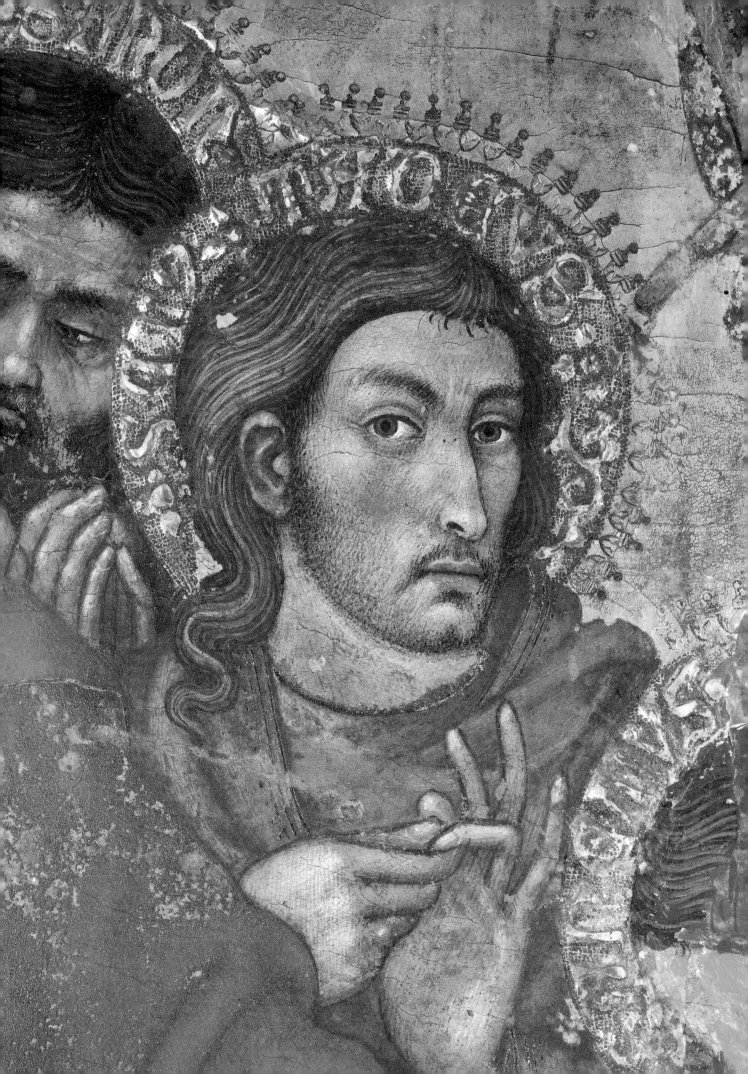

'Hail most saintly Lady': change and continuity in Marian altarpieces[1]

On 17 April 1320 the Sienese artist Pietro Lorenzetti undertook to paint an altarpiece for Bishop Guido Tarlati of Arezzo. In the middle of the altarpiece 'must be the image of the Virgin Mary with her Son and with four collateral figures [according] to the wishes of the Lord Bishop'. This altarpiece – destined for the high altar of the baptismal church or Pieve of Arezzo – was additionally to be worked 'with the best gold … and with other ornaments of the best silver … ultramarine blue … and in good and select colours'.[2] Like so many early fourteenth-century altarpieces, the polyptych executed by Pietro Lorenzetti[3] for Bishop Tarlati has suffered considerable alteration and damage during its long history (Plate 240). Sometime in the sixteenth century it was removed from its position over the high altar and placed on a smaller altar in the church. At that time it was stripped of all the vertical pieces of its frame, including the sturdy outer buttresses or columns (columpnae) also mentioned in the commissioning document. It has now been restored to its original position over the high altar, and despite the loss of its original framework, this composite panel painting still represents an impressive example of early fourteenth-century Sienese altarpiece design.

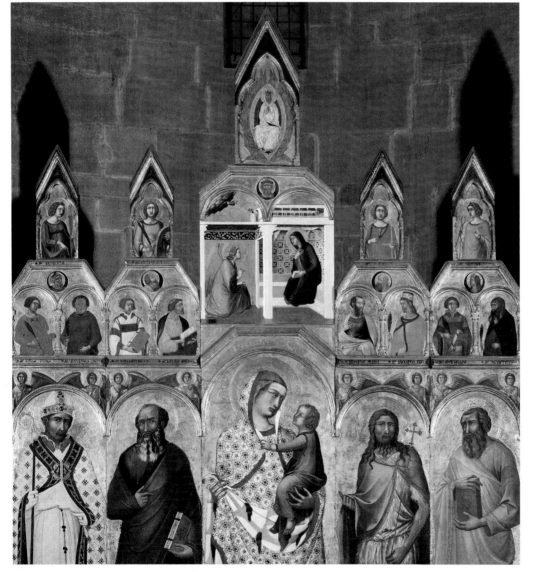

Plate 240 Pietro Lorenzetti, *The Virgin and Child with Saints*, the 'Arezzo polyptych', 1320, tempera on panel, 298 x 309 cm, high altar, Pieve, Arezzo. Photo: Scala.

Plate 239 (Facing page) Taddeo di Bartolo, *Saint Thaddeus*, detail of *The Virgin of the Assumption with Apostles* (Plate 244). Photo: Lensini.

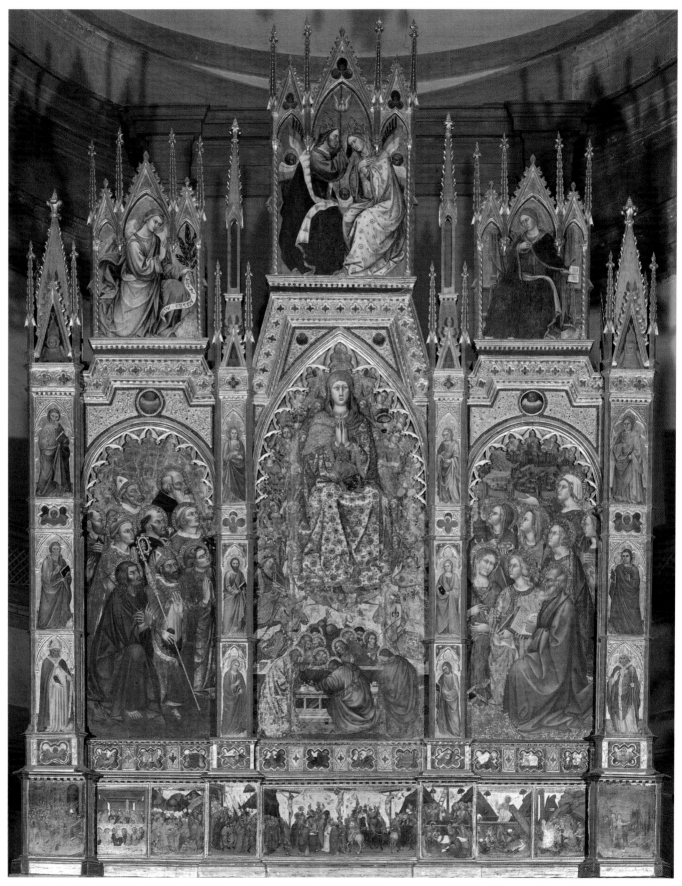

Plate 241 Taddeo di Bartolo, *The Virgin of the Assumption and Saints*, *c*.1394–1401, tempera on panel, 525 x 420 cm, high altar, Duomo, Montepulciano. Photo: Lensini.

In 1401 another Sienese painter, Taddeo di Bartolo, signed an altarpiece for the high altar of the Pieve of the southern Tuscan town of Montepulciano (Plate 241). From an inscription on the lower part of the central painting, it appears that on this occasion the commissioner was Jacopo di Bartolommeo Aragazzi, who, apart from belonging to one of the town's most important families, was also the archpriest of the Pieve.[4] Although this monumental altarpiece has retained much more of its original frame and predella than the Arezzo polyptych, it too has suffered structural damage – most notably the cutting of the ends of the lower predella in the early nineteenth century when the furnishings of the church (by then a cathedral) were extensively reorganized.[5]

These two works, executed some 80 years apart, offer striking evidence of the continuing success of Sienese artists within the field of altarpiece painting. Nor were such commissions isolated examples. Beginning in the first decade of the century with Duccio's commission for a polyptych in San Domenico, Perugia,[6] Sienese painters regularly supplied altarpieces to churches throughout Tuscany and Umbria and occasionally further afield. Florentine painters also contributed decisively and creatively to this particular field of artistic endeavour. By contrast, artists active in Padua produced far fewer painted altarpieces, creating instead sculpted ensembles with which to embellish the altars of the city's churches (Chapter 8, Plates 222, 227).

TWO 'PROVINCIAL' ALTARPIECES

A more detailed scrutiny of these two Sienese high altarpieces reveals a number of broad similarities, but also a number of notable differences between them. Clearly, it is the differences which seem, at first sight, to be most striking. Pietro Lorenzetti's Arezzo altarpiece presents a good example of an

early fourteenth-century Sienese polyptych – a type which, in itself, was the culmination of a steadily evolving development within altarpiece design.[7] Thus, it has a characteristic three-tiered structure made up of a main register of five panels, each depicting a three-quarter-length representation of a holy figure (Plate 240). The central panel is larger than the four side panels in order to draw attention to the most important holy figures – the Virgin and Child. Correspondingly, the central panels in the second and third tiers of the polyptych are larger than those on either side of them. This enabled the painter to depict two key Marian images on a larger scale than that of the male and female saints on the adjacent panels. The design of the polyptych thus provided a versatile format for conveying the greater or lesser significance of the holy figures portrayed upon it.

In terms of its format and subject, the Arezzo polptych belongs to a 'family' of Sienese altarpieces which began in the late thirteenth century with the simple designs of Guido da Siena's single-tier altarpieces and the later two-tier 'Polyptych 28' from Duccio's workshop, and gradually developed into the more complex formats exemplified by Simone Martini's high altarpiece for Santa Caterina, Pisa (Plate 242).[8] In particular, the truncated gable format of the second tier of the Arezzo polptych probably represents an adaptation of the upper register of the front face of the *Maestà* – Duccio's influential high altarpiece for Siena Duomo (cf. Plate 240 and Chapter 3, Plate 67).

Quite apart from providing his patron with an up-to-date altarpiece design, Pietro Lorenzetti also offered a compelling treatment of the holy figures portrayed and the cults associated with them. For example, the painter's depiction of the relationship between the Virgin and Child is extraordinarily tender and emotive. Additionally, the unusual choice of colours for the Virgin's mantle – blue motifs on a white ground – and its delicate pattern gives a grace, lightness

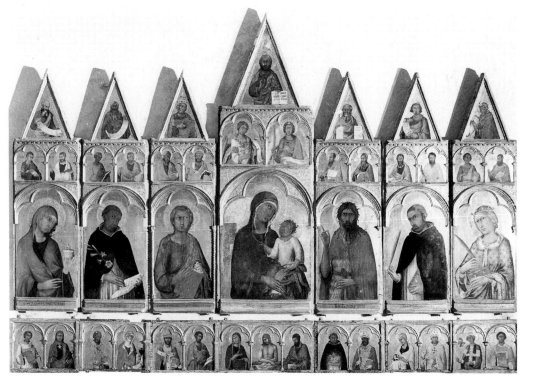

Plate 242 Simone Martini, *The Virgin and Child with Saints*, the 'Santa Caterina polyptych', 1319, tempera on panel, 195 x 340 cm, Museo Nazionale di San Martino, Pisa, formerly over the high altar of Santa Caterina, Pisa. Photo: Soprintendenza ai beni Ambientali Architettonici, Artistiche e Storia per le Provincie di Pisa, Lucca, Livorno, Massa Carrara. Archivio Foto 74037.

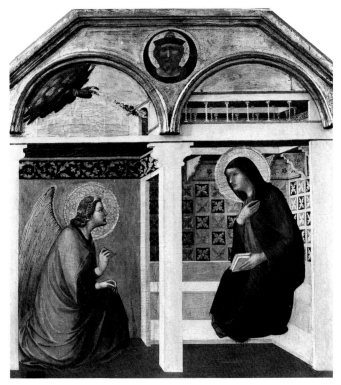

Plate 243 Pietro Lorenzetti, *The Annunciation*, detail of the Arezzo polyptych (Plate 240). Photo: Mori Maria Luisa/Foto Gualdani, Arezzo.

and harmony to this entire altarpiece painting.[9] Similarly, a degree of pictorial illusionism has been deployed to great effect on *The Annunciation* (Plate 243).[10] Bishop Tarlati thus obtained from Pietro Lorenzetti an impressive work of art with which to embellish an important church under his patronage.

By contrast, Taddeo di Bartolo's altarpiece is much more massive and monumental in scale (Plate 241). The main register is composed of three panels on each of which is painted a complex figural composition. The central painting portrays an ambitiously conceived scene of the Virgin Mary at the moment of her assumption into heaven, with the apostles gathered around her empty tomb and Saint Thomas receiving her girdle (Plate 244). On either side of this arresting image are rank upon rank of saints, who are represented witnessing this glorious event. Unlike the quite intimate portrayal of three-quarter-length figures of saints on the Pietro Lorenzetti altarpiece, these saints are depicted as a company of full-length standing figures. The effect is analogous to the heavenly company gathered around the throne of the Virgin in the early Sienese *Maestàs* by Duccio, Simone Martini, Lippo Memmi and Ambrogio Lorenzetti.

As in the case of Pietro Lorenzetti's earlier Arezzo polptych, the Marian content of the central painting's subject-matter is further elaborated in a series of upper panels set over the main part of Taddeo's altarpiece. At the centre appears a scene of the coronation of the Virgin, while on either side are the Archangel Gabriel and the Virgin of the Annunciation. The tripartite organization and ornate mouldings of the framing of the upper panels are much more complex than the simple, unadorned mouldings on the Arezzo polptych. Elsewhere the framework is extraordinarily ornate, incorporating elaborate punched patterns worked in

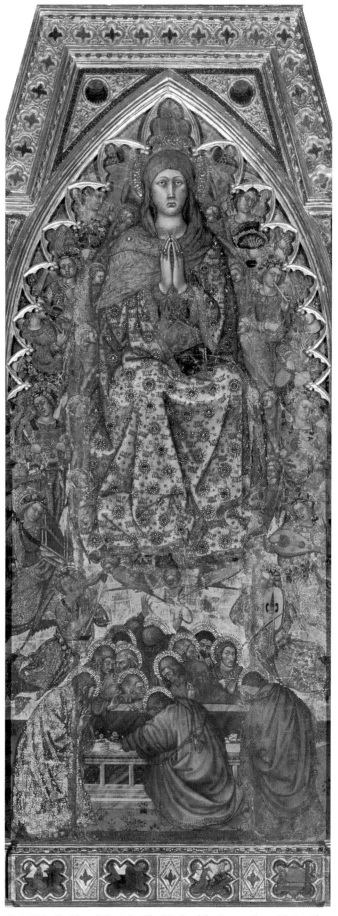

Plate 244 Taddeo di Bartolo, *The Virgin of the Assumption with Apostles*, detail of *The Virgin of the Assumption* (Plate 241). Photo: Lensini.

relief and inset with crystal.[11] Meanwhile, the surfaces of the four broad piers which separate and frame the three principal parts of the altarpiece are embellished with a series of twelve standing saints. Although the Arezzo polyptych probably had a predella[12] which – like that of Simone Martini's Santa Caterina polptych (Plate 242) – comprised a series of half-length saints, it would only have constituted a single sequence of paintings. Taddeo di Bartolo's altarpiece, by contrast, has an ambitiously conceived two-tier arrangement with an upper predella comprising a series of pierced quadrilobes which frame twelve Old Testament scenes (beginning with *The Creation of Adam* and ending with *The Judgement of Solomon*) and a lower predella of eleven narrative paintings of the Passion of Christ, nine on the front face and one on each short end (beginning with *The Raising of Lazarus* and ending with *The Three Maries at the Tomb*).

Despite the striking differences between the two paintings in Arezzo and Montepulciano, they also share a number of features. They were both designed to appear over a high altar: the most important location within a church. Each, in terms of its scale, gilded surfaces, opulent ornament and brightly coloured paintings, must once have acted as an eye-catching focal point within the dark interior of the Romanesque *pieve* in which it was placed. A fifteenth-century Sienese painting acts as a valuable illustration of how the high altarpiece of a church (just visible on the right-hand side of the painting) tended to be much larger and more ornate in its design than altarpieces located over the side altars (Plate 245).

Both altarpieces also exemplify other continuities in fourteenth-century altarpiece design. Most importantly, they allude in a specific and concrete way to the dedication of the altar and church to which they belong. Unlike altars, altarpieces did not have, by long tradition, a specifically and officially designated role within the liturgy. By the fourteenth century, however, official ecclesiastical directives instructed that an altar should be embellished by an image (*imago*) which should reflect the dedication of the altar to a particular saint

or religious cult. The image concerned might be an inscription, a sculpture or a painted altarpiece.[13] The dedication of both the Pieve in Arezzo and the Pieve in Montepulciano was to the Virgin Mary, and the high altar undoubtedly, therefore, shared this dedication.[14] Thus, Pietro Lorenzetti's altarpiece shows the Virgin as the central focal point of its iconographic scheme (Plate 240). She is seen principally in her guise as the mother of Christ, but also at the moment of both the annunciation and the assumption. In Taddeo di Bartolo's altarpiece, meanwhile, the central panel is devoted to a portrayal of the miraculous circumstances of the Virgin's assumption into heaven. In addition, the annunciation and her coronation as queen of heaven are portrayed in the upper pinnacle panels (Plate 241). In short, the two altarpieces decisively commemorate and celebrate both the cult of the Virgin Mary and her honorific role as titular saint of the church for which they were commissioned.

Quite apart from their specifically Marian imagery, the two altarpieces also include a large number of other holy figures. We know in the case of the Arezzo polyptych that the choice of these figures lay within the control of Bishop Tarlati,[15] and therefore it is likely that the choice of saints was of particular significance for both the bishop and his fellow citizens of Arezzo. On the outermost left panel of the main tier of the altarpiece appears a bishop saint identifiable as Donatus, the first Bishop of Arezzo and the city's principal patron saint (Plate 240). As Bishop of Arezzo, Guido Tarlati must have derived some satisfaction from the inclusion of his early and illustrious predecessor. Elsewhere in the altarpiece appear other saints whose cults were notably observed within Arezzo. Thus, on the extreme right of the second tier are Saints Marcellinus and Augustinus, early Christian martyrs from Monterongriffoli near Arezzo, whose relics were preserved in the church.[16]

Likewise, on the Montepulciano altarpiece among the female saints portrayed on the right-hand panel, there appears Antilla, the principal patron saint of Montepulciano,

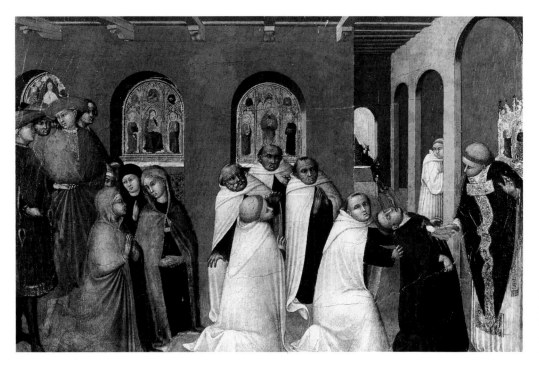

Plate 245 Sassetta, *A Miracle of the Sacrament*, *c.*1430, tempera on panel, 24 x 38 cm, Bowes Museum, Barnard Castle, Durham.

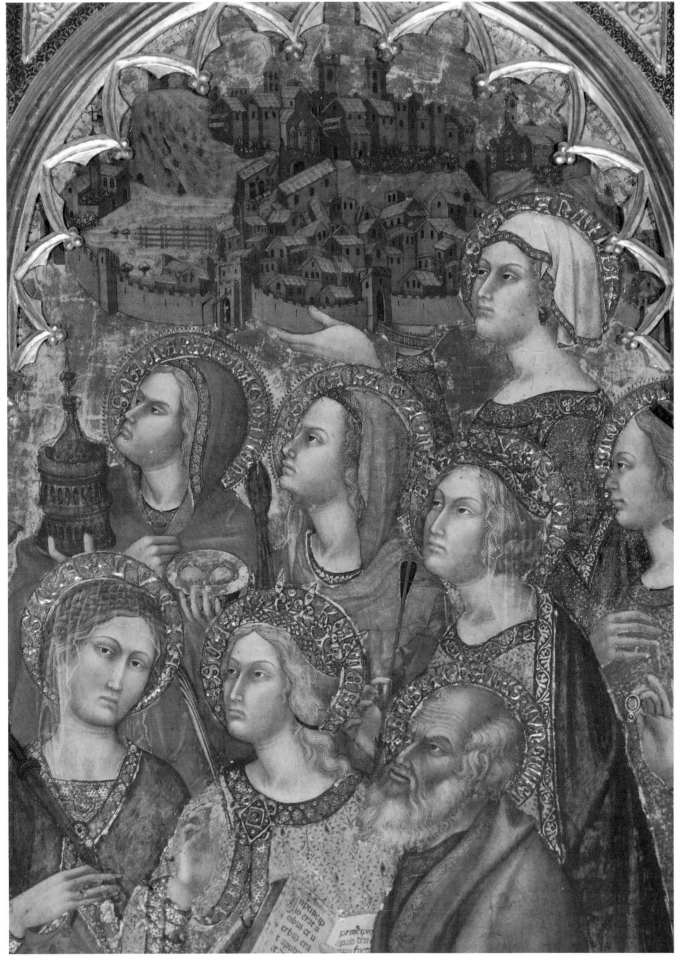

Plate 246 Taddeo di Bartolo, *Saint Antilla*, detail of right-hand panel of *The Virgin of the Assumption* (Plate 241). Photo: Lensini.

presenting a model of the town itself to the Virgin of the Assumption (Plate 246). On the extreme right of the panel is another rarely depicted saint, Mustiola, whose cult was particularly popular in nearby Chiusi, a town under whose ecclesiastical jurisdiction Montepulciano had intermittently been placed. Similarly, on the left-hand panel among the nine male saints appears Saint Donatus (Plate 241). Until 1400 Montepulciano had been in the diocese of Arezzo. Accompanying Saint Donatus are painted figures of other male saints such as Augustine, Dominic and Francis, all founders of religious orders which had houses either within Montepulciano itself or in its close vicinity.[17]

A comparison of the Arezzo and Montepulciano altarpieces reveals a number of significant characteristics of this genre of religious art. First, as altarpieces they constituted a family of objects which had certain features in common – these features arising directly from their designated function as paintings which embellished altars within churches and other buildings. The subject-matter of altarpieces was intimately linked to their locations, and because altars on the whole were either dedicated to or associated with particular *holy persons*, the main part of an altarpiece tended to show figures – narrative being confined to subsidiary parts such as pinnacle or predella panels. Even in the case of Taddeo di Bartolo's high altarpiece, which ostensibly has as its central image a narrative of the Virgin, the subject should more properly be seen as honouring the *person* of the Virgin, albeit at the moment of her assumption into heaven.

Because they were designed to serve such well-established religious and devotional functions, there tended to be a 'conservative' factor operating within altarpiece design which arguably served to inhibit rapid stylistic and iconographic change and innovation. Having said this, however, due to the proliferation of altars within fourteenth-century churches and chapels, there was always a steady demand for altarpieces from painters (and, to a lesser degree, from sculptors). As a result of this demand and because of the prestige attached to such paintings and sculptures (particularly if they became the objects of fervent religious devotion), the altarpiece as an artistic genre stimulated artistic innovation not only in terms of its physical structure or 'morphology', but also in iconographic and stylistic terms.[18] We have seen how both Pietro Lorenzetti and Taddeo di Bartolo imaginatively adapted their altarpiece designs to accommodate both the conventions of altarpiece painting and the specialized requirements of their particular designated sites. We have also seen how Taddeo di Bartolo's Marian altarpiece for Montepulciano is much more monumental and complex in format and ornamentation, and also much more 'narrative' in content, than the more iconic appearance of Pietro Lorenzetti's altarpiece for Arezzo. This raises the question of how Taddeo di Bartolo arrived at such a resolution to the demands of his Montepulciano altarpiece commission. It is to this question that the essay now turns.

SIENESE NARRATIVE ALTARPIECES

It is clearly the case that, when designing his high altarpiece for Montepulciano, Taddeo di Bartolo took inspiration from both the impressive scale and the celebratory Marian imagery

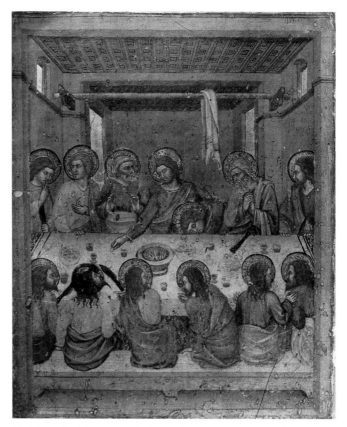

Plate 247 Taddeo di Bartolo, *The Last Supper*, 45 x 31.5 cm, lower predella panel of *The Virgin of the Assumption* (Plate 241). Photo: Lensini.

of Duccio's *Maestà* – the early high altarpiece for the cathedral of Taddeo's home town. Indeed, many of the Passion scenes on the lower predella of the Montepulciano altarpiece have close similarities – albeit subject to adjustment and variation – to analogous scenes on the rear of the *Maestà* (cf. Plates 247, 248).[19] Unlike the *Maestà*, however, the

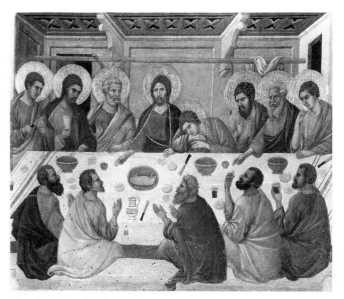

Plate 248 Duccio, *The Last Supper*, c.1308–11, tempera on panel, c.50 x 53 cm, rear face of the *Maestà*, Museo dell'Opera del Duomo, Siena, formerly high altarpiece of the Duomo, Siena. Photo: Lensini.

Montepulciano altarpiece does not take as its central image the Virgin Mary in her familiar guise as mother of Christ, but rather portrays her at the moment of her assumption into heaven.

As the paintings in the upper register of the front face of the *Maestà* clearly indicate, the commemoration and celebration of the last days of the Virgin was an important feature of fourteenth-century Marian belief (Chapter 3, Plate 67). Such religious narrative focused decisively upon the belief in the corporeal assumption of the Virgin into heaven. Thus, it was believed that at the time of her burial, her soul was immediately received into heaven. Three days later (exactly the number of days that elapsed between Christ's death and Resurrection) the apostles witnessed the miraculous elevation of the body of the Virgin from her tomb and her passage into heaven. A subsidiary narrative event provides a further explicit parallel with events following Christ's Resurrection. Saint Thomas, who doubted the reality of Christ's Resurrection and was thus invited to place his hand into Christ's side (John 20:24–29), was also believed to have questioned the reality of the Virgin's assumption. Accordingly, she is said to have dropped her girdle to Thomas as proof. In the case of the *Maestà* the painting of the Virgin of the Assumption is now lost. In Taddeo di Bartolo's Montepulciano altarpiece, however, it not only remains but indeed has become the central painted subject of this work (Plate 244).

The choice of principal subject-matter for the Montepulciano altarpiece was almost certainly related, in general terms, to the particular Sienese commitment to the cult of the Virgin of the Assumption. As discussed in Chapter 3, Siena Duomo was dedicated to the Virgin of the Assumption, and the imagery of both the high altarpiece and the stained glass window in the chancel behind it alluded in specific and direct manner to this dedication (Chapter 3, Plate 79). Additionally, the Feast of the Assumption possessed a particular significance and played an important role within the ongoing political and religious life of Siena. It was on the Feast of the Assumption in 1260, before the crucial battle of Montaperti, that the city was first formally dedicated to the Virgin Mary, and from then onwards (and indeed to this day) this particular Marian feast has been commemorated and celebrated by an elaborately staged civic ritual. Nor was it only Siena itself and its citizens who participated in the civic celebration. An important feature of the ceremony was the arrival within the city of delegates from Siena's subject towns and territories – Montepulciano among them. On the Feast of the Assumption, these representatives went in procession to the cathedral and presented huge wax candles – *ceri* – to the Virgin, herself represented on the high altarpiece: a ritual act which embodied both their devotion towards the Virgin and a reiteration of their loyalty to Siena itself.[20]

The choice of this particular subject for a high altarpiece in Montepulciano may also have had a much more specific political significance for Montepulciano itself. Throughout the thirteenth and fourteenth centuries Montepulciano had a chequered history. Situated between Siena, Perugia and Arezzo, at various times it had come under the rule of one or other of these three cities. During the fourteenth century, however, the Sienese had established the predominant

Plate 249 Reconstruction by Norman Muller of Bartolommeo Bulgarini, *The Nativity and Adoration of the Shepherds with Saints*, the 'Saint Victor altarpiece', c.1350, various collections, formerly over the altar of Saint Victor, Duomo, Siena. Reproduced by permission of Norman Muller.

political influence over the town. Nevertheless, due to its position on the south-eastern edge of Siena's territory and within close vicinity of the main road linking Florence with Rome, Montepulciano also became an objective of Florentine territorial expansion. The Florentines finally realized their ambitions in 1390, when Montepulciano (fearful of both the depredations of marauding mercenaries and political domination by Gian Galeazzo Visconti of Milan) placed itself under Florentine control. It was only in 1404, however, that Siena finally conceded to this fact. From then on Montepulciano became a Florentine subject town, as witnessed by its impressive fifteenth and sixteenth-century Florentine style architecture. Nevertheless, even as late as 1495, Montepulciano was in rebellion against Florence, again allying itself with Siena. In the context of this political history, therefore, it is at least plausible that the Montepulciano altarpiece, executed by a Sienese painter and depicting a highly Sienese subject, represented yet another episode in a long and well-established tradition of close political and cultural ties between Montepulciano and Siena.[21]

Apart from celebrating the Virgin of Assumption and emulating the scale and – to a lesser degree – the complexity of Duccio's high altarpiece for Siena Duomo, what further stimulus might Taddeo di Bartolo have received from other earlier Sienese and specifically Marian altarpieces? From the 1330s onwards, the eastern end of Siena Duomo was embellished with a series of Marian altarpieces. Careful historical reconstruction of the commissions and original

contexts of these altarpieces – themselves now divested of many of their constituent parts and distributed in a variety of modern art collections – reveals that they once embellished four altars, each of which housed relics of the one of city's four principal patron saints.[22] Taking these altarpieces in the order in which they were originally intended to be 'read' (rather than in the chronological order of their execution), they constituted Pietro Lorenzetti's *Birth of the Virgin* (Plate 250) with the now lost additional side panels of *Saints Sabinus and Bartholomew*,[23] Simone Martini and Lippo Memmi's *Annunciation with Saints Ansanus and Massima*,[24] Bartolommeo Bulgarini's *Nativity and Adoration of the Shepherds with Saints* and *Saint Victor* and *Saint Corona* (Plate 249),[25] and finally Ambrogio Lorenzetti's *Purification of the Virgin* with the now lost additional side panels of *Saint Crescentius and the Archangel Michael*.[26] These four altarpieces, executed in the fourth and fifth decades of the fourteenth century, thus originally complemented the imagery on the front of the *Maestà* (Chapter 3, Plate 65) both in their Marian focus and in their subordinate representations of the city's principal patron saints – Sabinus, Ansanus, Victor and Crescentius.

It has rightly been observed that one of the most striking

and decisive features of fourteenth-century Sienese altarpiece production is the way in which these four altarpieces demonstrably acted as models for subsequent altarpieces produced by Sienese painters for various churches both within Siena and in other towns. For example, when in the 1390s Bartolo di Fredi painted (probably for Sant'Agostino in San Gimignano) an altarpiece of *The Purification of the Virgin*, he closely modelled its figural composition and spatial setting on Ambrogio Lorenzetti's painting for the altar of Saint Crescentius. Bartolo similarly utilized Bulgarini's representation of the Nativity of Christ in altarpieces executed for churches in Siena's subject territories. In the 1390s Paolo di Giovanni Fei likewise produced a variation of Pietro Lorenzetti's *Birth of the Virgin* for the Sienese church of San Maurizio (Plate 254).[27] This particular feature of fourteenth-century Sienese altarpiece painting could be interpreted as evidence of a lack of originality on the part of later painters – and thus as yet another symptom of the crisis that was presumed to have occurred in art in the years after the Black Death.[28] There is, however, a less pejorative and more positive interpretation of this process. We have seen that in Taddeo di Bartolo's Montepulciano altarpiece such emulation was by no means a matter of simple inability on the part of

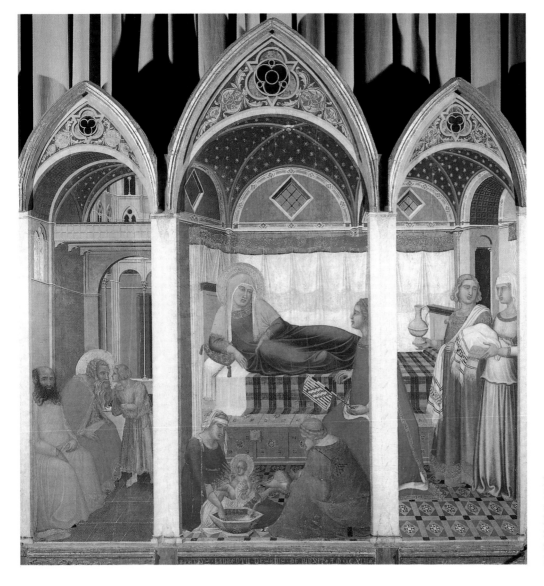

Plate 250 Pietro Lorenzetti, *The Birth of the Virgin*, 1342, tempera on panel, 188 x 183 cm, Museo dell'Opera del Duomo, Siena, formerly over the altar of Saint Sabinus, Duomo, Siena. Photo: Lensini.

the painter to furnish an imaginative and original interpretation of the events to be portrayed. On the contrary, the Marian altarpieces within Siena Duomo became the objects of local Sienese veneration precisely because of the combination of the religious significance attached to the holy persons celebrated on them and the compelling visual qualities of the images themselves. These paintings were, therefore, highly effective religious images and were thus deemed well worth replicating in altarpieces for other churches within the city itself and in neighbouring towns.

A closer analysis of Pietro Lorenzetti's *Birth of the Virgin* also reveals how extremely skilfully the painter resolved the problem inherent in the very nature of painting a 'narrative' altarpiece: namely, how to depict a narrative scene without detracting from or diminishing the significance of the central figure in whose honour the altarpiece was painted (Plate 250). The birth of the Virgin involved a number of key figures – most obviously the newborn baby and her mother Anne, but also the Virgin's father Joachim, who had an important but subsidiary role as the recipient of the news of the birth. Moreover, by the time of the execution of this particular altarpiece, painters had also established a tradition of further embellishing this narrative event by the inclusion of such domestic details as the bathing of the newborn baby and women bringing Anne gifts. Both details were undoubtedly derived from well-established social practices surrounding birth in fourteenth-century Italian society.

The complexity of the narrative subject alone therefore demanded, on the one hand, the representation of a number of figures involved in various kinds of activity surrounding the birth of the child and, on the other, an ability to convey to the spectator the sense of Joachim receiving the news of his child's birth *after* the event of the birth itself. Looking at Pietro Lorenzetti's painting, we can see how effectively the painter has represented all the key figures associated with this narrative event. In addition, by exploiting the triptych format of his altarpiece and utilizing the left-hand panel to locate his painting of Joachim leaning forward to hear what the youth is telling him, he effectively separated two aspects of the narrative event and conveyed a sense of how one event was consequent upon another.

In addition to the skilful figural representation, Pietro also supplied a richly descriptive setting for this narrative event. Thus, the birth chamber is represented as a vaulted room with the walls around the bed covered with hangings and the floor comprising colourful patterned tiles. The bed is covered with a characteristic Sienese chequered cloth and has a handsome wooden coffer running its entire length. Meanwhile, the vestibule in which Joachim and his male companion are seated offers a glimpse of an elegant courtyard beyond. The sophistication of the spatial treatment is further enhanced by the use of the mouldings of the pointed arches of the triptych's upper frame as part of the fictive painted architecture. Indeed, the latter detail neatly demonstrates the way in which a painter of fourteenth-century altarpieces might well deploy representational skills derived from working in another medium, such as fresco painting (Plate 251). Such pictorial solutions – whether in fresco or altarpiece painting – were not determined simply by the medium in question, but rather by the painter's attempt to make the holy figures appear life-like and actively involved with both one another and the spectator.

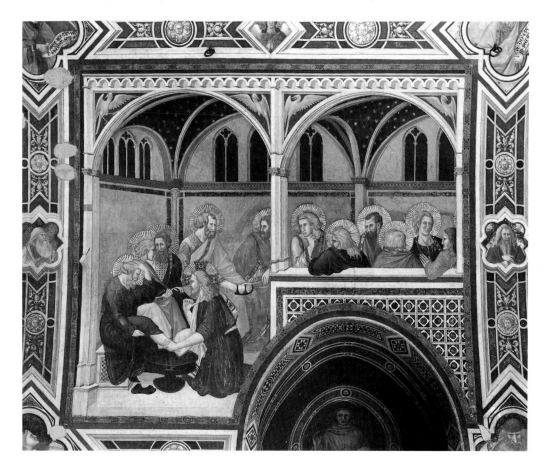

Plate 251 Pietro Lorenzetti, *The Washing of the Feet*, c.1315–19, fresco, south transept, Lower Church, San Francesco, Assisi. Photo: Archivio Fotografico Sacro Convento, Assisi.

Recognition of the sophistication of Pietro Lorenzetti's pictorial illusionism and his ability to furnish vivid naturalistic detail should not, however, obscure the painter's skill in meeting the second major requirement of the commission of a Marian altarpiece for Siena Duomo: that is, the celebration of the Virgin herself. *The Birth of the Virgin* was principally designed to serve the cult of the Virgin, and more particularly the very special circumstances of her birth which singled out her unique role as the future mother of Christ. As such, the altarpiece would have been the focal point for religious celebrations which took place on the Feast of the Birth of the Virgin (8 September). In addition, it celebrated the cult of Saints Sabinus and Bartholomew, whose relics were contained within the altar. Seen in its original state (with side panels depicting standing figures of Sabinus and Bartholomew[29] and a predella below), this dual religious function would have once been clear. Additionally, despite the distribution of the painted scene *across* the three central panels, it is striking how Pietro Lorenzetti skilfully conveyed the importance of the Virgin herself. She appears, left of centre, within the central and most important panel of this composite altarpiece. Her position at the lower edge of the painting places her close to the spectator/worshipper in front of the altar – and significantly she is portrayed looking in the general direction of the viewer. Meanwhile Saint Anne, herself the object of great veneration in the later medieval period, is represented as an imposing centrally placed figure.[30] The emphatic diagonals of the pavement, which are also clearly visible on each of the side panels, further serve to focus attention on these two centrally placed cult figures.

Compared to the birth of the Virgin, the subject of her assumption lent itself more readily to the representation of the Virgin as a centrally placed iconic figure upon an altarpiece. In his treatment of the subject for the Montepulciano altarpiece, Taddeo di Bartolo employed a standard device of showing her high within the picture field and surrounded by a mandorla of cherubim heads (Plate 244). While Taddeo's treatment conveys the impression of Mary as a solid, three-dimensional, seated figure, she is nevertheless represented as removed from earthly reality. The apostles, meanwhile, are portrayed in highly animated poses. By such devices as showing the back view of Thomas's head in foreshortening and Thaddeus (the painter's name saint) looking directly outwards to the spectator, Taddeo skilfully involved the spectator with the actions of the apostles. The viewer is thus encouraged to share in the apostles' privileged witnessing of the Virgin's miraculous assumption into heaven.

Taddeo's treatment of the assumption theme represents the outcome of several generations of fourteenth-century Sienese painters' pictorial interpretation of this important subject – one which, as we have already seen, had particularly strong resonances for their predominantly Sienese audiences. Broadly speaking, this subject followed two lines of development.[31] The first, which is well represented by both the late thirteenth-century stained glass window in Siena Duomo (Chapter 3, Plate 79) and Pietro Lorenzetti's early fourteenth-century pinnacle panel on the Arezzo polyptych (Plate 240), shows the Virgin enclosed within a mandorla – an apt symbol for her exalted state. It was this basic version that Taddeo chose to adopt for his Montepulciano altarpiece. An

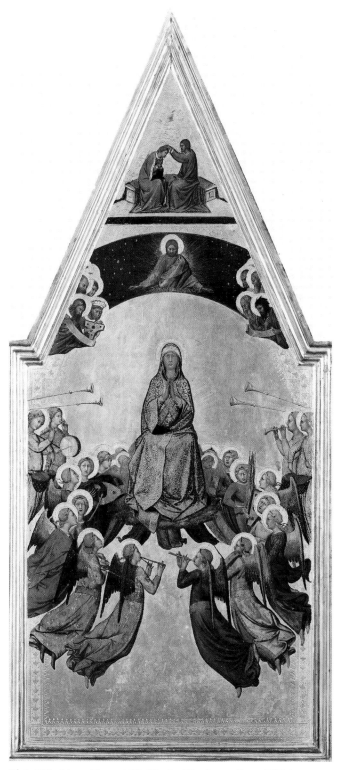

Plate 252 Lippo Memmi, *The Virgin of the Assumption*, c.1330, tempera on panel, 70 x 30 cm, Alte Pinakothek, Munich. Photograph by courtesy of Bayerisches Staatsgemäldesammlungen.

example of the second – and arguably more sophisticated – treatment of Mary's heavenly ascent occurs on a small panel executed by Lippo Memmi which shows Mary as a frontally placed, seated figure with her hands folded in prayer, yet surrounded by a circle of angel musicians seen in depth (Plate 252).[32] A later treatment of this theme by Bartolommeo

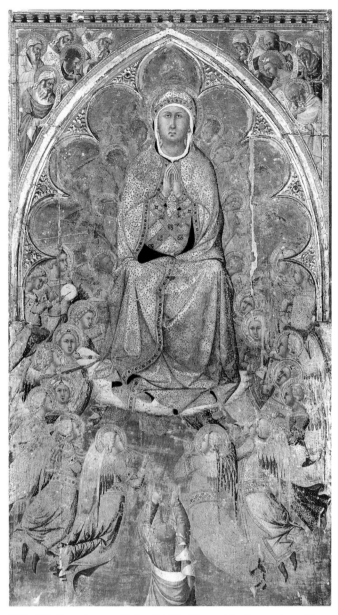

Plate 253 Bartolommeo Bulgarini, *The Virgin of the Assumption with Saint Thomas*, 1360s, tempera on panel, 205 x 112 cm, Pinacoteca, Siena, formerly in the hospital church of Santa Maria della Scala, Siena. Photo: Lensini.

Bulgarini shows a skilful combination of the two types of image. Once the central panel of an altarpiece – probably executed during the 1360s for the Sienese church of Santissima Annunziata attached to the hospital of Santa Maria della Scala – Mary is here represented not only as framed by a mandorla of cherubim, but also as if rising up from within a circle of music-making angels (Plate 253).[33] Below these figures Thomas appears stretching upwards to receive the Virgin's girdle – a device also adopted by Taddeo in his later altarpiece. Taddeo's inclusion of the Virgin's tomb, filled with lilies, was similarly derived from the work of earlier Sienese painters – a notable example being the central pinnacle panel of the ambitiously conceived altarpiece by Bartolo di Fredi for a Franciscan church in Montalcino (Plate 255).[34]

FLORENTINE MARIAN ALTARPIECES

In terms of its Marian iconography, Taddeo di Bartolo's Montepulciano altarpiece clearly belonged to a well-established Sienese pictorial tradition. Nevertheless, the ranked tiers of saints gathered on either side of the central image of the Virgin of the Assumption were not standard on later Sienese Marian altarpieces. Although ranks of saints had been a distinguishing feature of early fourteenth-century Marian altarpieces, subsequent ones tended to depict accompanying figures of saints on side panels as either single or paired figures (Plate 254). They are thus represented as existing within in a discreet spatial environment of their own, rather in the way that a statue of a saint might appear within its own niche upon a sculpted church façade. Even in later Sienese examples which rivalled Taddeo's Montepulciano altarpiece in their monumentality and ambitious scale, there was apparently not a return to the earlier practice of portraying ranks of accompanying saints. There was, however, an increasing concern with narrative. Thus, in Bartolo di Fredi's *Coronation* altarpiece, the side wings of this impressively complex Marian altarpiece were devoted not to a representation of saints but rather to a series of narrative scenes from the life of the Virgin (Plate 255).

How, then, does Taddeo di Bartolo's treatment of the accompanying saints in his Montepulciano altarpiece relate to various precedents? On Taddeo's altarpiece the accompanying saints are separated from the central figural grouping by the pilasters of the frame. Yet in terms of their arrangement in three superimposed rows, they give the impression of co-existing in the same spatial environment as the Virgin and the apostles – an effect given further impact by the diagonal lines incised on the red carpets on which the saints are standing and which converge towards the central scene of the assumption. In terms of its unified figural composition, Taddeo's altarpiece finds its closest counterpart in Florentine Marian altarpieces – particularly those designed to celebrate the coronation of the Virgin. The signed altarpiece by Giotto in the Baroncelli Chapel of Santa Croce, for example, provides an early impressive example of this type of Marian altarpiece (Chapter 8, Plate 214). Nevertheless, this prototype for Taddeo's representation of a community of saints witnessing a key event in the life of the Virgin was realized – in its original fourteenth-century form[35] – as a simple polyptych of fairly modest dimensions, as was appropriate to its location over the altar of a privately owned funerary chapel. The more immediate and impressive Florentine models for Taddeo's Montepulciano altarpiece were produced in the second half of the century.

One of the best examples of this particular aspect of Florentine altarpiece design occurs in Jacopo di Cione's *Coronation of the Virgin*, an ambitious, multi-storied altarpiece originally executed for the high altar of the Benedictine church of San Pier Maggiore in Florence. This altarpiece – which rivalled Duccio's *Maestà* in scale – was among the largest to have been painted in Florence in the second half of the fourteenth century. Today it survives only in pieces, themselves located within a number of modern art galleries. Fortunately, the three principal panels of the main register, together with a series of six narrative scenes celebrating key

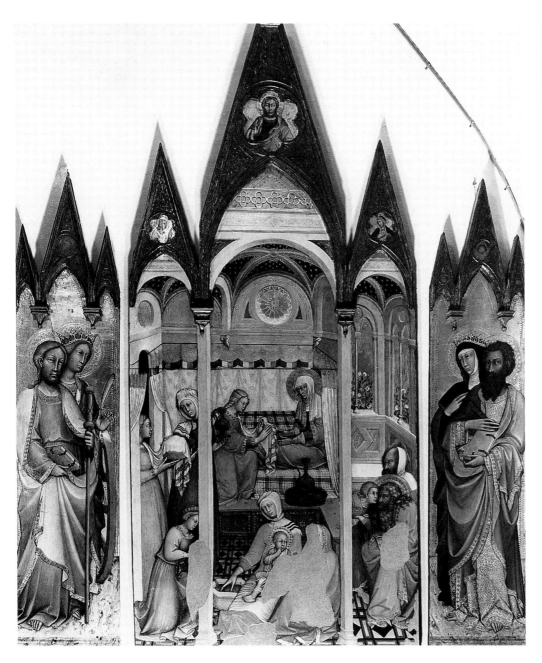

Plate 254 Paolo di Giovanni Fei, *The Birth of the Virgin with Saints*, 1391, tempera on panel, 259 x 204 cm, Pinacoteca, Siena, formerly in the church of San Maurizio, Siena. Photo: Lensini.

events in the life of Christ and three panels depicting the Trinity attended by angels, are gathered together in the National Gallery in London. Recent technical investigation has made possible a plausible reconstruction of the original form of this monumental and complex altarpiece (Plate 256).[36] The reconstruction demonstrates the way in which the original framework was both architectonic in its form and highly ornate in its decoration.

Apart from supporting a large number of wooden panels and rendering them clearly visible above the high altar, this elaborate frame also imposed a sophisticated hierarchical order upon the painted imagery it was designed to enhance. The simple Gothic arch of the central panel, which framed the complex architectonic canopy of Christ and Mary's throne, gave these central figures a greater prominence than the groups of saints portrayed on either side. The twin arches, with their single pendant boss, additionally served to emphasize the impression that these saints – 48 in total – were

gathered together in one unified spatial setting. The exquisitely patterned carpet which is represented throughout the three panels would have further contributed to an impression of spatial unity. Similarly, while the twisted columns set between the central panel and the side panels would once have set apart the most important religious figures, the fact that these columns overlapped details of the saints' attributes would have enhanced the impression of looking through an arcade to a point where the company of saints were gathered together to witness the glorious event of the Virgin's coronation by her Son.

The iconography of the San Pier Maggiore altarpiece decisively commemorates the cult of the Virgin in her guise as queen of heaven. This choice of subject-matter, with its joyous, courtly imagery, was appropriate for a high altarpiece which would have acted as a visual backdrop to the celebration of high masses, events which were customarily marked by a greater degree of pomp and ceremony than other

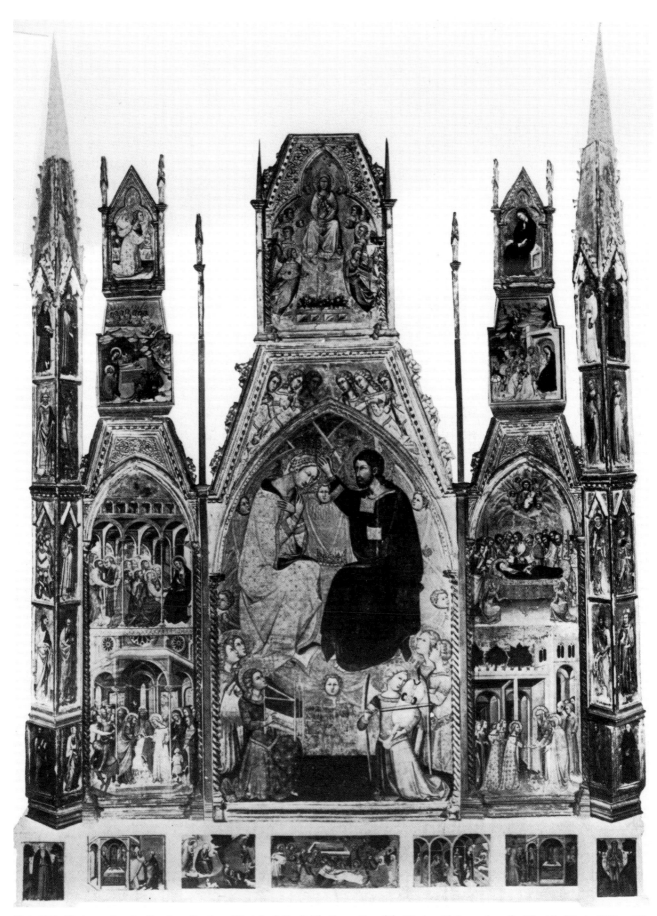

Plate 255 Photomontage by Gaudenz Freuler of Bartolo di Fredi, *The Coronation of the Virgin with Scenes from the Life of the Virgin*, 1388, *c.*370 x 280 cm, various collections, formerly in San Francesco, Montalcino. Reproduced from Gaudenz Freuler, 'Bartolo di Fredi's altar für San Francesco in Montalcino', *Bruckmanns Pantheon*, XLIII, 1985, by permission of Gaudenz Freuler.

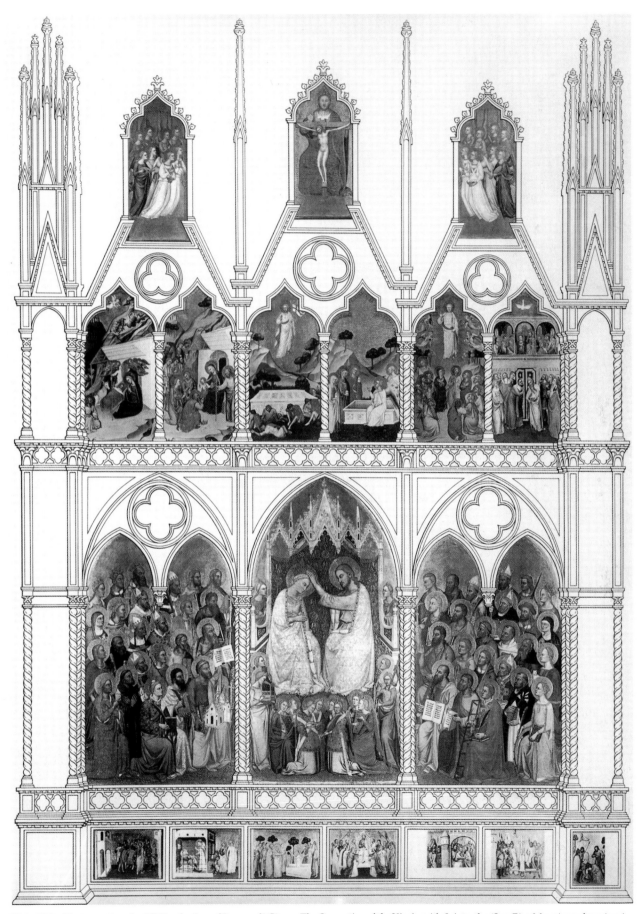

Plate 256 Photomontage by Jill Dunkerton of Jacopo di Cione, *The Coronation of the Virgin with Saints*, the 'San Pier Maggiore altarpiece',
1370–71, various collections, formerly over the high altar of San Pier Maggiore, Florence. Reproduced from *Art in the Making: Italian
Painting before 1400*, 1989. Reproduced by permission of the Trustees, The National Gallery, London.

Plate 257 Jacopo di Cione, *Saints*, left-hand side panel of the San Pier Maggiore altarpiece (Plate 256), 1370–71, tempera on panel, 200 x 113 cm, National Gallery, London. Reproduced by permission of the Trustees, The National Gallery, London.

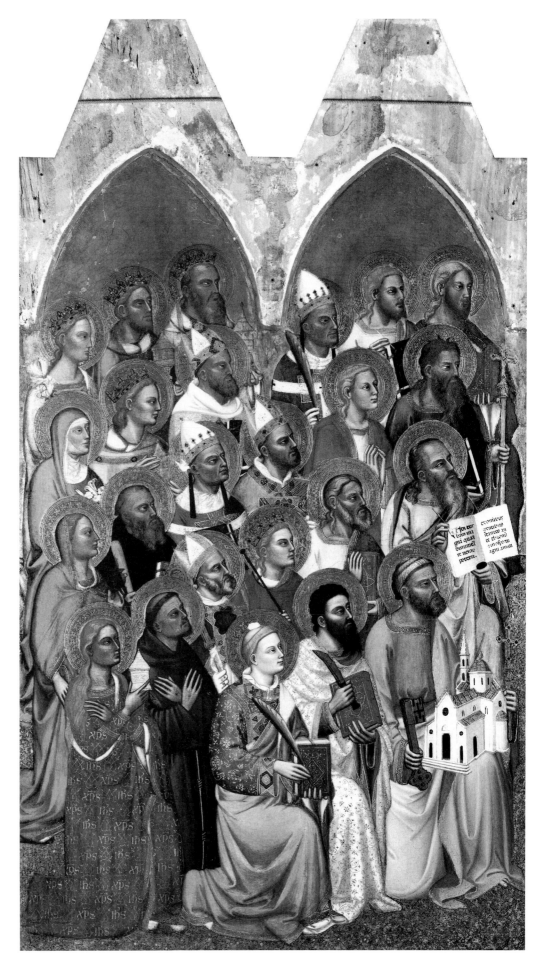

liturgical occasions. Additionally, the subject may have had a bearing on the privileged ecclesiastical status of the abbess of the Benedictine convent of San Pier Maggiore. When a new bishop of Florence first entered his cathedral, by tradition he spent his first night in the city within the convent of San Pier Maggiore as a guest of the abbess. As part of this ceremony, the bishop and his retinue would enter the church of San Pier Maggiore and exchange gifts with the abbess and her community of nuns. Elaborate protocol was observed during such ceremonial events in order that the abbess did not endanger her privileged immunity from episcopal control.[37] The courtly and essentially 'feminine' theme of the coronation of the Virgin portrayed on Jacopo di Cione's altarpiece would have been a highly appropriate adjunct to a religious ritual which thus acknowledged the unusual ecclesiastical status afforded to this abbess.[38]

In addition to the Marian imagery on the San Pier Maggiore altarpiece, a further important theme has been woven into its iconography. Unlike the Pieve of Montepulciano, which was dedicated to the Virgin, the church for which Jacopo di Cione's altarpiece was destined was dedicated to Saint Peter. In order to conform to the ecclesiastical directive that an altarpiece painting should draw attention to the titular saint of the altar concerned, Jacopo di Cione included a representation of Saint Peter himself in the foremost row of saints on the *right* of Christ and the Virgin – and thus in the place of greatest honour (Plate 257). This portrayal of the titular saint of the church is made further explicit by a graphic representation in miniature of the church of San Pier Maggiore itself balanced upon Saint Peter's knee. Moreover, within the lunette over the principal portal of this tiny church is depicted Saint Peter's well-known attribute of the crossed keys. Although, as the principal apostle, Peter would characteristically have been placed in a prominent position in any representation of the community of saints, the inclusion of the miniature church dramatically highlights his importance as titular saint of this prestigious Benedictine church. Significantly, those saints most closely associated with the Bishop of Florence – Zenobius, Bishop and patron saint of Florence, and Reparata, the titular saint of Florence's first cathedral – although included on the altarpiece, are not afforded prominent positions within its figural composition.[39] The celebration of Saint Peter is given further emphasis within the predella. Modern reconstruction suggests that this series began at the base of the left-hand pier with a now lost scene of Christ awarding the keys of heaven to Peter, and continued with a series of scenes depicting events from his mission as an apostle and his eventual martyrdom. The series ended with a scene at the base of the right-hand pier of *The Decapitation of Paul* (Plate 256). The predella, it has been suggested, thus formed three discreet parts, each series of three scenes commemorating and celebrating the three principal feasts of Saint Peter within the Church's calendar.[40]

There is no documentary evidence that Taddeo di Bartolo worked in Florence. His surviving work, however, includes more than one suggestion of familiarity with Florentine precedents. As well as including saints on his Montepulciano altarpiece whose disposition is analogous to those on Jacopo di Cione's San Pier Maggiore altarpiece, he also painted a *Last Judgement, Paradise* and *Hell* for a major chapel in the Pieve of

San Gimignano which were indebted to the murals of these subjects by Nardo di Cione in the Strozzi Chapel in Santa Maria Novella, Florence.[41] It would be a mistake, however, to assume that Taddeo di Bartolo's inspiration for the ranked saints of the Montepulciano altarpiece was solely Florentine in origin. We noted earlier that the lower predella of the Montepulciano altarpiece showed clearly that Taddeo had studied Duccio's *Maestà*. The *Maestà* also offered a striking precedent for the portrayal of a group of standing saints gathered around the major cult figures of the Virgin and Child (Chapter 3, Plate 65). Arguably, therefore, the Montepulciano altarpiece represents an imaginative and creative fusion of earlier Sienese and subsequent Florentine contributions to this genre.

PADUAN ALTARPIECES

Interestingly, although we have no documentary evidence that Taddeo actually worked in Florence, there is a well-substantiated historical tradition that he worked in Padua – probably for the Carrara.[42] Could Taddeo, therefore, have derived any inspiration for his Montepulciano altarpiece from painted altarpieces that he had seen within Padua? As we noted earlier, the altars of Padua's churches were characteristically embellished with statuary or – as in the case of the confraternity tabernacle of the Madonna della Mora in the Santo – by a combination of painting and sculpture.[43] A number of painted altarpieces do, however, survive to give an indication of the formats favoured by Paduan and north Italian patrons. Thus, in 1344 the Paduan painter Guariento signed an altarpiece depicting *The Coronation of the Virgin* (Plate 258). From the fragmentary inscription, it appears that this altarpiece may have been commissioned when Fra Alberto was archpriest of the church of San Martino in Piove di Sacco, a town 20 kilometres south-east of Padua and within its territory.[44] Given the wording of the inscription and the fact that Saint Martin – titular saint of the church – is represented in the upper part of the painting, it seems likely that the altarpiece was intended for San Martino.

Now in a nineteenth-century frame in the Norton Simon Foundation, Los Angeles, its present-day appearance is somewhat odd in terms of both design and iconography. A plausible modern reconstruction, based on detailed examination of the physical construction of the altarpiece, reveals that it probably once took the form of a polyptych with eighteen – not the present twelve – narrative scenes arranged on either side of the central painting of *The Coronation of the Virgin* (Plate 259).[45] The central subject would, therefore, have once clearly established that the altarpiece primarily commemorated the role of the Virgin as mother of Christ, queen of heaven and divine mediatrix. The narrative paintings would then have served to emphasize this message further.[46] For example, in the top left-hand corner the painting of *The Annunciation* would have shown the Virgin accepting her part in the incarnation of Christ, whilst her unique role as prime mediatrix would have been made even more explicit in the final scene of *The Last Judgement*, where she is shown presenting a woman to Christ in Glory. On the basis of comparison with other, better preserved

Plate 258 Guariento, *The Coronation of the Virgin with Scenes from the Life of Christ*, 1344, tempera on panel, central panel 132 x 70 cm, each side panel 42.5 x 39.5 cm, Norton Simon Foundation, Pasadena, M1987.3J-32P, formerly in San Martino, Piove di Sacco.

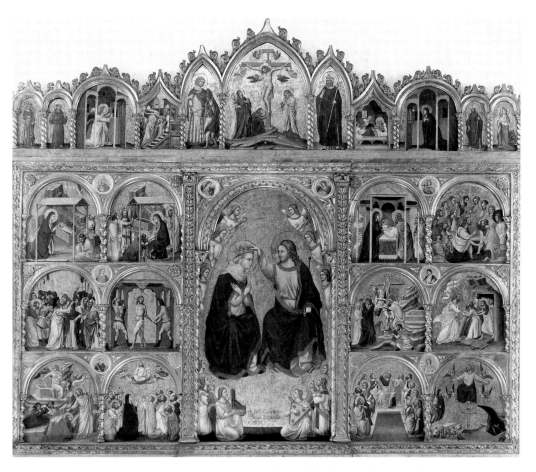

examples of north Italian altarpieces – such as Paolo Veneziano's *Coronation* polyptych[47] – it seems likely that the upper register of the altarpiece once comprised a series of four narrative scenes from the early life of the Virgin, each framed by standing saints. These narrative paintings, including the surviving *Crucifixion*, would once have been set within round-headed arches, in turn topped by pointed gables.

In terms of its format, therefore, this Marian altarpiece – produced by a Paduan painter within a Paduan context – would have been generically similar to other north Italian altarpieces. For example, in its vivid colours and extravagant

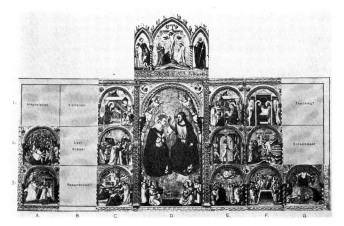

Plate 259 Photomontage by John White of Guariento, *The Coronation of the Virgin* polypytch (Plate 258). Reproduced from John White, 'The reconstruction of the polyptych ascribed to Guariento in the collection of the Norton Simon Foundation', *Burlington Magazine*, 117, 1975.

decorative quality, it displays a close similarity to fourteenth-century Venetian altarpieces (cf. Plates 258, 260). Guariento's altarpiece also provides evidence of a marked preference for a wide horizontal format, contrasted with the tall multi-tiered polyptychs being produced in Tuscany by this date. Furthermore, the subsidiary paintings on either side of the central panel take the form not of a series of standing saints, but rather of a series of narrative scenes which are in turn framed by a series of round-headed arches. It is possible to find occasional examples of north Italian altarpieces with standing saints framing a 'narrative' subject from the life of the Virgin – a case in point being Lorenzo Veneziano's *Death of the Virgin* of 1366 for the Duomo of Vicenza. Such examples were indeed the exception, however, the generally preferred north Italian format being that of narrative painting throughout the altarpiece as a whole.

The badly damaged polyptych which still stands in its original location over the altar of Padua Baptistery provides another rare surviving example of a painted altarpiece produced within a Paduan context (Plate 261). Unlike the other Marian altarpieces we have been examining, its central iconic image is a conventional representation of the Virgin and Child. The side panels, meanwhile, are devoted to a celebration of the life of Saint John the Baptist presented in the form of a series of narrative paintings. In the upper register, Saints Francis and Sebastian, the four Fathers of the Church, and a large number of minor saints are depicted on either side of a painting of *Christ's Baptism*. On the predella appears the eucharistic image of *Christ in the Tomb*, flanked by a series of three-quarter-length saints. The identities of Fina Buzzacarina and Francesco Il Vecchio, the patrons responsible for the

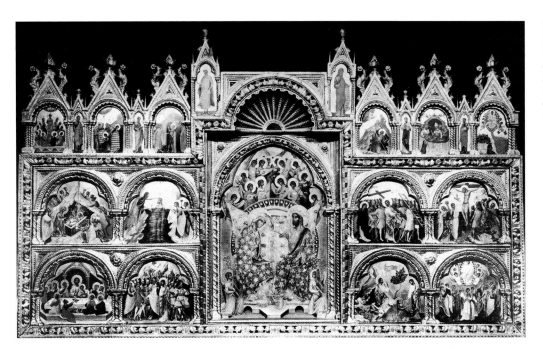

Plate 260 Paolo Veneziano, *The Coronation of the Virgin with Scenes from the Life of Christ*, *c.*1350, tempera on panel, 128 x 251 cm, Accademia, Venice, formerly in the church of Santa Chiara, Venice. Photo: Osvaldo Böhm.

entire painted scheme within the baptistery – both murals and altarpiece – are likewise commemorated in the Buzzacarini and Carrara coats-of-arms painted on the altarpiece predella.[48]

The treatment of the life of the Baptist is unusually extensive, and includes such rare scenes as the martyrdom of Saint Zacharias and Saint Elizabeth carrying the young Saint John the Baptist into the wilderness to escape the massacre of the innocents. This can be accounted for by the painting's function as an altarpiece within a baptistery. It is significant, however, that Giusto de'Menabuoi combines Florentine and Paduan elements within this one altarpiece. The representation of the central figures of the enthroned Virgin and Child is very Florentine in terms of the monumentality of

the figures and competent treatment of the spatial volume of the throne. The overall horizontal format of the polyptych, meanwhile, and its organization into a series of narrative scenes are highly reminiscent of north Italian altarpiece design. It appears, then, that in this case Giusto de'Menabuoi – himself a Florentine painter – creatively combined the pictorial legacy of his own Florentine training with a local and distinctively north Italian tradition in altarpiece design.

Comparison of these two examples of Paduan altarpieces with Taddeo di Bartolo's Montepulciano altarpiece suggests that the Sienese painter appropriated little, if anything, from Paduan precedents. It may be concluded, therefore, that the stature and effectiveness of Taddeo's own local Tuscan tradition of producing altarpiece painting were sufficient to

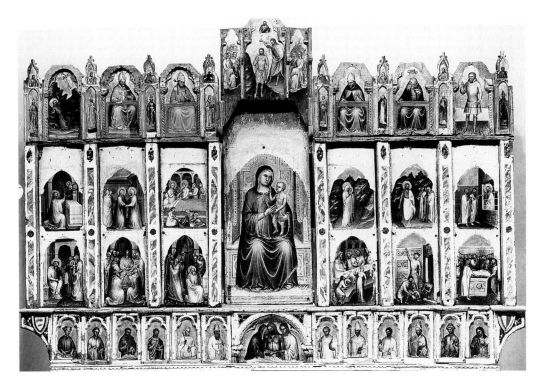

Plate 261 Giusto de'Menabuoi, *The Virgin and Child with Scenes from the Life of Saint John the Baptist*, 1370s, tempera on panel, *c.*209 x 282 cm, Baptistery, Padua. Reproduced by courtesy of Musei Civici Padova, Gabinetto Fotografico.

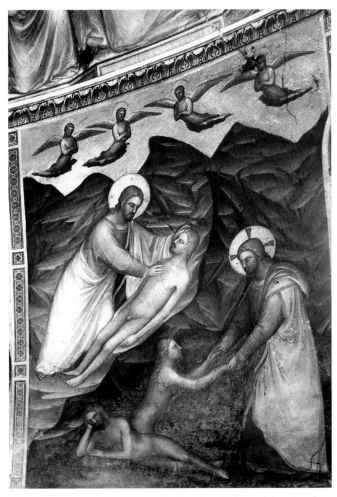

Plate 262 Giusto de'Menabuoi, *The Creation of Adam and Creation of Eve*, 1370s, fresco, drum of the Baptistery, Padua. Reproduced by courtesy of Musei Civici Padova, Gabinetto Fotografico.

render insignificant the possible impact of north Italian altarpieces which he encountered during his stay in Padua. Nevertheless, it may be that, in one area of the Montepulciano altarpiece at least, Taddeo drew upon Paduan art. A

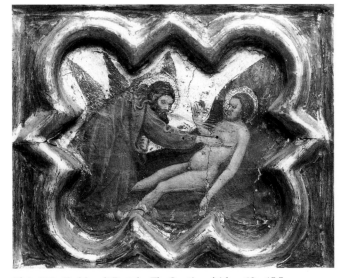

Plate 263 Taddeo di Bartolo, *The Creation of Adam*, 12 x 15.5 cm, upper predella of *The Virgin of the Assumption* (Plate 241). Photo: Lensini.

comparison of Giusto de'Menabuoi's treatment of the creation of Adam within the drum of Padua Baptistery and Taddeo's version of this same biblical event in the upper predella of the Montepulciano altarpiece reveals that, despite their markedly different scale, the treatment of the recumbent figure of Adam is broadly similar (cf. Plates 262, 263). Additionally, Taddeo may well have studied Giotto's rendition of this Old Testament subject in the painted border of the Arena Chapel – a small-scale painting which was also composed within a quadrilobe format (Chapter 4, Plate 98).[49] It is possible, therefore, that the powerful sway of Padua's well-developed tradition of pictorial narrative in mural form provided a stimulus for the Sienese painter when he later came to execute altarpiece commissions within his own locality.

CONCLUSION

In terms of its monumental scale and elaborate appearance, Taddeo di Bartolo's Montepulciano altarpiece is a triumphant culmination of the rich tradition of altarpiece painting in fourteenth-century Tuscany. As we have seen, there is something distinctively Sienese in its iconography – drawing as it does not only upon earlier Sienese formulae for depicting the circumstances of the Virgin's death, assumption and coronation, but also upon Duccio's detailed narrative of the Passion of Christ. A further distinctive Sienese quality occurs in the very worksmanship of the altarpiece as a whole. The altarpiece constitutes an extraordinary amalgam of gilding, painting, glazing, relief, punched decoration and inset crystal. For example, the mantle of the Virgin of the Assumption, painted in white and modelled in blue, is covered with the word 'Ave' – the first word of the traditional Marian prayer 'Ave Maria' – and a myriad of starbursts worked in gold leaf, each of which has a coloured crystal boss as a centrepiece. The comparison that most readily comes to mind is with the elaborate artefacts for which fourteenth-century Sienese metalworkers were celebrated. Conversely, the altarpiece's strikingly architectonic quality, elaborate structure, and unified figural composition apparently draw upon the remarkable series of altarpieces produced within Florence and its environs within the second half of the century.

The Montepulciano altarpiece also provides evidence of the way in which a painter would naturally draw on his own experience of working in other media and studying the work of other artists. Thus, it seems that the monumentality of the figures on the main register may have been affected by Taddeo's own recent experience of executing mural schemes for churches in Pisa and Liguria.[50] Additionally, it has been observed perceptively that the block-like physiognomy of the Virgin of the Assumption, her frontal pose and particular facial features, are closely comparable to Sienese polychromed wooden sculpture.[51] We have also seen how Taddeo di Bartolo apparently studied details of contemporary Paduan murals. Further suggestive comparisons can be made between the Old Testament scenes on the altarpiece and the Old Testament series executed by Bartolo di Fredi for the Pieve of San Gimignano – a church in which Taddeo di Bartolo himself executed two altarpieces and a mural scheme.[52]

We noted earlier how the location of Jacopo di Cione's coronation altarpiece in San Pier Maggiore, together with the special religious circumstances in which it functioned, conceivably had a significant bearing on the iconography of that work. Were there similarly specific local circumstances which affected the iconography of Taddeo's Montepulciano altarpiece? We have already seen how its Marian imagery, so beloved of the Sienese, might well have had a political dimension to it, and how the altarpiece also celebrated saints with a particular significance for the community of Montepulciano. There appears, however, to have been one further local factor which may account for the particular iconographic programme of the altarpiece.

On 9 April 1400 Pope Boniface IX elevated the status of the Pieve of Montepulciano to that of a Collegiata, thereby making its clergy directly responsible to the Holy See and removing the church from the jurisdiction of the diocese of Arezzo. Jacopo di Bartolommeo Aragazzi, the commissioner of the altarpiece, was granted the title of abbot – which, although not of comparable status to a bishop, gave him the right to use the two principal insignia of a bishop, namely the crozier and mitre. He was also authorized to ordain the minor orders of clergy.[53] How might this recent development in the history of the Pieve of Montepulciano have affected the execution and pictorial resolution of the altarpiece? First, the very commission and execution of the altarpiece (which, on stylistic grounds, appears to have been initiated in the mid 1390s) may have been part of Jacopo Aragazzi's campaign at the Holy See to secure elevated ecclesiastical status for his church.[54] Secondly, as has already been noted, Saint Donatus, arrayed in the robes and accoutrements of his episcopal rank, is a prominent figure within the left-hand panel of the main register of the altarpiece. Indeed, the accoutrements of his office receive even greater emphasis by virtue of the fact that the jewels on his crozier and mitre and the clasp of his cope are all worked in relief. Thus, through the prominent representation of this bishop saint, Jacopo Aragazzi was able to advertise and celebrate his own newly acquired ecclesiastical rights and privileges. Elsewhere on the altarpiece appear other representations of saints with episcopal status and – in the form of the deacon saints Stephen and Lawrence – august representatives of the minor clerical orders. Moreover, by additionally representing Saint John the Baptist and the Archangel Michael, Taddeo di Bartolo included a pointed reference both to baptism and the Day of Judgement – reflecting, in the words of Gail Solberg, 'the temporal span of Jacopo's charge of souls'.[55]

Since such iconographic choices reflected the particular wishes of the commissioners of altarpieces, it is likely that Jacopo Aragazzi was directly responsible for the peculiarly apt choice of saints for the main register of the altarpiece. What, however, of Taddeo's own unique contribution to this grandly conceived altarpiece painting? Two examples must suffice to show the likely nature of Taddeo's contribution. As we have seen, it was clearly important to the patron and his community that the high altarpiece should allude to the history of the Pieve and its status as the principal church of Montepulciano. In order to meet this particular requirement, Taddeo included a representation of the town's principal patron saint – Antilla – in a prominent position within the figural design of the altarpiece (Plate 246). We have seen in other examples of fourteenth-century altarpieces that the inclusion of a city's patron saint was a fairly conventional device. What is striking, however, about Taddeo's representation of Saint Antilla is that she is shown presenting a model of the town of Montepulciano to the Virgin of the Assumption. This iconographical convention was already well established within fourteenth-century religious art.[56] This particular instance, however, is remarkable in the painter's evident determination to provide an accurate – albeit generic – representation of Montepulciano, including a clearly identifiable depiction of its principal gateway, its relatively sparsely populated lower town, and its much more important upper town (the Sasso) – the site of the Pieve and the Palazzo Comunale, both of which are visible in this painted detail. Indeed, in terms of the Pieve itself, it is possible to see how the now lost Romanesque church was once oriented in a completely different direction and comprised a modest three-aisled structure culminating in a triple apse, with a campanile beside the principal body of the church. Although representation of specific city locations had been anticipated by other fourteenth-century Sienese painters (Chapter 7, Plate 182), Taddeo di Bartolo's recording of this specific civic location is remarkably assured and brings to the altarpiece format an unusual degree of naturalism and topicality.

Turning to the representation of the assumption of the Virgin on the central panel of the altarpiece, among the group of apostles one figure in particular is strongly differentiated. An apostle whose inscribed halo identifies him as Thaddeus is shown looking out directly at the spectator (Plate 239). Quite apart from deploying this eye-catching device, Taddeo di Bartolo drew further attention to him by making his face much lighter in tone. Through this figure the spectator is encouraged to empathize with the apostles – an impression confirmed by Saint Thaddeus's hand gesture which resembles a fourteenth-century scholar, teacher or preacher enumerating the points of an argument.[57] We are thus encouraged to join in with the apostles' collective act of witnessing and communicating the significance of the Virgin's corporeal assumption.

Since Thaddeus is the name saint of the painter himself, various art historians have proposed that this represents a self-portrait. For one scholar, this self-portrayal signifies Taddeo's sense of status and self-esteem as an artist. However, it has also been plausibly argued that the youthful features of the saint are unlikely to be those of the 40 year old painter.[58] Rather, by deploying his skills as a painter, Taddeo drew attention to his name saint whilst also keeping within the bounds of religious decorum. He thus represented Thaddeus as a figure who was both palpable and realistic, yet also idealized so as to remove him from the mundane concerns of ordinary people. In these two details of this magnificent late fourteenth-century altarpiece painting, we find encapsulated the fine balance characteristically maintained by painters of this particular genre of religious art. On the one hand, they observed the conventions expected for such art and, on the other, they constantly challenged and reformulated the conventions to push further the boundaries of artistic experiment and innovation.

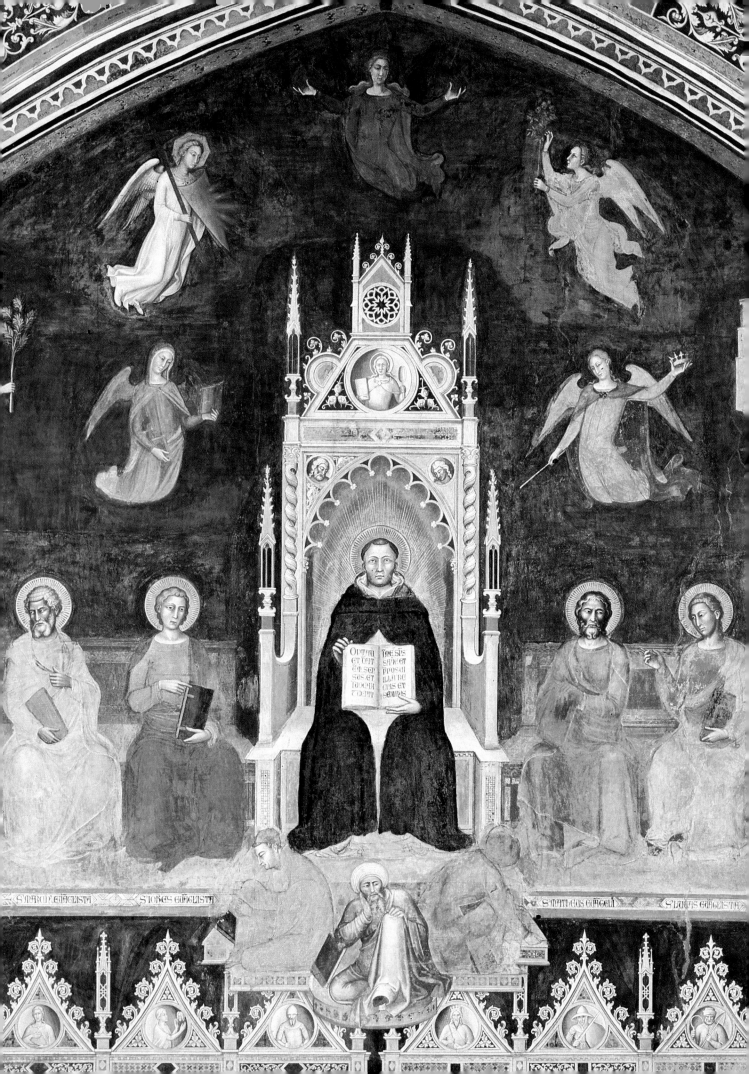

S·MARCUS·EUAGLISTA S·IOHES·EUAGLISTA S·MATHEUS·EUAGLI S·LUCAS·EUAGLISTA

The art of knowledge: two artistic schemes in Florence

According to the Florentine chronicler Matteo Villani, one of the first civic initiatives to be taken in Florence after the Black Death was the founding of the university. In his account, Villani described how the Florentine government desired a university in order to attract people to a city depopulated by the plague. It also wanted to increase the fame and honour of Florence by giving its citizens the means to acquire knowledge, and hence enhance their sense of civic virtue. Villani further observed that the reason why the Pope, Clement VI, and his college of cardinals willingly granted Florence the privilege of founding a university was that the city was 'full of every practical skill [*arte*] and professional accomplishment [*mestiere*]'.[1]

It is significant that Villani chose to use the words *arte* and *mestiere* – words that imply value was being placed upon essentially practical rather than intellectual skills. In a city whose economic wealth was primarily based on its textile industry and whose political regime was orchestrated by the trade and craft guilds, Villani's pithy description of Florence's achievement was most apt. Yet, when describing the reasons why the Florentine government wished to have a university in its city, Villani spoke of the citizens becoming knowledgeable – *scenziati* (*sic*). By using an adjective that derived from the Latin *scientia* (knowledge), Villani showed an awareness of the kind of scholarly curriculum that the *studium* would embrace. Like any other medieval university, the *studium* would teach academic subjects such as canon and civil law, theology, philosophy, medicine and the humanities.[2] The *studia* thus aimed to cultivate in their students not the practical skills associated with *arte* and *mestiere* but the processes of abstract intellectual thought.

Arguably, the creative tension between, on the one hand, the essentially practical application of manual skills and, on the other hand, the abstract intellectual processes of learning and the dissemination of knowledge also informed a number of works of art produced in Florence during the fourteenth century. Two in particular stand out, precisely because their subjects are so self-evidently about knowledge and its benefits for humanity. The first and earlier artistic scheme is the elaborate sequence of sculpted reliefs that embellishes the lower zone of the campanile of the cathedral, situated at the very heart of the city's ecclesiastical centre and thus accessible to the public at large (Plate 265). Executed over a long period, lasting from the late 1330s to the late 1350s, the work was undertaken, first, by the sculptor Andrea Pisano and his workshop and then, after his departure from the city, by other sculptors working in the cathedral workshop. The impressive fourteenth-century sculpted programme presents an ambitious scheme of figures and narrative scenes. These include scenes from the Creation as recounted in the Book of Genesis and representation of the practitioners of the seven

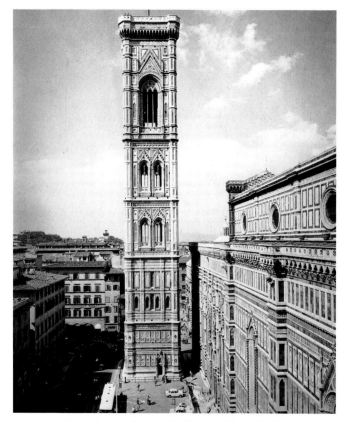

Plate 265 General view, Campanile, Florence. Photo: Scala.

mechanical arts, together with other persons, both biblical and legendary, who were believed to be the inventors of activities useful to humanity. In addition, the scheme included representations of the seven virtues, the seven liberal arts, the seven planets and the seven sacraments.

The second example of a fourteenth-century Florentine work of art whose subject is a celebration of learning is a single fresco from a mural scheme. Painted between 1366 and 1368 by Andrea Bonaiuti, and located on the west wall of the chapter-house of the Dominican priory of Santa Maria Novella and thus available only to a very specialized audience, it depicts Saint Thomas Aquinas at the centre of a complex figural grouping (Plate 266). Like the campanile programme, it includes an array of personifications, among whom feature the liberal arts as well as illustrious practitioners of various kinds of knowledge. Also woven into the painting's imagery are representations of the seven virtues, the seven planets and the seven gifts of the Holy Spirit.

Whilst the campanile reliefs and *The Triumph of Saint Thomas Aquinas* differ in points of detail and emphasis, they share one broad and crucial characteristic. Both works of art

Plate 264 (Facing page) Andrea Bonaiuti, *Saint Thomas Aquinas*, detail of *The Triumph of Saint Thomas Aquinas* (Plate 266). Photo: Scala.

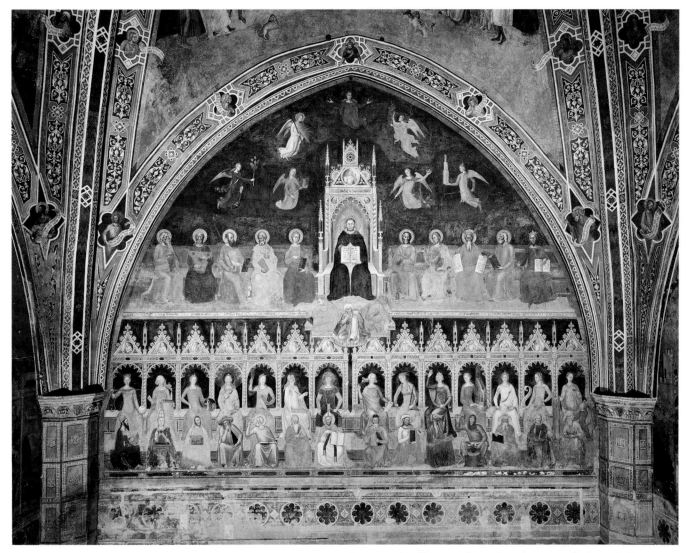

Plate 266 Andrea Bonaiuti, *The Triumph of Saint Thomas Aquinas*, 1366–68, fresco, west wall, chapter-house (now known as the Spanish Chapel), Santa Maria Novella, Florence. Photo: Scala.

seek to portray knowledge. Moreover, both attempt to express in visual form the essentially complex body of knowledge that late medieval scholarship encompassed. Furthermore, in their organization both schemes try to convey something of the highly systematic nature of medieval intellectual inquiry. Given that the schemes shared this common aim, despite their markedly different contexts and the different artistic media involved, how did the resulting works differ in their treatment of knowledge as a subject? What are the principal iconographical and formal differences between the artistic schemes and how can such differences best be explained?

THE IMAGERY

The campanile reliefs

The sequence of reliefs on the campanile begins with a series of 21 marble hexagonal reliefs situated on the first of the panelled zones of the richly embellished exterior of the monument. Originally set within a framework of encrustation that combined green, pink and white marble worked in an elaborate pattern (Plate 265), these reliefs are now on display

in the Museo dell'Opera del Duomo and have been replaced on the campanile by copies.[3] On the left-hand side of the west and principal face of the campanile appear three scenes from the Book of Genesis – the creation of Adam, the creation of Eve and Adam and Eve's first labours.[4] The four remaining reliefs on the west face depict the Old Testament figures of Jabal, Jubal, Tubalcain and Noah, representing, respectively, the first herdsman, the first musician, the first smith and the first cultivator of vines (Plates 267 and 268). On the south face of the campanile four of the seven hexagonal reliefs are devoted to the depiction of four of the mechanical arts – *Armatura, Medicina, Venatio* and *Lanificium* – each represented in terms of specific types of occupation associated with these arts. The three remaining reliefs of this sequence portray three further inventors: Gionitus who, according to the thirteenth-century Florentine scholar Brunetto Latini, was the fourth son of Noah and the first astronomer; Phoroneus who was believed to have arbitrated in a dispute between the Greek goddess Hera and the Greek god Poseidon and was therefore credited with the invention of law; and Daedalus, the legendary Greek craftsman and patron of artists who, among his many creations, invented the means of flight (Plate 269).

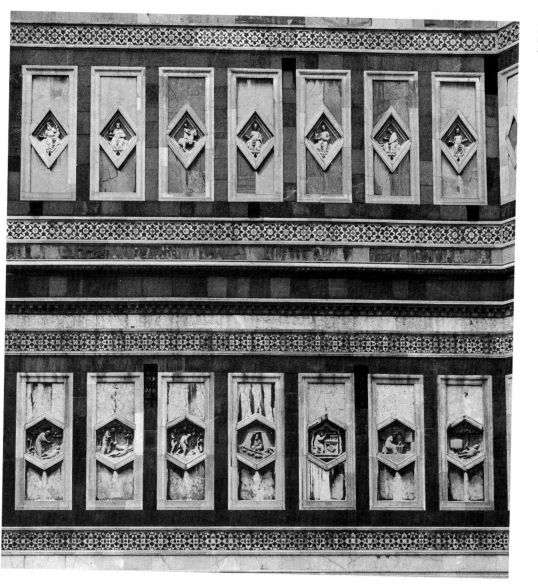

Plate 267 West face, Campanile, Florence. Photo: Tim Benton.

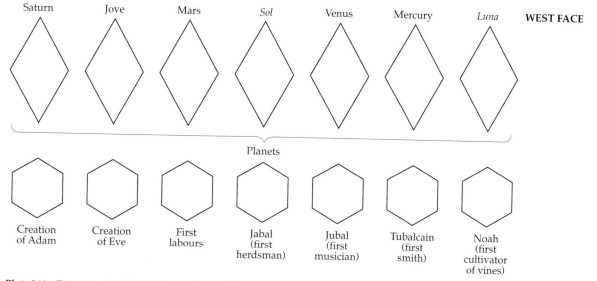

WEST FACE

Saturn Jove Mars *Sol* Venus Mercury *Luna*

Planets

Creation of Adam Creation of Eve First labours Jabal (first herdsman) Jubal (first musician) Tubalcain (first smith) Noah (first cultivator of vines)

Plate 268 Diagram of reliefs on the west face of the Campanile, Florence.

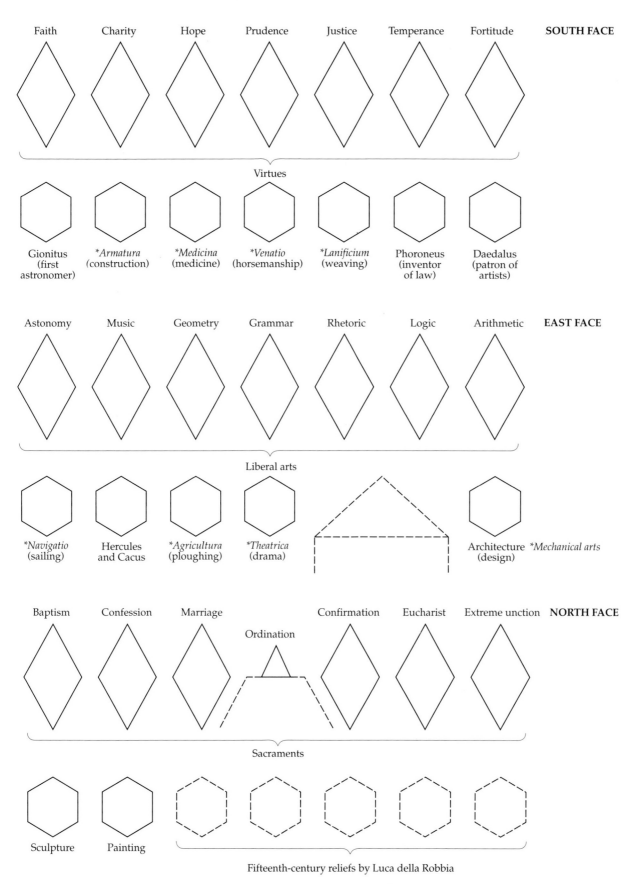

Plate 269 Diagram of reliefs on the south, east and north faces of the Campanile, Florence.

On the east face of the campanile, due to the presence of a doorway only five reliefs appear. Four of these portray the remaining three mechanical arts – *Navigatio, Agricultura* and *Theatrica* – and the practical skill of architecture, represented by a seated figure working with dividers. The remaining relief on this face depicts one of the feats of the Greek hero and demi-god Hercules: the slaying of the cattle thief Cacus (Plate 269). Finally, on the north face, opposite to the cathedral, are two reliefs depicting the practical skills of sculpture, as a sculptor in the act of carving a statue, and painting, as a painter working on a panel.[5]

This sculpted programme, devoted primarily to celebrating those occupations of direct benefit to humanity, was further elaborated by a second sequence of 28 reliefs located in the zone directly above that containing the hexagonal reliefs. Set in lozenge-shaped frames (with one exception) and with a background of deep blue glazed terracotta, this upper series begins on the west face of the campanile, above the Genesis series, with representations of the planets in the form of the seven major deities of the ancient pantheon (Plates 267 and 268). On the south face, above the mechanical arts and mythical inventors, are representations of the three theological and four cardinal virtues. On the east face appears a further series of female figures, this time representing the liberal arts (Plate 269). Finally, and most appropriately given that they are opposite the cathedral, the reliefs on the north face depict the seven sacraments, showing, in tellingly concentrated form, the liturgical rites associated with these Christian ceremonies (Plate 270). In addition to this ambitious scheme of sculpted reliefs, the campanile bears a series of niches set high above street level and intended to house sculpted figures of Old Testament prophets and sibyls (who, as the inspired seeresses of antiquity, were generally deemed to be the pagan counterparts of the prophets). Although Andrea Pisano and his workshop executed a number of these statues, the figural programme remained unfinished and was only completed in the early fifteenth century.[6]

A number of conclusions may be drawn from this account of the campanile's sculpted programme. Its multiple detail and systematic organization put into visual form the complex but orderly nature of medieval scholasticism. The aims of scholasticism may be conveniently summed up by reference to *Speculum Maius* (*The Great Mirror*) by the thirteenth-century theologian Vincent of Beauvais. Divided into four books – *The Mirror of Nature, The Mirror of Instruction, The Mirror of Morals* and *The Mirror of History* – this encyclopaedic work, like others of its kind, attempted to embrace the sum total of human knowledge, moral ideas and God's cosmic plan for humanity into a comprehensive and compellingly unified scheme. Thus, in *The Mirror of Instruction*, the author, whilst reviewing the different branches of knowledge and the skills that human beings have developed, discoursed on the identities and significance of both the liberal and the mechanical arts. Similarly, in *The Mirror of Morals*, the author offers an exposition on the seven virtues and their role in teaching people how to act according to the will of God.[7] The campanile reliefs thus graphically exemplify the tendency within medieval scholasticism to *personify* abstract intellectual concepts. Particular virtues, for example – such as charity or prudence – are portrayed as women, each carrying objects or

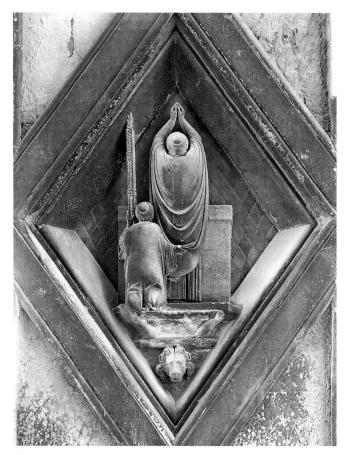

Plate 270 Cathedral workshop, *Eucharist*, 1350s, marble and glazed terracotta relief, 87 x 63.5 cm, north face, Campanile, Florence (original sculpture now removed to the Museo dell'Opera del Duomo, Florence). Photo: Alinari.

attributes that allude to the quality that the virtue was believed to embody. Similarly, the liberal arts are shown as women, each portrayed either as engaged in an activity, or as holding an object, associated with the particular scholarly pursuit that she represents.

As comparisons with Giotto's Arena Chapel virtues or Ambrogio Lorenzetti's depiction of the liberal arts in the Sala dei Nove in the Palazzo Pubblico in Siena reveal, there was a rich and well-established pictorial tradition for the representation of these allegorical figures. Within this tradition, marked variations of detail could and did occur. Nevertheless, local variations remained subordinate to an overarching and commonly understood scholastic system.

The campanile scheme offers in addition a clear demonstration of how medieval knowledge, whilst always securely rooted within a Christian framework based upon the Bible and the writings of later theologians and churchmen, also gave recognition to the value of the learning of antiquity. Thus, the planets on the campanile are portrayed as pagan deities, albeit in contemporary guise – a monk for Jupiter and a knight on horseback for Mars, for example (Plate 271). In these instances, the designer of the campanile programme was utilizing a complicated cultural process, evolved over many centuries, whereby knowledge of astronomy derived from both classical and later Arabic sources had been assimilated by medieval Christian scholars and translated into

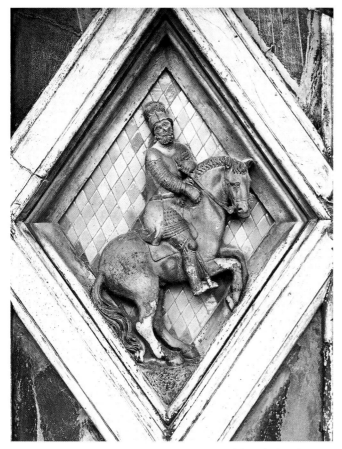

Plate 271 Cathedral workshop, *Mars*, 1340s, marble and glazed terracotta relief, 87 x 63.5 cm, west face, Campanile, Florence (original sculpture now removed to the Museo dell'Opera del Duomo, Florence). Photo: Scala.

a system of astrological belief. It was believed that each person's character, professional occupation and fate was governed by the planets – a world-view worked out in particularly complex pictorial form in the remarkable mural scheme of the Salone of the Palazzo della Ragione in Padua.[8]

At least three mythical heroes of antiquity – Phoroneus, Daedalus and Hercules – are portrayed in such as way as to suggest that they were perceived as symbolic benefactors of humanity. Indeed, it may also be that the stately woman standing beside the loom in *Lanificium* was intended to represent the goddess Minerva, who was reputed to have introduced the skill of weaving to humanity (Chapter 7, Plate 203). Similarly, the figures in *Sculpture* and *Painting* may represent, respectively, the classical sculptor Phidias and the classical painter Apelles.[9]

Finally, the meaning of the entire scheme turns on its predominant Christian message. The reliefs begins with three biblical scenes and in their upper series incorporate representations of both the Christian virtues and the Christian sacraments. Significantly, however, the scheme does not include any representations of the temptations of Adam and Eve or their fall. Instead, following the portrayal of two divine acts of creation, the scheme immediately proceeds with representations of different kinds of labour. The overall – and very positive – message of this sculpted series thus appears to be that human beings can contribute to their redemption and

avoid the possibly malign influence of the planets by acquiring both practical skills and theoretical knowledge – the latter by the cultivation of the liberal arts. However, the depiction of the seven sacraments acted as a reminder that, despite the advantages gained from skills and knowledge, only by the observance of the sacraments could human effort and creativity fully secure divine approbation and mercy.[10]

The chapter-house murals

The second work of art to be considered here decorates the wall of a large chapel that opens off the Chiostro Verde – the principal cloister – of the Dominican priory of Santa Maria Novella (Plate 272). Now known as the Spanish Chapel,[11] this chapel originally had a dual function. First, it acted as the funerary chapel of the wealthy Florentine merchant Buonamico Guidalotti who, in his will of 2 August 1355, bequeathed a substantial sum of money to the Dominicans for 'ornamenting and painting' the chapel.[12] The tomb slab of Buonamico di Lapo Guidalotti and his wife now lies directly in front of the chapel's altar.[13] Secondly, and much more significantly for our present purposes, this spacious room functioned as the chapter-house for the Dominican friars – a religious order deeply committed to scholarship – which, from 1311 onwards, had a *studium* of its own based within the priory of Santa Maria Novella.[14]

The programme of the overall painted scheme is very skilfully tailored to complement the dual function of both funerary chapel and chapter-house (Plate 273). Although the precise details of the meaning of the scheme are open to debate,[15] it is clear that its painted programme was designed, first, to celebrate and commemorate Christ's death on the Cross, his subsequent Resurrection and Ascension into heaven, and the closely associated message of human redemption attached to these sacred events (a religious theme clearly of key importance to Buonamico Guidalotti and his family). Thus, upon the altar wall is a large and expansive mural of *The Way to Calvary*, *The Crucifixion* and *The Descent into Limbo*. In the vault immediately above the altar wall appears *The Resurrection* and in the vault above the entrance wall, *The Ascension*. Secondly, the painted programme illustrates and exemplifies key activities of the Dominican Order. On the left-hand wall and its adjacent vault, the Dominican belief in the value of acquiring and disseminating knowledge is graphically portrayed. In the vault appears the scene of the Pentecost, when the apostles received the Holy Spirit and were thus able to disseminate their message in different languages – an apt biblical precedent for the Dominicans' commitment to teaching (Plate 274). Below the vault on the western wall appears *The Triumph of Saint Thomas Aquinas*, a painting that, quite apart from its celebration of knowledge, also honoured the theological learning of the Dominican Order's revered saint, Thomas Aquinas (Plate 266).

On the opposite wall appears another scene whose multiple details are the subject of various interpretations (Plate 272). What is uncontroversial, however, is that it represents a glorification of the Dominican Order, with the major Dominican saints – Dominic, Thomas Aquinas and Peter Martyr – performing vital roles in assisting in the

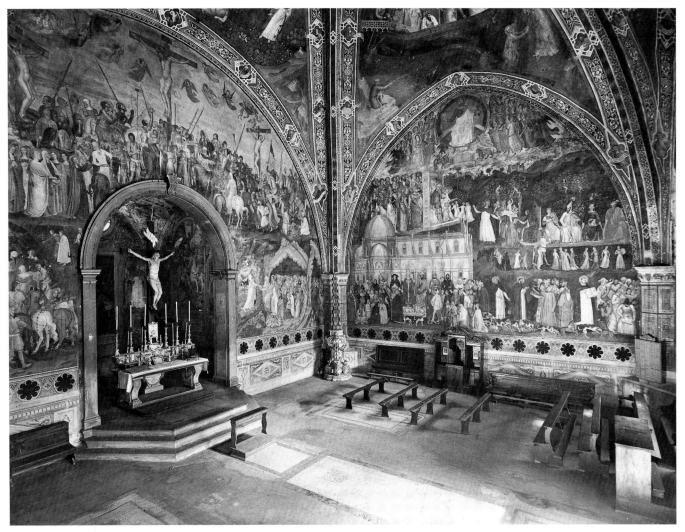

Plate 272 General view, chapter-house, Santa Maria Novella, Florence. Photo: Alinari.

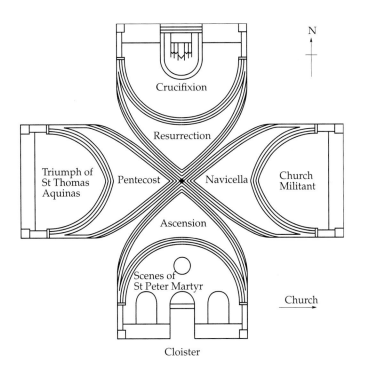

process of human redemption. Confirmation of such an interpretation appears in the form of another Dominican, represented giving absolution to a kneeling figure (Plate 275). The Dominican Order's close identification with the principal ecclesiastical and secular authorities of Christendom is further emphasized by the impressive representation of the Pope, the Holy Roman Emperor and other representatives of Christian authority, all located in front of Florence Duomo, complete with its Campanile. The scene of *The Navicella* in the vault above, with its associated symbolism of the ship of the Church, further endorses such a reading of this particular part of the painted scheme (Plate 273). Finally, the paintings on the south entrance wall depict several episodes from the life of Saint Peter Martyr, each apparently designed to emphasize his activities and merits as an important and locally revered Dominican saint.

Plate 273 Diagram of murals in the chapter-house, Santa Maria Novella, Florence. Reproduced from Julian Gardner, 'Andrea di Bonaiuto and the chapterhouse frescoes in Santa Maria Novella', *Art History*, 2, 1979 by permission of the author.

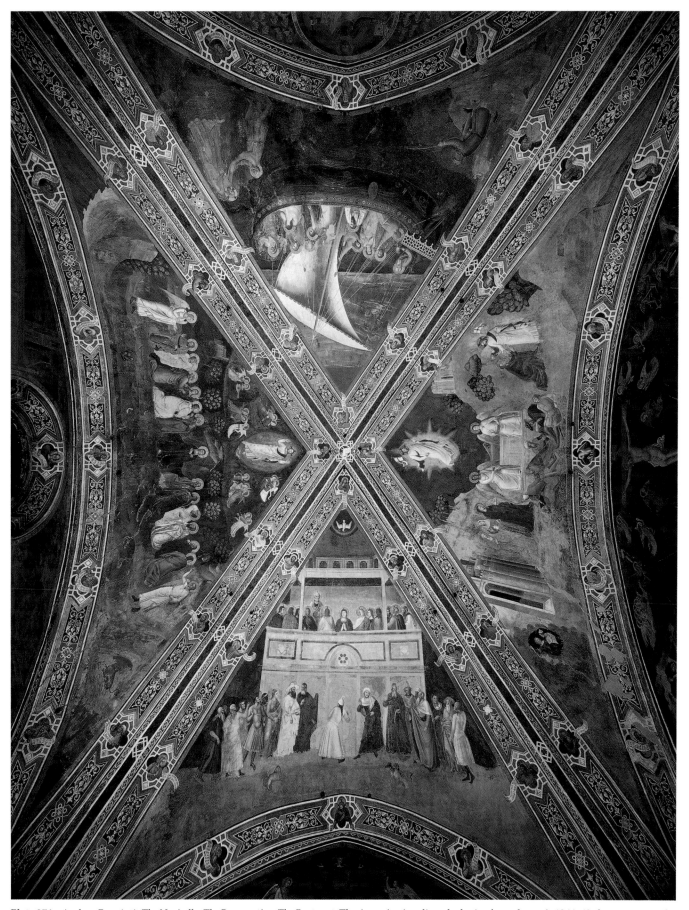

Plate 274 Andrea Bonaiuti, *The Navicella*, *The Resurrection*, *The Pentecost*, *The Ascension* (reading clockwise from the top), 1366–68, fresco, west web of vault, chapter-house, Santa Maria Novella, Florence. Photo: Scala.

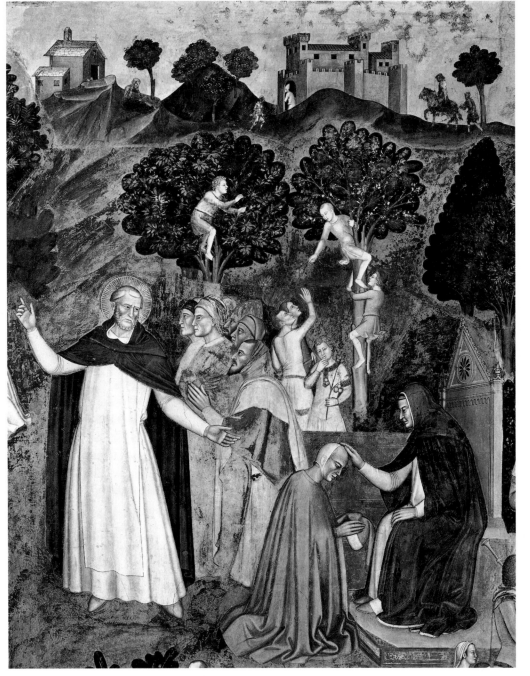

Plate 275 Andrea Bonaiuti, *A Dominican Giving Absolution*, detail of *The Church Militant*, 1366–68, fresco, east wall, chapter-house, Santa Maria Novella, Florence. Photo: Index.

The Triumph of Saint Thomas Aquinas

The particular theme of the nature, acquisition and dissemination of knowledge is addressed in the painting of *The Triumph of Saint Thomas Aquinas* on the west wall (Plate 266). Aquinas is represented at the centre of a complex figural scheme.[16] He is shown seated upon an elaborate throne, at the apex of which appears a fictive roundel that depicts a half-length female figure representing wisdom (Plate 276). Aquinas holds an open book upon which is a painted biblical text, taken from the Book of Wisdom (Plate 264).[17] Above the enthroned saint, appearing as heavenly bodies, are the seven virtues. As appropriate to their traditionally greater status, the three theological virtues appear at the very top of the painted scheme. On either side of

the saint is a sequence of Old Testament prophets, together with Saint Paul and the four Evangelists. Apart from David, who carries his attribute of the harp, all these saints hold books, some of which are open and once had texts clearly painted upon their pages. At the feet of Aquinas, in poses suggestive of both subjection and deep despondency, are three further figures. Traditionally identified as Arius, Averroes and Sabellius[18] – three writers whose teachings were decisively rejected by the Church – they present a striking antithesis to the triumphant demeanour of the other figures within the painting.

The lower half of the painting presents a sequence of elaborately decorated seats, similar in style to intricately carved choir stalls that have survived from fourteenth-century Italy (Chapter 8, Plate 224). Seated on them

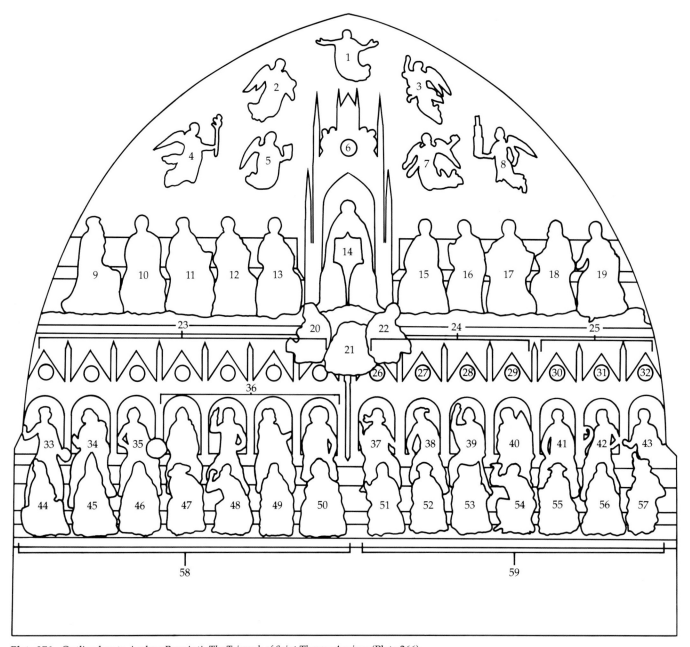

Plate 276 Outline key to Andrea Bonaiuti, *The Triumph of Saint Thomas Aquinas* (Plate 266).

Key:

1 Charity	16 St Luke	31 Venus	46 Plato
2 Faith	17 Moses	32 Moon	47 St Jerome
3 Hope	18 Isaiah	33 Civil law	48 St Dionysius Areopagite
4 Temperance	19 Solomon	34 Canon law	49 St John Damascene
5 Prudence	20 Sabellius	35 Ancient theology	50 St Augustine
6 Wisdom	21 Averroes	36 Four theological sciences	51 Pythagoras
7 Justice	22 Arius	37 Arithmetic	52 Euclid
8 Fortitude	23 Seven gifts of the Holy Spirit	38 Geometry	53 Ptolemy
9 Job	24 Quadrivium	39 Astronomy	54 Tubalcain
10 David	25 Trivium	40 Music	55 Aristotle
11 St Paul	26 Sun	41 Dialectic	56 Cicero
12 St Mark	27 Mars	42 Rhetoric	57 Donatus
13 St John Evangelist	28 Saturn	43 Grammar	58 Theological sciences
14 St Thomas Aquinas	29 Jove	44 Justinian	59 Liberal arts
15 St Matthew	30 Mercury	45 Clement V or Innocent IV	

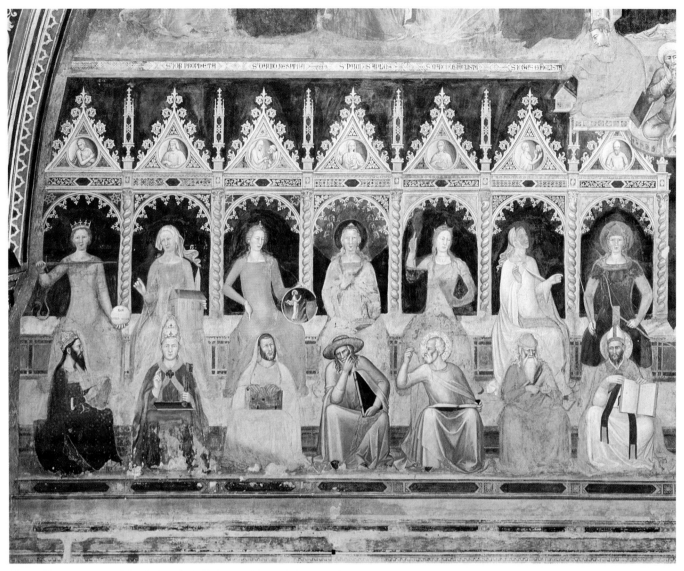

Plate 277 Andrea Bonaiuti, *The Theological Sciences*, detail of *The Triumph of Saint Thomas Aquinas* (Plate 266). Photo: Scala.

are fourteen female figures. The seven women on the left have been convincingly identified as personifications of civil and canon law and various branches of theology (Plate 277). On the right appear the more familiar figures representing the seven liberal arts (Plate 278). Their identities are rendered the more graphic by the presence of male figures seated below them. Each of these figures acts as an historical representative of the particular branch of knowledge that the female allegorical figure above personifies. Thus, below civil law appears the figure of Justinian, the Roman Emperor who is believed to have been responsible for drawing up the principal code of law practised by civil lawyers in the medieval period. Similarly, Arithmetic is shown in the company of the Greek mathematician Pythagoras, and Grammar with the fourth-century Roman grammarian Donatus. Finally, another strand of medieval encyclopaedic knowledge has been woven into the painting by incorporating a series of roundels into the backs of the chairs upon which the liberal arts and theological sciences are seated. The roundels on the left display figures who personify the seven gifts of the Holy Spirit. The roundels on the right represent

the seven planets, appearing as pagan deities, albeit in contemporary guise.

Quite apart from the identities of the painted figures, the number of painted texts (many of which have now been erased) would suggest that this painting was conceived with a specifically didactic message in mind. As such, it belongs to a class of images primarily designed to celebrate Saint Thomas Aquinas as a theologian and teacher and, more specifically, to claim that his writings were divinely inspired, superior to those of non-Christian authors and immensely significant for the Christian community as a whole.

THE PROGRAMME

Which individuals or groups were responsible for devising these two complex schemes of imagery? In particular, what were the relative roles and areas of expertise of those who commissioned them and those who executed them? In commissions for images of highly conventional religious subjects – such as the Virgin and Child – the allocation of

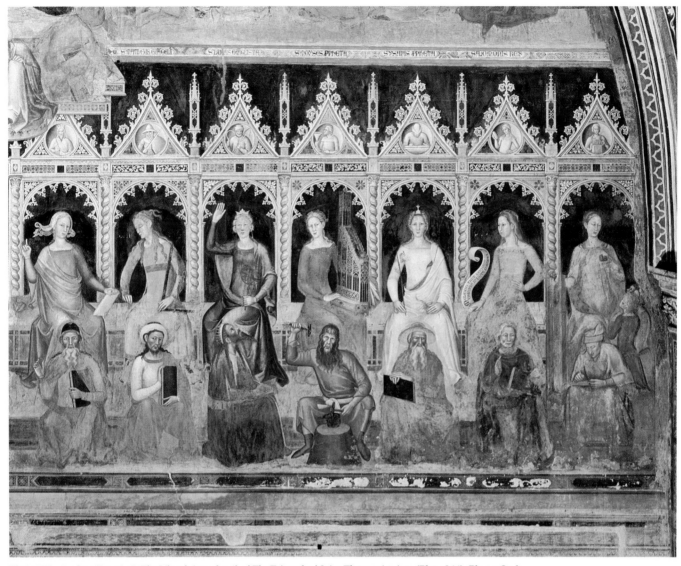

Plate 278 Andrea Bonaiuti, *The Liberal Arts*, detail of *The Triumph of Saint Thomas Aquinas* (Plate 266). Photo: Scala.

likely responsibilities between patrons and artists is relatively unproblematic. Given the familiarity of the subject, a patron could simply stipulate a painting or sculpture of 'Nostra Donna' and rely on the skill and expertise of the artist employed to render this subject in a way that conformed to various well-established expectations regarding the representation of holy figures. However, when dealing with a scheme such as the one for the campanile reliefs or the chapter-house murals, the issue of relative responsibilities and roles becomes much less easy to resolve. For example, quite apart from the patrons and artists themselves there is also the possibility that scholars familiar with the minutiae of medieval scholasticism played a part in drawing up the complex iconographical schemes embodied. What evidence, therefore, do we have concerning the commissioning and execution of the two programmes in question?

The campanile reliefs

In the case of the Florentine Campanile, we know that on 12–13 April 1334 Giotto was appointed as the master-in-charge of the cathedral project or, in the words of the document itself, as 'the master and governor of the fabric and workshop of the church of Santa Reparata [that is, the Duomo in Florence]'.[19] It is not known what precise range of expertise Giotto brought to bear on the cathedral design, in particular on that of the campanile. According to a fourteenth-century Florentine verse chronicle by Antonio Pucci,[20] Giotto was responsible for designing at least some of the reliefs. Certainly, Giotto's skills as a painter with a keen appreciation of architecture – as evidenced by the convincing representation of architecture and its ornamental detail in a number of his paintings – would lend plausibility to Pucci's claim. In addition, Giotto's proposed role in the campanile's design would account for the inventive narrative compositions of the hexagon reliefs and, indeed, the rich polychromy of the building as a whole.[21] It seems, therefore, that from his appointment as master-in-charge of work on the cathedral in 1334 until his death in 1337 Giotto may well have supervised and contributed to the design of the campanile project.

After Giotto's death, the precise sequence of responsibility for oversight of the campanile project is unclear. In 1340, however, the sculptor Andrea Pisano is mentioned as the

principal master of the works of the Opera del Duomo.[22] There is, moreover, good historical evidence that he was a major contributor to the sculpted programme of the campanile. Pucci described how its original design was modified by Andrea Pisano before being completed by Francesco Talenti. Whilst there is considerable debate about the extent to which Andrea Pisano changed Giotto's design – and whether or not this contributed to his dismissal from the post of *capomaestro* around 1343[23] – it is uncontroversial that the Pisan sculptor, who had completed the magnificent bronze door for the nearby baptistery in 1336, was responsible for carving a number of the hexagonal and the lozenge-shaped reliefs. Other reliefs were executed by members of the cathedral workshop under his direction. After Andrea Pisano's departure from Florence in the early 1340s the remaining reliefs – most notably the sacraments series – were completed by others.[24] Although documents clearly refer to the Opera del Duomo (which, from 1331, was under the direction of the powerful wool guild, the Arte della Lana) as responsible for initiating, financing and overseeing the progress on the campanile scheme as a whole, there is no indication of any individual member of the board of works or the wool guild being specifically responsible for devising the overall programme of reliefs. Who might, then, have been responsible for this task? As is often the case in respect of fourteenth-century commissions, it is very much a matter of weighing in the balance a number of possibilities. The scheme is at once very comprehensive and yet organized into discreet and well-defined parts, which would suggest that an overall plan was always intended. Indeed, it has been suggested that the campanile's programme was part of an even more comprehensive and co-ordinated scheme of imagery, which incorporated the existing mosaic programme of the baptistery, with its extended cycle of scenes from the Old and the New Testaments, and the sculpted Marian programme on the façade of the cathedral.[25] If such a reading of these three adjacent monuments is correct, then Florence's principal ecclesiastical centre may lay claim to having enjoyed a programme of sculpted and mosaic imagery as complex and all embracing as any executed for a north European Gothic cathedral.

There were, moreover, precedents within Italy for schemes whose imagery celebrated knowledge and its role in God's plan for humanity's salvation. The painted scheme on the upper walls of the Salone in the Palazzo della Ragione in Padua provides one particularly striking example (Chapter 7, Plate 200). Since Giotto is traditionally associated with the original early fourteenth-century paintings for the Salone,[26] and since – and as we have seen – there is evidence that he also participated in the design of the campanile reliefs, it is entirely plausible that the earlier Paduan scheme may have exerted an implicit influence. If, however, the fifteenth-century repainting of the Paduan scheme replicates the fourteenth-century original, it would appear that in Padua far greater precedence was given to matters of astrological belief than in Florence at the same period. Thus, in the Salone, the planetary deities (and their associated zodiacal signs) have a much more prominent role than in the campanile programme. On the campanile the mechanical arts are arguably the most prominent and striking of the reliefs, whilst

Plate 279 *Painting*, detail of fifteenth-century repainting of early fourteenth-century mural scheme attributed to Giotto, Salone, Palazzo della Ragione, Padua. Reproduced by courtesy of Musei Civici Padova, Gabinetto Fotografico.

in the Salone they feature in relatively small painted scenes (Plate 279).

The campanile reliefs, however, constitute a sculpted not a painted monument. It is significant, therefore, that precedents existed in medieval Italian sculpture for the execution of encyclopaedic programmes for the embellishment of key sites such as the cathedral complex or the principal square of a town. One such, by the notable Pisan sculptor Nicola Pisano, is the late thirteenth-century Fontana Maggiore in Perugia, located in the city's principal square beside the Duomo and the Palazzo dei Priori (Chapter 2, Plate 40). Finished in 1278, this complex scheme encompasses 25 sculpted figures ranged around the fountain's upper basin and 50 reliefs encircling its polygonal lower basin. Around the upper basin appear saints and prophets, together with personifications of Lake Trasimene and Chiusi, nearby locations that contributed to the city's economic wealth. On the lower basin appear representations of the labours of the months (Chapter 7, Plate 205), personifications of philosophy and the liberal arts, heraldic civic emblems, and scenes from biblical and antique sources. Other sculpted figures portray heroic figures from Perugia's ancient and contemporary history.[27] The overall scheme of the Perugian fountain was thus even more ambitious and encyclopaedic than that of the Florentine Campanile.

Similarly complex sculpted schemes also occurred within the series of monumental pulpits executed between 1260 and 1310 by Nicola Pisano for the Baptistery of Pisa and Siena Duomo and by Giovanni Pisano for the Duomos of Siena, Pistoia and Pisa. Although their narrative reliefs were, appropriately enough, primarily biblical in subject-matter, they also incorporated sculpted figures of saints, prophets, sibyls, Christian virtues and the liberal arts. The last of these pulpits to be executed – that by Giovanni Pisano for Pisa Duomo – displays a particularly ambitious repertoire of allegorical figures (Plate 280). Thus, among the numerous caryatid figures that support the pulpit are *Ecclesia* (a female personification of the Church), the seven virtues and the seven liberal arts (Plate 281).[28]

Plate 280 Giovanni Pisano, pulpit, 1302–10, Duomo, Pisa. Photo: Scala.

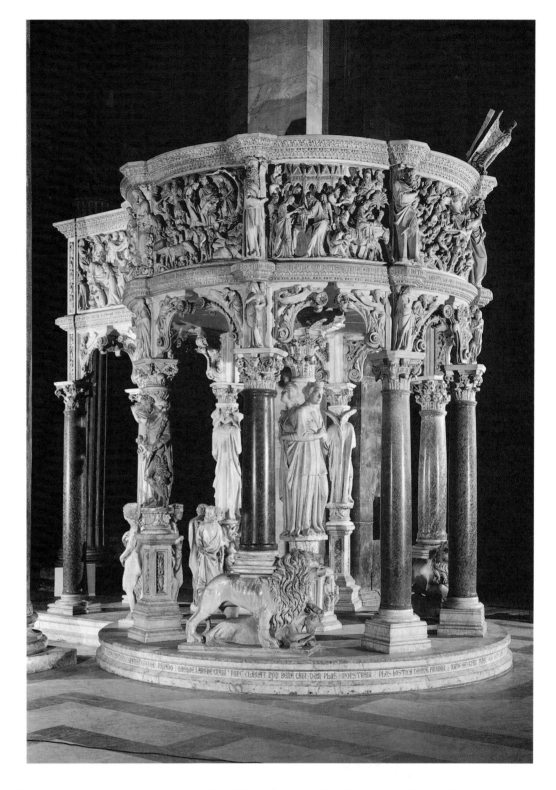

What are notably missing from such Tuscan and Umbrian sculpted monuments are representations of the mechanical arts. As already suggested, Giotto's experience in working on the painted scheme in the Salone in Padua may have exerted an influence on the prominent representation of this particular aspect of medieval encyclopaedic learning on the Florentine Campanile. Representations of the mechanical arts also occur, however, in at least two other fourteenth-century monumental schemes designed to embellish important civic buildings. They appear in compressed form upon one of the

36 elaborately carved sculpted capitals of the ground-floor loggia of the Palazzo Ducale in Venice – a building that, as the doge's residence, seat of government and judiciary, had an equivalent function and status to that of the communal palaces of central Italy (Plate 282). The overall scheme of sculpture upon the capitals of the Palazzo Ducale again illustrates a wide range of subject-matter, drawing upon the learning and lore of medieval scholasticism, and provides a telling illustration of the tenacity of such allegorical iconography within prestigious civic schemes of sculpture.[29]

Plate 281 Giovanni Pisano, *Geometry and Music*, detail of pulpit (Plate 280). Photo: Alinari.

Similarly, it has plausibly been suggested that, in Ambrogio Lorenzetti's painting of *The Good City* in the Sala dei Nove of the Palazzo Pubblico in Siena, many of the activities of the painted figures inside and outside the city were intended to allude to the mechanical arts (Chapter 7, Plates 186 and 189).[30] It is significant in the present context, moreover, that this impressive painted scheme (which also incorporates representations of the virtues and depictions of both the liberal arts and the planetary deities within its wide painted borders: Chapter 7, Plates 182–184), was being executed between 1338 and 1340, at the same time as the campanile reliefs were being sculpted and installed.

There was, then, a well-established tradition within fourteenth-century Italian art of embellishing key civic sites with complex pictorial schemes whose subject-matter emphatically celebrated the broad scope of human endeavour

Plate 282 Anonymous, *The Mechanical Arts*, fourteenth century, Istrian stone, capital on the ground-floor loggia of the Palazzo Ducale, Venice (original sculpture now removed to the Museo dell'Opera del Palazzo Ducale, Venice). Photo: Osvaldo Böhm.

and knowledge as codified by medieval scholars. Within this tradition, the programme for the Florentine Campanile was remarkable for its organization and coherence. Furthermore, it was unusual in the prominence that it afforded to the mechanical arts and the depiction of creative and practical endeavours.

Although the members of the Opera del Duomo and of the Florentine government might well have been aware of such precedents and of their potential for embellishing key civic monuments, it is also highly likely that the artists directly responsible for designing and executing the campanile reliefs would themselves have been alert to the potential of other schemes. Moreover, both Giotto and Andrea Pisano – the two major fourteenth-century artists closely associated with the campanile project – were capable of orchestrating complex schemes of imagery, as amply attested by other surviving works of art securely attributed to them. In short, it seems that the Opera would have exercised close scrutiny of the project as a whole, and therefore the possibility that a scholarly expert devised a written specification of exactly what subjects were to appear on the campanile reliefs cannot entirely be excluded. However, the familiarity of the subject-matter and the known skills and experience of the major artists involved are probably sufficient to account for the sophistication of the sculpted scheme and its iconographic programme.

The chapter-house murals and The Triumph of Saint Thomas Aquinas

In the case of the commission for the paintings in the chapter-house of Santa Maria Novella, a rather different situation pertained from that of the essentially civic scheme of the Florentine Campanile. In 1365 the painter Andrea Bonaiuti agreed with the prior Fra Zenobius Guasconi to decorate the chapter-house of Santa Maria Novella within two years. For this work the painter was to receive a house, which he and his wife were to own during their lifetimes.[31] Although some scholars have doubted that the complex scheme of paintings could have been executed within the designated two-year span, evidence of careful underdrawing and the stylistic uniformity of the paintings themselves suggest that Andrea Bonaiuti organized and closely supervised an energetic campaign of painting by his workshop.[32] The money for the painting of the chapter-house, as noted earlier, was provided by Buonamico Guidalotti, and it is possible, therefore, that he may have had some say as to the subject-matter of the paintings. Given the specifically Dominican context of the paintings, however, it is likely that the decisive influence was that of the Dominican community.

The Dominicans were a religious order with a specific vocation for the acquisition and dissemination of knowledge in both written and – through preaching – oral form. There is also a significant body of historical evidence to suggest that they had long recognized the potential of art as an aid in the regular devotional meditations undertaken by the friars themselves. Moreover, the priory of Santa Maria Novella was the site of a *studium* and therefore its members were actively involved in learning and teaching. Furthermore, by statute, a considerable part of the curriculum of the *studium* was drawn from the works of Thomas Aquinas.[33]

The chapter-house of the priory also played a crucial role within the life of this scholarly religious community. It was not only used for communal assemblies on a number of occasions during the liturgical year, but it was also the place where the whole community met on a daily basis and where the friars confessed their faults to the prior. Similarly, it was the site where the Dominican community of Santa Maria Novella conducted its official religious and administrative affairs. It was in the chapter-house that the prior was elected and important visitors were received. Finally, it was the location, from time to time, for meetings of both the Provincial Chapters of the Dominican Order in central Italy and, much more rarely, the General Chapters of the Dominican Order as a whole.[34]

Given the varied and crucial role of the chapter-house in the devotional, administrative and intellectual life of the community of Santa Maria Novella – and occasionally of the wider Dominican Order as well – it is highly likely that an eminent member of the priory was responsible for devising the content of the overall scheme. He probably provided Andrea Bonaiuti with a detailed specification of both the subjects for the paintings and the sophisticated allegorical scenes on the east and west walls. Is it possible to speculate on the identity of this apparently erudite Dominican?

The claims of one particular candidate have repeatedly been urged. Fra Jacopo Passavanti (d.1357) was prior of Santa Maria Novella during 1354–55 and the author of an influential devotional treatise – *De specchio vera penitenza* (*The Mirror of True Repentance*) – which was reproduced in numerous manuscript copies during the fourteenth century. It has been suggested that the treatise anticipates much of the detail in *The Church Militant* on the east wall, where penitential themes are prominent (Plate 275).[35] The possibility of Fra Jacopo Passavanti having been involved in the design of the chapter-house programme receives further support from the fact that he acted as executor of Buonamico Guidalotti's will when, in 1355, the wealthy merchant bequeathed money to the Dominicans of Santa Maria Novella for the painting of their chapter-house.

The link between Passavanti, Buonamico Guidalotti and the chapter-house is both appealing and suggestive and may, indeed, implicitly provide the explanation for the eruditely Dominican iconography of the scheme. However, the case is far from conclusive. It was not until ten years later that the chapter-house paintings were actually executed, at the direction of another prior – Fra Zenobius Guasconi. By that date Fra Jacopo Passavanti was dead. It is, of course, possible that he had drawn up a detailed plan for the pictorial scheme

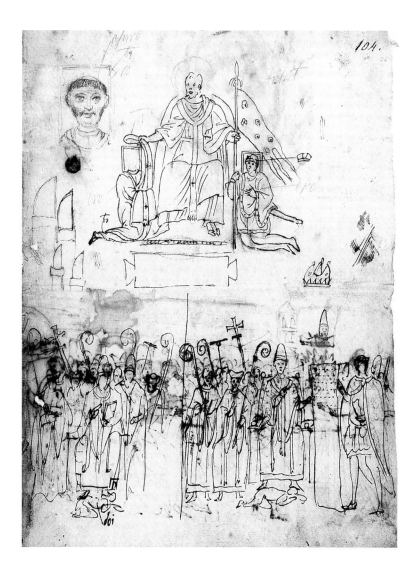

Plate 283 *Enthroned Pope with an Anti-Pope below his Feet*, drawing after a tenth-century mural once in the Audience Hall of Calixtus II in the Lateran Palace, Rome, Biblioteca Apostolica Vaticana, Cod. Barb. Lat. 2738, folio 104 recto.

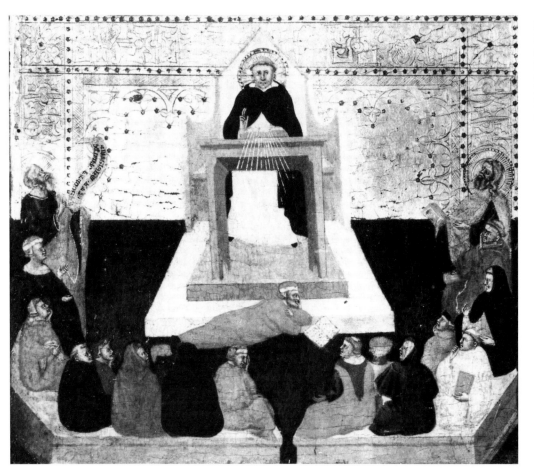

Plate 284 Attributed to the Biadaiolo Master, *The Triumph of Saint Thomas Aquinas*, 1320s, tempera, detail of a panel 66.8 x 47.4 cm, the Metropolitan Museum, New York, Robert Lehman Collection, 1975 (1975.1.99).

for his priory's chapter-house before his death and that Andrea Bonaiuti faithfully followed the directions of the specifications. Alternatively it may be that other scholarly members of the Dominican community were responsible either for devising the entire programme or for revising and elaborating upon an initial scheme proposed by Passavanti.[36]

Apart from the possible role of Passavanti or other Dominicans at Santa Maria Novella, what other evidence is there of a characteristically Dominican concern with the allegorical portrayal of knowledge as exemplified by *The Triumph of Saint Thomas Aquinas*? The personification of intellectual concepts and abstract ideas in the form of specific figures, whether mythical or historical in origin, was well established in medieval art. Moreover, the predominantly figural composition of the painting and its orderly organization into a hierarchy of figures, with those deemed most important at the top of the painting and those deemed of less importance lower down, were broadly derived from the arrangement of sculpted figures on the façades of many north European cathedrals. Indeed, the motif of Aquinas, seated with defeated adversaries below his feet (Plate 266), is itself reminiscent of the statues of virtues standing triumphant above crouching vices on such cathedral portals. In addition, it has been observed that the portrayal of Aquinas enthroned in triumph echoes similar depictions from early Christian art, of seated patriarchs or emperors presiding over church councils or synods devoted to the unmasking and condemnation of heresy (Plate 283).[37] It may be significant that in the fourteenth century several such mural paintings could still be seen in Rome and Naples – cities in

which the Dominican Order had large and well-established priories.

However, by the late 1360s, when Andrea Bonaiuti's *Triumph of Saint Thomas Aquinas* was executed, a more precise pictorial scheme had been devised to represent Aquinas's particular achievements as a scholar and saint. Significantly, two images were produced within two decades of Aquinas's canonization in 1323 and both apparently originated from churches belonging to the Dominican Order. An early fourteenth-century painting – which is one of a series on a panel attributed to the painter responsible for the illumination of the Biadaiolo manuscript (Chapter 7, Plate 206) – constitutes the earlier of these (Plate 284).[38] Aquinas is shown seated on a teaching chair (*cathedra*)[39] before a tall desk. He thus appears in the guise of a medieval doctor lecturing his pupils. From a book in front of him, a network of gold lines fans out in the direction of his audience of clerics and laymen. This device of gold rays symbolizing heavenly light and, by extension, the *illumination* that Aquinas's writings shed upon the minds of his readership, became a standard feature in paintings of this type. Standing on either side of the saint are two unidentified saints or prophets. Below the dais of the saint's *cathedra*, meanwhile, is a recumbent bearded figure. The figural composition of this small painting encapsulates the most important features of the new pictorial iconography devised by the Dominicans to celebrate the elevation of their famous scholar to sainthood. In summary, it portrays Aquinas as a teacher whose writings *enlighten* the minds of both the clergy and the laity by virtue of the orthodoxy of his teaching (as personified by the two saints), with the

Plate 285 Circle of Simone
Martini and Lippo Memmi, *The
Triumph of Saint Thomas Aquinas*,
*c.*1340–45, tempera on panel,
Santa Caterina, Pisa. Photo:
Scala.

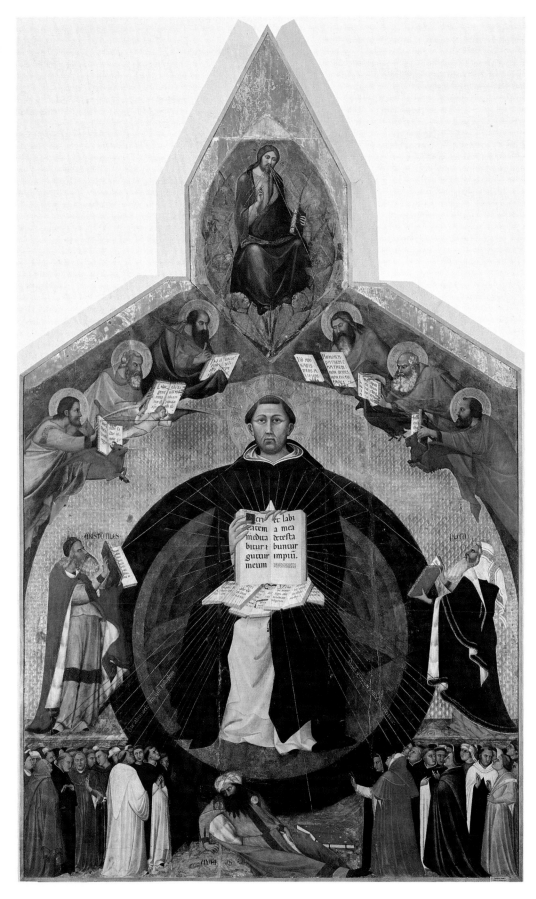

consequent power of refuting heresy (which is personified by the figure at his feet).

The second, slightly later, image was a panel apparently commissioned for the principal Dominican church in Pisa – Santa Caterina (Plate 285). (The attribution of the panel is keenly debated but it is likely that it originated from a painter working in Pisa within the orbit of the Sienese painters Simone Martini and Lippo Memmi.[40]) It shows a further elaboration of the iconography devised in celebration of Aquinas's canonization. Aquinas appears at the centre of the painting, placed before a circular form whose meaning is open to speculation but which probably alludes to the comprehensive nature of Aquinas's work and its heavenly inspiration.[41] A complex system of gold lines connects the saint and the books on his lap to other parts of the painting. The geometric pattern thus created articulates the message of the painting. The mind of Aquinas is directly inspired by both the words of Christ and the writings of Moses, Saint Paul and the four Evangelists – all of whom are represented in the upper part of the painting as at once receiving inspiration from Christ and, in turn, inspiring Aquinas. At a lower and therefore less prestigious level, the works of the conveniently labelled figures of Aristotle and Plato also offer inspiration to Aquinas, thereby acknowledging the debt that he owed to these classical philosophers. By contrast, below Aquinas's feet there appears a turbanned figure, identified by a painted title as the twelfth-century Muslim scholar Averroes. His book, represented with its cover uppermost, is transfixed by a single ray of light issuing from Aquinas's book. This pictorial device enabled the painter to express in visual terms the saint's emphatic rejection of the teachings of Averroes and his followers. Finally, in the lower left- and right-hand corners of the painting appear two groups of clerics and laymen inspired and enlightened by Aquinas's own teaching.

Andrea Bonaiuti's painting is clearly executed on a much more monumental scale than either of these precedents. Moreover, in terms of its portrayal of the theological sciences, the liberal arts and representative practitioners of these branches of intellectual inquiry, *The Triumph of Saint Thomas Aquinas* offers a much more sophisticated elaboration of the new Thomist iconography (Plate 266). Such sophistication notwithstanding, it is also apparent that Bonaiuti's painting conforms to an already established format and convention for the celebration of the latest Dominican saint. The speed at which this innovative and distinctively Dominican iconography developed, together with the steadily increasing sophistication of the images themselves, is suggestive of the active participation of members of the Dominican Order in the design of the paintings concerned. This is no less true of *The Triumph of Saint Thomas Aquinas* in the chapter-house of Santa Maria Novella than of the two precedents discussed above. Indeed, what more suitable location might there be for the further elaboration of an iconography dedicated to the celebration of Aquinas's knowledge than the chapter-house wall of a prestigious Dominican *studium*?

THE ARTISTS

What more may be said, then, of the roles of the artists within the two major Florentine schemes discussed? We have already suggested that in the case of the campanile there was considerable scope for both Giotto and Andrea Pisano to influence the design of the scheme by virtue of the precedents available to them. By contrast, it has been suggested that the design of *The Triumph of Saint Thomas Aquinas* – although not without precedent – was probably more directly influenced by one or more of the Dominicans for whom it was created. Granted these broadly contrasting contexts, do either of the works in question offer further clues as to possibly distinctive contributions by the artists themselves?

The campanile reliefs

Since Giotto died in 1337 and, in any case, was not a sculptor, consideration of the reliefs themselves on the campanile is only likely to shed light upon the role of Andrea Pisano. It is possible to detect a number of different hands at work on the various reliefs.[42] Nevertheless, there does seem to have been a single mind at work, calculating carefully how the scenes should be represented and exactly where they should be located on the four faces of the campanile. It is also apparent from the reliefs on the west and south faces that careful thought had been given to the achievement of overall compositional harmony within each individual sequence of seven reliefs. This is particularly clear upon the west face, where the reliefs are framed at either end: on the left, by the figure of God bending over the recumbent Adam and, on the right, by the reclining figure of the inebriated Noah. In the middle, and thus equidistant from the two outermost reliefs, appears Jabal, seated outside his tent. The position of this figure and the contours of the tent provide a visually compelling centrepiece to the entire sequence of reliefs on the west face (Plate 267). Although this complex enterprise would undoubtedly have required detailed discussion between the various sculptors working on it, it seems entirely plausible to attribute its impressive overall organization and coherence to Andrea Pisano, the formally appointed *capomaestro*.

Two further aspects of the sculpted scheme are sufficiently distinctive to be candidates for Andrea Pisano's personal responsibility. First, the major part of the sculpture was skilfully executed in relief, a form of sculpture that, by its very nature, is highly pictorial. Thus, like a painting, the carving on the surface of the relief can supply a convincing illusion of three-dimensional objects grouped within spatial settings. It differs from painting, however, in that the backgrounds of such settings are achieved by carving into the depth of the marble slab. They are, therefore, literally further back from the spectator than the foreground details. The hexagonal reliefs of the campanile constitute a highly impressive example of such relief carving. In *The Creation of Adam*, the figures of God and Adam have been carved in some depth and therefore appear to the spectator not only as the nearest and most palpable objects, but also as convincingly integrated within an outdoor landscape setting (Plate 286). Such an effect has been realized by subtly differentiated gradations within the depth of the marble slab upon which the relief has been worked. Similarly, in the case of *Medicina*, a convincing sense of the enclosed space of a busy apothecary's shop has been achieved by the sculptor's assured control of the techniques of carving in relief

Plate 286 Andrea Pisano, *The Creation of Adam*, c.1334–37, marble relief, 83 x 69 cm, west face, Campanile, Florence (original sculpture now removed to the Museo dell'Opera del Duomo, Florence). Photo: Alinari.

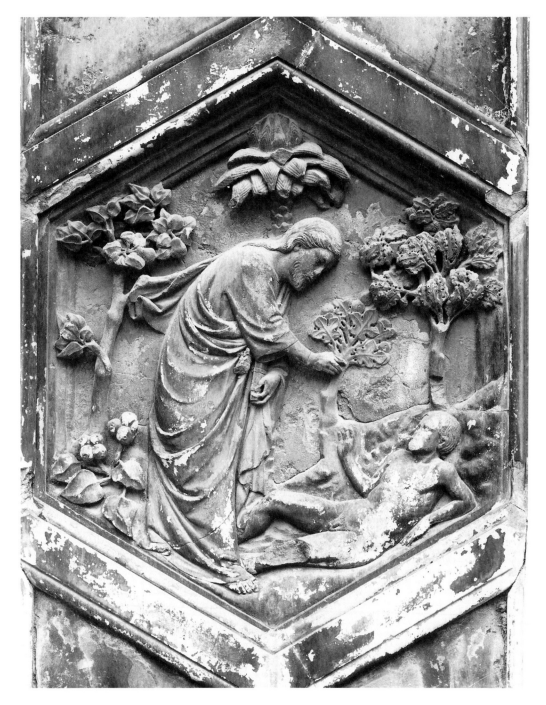

(Plate 287). Even if Andrea Pisano was not personally responsible for carving every relief, it is likely that as *capomaestro* he insisted upon an extremely high standard of relief carving throughout the campanile reliefs for which he was organizationally responsible.

Secondly, a lively balance has been achieved between, on the one hand, keen observation of contemporary dress, practices and customs and, on the other hand, the evocation of the dress, practices and customs of antiquity. In the relief of *Medicina*, for example, it is significant that, within the limited space afforded, a variety of contemporary costumes has been depicted, including that of the apothecary, who is dressed in the manner of a fourteenth-century physician. On the shelf behind him are portrayed various kinds of vessels used in contemporary practice of medicine. In addition, two of the women patients are shown holding the woven baskets in which urine samples were customarily carried.[43] Similar kinds of well-observed detail occur on some of the other reliefs.

What is more unusual, however, is the confident way in which antique subjects, such as Hercules' defeat of Cacus, are portrayed in classical form. Hercules appears as the muscular and semi-naked heroic figure that represents this classical hero and demi-god on numerous antique reliefs and statues (Plate 288). Similarly, the reclining figure of Adam (Plate 286) and, indeed, the sculpted nude in *Sculpture* (Plate 289) are remarkably classical in form in the way in which they are rendered. Quite apart from the boldness implicit in the

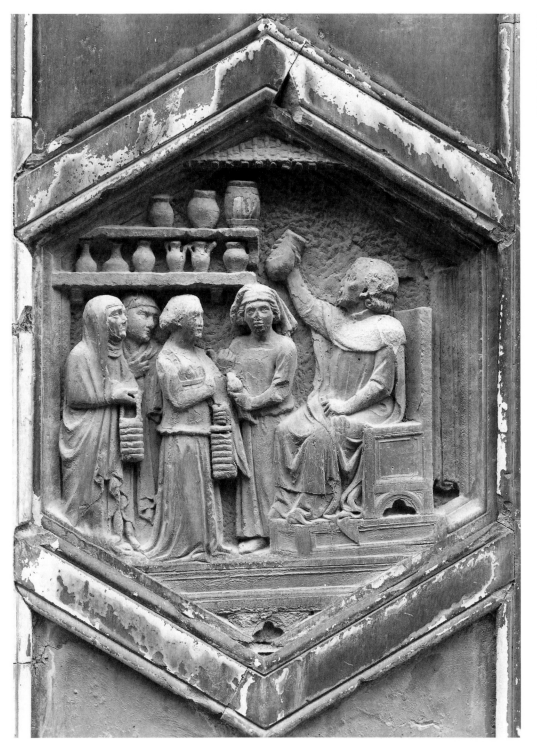

Plate 287 Workshop of Andrea
Pisano, *Medicina, c.*1337–43,
marble relief, 83 x 69 cm, south
face, Campanile, Florence
(original sculpture now
removed to the Museo
dell'Opera del Duomo,
Florence). Photo: Alinari.

celebration of nakedness – which in the medieval period carried with it certain kinds of negative connotation – these nude male figures are remarkably assured in their emulation of the idealized proportions and graceful forms of antique sculptures. Meanwhile, in *The Creation of Eve*, the figure of Eve provides a convincing rendition of the classical female nude, whilst the so-called Minerva figure in *Lanificium* bears a remarkable similarity to the representations of Roman matrons in antique art (Chapter 7, Plate 203). A further sense of the delicate balance between observation of contemporary practice and emulation of antique precedent is achieved in

Agricultura, where the energetic stance of the man at his plough suggests both observation of a *contadino* (countryman) at work and also careful study of antique funerary slabs, where similar scenes are represented in Roman art (Plate 290).[44]

The Triumph of Saint Thomas Aquinas

In contrast to the sculptors of the campanile reliefs, in *The Triumph of Saint Thomas Aquinas* Andrea Bonaiuti could utilize the full range of pictorial illusionism and colour (Plate 266).

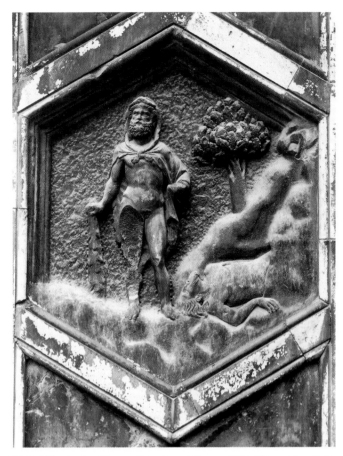

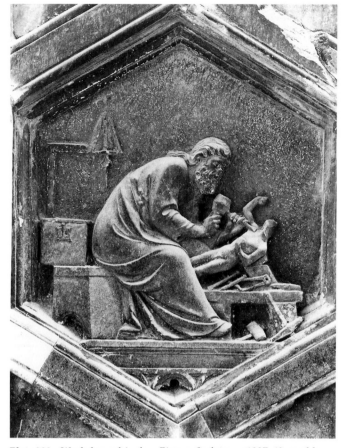

Plate 288 Andrea Pisano, *Hercules and Cacus*, *c*.1337–43, marble relief, 83 x 69 cm, east face, Campanile, Florence (original sculpture now removed to the Museo dell'Opera del Duomo, Florence). Photo: Scala.

Plate 289 Workshop of Andrea Pisano, *Sculpture*, *c*.1337–43, marble relief, 83 x 69 cm, north face, Campanile, Florence (original sculpture now removed to the Museo dell'Opera del Duomo, Florence). Photo: Alinari.

The painting's subject does not, however, offer enormous scope in terms of the representation of expansive spatial settings or lively narrative details. It was, rather, in the other chapter-house murals that Andrea Bonaiuti was able to demonstrate his competence in such techniques (Plate 272). Nor, apparently, did Andrea Bonaiuti wish to utilize the resources of antique art in *The Triumph of Saint Thomas Aquinas* in order to render his subject more historically accurate. The fourth-century Roman grammarian Donatus is arrayed in the costume of a fourteenth-century school-teacher (Plate 278). Meanwhile, the third seated figure from the left, who has convincingly been identified as Plato,[45] is shown swathed in a mantle that, whilst antique in derivation, belonged to a highly generalized repertoire of costume detail commonly adopted in Christian art for sages, prophets and the like (Plate 277).

Whilst relatively austere and restrained in terms of its design and overall conception, Andrea Bonaiuti's figural composition is highly effective in that its stringently geometrical layout offers a clear indication of the relative importance attached to the various persons represented within it. He also introduced a number of inventive illusionistic details within this highly formalized scheme. At the very apex of the broad, painted frame there appears a half figure of Christ set within a quadrilobe frame. Strikingly, this figure is represented as leaning out of the painted framework so as to imply that he is actively bestowing his divine wisdom

upon Thomas Aquinas, enthroned below (Plates 266 and 274). Similarly, the platform upon which the saint's *cathedra* rests, and upon which the representatives of allegedly unsound learning are seated, is shown overlapping the backs of the seats of two of the personifications of learning. It thus appears to project into the space of the chapter-house itself. It is as if these three censured scholars – together with the 'false' knowledge for which they were responsible – do not properly belong to the idealized ambience inhabited by Aquinas and his learned companions.

The Triumph of Saint Thomas Aquinas also provides compelling evidence for Andrea Bonaiuti's inventiveness in the portrayal of individual figures. To take but one example, one of the liberal arts – Music – is shown in a graceful pose that is achieved by the alignment of her head at a different angle from that of her body (Plate 291). On her lap is portrayed a portable organ, which is notable both for its intricately rendered detail and its competent perspective. Below her appears Tubulcain, depicted not, as on the campanile, as the first practitioner of metal-work, but rather as the person who discovered different notes by beating out sounds on an anvil. This figure's dramatic pose, suggestive of great physical exertion, and the intense expression on the luxuriantly bearded, weather-beaten face, offer graphic indications of Andrea Bonaiuti's imaginative versatility in the portrayal of a variety of human physiognomies and types.

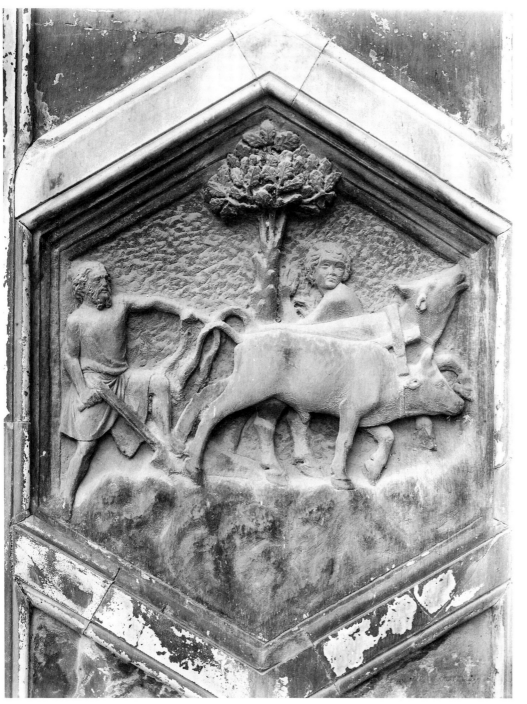

Plate 290 Workshop of Andrea Pisano, *Agricultura*, *c*.1337–43, marble relief, 83 x 69 cm, east face, Campanile, Florence (original sculpture now removed to the Museo dell'Opera del Duomo, Florence). Photo: Alinari.

CONCLUSION

In the campanile reliefs and *The Triumph of Saint Thomas Aquinas* we encounter two schemes designed to celebrate knowledge. Both rely on a repertoire of imagery inspired by the work of medieval scholasticism and already fully expressed in medieval Gothic art. Both also embrace a multiplicity of details, which are, nevertheless, combined into a coherent scheme, whose very organization signifies the hierarchy of values attributed to different kinds of human endeavour. Such similarities notwithstanding, the two works are significantly different. Quite apart from one being executed in sculpture and the other in paint, their basic

orientations are quite distinct. As our analysis has revealed, each scheme is peculiarly well suited to its particular location and function. Thus, the hexagonal reliefs of the campanile – with their lively portrayal of contemporary rural and urban trade activities, dignified by the appearance of mythical figures of antiquity – are particularly appropriate for their venue, facing outwards onto the city's urban fabric and public thoroughfares. The subsidiary scheme of allegorical figures, such as the virtues and the liberal arts together with representations of the planetary deities and the Christian sacraments, further added to the meaning and effectiveness of this sculpted programme. The campanile reliefs decisively celebrate the city's contemporary commercial traditions and

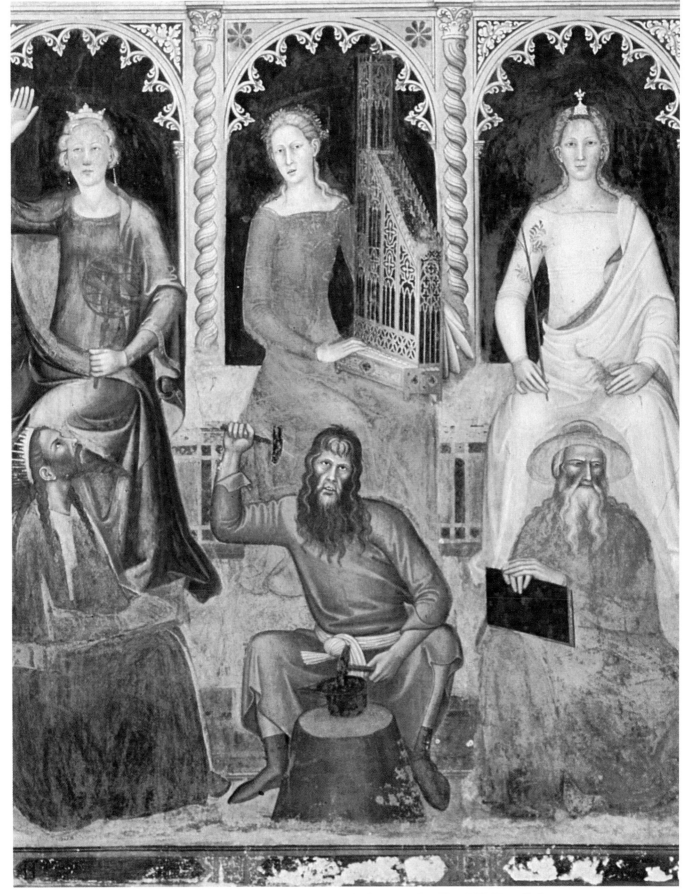

Plate 291 Andrea Bonaiuti, *Music and Tubulcain*, detail of *The Triumph of Saint Thomas Aquinas* (Plate 266). Photo: Scala.

achievements. In addition, by placing an added emphasis upon the practices of architecture, sculpture and painting, the scheme shows a keen awareness of the particular craft traditions that were both valued in antiquity and contributed so decisively to Florence's contemporary reputation as a place where *arte* and *mestiere* flourished.

Meanwhile, the programme of *The Triumph of Saint Thomas Aquinas* concentrates, appropriately enough, on the kinds of knowledge espoused by Thomas Aquinas and the Dominicans. The message of this painting was that Aquinas's knowledge was God given, wide ranging and drew upon both biblical authority and the legacy of ancient philosophy. It was also designed to demonstrate which elements of knowledge might legitimately be embraced and which were erroneous and therefore to be excluded. It has been suggested that, in terms of its composition, *The Triumph of Saint Thomas Aquinas* offers little sense of spatial penetration and thus is somewhat old-fashioned in style and impact.[46] Yet, as has also been observed, the painting's composition is peculiarly effective when viewed from a position directly opposite it.[47] Since the Chapter of the Dominican friars would have been seated around the walls of the chapter-house, at least a proportion of the assembled friars would have enjoyed such a vantage point.

In contrast to the outward-looking, external orientation of the campanile reliefs, the chapter-house mural presents an essentially inward-looking, internally coherent scheme of knowledge. Whilst the campanile scheme endeavoured to address the widest possible range of civic interests, professional skills and intellectual knowledge, the chapter-house mural, although no less ambitious in the scope and range of knowledge that it portrayed, was concerned primarily with the achievements of a major Dominican saint and the utilization of his intellectual legacy in the government of both the Dominican community at Santa Maria Novella and the Dominican Order at large.

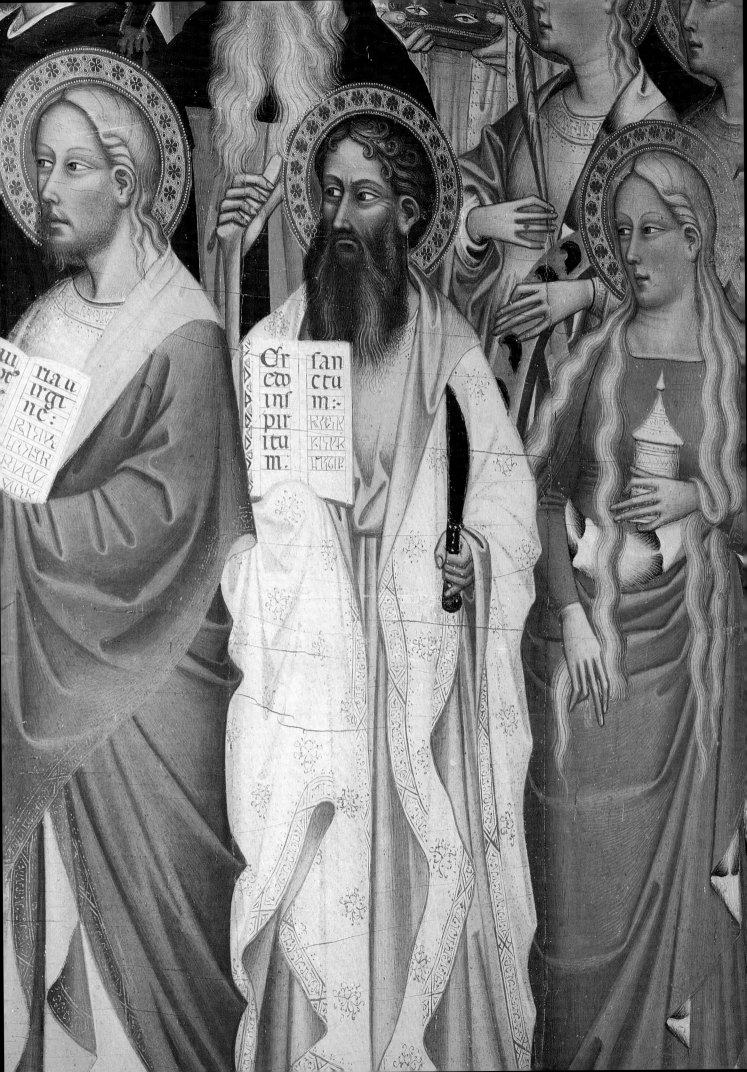

Women as patrons: nuns, widows and rulers

Looking at commissioners of art and architecture involves treating art history as a broad discipline where the study of who initiated works of art and their uses and meanings is as important as consideration of the artists and techniques used to construct them. While some interest has been expressed in the largely male patronage of church and state, drawing attention to the commissioning powers of the tiny number of women patrons – who operated on the margins of the powerful masculine institutions of family, religion and state – entails the further step of highlighting a group of buyers who were politically and economically weak, as well as restricted in what they could command. Arguably, however, a study of their purchases can suggest the way every aspect of the creation and consumption of art was gendered. And it can tell us more about the way the apparently 'neuter' townscapes of Siena, Florence and Padua were actually masculine in significance.

Governmental patronage was marked as men-only: Communes forbad women political rights, while in autocracies women such as Joanna of Naples or Sancia of Majorca were given sovereignty only in default of male heirs, and as temporary bridges for the expected male successor. Guild commissions were also markedly masculine, because even guilds that accepted widows did not include them on the committees which decided on matters of patronage. From parish church to cathedral to papacy, the patronage of the entire ecclesiastical establishment was masculine, since women could not be priests. While some confraternities included women and individual women may well have donated altarpieces to their confraternities, the groups which governed any joint confraternity commissions seem to have been composed only of men. Some sororities – female confraternities – existed and it is to be expected that they would have commissioned occasionally.[1]

Only a few social categories of women could commission paintings, sculptures and buildings in fourteenth-century Siena, Florence and Padua. These were widows, members of religious communities, and the women who were either rulers themselves, like Queen Joanna of Naples, or the married or dowager consorts of powerful rulers. (In practice, female commissions often involve two or even three of these categories operating together, as when Abbess Anna of the convent of San Benedetto at Padua commissioned murals for the church built by her sister Fina Buzzacarina, wife of the ruler of Padua. However, for the purposes of the argument it seems helpful to deal with the different sorts of commissioning women separately.) While we may guess that women would have commissioned a wide range of domestic objects and images, personal adornment or clothing, the very small number of surviving buildings, sculptures and

paintings documented as having been bought by female commissioners was attached to and preserved by the Church.[2] The passage of time has therefore given us a strongly pious picture, which certainly fits with the strictures of the males who wrote treatises on how women should behave. But the assumption in wills that such items as household furnishings, linen or jewelled belts could belong to women should warn us that there may have been other kinds of art regarded as appropriate for women to own and buy which have had small chance of surviving.[3] We also find that the women who could commission were from the wealthy classes. Although modest sororities may have allowed women of quite humble social position to commission, no items created by them survive, and the convents that managed to order works existing today tended to be those to which the wealthy sent their daughters. We know that convents included women of lesser degree, but in practice the items that we can look at were made for a narrow social band of women. In contrast, men with moderate incomes (like artisans) could join together in guilds and confraternities to control artistic commissions.

We must be careful in considering women as patrons not to think in terms of individual autonomy. Women, like men, were usually surrounded by groups of men when they negotiated the development of a commission. They had to use male lawyers, liaise with male clerics and, normally, hire male artists. All but the most isolated widow would have some male relatives they would need to mollify, even if the woman was the only person inscribing the contract. Nuns commissioned as groups, discussing their decisions in chapter and voting for what they wanted, or if they commissioned smaller pieces individually, they still did so as members of a convent. Religious communities which were relatively open had enough public freedom to manage their own affairs to some extent. But those in full *clausura* (where nuns were restricted to their cloister) were very dependent on male stewards, male priests, and often brother monks to do their bidding. The female ruler or consort was surrounded by the masculine state executive and male court officers. Women, then, commissioned with men surrounding their decision-making and often as groups of women.

FEMININE BEHAVIOUR AS DEFINED BY MEN

Did women have to speak as the masculine-defined feminine to be allowed to speak at all artistically? Or did some women redefine the feminine in their own terms when they showed forth their views on an altarpiece or muralled chapel? How did men say women should commission? Although no texts address at any length the question as to what kinds of images

Plate 292 (Facing page) Attributed to Giovanni del Biondo, detail of *The Annunciation with Saints* (Plate 293). Note profile of Saint Agatha on right-hand edge. Photo: Index/P. Tosi.

women could decorously commission, treatises on the way women should live written by men in the fourteenth century suggest by analogy something of the way women were supposed to act as viewers, and the sorts of representations they might have felt able to display, as well as ways in which they might have felt able to be portrayed as donatrices. The treatise written in verse by the Florentine Francesco da Barberino, *Reggimento e costumi di donna* (*The Rule and Customs of a Lady*), was composed between 1314 and 1316. Although this came from just one city and indeed is a limited source of information, it is indicative of masculine attitudes of this time.

Francesco began with advice on the behaviour of the young woman. He wrote that only women from the loftier grades of society needed to read and write, and the lower the social grade the more the young woman should be educated in sewing and cooking. Even so, Francesco argued, literacy was really only important if one intended a girl to enter a convent. In his view, the most important element in the girl's behaviour was the appearance of 'vergogna' or bashfulness. Francesco considered the most important indicator of her bashfulness to be the conduct of her gaze. 'When in company', he advised, 'she should hardly raise her eyes because a wise man could tell immediately in a glance the meaning of any other comportment.'[4] She was to speak quietly and temperately only when spoken to, and if asked to sing she was to do so 'with eyes lowered'.[5] She should laugh, dance, eat or weep modestly; should any man help her up into the saddle, she should 'keep her clothes wrapped tightly round her, her eyes lowered, and appear humble'.[6] She should rarely appear in public – and Francesco lists as public locations 'the balcony, window, doorway and cloister',[7] as well as the obvious public places outside the house. The feminine was seen as passive, private and shy; the young woman was taught that she had a very limited scope in looking. Even looking out of doors and windows was frowned upon. Looking around one in company and looking back at men were forbidden. The woman of breeding learned to look down.

Francesco advised the well-to-do widow to dress plainly, wear a veil and eschew make-up. She was warned never to speak to a man alone except for priests and monks, not to go out into the streets often, nor sit constantly at the window. Her whole attention was to be taken up with the devout education of her children, guarding and increasing the wealth of her family, and celebrating her spouse's memory, for whose soul she should constantly give alms. His parting words stress that she was to centre her existence in the house – for he advised her to lock her doors early in the evening and unlock them late in the morning.[8]

Francesco also devoted a part of his poem to the life of the nun. As with the widow and the maiden, the emphasis is on chastity and privacy. He advised the nun to obey her rule and her abbess. He forbad nuns to send or receive letters without the knowledge of the abbess. Visitors among the devout or relatives coming to the parlour to converse with the nuns should not be frequent. No nun should go out by herself, and in speaking the nun should behave like the young girl: 'timidly and bashfully'.[9] The community was to share all things in common, sleeping in one dormitory, eating moderately and listening to improving readings at mealtimes.

The emphasis was on community rather than individuality and the rejection of opulent clothing or jewellery – even of beautiful rosary beads, for instance.[10]

Although they do not deal with the behaviour of the nun, the poem addressed by Antonio Loschi to the learned widow Maddalena Scrovegni of Padua in 1389 and the treatise on the behaviour of widows by Giovanni Dominici of Florence composed soon after 1400 substantially repeat the strictures of Francesco da Barberino.[11] Both stressed the need for the widow to be utterly chaste, and associated this with privacy in the home and extreme frugality. Dominici did, however, allow that in giving alms for her and her husband's souls, the widow could spend on the building of a church, monastery or hospital. But he warned that it would be better to rebuild foundations already established than to found new ones of her own, and was very anxious that she should realize there could be excesses in devoutness: acts of mercy or gifts which drew dangerous publicity, or piety which involved too much contact with clerics or monks.

These rule books were largely addressed to men in charge of women of the upper classes. Servants, and the few women who were able to sell items (usually food) in the streets, had to negotiate the public domain differently to their mistresses. However, poorer women were restricted in their access to public places relative to poorer men. Presumably, a study of treatises describing the way men should behave to other men regarded as their betters would disclose the power of upper-class males over men who bowed their heads before them. And such class rules would surely inform the exchanges of women too. Nevertheless, it is important to begin to consider the way in which, broadly speaking, viewing was gendered.

The regime of looking advised by Francesco trained women from youth not to look around freely. Where he tells us that the male gaze would be ranging freely, judging women's chastity by their appearance – and in general owning the public domain – he confines women to looking at the ground except in all-female company, and peeping (when no man was looking) in the public arena on the infrequent occasions when they went out. The licence to commission imaginative and convincing representations of a devout sort at which they would be able to look freely must have held special delight for women in such a situation.

Women commissioners often put the female viewer first by devices like including a donatrix portrait with which women could identify or, when the image was made for female-only communities, stressing female responses in a holy scene. Where the audience was of both sexes, the female spectator could be provided with the pleasure of seeing images of equal numbers of female and male religious or secular heroes, or attention could be drawn to the prowess of one particular female saint. The woman commissioner might even offer women the satisfaction of images of the Apocalypse when all would be destroyed, all remade and all judged for their misdemeanours. As a woman it might have been enjoyable to imagine the Last Judgement when the social order disappeared.

Women were strictured to adopt the contemplative mode of life by remaining in their houses and venturing out inconspicuously for devotion, or in religious communities encouraged by men to shun the world. Therefore, any widow,

ruler or nun seen to praise religious heroines who had led active, outward-bound lives, like Saints Helena, Elizabeth or Felicity, and to embellish their churches publicly by making conspicuous artistic gifts to their communities, were acting on the public stage much more prominently than the masculine moralists approved. For example, the magnificent altarpieces ordered by the nuns at Santa Felicità and San Pier Maggiore in Florence, or the Chapel of Saint Louis of Toulouse for San Benedetto, Padua, or the spectacular *Crucifixion* given by Maria Bovolina to the people of Bassano were each properly feminine in their devoutness. However, the grandeur and magnanimity of such commissions in encouraging devoutness or in benefiting the community were too public-spirited; they did not conform to the self-effacing, unobtrusive behaviour delineated by male moralists. Even the way some individual nuns commissioned commemorative altarpieces to adorn their churches, or commissioned small devotional images for their own use, seem in the light of Francesco da Barberino's strictures too beautiful, too personal and too self-advertising.

WIDOWS

The legal position of the married woman meant that (unless she was the consort of a ruler or a ruler in her own right) she was unlikely to be able to commission any images or buildings. Her dowry was administered by her husband, and the income from it belonged to him as compensation for his labour.[12] A wife might be required to commission on behalf of her husband were he to be exiled, though I have not so far found an example of this occurring in the fourteenth century.[13] A wife could make a will with her husband's permission, and in it she could choose her place of burial and endow a funerary chapel. Should this result in a commission organized by her executors, the dead woman could be thought of as having caused the work of art. Possibly some images which include the votive portrait of a donatrix may have been made in these circumstances.

The widow was in a better position to commission, since she received control of her dowry, tended to be provided with some of the income from her dead spouse's estate, and could buy, sell, contract and sue in her own right. It is important to realize that in some cities (like Florence) the widow still had to have a legal guardian or *mundualdus* (chosen by her) to do any of these things, and that unless she had passed the age of childbearing her relatives would strongly encourage her to remarry.[14] It is also important to stress that the widow would be expected to conserve her dowry to benefit her children. Therefore, the commissioning widow would tend to be an older woman, perhaps without a direct heir jealous of the dowry or, if she was a younger woman, without close relatives. A couple could dissolve their marriage vows and separate in order to follow a spiritual vocation. In this situation a woman who remained outside a regular religious community acquired the legal status of a widow.

Widows were occasionally left in a position where they were expected to commission funerary chapels for their spouses. An impressive example of an altarpiece for such a project may now be seen in the Galleria dell'Accademia in Florence; it was commissioned soon after the death of her

husband in 1379 by Madonna Andreola di Jacopo di Donato Acciaiuoli. Attributed to Giovanni del Biondo, the polyptych[15] adorned the mortuary chapel of her husband Mainardo Cavalcanti, which was situated in the sacristy of the Dominican church of Santa Maria Novella (Plate 293). Madonna Andreola had the arms of the Cavalcanti family – into which she had married only in 1372 – painted on the sides of the piers supporting the altarpiece, and placed those of her own natal family below her husband's.[16] This acted as a symbol of herself on the image, and suggests that she saw her commission as benefiting her kin as well as her husband's. Chojnacki's work on the fifteenth century has shown how women were socially positioned to consider themselves as belonging to more than one family group: women's wills tended to benefit their spouse's *and* their own kin, while those of men concentrated on natal relations only.[17] As the focus of her image, Madonna Andreola had placed the Annunciate Virgin. While this was a thoroughly conventional choice, it was also the beginning in biblical terms of a new era for women, when Mary's conception and birth-giving expunged the sin of Eve. Madonna Andreola chose to have a variety of saints painted on the two side leaves of the tall altarpiece, with male saints dominating in number. These saints' names are carefully written along the base. She included her own name saint – Andrew – placed in the front row far left, and the name saint of her father – James – also in the front row and to the immediate right of the Virgin. The central inscription panel has been scraped to remove any information of her dedication, the artist's name and date. Where the left-hand panel has evenly spaced rows of saints, some squashing has occurred on the right margin of the right-hand piece – as if quite late in the design the artist had been asked to include one more woman. Here are Lucy, Elizabeth, Catherine, Margaret, Dorothy and the Magdalen – and the profile of Agatha just pokes in at the very edge of the bottom row (Plate 292).

The appearance of a portrait of a contemporary woman on a votive or funerary image is found occasionally throughout medieval art in western Europe, and even earlier in some late antique pagan pieces where, from the start, donors are shown as being of smaller size than their deities.[18] This suggests that the notion of women's spiritual equality with men had some meaning. The portrayal of 'Madonna Muccia wife of the former Guerino Ciantari' on a large panel representing the enthroned Virgin and Child (originally in the church of San Francesco, Lucignano in Val di Chiana) is unusual but not without precedent (Plate 294). Madonna Muccia is shown kneeling on the right in diminutive size, wearing the veil of a matron and a dress with a scoop neck. The inscription is written along the base of the panel behind her. This fine panel has been associated with others in the Sienese style by an unknown artist and dated around 1320. Without further documentation it is not clear whether the panel was commissioned by her or according to her will by executors.[19]

A more elaborate but even less documented example survives in the church of Sant'Agostino at Montalcino in Sienese territory.[20] The church was built in the second half of the fourteenth century, and the murals date from soon after this time. This is a much larger and more complex commission providing the mural decoration of a chapel on

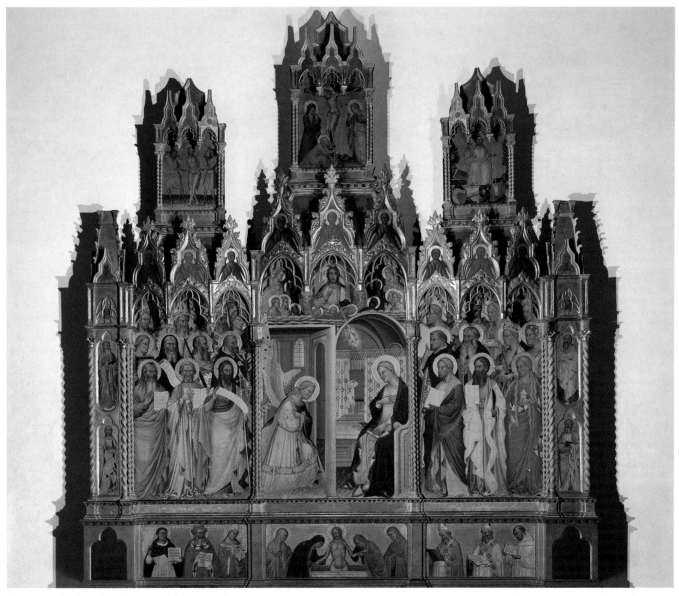

Plate 293 Attributed to Giovanni del Biondo, *The Annunciation with Saints*, after 1380, polychrome wood, 406 x 377 cm, Galleria dell'Accademia, Florence, formerly in Santa Maria Novella, Florence. The Cavalcanti arms now appear on the sides of the pinnacles. Photo: Scala.

the south aisle of the church, strategically placed opposite the entrance door on the north aisle (Plate 295). At the sides of the arched recess sheltering the altar are large hollowed-out niches – presumably to carry life-size statuary. The chapel celebrates the birth and Resurrection of Christ, the life of the first monk Anthony Abbot, and the hope of the protection of the saints for the donatrix and others. Following the doctrine that the altar signified Christ's sepulchre, immediately above it is painted *The Lamentation* with the donatrix kneeling to the right at the edge of the biblical mourners and protected by a standing male saint. She is at the level of, and the same size as, the holy figures. Dressed in brown, black and white, she has the matron's veil though hers is attractively striped in red and black. Such dress suggests the widow. Below, on either side, running towards the altar are, arguably, the shepherds of the Nativity carrying gifts of eggs and sheep, as if to suggest that the altar also signifies the crib – and, in general, the body of Christ in and beyond birth and death. (Interest in

the new Feast of Corpus Christi is well documented in the period, and the chapel could provide for this in its focal position opposite the entrance door.) On either side of the central scene we see the life of the first hermit – Anthony Abbot – who was such a hero for the fervent religious communities of the fourteenth century. The arrangement of the small story round the large central one recalls the large Tuscan and Sienese altar-panels of the period. The intrados represents saints with red crosses on their breasts protecting two children and a man (possibly the family of the donatrix) and a city. Here then, arguably, is a widow who had herself represented as conformingly feminine in her devoutness, but who publicly claimed personal prominence in the size of her portrayal, her presence with the saintly mourners, and the powerful spiritual protectors she clustered around her. Such public prominence and the gift to the congregation of so rich a devotional image push firmly at the masculine definitions of what women should do.

donors, and she is wearing the most austere black clothing with a white veil (Plate 297). Her appearance suggests a member of a confraternity, and such a role was indeed regarded as appropriate for a widow to assume. But Maria's dedicatory inscription is nonconformist both in asking for the prayers of all the people of Bassano for her soul when they meditate on the Passion of Christ with the help of her image, and in taking as her mentor Saint Helen, the active, outward-bound widow and mother of the Emperor Constantine:

> Bona Maria de'Bovolini, emulating Helen, the finder of the cross and the nails, dedicated this herself, to the piety of the people of Bassano, that they might pray for her to Christ our Lord.[22]

Maria had herself painted as if beside the place of stones – Golgotha – where, according to the legend of the True Cross, Helen had unearthed the crucifix, having travelled to the Holy Land on her search. Since she placed her arms on the panel, it seems likely that she was from a powerful family in Bassano, though one which was regarded as at least one social grade below the consorts of the rulers of Padua.

Plate 294 Anonymous Sienese artist, *The Virgin and Child with the Donatrix Madonna Muccia, c.*1320, polychrome wood, 166 x 90 cm, Museo Civico, Lucignano, Val di Chiana, formerly in San Francesco, Lucignano. Photo: Lensini.

A large *Crucifixion* with a long inscription stating that it was dedicated by Maria Bovolina at Bassano shows that women in the territory of Padua were also capable of offering the feminine as public and magnanimous (Plate 296). *The Crucifixion*, which is the only signed work by Guariento of Padua, is inscribed 'GUARIENTUS PINXIT' (Guariento painted it) at the foot of the cross.[21] It was originally hung in the church of San Francesco on the central piazza in a dependency of Padua. At nearly four metres high, *The Crucifixion* is a lavish gift, and the choice of the highly regarded painter from the local capital must also have impressed the people of Bassano. Maria is represented kneeling to the left at the feet of the Saviour in the position of honour (on the right hand of Christ) usually taken by male

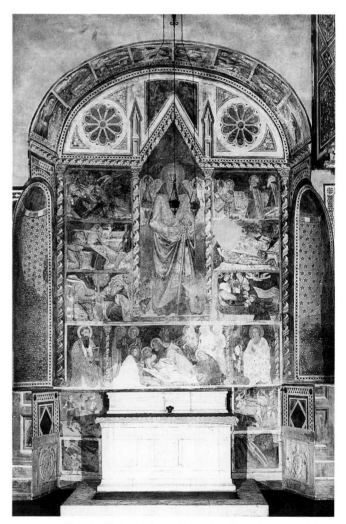

Plate 295 Chapel of Saint Anthony Abbot, Sant'Agostino, Montalcino. Photo: Lensini.

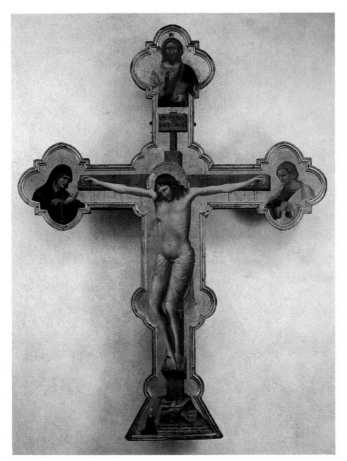

Plate 296 Guariento, *The Crucifixion with Bona Maria Bovolina*, *c*.1332, tempera on panel, 360 x 280 cm, Museo Civico, Bassano del Grappa, formerly in San Francesco, Bassano. Photo: Museo-Biblioteca-Archivio di Bassano del Grappa.

With these two large-scale and public-spirited commissions in mind, it is worth looking at the Bardi di Vernio Chapel in Santa Croce, Florence. A tomb and its decorated surround with the portrayal of a woman donor are tucked in next to that of a man in a chapel bearing the arms of the Bardi di Vernio at Santa Croce (Plate 298). If this is accepted as likely to have been occasioned by a woman, it should be regarded as modestly private and familial in comparison with *The Crucifixion* of Maria Bovolina and the chapel murals at Montalcino. Irene Hueck has shown that the Bardi gained their new title and new arms when Pietro de'Bardi was able to buy the fief of Vernio with its castle from Margerita Salimbeni, his mother-in-law, in 1332.[23] The murals on the tombs have been attributed to Taddeo Gaddi, and dated soon after the acquisition of the fief. While historians have doubted the authenticity of the donatrix portrayal on the grounds that the woman is shown in unseemly proximity to the entombment, the comparison with the donatrix at Montalcino, and indeed with the image of Maria Bovolina, suggests that devout women might want to have themselves shown close to Christ. As Andrew Ladis has pointed out, the entombment which the donatrix venerates is exceptional in that it omitted Saint John the Evangelist, and instead portrayed the dead Christ closely encircled by women – his mother, the Magdalen and the other Marys.[24] The wife of Pietro, through whom the Bardi had gained their new castellated arms in 1332, could have had the prestige to will or commission such a feminine funerary image. The small size of the tomb relative to the male one beside it, and the way the feminine is pushed to the private, more hidden, inner position on the north wall where the male tomb is on the outer location, are fully consistent with fourteenth-century concepts of gender differences.

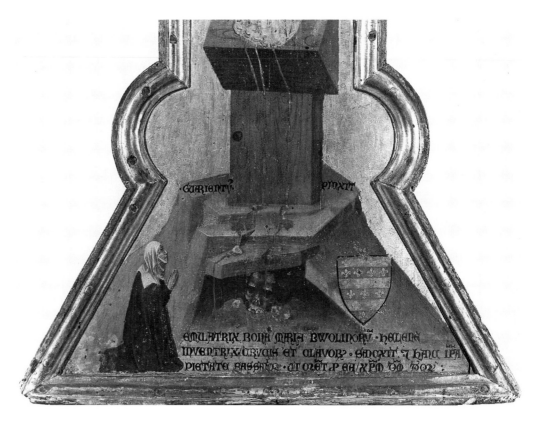

Plate 297 Guariento, *Maria Bovolina*, detail of *The Crucifixion with Bona Maria Bovolina* (Plate 296). Photo: Museo-Biblioteca-Archivio di Bassano del Grappa.

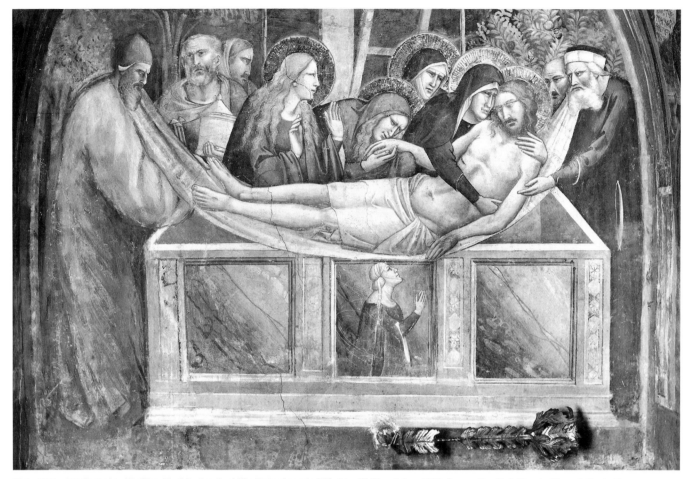

Plate 298 Attributed to Taddeo Gaddi, detail of *The Entombment of Christ with Donatrix*, *c.*1332, fresco, Bardi di Vernio Chapel, Santa Croce, Florence. Photo: Index.

The commissioning power of widows seems to have covered quite a wide range, from relatively modest funerary images for themselves alone, to funerary images providing for their kin, to representations which could enrich the devotional life of their towns in quite general terms. Since women were supposed to be private in their spheres of existence and dependent on male relatives, the more public-spirited commissions commemorating the donatrix with portraits, like the large muralled chapel at Montalcino and the splendid *Crucifixion* at Bassano, entailed women deviating from the roles presented for them by the men who controlled society.

CONSORTS OF RULERS AND QUEENS

The difference between the patronage of upper-class and noble widows and that of the consorts of rulers is largely one of degree, with the latter sometimes having considerable vestiges of power not available to the relicts of slightly lower estate. The distinction lies partly in the way the married woman of this high position could be expected to further the dynastic patronage of her husband, and occasionally her role might be documented. In addition, she might have had a marriage settlement giving her some personal income held by guardians, allowing her to pursue some more personal schemes and avoiding in a small way the total legal and financial obliteration of wives from other ranks of society.

One leading wife who can be proved to have pursued some personal patronage, and who probably handled a very important commission for her husband, is Fina Buzzacarina, consort of the ruler of Padua.

What is probably the upper limit of Fina's personal patronage is indicated by her building of the large chapel in honour of Saint Louis of Toulouse in the convent church of San Benedetto at Padua. In doing so she was benefiting her sister Anna, the abbess, and the community of women whom she entrusted in her will of 1378 with the task of annually reciting the complete Psalter on her behalf. The chapel, which was destroyed in the bombing of World War II, has been rebuilt and is situated on the left of the presbytery, occupying the east end of the north aisle. Fina's 'matronage' was recorded by her sister in an extant inscription when Anna came, in 1394, to decorate the chapel with murals probably by Giusto de'Menabuoi celebrating the life of Louis, a Franciscan bishop, and the Apocalypse:

> This chapel was built in the honour of the most blessed Louis by the illustrious and generous lady Donna Fina de'Buzzacarini of worthy memory, once the consort of Don Francesco il Vecchio da Carrara, and adorned with narratives by her full blood sister the lady Donna Buzzacarina, nun and venerable abbess of this sacred and honoured place, because of her devotion and her consideration for Donna Fina, erstwhile ruler of this bountiful and good city, who, being poured out as the first libation, pre-deceased her.[25]

The chapel, which Fina endowed in her will of 1378, was constructed of brick and prefaced by a triumphal arch. Pre-war photographs record that the soffit of the triumphal arch illustrated scenes from the Apocalypse, while the wall adjacent to the high altar chapel represented the deeds of Saint Louis with his investiture as bishop clearly recognizable (Plate 299). The window splays were adorned with busts of prophets. The choice of Saint Louis of Toulouse suggests an enthusiasm for Franciscan ideals, while the choice of the Apocalypse recalls the theme of the altar chapel in the baptistery decoration commissioned by the Carrara family (with probable intervention by Fina herself).

Whereas her personal patronage of the Chapel of Saint Louis of Toulouse is precisely documented, Fina's role in the

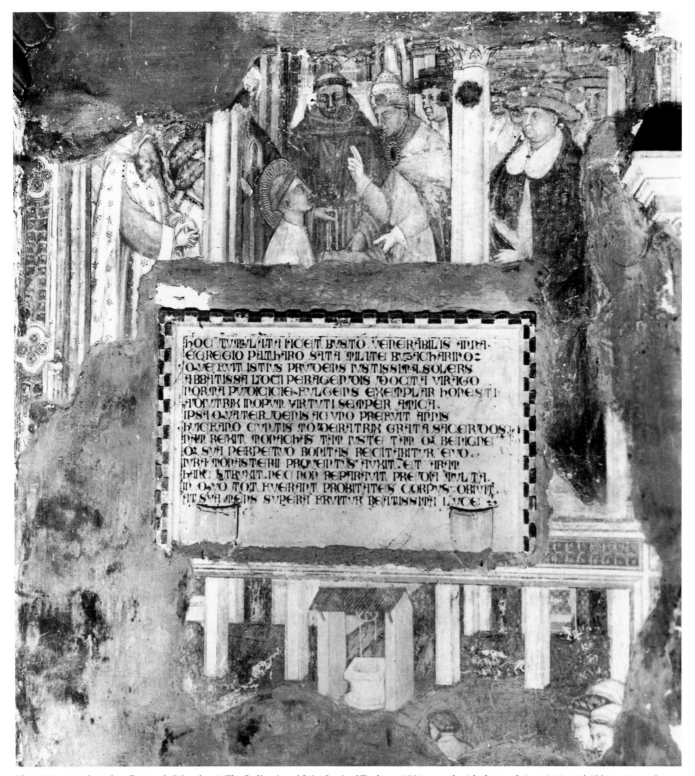

Plate 299 Attributed to Giusto de'Menabuoi, *The Ordination of Saint Louis of Toulouse*, 1394, mural with the tomb inscription of Abbess Anna, San Benedetto, Padua (pre-war photograph). Reproduced by courtesy of Musei Civici Padova, Gabinetto Fotografico.

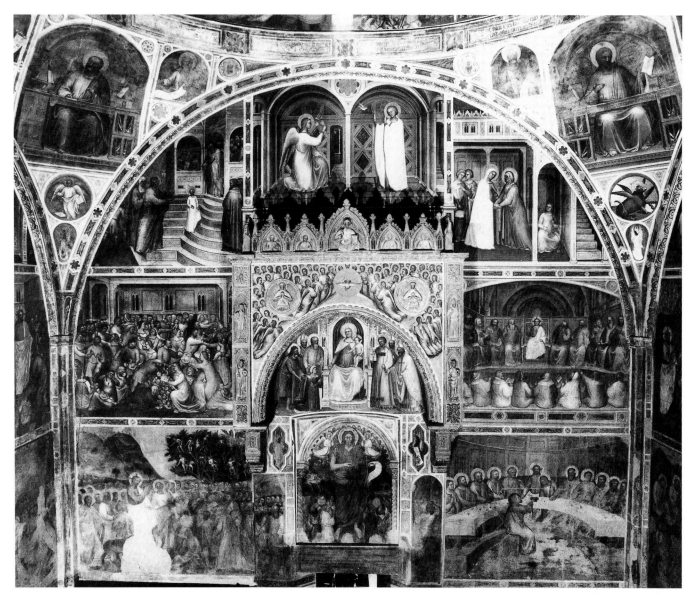

Plate 300 Attributed to Giusto de'Menabuoi, *The Virgin and Child with Saints and Fina Buzzacarina*, c.1375, mural with sculpted canopy, Baptistery, Padua. Photo: Barbara Piovan.

decoration of Padua Baptistery remains only that of a good circumstantial case. This scheme entailed no less than the adaptation of the central baptismal place for the diocese to serve as a funerary chapel for Francesco il Vecchio da Carrara. But while the decoration is scattered with his heraldry and Fina's only appears once on the altarpiece, it is she who is portrayed over the site of her tomb above the original main doorway in the manner of the donatrix (Plate 300), and she is the only person documented as associated with the chapel. In her will of 1378, she chose that her body should be buried in the baptistery, and she ordered that there should be 'an honourable sepulchre for her in the baptistery according to her dignity and considering the conditions of the status and magnificent birth of her lord Francesco da Carrara, and with regard to the "attentis et respectibus" of the said testatrix'. The phrase 'attentis et respectibus' could be translated as the 'directions and views' of Fina Buzzacarina. Fina also asked that the baptistery 'should be dowered from the goods of the Magnificent Lady testatrix according to the judgement of her

husband and *comissarius* [executor]'. She ordained that this endowment should allow the appointment of two priests to provide her funerary masses and pray for her soul continuously. Finally, Fina left 'solely for the decoration and the adornment of the chapel itself and the altar which exists in it, all the silver and all her clothing which the said testatrix may be found to have at her death'.[26] Fina was dependent on the post-mortem decisions of her husband except with regard to her right to choose the place of her burial and to dispose of the actual clothing and money on her body at death. Although the 'ornatum' and 'ornamento' for the chapel and altar placed at the end of her deposition could refer to religious vessels or hangings and cloths to adorn the altar, they could equally refer to an altar-panel like the one attributed to Giusto de'Menabuoi presently on the altar representing the life of the Baptist, which is the only object in the baptistery to show the Buzzacarini arms.

There is no precise evidence as to the dating of the vast and complex scheme of decoration for the baptistery, so it can be

argued that Fina could have played some part in its design during the 1370s. With the permission of her husband, Fina benefited at least seventeen women in her will, which made their son Francesco il Novello her universal heir. Analogously, as long as the main function of the baptistery was clearly sustained as glorifying the Carrara dynasty, Fina may have been allowed to honour the second sex in some areas of the programme. She was a woman of immense wealth, having inherited from both her father and an uncle, and possessing a large dowry. In 1376, for example, Francesco il Vecchio insisted on the repayment of 10,000 ducats specified

as belonging to Fina which he had lent to the Florentine Commune. While her husband administered her possessions and – according to jurists – took their income as payment for his labour, the wealth was regarded as belonging to her. Conceivably, it was something which was negotiable with her husband, if its disposal benefited him and their son and heir.

Most unusually, the importance of women saints in the baptistery is stressed by giving them half the space in the ranks of seated saints portrayed in the dome closest to the viewer and inscribed with their names at their feet (Plate 301). As stated by Margaret King, only one-quarter of saints

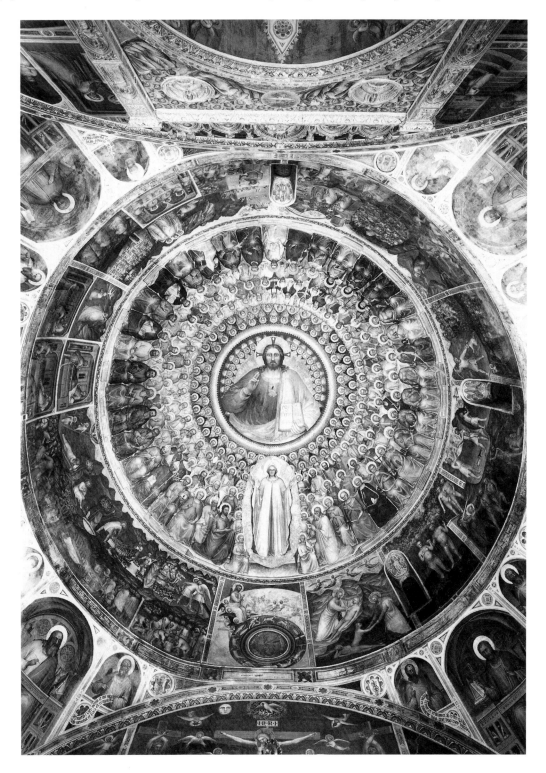

Plate 301 Attributed to Giusto de'Menabuoi, dome, *c.*1375, fresco with tempera additions, Baptistery, Padua. Photo: Barabara Piovan.

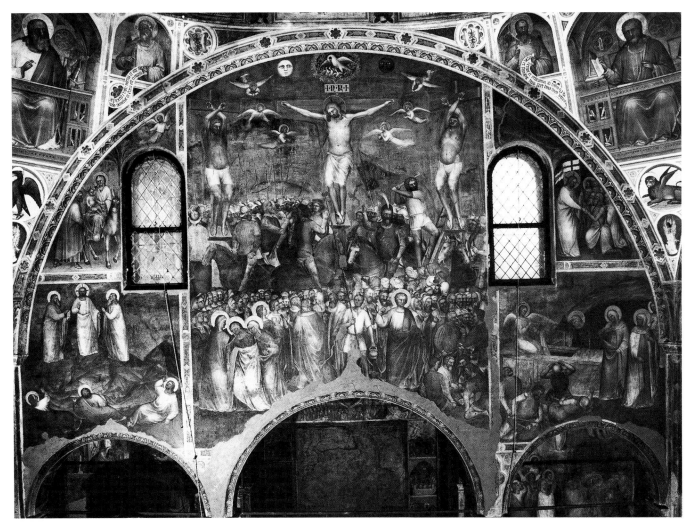

Plate 302 Attributed to Giusto de'Menabuoi, *The Crucifixion*, c.1375, fresco with tempera additions, Baptistery, Padua. Photo: Barabara Piovan.

recognized by the Church in 1300 were female, and the situation did not change during the following century.[27] Such images usually show no women at all, or a few of small size on the margins of a representation of saints. In addition, among the patriarchs represented above the saints were included, again unusually, some of the biblical matriarchs: Anne, Elizabeth, Sara, Rachel and Leah. Below on the drum, with its narrative of the events of Genesis, the sequence ends with the story of the betrayal of Joseph, typologically foretelling the betrayal of Christ by Judas, and leading the viewer down to consider the events of the New Testament culminating on the altar wall below with the Crucifixion. On the walls there is some emphasis on women in the New Testament scenes: in the Marriage at Cana where Christ turned water into wine; in the birth of the Baptist which probably contains portraits of Fina and her three daughters Caterina, Gigliola and Lieta; in the Massacre of the Innocents; and in the choice of the pelican as the symbol of the sacrifice of Christ for humanity (Plate 302).[28]

Fina's tomb was placed over the main entrance in a way which is fully integrated into the complex programme of the baptistery as a whole. Physically, the muralled scenes of the life of the Virgin and the young Christ on this wall lap up the sides of her tomb canopy with perfect neatness.

Iconographically, the placing of her tomb in the centre of the wall celebrating the life of the Virgin meant that the scene of the annunciation could be situated over it in a way which suited the general scheme of the baptistery as a whole, and in its promise of the coming of Christ the annunciation was conventionally appropriate for her funerary monument. This looks like a studied result rather than something patched together after her death.

Fina's participation in this decorative scheme would imply quite a high level of spiritual erudition. For the scheme is, arguably, designed to show the whole plan of salvation from the beginning of the world and the fall of Adam to the possibility of salvation through the coming of Christ, as prophesied by John the Baptist, and through the promise of the second coming as foretold by John the Evangelist. The Baptist and Evangelist appear frequently in the scheme and, most crucially for this argument, appear together as intercessors for Fina in the painted tomb where she is seen kneeling to honour the Virgin (Plate 300). The Baptist is the last prophet of the first coming, while the Evangelist is the first prophet of the last coming. They are the key figures for the meanings of the entire programme, and their presence closest to Fina on the tomb suggests that the tomb was not an afterthought. The theme of salvation is partly narrated, but it

is also demonstrated through typological links which show the way the events in the Old presaged those in the New Testament. Interwoven with this grand theme, the decoration also provides the appropriate accompaniment to the celebration throughout the liturgical year of the major feasts and fasts of the calendar. It underlines the significance of the readings for the sequence of masses sung and said by the two priests with whom Fina had endowed the chapel. As a third important theme, the decoration was designed to act as an appropriate backdrop to the blessing of the baptismal water for the whole diocese which took place here at Easter and Pentecost, when the greater litany of the saints, who had been so meticulously detailed on the dome above, was sung.[29] This is a long invocation for the mercy of God and the intercession of a host of saints inserted into the services of the Missal at Easter and Pentecost. The saints are grouped according to different categories (archangels, evangelists, martyrs, bishops and confessors, founders of religious orders, virgin martyrs, holy virgins and widows), and the invocation follows an order giving precedence to God the Father, his Mother, the angels, apostles and evangelists, and so on, down to the level of the virgin martyrs, holy virgins and widows. It is interesting that, while the litany and the Missal gave priority to John the Baptist and John the Evangelist next to the Virgin and Christ, Fina's dome pulled the chaste females, such as Mary Magdalen, Martha, Mary sister of Lazarus, and Agnes, from the lower-most position ending the litany into the foreground beside the Virgin Mary. The erudition of the inscription placed by Fina's sister in the chapel at San Benedetto, and the way the Abbess Anna was in turn described on her tombstone in that church as 'a learned virago', suggest circumstances in which the sisters might have played some part in developing this complex dynastic commission.[30]

It is a crucial paradox that the very mechanisms of marginalization could offer the second sex alternative and unexpectedly powerful routes to privilege. Here, by the very act of decorously being placed on the wall over the entrance (arguably leaving a position under the dome, between font and altar, for her son and husband), Fina obtained a location of great leverage. It is for her awaiting judgement in her tomb, and for the viewer entering the chapel for the first time, that the entire path of salvation is laid out on the altar wall opposite. The drum and dome with Christ as judge, the creation of the world, and the Crucifixion are all orientated to the spectator at the main entrance.

A queen might have even greater powers to commission as head of her court and her domain. One Neapolitan tomb contracted in 1343 employed Florentine artists and so may fairly be included here. Joanna, Queen of Naples (1326–82), used the commission of her grandfather Robert of Anjou's tomb in Santa Chiara to present the exact genealogical table which was the justification for her own sovereignty, and at the same time provided the superlative set-piece that gave the finishing touch over the high altar to the church and convent which her step-grandmother Queen Sancia had built. Her right to rule as her grandfather's universal heir against the claims of men remote from the line of succession is given religious affirmation in one of the key churches of Naples open for all her subjects to see. Of crucial importance to the

meanings with which Joanna weighted the tomb are the facts that it was here she was crowned in 1344, and it was here her barons had to swear allegiance to her.[31] The artists were instructed to place King Robert seated in majesty on the chest with his first and second wives on either side – Sancia to the left and Violante to the right. Immediately to the left of her step-grandmother Sancia, she placed herself. On the left-hand short side of the chest, she placed two women holding dogs on their laps who could be her two dead sisters, each called Maria. To the right of her grandmother Queen Violante, she placed her own father and mother, Charles of Calabria and Mary of Valois. On the right-hand short side of the chest are two young boys holding falcons, and another boy is beside Joanna on the front of the sarcophagus. Their identity has been debated, with suggestions that they could show heirs who had died in youth. One could be her only brother Carlo. The front face of the sarcophagus has three males and four women seated in majesty (Plate 303).

Joanna succeeded to the throne of her grandfather in 1343 when she was 17, ruling with the guardianship of her step-grandmother, who died in 1345. Although already married, Joanna ruled without sharing sovereignty with either her husband or her male cousins. Her contemporary biographer Tristano Caracciolo explained that her grandfather had had her educated to know the deeds of her family and emulate them, to follow a devout life, and to repair and embellish her royal residences. Her sense of history and piety is advertised in her tomb commission.[32] Her step-grandmother had played a major part in building the church, which was dedicated to Corpus Christi though popularly named Santa Chiara after the Franciscan nuns who followed the contemplative life here. Queen Sancia's arms (of the house of Majorca) were placed on the façade of the church. It seems to have been intended as the main court church, and was used – after the consecration in the presence of Sancia and Robert in 1340 – as the site of solemn regal ceremony.

To execute her tribute, Joanna commissioned Giovanni and Pacio da Firenze in 1343. The tomb (as recorded in photographs taken before bomb damage from World War II) was sheltered by a tall stone canopy with pointed gables supported on four elaborate pilasters. On these pilasters were a host of miniature niches, each with their elaborate canopies sheltering saints and prophets. Only two of the surviving statues are of women: the patrons of the second and third orders of the Franciscans, Clare of Assisi and Elizabeth of Hungary. Elizabeth was the great-aunt of Joanna's grandmother Marie.[33] The whole structure is placed on the wall between the public church and the nuns' choir, with grilled apertures adjacent that allowed the visitor to hear the offices and masses being sung throughout the day and night. The tomb expressed the dead man's hopes for mercy on the Last Day, showing God as judge on the lofty gable overseeing all. Immediately below, the dead man knelt in effigy to beg the intercession of the patron saints of the Franciscan Order that tended the church – Francis and Clare. Underneath, Joanna had instructed the sculptors to present the virtues of her grandfather which might merit him a place in heaven: he was shown seated in majesty surrounded by his religious and courtly advisers in government; beneath this he was presented as if lying in state, but surrounded by women

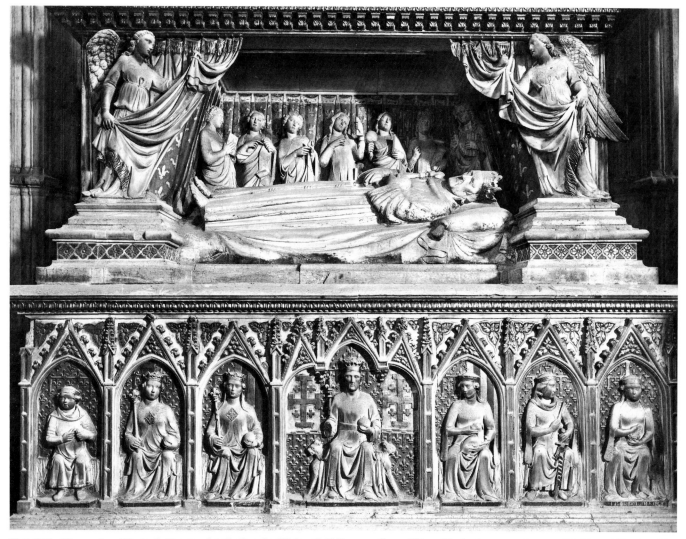

Plate 303 Giovanni and Pacio da Firenze, detail of tomb of Robert I, 1343, stone, Santa Chiara, Naples (pre-war photograph). Photo: Bildarchiv Foto Marburg.

personifying the liberal arts; and sustaining his tomb chest with its family tree are more women personifying the theological and cardinal virtues. Seated in the place of honour to the left of her grandfather and grandmother, Queen Joanna as donatrix appears to be uttering a funerary oration for her grandfather – and one in which she could make sure her own interests were well served. The inscription placed beneath the enthroned king has been attributed to her courtier Petrarch: 'See King Robert, replete with virtue.'[34] The tomb was the largest and most imposing to be made in the peninsula during the fourteenth century.

Consorts of rulers and queens had greater financial resources and more social power than the upper-class or noble widow. This is registered in the way Fina Buzzacarina could build a chapel to Saint Louis, the way Queen Joanna of Naples was required to commission a very large sculpted tomb, and the way her step-grandmother had joined with King Robert I to build the large church and cloister of Santa Chiara. However, in their loftier social position, their artistic statements were perhaps the more closely scrutinized by the masculine advisers surrounding them.

NUNS

As self-governing communities, convents would be able to commission works of art, relying on their income from the aggregate of their dowries and the endowments which they had received. In practice, since the nun's dowry was only one-tenth of the wife's and only very mature communities had accumulated enough security to be able to spend much on art and architecture, conventual commissioning was quite meagre. However, there tended to be some convents in any one city that could command impressive designs – often Benedictine or Cistercian foundations with sufficient wealth and support from the local families whose daughters were their inhabitants.

The inferiority of women even in the spiritual sphere, where in theory they were supposed to have equal opportunity of gaining grace, is signified in the fact that the first order of the monastic communities comprised only men. Women could belong to communities which were designated as second order, all of which were regular, or to third-order communities which might be regular or secular. The term 'regular' meant that the women lived together according to a

rule. The term 'secular' meant that they lived in separate households, and gathered together at intervals for prayer or good works or both. The second-order communities could belong to the earliest foundations like the Benedictines, or reformed branches of Benedictines like Vallombrosans or Cistercians. They could also be Franciscans or Dominicans. These second-order communities consisted of women who had taken solemn vows and who led a contemplative life, partially or fully enclosed. These kinds of communities comprised the daughters of wealthy families.

Third-order communities (also known as tertiaries) consisted of women who had not taken full vows, and could therefore leave the community more easily than could nuns who had taken all three vows of poverty, chastity and obedience. Those who lived together as regulars tended not to be enclosed, and could therefore beg alms out in the cities and villages. They could also work to earn money for the convent by, for example, doing laundry, providing food and making textiles, or they could take part in the kind of active charitable help to society in running hospices or giving education that was not possible for strictly enclosed second-order groups. The third-order seculars were completely open to society, with members living pious lives in their towns and cities.

Although these were the general patterns, in practice some communities designated as second order obtained special privileges, allowing them great flexibility in interpreting the rules of enclosure (*clausura*). As we shall see, the community at San Pier Maggiore in Florence was able to have contact with the public domain to take part in the ceremony of welcoming the Bishop of Florence. And, in practice, some communities originating as third orders asked especially to be allowed to live in the strictest enclosure, avoiding all contact with the world outside the convent. By and large, the older, second-order communities, which were patronized by wealthy families, were quite well endowed to fund their contemplative life and allow some patronage of art and architecture. The third-order regulars were usually poorer in endowment, but were at least able to seek alms in the streets.[35] The most strictly enclosed communities would need to rely most heavily on male go-betweens for their commissioning, while less strictly enclosed communities could work more directly as patrons. As we shall see, the altarpiece of Saint Humility shows her directly supervising the building of her convent, healing people in person, and travelling from place to place (Plate 316). She organized communities that followed the Benedictine rule as reformed by the Vallombrosans, and evidently lived in the manner of a third-order regular.

At the Benedictine convent of Santa Felicità in Florence, documents record that the decision-making of the chapter of nuns led by the abbess took place through the grille to a group of men gathered beside their parlour, suggesting a full *clausura*.[36] This chapter had their chaplain as their legal guardian and steward. The patronage of this convent, as detailed by the research of Francesca Fiorelli-Malesci, is a good example of the scope of items considered suitable for the use of women in enclosure, and for the local parish congregation which supported them: from the commissioning of illuminated books to the building of their convent and church (Plates 304–306).[37] The church was built at the end of the fourth or beginning of the fifth century, and the female convent was first recorded there in the eleventh century when the church was rebuilt. By the second half of the fourteenth century, the whole fabric needed repair and rebuilding. In 1361 the Abbess Costanza de'Rossi had the nuns' choir (and the buildings related to it) made, as well as working on the roof of the church. To help pay for this, the chapter granted a long lease on one of the convent's farms. When this sum and the help of their parishioners were still insufficient, the convent applied to the Bishop of Florence to be allowed to sell some land by their orchard; still later, in 1366, the nuns sold off more property. A fifteenth-century map shows the simple

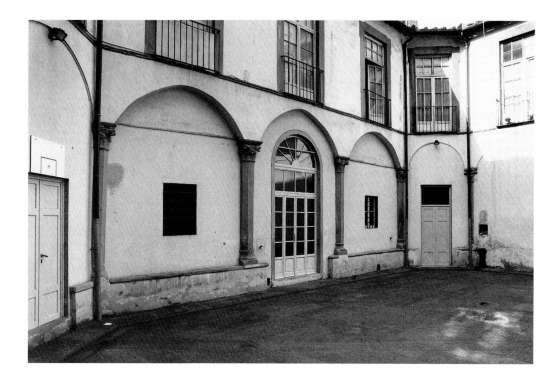

Plate 304 Cloister, *c.*1340, walled in during the seventeenth century, Santa Felicità, Florence. Photo: Tim Benton.

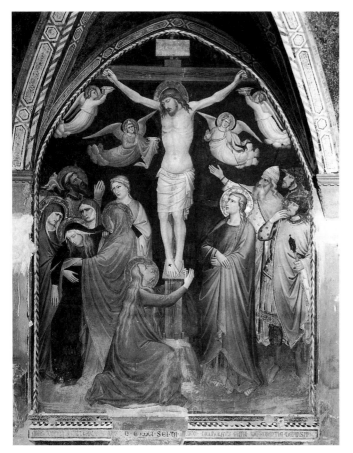

Plate 305 Niccolò di Pietro Fiorentino, *The Crucifixion*, 1387, fresco, chapter-house, Santa Felicità, Florence. Reproduced by permission of the Conway Library, Courtauld Institute of Art.

church with its tall campanile and cloister attached to the south flank which the convent built and repaired (Plate 307). A careful examination of the present façade allows one to trace the fourteenth-century appearance, with the plain gabled roof-line marked by the presence of the arms now in place, and the circular window of the Trecento enlarged and modernized. The body of women who undertook this enterprise with the help of their male agents and parishioners was a small one: in a document of 1361 six nuns were judged the quorum of two-thirds of the community required to vote on a decision of the chapter, and in the 1383 visitation only seven nuns were listed as living here.[38] At the same time during the second half of the fourteenth century, the families of the parish joined to endow and adorn the side altars of the public church.

The convent buildings were arranged around a cloister, which was, unusually, octagonal with narrow bays cutting the corners of the large basic square (Plate 304). This may have been a device to obscure the lop-sidedness of a complex of buildings which had developed over 1000 years. Stylistically the cloister appears to date from the 1340s. To the east side was placed the chapter-house, which had a finely vaulted roof supported on octagonal pillars. The nuns' choir was placed directly over the chapter-house. Both were beside the presbytery of the parish church. They furnished their choir with textiles and wooden seating as well as a lantern and grille in the 1360s. By 1387 the nuns were able to record that 'we had painted the chapter-house of the women which cost 110 florins'.[39] As their altarpiece they had a muralled *Crucifixion* which was signed and dated by the painter 'Nicolo di Pietro Fiorentino 6 March 1387' (Plate 305).[40] On their vault

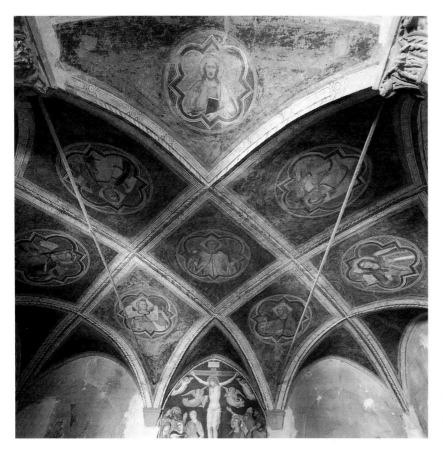

Plate 306 Chapter-house, view of vault facing the altar showing Christ with the seven virtues, 1387, Santa Felicità, Florence. Reproduced by permission of the Conway Library, Courtauld Institute of Art.

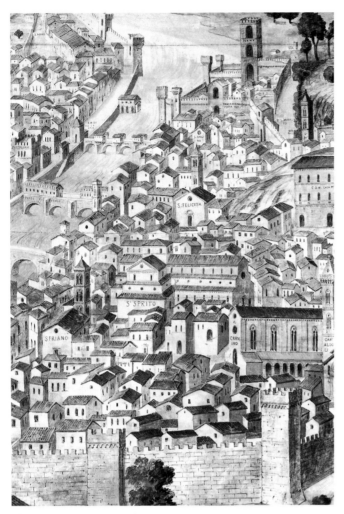

Plate 307 Detail of map of Florence, 1490, Museo Storico Topografico Firenze com'era. Photo: Alinari.

they had painted the seven virtues and Christ (Plate 306). All this was perfectly decorous for the enclosed feminine. Yet when the viewer stands facing the altar and looks up to find Christ the Redeemer, she will see that the three virtues orientated on the same axis for this prime viewpoint are not the three theological virtues of the words of Saint Paul – Charity, Faith and Hope – but rather Charity, Faith and Prudence (Plate 306). Might the convent have felt it could afford prudence even more often than hope? This was the room in which the abbess conducted business, in which the nuns discussed and voted for their communal acts, in which the community considered its strengths and weaknesses, and in which the abbess read the rule to her nuns. It was here that the community did its artistic commissioning. During the 1380s the convent documents record work also on the campanile, organ, refectory, dormitory, kitchen, parlour, and the rooms of their priest. The abbess even saw to the erection in 1381 for twelve florins of the tall column which graced the former graveyard – now a piazza – at the front of the church. In this sense the chapter played a part in shaping the appearance of the city beyond the convent in a public way not usually associated with the feminine.

Between 1395 and 1399 the chapter commissioned a painting for the high altar from Niccolò di Pietro Gerini

(otherwise known as Fiorentino), Spinello Aretino and Lorenzo di Niccolò for 100 gold florins (Plate 308). The polyptych consisted of two tiers, with the lower tier devoted to bust portraits of twelve male saints and the upper tier centring on the coronation of the Virgin, hymned by a crowd of noisy angels playing bagpipes, drums, pipes and stringed instruments. This coronation is flanked by images of eight full-length saints. The nuns chose to have their protector Saint Benedict to the far right, while the place of honour to the left went to their own patron Saint Felicity.[41] Although this enclosed community appointed three men as the *opera* to act as their go-betweens with the artists, it was made clear on the panel in the inscription that it was the commission of the nuns: 'This panel was caused to be made by the convent chapter of the monastery of Santa Felicità, from money belonging to the said monastery at the time of the abbess Lorenza de'Mozzi in the year 1401.'[42]

In 1395 the convent ordered a window to be made by Niccolò Tedesco, and a mural for the high altar chapel by Neri d'Antonio. The window was carefully specified as representing at the top the annunciation, in the middle Saints Gregory and Ambrose, and at the foot Saints Felicity and Mary Magdalen. The women were at the bottom of the pile – but their figures would be the more visible. This window and the magnificent mural decoration of the chapel – which portrayed the Last Judgement on the triumphal arch and on the walls of the apse narrated the story of Saint Felicity, widowed mother of seven sons with whom she was martyred – were destroyed in the early seventeenth century.

Because they did not want the bell ropes to hang down in the way of these murals, the convent went to the trouble of making a new sacristy whence the bells could be rung. A missal dating from the mid fourteenth century survives from the abbey. It has been argued that it corresponds to that bought by Abbess Costanza de'Rossi from the monks at the Badia in Florence, recorded in an account book dated 1350–58 (Plate 309).[43] Distinctively, the illuminator had been asked to celebrate the martyrdom of the seven sons of their patron Saint Felicity. While the soldiers of the Roman Emperor Antoninus massacre her elder boys, the saint, wearing Benedictine garb, clings to her smallest son, who is being torn from her grasp.[44] Thus, at Santa Felicità there is a relatively full record of the way in which the conventual institution, with its community of nuns and continuous control over some income, could, co-operating with its parishioners (who were often relations), consistently pursue a large building and decorative programme over a long period. No such opportunities were available to secular women in the orbit of the family.

Although much conventual patronage would be aimed at the enclosed all-female audience or encourage devoutness in the local parishioners, the commission of the high altar for the church of San Pier Maggiore in Florence seems to have been planned in order to enhance the prestige of the convent at a traditional ceremony before a congregation of diocesan dignitaries. On this occasion, which was popularly known as 'the marriage of the abbess', the nuns exercised their ancient privilege in formally welcoming the incoming Bishop of Florence to his See, appearing in public with the new incumbent despite *clausura*. Since this was a rite of passage

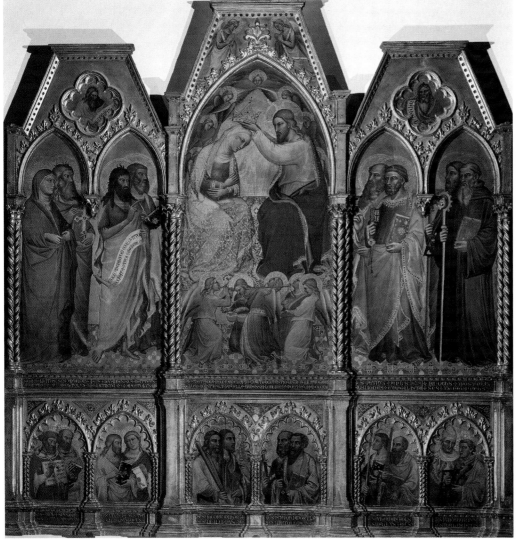

Plate 308 Niccolò di Pietro Gerini, Spinello Aretino and Lorenzo di Niccolò, *The Coronation of the Virgin with Saints*, 1395–1401, polychrome wood, 275 x 218 cm, Galleria dell'Accademia, Florence. Photo: Scala.

which a new appointee had to undergo in order to enter office, the ceremony placed the community of nuns in an unusually public role acting on behalf of the diocese of Florence.

The convent of San Pier Maggiore was founded in the eleventh century and consisted of a community of Benedictine nuns. The church itself was of even earlier foundation – possibly fourth century and predating the creation of the bishopric of Florence.[45] In token of this early power, each incoming bishop gave homage to the abbess by presenting her with a horse and a ring. In exchange for this homage on his entry to the city, the bishop was entertained with a splendid meal and given a bed. A knowledge of this ceremony helps one to understand why the community approved the subject of the coronation of the Virgin for their high altar in 1370. While the coronation was a common one for high altars in general and for such a community – and had indeed been chosen by the nuns at Santa Felicità – it was arguably made with a view to counterpointing the ceremony. Where the image showed Christ honouring his mother (with the gift of a crown) and the two enthroned side by side, the ceremony entailed the man honouring the woman with the gift of a ring and showed the pair seated together. On 30 May 1400, for

example, the welcome of a new bishop took place. The bishop gave the abbess his horse outside the church, and then, as the trumpets sounded, he entered the church and the convent:

> There everything was well furnished and ordered, and there was seated the abbess, and beyond her were all the other nuns kneeling. As the bishop reached her, the abbess knelt before him and kissed his hand. Then they sat down together, and all was done and said as is the custom, and he married her and gave her the ring. Then he went to the choir, and walked up to the altar, and prayed there and kissed it, and then he stepped down again to the choir, where a beautiful bed had been made, and there he sat down on it for a little while, and the abbess gave the bed to the said bishop, as is the custom.[46]

To provide a fitting adornment for their presbytery, a very large polyptych was commissioned by the convent in 1370 (Chapter 9, Plates 256, 257). The convent's account books record payments between November of that year and September 1371 when the panels were varnished. The accounts record that Ser Taddeo (their steward) paid various sums for the designing of the altarpiece in 1370. The next year he paid further sums for colours, paintpots, gold, the transport of the panel, nails and curtain rings, but this time he intended to

Plate 309 Attributed to 'Ser Monte of the Badia', Florence, Missal showing the martyrdom of Saint Felicity's seven sons, 1358, convent of Santa Felicità, Bodleian Library, Oxford, MS Canon. Liturg. 382, folio 213 recto.

claim these sums back from the *opera*. Presumably the chapter had appointed an *opera* to organize the commission for them. The final record referring to the altarpiece is a payment of 25 florins 'as a donation towards the panel' made by a member of the Albizzi family in 1383. All but the predella panels narrating the life of their patron saint – Peter – are in the National Gallery, London.[47] On stylistic grounds the altarpiece is attributed to Jacopo di Cione. The whole of the lower order of this pictorial complex was devoted to showing a crowd of saints surrounding the coronation, with Saint Peter holding a model of their church in his arms at lower left. As well as honouring the Virgin Mary and their titular saint, the altarpiece was created to accompany the church services throughout the year, with the life of Christ being painted in a series of panels forming the second tier of images and representing the adorations of the shepherds and the kings, the Resurrection, the Marys at the sepulchre, the Ascension and Pentecost. At the apex was the Trinity.

It appears that in the fourteenth century only very long-established communities (Benedictine or Cistercian foundations like Santa Felicità, for instance) were able to undertake such extensive shaping of their part of the urban landscape. Younger, poorer communities were likely to begin by taking over the house or houses of one of their members –

Plate 310 Francesco Vanni, detail of map of Siena showing close-up of San Paolo site at Via delle Sperandie, *c*.1575. Photo: Lensini.

probably a widow – and adapting the architecture piecemeal. A variant on this gradualist approach is recorded in the remaining traces of the façade of the fourteenth-century church of the nuns of San Paolo in Siena – with a single central door, circular window (now bricked in) and plain gable. The sixteenth-century map of Francesco Vanni describes a cluster of buildings around this church on the Via delle Sperandie, which was simply family housing donated to the community in wills resulting from the plague and adapted for communal living (Plate 310). The community had begun in 1336 as a third-order gathering outside the Porta San Marco at a hermitage with an orchard and cloister given by Fra Luca to Donna Biccie, widow of Lando da Siena. Naming itself La Certosina, the community opted in 1344 for *clausura* with the title of San Paolo. Following two legacies handed over by the Bishop of Siena in 1361, the chapter of twelve nuns responded to the bishop with a long letter welcoming the proposed move to the houses in the Via delle Sperandie inside the Porta San Marco, with complaints about the dampness, coldness and smallness of their present convent. They had decided that with the agreement of the bishop and the civic authorities, they would move to the houses they had received through one of the testaments, which would be a healthier location; using the income from the other will, they could adapt this housing to make a chapel, living quarters, cloisters and gardens for their needs.[48]

Although nuns were supposed to hold all property in common, there are some painted panels inscribed as having been commissioned by a nun or nuns. Presumably their communities allowed them to spend from inheritances acquired by them, given that an altarpiece would often embellish the convent church, and in turn they would be able to possess the spiritual comfort of their portrait honouring some holy figure. The earliest inscribed work by Giusto de'Menabuoi is a case in point here, since it also includes his portraits of two Dominican sisters kneeling on either side of a huge enthroned Virgin and Child (Plate 311). The panel has the inscription: 'Giusto painted it. This work was commissioned by sister Isotta, daughter of the now dead Lord Simone de Terçago, in the month of March 1363.'[49] The panel is in the Schiff-Giorgini Collection, Rome, and is first recorded in a Milanese collection. The Terçago were an important merchant family of the city of Milan.[50] As with the convention of representing the Madonna della Misericordia, whose mercifulness is shown by the way she shelters people with her outstretched robe, the suppliants are formally continuations of the cloak of the Virgin, so that they comfortingly share her space and humbly form her support.

Even when no inscription has survived, where an image provides the portrayal of an individual nun it is a fair assumption that the commission was of this sort. The representation of a Franciscan nun kneeling to the right of the Virgin and Child on a magnificent altarpiece in the refectory of the female conventual church of Santa Chiara at San Gimignano suggests that this is probably a votive or commemorative commission of an individual nun (Plate 312). Out of the eight saints she had depicted surrounding the Virgin and Child, three are female: Catherine, Agnes and Clare. Along the top are the richly dressed Saints Peter, Michael, John the Baptist and John the Evangelist. Attributed

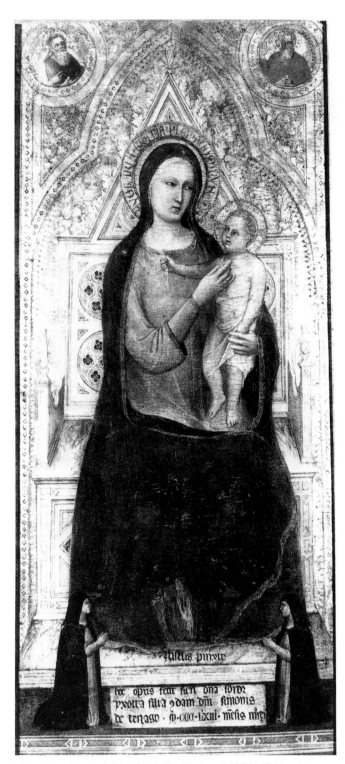

Plate 311 Giusto de'Menabuoi, *The Virgin and Child with Donatrix Isotta Terçago*, 1363, polychrome wood, 103 × 48 cm, Schiff-Giorgini Collection, Rome.

to Memmo di Filipuccio on stylistic grounds and thus dated between 1290 and *c*.1310, the altarpiece states the humility of the donatrix in her small size, and her identification with the rigour of her mentors Francis and Clare through the austerity of their clothing. The painter has employed a fabulous richness in colouring and damascene effects to render the varieties of cloth that adorn six of the saints and the Virgin

Plate 312 Attributed to Memmo di Filipuccio, *The Virgin and Child with Saints and Franciscan Donatrix,* 1290–*c.*1310, polychrome wood, 120 x 217 cm, Museo Civico, San Gimignano, formerly in refectory, Santa Chiara, San Gimignano. Photo: Lensini.

and Child. Yet this splendour throws into relief the brown drabness of the donatrix and the monochrome saints beside her on the lower right whose rule she follows.[51]

It would appear that nuns with wealthy relations could claim an individual commemoration beyond that communality advised by moralists like Francesco da Barberino, and show conspicuous personal generosity to their convents and even to the congregations which gathered in their public churches. The commissioning powers of some relatively wealthy communities of nuns could be extensive, might have considerable public prestige (as at San Pier Maggiore), and uniquely provided the only institutional patronage women could control securely from generation to generation over a long period. However, most monastic communities were poor and weak, and able only to govern the most meagre sums on upkeep for their fabric, or on the most modest adaptations of ordinary civic housing to create a cloistered life. While the emphasis in all monastic rules was on the sharing of all things in common, individual nuns did occasionally obtain permission to commission images with personal commemorations to benefit their convents, and did sometimes bring with them small devotional images for use in their cells.

Like widows and nuns, tertiaries occasionally appear as donatrices on altarpieces or other images. Careful study of the clothing of the different orders in the lay and religious worlds would assist more precise identifications, but some women who are portrayed with white veils and drab cloaks were possibly identifying themselves as third-order seculars.[52] This might apply to Bona Maria Bovolina, for example (Plate 297).

Indeed, a widow who commissioned a design which spectacularly benefited all worshippers in the church may have been regarded as too self-promoting were she not to have the status given to tertiaries. It seems possible that a donatrix wearing the white veil associated with tertiaries of secular groups contributed to the commission of a very large altarpiece, attributed to Guariento, of *The Coronation of the Virgin*. The scene is placed lower right and could well be 'a particular judgement' recording the hopes of the commissioner that she may achieve the intercession of the Virgin at the Last Day (Plate 313). As confirmed by the curator of the collection, the figure of the woman with the white veil does *not* possess a halo round her head, although representations of men behind her *do* have punched and gilded haloes, as does the Virgin holding her hand. The curator has examined the punch marks that form the haloes surrounding the other figures in the altarpiece, and has found none unfinished nor any which could be regarded as ambiguous. The inscription in the centre below the coronation does, however, speak in the plural ('1344 in the time of our [indecipherable] Alberto'), so perhaps the donatrix financed this for a parish or a convent.[53]

In exploring such new art-historical territory, it seems important (despite the resulting 'patchy' effect) to keep mainly to examples which are well marked with donatrix portraits, inscriptions or documents. Through building up a picture of what women's commissions looked like, it may be possible to get closer to resolving what are at present somewhat open-ended discussions as to patronage. For example, there is the question of the patronage of the mural of

Plate 313 Attributed to Guariento, *A Particular Judgement*, detail of *The Coronation of the Virgin*, 1344, tempera on wood, 42.5 x 39.5 cm, Norton Simon Foundation, Los Angeles.

the *Arbor Crucis* (Tree of the Cross) in the refectory of Santa Croce in Florence (Plate 314). Here a woman is shown kneeling at the base of the tree to the left, distinguished by her smaller size from the holy figures beside her. She is probably to be identified as wearing the dress of a Franciscan tertiary regular or possibly secular. Significantly, the painter has been asked to place representations of Saints Clare and Elizabeth of Hungary in the framing of the scene beneath her to left and

right. While Clare was the founder of the second-order Franciscans, Saint Elizabeth of Hungary was the patron of the Franciscan tertiary women, and she is painted in clothing resembling that of the donatrix. Elizabeth holds her robe full of roses to allude to the miracle which had occurred when her furious husband had discovered her disobeying his order that she should not go out into the streets and give bread to the poor. When he commanded her to open her cloak to show

Plate 314 Attributed to Taddeo Gaddi, detail of *Arbor Crucis* showing donatrix or devotée, border of mural with Saints Clare and Elizabeth and the Manfredi family arms, and sides and base with saints and the Last Supper, *c.*1330–60, fresco, life-size, refectory, Santa Croce, Florence. Photo: Scala.

him the food she was carrying, he was confounded because the bread turned to roses. Arguably, the tertiary who kneels behind Saint Francis may represent some member of the community who was regarded as especially holy. Equally, she may represent the woman who gave the mural to her fellow tertiaries. Andrew Ladis has shown that the arms painted on the border of the mural were those of the Manfredi family, and has suggested that this might indicate a commission by Madonna Vaggia Manfredi, who died at the convent in 1345.[54] The theme of spiritual and temporal food which is the import of the mural would be considered an appropriate one for a woman to present.[55]

There is also the question as to the identity of the woman dressed in secular clothes who kneels at the feet of Saint Catherine of Siena in the mural attributed to Andrea Vanni in San Domenico in Siena (Plate 315). The present framing of the mural and many reproductions cut off this figure to head and shoulders, but the full image of what appears to be the earliest representation of Saint Catherine as saint, holding her lily (to signify her purity), shows that the woman is in a pose recalling those of donatrices who were widows. Rather than praying, her hands are crossed in the position so often given to the Magi in adoration of the Christ Child. The intimate gesture of blessing which the painter gave to the new saint and her suppliant might, arguably, be more suitable to representing a holy woman, but as we saw in the discussion of widows' commissions, women did like being shown physically close to their divine exemplars.[56]

Finally, there is the spectacular puzzle of the altarpiece which celebrated the life of Saint Humility attributed to Pietro

Lorenzetti (Plate 316). Saint Humility (1226–1310) founded the 'donne di Faenza' and followed the Vallombrosan rule, which was a reformed Benedictine Order taking its name from its founding monastery at Vallombrosa. She founded two monasteries: one at Santa Maria Novella in Faenza and the second at San Giovanni Evangelista, near Florence. The altarpiece was made to be placed over her body at the high altar of the convent church of San Giovanni Evangelista. When this church, which was in a vulnerable location just outside Florence, was destroyed in wartime in 1529, the altarpiece was brought within the city. At this time the inscription running originally along the base was recorded: 'Here are the miracles of the blessed Humility, first abbess and founder of this monastery, and in this altar is her body.'[57] The inscription included the date read variously as 1310, 1316 or 1341. Saint Humility was buried in the common grave of the convent in 1310, but exhumed in 1311 and placed below the high altar of her convent church in a tomb above ground. She is first mentioned in a record dated 1311 as 'blessed' in a service book belonging to the convent. Indulgences were granted in association with her cult by the Avignon papacy in 1317. But the earliest documentation of the written legends of her life as a local saint date from the 1330s. These dates, consequently, could be related to an earlier or a later dating of the altarpiece. At the feet of the standing figure of the *beata* which dominates the altar-panel kneels a woman dressed in a white veil and a black cloak, and therefore not marked as being a member of this community. Luisa Marcucci has argued that this represents a younger follower of Humility named *beata* Margherita, whom she identifies as appearing in

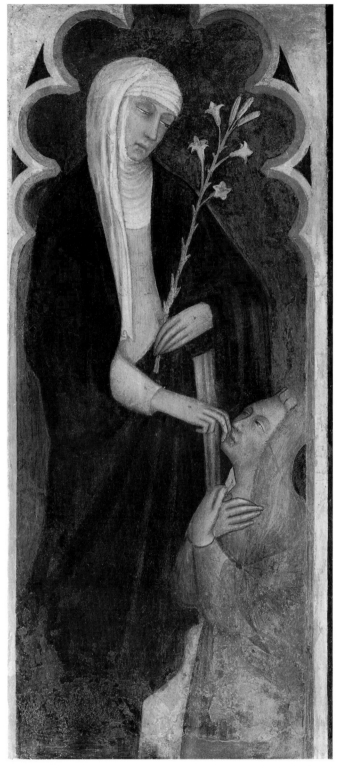

Plate 315 Attributed to Andrea Vanni, *Saint Catherine of Siena and Donatrix or Devotée*, *c*.1375–98, mural, life-size, Cappella delle Volte, San Domenico, Siena. Photo: Lensini.

one of the narratives on the panel as a companion of Saint Humility when she entered Florence.[58] However, this woman does not wear a black cloak, and the habit of Humility is a grey dress, brown mantle and black veil with white rim. Such representations were made by donors of persons whose cult they were hoping to further: here perhaps as part of a campaign to have the *beata* Margherita accepted as a local

saint. Otherwise, the figure could represent the commissioner of the altar-panel. As we have seen, individual nuns whose families left them legacies did occasionally provide such images to their communities, marked with the privilege of their portraits, even though the personal nature of their commissions defied the theory of the common life. More work on the traditions for showing candidates for beatification and female commissioners may help to resolve this question. In the meantime it is clear that the story of the active life of Saint Humility was one which broke the bounds of what the solemn treatise writers like Francesco da Barberino thought proper for the feminine. If a woman did commission this altarpiece, she was advertising for all to see the status of a woman who had dissolved her marriage to follow the religious life, healed people when doctors had failed, preached to her community, read lessons in the refectory despite her illiteracy, travelled outside the convent, and supervised the building of her convent (Plate 316).

CONCLUSION

The study of female commissions shows what kinds of images and buildings women could obtain some control over. Sometimes these designs conformed to the self-abnegating roles assigned to the feminine by the masculine moral theorists: as, say, in the modest adaptations of family houses, on the very edge of the city of Siena, to form their convent by the community of San Paolo. Sometimes commissions were more attention-seeking like *The Crucifixion* of Bona Maria Bovolina, with its portrait of the donor, its inscription asking for the prayers of the people of Bassano for her soul, and her exhortation to honour the example of the outward-bound and active explorer Saint Helen. Most commissions balanced conformity to some masculine strictures as to the acceptable feminine with some elements of independence by representing the interests of the donatrix or group of women patrons. Conformity in one sense might permit unconventionality in some other manner, as in the way the tomb of Robert I highlighted his commemoration and was the proper commission of his heir, yet allowed the patron to represent her right to rule in a key religious location in Naples.

Because the woman commissioner was always in a minority, artists had to adapt conventions created with the masculine patron in mind. Moral theorists were acutely sensitive, for example, about the appearance of women in public, so their artists would have had to be extremely careful of the way in which their paymistresses were shown, and where they were on show. Because of the construction of the feminine as different to the masculine, the range of meanings for images also differed when women were commissioners. Thus, the significance of the three Marys at the tomb, shown in the upper tier of panels on the altarpiece of San Pier Maggiore over the coronation, would have had a special emphasis because of the way it stressed that women were the first witnesses of the Resurrection. Or, for instance, because of the notion of woman as caring and nurturing, a donatrix could perhaps be portrayed in a more intimate relationship with a holy figure than could a man: as in the tomb painting of the Bardi di Vernio Chapel in Santa Croce, in

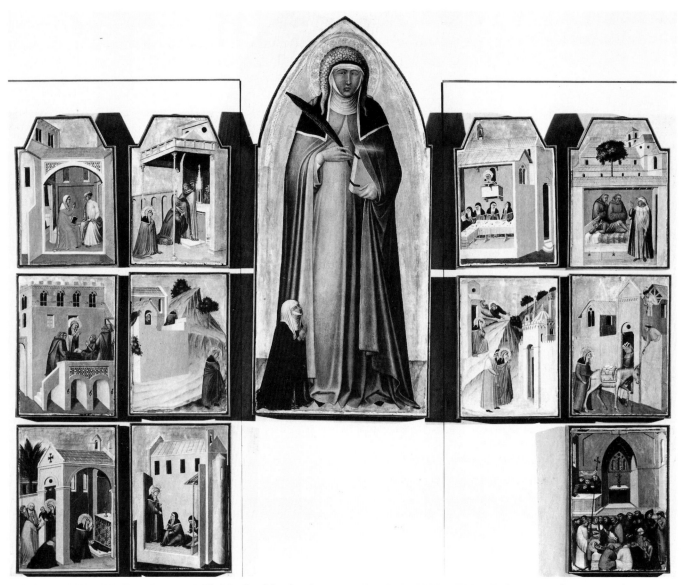

Plate 316 Attributed to Pietro Lorenzetti, *The Miracles of the Blessed Saint Humility*, 1310 or 1316 or 1341, polychrome wood, centre panel 128 x 57 cm, Uffizi, Florence, formerly in convent church of San Giovanni Evangelista. Photo: Scala.

the chapel of Saint Anthony at Montalcino, in the donatrix who holds the hand of the Virgin in Guariento's *Coronation*, and perhaps in the fresco of Saint Catherine of Siena with a suppliant. A study of women as patrons also highlights the masculinity of most townscapes and representations. Art was made by men for men, and it perpetuated as normal, ordinary and unquestioned the control by men of the public sphere.

Some women patrons produced minor transgressions of these norms, and such transgressions do at least show how flexible the artistic conventions were, and that women could conceive of shifts in meanings. However, these statements by female patrons were exceptional, thus representing the normality of a regime of masculine making and interpretation for succeeding generations of artists and spectators.

Notes

INTRODUCTION

1 The essays, 'Die Sammler', 'Das Altarbild' and 'Das Porträt' ('The collectors', 'The altarpiece' and 'The portrait') appeared under the general title *Beiträge zur Kunstgeschichte von Italien* (*Contributions to the History of Italian Art*). For an informative account of the genesis of these three essays, see Humfrey in his editorial introduction to Burckhardt, *The Altarpiece in Renaissance Italy*, pp.9–11.

2 Humfrey in Burckhardt, *The Altarpiece in Renaissance Italy*, p.9.

3 See, for example, van Os, *Sienese Altarpieces*; Humfrey and Kemp, *The Altarpiece in the Renaissance*; Humfrey, *The Altarpiece in Renaissance Venice*; Borsook and Gioffredi Superbi, *The Italian Altarpiece*. See also the bibliography on Italian Renaissance altarpieces given in Burckhardt, *The Altarpiece in Renaissance Italy*.

4 Janson, *Form Follows Function*; see also van Os, 'Some thoughts on writing a history of Sienese altarpieces', in *Sienese Altarpieces*, II, pp.19–24.

5 Thus, he uses the term *Aufgaben* in his title: *Der Lebensraum des Künstlers in der florentinischen Renaissance: Aufgaben und Auftraggeber, Werkstatt und Kunstmarkt* (the English translation is published as *The World of the Florentine Renaissance Artist: Projects and Patrons, Workshop and Art Market*). The acknowledgements to Burckhardt are on pp.193, 286. See also the editorial introduction by Alison Luchs in this edition.

6 As amply demonstrated by Julian Gardner's study of thirteenth- and fourteenth-century tomb sculpture for high-ranking ecclesiastics, *The Tomb and the Tiara*.

7 Giorgio Vasari in his highly influential *Lives of the Artists* (1550, 1568) consistently presented Italian art in terms of a progression from humble beginnings to a level of perfection and grandeur in his own day.

8 See Humfrey in his editorial introduction to Burckhardt, *The Altarpiece in Renaissance Italy*, p.10.

9 Giving some substance to the complaint voiced by Heinrich Wölfflin, as a student, that one of Burckhardt's lectures was simply 'visual instruction'. This criticism is expressed in a letter to Wölfflin's parents dated 23 October 1882, published in Gantner, *Jacob Burckhardt und Heinrich Wölfflin*, p.20.

CHAPTER 1

1 Braunfels, *Urban Design in Western Europe*, p.2.

2 Giovanni Villani, *Nuova cronica*. The original manuscript in eight books was written around 1333, but subsequently revised.

3 Cited in Weinstein, 'The myth of Florence', p.21.

4 Giovanni Villani, *Nuova cronica*. Both Giovanni Villani and his son served in the Florentine government.

5 According to Gneo Pompeo Strabone (89B.C.), cited in Puppi and Universo, *Padova*, p.10.

6 Dante, *Convivio*, 1 III 4, cited in Branca, *Mercanti scrittori*, p.xxvi.

7 Cited in Berrigan, 'A tale of two cities', p.73.

8 Stopani, *La via francigena*. In Siena today, the line of the Via Francigena is traced in the Via Montanini, Banchi di Sopra, Banchi di Sotto and the Via del Porrione.

9 Bellucci and Torriti, *Il Santa Maria della Scala*, pp.23–35. Alternative explanations for the name of the hospital include the derivation 'ante gradus Sancte Marie' (before the steps of the cathedral) and the story that Sorore discovered three steps in the hospital, symbolizing the Trinity.

10 Cited in Chierici, 'La casa senese al tempo di Dante', p.350.

11 Nardi, 'I borghi di S. Donato', p.35.

12 Nardi, 'I borghi di S. Donato', p.57, n.98.

13 Chierici, 'La casa senese al tempo di Dante', p.348.

14 See Chapter 2.

15 Prunai *et al.*, *Il Palazzo Tolomei a Siena*, p.64.

16 Prunai *et al.*, *Il Palazzo Tolomei a Siena*, p.69.

17 Agnolo di Tura, *Cronache senesi*, p.454; Decisions of the Consiglio Generale

C.G. 103, c.152, 20 December 1326, cited in Balestracci and Picinni, *Siena nel Trecento*, p.23.

18 Balestracci and Piccinni, *Siena nel Trecento*, p.33.

19 Puppi and Universo, *Padova*, p.23 and p.29, n.18.

20 Cited in Verdi, *Le mura ritrovate*, p.32.

21 See Chapter 2.

22 Benzato and Pietrogrande, 'Brevi note su Palazzo Zabarella', p.74.

23 See Maretto, *I portici della città di Padova*.

24 Cessi, 'Le prime sedi communali padovane'.

25 Giovanni da Nono, 'Visio Egidii Regis Patavie'.

26 Ongarello, *Cronica*, c.64, cited in Prosdocimi, 'Note su fra Giovanni degli Eremitani', p.48.

27 Prosdocimi, 'Note su fra Giovanni degli Eremitani'.

28 Puppi and Universo, *Padova*, p.63 and Prosdocimi, 'Note su fra Giovanni degli Eremitani'.

29 Fabris, 'La cronaca di Giovanni da Nono'. See also the descriptions in Hyde, *Padua in the Age of Dante*, pp.29ff. and 'Medieval descriptions of cities'.

30 Puppi and Universo, *Padova*, p.51.

31 Gatari, *Cronaca carrarese*.

32 See Norman, 'Carrara patronage of art' [Chapter 8 in the companion volume to this one].

33 Fanelli, *Firenze*, p.9.

34 Brattö, *Liber Estimationum*.

CHAPTER 2

1 The Italian word *città*, from which the English 'city' derives, refers equally to the largest and the smallest of urban areas.

2 The fresco on the wall is original, although the vault appears to have been repainted.

3 *Civiltà* = civilization, specifically that mixture of civilization and elegance that was considered a mark of the best in Italian society.

4 This practice is discussed further in Norman, 'City, *contado* and beyond: artistic practice' [Chapter 2 in the companion volume to this one].

5 The remaining two bays of the width, together with their loggia and balcony, were built between 1333 and 1353. The extension to the long side, and the tower, date from 1429–43.

6 The city of Siena was divided into three parts or *terzi*. See Norman, 'The three cities compared: patrons, politics and art' [Chapter 1 in the companion volume to this one].

7 Quoted in Bowsky, *A Medieval Italian Commune*, p.91.

8 Archives of the Commune of Siena, Decisions of the Consiglio Generale, C.G. 52, c.25 and C.G. 52, cc.82v., 85. 'Ut opus de palatio dicti communis fine laudabili compleatur', quoted in Brandi, *Il Palazzo Pubblico*, p.417.

9 A single-storey building containing the treasury and finance offices.

10 This wide open space on the hillside, just outside the original line of the town walls, was already established as the principal open space of the city; and the Council had already erected a retaining wall across the bottom of the slope.

11 Archives of the Commune of Siena, Decisions of the Consiglio Generale, 15 December 1287, C.G. 35, cc.9, 9v., 10; quoted in Brandi, *Il Palazzo Pubblico*, p.415. Private houses on either side of the Dogana were purchased the following year.

12 The stability of this building is even more impressive when one learns that the stream which feeds the Fonte Gaia in the Campo also flows under it and still carries water.

13 The present central entrance may be the result of later alterations, since one fifteenth-century image (Chapter 7, Plate 180) shows the doorway in a different position.

14 Traces of this door can be clearly seen in the walls of the sixteenth-century staircase.

15 Bowsky, *A Medieval Italian Commune*.

16 Equally, if the dais of the Nine was against the back wall, they would have been viewed in front of the allegory of *Good Government*; and their view of the room would have been bounded by the contrasting images of the fruits of good and bad government.

17 There are clear traces, behind the plaster of the sixteenth-century stairway, of at least one opening with mouldings matching those of the façade.

18 The decoration is discussed in more detail in Norman, 'Civic patronage of art' [Chapter 7 in the companion volume to this one].

19 If this suggestion is correct, the stairs must have been sited in the narrow space between the *torrione* and the wing of the Podestà.

20 The painted border of the Sala dei Nove suggests that there was a doorway against the window wall of the room. The present doorway was opened sometime in the fifteenth century. It is significant that the floor levels of the Sala dei Nove and the Sala del Consiglio, the two most important rooms of the Palazzo, do not match, as would surely have been the case had it been intended to link them.

21 Southard, 'The Frescoes in Siena's Palazzo Pubblico' and Bowsky, *A Medieval Italian Commune*.

22 Access to this space, now converted to a theatre, is through the *cortile* of the wing of the Podestà. Although this area has been entirely reconstructed, it seems likely that it represents the original access route.

23 Again the original access is not entirely clear, and there may have been a stair in the narrow space between this wing and the central *torrione*.

24 The name derives from the nickname given to the first of the city's bell-ringers.

25 Biblioteca Comunale di Siena, Cod. A III 26, c.83, quoted in Schevill, *Siena*.

26 The brothers Minuccio and Francesco di Rinaldo. Schevill, *Siena*, describes them as from Perugia, but it has also been suggested they were Aretines.

27 A payment to '*maestro* Lippo' is recorded in the accounts for 1341. Archivio di Stato, Bi.407, c.211, quoted in Brandi, *Il Palazzo Pubblico*.

28 Strict laws governed behaviour in the Campo: no animals to be slaughtered, citizens not to be shaved there, and so on; and there were officials to see that the regulations were observed.

29 This was replaced in the fifteenth century by a sculpted basin by Jacopo della Quercia, a replica of which remains today.

30 Their number is also acknowledged in the nine battlements that crown the central *torrione*.

31 This interpretation is based on the recognition that medieval masons seem to have delighted in simple mathematical relationships between parts of buildings, and presumably also their surrounding space. In this case the correspondences of measurement are not precise, although one may assume that the masons would have been equally satisfied with approximations that produced the desired harmony.

32 The 87 metre height of the stonework of the tower approximates to a diagonal of the Campo, to the edge of the brick area, on a line leading from the base of the tower to the main exit towards the cathedral.

33 Three of the irregular segments measure almost exactly 23 metres, and the total length of all nine segments is a little over 220 metres (9 x 23 = 207).

34 Machicolations: in medieval military architecture, a series of openings under a projecting parapet between the corbels that support it, through which missiles can be dropped (Fleming *et al.*, *The Penguin Dictionary of Architecture*).

35 Braunfels, *Mittelalterliche Stadtbaukunst in der Toskana*, p.250, quoted in White, *Art and Architecture in Italy*, p.227.

36 See White, *Art and Architecture in Italy*, p.229, where it is described in detail.

37 Quoted in Bowsky, *A Medieval Italian Commune*, p.14.

38 Discussed in greater detail in Chapter 7 and in Norman 'Civic patronage of art' [Chapter 7 in the companion volume to this one].

39 Interestingly, this scroll is actually written on parchment set into the surface of the fresco.

40 There is uncertainty as to whether the pitched, tiled roof was intended to be other than a temporary covering. If it was no more than that, the collision between the new Cappella and the Palazzo represents a similar approach to alterations to what is found in the various redesignings of the cathedral.

41 Giovanni's executed version is less rich than what was shown in his design (preserved in the Opera del Duomo, Siena).

42 White, *Art and Architecture in Italy*, pp.504–5.

43 The Palazzo Vecchio (the Old Palace) was given its name in the sixteenth century to distinguish it from the new Pitti Palace on the other side of the Arno. As the centre of government and home of the priors, who governed the city, it would be more accurately described as the Palazzo dei Priori, or dei Signori (the Rulers' Palace), like its piazza. For convenience, the common name, Palazzo Vecchio, is used here.

44 See Rubinstein, 'The Piazza della Signoria in Florence'. The actual order dates from 30 March 1285 and is quoted in Gherardi, *Le Consulte della Repubblica Fiorentina*, I, p.195.

45 See Becker, *Florence in Transition*, p.5.

46 This bond for good behaviour has some meaning in the light of a knightly code of conduct which involved a sacred duty to avenge wrongs done to one's family.

47 The *arti maggiori* were: judges and notaries; cloth finishers; bankers; wool traders; silk merchants; physicians, apothecaries and spice dealers; and furriers.

48 From 1282 five of the *arti minori* were officially allowed to participate, although in practice their involvement meant little direct participation in government. Under the democratic rule of Giano della Bella, himself a member of the Arte di Calimala, a further nine *arti minori* were included.

49 The Capitano del Popolo served as the chief executive and leader of the full Council, of which the Priorate formed an inner cabinet committee.

50 The *cortile* of the Bargello in Florence is an irregular space measuring slightly over 27 by 33 metres. This compares with the *cortile* of the Podestà at Siena which measures only 19 by 29 metres.

51 Walter de Brienne, Duke of Athens, ruled Florence as a dictator from 1342 to 1343.

52 At the same time new windows were opened on the west side and a new stone stairway was added to the *cortile*.

53 It is interesting that, in order to accommodate the structural piers, some of the old windows had to be partly blocked.

54 See Spilner, 'Giovanni di Lapo Ghini'.

55 The connection with Poppi was first made by Giorgio Vasari, who attributed that castle to Leopoldo Tedesco, whom he names as the father of Arnolfo di Cambio. The connection is rather too neat and ignores the fact that the Castle of Poppi was built in two sections at different periods. None the less there may be some link in that the Guidi family was long connected with Florence. It was Guido da Battifolle as *vicario* (governor) of Florence in 1316 who promoted the enlargement of the Bargello. The Castle at Poppi dates from *c*.1290 and from the early Trecento; and one may assume that so nearly contemporary a structure would have been known to masons and designers in Florence.

56 Trachtenberg, 'What Brunelleschi saw'; 'Archaeology, merriment and murder'.

57 Lensi-Orlandi, *Il Palazzo Vecchio di Firenze*, records the order of the Council of 21 July 1294: '… facta super facto Palatii pro Communi Florentiae faciendi et de loco et super loco inveniendo in quo dictum Pallatium fieri debeat' (… ordered for the making of a palace for the Commune of Florence and for finding and deciding a site on which the said palace shall be built.) Of the 87 members present only 56 voted in favour, and 31 against; and the site was not finally decided until the year construction started.

58 This site had been deliberately left levelled as a demonstration of the power of the Commune and the likely fate of disruptive magnates.

59 In the Trecento the Palazzo extended no further east than the five bays facing the Piazza degli Uberti. Although the Duke of Athens did begin extensions in 1343, these were uncompleted on his expulsion; and the matching walling of the upper floor of the north façade was built over a century later. The Palazzo was extensively remodelled under Michelozzo in 1445, and enlarged and remodelled again under Vasari in the sixteenth century, with further modification to the eastern extensions later.

60 One should notice that the arched corbels are more closely spaced beneath the tower. There is also a change in materials, for those corbels are made of a harder grey stone in place of the yellow stone of the rest of the building.

61 Becker, *Florence in Transition*, p.15.

62 Original document, Archivio di Stato di Firenze, *Provvisioni* 214, fol.30v. (9–11 August 1330); Davidsohn, *Forschungen zur Geschichte von Florenz*, IV, p.502, quoted in Rubinstein, 'The Piazza della Signoria in Florence'.

63 Portions of the original paving were revealed during excavations in the square in 1969, and are illustrated in Lenzi-Orlandi, *Il Palazzo Vecchio di Firenze*.

64 It gets its present name, Loggia dei Lanzi, from the lancers stationed there by the Medici Dukes, but its original function was as an external extension of the Palazzo Vecchio.

65 Significantly the civic, or moral, virtues face the square and the Christian virtues face the Via della Ninna and the church of San Pier Scheraggio. (I am grateful to Professor Benton for drawing this detail to my attention.)

66 See Spilner, 'Giovanni di Lapo Ghini'.

67 The fresco from the prison called the Stinche (now in the Palazzo Vecchio), showing the expulsion of the Duke of Athens, also shows the tower-like *anteportae*, or defensive outer gates, that he built. These would have been standard defensive works in military architecture (they were demolished in 1349). They were

supported by a stone *échaugette*, or defensive balcony, in the north-east corner of the *cortile*, traces of the supports for which were visible during the restoration of the 1970s. They were not enough to protect the Duke; but the ease with which the building could be adapted for military defence is certainly echoed in the rather forbidding exterior. The Duke also planned an additional courtyard to the east, like the Bargello, creating a new door in the east wall for access. See Spilner, 'Giovanni di Lapo Ghini'.

68 Now known as the Sala del Dugento.

69 A fragment of a decorated ceiling survives alongside the tower, which is as rich as the ceiling in the Sala del Consiglio at Siena.

70 Such evidence as survives is discussed in Norman, 'Civic patronage of art' [Chapter 7 in the companion volume to this one].

71 They are even grouped in pairs over each door, for extra protection.

72 Boccaccio, *The Decameron*, ed. Macwilliam, First Day, Introduction, p.50.

73 Padua lacked any strong international banking trade like Florence or a woollen industry on the scale of Siena. There were great magnates, certainly, but Enrico Scrovegni is the only great Paduan known to have been intimately connected with trade.

74 Giovanni da Nono, 'Visio Egidii Regis Patavie'.

75 See Moschetti, 'Principale palacium communis Padue', 1932, pp.143–92; 1933, pp.99–105; 1934–39, pp.189–261.

76 Giovanni da Nono, 'Visio Egidii Regis Patavie', lists fourteen 'palaces' of the Commune, some of which were no more than covered markets.

77 The six main guilds in Padua were the butchers, bakers, cheesemongers, greengrocers, fishmongers and taverners. This is in marked contrast to Florence where such men would have been confined to the *arti minori*.

78 Quoted in Hyde, *Padua in the Age of Dante*, p.244. Such was the power of the Union of Guilds that in 1293 its councils and officials were accepted as a supplementary constitution.

79 Beneath the Palazzo del Podestà was an ironmongery market and beneath the Palazzo degli Anziani the salt market. It is significant that these two important trades were allotted such special positions (see Hyde, *Padua in the Age of Dante*, pp.42–3).

80 This part of the building is identified as the Loggia del Podestà by Fabris, 'Il Palazzo del Podestà'. The plan published in Fantelli and Pellegrini, *Il Palazzo della Ragione in Padua*, describes it as the Palazzo del Consiglio. Both appear to have been part of the same structure filling the block to the east of the Palazzo della Ragione.

81 The upper part of the walls of the Salone are slightly inclined inwards to support the roof and the loggias act as vital buttresses (see the seventeenth-century restorer's drawing reproduced in Fantelli and Pellegrini, *Il Palazzo della Ragione in Padua*, p.27).

82 There were also difficulties in joining the new structure to the blind arcading of the old building.

83 There was a major fire in 1420, and in 1776 the roof was ripped off in a whirlwind, so it is difficult to be sure how much remains.

84 Discussed in Norman, 'Civic patronage of art' and 'Art and learning' [Chapters 7 and 10 in the companion volume to this one].

85 For a detailed interpretation see Barzon, *Gli affreschi del Salone di Padova* and *I cieli e la loro influenza negli affreschi del Salone di Padova*.

86 The basilica at Vicenza is better known for its recasing by Palladio in the sixteenth and early seventeenth centuries. The Gothic structure built in the mid fifteenth century was given surrounding loggias like those at Padua, but they collapsed shortly after building.

CHAPTER 3

1 Anonymous, in *Cronache senesi*, p.90, trans. from White, *Duccio*, pp.96–7:

> E in quello dì, che si portò al Duomo si serroro le butighe e ordinò el vescovo una magnia e divota conpagnia di preti e frati con una solenne procisione, aconpagnato da'signori Nove e tutti e gli ufiziali del comuno, e tutti e'popolani … e aconpagniorno la detta tavola per infino al Duomo, facendo la procisione intorno al Chanpo come s'usa, sonando le chanpane tutte a gloria per divozione di tanta nobile tavola quanto è questa.

2 Vasari, *Le vite*, ed. Bettarini, p.260:

> … e nel Duomo fece una tavola, che fu allora messa all'altare maggiore … era così dipinta dalla parte di dietro come dinanzi, essendo il detto altar maggiore spiccato intorno intorno, dalla detta parte di dietro erano con molta diligenza state fatte da Duccio tutte le principali storie del Testamento Nuovo in figure piccole molto belle. Ho cercato sapere dove

oggi questa tavola si truovi, ma non ho mai, per molta diligenza che io ci abbia usato.

3 Brandi, *Il restauro della Maestà di Duccio*, pp.18–19; Stubblebine, *Duccio di Buoninsegna and his School*, pp.35–7; White, *Duccio*, p.80; Bomford *et al.*, *Art in the Making*, Appendix I, p.190.

4 White, 'Measurement, design and carpentry in Duccio's *Maestà*'; White, *Duccio*, pp.80–134, 201–8; Davies, *The Early Italian Schools Before 1400*, p.21.

5 Since the central pinnacle paintings on both the front and back faces of the altarpiece have not been recovered, their exact number and subjects are still a matter of scholarly debate. The subject of the lost scene (or scenes) from the back surface of the predella is likewise a matter for debate. For further discussion of these two points, see below, pp.60–73.

6 White, *Duccio*, p.80.

7 White, *Duccio*, doc.28.

8 White, *Duccio*, doc.30.

9 Pope-Hennessy, 'A misfit master', p.45; Davies, *The Early Italian Schools Before 1400*, pp.19–20.

10 White, *Duccio*, pp.81–3.

11 White, *Duccio*, pp.82–8.

12 Van Os, *Sienese Altarpieces*, I, p.42.

13 White, *Duccio*, p.82; for the discovery of the pinnacle panels, see Stubblebine, 'The angel pinnacles'.

14 Stubblebine, 'The angel pinnacles', p.149; White, *Duccio*, p.82.

15 In 1302 Duccio received a commission for a now lost altarpiece with a predella for the Palazzo Pubblico in Siena. In the same year Cimabue also received a commission for an altarpiece with a predella for the Pisan hospital of Santa Chiara.

16 White, *Duccio*, p.93.

17 Davies, *The Early Italian Schools Before 1400*, p.19; Bomford *et al.*, *Art in the Making*, pp.83, 86.

18 Bomford *et al.*, *Art in the Making*, p.78.

19 White, 'Measurement, design and carpentry in Duccio's *Maestà*, pp.550–5; White, *Duccio*, pp.91–2.

20 Gardner von Teuffel, 'The buttressed altarpiece', pp.36–40; cf. White, *Duccio*, pp.91, 180, n.18.

21 See also below, p.78.

22 Gordon, 'A Perugian provenance for the Franciscan double-sided altarpiece by the Maestro di San Francesco'.

23 White, 'Measurement, design and carpentry in Duccio's *Maestà*', pp.356–64; White, *Duccio*, pp.93–5, 201–8.

24 Stubblebine, 'Duccio and his collaborators'; *Duccio di Buoninsegna and his School*, pp.39–45.

25 White, *Duccio*, pp.102–19.

26 Bomford *et al.*, *Art in the Making*, pp.83–9.

27 Bomford *et al.*, *Art in the Making*, fig.50.

28 White, *Duccio*, p.122.

29 For evidence of other alterations or second thoughts (*pentimenti*) on the *Maestà*, see below, p.76, and also White, *Duccio*, pp.115–16; Deuchler, 'Duccio Doctus: new readings for the *Maestà*', pp.545–6; Sullivan, 'Duccio's *Raising of Lazarus*'; Davies, *The Early Italian Schools Before 1400*, p.17; Bomford *et al.*, *Art in the Making*, pp. 79–83.

30 White, *Duccio*, pp.101–2.

31 White, *Art and Architecture in Italy*, pp.83–8, pl.42.

32 White, *Duccio*, p.98, fig.61.

33 Van der Ploeg, 'Architectural and liturgical aspects of Siena cathedral', pp.135–9.

34 White, *Duccio*, p.95; van Os, *Sienese Altarpieces*, I, pp.11–12.

35 Van Os, *Sienese Altarpieces*, I, pp.17–20.

36 'MATER SCA DEI/SIS CAUSA SENIS REQUIEI/SIS DUCCIO VITA/TE QUIA PINXIT ITA.'

37 White, *Duccio*, p.120.

38 Sullivan, 'Some Old Testament themes'.

39 White, *Duccio*, p.132.

40 Stubblebine, 'The back predella of Duccio's *Maestà*', and Sullivan, 'The Anointing in Bethany', both propose that the Ministry cycle on the back face of the predella had in addition a scene on each of the short ends of the box-like predella. This would increase the number of lost paintings to three. The authors have different opinions as to what were the subjects of these scenes.

41 White, *Duccio*, pp.124–31; Deuchler, 'Duccio Doctus: new readings for the *Maestà*', pp.541–4; *Duccio*, pp.58–63.

42 The term 'boustrophedonic' owes its derivation to the Greek words *bous* (ox) and *strophe* (turn). In ploughing, a farmer drove an ox and plough up one furrow

and then, after turning, down the next, these movements forming a classic boustrophedonic pattern.

43 Deuchler, 'Duccio *Doctus*: new readings for the *Maestà*', pp.543–4.

44 White, *Duccio*, pp.131–2.

45 White, *Duccio*, pp.132–3.

46 Where these two paintings were located at the time of the painting of the *Maestà* is not known, but it seems likely that the *Saint Peter* panel was located in the now destroyed Sienese church of San Pietro in Banchi and that Guido da Siena's painting once functioned as a Lenten hanging for an altar in one of Siena's churches, possibly the cathedral itself. See Torriti, *La Pinacoteca*, pp.11, 18–20. At all events, as Siena's major painter, Duccio was undoubtedly familiar with both these paintings, which provided him with models for a number of the narrative scenes on the *Maestà*.

47 Deuchler, 'Duccio *Doctus*: new readings for the *Maestà*', pp.545–6; Sullivan, 'Duccio's *Raising of Lazarus*'.

48 Sullivan, 'Duccio's *Raising of Lazarus*', pp.382–6.

49 The provenance of the painted triptych was Spedaletto, a fortified *grancia* (grange) which belonged to the hospital of Santa Maria della Scala. Whether the painting was originally commissioned for Spedaletto is not known. For the correspondances between this painting and the *Maestà*, see Sullivan, 'The Anointing in Bethany'. On the Massa Marittima altarpiece, see *Mostra di opere d'arte restaurate*, I, cat. no.6; van Os, *Sienese Altarpieces*, I, pp.56–7.

50 For a discussion of the complex question of dating and attribution, see White, *Duccio*, pp.140–50; Gardner, 'The Stefaneschi altarpiece'.

51 It is interesting to note in this context the count given by White, *Duccio*, p.102, of 1 main scene, 58 narratives and 30 single figures for the *Maestà*, compared with 62 narratives for the three painted cycles of the Upper Church, San Francesco, Assisi and 38 narrative paintings and 14 grisaille figures for Giotto's Arena Chapel cycle. See also White's perceptive remark in *Art and Architecture in Italy*: 'compressed within the compass of an altarpiece is the equivalent of an entire programme for the fresco painting of a church' (p.289).

52 Deuchler, 'Duccio *Doctus*: new readings for the *Maestà*', pp.546–8.

53 For example, in the thirteenth-century *Meditations on the Life of Christ* attributed to Giovanni de Caulibus, the Italian Franciscan author urges his reader when meditating upon the 'disputation in the Temple' to consider how, when Mary and Joseph went to search for the young Jesus, 'they left the house to look for him in the neighbourhood, for one could return by several roads, as he who returns from *Siena* to Pisa might travel by way of Poggibonsi or Colle or other places' (p.89; emphasis added). My attention was first drawn to this passage by van Os, *Sienese Altarpieces*, I, p.54.

54 White, *Duccio*, p.80.

CHAPTER 4

1 Fry, 'Giotto', in *Vision and Design*, p.176.

2 Fry, 'Giotto', in *Vision and Design*, pp.176–7.

3 Fry, 'Giotto', in *Vision and Design*, p.177.

4 Fry, 'Giotto', in *Vision and Design*, p.177.

5 White, *Art and Architecture in Italy*, pp.340–1.

6 Stubblebine, *Giotto*, p.110.

7 Ghiberti, *I commentari*, in von Schlosser, p.36.

8 Vasari, *Lives of the Artists*, p.32.

9 Stubblebine, *Giotto*.

10 The evidence is cited by Rizieri Zanocco in 'The Annunciation at the Arena of Padua'. Zanocco also discusses the traditional belief that the Arena had been the site for dramatic representations of the mystery of the annunciation since the late thirteenth century.

11 Stubblebine, *Giotto*, p.107. In the opinion of Ursula Schlegel, 'On the picture program of the Arena Chapel', this document demonstrates that *The Last Judgement* painted on the west wall of the chapel (Plate 102) must have been completed well before the beginning of 1305, since the building itself is represented at the base of this fresco, accurate in most particulars but without the bell-tower to which the friars took exception (Plate 104).

12 Although the modern tendency is to associate usury with extortionate rates of interest, in the medieval period the exaction of interest *per se* was forbidden to clerics and the laity. It should be noted that, whilst the injunction against usury provided some brake on the abuse of economic power, it could also serve as an inhibiting restriction on mercantile enterprise and development.

13 Dante, *Inferno* XVII, ll.43–78, *Divine Comedy* 1, pp.216–19.

14 Scrovegni appears to have succeeded in this last respect, at least in the eyes of one later commentator. The chapel is mentioned in the following terms in

Bartolommeo Scardeone's *De Antiquitate Urbis Patavii et Claris Civibus Patavinis*, published in 1560:

> Behold this which was the home of heathen, constructed by a great multitude,/Has been demolished with great wrath/And is now miraculously abandoned./Those who led a life of luxury in happy times,/Having lost their wealth, are no longer even spoken of,/But Enrico Scrovegni, the knight,/Saves his honest soul; he respectfully makes for them a feast./For he solemnly dedicated the temple to the mother of God,/So that he would be blessed with eternal grace./Divine virtue replaced the profane vices,/The heavenly joys which are superior replaced earthly ones.
> (Stubblebine, *Giotto*, p.111)

It was Scardeone, in this same text, who transcribed the inscription originally found on Scrovegni's tomb.

15 Giovanni da Nono, *Liber de Generacione Aliquorum Civium Urbis Padue*.

16 See Rough, 'Enrico Scrovegni', in which the relevant documents are cited and translated.

17 Rough, 'Enrico Scrovegni'.

18 The former emphasis is detailed by Shorr, 'The role of the Virgin in Giotto's *Last Judgement*', the latter by Schlegel, 'On the picture program of the Arena Chapel'. Schlegel also connects the theme of usury to Scrovegni's membership of the Cavalieri Gaudenti.

19 As argued in Harrison, 'Giotto and the "rise of painting"' [Chapter 4 in the companion volume to this one].

20 See Rough, 'Enrico Scrovegni', p.24.

21 The compelling evidence for the identification of this figure as Judas is given in Schlegel, 'On the picture program of the Arena Chapel'. A similar hanging figure is to be found in the mosaic of *The Last Judgement* in the Baptistery in Florence (Plate 103), where it is clearly labelled 'GIUDA'. Giotto's knowledge of this important work is reflected both in the overall organization of his own composition and in various of its details.

22 The case for such prior experience is argued by Gioseffi, *Giotto architetto*, in part on the basis of readings of the architectural constructions in Giotto's paintings.

23 Martindale, *The Rise of the Artist*, pp.22–3.

24 Hueck, 'Zu Enrico Scrovegni's Veränderung der Arenakapelle'.

25 Hills, *The Light of Early Italian Painting*, p.43.

26 Tintori and Meiss, *The Painting of the 'Life of St Francis'*.

27 Hills suggests (on the authority of Oertel, 'Wandmalerei und Zeichnung in Italien' and Tintori and Meiss, *The Painting of the 'Life of St Francis'*) that the so-called *giornata* technique 'was probably brought to Assisi by Roman-trained artists in the last two decades of the thirteenth century' (p.61). If true, this might provide further grounds for associating Giotto with the relevant programme of work at Assisi. Although there is evidence that he spent time in Rome early in his career, there is no surviving Roman fresco scheme with which he can plausibly be associated.

28 This account largely follows the instructions given in Cennino Cennini's *Il libro dell'arte* (*The Craftsman's Handbook*), written at the end of the fourteenth century. Cennini gives his skills an appropriate pedigree:

> … follow this method in everything which I shall teach you about painting: for Giotto, the great master, followed it. He had Taddeo Gaddi of Florence as his pupil for twenty-four years; and he was his godson. Taddeo had Agnolo, his son. Agnolo had me for twelve years: and so he started me on this method.
> (p.46)

Cennino's testimony serves incidentally to support the view that Giotto's workshop is likely even by the date of the Arena Chapel programme to have included other artists of considerable ability. The Taddeo Gaddi who is said to have been his pupil for 24 years is the same artist whose remarkable and independent decorations in the Baroncelli Chapel are discussed in Chapter 8.

29 The evidence for these and other changes is given in Tintori and Meiss, *The Painting of the 'Life of St Francis'*, pp.206–8.

30 Hills, *The Light of Early Italian Painting*, p.44.

31 Hills, *The Light of Early Italian Painting*, p.52.

32 Baxandall, *Giotto and the Orators*, pp.70–1.

33 Baxandall, *Giotto and the Orators*, p.78.

34 See Hyde, *Padua in the Age of Dante*, pp.303–5.

35 Hills, *The Light of Early Italian Painting*, p.65.

36 On Paduan civic humanism, see Hyde, *Padua in the Age of Dante*, ch.7, pp.283ff.

CHAPTER 5

1 Herklotz, *Sepulcra e monumenta del medioevo*, pp.143ff.

2 Herklotz, *Sepulcra e monumenta del medioevo*, p.193.

3 Herklotz, *Sepulcra e monumenta del medioevo*, p.224.

4 Herklotz, *Sepulcra e monumenta del medioevo*, p.170.

5 Herklotz, *Sepulcra e monumenta del medioevo*, pp.192–3.

6 Pope-Hennessy, *Italian Gothic Sculpture*, 3rd edn, p.182.

7 Gardner, *The Tomb and the Tiara*, pp.97–101.

8 Seidel, 'Das Grabmal von Kaiser Heinrich VII, in Pisa', pp.33–64. Garzelli, *Sculture toscane nel dugento e nel trecento*, pp.77ff.

9 Prestifilippo and Smitta, *Messina artistica, e monumentale*, pp.94–6; Carli, *Goro di Gregorio*, pp.41–4.

10 'Caelavit Ganus opus hoc insigne senensis laudibus immensis est sua digna manus.'

11 Venturi, *Storia dell'arte Italiana IV*, pp.402–6.

> Pistorii Flamen cleri populorum solamen/gloria maiorum patrie decus atque suorum/culmen honestatis Thomas heros pietatis/formosus mitis virtutum florida vitis/fons decretorum flos cleri gemmaque morum/hic iacet alme velis pater hunc tibi iungere celis/annis exemptis trinis cum mille trecentis/a xpo nato requievit fine beato/venerabilis pater dominus Thomas olim pistoriensis/episcopus hic iacet/ob cuius memoriam dominus Jacobus et socus domini/Andrea germani ipsius fecerunt fieri hoc/monumentum qui obiit die XXX Iulii anni predicti.

12 Berger, *Ways of Seeing*.

13 Jovino, *La chiesa e il chiostro maiolicato di S. Chiara in Napoli*, pp.67–8; Valentiner, *Tino di Camaino*, pp.120–3, 153, 159–62.

14 Gonzati, *La basilica di Sant'Antonio di Padova*, II, pp.66–7.

15 Gonzati, *La basilica di Sant'Antonio di Padova*, II, pp.56–7.

16 *Mostra di opere d'arte restauraute nelle province di Siena e Grossetto*, II, pp.20–4, catalogue entry by Giovanni Damiani. Bauch, *Das Mittelälterliche Grabbild Figurliche Grabmäler*, pp.174–8, discusses some French precedents.

17 Giglioli, *Pistoia*, pp.53–4, and Ciampi, *Vita e poesie di Messer Cino da Pistoia*, pp.147–53.

18 Ciampi, *Vita e poesie di Messer Cino da Pistoia*.

19 'Anno Domini MCCCXXIV indictione VII magister Peruccius operarius ecclesie fecit fieri opus magistro Goro Gregori de Senis.'

20 Carli, *Goro di Gregorio*, pp.13–39.

21 Gregory the Great, *The Dialogues of Gregory*, pp.119–20.

22 Churchill, 'Giovanni Bartolo of Siena', pp.120–5.

23 Bagnoli's entry on Romanelli in *Scultura dipinta*, pp.83–4. For the red-faced angel head, see also Petzold, 'His face like lightening', pp.149–53.

24 Moschetti, 'Il tesoro della cattedrale di Padova', p.103.

25 *Scultura dipinta*, pp.31–3.

26 In Italy at this date, the year began on the Feast of the Annunciation, 25 March.

27 *Scultura dipinta*, pp.31–3.

> Domene dio fece scolpire quest croce in questo\legno alando pieri da siena asimilitudine del\vero ihu xpo per dare memoria ala gente\de la passione di iesu xpo figliuolo di Dio\e della beata virgine maria, adunqua\tu verace croce santa di yhu expo filio\di dio rende el detto lando a dio.\O beata virgine maria madre di xhu xpo\figliuolo di dio. prega la santa croce\del tuo figluolo che renda eldetto lando adio.\O iohanni evangelista discepolo amato da yhu xpo figluolo di dio. prega la santa\croce di yhu xpo figluolo di dio che renda\el detto lando adio.\O ioanni bactista che rendesti testimonio\a yhu xpo figluolo di dio prega la santa\croce di yhu xpo figluo di dio che renda el detto landa adio.\O maddalena amatrice di xhu xpo figluolo\di dio prega la santa croce che renda el detto lando adio.\tucti i santi e sante pregate xhu xpo figliolo\di dio che abbia misericordia del detto lando, et di tutta\sua famiglia, che li faccia salvi e guardili da le mani\del nimicho di dio. yesus – yesus – yesus – xps filius dei\vivi abbi misericor di tucto el omana generatione\amen.

28 Ringbom, *From Icon to Narrative*, p. 11: Gregory to Secundinus.

29 Thomas Aquinas, *Summa theologica, Secunda secundae*, III, pp.175–6.

30 'Anno Domini MCCCXXXVII\di gennaio\fu compiuta\questa fi\gura a si\militudine\di ihu xpo\crocefissio\figluolodi\dio vivo et vero. Et\lui dovendo adorare\et non que\sto legno.' Text in *Scultura dipinta*, pp.67–8.

31 'Nos numquam adoravimus facturam manuum nostrarum sed adoramus dominum coeli et terrae, qui est imperator perpetuus et deus eternus.' Wattenbach, 'Über die Legende von den heiligen Vier Gekronten', p.1300.

32 'yesus xpo per la tua misericordie si sia racomandata l'anima di lando pieri orafo il quale fabrico questo crocifixo.' Text in *Scultura dipinta*, p.68.

33 *Scultura dipinta*, pp.56–60.

CHAPTER 6

1 Only the lowest storey of the campanile had been completed when Giotto died in 1337. The literature is summarized in Recht, *Les batisseurs des cathedrales gothiques*, pp.266–8; Trachtenberg, *The Campanile of Florence Cathedral*, accepts the drawing as a faithful representation of Giotto's design and bases a detailed analysis of Giotto's architectural language on this assumption.

2 Another pretext for the drawing of a new campanile is recorded in 1389, when the poor state of repair of the Sienese Campanile led to an unsuccessful request by the *capomaestro* Giovanni di Cecco for funds to pull it down and build a new one (Lusini, *Il duomo di Siena*, I, pp.280–6).

3 Guasti, *Santa Maria del Fiore*, doc.465, p.312. On 29 April 1412 the *signori* debated what name to give to the cathedral, 'known vulgarly as Santa Maria del Fiore', and to the Office of Works, henceforward to be known as 'Gli Operai di Santa Maria del Fiore'. Giovanni Villani had placed the foundation ceremony in 1294 on:

> il dì di santa Maria di settembre per lo legato del papa cardinale e più vescovi, e fuvi la podestà e capitano e' priori, e tutte l'ordini delle signorie di Firenze, e consagrosssi ad onore d'Iddio e di santa Maria, nominandola Santa Maria del Fiore con tutto che mai no' le si mutò il primo nome per l'universo popolo, Santa Reparata.

> (Mary's day in September [the eighth day of the Nativity], in the presence of the Papal legate and many bishops; and there was the Podestà, the Capitano and the Priors and all the orders of the *Signorie* of Florence. And they consecrated it to the honour of God and to Saint Mary, naming it Santa Maria del Fiore; nevertheless, there was no change in the name given by the general public, Santa Reparata.)

> (*Nuova Cronica*, bkIX, ch.9, vol.II, p.26)

A complicated formula is normally used to refer to the church: 'Pro honore et reverentia domini nostri Iehsu Christi et beate Marie Virginis matris sue ac etiam sancte Reparate virginis, et ad honorem et decus civitatis et populi Florentini.' (For the honour and reverence to our lord Jesus Christ and to the Blessed Virgin Mary his mother and to the virgin saint Reparata and to the honour and dignity of the city and people of Florence.) (Guasti, *Santa Maria del Fiore*, doc.6, 11 September 1294, p.3.)

4 The following account is based on Carli, *Il duomo di Siena*, and Pietramellara, *Il duomo di Siena*, modified in the light of Middeldorf-Kosegarten, *Sienesische Bildhauer*.

5 A masonry outer shell replaced this wooden skin in 1666, along with a new stone lantern (Pietramellara, *Il duomo di Siena*, p.68).

6 Guasti, *Santa Maria del Fiore*, p.xxiii and p.2, doc.3.

7 See King, 'The arts of carving and casting' [Chapter 5 in the companion volume to this one].

8 For a good summary of the literature, see Romanini, *Arnolfo di Cambio*, pp.103–43.

9 The authors were listed as Lorenzo di maestro Maitani and Niccola Nuti (both from Siena) and three Florentines: Cino di Francesco, Tone di Giovanni and Vanni di Cione. The document was dated 17 February 1321–22 (Milanesi, *Documenti per la storia dell'arte senese*, I, p.186, n.34, reproduced in Pietramellara, *Il duomo di Siena*, pp.55–6).

10 The blind windows on the interior were added by Baccani in a restoration project of 1838–42 to match the windows in the rest of the nave (Giorgi, 'Lo sviluppo del corpo basicale', p.45).

11 Other members of the group were Giovanni di Santa Maria a Monte, Gherardo di Bindo and Stefano di Meio (Sienese). The report was drafted in the name of Francesco Talenti and Benci di Cione. The Sienese were paid for their work on the survey in 1356, Francesco Talenti in 1358 (Lusini, *Il duomo di Siena*, I, pp.180–1).

12 For a detailed description, see van der Ploeg, *Art, Architecture and Liturgy*, pp.63–81 and Appendix I.

13 See Pietramellara, *Il duomo di Siena*, where the measured drawings show that there is insufficient height above the original floor of the Crypt of the Statues to fit in a crypt below the level of the choir.

14 For the most succinct summary of its findings, by the American who took over as archaeological director in 1969, see Toker, 'Florence cathedral: the design stage', pp.214–31. A critical analysis is provided in Rocchi *et al.*, *Santa Maria del*

Fiore, which also includes detailed measured drawings of the archaeological dig and the whole fabric.

15 The proximity of the hospital to the old cathedral can be deduced from the frequent mention in documents of 'Hospitalis ante maiorem senarum ecclesiam' (The hospital before the major church of the Sienese) or 'Hospitalis S. Marie ante gradus' (1147) or descriptions of the hospital as 'ante ecclesiam Sanctae Mariae' or 'ante maiorem senensis ecclesiam' (1195) (cited in Pietramellara, *Il duomo di Siena*, p.21).

16 Benvoglianti, 'De Urbis Senae Origine et Incremento' (cited in Pietramellara, *Il duomo di Siena*, pp.65–6):

> … ebbe dunque la nostra chiesa una confessione più bella di tutte l'altra d'Italia sostentata da 15 colonne con 3 ordini di volte rilevate e illustre. I muri de la qual pochi anni innanzi si videro dipinti assai graziosamente, quando si scavò il pavimento della chiesa. Si scendeva in quella dove è adesso la ruota nel mezzo del pavimento.

> (… so our church had a confessio [crypt] more beautiful than any in Italy supported by 15 columns with 3 rows of decorated and painted vaults. The walls [of the crypt] painted quite graciously were seen a few years ago, when the pavement of the church was excavated. The descent into it was located where today is the wheel in the middle of the pavement.)

17 According to the sixteenth-century chronicler Sigismondo Tizio (Carli, *Il duomo di Siena*, p.143).

18 Money was short. On 11 February 1299 Fazio Fabbri complained of the lack of funds, which threatened the abandonment of the project (Lusini, *Il duomo di Siena*, I, p.96). The excitement caused by a document of 1376 which was interpreted to mean that a completely new façade was built one bay further to the west of a 'simple' façade has now been discounted by a somewhat rudimentary archeological survey in 1940, which showed that only one façade can have been built here.

19 Middeldorf-Kosegarten, *Sienesische Bildhauer*.

20 See p.134 above.

21 See Chapter 2.

22 'Item: nobis videtur, quod in dicto opere non amplius procedatur, quia metis predicte ecclesie, finito novo opere, non remaneret in medio crucis, ut rationabiliter remanere deberet.' (Lusini, *Il duomo di Siena*, I, p.183, trans. Colin Cunningham.)

23 Lusini, *Il duomo di Siena*, I, p.183, trans. Colin Cunningham:

> Item: nobis videtur, quod super dicto opere non procedatur, cum sit necesse dissipare de opere Domus veteris a medietate metis supra, versus opus inceptum iam novum.

> Item: nobis videtur, et patet quod in dicto opere non procedatur; quia volendo disipare opus vetus, causa coniungendi cum dicto novo opere, fieri non posset absque magno periculo metis et voltarum veterum.

24 Lusini, *Il duomo di Siena*, I, p.182.

CHAPTER 7

1 Saint Bernardino, *Le prediche volgari*, III, p.373: 'voi l'avete dipènta di sopra nel vostro Palazo, a vedere la Pace dipènta è una allegreza. E cosi è una scurità a vedere dipènta la Guerra dall'altro lato.'

2 See above, p.148, below, note 10, and Norman, 'Civic patronage of art' [Chapter 7 in the companion volume to this one].

3 This opening was embellished in the late fifteenth century with painted decoration; see Southard, 'The Frescoes in Siena's Palazzo Pubblico', I, pp.274, 294–5.

4 'AMBROSIVS LAURENTII DESENIS HIC PINXIT UTRINQUE.' This inscription was repainted in the seventeenth century. See Southard, 'The Frescoes in Siena's Palazzo Pubblico', I, p.272. In many cases the painted inscriptions on the three murals have letters missing or have been abbreviated. For the sake of clarity, however, when cited the inscriptions will be given in full.

5 'Figuris pictis et positis in cameris dominorum Novem.' Details of the payments are published in Rowley, *Ambrogio Lorenzetti*, I, pp.140–2.

6 A decade after the completion of the paintings, a large area on two walls adjacent to the north-east corner of the room was completely repainted (*c*.1350–60). This fourteenth-century restoration included the figures to the right of the enthroned male figure in the mural on the north wall (Plate 184) and the cityscape on the exteme left of the east wall (Plate 186). Further restoration is documented in 1491, 1518, 1521, 1830, 1879–80, 1951–52 and 1986–89. The quatrefoils in the lower borders on the north and east walls have been entirely

repainted. The timbered, coffered ceiling has been lowered and thus covers the top halves of five quatrefoils above the mural on the north wall. A number of doors were installed, probably in the fifteenth century, resulting in loss of some of the paintings' original inscriptions and of the painted areas above these doors. See Southard, 'The Frescoes in Siena's Palazzo Pubblico', I, pp.273–6.

7 Since there are no contemporary descriptions of the paintings' subjects, their titles are open to debate and vary from one scholar to another. For the sake of clarity, the most succinct of the titles suggested have been adopted.

8 The opening verse of the Book of Wisdom: 'DILIGITE IUSTITIAM QUI IUDICATIS TERRAM.' (Love justice, you who judge the earth.) This biblical text also appears on the scroll held by the Christ Child in Simone Martini's *Maestà* in the adjacent room.

9 The rope around the wrist was first noted by Skinner, 'Ambrogio Lorenzetti: the artist as political philosopher', p.43.

10 The inscription can be reconstructed as: 'SALVET VIRGO SENAM VETEREM QUAM SIGNAT AMENAM.' (May the Virgin preserve Siena the ancient whose loveliness may she seal.) The same image and text also appear on the seal of the city of Siena, which is depicted embedded in the wall below the wide border of Simone Martini's *Maestà*.

11 This fact is suggested by White, *Art and Architecture in Italy*, pp.390–1.

12 This wall was originally an outside wall and therefore very vulnerable to the depredations of cold and damp.

13 This is probably a corruption of the Latin *tyrannis* (tyranny).

14 Southard, 'The Frescoes in Siena's Palazzo Pubblico', I, p.291.

15 Starn, 'The republican regime of the *Room of Peace*', pp.18–23. For a more detailed discussion of the painted texts and the significance of the balance between textual and painted matter, see Starn and Partridge, 'The republican regime of the Sala dei Nove', pp.28–48.

16 Rubinstein, 'Political ideas in Sienese art', pp.179–89; Skinner, 'Ambrogio Lorenzetti: the artist as political philosopher', esp. pp.3–6.

17 *Il constituto del comune di Siena dell'anno 1262* and *Il constituto del comune di Siena volgarizzato nel 1309–1310*.

18 Rubinstein, 'Political ideas in Sienese art', p.183; Skinner, 'Ambrogio Lorenzetti: the artist as political philosopher', p.35.

19 Frugoni, *A Distant City*, p.124; Rubinstein, 'Political ideas in Sienese art', p.183.

20 Rubinstein, 'Political ideas in Sienese art', pp.182–3; Skinner, 'Ambrogio Lorenzetti: the artist as political philosopher', p.38.

21 Frugoni, *A Distant City*, pp.121–3. In order to explain this discrepancy in the painting, the author makes the ingenious but somewhat implausible suggestion that during a later restoration the two titles were transposed.

22 Skinner, 'Ambrogio Lorenzetti: the artist as political philosopher', pp.15–17, 37–40.

23 Starn and Partridge, 'The republican regime of the Sala dei Nove', p.45.

24 As argued by Latini, *Li livres dou tresor*, bkII, chs28, 38, pp.197–9, 204–5. See also Skinner, 'Ambrogio Lorenzetti: the artist as political philosopher', p.34.

25 Latini, *Il tesoretto*, ll.175–7, p.10: 'Ma tutti per comune/tirassero una fune/di Pace e di ben fare.'

26 The 1262 constitution gave the Twenty-four power to promote the good and pacific state of the people and Commune of Siena. See *Il constituto del comune di Siena dell'anno 1262*, p.72. See also Frugoni, *A Distant City*, p.136.

27 Rubinstein, 'Political ideas in Sienese art', pp.180–1. The initials now read C.S.C.C.V., the extra letter probably being inserted incorrectly by a later restorer.

28 'Bonum commune … est melius et divinius quam bonum unius', cited in Rubinstein, 'Political ideas in Sienese art', p.184.

29 Rubinstein, 'Political ideas in Sienese art', p.185.

30 Borgia *et al.*, *Le Biccherne*, nos28, 38, pp.96, 116.

31 Skinner, 'Ambrogio Lorenzetti: the artist as political philosopher', pp.22–5, 42–4.

32 Vasari, *Le vite*, ed. Bettarini, p.116:

> nella sala grande del Podestà di Firenze dipinse il Comune … in forma di giudice con lo scettro in mano, lo figurò a sedere e sopra la testa gli pose le bilance pari per le giuste ragioni ministrate da esso, aiutato da quattro Virtu che sono la Fortezza con l'animo, la Prudenza con le leggi, la Giustizia con l'armi e la Temperanza con le parole.

33 For further discussion of the Tarlati monument and its sculpted programme, see Chapter 5.

34 Rubinstein, 'Political ideas in Sienese art', p.180; Skinner, 'Ambrogio Lorenzetti: the artist as political philosopher', pp.25–31.

35 Freyhan, 'The evolution of the *Caritas* figure'. Ambrogio Lorenzetti had only a few years previously portrayed Charity with these attributes in an altarpiece

depicting the Virgin and Child with saints for Massa Marittima, a painting that is generally dated *c.*1335–37.

36 Skinner, 'Ambrogio Lorenzetti: the artist as political philosopher', p.45.

37 Latini, *Li livres dou tresor*, bkII, chs1, 57, 74, 81, pp.175, 231, 250, 260. See also Skinner, 'Ambrogio Lorenzetti: the artist as political philosopher', pp.48–55. The whole area to the right of the ruler figure has been repaired, but it is likely that the basic design and iconography of the original painting have been preserved.

38 Rubinstein, 'Political ideas in Sienese art', pp.186–8; Skinner, 'Ambrogio Lorenzetti: the artist as political philosopher', pp.6–9, 32–3.

39 Feldges-Henning, 'The pictorial programme of the Sala della Pace', pp.150–5.

40 Greenstein, 'The vision of peace', pp.449–503.

41 The Fontana Maggiore, Perugia depicts the labours of the months twinned with their zodiacal signs, the liberal arts and philosophy. The Campanile, Florence, likewise depicts the seven planets, the seven virtues, the seven liberal arts and practitioners of arts and sciences (see Chapter 10). The repainted fourteenth-century programme of the Salone in the Palazzo della Ragione, Padua also includes the planets and their children as well as the labours of the months and the signs of the zodiac. For further discussion of the Paduan programme, see Chapter 4 and Norman, 'Civic patronage of art' [Chapter 7 in the companion volume to this one].

42 Bridgeman, 'Ambrogio Lorenzetti's dancing "maidens"'. Bridgeman's point that girls dancing in a public thoroughfare would be thought shocking is, however, open to debate. For example, in 1343 when the water first reached the fountain in the Campo, the festivities included men, women and clergy dancing. See the anonymous account in *Cronache senesi*, pp.311, 490, 537, cited by Waley, 'Ambrogio Lorenzetti's dancing maidens', p.142.

43 De Angelis, 'Ambrogio Lorenzetti's dancing "maidens"', p.142; Starn, 'The republican regime of the *Room of Peace*', p.20; Frugoni, *A Distant City*, pp.162–3; Greenstein, 'The vision of peace', pp.502–3.

44 Starn, 'The republican regime of *Room of Peace*', pp.20–1; Starn and Partridge, 'The republican regime of the Sala dei Nove', pp.53–4.

45 Greenstein, 'The vision of peace', p.493.

46 Frugoni, *A Distant City*, pp.165–9; Starn, 'The republican regime of *Room of Peace*', pp.25–6; Starn and Partridge, 'The republican regime of Sala dei Nove', pp.56–7.

47 White, *The Birth and Rebirth of Pictorial Space*, p.96; *Art and Architecture in Italy*, p.391. Given the illusion of brightly lit walls left and right of the dancing youths, the suggestion made by, respectively, Frugoni, *A Distant City*, p.48, Greenstein, 'The vision of peace', pp.496–7, and Starn and Partridge, 'The republican regime of the Sala dei Nove', p.19, that the city appears to be illuminated from the left and thus as if by one or all of the virtues in *The Good Government* would seem to go against the visual evidence of the painting itself.

48 White, *The Birth and Rebirth of Pictorial Space*, pp.93–6; *Art and Architecture in Italy*, pp.391–2. Greenstein's argument, in 'The vision of peace', pp.496–7, that the painting's perspectival construction is not intended for the viewer but for the figure of Peace on the north wall, appears at odds with the visual evidence of the painting itself.

49 Braunfels, *Mittelalterliche Stadtbaukunst*, p.85. See also Chapter 3.

50 This was probably painted in 1345 and therefore later than the Sala dei Nove paintings. See Southard, 'The Frescoes in Siena's Palazzo Pubblico', I, pp.237–41; Norman, 'Civic patronage of art' [Chapter 7 in the companion volume to this one].

51 Belting, 'The new role of narrative in public painting', pp.159–60.

52 Rubinstein, 'Political ideas in Sienese art', pp.188–9.

53 Skinner, 'Ambrogio Lorenzetti: the artist as political philosopher', p.33.

54 Skinner, 'Ambrogio Lorenzetti: the artist as political philosopher', p.33; Frugoni, *A Distant City*, pp.154–7; Starn and Partridge, 'The republican regime of the Sala dei Nove', pp.25–6.

55 White, *The Birth and Rebirth of Pictorial Space*, pp.97–8.

56 Feldges-Henning, 'The pictorial programme of the Sala della Pace', pp.160–1; Frugoni, *A Distant City*, pp.127–8.

57 Greenstein, 'The vision of peace', pp.494–6.

58 See Chapter 2, note 16; Starn and Partridge, 'The republican regime of the Sala dei Nove', pp.18, 28.

59 *Il constituto del comune di Siena volgarizzato nel 1309–1310*, dist.vi, rub.2, II, p.488: 'Che essa città e popolo tutto, e il contado et giurisditione d'essa in pace perpetua et pura giustitia si conservi ... che essa città sia governata per huomini amatori et di pace et di giustitia'; dist.vi, rub.16, II, p.498: 'Li Nove ... abiano licentia e libera podestà et balia e pieno officio di reducere la città e il comune e popolo di Siena a vera et dritta e leale pace et unità, communalmente et singularmente'.

60 Frugoni, *A Distant City*, p.135.

61 Agnolo di Tura, in *Cronache senesi*, p.524.

62 Siena, Archivio di Stato, Consistoro 2 (1347, 1 November to 31 December), fol.8v., cited by Starn, 'The republican regime of the *Room of Peace*', pp.4–5.

63 Indeed, for Starn and Patridge, 'The republican regime of the Sala dei Nove', pp.33–4, Ambrogio Lorenzetti may have composed the painted texts themselves. It seems more likely, however, that these were the products of collaboration between the painter and a person accustomed to writing ethical–didactic material of the kind included within the painted scheme of the Sala dei Nove.

64 Starn and Partridge, 'The republican regime of the Sala dei Nove', p.55.

65 Stefanini translates the female pronoun *la* literally; the ambiguity of the androgynous figure of Tyranny contributes to the sinister effect of the painting as a whole.

66 The translations in the Appendix are taken from Stefanini, Appendix 1, in Starn and Partridge, *Arts of Power*.

CHAPTER 8

1 Siena, Archivio di Stato, Diplomatico, Archivio Generale, 1 June 1340. Vannes's will survives in two versions, the shorter only detailing the bequest to the Abbey of San Galgano and the longer the bequests to both San Galgano and the hospital of Santa Maria della Scala. For a full discussion of the contents of this will and its significance for the painting of a chapel adjacent to the Oratory of San Galgano at Montesiepi, see Norman, 'The commission for the frescoes at Montesiepi'.

2 Women as widows, or more exceptionally in their own right, were occasionally involved in the foundation of such funerary chapels. Thus, for example, the Velluti Chapel in the south transept of Santa Croce, Florence was commissioned by Monna Gemma de'Pulci, widow of Filippo Velluti, in remembrance of her dead son Alessandro Velluti. See Ladis, 'The Velluti Chapel at Santa Croce'. For a number of other examples, see Chapter 11.

3 In Italy at this date, the year began on the Feast of the Annunciation, 25 March.

4 The Latin inscription is given in Ladis, *Taddeo Gaddi*, p.88. In translation, it reads: 'In the name of our Lord, in the month of February in the year 1327, this chapel was begun and built for Bivigliano and Bartolo and Salvestro Manetti and for Vanni and Pietro Bandini of the Baroncelli family in honour of and reverance of our Lord God and his Mother, the Virgin Mary Annunciate [and] ... for the cure and health of our souls and of all our dead.' For the patrons, see Janson-La Palme, 'Taddeo Gaddi's Baroncelli Chapel', pp.31–71. Since Vanni and Pietro only died in 1340 and 1356, respectively, the chapel was initiated well within their lifetimes.

5 Borsook, 'Notizie su due Cappelle', pp.89–98; Hall, 'The *Tramezzo* in Santa Croce', pp.325, 334; Ladis, *Taddeo Gaddi*, p.89.

6 Gardner, 'The decoration of the Baroncelli Chapel', p.100, cf. Paatz, *Die Kirchen von Florenz*, I, p.500, who argue for a date of 1328.

7 The window is now closed up and has inserted into its base an eighteenth-century tomb. See Gardner, 'The decoration of the Baroncelli Chapel', p.100.

8 It is possible that the walls of the second bay also contained narrative frescoes, possibly depicting scenes from the last days of the Virgin. For discussion of the present sixteenth-century painting of *The Assumption of the Virgin* in the second bay, see Gardner, 'The decoration of the Baroncelli Chapel', p.111, n.17.

9 Gardner, 'The decoration of the Baroncelli Chapel', pp.98–9.

10 Zeri, 'Due appunti su Giotto', pp.75–9.

11 'OPUS MAGISTRI JOCTI' (The Work of Master [master painter] Giotto). For a detailed discussion of the extent to which Giotto participated in the production of the Baroncelli altarpiece, see Gardner, 'The decoration of the Baroncelli Chapel', pp.106–10.

12 Ladis, *Taddeo Gaddi*, pp.23–4; cf. Gardner, 'The decoration of the Baroncelli Chapel', p.110.

13 The tomb is generally attributed to Giovanni di Balduccio. For fourteenth-century painters' contribution to the design of stained glass, see Ladis, 'The Velluti Chapel at Santa Croce', p.241.

14 Gardner, 'The decoration of the Barconcelli Chapel', pp.105–6; Ladis, *Taddeo Gaddi*, pp.13, 35, 88; Lavin, *The Place of Narrative*, p.68.

15 Saint Peter for Pietro; Saints John the Baptist and Evangelist for Vanni (a diminutive of Giovanni); Saint Sylvester for Salvestro; Saint Bartholomew for Bartolo (a diminutive of Bartolommeo). See Gardner, 'The decoration of the Baroncelli Chapel', p.104. Saint Louis of Toulouse might well be the name saint for the unusually named Bivigliano; see Ladis, *Taddeo Gaddi*, p.22, n.1.

16 Hills, *The Light of Early Italian Painting*, pp.76–9.

17 Ladis, *Taddeo Gaddi*, p.27–9.

18 Hills, *The Light of Early Italian Painting*, pp.82–3.

19 Maione, 'Fra Simone Fidati e Taddeo Gaddi'.

20 Ladis, *Taddeo Gaddi*, pp.28, 89–90.

21 Cited in Janson-La Palme, 'Taddeo Gaddi's Baroncelli Chapel', p.411.

22 Also known as the Chapel of San Giacomo because of its fourteenth-century dedication to Saint James the Great. In 1503 the chapel became the repository for the relics of Saint Felix and was, therefore, rededicated to that saint. Consequently, it is now generally known as the Chapel of San Felice.

23 Sartori, 'Nota su Altichiero', doc.X, pp.311–14.

24 Sartori, 'Nota su Altichiero', doc.XIII, pp.318–20.

25 Sartori, 'Nota su Altichiero', doc.XIII, p.320, no.37; Simon, 'Altichiero versus Avanzo', pp.252–4; Sartori, 'La Cappella di S. Giacomo', p.281; Bourdua, 'Aspects of Franciscan Patronage', p.57, n.121.

26 Sartori, 'Nota su Altichiero', doc.XIII, p.320, no.38.

27 For an account of these early attributions for the chapel's paintings, see Simon, 'Altichiero versus Avanzo', pp.263–6. For more recent support of Avanzo's contribution to the chapel's paintings, see D'Arcais, 'La decorazione della Cappella di San Giacomo', pp.19–20, 32–3.

28 Most notably, Simon, 'Altichiero versus Avanzo'. There is, however, a marked difference in style between five of the lunette paintings and the rest of the chapel's paintings. Whether this can be attributed to the change of painter at an early stage in the execution of the painted scheme (as suggested by Richards, 'Altichiero and Humanist Patronage', p.213), or rather an assistant of Altichiero being given responsibility for the design and painting of these five paintings, is still a matter of scholarly conjecture. Sartori, 'Nota su Altichiero', p.303, claims to have deciphered Altichiero's signature twice on *The Battle of Clavigo* (Plate 231). Close examination of the painting in question reveals that, from the chapel floor at least, these signatures are no longer clearly visible.

29 Simon, 'Altichiero versus Avanzo', pp.266–71; Richards, 'Altichiero and Humanist Patronage', pp.183–6; Norman, 'Carrara patronage of art' [Chapter 8 in the companion volume to this one].

30 Edwards, 'The Chapel of S. Felice', pp.161–8.

31 Wolters, 'Il Trecento', pp.23, 25, points out that the classicizing cornice was probably added in the sixteenth century at the time when the chapel became the receptacle for the relics of Saint Felix. Cf. Edwards, 'The Chapel of S. Felice', p.163, who states that the cornice belongs to the fourteenth-century architectural programme.

32 For the tomb's epitaph, dated 1337, see Gonzati, *La basilica di Sant'Antonio*, II, p.37. From it one learns that Bonifacio's grandfather, Guglielmo dei Rossi (who married a Carrara), and his sons (uncles to Bonifacio), Pietro, Marsiglio and Rolando, are buried in this tomb monument.

33 For the documentary record of its removal from the chapel, see Sartori, 'La Cappella di S. Giacomo', pp.352–3. For an illustration of the tomb slab and a transcription of its epitaph, see Wolters, *La scultura veneziana gotica*, pl.599, cat. no.157. The front face of the tomb of Bartolommea Scrovegni, d.1333, sister of Enrico Scrovegni and wife of Marsiglio da Carrara, has been placed in the central bay of the south wall of the chapel directly below *The Crucifixion* (illus. Wolters, *La scultura veneziana gotica*, pl.76, cat. no.25). According to Gonzati, *La basilica di Sant'Antonio*, II, p.35, n.xiv, Bartolommea was buried in the chapel before it came under the patronage of Bonifacio Lupi.

34 In 1503 the original fourteenth-century altar was replaced by another. As evident in older views of the chapel (Plate 222), the sixteenth-century altar was set upon a flight of steps in order to display the relics of Saint Felix inside it. See D'Arcais, 'La decorazione della Cappella di San Giacomo', p.16; Wolters, 'Il Trecento', p.25.

35 Wolters, *La scultura veneziana gotica*, cat. no.129.

36 Voragine, *The Golden Legend*, pp.368–77, esp. pp.369–73.

37 As pointed out by Plant, 'Portraits and politics in late Trecento Padua', pp.418–19, these chivalric sources describe Saint James intervening at the battles of Clavigo on a white charger. The collapsing walls seen in *The Battle of Clavigo* (Plate 231) belong to another miracle of Saint James when, at the seige of Pamplona by Charlemagne, the saint caused the walls of the town to fall. Since Charlemagne was believed to be an exemplar of a perfect Christian knight, this allusion to him was probably intended to be conducive to the reputation of the patron of the chapel.

38 Gatari, *Cronaca*, pp.54, 61; Sartori, 'Nota su Altichiero', pp.321–2; Bourdua, 'Aspects of Franciscan Patronage', pp.25–7.

39 Gatari, *Cronaca*, pp.417–18.

40 The epitaph on Bonifacio's tomb (published in Sartori, 'Nota su Altichiero', p.302) has a date of 28 January 1389. Yet the Gatari refer to him being alive in June 1390. This issue is further complicated by the fact that his nephew and heir was also named Bonifacio. See Bourdua, 'Aspects of Franciscan Patronage', pp.25–6.

Given the investment that Bonifacio had made in the chapel and its decoration, it seems highly likely that he commissioned his tomb and its epitaph before his death.

41 For the documents for the commission of this oratory, see Sartori, 'Nota su Altichiero', pp.305–11. See also Bourdua, 'Aspects of Franciscan Patronage', pp.28–9, 31–2.

42 Cenci, 'Bonifacio di Lupi', p.91; Sartori, 'Nota su Altichiero', p.302.

43 Sartori, 'Nota su Altichiero', doc.XVI, pp.323–4.

44 Sartori, 'Nota su Altichiero', p.302, doc.XIV, p.321.

45 Sartori, 'Nota su Altichiero', doc.XII, pp.316–18.

46 Sartori, 'Nota su Altichiero', pp.317–18.

47 Sartori, 'Nota su Altichiero', doc.XI, pp.314–15.

48 Sartori, 'La Cappella di S. Giacomo', doc.I, pp.305–6.

49 Sartori, 'Nota su Altichiero', pp.299–300; Simon, 'Altichiero versus Avanzo', pp.256–8.

50 Cenci, 'Bonifacio di Lupi', p.92, Wolters, *La scultura veneziana gotica*, p.171.

51 Sartori, 'La Cappella di S. Giacomo', doc.III, pp.309–10.

52 Edwards, 'The Chapel of S. Felice', p.171.

53 Plant, 'Portraits and politics in late Trecento Padua', p.418.

54 Plant, 'Portraits and politics in late Trecento Padua', p.410.

55 Plant, 'Portraits and politics in late Trecento Padua', pp.412–13, 421.

56 Plant, 'Portraits and politics in late Trecento Padua', pp.408–10, 413–14.

57 Plant, 'Portraits and politics in late Trecento Padua', p.408.

58 Edwards, 'The Chapel of S. Felice', pp.172–3.

59 Plant, 'Portraits and politics in Padua', p.408.

60 D'Arcais, 'Jacopo da Verona e la decorazione della Cappella Bovi'; Grossato, *Da Giotto al Mantegna*, cat. nos.57–9. This mural has now been detached and relocated in the Museo Civico in Padua.

61 Giles, *The Strozzi Chapel in Santa Maria Novella*, pp.59–60, 63–4. It has also been suggested that the features of Saint Thomas Aquinas on the chapel's altarpiece are those of its patron, Tomaso di Rossello Strozzi. For further discussion of this altarpiece and its iconography, see Norman, 'Art and religion after the Black Death' [Chapter 9 in the companion volume to this one].

CHAPTER 9

1 The title is derived from the opening line of a fourteenth-century Florentine *lauda* in praise of the Virgin, translated in full in Wilson, *Music and Merchants*, p.23.

2 Borghese and Banchi, *Nuovi documenti*, pp.10–11. For further discussion of the commission and imagery of this altarpiece, see van Os, *Sienese Altarpieces*, I, pp.69–74. For reconstruction of its original appearance, see Cämmerer-George, *Die Rahmung der toskanischen Altarbilder*, pp.147–8; Gardner von Teuffel, 'The buttressed altarpiece', pp.33–4; *Arte nell'Aretino*, pp.26–36.

3 On the lower frame is the inscription: 'PETRUS LAURE[N]TII HA[N]C PI[N]XIT DEXTRA SENE[N]SIS' (Pietro Lorenzetti of Siena painted this skilfully).

4 'TADDEO DI BARTOLO DA SIENA DIPINSE QUESTA OP[ER]A AL TEMPO DI MESSERE IACOPO DI BARTOLOMEO ARCIPRETE DI MONTE PULCIANO ANO DNI MCCCC...' (Taddeo son of Bartolo from Siena painted this work at the time of Jacopo son of Bartolommeo archpriest of Montepulciano in the year of our lord 1400...) The final figure on this painted text has been erased, but since the late nineteenth century the date has been regularly recorded as 1401.

5 Solberg, 'Taddeo di Bartolo', pp.486–98. For this scholar's detailed treatment of this altarpiece in all its aspects, see pp.137–9, 477–547. For a detailed photographic survey, see Barcucci, *Il trittico dell'Assunta*.

6 For various views on the date and provenance of this early altarpiece, see Norman, 'Duccio: the recovery of a reputation' [Chapter 3 in the companion volume to this one].

7 Charted by White, *Duccio*, pp.63–79; van Os, *Sienese Altarpieces*, I, pp.63–75. See also Maginnis, 'Pietro Lorenzetti: a chronology', pp.184–7.

8 For the patronage and iconography of this altarpiece, see Cannon, 'Simone Martini'; van Os, *Sienese Altarpieces*, I, pp.65–9.

9 Hills, *The Light of Early Italian Painting*, pp.101–2.

10 In the restoration of 1976 the modern vertical mouldings which separated the five main panels were removed. The original frame must, however, have included similar features. The modern mouldings which divided the scene of *The Annunciation* have also been removed, thereby revealing Pietro's original division by means of a painted pier. See the plausible reconstruction of the original format of the altarpiece in *Arte nell'Aretino*, p.34.

11 Solberg, 'Taddeo di Bartolo', pp.500–1. As noted by Solberg, pp.497–8, certain ornamental details on the frame are probably the result of restoration dating to the beginning of the twentieth century.

12 As described in Vasari, *Le vite*, ed. Bettarini, II, p.145.

13 As set out in the 1310 decree of the Synod of Trier, quoted in von Simpson, 'Über die Bedeutung von Masaccios Trinitäts-fresko', p.122, n.9.

14 The Pieve in Arezzo is still known as Santissima Maria del Pieve. The present cathedral in Montepulciano is dedicated to the Virgin of the Assumption. It is not known whether the early Pieve shared in this dedication.

15 As stated in the original contract of 1320.

16 Van Os, *Sienese Altarpieces*, I, p.71.

17 Van Os, *Sienese Altarpieces*, II, p.151, Solberg, 'Taddeo di Bartolo', pp.501–4.

18 For a useful discussion of the methodological implications of studying the Renaissance altarpiece as a genre, see van Os, *Sienese Altarpieces*, II, pp.19–24, reprinted in Humfrey and Kemp, *The Altarpiece in the Renaissance*, pp.21–33. See also Kemp's perceptive comments in the 'Introduction' to this volume.

19 Solberg, 'Taddeo di Bartolo', pp.525–35.

20 Waley, *Siena and the Sienese*, pp.162–3.

21 Benci, *Storia di Montepulciano*, pp.49–77; van Os, *Sienese Altarpieces*, II, p.151.

22 From at least the 1360s onwards, these altarpieces were situated on the eastern side of the north and south transepts and in the eastern extension to the north and south transepts. The altars of Saints Sabinus and Crescentius faced one another across the transept proper, while the altars of Saints Ansanus and Victor were situated in the eastern extensions of the north and south transepts. See the plan given by Aronow, 'A description of the altars in Siena Cathedral', p.226.

23 Signed and dated 1342. There are records (cited in Beatson *et al.*, 'The St. Victor altarpiece', p.610, n.1) of payments of 1335 by the Opera del Duomo to the painter and to master Ciecho (to the latter for the translation of the story of Saint Sabinus from Latin). A panel in the National Gallery, London, *Saint Sabinus before a Governor*, has been plausibly identified as part of the original predella of this altarpiece. The presence of side panels depicting Saints Sabinus and Bartholomew is verified by entries in cathedral inventories of 1429 and 1446.

24 Signed and dated 1333. There are records of payments to the painters in probably 1330 and 1332 (as argued in Frederick, 'The dating of Simone Martini's S. Ansano altar-piece'). For an illustration of this altarpiece in its nineteenth-century frame, see Norman, 'The three cities compared' [Chapter 1 in the companion volume to this one]. For a reconstruction of its original frame, see Cämmerer-George, *Die Rahmung der toskanischen Altarbilder*, pp.575–6: it may have had a predella. For identification of the female saint as Massima, mother of Ansanus, see Beatson *et al.*, 'The St. Victor altarpiece', p.610, n.2.

25 For the reconstruction of the Saint Victor altarpiece, see Frederick, 'A program of altarpieces'; van Os, *Sienese Altarpieces*, I, pp.85–7, albeit with the female saint identified as Catherine of Alexandria; Beatson *et al.*, 'The St. Victor altarpiece', where she is more plausibly identified as Victor's fellow martyr Corona. The present locations of the paintings are *The Nativity and Adoration of the Shepherds with Saints* (Cambridge, Mass., Fogg Art Museum); *Saint Victor* and *Saint Corona* (Copenhagen, Statens Museum for Kunst); *The Crucifixion* (Paris, Louvre); *The Blinding of Saint Victor* (Frankfurt, Städelsches Kunstinstitut).

26 Signed and dated 1342. There are records (cited in Beatson *et al.*, 'The St. Victor altarpiece', p.610, n.1) of payment in 1339 for a predella. The presence of side panels depicting Saint Crescentius and the Archangel Michael is verified by entries in the cathedral inventory of 1458. For an illustration of this altarpiece, see Norman, 'Change and continuity' [Chapter 9 in the companion volume to this one].

27 For a very thorough exploration of this trend in fourteenth and fifteenth-century Sienese painting, see van Os, *Sienese Altarpieces*, II, pp.99–128.

28 As compellingly rehearsed in Meiss, *Painting in Florence and Siena after the Black Death*.

29 At the outer edges of the panel are long grooves in which wooden dowels would have been placed in order to attach the lateral panels to the central panel. See van Os, *Sienese Altarpieces*, I, p.80.

30 Van Os, *Sienese Altarpieces*, I, p.82, plausibly suggests that the monumental figure of Anne might be derived from contemporary sculpture.

31 This development is traced in greater detail in van Os, *Marias Demut*, ch.4, pp.145–85, and *Sienese Altarpieces*, II, pp.140–51.

32 Van Os, *Marias Demut*, p.166, believes that this small painting may reflect a lost prototype by Lippo Memmi's brother-in-law and close associate Simone Martini.

33 Solberg, 'Taddeo di Bartolo', p.520.

34 For a detailed account of this altarpiece's commission and its modern reconstruction, see Freuler, 'Bartolo di Fredis Altar ... in Montalcino'; Harpring, *The Sienese Trecento Painter Bartolo di Fredi*, pp.87–102, cat. nos15–23, pp.153–5. The altarpiece would have been framed by two painted wooden statues of the Virgin Annunciate and the Archangel Gabriel, attributed by Freuler to Angelo di Nalduccio.

35 The frame in which the altarpiece is now displayed is fifteenth-century in date. See Chapter 8.

36 For a well-informed account of the physical structure and make-up of this altarpiece, its modern reconstruction, and a transcription of the accounts for its commission, see Bomford *et al.*, *Art in the Making*, cat. no.8, pp.156–89, Appendix III, pp.197–200. On both documentary and stylistic evidence, it appears that Jacopo di Cione was the main executant of the altarpiece while Niccolò di Pietro Gerini played a secondary role in its design. Two other painters named in the documents apparently only made very minor contributions to the completion of the altarpiece and its installation.

37 Trexler, *Public Life in Renaissance Florence*, p.273. See also Chapter 11.

38 King, 'Medieval and Renaissance matrons', p.375. It should be noted, however, that in 1383 the Albizzi made what appears to be a final payment for the altarpiece. This influential local family (who had the patronage of five chapels in the church) may therefore have had patronal rights over the high altar of San Pier Maggiore. See Gordon in Davies, *The Early Italian Schools Before 1400*, p.53; Bomford *et al.*, *Art in the Making*, p.156.

39 Probably identifiable as the bishop saint third from the left in the second row and the female saint on the extreme left of the fifth row. See Gordon in Davies, *The Early Italian Schools Before 1400*, p.46.

40 Namely, the Feasts of Saint Peter in Prison, the Chairing of Saint Peter, and the Martyrdom of Saints Peter and Paul. See Offner *et al.*, *Corpus*, 4, VII, p.32.

41 This point is also noted in Solberg, 'Taddeo di Bartolo', pp.238, 798–805.

42 Solberg, 'Taddeo di Bartolo', pp.121–2.

43 Bourdua, 'Aspects of Franciscan Patronage', pp.18–19. This sculpted and painted scheme is illustrated in King, 'The arts of carving and casting' [Chapter 5 in the companion volume to this one].

44 D'Arcais, *Guariento*, pp.74–5. For documents relating to the painter's property transaction in Piove di Sacco and dealings with Fra Alberto, see docs7, 8, p.51.

45 White, 'The reconstruction of the polyptych ascribed to Guariento'.

46 While 'northern' in format, it is apparent that in terms of the organization of the painted narrative of the altarpiece, Guariento had studied Giotto's narrative scheme in the Arena Chapel in Padua. See White, 'The reconstruction of the polyptych ascribed to Guariento', pp.525–6.

47 The altarpiece's ornate frame is generally well preserved but the altarpiece itself has lost its central pinnacle panel of *The Crucifixion*. See Muraro, *Paolo da Venezia*, pp.64–5, 127–8.

48 For a discussion of the altarpiece and its iconography, see Delaney, 'Giusto de'Menabuoi', pp.237–41, 377–9; Bellinati, 'Iconografia e teologia', p.79–81.

49 Solberg, 'Taddeo di Bartolo', p.546.

50 Solberg, 'Taddeo di Bartolo', p.511.

51 *Scultura dipinta*, entry by A. Bagnoli, p.111, n.24.

52 Solberg, 'Taddeo di Bartolo', pp.544–5; see also Norman, 'The case of the *beata Simona*'.

53 Van Os, *Sienese Altarpieces*, II, pp.150–1; Solberg, 'Taddeo di Bartolo', pp.501–2.

54 Lightbown, *Donatello and Michelozzo*, I, p.145; Solberg, 'Taddeo di Bartolo', pp.501–11.

55 Solberg, 'Taddeo di Bartolo', p.503.

56 For example, in the painted lunette over the now lost tomb of Fina Buzzacarina in the Baptistery of Padua, one of the city's major patron saints, Daniel, is shown holding a simple model of the city. Other examples are Meo da Siena's painting of the patron saint of Perugia, Ercolano, with a model of the city in his hands; Tommaso da Modena's mural in Santa Caterina, Treviso, of *Saint Catherine of Alexandria with Treviso*; and Taddeo di Bartolo's own altarpiece for the Pieve of San Gimignano which depicts the enthroned Saint Geminianus with a model of the town in his lap. These three examples are all illustrated in Frugoni, *A Distant City*, pls38, 39, 41.

57 Symeonides, *Taddeo di Bartolo*, p.91.

58 Pope-Hennessy, *The Portrait in the Renaissance*, pp.3–4; Symeonides, *Taddeo di Bartolo*, p.91; van Os, *Sienese Altarpieces*, II, pp.149–50; cf. Solberg, 'Taddeo di Bartolo', p.519.

CHAPTER 10

1 Matteo Villani, *Cronica*, bkI, ch.8, p.17.

2 See Rashdall, *The Universities of Europe in the Middle Ages*, I, p.87–139, 233–52. For the foundation and early history of Florence's *studium*, see Brucker, 'Florence and its university', pp.220–36.

3 Becherucci, in Becherucci and Brunetti, *Il Museo dell'Opera del Duomo a Firenze*, I, p.233.

4 The identification of the subject-matter of the sculpted reliefs on the campanile in this essay follows that of Julius von Schlosser's seminal essay, 'Giusto's Fresken in Padua und die Vorläufer des Stanza della Segnatura', pp.53–76. See also Becherucci, in Becherucci and Brunetti, *Il Museo dell'Opera del Duomo*, I, pp.233–4. It should be noted, however, that because the mechanical arts are out of sequence and interspersed with other subjects, Evans, 'Allegorical women and practical men', p.325, remains unconvinced that the reliefs represent the mechanical arts.

5 *Painting* is carved on two pieces of marble. Gilbert, 'Review of Trachtenberg, *The Campanile*', pp.430–1, argues convincingly that the door on the east face was once smaller, allowing for *Sculpture* and the right half of *Painting* to be situated on this side of the campanile. When the door was later enlarged, these two reliefs were removed and only installed on the north face when Luca della Robbia's five fifteenth-century reliefs representing exponents of various kinds of intellectual pursuit were completed. Luca della Robbia was probably responsible, therefore, for the triptych represented on the right-hand portion of *Painting*.

6 See Becherucci, in Becherucci and Brunetti, *Il Museo dell'Opera del Duomo*, I, pp.241–5; Pope-Hennessy, *Italian Gothic Sculpture*, 2nd edn, pp.191–2; Trachtenberg, *The Campanile of Florence Cathedral*, pp.50, 86.

7 This parallel is noted in Moskowitz, *The Sculpture of Andrea and Nino Pisano*, pp.32–3.

8 For further discussion of this point, see Norman, 'Civic patronage of art' and 'Art and learning' [Chapters 7 and 10 in the companion volume to this one].

9 For the proposed identification of Minerva, see Trachtenberg, *The Campanile of Florence Cathedral*, p.94; Moskowitz, *The Sculpture of Andrea and Nino Pisano*, p.38; cf. Evans, 'Allegorical women and practical men', pp.327–8, who proposes the alternative identification of the biblical Naamah, Lamech's daughter (Genesis 4:22), traditionally believed to be the inventor of weaving. Vasari, in his *Lives of the Artists*, first proposed the identification of Phidias and Apelles.

10 Von Schlosser, 'Giusto's Fresken in Padua', p.76, see also Trachtenberg, *The Campanile of Florence Cathedral*, pp.88, 93–6.

11 Around 1566 the Spanish community in Florence was given permission to use the chapter-house and its chapel for private devotions, hence the present name of the Spanish Chapel.

12 See the extracts printed in Offner *et al.*, *Corpus*, 4, VI, p.17.

13 For a transcription of the inscription on the tomb slab, see Gardner, 'Andrea di Bonaiuto and the chapterhouse frescoes', p.109.

14 Gardner, 'Andrea di Bonaiuto and the chapterhouse frescoes', p.120.

15 See Romano, 'Due affreschi del Cappellone degli Spagnoli'; Borsook, *The Mural Painters of Tuscany*, pp.48–54; Gardner, 'Andrea di Bonaiuto and the chapterhouse frescoes'; Offner *et al.*, *Corpus*, 4, VI, pp.18–19.

16 The identification of the figures represented in *The Triumph of Saint Thomas Aquinas* follows closely that of von Schlosser in 'Giusto's Fresken in Padua', pp.44–52. See also Meiss, *Painting in Florence and Siena after the Black Death*, ch.4, pp.94–104; Borsook, *The Mural Painters of Tuscany*, pp.49–50; Romano, 'Due affreschi del Cappellone degli Spagnoli', pp.182–99; Offner *et al.*, *Corpus*, 4, VI, pp.22–31.

17 Wisdom VII:7–8. In translation the Latin inscription reads: 'Therefore I prayed and understanding was given to me, I called upon God, and the spirit of Wisdom came to me.' These verses are used for the opening of the Mass for the feast day of Saint Thomas Aquinas (7 March).

18 The first known author to identify these figures thus was Vasari in the first edition of *Lives of the Artists* (1550). However, circumstantial evidence for the accuracy of Vasari's identification occurs in a fifteenth-century painting executed within the circle of the Dominican painter Fra Angelico. In this painting three figures closely resembling those in *The Triumph of Saint Thomas Aquinas* are clearly labelled as Arius, Averroes and Sabellius. The reasons why these three persons would have been particularly apt are these. Arius (*c*.260–330) was an early Christian writer whose anti-Trinitarian views were condemned as heretical by the early Church. Averroes (1126–98) was a Muslim writer who wrote extensive and highly influential commentaries on the works of Aristotle. Sabellius was a third-century Roman writer whose views on the Trinity were also condemned by the Church. Aquinas in his theological works took issue with all three writers and, in particular, with Averroes, whose views on the unity of the human intellect and the

consequent lack of necessity for personal immortality Aquinas vigorously disputed in his work *The Treatise against the Averroists on the Unity of the Intellect*.

19 Published in Trachtenberg, *The Campanile of Florence Cathedral*, doc.44, p.182.

20 The *Centiloquio*, written in 1373, was a versification of Giovanni Villani's chronicle of Florence. The relevant extract is published in Trachtenberg, *The Campanile of Florence Cathedral*, p.206.

21 Trachtenberg, *The Campanile of Florence Cathedral*, p.27. This author also associates the beautifully executed and highly finished fourteenth-century drawing of a campanile, now housed in the Museo dell'Opera del Duomo in Siena (Chapter 6, Plate 157), with Giotto and the campanile project. For a more cautious and judicious assessment of the drawing's relationship to Giotto and the Florentine Campanile, see Chapter 6 and White, *Art and Architecture in Italy*, pp.244–6.

22 Published in Trachtenberg, *The Campanile of Florence Cathedral*, doc.57, p.184.

23 In Trachtenberg's view (*The Campanile of Florence Cathedral*, chs2 and 3, pp.21–84), during Giotto's period of office the campanile was erected to the level of the lower base, and on supporting walls that were too thin. Subsequently, Andrea Pisano had to reinforce the campanile by building a 'skin' of walls inside it. Cf. Kreytenberg, 'Der Campanile von Giotto', who argues that the base of the campanile was constructed as a single architectural project. According to Kreytenberg, during Giotto's period of office the exterior walls, covered in marble, were erected to the height of the lower zone of the base and the inner walls to the height of the niches. From 1337 Andrea Pisano continued the construction according to Giotto's design, but it was as a consequence of the sculptor's attempt to deviate from the design that he was dismissed around 1343.

24 Cf. Becherucci, in Becherucci and Bettini, *Il Museo dell'Opera del Duomo*, pp.241–5, esp.p.243, who argues that the campanile sculptures were not carried out by working round the structure from the base upwards, but rather that the reliefs on the entire west face (including those of the prophets) were executed in a single campaign. The sculptor returned to Florence in 1348 to continue work on the south face of the campanile until his death in about 1350.

25 Trachtenberg, *The Campanile of Florence Cathedral*, pp.98–104.

26 See Chapter 4.

27 For more detailed analysis of the fountain's sculpture, see Pope-Hennessy, *Italian Gothic Sculpture*, 2nd edn, pp.172–4, 274; White, *Art and Architecture in Italy*, pp.88–91.

28 For more detailed analysis of the Pisa Duomo pulpit, see Pope-Hennessy, *Italian Gothic Sculpture*, 2nd edn, pp.177–9, 275; White, *Art and Architecture in Italy*, pp.133–9. For the three other pulpits, see Pope-Hennessy, *Italian Gothic Sculpture*, 2nd edn, pp.170–2, 177, 274–5; White, *Art and Architecture in Italy*, pp.74–88, 122–130.

29 The dating of this sculpted scheme is highly problematic, but it appears that a number of the capitals were executed in the mid decades of the fourteenth century. See Wolters, *La scultura veneziana*, I, pp.43–4, 173–8.

30 See Chapter 7.

31 See the extracts printed in Offner *et al.*, *Corpus*, 4, VI, p.10.

32 Offner *et al.*, *Corpus*, 4, VI, pp.19–20.

33 Gardner, 'Andrea di Bonaiuto and the chapterhouse frescoes', p.120.

34 Gardner, 'Andrea di Bonaiuto and the chapterhouse frescoes', pp.111–12, 119.

35 See, for example, Antal, *Florentine Painting and its Social Background*, p.199; Offner *et al.*, *Corpus*, 4, VI, p.17.

36 For example, Meiss, *Painting in Florence and Siena after the Black Death*, p.102, suggests that the programme for the chapter-house murals was worked out in the *studium* of Santa Maria Novella, probably in consultation with the painter.

37 Gardner, 'Andrea di Bonaiuto and the chapterhouse frescoes', pp.120–1.

38 Offner *et al.*, *Corpus*, 3, II, part 1, p.46. The other paintings on this panel are: *The Virgin and Child between Saint Peter Martyr and a Bishop Saint*; *The Nativity*; *The Crucifixion* and, in the gable, *The Last Judgement*. The prominence of two major Dominican saints on the panel suggests a Dominican setting for the painting.

39 In medieval Latin the word *cathedra* was commonly used for the chair from which the professor or master lectured. See Niermeyer, *Mediae Latinitatis Lexicon Minus*, p.158.

40 For a discussion of the style, authorship and dating of this panel, see Meiss, 'The problem of Francesco Traini'; Coor, 'Two unknown paintings by the Master of the *Glorification of Saint Thomas*'; Mallory, 'Thoughts concerning the "Master of the Glorification of Saint Thomas"'.

41 This puzzling form consists of five concentric circles, painted in gradations of reddish purple and enclosed in a wide black circle. For Romano, 'Due affreschi del Cappellone degli Spagnoli', p.187, it represents the seven planetary spheres. There are, however, only five spheres (or six, if the black circle is counted).

42 The authorship of the hexagonal and lozenge-shaped reliefs is very controversial. For example, Kreytenberg, *Andrea Pisano und die Toskanische Skulptur*, distributes the work between Andrea Pisano, his son Nino Pisano, the anonymous 'Noah Master', the 'Armatura' Master, the 'Luna' Master, the 'Saturn Master', the documented Gino Micheli da Chastello and Maso di Banco (better known as a painter). Moskowitz, *The Sculpture of Andrea Pisano*, meanwhile, more sensibly divides the sculptures between Andrea Pisano, members of his workshop, and members of the cathedral workshop, among whom the sculptor Arnolfo Arnoldi might have featured.

43 See King, 'Luke the Evangelist as artist and physician', p.252.

44 For a very thorough analysis of the classicism of the campanile reliefs and the kinds of antique sources that Andrea Pisano and his workshop might have utilized, see Moskowitz, 'Trecento classicism and the campanile hexagons'.

45 See Offner *et al.*, *Corpus*, 4, VI, p.22, n.5 and p.24, n.12. In support of such an identification for this figure, it is significant that the figure of Plato in the Pisan *Triumph of Saint Thomas Aquinas* is also represented as bearded and with a mantle over his head (Plate 285).

46 As argued by Meiss, *Painting in Florence and Siena after the Black Death*, ch.4, pp.94–104, in his analysis of the chapter-house mural scheme.

47 Gardner, 'Andrea di Bonaiuto and the chapterhouse frescoes', pp.119–20.

CHAPTER 11

1 I have found no fourteenth-century evidence for the statements in this sentence, but can only extrapolate from the few instances I have traced so far in the following hundred years or so.

2 Women's commissioning of small devotional tryptychs and illuminated manuscripts – where these can be identified as for women who were not entering a convent – would be an interesting field in which to attempt to gather data.

3 For example, Margareta, wife of Cino da Pistoia, was left all the household furnishings, her jewelled belts and girdles, and her and his linen by her husband; see Ciampi, *Vita*, pp.145–6.

4 Barberino, *Reggimento*, p.11: 'quando sta fra gente gli occhi suoi lievi poco, però che nel guardare si coglie tosto, dall uomo che è ben saggio, lo intendimento dell'atrui cavaggio'.

5 Barberino, *Reggimento*, p.13: 'occhi chinati'.

6 Barberino, *Reggimento*, p.14: 'panni chiusa, cogli occhi bassi e umile sembianza'.

7 Barberino, *Reggimento*, p.24: 'balcone, finestra, uscio, chiostro'.

8 Barberino, *Reggimento*, pp.122–8.

9 Barberino, *Reggimento*, p.158: 'quelle che vegnono a parlare istian tementi tutte e vergognose'.

10 Barberino, *Reggimento*, pp.155–70.

11 King, 'Goddess and captive', pp.103–27. Dominici, *Regola del governo di cura familiare*, *passim* but especially p.122.

12 Bellomo, *La condizione giuridica della donna in Italia*.

13 Foster-Baxendale, 'Exile in practice', pp.720–56.

14 Pertile, *Storia del diritto Italiano*, p.239: in areas where Roman law pertained like the Veneto, Genoa and Rome, Pertile found no use of the *mundualdus*. Thomas Kuehn considered its implications in fifteenth-century Florence. See Kuehn, '"Cum consensu mundualdo"', pp.309–33.

15 *The Galleria dell'Accademia*, p.90, inv. no.1890, n.8606.

16 Offner *et al.*, *Corpus*, 4, V, pp.107–14.

17 Chojnacki, 'Patrician women in early Renaissance Venice', pp.176–203.

18 Herklotz, *Sepulcra e monumenta del medioevo*, pp.191–2 lists pagan Roman examples of female donors.

19 Bellosi *et al.*, *Arte in Valdichiana dal XIII al XVIII secolo*. The dating and attribution are discussed in *Mostra di opere d'arte restaurate nelle province di Siena e Grosseto*, III, pp.37–40.

20 I am indebted to Charles Cooper and Dr Colin Cunningham for drawing my attention to this muralled chapel. Fanti, *Guida storico-artistica della città di Montalcino*, p.37.

21 Spiazzi, 'Padova', p.112 dates *The Crucifixion* to c.1332.

22 D'Arcais, *Guariento*, p.58: 'EMULATRIX BONA MARIA BOVOLINORUM HELENAE INVENTRICIS CRUCIS ET CLAVORUM SANCXIT HANC IPSA PIETATE BASSANORUM UT ORENT PRO EA CRISTUM DOMINUM NOSTRUM.'

23 Hueck, 'Stifter und Patronatsrecht', pp.263–70. The author points out that Pietro's brother Andrea acquired the castle of Mangona at about the same time, and considers that either or both brothers could be the commissioners of the tombs.

24 Ladis, *Taddeo Gaddi*, pp.136–41. The other Marys included Mary the wife of Cleophas and Mary the mother of James.

25 Bettini, *Giusto de'Menabuoi*, pp.102–3, 138, n.4: 'FUIT HAEC CAPELLA CONSTRUCTA IN HONOREM BEATISSIMI LUDOVICI PER ILLUSTREM ET GENEROSAM DOMINAM FINAM DE BUZZACARINIA BONAE MEMORIAE OLIM CONSORTEM MAGNIFICI DOMINI FRANCISCI SENIORIS DE CARARIA, ET HISTORIATA PER EIUS SOROREM GERMANAM DOMINAM BUCACARINAM RELIGIOSAM ET VENERABILEM ABBATISSAM HUIUS SACRI ET COLENDI LOCI OB DEVOTIONEM ET INTUITUM PRAELIBATA DOMIN[A]E FIN[A]E QUONDAM DOMIN[A]E HUIUS ALM[A]E EGREGI[A]E CIVIT[AT]IS. IN MCCCLXXXXIV DE MENSE AUGUSTI COMPLETA.' The pre-bombing state with the murals partly intact is shown in pls155–6, 158–65. The Apocalypse is very attenuated in comparison with that in the baptistery.

26 See King, 'Medieval and Renaissance matrons', pp.377–8, n.11 for the Latin.

27 King, *Le donne nel rinascimento in Italia*, p.152.

28 McCulloch, *Medieval Latin and French Bestiaries*, p.156. The mother pelican pierces her side and sheds her blood over her dead chicks, thus reviving them.

29 The interpretation of the baptistery decoration as intended to accompany the annual liturgy, with special reference to the blessing of the baptismal waters, as well as the theology of salvation is pursued at greater length in the BBC/Open University television programme, *The Baptistery, Padua*.

30 Bettini, *Giusto de'Menabuoi*, p.108. The abbess was described in her tomb inscription of 1398 as 'a learned virago in her dealings' ('PERAGENDIS DOCTA VIRAGO'). King, *Le donne nel rinascimento in Italia*, pp.183–277 has explored the association between the scholarly woman and the virago at this period.

31 Cercano di Varese, *La chiesa di santa Chiara*, *passim*, pp.24–8.

32 *Storia di Napoli*, p.228.

33 Musto, 'Queen Sancia and the spiritual Franciscans', pp.181, 190.

34 'CERNITE ROBERTUM REGEM VIRTUTE REFERTUM.'

35 An interesting question to research would be how far the second-order were superior to the third-order communities in commissioning art. Canosa, *Il velo e il cappuccio*, offers a good introduction to the complexities of the different female orders before the Council of Trent.

36 Fiorelli-Malesci, *La chiesa di santa Felicità a Firenze*, p.312.

37 Fiorelli-Malesci, *La chiesa di santa Felicità a Firenze*, *passim* but especially pp.20–64 for discussion and analysis, pp.291–323 for documentation.

38 Visitations were periodic 'spiritual audits' conducted by bishops to examine a community's adherence to the rules of the religious life.

39 Fiorelli-Malesci, *La chiesa di santa Felicità a Firenze*, p.64.

40 Fiorelli-Malesci, *La chiesa di santa Felicità a Firenze*, pp.251–9.

41 Fiorelli-Malesci, *La chiesa di santa Felicità a Firenze*, p.152.

42 Fiorelli-Malesci, *La chiesa di santa Felicità a Firenze*, p.152: 'QUESTA TAVOLA FECE FARE IL CAPITOLO CONVENTO DEL MONISTERIO DI SANTA FELICITÀ DE DENARI DEL DETTO MONISTERIO AL TEMPO DELLA BADESSA LORENZA DE'MOZZI ANNO DOMINI MCCCCI.'

43 Fiorelli-Malesci, *La chiesa di santa Felicità a Firenze*, p.293.

44 Pächt and Alexander, *Illuminated Manuscripts in the Bodleian Library*, p.17, no.168.

45 Paatz, *Die Kirchen von Florenz*, IV, p.52.

46 Cocchi, *Le chiese di Firenze*, I, pp.97–105. The church collapsed in the eighteenth century. For the ceremonies of 1286, 1301 and 1383, see pp.102–3. The account books of the convent recorded the expenses of providing food, fodder and the materials for the new bishop's bed. The details of the ceremony varied, but the basic exchange seems to have been the horse and the ring for the bed. The ceremony of 1400 is described in *L'osservatore fiorentino su gli edifizi della sua patria*, pp.91–104:

> Domenica mattina à 30 di Maggio 1400 sposò Mess. lo Vescovo, e donò alla Badessa di S. Pietro il cavallo suo; e similmente tutti gli altri sposarono, e sonando le trombe entrò in S. Pietro, e in sulla porta erano due Parati, e l'uno dava l'acqua benedetta, l'altro l'incenso; e andarono per Chiesa dentro nel Monistero. Ivi era acconcio e ordinato molto bene. Ivi sedea la Badessa e più là erano tutte le altre Monache ginocchioni; e ivi come giunse alla Badessa, la Badessa si gettò inginocchioni, e baciogli la mano. Poi si posero a sedere insieme, e fatto e detto quello che ò d'usanza, si la sposò e diegli l'anello. Poi se ne venne in Coro, e andò all'Altare, e orò e baciollo, poi ritornò in giù, e in mezzo del Coro era fatto un bello letto, e ivi si pose suso a sedere, e stette un poco, e la Badessa donò esso letto al Vescovo predetto, come è usanza.

47 Gronau, 'The San Pier Maggiore altarpiece', provides a transcription of the account books for 1370–71. Bomford *et al.*, *Art in the Making*, p.156: 'aiuto alla tavola dell'altare maggiore'. Davies, *The Early Italian Schools Before 1400*, pp.45–54.

48 Pallassini, *Il monastero e la chiesa delle monache di s. Paolo in Siena*, pp.1–18.

49 'JUSTUS PINXIT. HOC OPUS FECIT FIERI DOMINA SOROR YXOTTA FILIA QUONDAM DOMINI SIMONIS DE TERCAGO MCCCLXIII MENSIS MARCI': Bettini, *Giusto de'Menabuoi*, p.110; Davies, *The Early Italian Schools Before 1400*, pp.40–1. This polyptych is now divided between the Schiff-Giorgini Collection in Rome and the Kress Study Collection at the University of Georgia Museum of Art, Athens, Georgia. The surviving side panels showing Saints Anthony Abbot, Thomas Aquinas, John the Baptist, Catherine of Alexandria, Paul and Augustine are in the Kress Study Collection.

50 Spiazzi, 'Giusto a Padova', pp.84–5;. Delaney, 'Giusto de'Menabuoi in Lombardy', pp.19–35, figs1–6. Delaney considered the habits of the donors were those of third-order regular Dominicans. Further items were identified by Roberto Longhi – a three-quarter-length figure of Saint Cecily and six small roundels with Dominican saints among them. See Longhi, 'Calepino Veneziano', pp.79–90.

51 *Mostra di opere d'arte restaurate nelle province di Siena e Grosseto*, II, p.41, no.11. The panel was in the refectory of Santa Chiara in 1865.

52 Mattessini, *Le origini del Terz'ordine francescano*, pp.25–6 shows that the clothing regulations were quite broad. Women were to wear inexpensive, drab clothing without elaborate pleating. Silk was forbidden but linen and sackcloth, as well as lambskin, were permitted. Saint Humility (Plate 316) has a lambskin on her head as her head-dress.

53 D'Arcais, *Guariento*, pp.62–3. As argued by D'Arcais, 'Alberto' may have been the archpriest of San Martino at Piove di Sacco, who is mentioned in Paduan archives in relation to Guariento. I am indebted to Gloria Williams, curator of the Norton Simon Foundation, for her meticulous report (4 April 1994) and to Tony Coulson for encouragement in the investigation.

54 Cited in Becherucci, *I musei di santa Croce e di santo Spirito*, pp.163–5.

55 Rossetti, *La beata Angelina dei Conti di Monteriggione*, p.242 described the rule of the tertiary regulars at Foligno which quoted San Bernardo: 'Quando mangi non magnate con tutto l'anima, ma attendete alla lettione, accioché l'anima insieme col corpo sia refettionata.' (When you eat do not eat with all your soul, but listen to the reading so that at the same time the body and the soul may be refreshed.)

56 Torriti, *La casa di santa Caterina e la basilica di san Domenico a Siena*, pp.40–2. Saint Catherine received the stigmata in 1375.

57 'HEC SUNT MIRACULA BEATE HUMILITATIS PRIME ABBATISSE ET FUNDATRICIS HUIUS VENERABILIS MONASTERI ET IN ISTO ALTARI EST CORPUS EIUS.'

58 Cited in Volpe, *Pietro Lorenzetti*, pp.174–84.

Bibliography

PRIMARY SOURCES

ALIGHIERI, DANTE, *The Divine Comedy*, trans. and ed. J.D. Sinclair, 2nd edn, Oxford and New York, 1961, 3 vols.

ANONYMOUS, in *Cronache senesi*, ed. A. Lisini and F. Iacometti, in *Rerum Italicarum Scriptores*, n.s., XV, 6, 1, Città di Castello, 1931–39, 2 vols.

BARBERINO, FRANCESCO DA, *Reggimento e costumi di donna*, ed. G.E. Sansoni, Turin, 1957.

BENVOGLIANTI, BARTOLOMMEO, *De Urbis Senae Origine et Incremento*, Rome, 1621.

BERNARDINO, SAINT, *Le prediche volgari di San Bernardino dette nella Piazza del Campo l'anno MCCCCXXVII*, ed. L. Banchi, Siena, 1880–88, 3 vols.

BOCCACCIO, GIOVANNI, *The Decameron*, trans. G.H. Macwilliam, Harmondsworth, 1972.

BORGHESE, SCIPIONE and BANCHI, LUCIANO (eds), *Nuovi documenti per la storia dell'arte senese*, Siena, 1898.

Breves officialium communis senensis (1250), ed. L. Banchi, in *Archivio storico italiano*, 3, 1866, pp.7–104.

CENNINI, CENNINO D'ANDREA, *The Craftsman's Handbook: The Italian 'Il libro dell'arte'*, trans. D.V. Thompson, Jr, 2nd edn, New York and London, 1954.

DA NONO, GIOVANNI, *Liber de Generacione Aliquorum Civium Urbis Padue*, see P. Rajna, 'Le origini delle famiglie padovane e gli eroi romanzi cavalereschi', *Romania*, IV, 1875.

DA NONO, GIOVANNI, 'Visio Egidii Regis Patavie', ed. G. Fabris, *Bollettino del Museo Civico di Padova*, n.s., 10–11 (27–28), 1934–39, pp.1–30.

DATI, GREGORIO, *Istoria di Firenze dall'anno 1380 all'anno 1405*, ed. L. Pratesi, Florence, 1902.

DE CAULIBUS, GIOVANNI (attrib.), *Meditations on the Life of Christ: An Illustrated Manuscript of the Fourteenth Century*, trans. I. Ragusa and ed. I. Ragusa and R.B. Green, Princeton, 1961.

DI TURA, AGNOLO, in *Cronache senesi*, ed. A. Lisini and F. Iacometti, in *Rerum Italicarum Scriptores*, n.s., XV, 6, 1, Città di Castello, 1931–39, 2 vols.

DI MONTAURI, PAOLO DI TOMMASO, in *Cronache senesi*, ed. A. Lisini and F. Iacometti, in *Rerum Italicarum Scriptores*, n.s., XV, 6, 1, Città di Castello, 1931–39, 2 vols.

DOMINICI, GIOVANNI, *Regola del governo di cura familiare*, ed. D. Salvi, Florence, 1980.

FERRARESE, RICCOBALDO, *Compilatio cronologica* (c.1312–18), Rome, 1474, fol.101v., in P. Murray, 'Notes on some early Giotto sources', *Journal of the Warburg and Courtauld Institutes*, 16, 1953, p.60, n.1.

GATARI, GALEAZZO, BARTOLOMMEO and ANDREA, *Cronaca carrarese*, ed. A. Medin and G. Tolomei, in *Rerum Italicarum Scriptores*, n.s., XVII, 1, Città di Castello, 1909–31.

GHIBERTI, LORENZO, *I Commentari*, in J. von Schlosser, *Lorenzo Ghibertis Denkwördigkeit*, Berlin, 1912.

GREGORY THE GREAT, *The Dialogues of Gregory*, trans. 'P.W.', Paris, 1608, ed. E.G. Gardner, London, 1911.

Il constituto del comune di Siena dell'anno 1262, ed. L. Zdekauer, Milan, 1897.

Il constituto del comune di Siena volgarizzato nel 1309–1310, ed. A. Lisini, Siena, 1903, 2 vols.

JOSEPHUS, FLAVIUS, *The Jewish War*, trans. and ed. G.A. Williamson, Harmondsworth, 1959.

KING, MARGARET, 'Goddess and captive: Antonio Loschi's epistolary tribute to Maddalena Scrovegni', *Medievalia et Humanistica*, 10, 1988, pp.103–27.

LATINI, BRUNETTO, *Li livres dou tresor*, ed. F.J. Carmody, Berkeley, 1948.

LATINI, BRUNETTO, *Il tesoretto* (1263), trans. and ed. J. Bolton Holloway, New York, 1981.

MILANESI, GAETANO, *Documenti per la storia dell'arte senese*, Siena, 1854–56, 3 vols.

PORTENARI, ANGELO, *Della felicità di Padova*, Padua, 1623.

ROLANDINUS, *Rolandini Patavini cronica … (c.1200–62)*, in *Rerum Italicarum Scriptores*, VIII, 1, Città di Castello, 1903, etc.

SCARDEONE, BARTOLOMMEO, *De Antiquitate Urbis Patavii et Claris Civibus Patavinis*, Basle, 1560.

THOMAS AQUINAS, SAINT, *Summa theologica, Secunda secundae*, Douai, 1614.

VASARI, GIORGIO, *Le vite de'più eccellenti pittori, scultori e architettori nelle redazioni del 1550 e 1568*, Volume II, *Testo*, ed. R. Bettarini, commentary P. Barocchi, Florence, 1966.

VASARI, GIORGIO, *Lives of the Artists*, abridged version, trans. and ed. J. Conaway Bondanella and P. Bondanella, Oxford, 1991.

VILLANI, GIOVANNI, *Cronica di Giovanni Villani a miglior lezione ridotta*, ed. F. Gherardi-Dragomanni and I. Moutier, Florence, 1845, 4 vols.

VILLANI, GIOVANNI, *Nuova cronica*, ed. G. Porta, Parma, 1990, 3 vols.

VILLANI, MATTEO, *Cronica di Matteo Villani a miglior lezione ridotta*, ed. F. Gherardi-Dragomanni and I. Moutier, Florence, 1846, 2 vols.

VORAGINE, JACOBUS DE, *The Golden Legend*, trans. and ed. G. Ryan and H. Ripperger, New York, 1948.

SECONDARY SOURCES

ALPATOFF, M., 'The parallelism of Giotto's Paduan frescoes', *Art Bulletin*, 29, 1947, pp.149–54, reprinted in *Giotto: The Arena Chapel Frescoes*, ed. J.H. Stubblebine, New York, 1969, pp.156–69.

ANTAL, F., *Florentine Painting and its Social Background*, London, 1948.

ARONOW, G., 'A description of the altars in Siena Cathedral in the 1420s', in H. van Os, *Sienese Altarpieces, 1215–1460: Form, Content, Function*, II, pp.226–42.

Arte nell'Aretino: dipinti e sculture restaurati dall XIII al XVIII secolo, entry by A.M. Maetzke, Florence, 1979–80.

BALESTRACCI, D. and PICCINNI, G., *Siena nel Trecento. Assetto urbano e strutture edilizie*, Florence, 1977.

BARASCH, M., *Giotto and the Language of Gesture*, Cambridge, 1987.

BARCUCCI, E., *Il trittico dell'Assunta nella Cattedrale di Montepulciano: pala d'altare di Taddeo di Bartolo*, Montepulciano, 1991.

BARGELLINI, P. et al., *Vita privata a Firenze nei secoli XIV e XV*, Florence, 1966.

BARZON, A., *Gli affreschi del Salone di Padova*, Padua, 1924.

BARZON, A., *I cieli e la loro influenza negli affreschi del Salone di Padova*, Padua, 1924.

BAUCH, K., *Das Mittelälterliche Grabbild Figurliche Grabmäler des 11 bis 15 Jahrhunderts in Europa*, Berlin, 1976.

BAXANDALL, M., *Giotto and the Orators: Humanist Observers of Painting in Italy and the Discovery of Pictorial Composition 1350–1450*, Oxford, 1971.

BEATSON, E.H., MULLER, N.E. and STEINHOFF, J.B., 'The St. Victor altarpiece in Siena Cathedral: a reconstruction', *Art Bulletin*, 68, 1986, pp.610–31.

BECHERUCCI, L., *I musei di santa Croce e di santo Spirito*, Milan, 1983.

BECHERUCCI, L. and BRUNETTI, G., *Il Museo dell'Opera del Duomo a Firenze*, I, Milan, 1969.

BECKER, M.B., *Florence in Transition*, Baltimore, 1967, 2 vols.

BELLINATI, C., 'Iconografia e teologia negli affreschi del Battistero', in *Giusto de'Menabuoi nel Battistero di Padova*, ed. A.M. Spiazzi, Trieste, 1989, pp.41–82.

BELLOMO, M., *La condizione giuridica della donna in Italia*, Turin, 1970.

BELLOSI, L. et al. (eds), *Arte in Valdichiana dal XIII al XVIII secolo*, Cortona, 1970.

BELLUCCI, G. and TORRITI, P., *Il Santa Maria della Scala in Siena, l'ospedale dai mille anni*, Siena, 1991.

BELTING, H., 'The new role of narrative in public painting of the Trecento: *historia* and allegory', *Studies in the History of Art*, 16, 1985, pp.151–68.

BENCI, S., *Storia di Montepulciano* (Florence, 1641), ed. I. Calabresi and P. Tiraboschi, Montepulciano, 1981.

BENZATO, D. and PELLEGRINI, F. (eds), *Da Giotto al Tardogotico. Dipinti dei Musei Civici di Padova del trecento e della prima metà del quattrocento*, Rome, 1989.

BENZATO, D. and PIETROGRANDE, E., 'Brevi note su Palazzo Zabarella', *Bollettino del Museo Civico di Padova*, 71, 1982, pp.71–8.

BERGER, J., *Ways of Seeing*, London, 1972.

BERRIGAN, J.R., 'A tale of two cities: Verona and Padua in the Late Middle Ages', in *Art and Politics in Late Medieval and Early Renaissance Italy, 1250–1500*, ed. C.M. Rosenberg, Notre Dame, 1990, pp.67–80.

BETTINI, S., *Giusto de'Menabuoi e l'arte del Trecento*, Padua, 1944.

BOMFORD, D., DUNKERTON, J., GORDON, D., ROY, A., with contributions from KIRBY, J., *Art in the Making: Italian Painting Before 1400*, London, 1989.

BORGIA, L. et al., *Le Biccherne: tavole dipinte delle magistrature senesi (secoli xiii–xviii)*, Rome, 1984.

BORSOOK, E., 'Notizie su due Cappelle in Santa Croce a Firenze', *Rivista d'arte*, 36, 1961–2, pp.89–106.

BORSOOK, E., *The Mural Painters of Tuscany from Cimabue to Andrea del Sarto*, 2nd edn, Oxford, 1980.

BORSOOK, E. and GIOFFREDI SUPERBI, F., *The Italian Altarpiece 1250–1550: History, Technique, Style*, Oxford, 1993.

BOURDUA, L., 'Aspects of Franciscan Patronage of the Arts in the Veneto during the Later Middle Ages', PhD thesis, University of Warwick, 1991.

BOWSKY, W.M., *A Medieval Italian Commune: Siena under the Nine 1287–1355*, Berkeley, Los Angeles and London, 1981.

BRANCA, V. (ed.), *Mercanti scrittori*, Milan, 1986.

BRANDI, C., *Il restauro della Maestà di Duccio*, Rome, 1959.

BRANDI, C. (ed.), *Il Palazzo Pubblico in Siena*, Milan, 1983.

BRATTÒ, O. (ed.), *Liber Estimationum, 1266, Goteborgs Universitets Arsskrift*, 62, 2, 1956, pp.3–164.

BRAUNFELS, W., *Mittelalterliche Stadtbaukunst in der Toskana*, Berlin, 1953.

BRAUNFELS, W., *Urban Design in Western Europe: Regime and Architecture, 900–1900*, 2nd edn, Chicago, 1988.

BRIDGEMAN, J., 'Ambrogio Lorenzetti's dancing "maidens": a case of mistaken identity', *Apollo*, 133, 1991, pp.245–50.

BRUCKER, G., 'Florence and its university, 1348–1434', in *Action and Conviction in Early Modern Europe: Essays in Memory of E.H. Harbison*, ed. T.K. Rabb and J.E. Seigel, Princeton, 1969, pp.220–36.

BRUCKER, G., 'The ciompi revolution', in *Florence and Italy: Renaissance Studies in Honor of Nicolai Rubinstein*, ed. P. Denley and C. Elam, London, 1988, pp.314–56.

BURCKHARDT, J., *Beiträge zur Kunstgeschichte von Italien*, ed. H. Trog, Basle, 1898.

BURCKHARDT, J., *The Altarpiece in Renaissance Italy*, trans. and ed. P. Humfrey, Oxford, 1988.

CAIROLA, A. and CARLI, E., *Il Palazzo Pubblico di Siena*, Rome, 1963.

CALORE, A., 'Case medioevale padovane a barbacani', *Bollettino del Museo Civico di Padova*, 63, 1974, pp.103–18.

CALORE, A., 'Nuove notizie sulle case dei Capodilista in Padova', *Bollettino del Museo Civico di Padova*, 61, 1972, pp.293–303.

CÄMMERER-GEORGE, M., *Die Rahmung der toskanischen Altarbilder im Trecento*, Strasbourg, 1966.

CANNON, J., 'Simone Martini, the Dominicans and the early Sienese polyptych', *Journal of the Warburg and Courtauld Institutes*, 45, 1982, pp.69–92.

CANOSA, R., *Il velo e il cappuccio: monacazioni forzate e sessualità nei conventi femminili in Italia fra Quattrocento e Settecento*, Rome, 1991.

CARLI, E., *Goro di Gregorio*, Florence, 1946.

CARLI, E., *Il duomo di Siena*, Genoa, 1979.

CAROCCI, G., *Studi storici sul centro di Firenze*, 2nd edn, Florence, 1988.

CENCI, G., 'Bonifacio di Lupi di Soragna e il Frati Minori', *Archivum Franciscanum Historicum*, 57, 1964, pp.90–109.

CERCANO DI VARESE, P.B., *La chiesa di santa Chiara*, Milan, 1913.

CESSI, R., 'Le prime sedi communali padovane', *Bollettino del Museo Civico di Padova*, 53, 1964, pp.57–80.

CHIERICI, G., 'La casa senese al tempo di Dante', *Bollettino senese di storia patria*, 28, 1921, pp.345–80.

CHOJNACKI, S.J., 'Patrician women in early Renaissance Venice', *Studies in the Renaissance*, 21, 1974, pp.176–203.

CHURCHILL, S.J.A., 'Giovanni Bartolo of Siena, goldsmith and enameller, 1364–85', *Burlington Magazine*, 10, 1907.

CIAMPI, S., *Vita e poesia di Messer Cino da Pistoia*, Pisa, 1813.

COCCHI, A., *Le chiese di Firenze, dal secolo IV al secolo XX*, Volume I, *Quartiere di San Giovanni*, Florence, 1903, 9 vols.

COOR, G., 'Two unknown paintings by the Master of the *Glorification of Saint Thomas*', *Pantheon*, 19, 1961, pp.126–35.

D'ARCAIS, F., *Guariento: tutta la pittura*, 3rd edn, Venice, 1980.

D'ARCAIS, F., 'Jacopo da Verona e la decorazione della Cappella Bovi in S. Michele a Padova', *Arte veneta*, 27, 1973, pp.9–24.

D'ARCAIS, F., 'La decorazione della Cappella di San Giacomo', in *Le pitture del Santo di Padova*, ed. C. Semenzato, Vicenza, 1984.

DAVIDSOHN, R., *Forschungen zur Geschichte von Florenz*, Berlin, 1908, 4 vols.

DAVIES, M., *The Early Italian Schools Before 1400*, revised by D. Gordon, London, 1988.

DE ANGELIS, A., 'Ambrogio Lorenzetti's dancing maidens', *Apollo*, 134, 1991, p.142.

DE VICCHI, M., 'L'architettura gotica senese', *Bollettino senese di storia patria*, 56, 1949, pp.3–52.

DELANEY, JR, B.J.,'Giusto de'Menabuoi: Iconography and Style', PhD thesis, Columbia University, 1972.

DELANEY, JR, B.J., 'Giusto de'Menabuoi in Lombardy', *Art Bulletin*, 58, 1976.

DEUCHLER, F., *Duccio*, Milan, 1984.

DEUCHLER, F., 'Duccio *Doctus*: new readings for the *Maestà*', *Art Bulletin*, 61, 1979, pp.541–9.

EDWARDS, M.D., 'The Chapel of S. Felice in Padua as *Gesamtkunstwerk*', *Journal of the Society of Architectural Historians*, 47, 1988, pp.160–76.

EVANS, M., 'Allegorical women and practical men: the iconography of the *Artes* reconsidered', in *Medieval Women*, ed. D. Baker, Oxford, 1978, pp.305–29.

FABRIS, G., 'La cronaca di Giovanni da Nono', *Bollettino del Museo Civico di Padova*, 8, 1932, pp.1–33 and 9, 1933, pp.167–200.

FABRIS, G., 'Il palazzo del Podestà e quello degli anziani in una guida trecentesca', *Bollettino del Museo Civico di Padova*, 18, 1925, pp.81–92.

FANELLI, G., *Firenze*, Bari, 1980.

FANELLI, G., *Firenze architettura e città*, Florence, 1973, 2 vols.

FANTELLI, P.L. and PELLEGRINI, F. (eds), *Il Palazzo della Ragione in Padua*, Padua, 1990.

FANTI, S., *Guida storico-artistica della città di Montalcino*, Montalcino, 1974.

FELDGES-HENNING, U., 'The pictorial programme of the Sala della Pace', *Journal of the Warburg and Courtauld Institutes*, 35, 1972, pp.145–62.

FIORELLI-MALESCI, F., *La chiesa di santa Felicità a Firenze*, Florence, 1986.

FLEMING, J., HONOUR, H. and PEVSNER, N., *The Penguin Dictionary of Architecture*, Harmondsworth, 1966.

FOSTER-BAXENDALE, S., 'Exile in practice: the Alberti family in fifteenth-century Florence 1401–1428', *Renaissance Quarterly*, 44, 1991, pp.720–56.

FREDERICK, K.M., 'A program of altarpieces for the Siena Cathedral', *Rutgers Art Review*, 4, 1983, pp.18–35.

FREDERICK, K.M., 'The dating of Simone Martini's S. Ansano altar-piece: a re-examination of two documents', *Burlington Magazine*, 128, 1986, pp.468–9.

FREULER, G., 'Bartolo di Fredis Altar für die Annunziata-Kapelle in S. Francesco in Montalcino', *Pantheon*, 43, 1985, pp.21–39.

FREYHAN, R., 'The evolution of the *Caritas* figure in the thirteenth and fourteenth centuries', *Journal of the Warburg and Courtauld Institutes*, 11, 1948, pp.68–82.

FRUGONI, C., *A Distant City: Images of Urban Experience in the Medieval World*, trans. W. McCuaig, Princeton, 1991.

FRY, R., 'Giotto', *Monthly Review*, London, 1901, reprinted in R. Fry, *Vision and Design*, London, 1920, pp.131–77.

GANTNER, J. (ed.), *Jacob Burckhardt und Heinrich Wölfflin: Briefwechsel und andere Dokumente … , 1882–1897*, Basle, 1948.

GARDNER, J., 'Andrea di Bonaiuto and the chapterhouse frescoes in Santa Maria Novella', *Art History*, 2, 1979, pp.107–38.

GARDNER, J., 'The decoration of the Baroncelli Chapel', *Zeitschrift für Kunstgeschichte*, 34, 1971, pp.89–114.

GARDNER, J., 'The Stefaneschi altarpiece: a reconsideration', *Journal of the Warburg and Courtauld Institutes*, 37, 1974, pp.57–103.

GARDNER, J., *The Tomb and the Tiara: Curial Tomb Sculpture in Rome and Avignon in the Later Middle Ages*, Oxford, 1992.

GARDNER VON TEUFFEL, C., 'The buttressed altarpiece: a forgotten aspect of Tuscan fourteenth century altarpiece design', *Jahrbuch der Berliner Museen*, 21, 1979, pp.21–65.

GARZELLI, A., *Sculture toscane nel Dugento e nel Trecento*, Florence, 1969.

GHERARDI, A. (ed.), *Le Consulte della Repubblica Fiorentina dall'anno MCCLXXX al MCCXCVIII*, Florence, 1896–98.

GIGLIOLI, O., *Pistoia*, Florence, 1904.

GILBERT, C., 'The earliest guide to Florentine architecture', *Mitteilungen des Kunsthistorischen Institutes in Florenz*, 14, 1969–70, p.46.

GILBERT, C., 'Review of Trachtenberg, *The Campanile*', *Art Quarterly*, 35, 1972, pp.427–32.

GILES, K.A., 'The Strozzi Chapel in Santa Maria Novella: Florentine Painting and Patronage, 1340–1355', PhD thesis, New York University, 1977, facsimile Ann Arbor, 1980.

GIORGI, L., 'Lo sviluppo del corpo basicale', in G. Rocchi, A. Bebber, R. Franchi, L. Giorgi and L. Marino, *Santa Maria del Fiore*, Milan, 1988.

GIOSEFFI, D., *Giotto architetto*, Milan, 1963.

Giotto e il suo tempo (Acts of the international congress for the celebration of the seven hundredth anniversary of Giotto's birth, 1967), Rome, 1971.

GLORIA, A., 'Gli origini dei fiumi dai tempi romani alla fine del secolo XII', *Atti e memorie della Reale Accademia delle Scienze, Lettere ed Arti in Padova*, 6, 1, 1891.

GONZATI, B., *La basilica di Sant'Antonio di Padova*, Padua, 1852–53, 2 vols.

GORDON, D., 'A Perugian provenance for the Franciscan double-sided altarpiece by the Maestro di San Francesco', *Burlington Magazine*, 124, 1982, pp.70–7.

GREENSTEIN, J.M., 'The vision of peace: meaning and representation in Ambrogio Lorenzetti's *Sala della Pace* cityscapes', *Art History*, 11, 1988, pp.492–510.

GRONAU, H.D., 'The San Pier Maggiore altarpiece: a reconstruction', *Burlington Magazine*, 76, 1945, pp.139–44.

GROSSATO, L. (ed.), *Da Giotto al Mantegna*, Milan, 1974.

GUASTI, C., *Santa Maria del Fiore*, Florence, 1887.

GUIDONI, E., *Arte e urbanistica in Toscana*, Rome, 1970.

GUIDONI, E., 'Città e ordini mendicanti. Il ruolo dei conventi nella crescità e nella progettazione urbana nei secoli XIII e XIV', *Quaderni medievali*, 4, 1977, pp.69–106.

HALL, M.B, 'The *Tramezzo* in Santa Croce, Florence, reconstructed', *Art Bulletin*, 56, 1974, pp.325–41.

HARPRING, P., *The Sienese Trecento Painter Bartolo di Fredi*, London and Toronto, 1993.

HARRISON, C., 'Giotto and the "rise of painting"', in *Siena, Florence and Padua: Art, Society and Religion 1280–1400*, I, ed. D. Norman, New Haven and London, 1995.

HERKLOTZ, I., *Sepulcra e monumenta del medioevo: studi sull'arte sepolcrale in Italia*, Rome, 1985.

HILLS, P., *The Light of Early Italian Painting*, New Haven and London, 1987.

HOSHINO, H., 'Francesco di Jacopo Del Bene', *Annuario dell'Isituto Giaponese di Cultura*, 4, 1966–67, pp.29–66.

HOSHINO, H., *L'Arte della Lana in Firenze nel basso medioevo*, Florence, 1980.

HOSHINO, H., 'Note sulla compagnia commerciale egli Albizzi del Trecento', *Annuario dell'Isituto Giaponese di Cultura*, 7, 1969–70, p.11.

HUECK, I., 'Stifter und Patronatsrecht: Dokumente zu zwei Kapellen der Bardi', *Mitteilungen des Kunsthistorischen Institutes in Florenz*, 20, 1976.

HUECK, I., 'Zu Enrico Scrovegni's Veränderung der Arenakapelle', *Mitteilungen des Kunsthistorischen Institutes in Florenz*, 17, 1973, pp.5–22.

HUMFREY, P., *The Altarpiece in Renaissance Venice*, New Haven and London, 1993.

HUMFREY, P. and KEMP, M. (eds), *The Altarpiece in the Renaissance*, Cambridge, 1990.

HYDE, J.K., 'Medieval descriptions of cities', *Bulletin of the John Rylands Library*, 48, 1966, pp.308–40.

HYDE, J.K., *Padua in the Age of Dante*, Manchester and New York, 1966.

HYDE, J.K., *Society and Politics in Medieval Italy*, 1973.

JANSON, H.W., *Form Follows Function – or Does It?* (Horst Gerson lecture, University of Groningen, 1981), Maarssen, 1982.

JANSON-LA PALME, R., 'Taddeo Gaddi's Baroncelli Chapel: Studies in Design and Content', PhD thesis, Princeton University, 1976.

JOVINO, G., *La chiesa e il chiostro maiolicato di S. Chiara in Napoli*, Naples, 1983.

KENT, D.V. and DALE, V., *Neighbors and Neighborhood in Renaissance Florence*, Locust Valley, New York, 1982.

KENT, F.W., *Household and Lineage in Renaissance Florence*, Princeton, 1977.

KENT, F.W., 'Palaces politics and society in fifteenth century Florence', *I Tatti Studies*, 2, 1987, pp.41–70.

KING, C., 'Medieval and Renaissance matrons, Italian style', *Zeitschrift für Kunstgeschichte*, 55, 1992, pp.372–93.

KING, C., 'National Gallery 3902 and the theme of Luke the Evangelist as artist and physician', *Zeitschrift für Kunstgeschichte*, 48, 1985, pp.249–55.

KING, C., 'The arts of carving and casting' in *Siena, Florence and Padua: Art, Society and Religion 1280–1400*, I, ed. D. Norman, New Haven and London, 1995.

KING, M.L., *Le donne nel rinascimento in Italia*, Milan, 1991.

KREYTENBERG, G., *Andrea Pisano und die Toskanische Skulptur des 14. Jahrhunderts*, Munich, 1984.

KREYTENBERG, G., 'Der Campanile von Giotto', *Mitteilungen des Kunsthistorischen Institutes in Florenz*, 20, 1978, pp.174–84.

KRISTEVA, J., 'Giotto's joy', in *Calligram: Essays in New Art History from France*, ed. N. Bryson, Cambridge, 1988, pp.27–52.

KUEHN, T., '"Cum consensu mundualdo": legal guardianship of women in Quattrocento Florence', *Viator*, 12, 1982, pp.309–33.

L'osservatore fiorentino su gli edifizi della sua patria, V, Florence, 1798, 8 vols.

LADIS, A., *Taddeo Gaddi: Critical Reappraisal and Catalogue Raisonné*, Columbia and London, 1982.

LADIS, A., 'The legend of Giotto's wit and the Arena Chapel', *Art Bulletin*, 68, 1986, pp.580–96.

LADIS, A., 'The Velluti Chapel at Santa Croce, Florence', *Apollo*, 120, 1984, pp.238–45.

LAVIN, M.A., *The Place of Narrative: Mural Decoration in Italian Churches, 431–1600*, Chicago and London, 1990.

LENSI-ORLANDI, G., *Il Palazzo Vecchio di Firenze*, Florence, 1977.

LIGHTBOWN, D., *Donatello and Michelozzo: An Artistic Partnership and its Patrons in the Early Renaissance*, London, 1980.

LONGHI, R., 'Calepino Veneziano', *Arte veneta*, 1, 1947, pp.79–90.

LUSINI, V., *Il duomo di Siena*, Siena, 1911, 2 vols.

LUSINI, V., 'Note storiche sulla topografia di Siena nel secolo XIII', *Bollettino senese di storia patria*, 28, 1921, pp.239–341.

MAGINNIS, H.B.J., 'Pietro Lorenzetti: a chronology', *Art Bulletin*, 66, 1984, pp.183–211.

MAIONE, I., 'Fra Simone Fidati e Taddeo Gaddi', *L'arte*, 17, 1914, pp.107–19.

MALLORY, M., 'Thoughts concerning the "Master of the *Glorification of Saint Thomas*"', *Art Bulletin*, 57, 1975, pp.9–20.

MARETTO, P., *I portici della città di Padova*, Padua, 1986.

MARTINDALE, A., *The Rise of the Artist in the Middle Ages and Early Renaissance*, London, 1972.

MATTESSINI, F., *Le origini del Terz'ordine francescano: regola antica e vita del beato Lucchese*, Milan, 1964.

MCCULLOCH, M., *Medieval Latin and French Bestiaries*, Chapel Hill, 1960.

MEISS, M., *Painting in Florence and Siena after the Black Death*, Princeton, 1951.

MEISS, M., 'The problem of Francesco Traini', *Art Bulletin*, 15, 1933, pp.97–173.

MELLINI, G.L., *Altichiero e Jacopo Avanzi*, Milan, 1965.

MIDDELDORF-KOSEGARTEN, A., *Sienesische Bildhauer am Duomo Vecchio*, Munich, 1984.

MOSCHETTI, A., 'Il tesoro della cattedrale di Padova', *Dedalo*, 6, 1925.

MOSCHETTI, A., 'Padova al tempo di Giotto', *Bollettino del Museo Civico di Padova*, 26, 1933, pp.65–86.

MOSCHETTI, A., 'Principale palacium communis Padue', *Bollettino del Museo Civico di Padova*, 25, 1932, pp.143–92; 26, 1933, pp.99–105; 27–28, 1934–39, pp.189–261.

MOSKOWITZ, A., *The Sculpture of Andrea and Nino Pisano*, Cambridge, Mass., 1987.

MOSKOWITZ, A., 'Trecento classicism and the campanile hexagons', *Gesta*, 22, 1, 1983, pp.49–65.

Mostra di opere d'arte restaurate nelle province di Siena e Grosseto, I, Genoa, 1979, 2 vols.

Mostra di opere d'arte restaurate nelle province di Siena e Grosseto, II, ed. A.M. Guidicci, Genoa, 1981.

Mostra di opere d'arte restaurate nelle province di Siena e Grosseto, III, ed. M. Ciatti, L. Martini and F. Torchio, Genoa, 1983.

MURARO, M., *Paolo da Venezia*, University Park and London, 1970.

MUSTO, R.G., 'Queen Sancia and the spiritual Franciscans', in *Women of the Medieval World: Essays in Honour of J.H. Mundy*, ed. J. Kirshner and S.F. Wemple, Oxford, 1985.

NARDI, P., 'I borghi di San Donato e di San Pietro a Ovile', *Bollettino senese di storia patria*, 3rd series, 25–7, 1966–68, pp.7–59.

NIERMEYER, J., *Mediae Latinitatis Lexicon Minus*, Leiden, 1976.

NORMAN, D.,'Astrology, antiquity and empiricism: art and learning', in *Siena, Florence and Padua: Art, Society and Religion 1280–1400*, I, ed. D. Norman, New Haven and London, 1995.

NORMAN, D., 'Change and continuity: art and religion after the Black Death', in *Siena, Florence and Padua: Art, Society and Religion 1280–1400*, I, ed. D. Norman, New Haven and London, 1995.

NORMAN, D., 'City, *contado* and beyond: artistic practice', in *Siena, Florence and Padua: Art, Society and Religion 1280–1400*, I, ed. D. Norman, New Haven and London, 1995.

NORMAN, D., 'Duccio: the recovery of a reputation', in *Siena, Florence and Padua: Art, Society and Religion 1280–1400*, I, ed. D. Norman, New Haven and London, 1995.

NORMAN, D., '"Splendid models and examples from the past": Carrara patronage of art', in *Siena, Florence and Padua: Art, Society and Religion 1280–1400*, I, ed. D. Norman, New Haven and London, 1995.

NORMAN, D., 'The case of the *beata* Simona: iconography, hagiography and misogyny in three paintings by Taddeo di Bartolo', *Art History* (forthcoming).

NORMAN, D., 'The commission for the frescoes at Montesiepi', *Zeitschrift für Kunstgeschichte*, 56, 1993, pp.289–300.

NORMAN, D., '"The glorious deeds of the Commune": civic patronage of art', in *Siena, Florence and Padua: Art, Society and Religion 1280–1400*, I, ed. D. Norman, New Haven and London, 1995.

NORMAN, D., 'The three cities compared: patrons, politics and art', in *Siena, Florence and Padua: Art, Society and Religion 1280–1400*, I, ed. D. Norman, New Haven and London, 1995.

OERTEL, R., 'Wandmalerei und Zeichnung in Italien', *Mitteilungen des Kunsthistorischen Institutes in Florenz*, 5, 1940, pp.217–314.

OFFNER, R., 'Giotto, non-Giotto', *Burlington Magazine*, 74, pp.259–68 and 75, pp.96–113, reprinted in *Giotto: The Arena Chapel Frescoes*, ed. J.H. Stubblebine, New York, 1969, pp.135–55.

OFFNER, R. *et al.*, *A Critical and Historical Corpus of Florentine Painting*, Section 3, Volume II, Part 1, New York, 1930.

OFFNER, R. *et al.*, *A Critical and Historical Corpus of Florentine Painting*, Section 4, Volume III, *Jacopo di Cione*, New York, 1965.

OFFNER, R. *et al.*, K., *A Critical and Historical Corpus of Florentine Painting*, Section 4, Volume V, *Giovanni del Biondo* (Part 2), New York, 1969.

OFFNER, R. *et al.*, *A Critical and Historical Corpus of Florentine Painting*, Section 4, Volume VI, *Andrea Bonaiuti*, New York, 1979.

ORIGO, I., *The Merchant of Prato*, London, 1957.

OS, H. VAN, *Marias Demut und Verherrlichung in der sienesischen Malerei 1300–1450*, The Hague, 1964.

OS, H. VAN, *Sienese Altarpieces, 1215–1460: Form, Content, Function*, Gröningen, 1984–90, 2 vols.

PAATZ, W. AND E., *Die Kirchen von Florenz*, Frankfurt am Main, 1952–55, 6 vols.

PÄCHT, O. and ALEXANDER, J., *Illuminated Manuscripts in the Bodleian Library*, Oxford, II, Oxford, 1970, 3 vols.

PALLASSINI, P., *Il monastero e la chiesa della monache di s. Paolo in Siena*, Siena, 1982.

PAMPALONI, G., *Firenze al tempo di Dante*, Rome, 1973.

PERTILE, A., *Storia del diritto Italiano della caduto dell'impero Romano alla codificazione*, III, Turin, 1898–1903, 8 vols.

PETZOLD, A., 'His face like lightening: colour as signifier in the representation of the holy women at the tomb', *Arte Medievale*, 6, 1992.

PIETRAMELLARA, C., *Il duomo di Siena*, Florence, 1980.

PLANT, M., 'Patronage in the circle of the Carrara family: Padua, 1337–1405', in *Patronage, Art and Society in Renaissance Italy*, ed. F.W. Kent and P. Simons, Oxford, 1987, pp.177–99.

PLANT, M., 'Portraits and politics in late Trecento Padua: Atichiero's frescoes in the S. Felice Chapel, S. Antonio', *Art Bulletin*, 63, 1981, pp.406–25.

PLOEG, K. VAN DER, 'Architectural and liturgical aspects of Siena cathedral in the Middle Ages', in H. van Os, *Sienese Altarpieces, 1215–1460: Form, Content, Function*, I, *1215–1344*, Groningen, 1984, pp.107–56.

POPE-HENNESSY, J. 'A misfit master', *New York Review of Books*, 20 November 1980, pp.45–7.

POPE-HENNESSY, J., *Italian Gothic Sculpture: An Introduction to Italian Sculpture*, 2nd edn, New York, 1985, 3rd edn, London, 1986.

POPE-HENNESSY, J., *The Portrait in the Renaissance*, New York, 1963.

PRESTIFILIPPO, S. and SMITTA, T., *Messina artistica, e monumentale*, Messina, 1974.

PREYER, B., 'Two Cerchi palaces in Florence', *Renaissance Studies in Honour of Craig Hugh Smyth*, II, ed. A. Morragh, Florence, 1985, pp.613–30.

PROSDOCIMI, A., 'Note su Fra Giovanni degli Eremitani', *Bollettino del Museo Civico di Padova*, 52, 1, 1963, pp. 15–61.

PRUNAI, G., PAMPALONI, G. and BEMPORAD, N. (eds), *Il Palazzo Tolomei a Siena*, Florence, 1971.

PUPPI, L. and UNIVERSO, M., *Padova*, Bari, 1982.

RASHDALL, H., *The Universities of Europe in the Middle Ages*, ed. F.M. Powicke and A.B. Emden, new edn, Oxford, 1936, 3 vols.

RECHT, R. (ed.), *Les batisseurs des cathedrales gothiques*, Strasbourg, 1989.

RICHARDS, J.C., 'Altichiero and Humanist Patronage at the Courts of Verona and Padua, 1360–1390', PhD thesis, University of Glasgow, 1988.

RINGBOM, S., *From Icon to Narrative*, Åbo, 1965.

ROCCHI, J., BEBBER, A., FRANCHI, R., GIORGI, L. and MARINO, L., *Santa Maria del Fiore*, Milan, 1988.

ROMANINI, A.M., *Arnolfo di Cambio*, 2nd edn, Florence, 1980.

ROMANO, S., 'Due affreschi del Cappellone degli Spagnoli: problemi iconologici', *Storia dell'arte*, 28, 1976, pp.181–213.

ROSSETTI, F., *La beata Angelina dei Conti di Monteriggione*, Florence, 1976.

ROUGH, R.H., 'Enrico Scrovegni, the Cavalieri Gaudenti and the Arena Chapel in Padua', *Art Bulletin*, 62, 1980, pp.24–35.

ROWLEY, G., *Ambrogio Lorenzetti*, Princeton, 1958, 2 vols.

RUBINSTEIN, N., 'Political ideas in Sienese art: the frescoes by Ambrogio Lorenzetti and Taddeo di Bartolo in the Palazzo Pubblico', *Journal of the Warburg and Courtauld Institutes*, 21, 1958, pp.179–207.

RUBINSTEIN, N., 'The beginning of political thought in Florence: a study in medieval history', *Journal of the Warburg and Courtauld Institutes*, 5, 1942, pp.182–227.

RUBINSTEIN, N., 'The Piazza della Signoria in Florence', in *Festschrift für Herbert Siebenhüner*, Würzburg, 1978.

RUSKIN, J., *Giotto and his Works in Padua: Being an Explanatory Notice of the Series of Wood-cuts Executed for the Arundel Society after the Frescoes in the Arena Chapel*, London, 1854.

SARTORI, A., 'La Cappella di S. Giacomo al Santo di Padova', *Il Santo*, 6, 1966, pp.267–359.

SARTORI, A., 'Nota su Altichiero', *Il Santo*, 3, 1963, pp.291–326.

SCHEVILL, F., *History of Florence from the Founding of the City through the Renaissance*, New York, 1936, reprinted 1961.

SCHEVILL, F., *Siena: The History of a Medieval Commune*, New York, 1964.

SCHLEGEL, U., 'On the picture program of the Arena Chapel' (1957), in *Giotto: The Arena Chapel Frescoes*, ed. J.H. Stubblebine, New York, 1969, pp.182–202.

SCHLOSSER, J. VON, 'Giusto's Fresken in Padua und die Vorläufer des Stanza della Segnatura', *Jahrbuch der kunsthistorischen Sammlungen des Allerhöchsten Kaiserhauses*, 17, 1896, pp.13–100.

Scultura dipinta, maestri di legname e pittori a Siena 1250–1450, Florence, 1987.

SEIDEL, M., 'Das Grabmal von Kaiser Heinrich VII, in Pisa', *Mitteilungen des Kunsthistorischen Institutes in Florenz*, 27, 1984.

SHORR, D., 'The role of the Virgin in Giotto's *Last Judgement*', *Art Bulletin*, 38, 1956, pp.207–14, reprinted in *Giotto: The Arena Chapel Frescoes*, ed. J.H. Stubblebine, New York, 1969, pp.169–82.

SIMON, R., 'Altichiero versus Avanzo', *Papers of the British School at Rome*, 45, n.s.32, 1977, pp.252–71.

SIMPSON, O. VON, 'Über die Bedeutung von Masaccios Trinitäts-fresko in S. Maria Novella', *Jahrbuch der Berliner Museen*, 8, 1966, pp.119–59.

SKINNER, Q., 'Ambrogio Lorenzetti: the artist as political philosopher', *Proceedings of the British Academy*, 72, 1986, pp.1–56.

SOLBERG, G.E., 'Taddeo di Bartolo: His Life and Work', PhD thesis, New York University, 1991.

SOUTHARD, E.C., 'The earliest known decoration for the Palazzo Pubblico', *Burlington Magazine*, 121, 1979, pp.517–18.

SOUTHARD, E.C., 'The Frescoes in Siena's Palazzo Pubblico, 1289–1539: Studies in Imagery and Relations to Other Communal Palaces in Tuscany', PhD thesis, Indiana University, 1978, facsimile Ann Arbor, 1980, 2 vols.

SPIAZZI, A.M., 'Giusto a Padova: la decorazione del battistero' in *Giusto de'Menabuoi nel battistero di Padova*, ed. A.M. Spiazzi, Trieste, 1989.

SPIAZZI, A.M., 'Padova', in *La pittura nel Veneto. Il Trecento*, I, ed. M. Lucco, Milan, 1992, pp.88–177.

SPILNER, P., 'Giovanni di Lapo Ghini and a magnificent new addition to the Palazzo Vecchio, Florence', *Journal of the Society of Architectural Historians*, 11, 1993, pp.453–65.

STARN, R., 'The republican regime of the *Room of Peace* in Siena, 1338–1340', *Representations*, 18, 1987, pp.1–32.

STARN, R. and PARTRIDGE, L., 'The republican regime of the Sala dei Nove in Siena, 1338–1340', in *Arts of Power: Three Halls of State in Italy, 1300–1600*, Berkeley, Los Angeles and Oxford, 1992, pp.11–59.

STEFANINI, R., Appendix 1 in R. Starn and L. Partridge, *Arts of Power: Three Halls of State in Italy, 1300–1600*, Berkeley, Los Angeles and Oxford, 1992, pp.261–6.

STOPANI, R., *La via francigena. Una strada Europea nell'Italia del medioevo*, 2nd edn, Florence, 1992.

Storia di Napoli, III, Naples, 1961, 11 vols.

STUBBLEBINE, J.H., 'Duccio and his collaborators on the cathedral *Maestà*', *Art Bulletin*, 55, 1973, pp.185–204.

STUBBLEBINE, J.H., *Duccio di Buoninsegna and his School*, Princeton, 1979.

STUBBLEBINE, J.H., 'The angel pinnacles on Duccio's *Maestà*', *Art Quarterly*, 22, 1969, pp.132–52.

STUBBLEBINE, J.H., 'The back predella of Duccio's *Maestà*', in *Studies in Late Medieval and Renaissance Painting in Honor of Millard Meiss*, ed. I. Lavin and J. Plummer, New York, 1977, pp.430–6.

STUBBLEBINE, J.H. (ed.), *Giotto: The Arena Chapel Frescoes*, New York, 1969.

SULLIVAN, R.W., 'Duccio's *Raising of Lazarus* re-examined', *Art Bulletin*, 70, 1988, pp.375–87.

SULLIVAN, R.W., 'Some Old Testament themes on the front predella of Duccio's *Maestà*', *Art Bulletin*, 68, 1986, pp.597–609.

SULLIVAN, R.W., 'The Anointing in Bethany and other affirmations of Christ's Divinity on Duccio's back predella', *Art Bulletin*, 67, 1985, pp.32–50.

SYMEONIDES, S., *Taddeo di Bartolo*, Siena, 1965.

The Galleria dell'Accademia, Guide to the Gallery and Complete Catalogue, Florence, 1987.

TINTORI, L. and MEISS, M., *The Painting of the 'Life of St Francis' in Assisi with Notes on the Arena Chapel*, New York, 1962, partially reprinted in *Giotto: The Arena Chapel Frescoes*, ed. J.H. Stubblebine, New York, 1969, pp.203–24.

TOFFANIN, G., *Cento chiese padovane scomparse*, Padua, 1988.

TOKER, F., 'Florence cathedral: the design stage', *Art Bulletin*, 60, 1978, p.220.

TORRITI, P., *La casa di santa Caterina e la basilica di san Domenico a Siena*, Genoa, 1983.

TORRITI, P., *La Pinacoteca Nazionale di Siena: i dipinti*, 3rd edn, Genoa, 1990.

TRACHTENBERG, M., 'Archaeology, merriment, and murder: the first cortile of the Palazzo Vecchio and its transformations in the Late Florentine Republic', *Art Bulletin*, 41, 1989, pp.565–609.

TRACHTENBERG, M., *The Campanile of Florence Cathedral, 'Giotto's Tower'*, New York, 1971.

TRACHTENBERG, M., 'What Brunelleschi saw: monument and site at the Palazzo Vecchio in Florence', *Journal of the Society of Architectural Historians*, 47, 1988, pp.14–44.

TREXLER, R.C., *Public Life in Renaissance Florence*, New York, 1980.

VALENTINER, W., *Tino di Camaino*, trans. J. Walther, Paris, 1935.

VAN DER PLOEG, K., *Art, Architecture and Liturgy*, The Hague, 1993.

VASOIN, G., *La signoria dei Carraresi nella Padova del'300*, Padua, 1988.

VENTURI, A., *Storia dell'arte Italiana*, Volume IV (1906), *La scultura del Trecento*, Milan, 1901–40, 11 vols.

VERDI, A., *Le mura ritrovate*, Padua, 1988.

VERDI, A., 'Il mercato padovano alla fine del secolo XIII secondo la descrizione contenute nella Visio Egidii Regis Patavie di Giovanni da Nono', in *Il Palazzo della Ragione in Padova a cura di Pier Luigi Fantelli e Franca Pellegrini*, Padua, 1990.

VOLPE, C., *Pietro Lorenzetti*, ed. M. Lucco, Milan, 1989.

WACKERNAGEL, M., *Der Lebensraum des Künstlers in der florentinischen Renaissance: Aufgaben und Auftraggeber, Werkstatt und Kunstmarkt*, Leipzig, 1938.

WACKERNAGEL, M., *The World of the Florentine Renaissance Artist: Projects and Patrons, Workshop and Art Market*, trans. A. Luchs, Princeton, 1981.

WALEY, D., 'Ambrogio Lorenzetti's dancing maidens', *Apollo*, 134, 1991, pp.141–2.

WALEY, D., *Siena and the Sienese in the Thirteenth Century*, Cambridge, 1991.

WATTENBACH, L., 'Über die Legende von den heiligen Vier Gekronten', *Sitzungsberichte der Königlichen Preussischen Akademie der Wissenschaften*, 2, 1896.

WEINSTEIN, D.,'The myth of Florence', in *Florentine Studies: Politics and Society in Renaissance Florence*, ed. N. Rubinstein, London, 1968, pp.15–44.

WHITE, J, *Art and Architecture in Italy 1250–1400* (The Pelican History of Art), 3rd edn, New Haven and London, 1993.

WHITE, J., *Duccio: Tuscan Art and the Medieval Workshop*, London, 1979.

WHITE, J., 'Measurement, design and carpentry in Duccio's *Maestà*', I, II, *Art Bulletin*, 55, 1973, pp.334–66, 547–69.

WHITE, J., *The Birth and Rebirth of Pictorial Space*, 3rd edn, London, 1972.

WHITE, J., 'The reconstruction of the polyptych ascribed to Guariento in the collection of the Norton Simon Foundation', *Burlington Magazine*, 117, 1975, pp.517–526.

WILSON, B., *Music and Merchants: The Laudesi Companies of Republican Florence*, Oxford, 1992.

WOLTERS, W., 'Il Trecento', in *Le sculture del Santo di Padova*, ed. G. Lorenzoni, Vicenza, 1984.

WOLTERS, W., *La scultura veneziana gotica 1300–1460*, Venice, 1976, 2 vols.

ZANOCCO, R., 'The Annunciation at the Arena of Padua, 1305–1309' (1937), in *Giotto: The Arena Chapel Frescoes*, ed. J.H. Stubblebine, New York, 1969, pp.127–31.

ZERI, F., 'Due appunti su Giotto', *Paragone*, 8, January 1957, pp.75–87.

ACKNOWLEDGEMENTS

Grateful acknowledgement is made to the following source for permission to use material in this book:

Chapter 7: Starn, R. and Partridge, L. (1992) *Arts of Power: Three Halls of State in Italy, 1300–1600*, University of California Press, copyright © 1992 The Regents of the University of California.

Index

Works of art are listed under names of artists. Where attributions are not known, works are listed under locations. If it is felt that confusion might arise, further information is given in parentheses. Names that contain reference to parentage or place of origin or principal activity are listed under Christian names. Other names are listed under family names. Page numbers in bold type are those on which illustrations appear. The abbreviations assis., attrib., assoc. and m. mean and assistants, attributed to, associate of, and married to, respectively.